LIFE AND WORK OF THOMAS EAKINS

4

P9-EAJ-026

LIFE AND WORK OF THOMAS EAKINS

The Life and Work of
THOMAS EAKINS

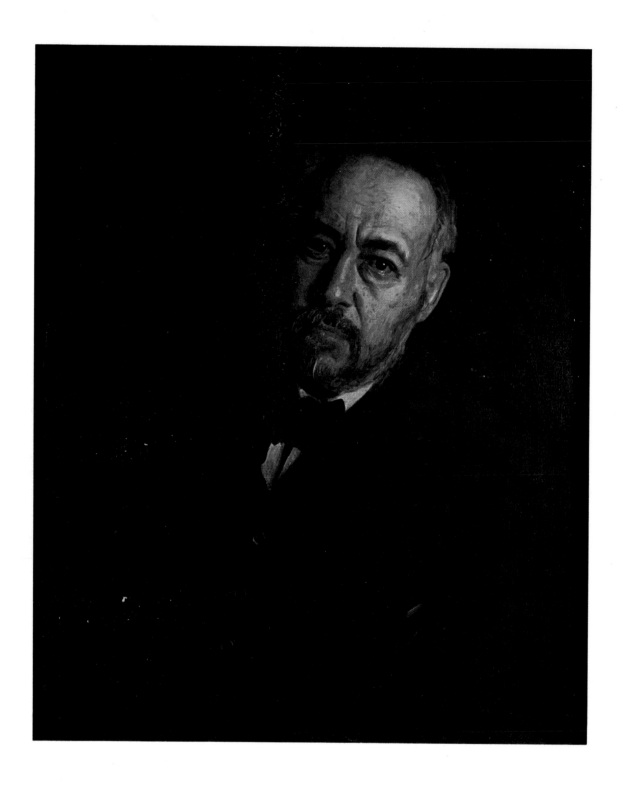

Plate 1 (frontispiece). *Self-Portrait*, 1902. Oil on canvas, 30″ × 25″ (76.2 × 63.5 cm). The National Academy of Design, New York.

THE LIFE AND WORK OF
THOMAS EAKINS

Gordon Hendricks

Grossman Publishers
New York, 1974

Copyright © 1974 by Gordon Hendricks
All rights reserved
First published in 1974 by Grossman Publishers
625 Madison Avenue, New York, N.Y. 10022
Published simultaneously in Canada by
Fitzhenry and Whiteside, Ltd.
SBN 670-42795-0
Library of Congress Catalogue Card Number: 73-4174
Text and black-and-white photographs printed in U.S.A.
Color photographs printed in Japan

To
Constance and Ted Richardson

Contents

List of Illustrations

Preface

The most substantial contribution to Eakins literature for many years has unquestionably been the biography published in 1933 by Lloyd Goodrich.* In the early 1930s, when Mrs. Eakins made her great gift of more than sixty of her husband's works to the Philadelphia Museum, when the Eakins–Homer–Ryder show was held in the Whitney Museum in New York, and when a spate of magazine articles on Eakins began to appear, Goodrich went to Philadelphia, talked to Mrs. Eakins and numerous friends and students of the artist, saw many original documents—many of which are now lost or unlocated—and wrote his conclusions. His catalogue, containing more than five hundred works, is a continuing source of valuable, almost indispensable information. It is the basic outline upon which all scholars must depend until a fuller list appears. Other works have turned up since Goodrich's book was published, and some of the dates and miscellaneous details concerning the works in Goodrich's list must now be changed. But art history had, in this writer, an intelligent, honest, responsible worker who had access to every known document concerning the artist. Unfortunately he wrote at a time when the identification of sources and the clear separation of fact from opinion was not *de rigueur*. Since the appearance of his work, therefore, a need has often been felt for a thorough examination of the facts of the artist's life which would continually identify sources and make clear the distinction between what the historian assumed and what he knew to be true.

New facts and a storehouse of previously unknown material from many individuals who knew the artist and his family were presented by Margaret McHenry in 1946. *Thomas Eakins Who Painted* is an incoherent, jumbled, frustrating book, but it is still possible for the specialist to come suddenly upon a sentence or phrase, which he had somehow missed before, that sheds a new light on some aspect of the artist's life. In her resolve to be "literary," McHenry obscures and sometimes distorts material that must have been clear to her, and her chronology is extremely questionable. But in spite of these weaknesses this book is still second-best in the spare list of Eakin biographies.

The most recent contribution to this list is Sylvan Schendler's *Eakins*. The author disclaims any attempt to write a biography, but ends up doing so nonetheless, and sometimes presents acute observations on the artist's life and milieu. He also disclaims any pretense to being a proper art historian, but this does not prevent him from entering the lists against art historians and disagreeing with them in conclusions about the artist's meanings and contribution. He appears to have done re-

* See Bibliography starting on page 305 for references mentioned in this preface.

search principally for the purpose of lending what he considered a scholarly leavening to a distended series of opinions about the psychological and social significance of the artist's paintings. He chiefly followed the research of Goodrich and McHenry, adding bits and pieces of his own. Like McHenry he strives for literary effect and often loses the reader in a maze of labored references to the interrelation of the arts, the sciences, and the mind.

Until recent years the relatively few magazine articles that had appeared on Eakins added little or nothing to what we know of the facts of the artist's life. They have not, therefore, contributed much to our understanding or appreciation of why he was the great, isolated figure he was. Without knowing what the artist did and when he did it, we cannot conjecture successfully about the "why" and its significance. It was a recognition of this state of affairs—the relatively small amount of work done and even that work flawed by a lack of documentation—that led to my own work. We do not need or want a book laden with the ornaments of learning, or one written in a ponderous academic style. But the facts must be set down, their sources given, and fact cleanly separated from opinion. This book, I hope, will accomplish this purpose.

An article of mine in the September 1964 issue of *The Art Bulletin* on the American painter Albert Bierstadt led to an invitation from the Philadelphia Museum to write a *catalogue raisonné* of the Eakins works in that collection. I had already done considerable work on the artist's life in connection with a forthcoming biography of Eadweard Muybridge, "the father of the motion picture," with whom Eakins was closely associated at the University of Pennsylvana in 1884–1885. But the Philadelphia project led me to uncover an enormous amount of previously unknown material and resulted in plans for a Philadelphia Museum catalogue, an Eakins photographic exhibition and catalogue,* the book *The Photographs of Thomas Eakins* (see Bibliography), a number of magazine articles, and now, in 1974, the present book.

During the seven years I have worked more or less intensively on the life and work of Thomas Eakins, I have been helped by numerous people. I can never express to all of them the particular appreciation I feel. I have occasionally referred to this debt of gratitude in appropriate parts of the text, but it would be impossible for me to give the proper acknowledgment to each of these individuals in terms of the significance or quantity of help I received. I therefore list them alphabetically with the author's

* The exhibition "Thomas Eakins: His Photographic Works" opened at the Pennsylvania Academy of the Fine Arts on January 7, 1970, supplanting the Academy's regular Annual.

conventional apology for inadequacy or possible omission: George Barker, Dr. Edward Louis Bauer, Susan Bloom, Barbara Burn, Edward T. Burns, Manuel Casañes Carruana, Guido Castelli, Harry F. S. Clark, Susan Cooley, Caroline Crowell, Frances Crowell, James Crowell, Will Crowell, Larry Curry, Jennie and Dan Dietrich, Charles B. Ferguson, Richard Finnegan, Joseph T. Fraser, Jr., Mrs. John Randolph Garrett and family, Frank Gettings, Mildred Goosman, Chris Huber, H. W. Janson, W. F. Keough, Jr., Dorothy Lapp, Michael Loeb, Thomas Lord, Laura Luckey, Walter Macdowell, Hyatt Mayor, Cynthia McCabe, Garnett McCoy, Ruth Minnick, Priscilla Muller, Maria Naylor, Beaumont Newhall, Robert Newkirk, Thomas Norton, Rolf Petersen, the staff of the newspaper room of the Philadelphia Free Public Library, Hobson Pittman, Brian Reade, Constance and Ted Richardson, Amelia Rosselli, Julia Sabine, Evanthia Saporiti, John Shellem, Theodore Siegl, Lucy Stephens, William B. Stevens, Jr., Margaret Tinkcom, Gertrude Toomey, Christine Trostle, Mary M. Walters, Ellen Welker, Hobart Lyle Williams, and Rudolph Wunderlich.

I am particularly grateful to Dr. Caroline Crowell and Mrs. John Randolph Garrett, Senior, the artist's nieces, for permission to quote from family letters.

Chronology

1844	July 25. Thomas Cowperthwaite Eakins born at 4 Carrollton Square, Philadelphia
1853	Enters Zane Street Grammar School; produces first known art
1857	Enters Central High School; moves to 1729 Mt. Vernon Street
1861	July 11. Graduates from Central High School
1862	October. Evidently first study at the Pennsylvania Academy of the Fine Arts
1864–1865	Attends Jefferson Medical College anatomy classes
1865?	First life study, at Pennsylvania Academy
1866	September 22. Sails for Europe for study in Paris October 29. Enters École des Beaux Arts for study with Jean Léon Gérôme and Augustin Dumont
1867	March. Evidently first work in oil at École
1869	August–September. Study with Léon Bonnat November 29. Leaves for Spain
1870	June–July. Returns to U. S. via Paris and probably England
1871	April 26. First exhibition, at Philadelphia Union League; shows *The Champion Single Sculls* and a portrait of M. H. Messchert
1872	June 4. Death of mother
1872–1875	Principal sculling and sailing works: *A Pair-Oared Shell*; *The Biglin Brothers Turning the Stake*; *The Biglin Brothers Racing*; *Sailing*; *Starting Out after Rail*; *Pushing for Rail*, etc.
1873–1874	Attends anatomy lectures at Jefferson Medical College
1874	First teaching, at Philadelphia Sketch Club
1875	*Portrait of Professor Gross* (*The Gross Clinic*)
1876	*Portrait of Professor Gross* rejected for 1876 Centennial Exposition. *The Chess Players*. First teaching at Pennsylvania Academy of the Fine Arts
1876–1877	*William Rush* paintings and sculpture
1877	May. Leaves the Academy, organizes the Philadelphia Society of Artists, teaches there
1878	March 22. Returns to the Academy to teach
1879	*Portrait of Professor Gross* gets bad reviews in New York and Philadelphia. *A May Morning in the Park* (*The Fairman Rogers Four-in-hand*) shows animals in rapid motion for the first known time in the history of art August. Christian Schussele, Eakins' Academy teacher,

dies, and Eakins succeeds him as "Professor of Drawing and Painting"

1880	Only religious painting, *Crucifixion*. First known work in photography about this time
1882	Fishing works, such as *Mending the Net, Shad Fishing at Gloucester*. Begins teaching at Brooklyn Art Guild. *The Pathetic Song*. First serious Academy discontent with teaching methods
	December. Sister Margaret dies
1883	Academy starts charging tuition; Fairman Rogers resigns. First professional work in sculpture about this time
1883–1885	*The Swimming Hole*
1884	January 19. Marries Hannah Susan Macdowell, a student
1884–1885	Work at the University of Pennsylvania with Eadweard Muybridge on the photography of motion
1886	February. Resigns from the Academy; many students follow him and organize the Philadelphia Art Students' League
1886 or 1887	Meets Samuel Murray
1887	July–October. Trip to Dakota Territory
1888	*Cowboys in the Badlands; Portrait of Walt Whitman*
	Begins seven-year teaching period at New York Art Students' League
1888–1889	*The Agnew Clinic*
1890–1892	*The Concert Singer*
1891	Begins to exhibit again at Academy
1892?	Philadelphia Art Students' League disbands
1892	Resigns from Society of American Artists
1892–1895	Brooklyn Memorial Arch and Trenton Battle Monument sculptures
1895	*Portrait of Frank Hamilton Cushing*
1896	May 12. Only one-man show during lifetime opens at Earle's Gallery in Philadelphia
1897	July 2. Niece Ella Crowell commits suicide and Eakins is forbidden to visit farm
1898–1899	Boxing and wrestling works: *Taking the Count, Salutat, Between Rounds, The Wrestlers*
1899	*The Dean's Roll Call*
	December 30. Death of father
1899–1900	Portraits of Mary Adeline Williams
1900	Exhibits in Paris World's Fair. *Antiquated Music* (Por-

	trait of Mrs. William D. Frishmuth). Moves back into Mt. Vernon Street from 1330 Chestnut Street about this time
1901	*Portrait of Leslie Miller*
1903–1905	Important clerical portraits: of Sebastian Cardinal Martinelli, Archbishop William Henry Elder, and Monsignor Diomede Falconio
1905	Portraits of John B. Gest and A. W. Lee
1906–1907	*Portrait of Helen Montanverde Parker* (*The Old-Fashioned Dress*)
c. 1908	Returns to *William Rush* theme
1910	*Portrait of Mrs. Gilbert Lafayette Parker*
1912	November 23. Exhibits in Lancaster, Pennsylvania
1914	Albert Barnes buys study for *The Agnew Clinic*
1913–1914	Last known work, *Portrait of Dr. Edward Anthony Spitzka*
1916	June 25. Dies
1917	November 5. Memorial Exhibition opens at Metropolitan Museum of Art, New York City
	December 23. Memorial Exhibition opens at Pennsylvania Academy of the Fine Arts
1929	November. Mrs. Thomas Eakins gives about sixty works to the Philadelphia Museum of Art
1938	December 27. Mrs. Thomas Eakins dies
1944	Centennial Exhibition
1961	October 8. Retrospective Exhibition opens at National Gallery, Washington, D. C.
1970	January 8. Exhibition of Eakins' photographs opens at Pennsylvania Academy of the Fine Arts
	September 22. Retrospective Exhibition at the Whitney Museum of American Art, New York City

Introduction

In 1844, when Thomas Eakins was born, romantic landscapes held sway in American art. Portraits were still a popular and recognized symbol of social status for the sitter, but the photograph had begun to supplant painting, and eventually the painter was called upon only for occasions of unusual celebrity or formality. In the Philadelphia of 1844 even such important portraitists as Thomas Sully and the last conspicuous Peale, Rembrandt, were in a decline, after an apogee in the 1820s and 1830s. The romantic landscapists, led by Thomas Cole and Asher Durand, and the practitioners of the new *genre*, such as William Sidney Mount and George Caleb Bingham, were in the mainstream, and by the early 1860s, when Eakins began to study painting seriously, landscape and genre were the principal preoccupations of American artists. In 1862, when Eakins began his study at the Pennsylvania Academy of the Fine Arts, Sully was in his decline, turning out patterned portraits that were only a shadow of his best work; Rembrandt Peale was dead.

Still-life, landscape, and genre, the only fields in art that held any promise for the future, were alien to Eakins' nature. So he began to "find" himself, as thousands before him had done, by drawing from life as it appeared before him in the living model and in antique casts. He soon discovered that the portrayal of the humanity about him, fashionable or not, was his vocation. He persisted in his way, despite onslaughts from friends and enemies alike, until his death in 1916, when he left behind not just the greatest portraits in American art but certainly the greatest over-all contribution of any American artist up to his time in any field.

He learned something of what portraiture was all about from paintings he knew well, such as those by Stuart, Neagle, and the Peales then at the Pennsylvania Academy of the Fine Arts, and in various private collections in Philadelphia to which he as an Academy student had access. But it is vain to try to find the influence of such Stuarts as the Academy's Washington portraits or of such Sullys as the portraits of Carey, Cooke, or the Kembles in Eakins' work. It is no less an exercise in frustration to try to find the influence of Jean Léon Gérôme, Eakins' principal teacher, although Gérôme was the artist whom Eakins most admired and to whom he gave the most credit. And of the impressionists and their immediate predecessors, whose work was swirling about the young American artist in his formative student years, there is no trace of an effect. Not quite the same can be said for Ribera and Velázquez, however, who were particular favorites. The work of these men has a directness and a psychological penetration that more than one historian has found closely parallel to Eakins'.

There is also much of Philadelphia in Eakins. E. P. Richardson sees

a parallel between Eakins' forthrightness and that of John Singer Sargent and Mary Cassatt, who were also Philadelphians. He also speaks of the city itself as having "a passion for the actual, a Dutch sense of the poetry of fact." * These are indeed Philadelphia qualities. But other Philadelphia traits—smugness, inertia, the languor of culture—are what drove Eakins nearly to desperation. Philadelphia could not be moved when the artist was born, it could not be moved during his lifetime, it could not be moved when he died neglected by the local establishment in 1916. Even now, except in the most glacial way, it still cannot be moved.**

During Eakins' lifetime, except for a few remarkable insights, his art was little appreciated. It was profoundly original and independent and, perhaps for this very reason, far from the mainstream. Originality by definition excludes understanding and appreciation except by a few. And although Eakins' work is often considered to be the greatest in American art, it has had a remarkably sparse influence. Few could paint like Eakins. But even fewer seemed to want to. What he did was so well-done and so complete that attempts at modification, enlargement, or emulation seem doomed from the outset.

* *Painting in America* (New York, 1956) page 320.
** Whatever is said about Philadelphia now, worse has been said about Philadelphia by Philadelphians, and on numerous occasions. In Eakins' time the *Inquirer*, the *Bulletin*, and the *Telegraph* were particularly sarcastic. Today the *Inquirer* and the *Bulletin* still upbraid the city for its lack of sensitivity.

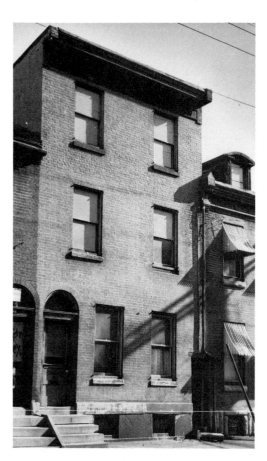

Fig. 1. Eakins' birthplace at 4 Carrollton
Square, Philadelphia, 1972. This is now
539 Tenth Street. When Eakins was born
here in 1844 the house was two-storied
as in the house at the right.

Fig. 2. Eakins' photograph of Emmor Cowperthwaite, his
uncle, c. 1882. 4⅛″ × 3¼″ (10.5 × 8.2 cm). Author's
collection. Taken in the backyard of 1729 Mt. Vernon
Street, Philadelphia.

Fig. 3. Caroline Cowperthwaite Eakins, Thomas Eakins'
mother, c. 1850. 6⅛″ × 4¼″ (15.5 × 10.8 cm), irregular.
Author's collection. Wet collodion photograph.

Birth, Childhood, Youth
1844-1866

Thomas cowperthwaite eakins was born on July 25, 1844, at 4 Carrollton Square in Philadelphia. The previous year his father Benjamin had married Caroline Cowperthwaite and moved from 10 Sergeant Street, a few blocks away, into the house in Carrollton Square (Fig. 1). There his bride had been living with her mother and sister since her father Mark's death several years before.

Today Carrollton Square is the block on the east side of 10th Street between Spring Garden and Green streets. And No. 4, Eakins' birthplace, still stands as No. 539 10th Street. It was, in Eakins' time, a two-story house, built in about 1831 by an Isaac Davis, when Carrollton Square itself was opened. Across the street, on the west side of 10th, there was a lumberyard and no street numbers. Thus we can settle on the fourth house from the northeast corner of Spring Garden and 10th as Eakins' birthplace—the corner house had a Spring Garden number.[1]

Mark Cowperthwaite is said to have come from Cumberland County in South Jersey, but the Cumberland County records of property holders show no such name, nor do the marriage records and such local histories as exist. Nor is there a Cowperthwaite in any appropriate local cemetery. But wherever Mark came from, the Philadelphia directory shows him set up as a ladies' shoemaker with his son Samuel at the corner of 6th and Spruce in 1835. His son Emmor, who lived well into the years

The Life and Work of
THOMAS EAKINS

of Thomas Eakins' artistic career, had apparently preceded him into the city (Fig 2). We know that he opened an upholstery shop at 16 Perry Street in 1833. Mark died in 1837 after forty-two years of married life, and his wife, Margaret Jones Cowperthwaite, then moved to the rented premises at 4 Carrollton Square, with her daughters Caroline and Eliza (Figs. 3 and 4). Caroline, Thomas Eakins' mother, born in 1820, was the youngest of ten children. Her brother, Thomas, for whom Thomas Eakins was named, was born in 1816, and his "worn out gold watch," given to the artist by his mother, was described among the few chattels listed in the 1883–1888 account book kept by Thomas Eakins. Uncle Tom died in the spring of 1886.

Eakins' father Benjamin (Fig. 5) was born on Washington's Birthday in 1818 on a farm in what later became Schuylkill Township in Chester County, a short distance up the river from Philadelphia. His father, Alexander, who then spelled his name Akens, had come from Ireland, according to family tradition, in about 1812, and in that year, on October 15, he married Frances Fife. If custom was observed, the two got married in Ireland first and set out to the Promised Land together.

In 1828 Alexander Akens traveled down to the Mayor's Court in Philadelphia

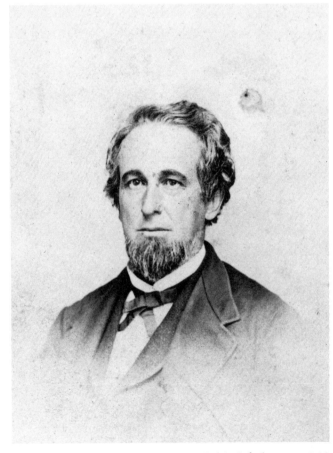

Fig. 4. Eakins' photograph of Eliza Cowperthwaite, his aunt, 1880s. 4⅜″ ×3⅜″ (11.1 × 8.6 cm). Author's collection. Taken in side yard of 1729 Mt. Vernon Street.

Fig. 5. Benjamin Eakins, Thomas Eakins' father, c. 1866. Author's collection. Carte de visite.

and became an American citizen, swearing in a citizenship certificate that

> he had behaved as a man of good moral character; attached to the principles of the Constitution of the United States and [was] well disposed to the good order and happiness of the same; and did absolutely and entirely renounce forever and adjure all allegiance and fidelity to every foreign prince, potentate, state and sovereignty whatever, and particularly to the King of Great Britain and Ireland of whom he was before a subject.

This certificate states that he had lived in America at some time before 1812, but the space for the number of years in America has been left blank; it may be that this clause of the instrument of naturalization was a perfunctory one. In any case, 1828 seems to have been the logical time for the change from "Akens" to "Eakins."

In Chester County Alexander Akens—or Eakins—set up as a weaver and is said to have traveled about on foot with his loom. He evidently never owned any land, since Chester County indices of grantors and grantees of deeds fail to list either an Akens or an Eakins. When Alexander Eakins died on August 4, 1839, he left his four children, Jane, John, Benjamin, and Frances, a spare list of chattels, and no real estate whatever. The list included corn "in the ear" and "in the ground"; thirty dollars' worth of hay; forty dollars' worth of wheat; a little rye, and straw; farm tools; a loom; two cows (fifty dollars); household goods—bureau, two beds, tables, chairs, a corner cupboard, clothes press, a dough trough. The total value came to two hundred fifty-nine dollars and eighty-one and a quarter cents. Alexander's daughter Fanny, then nineteen, was to be paid a dollar a week from the time of the will, May 1839, until her father's death—which made it only about ten weeks—and his son Benjamin was named executor. The will may even have been written by Benjamin, since it is in the fine copperplate style that was his as a writing master in later years.

Alexander's wife had died three years earlier, and there was apparently little to keep his son Benjamin on the farm. So he went to Philadelphia and settled down at 10 Sergeant Street as a writing teacher. How or why he became a writing teacher is not known, but it is as natural for the son of a weaver, a man with finely adept hands, to have become a writing master as it is for Thomas Eakins, the son of a writing master, to have taken another step and become a painter. Benjamin Eakins was able to establish good professional contacts early in his career, and he may have met Caroline Cowperthwaite during the course of his work. Knowing how to write in an "artistic" manner was a desirable accomplishment for the daughters of solid families in those days, and the Cowperthwaites, it was clear, had become definitely solid in the decade since the first of them had joined the Philadelphia commercial whirl.

Caroline and Benjamin Eakins stayed at 4 Carrollton Square until 1852, when they moved into 1201 Green Street. From 1201 Green they moved into 505 Green, where they stayed until they moved in 1857 into a house at 1725 Washington Street— an address later changed by the city to 1729 Mt. Vernon Street (Fig. 6). The house had

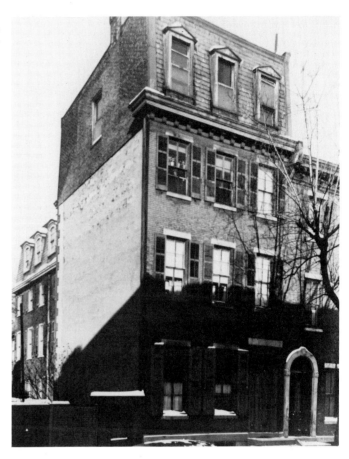

Fig. 6. 1729 Mt. Vernon Street, Philadelphia, c. 1936. Modern enlargement. The Historical Society of Pennsylvania.

been built four years earlier by a bricklayer, David C. Moore, and was sold to Benjamin Eakins on July 11, 1857, at a sheriff's sale, for $4800.

Three of the Eakinses' five children were born at Carrollton Square—Thomas in 1844, Frances in 1848, and Benjamin, Jr., in 1850. Benjamin, Jr., died when he was four months old, and he was buried in the family plot in Woodlands Cemetery in Philadelphia, the first of the family to lie in a burial ground that was to receive his brother Tom sixty-five years later.

For the first four years of his life Thomas Eakins was an only child, and the affection and attention of doting parents, uncles, aunts, and the surviving grandparent —Margaret Cowperthwaite—were lavished upon him. When his sister Frances came along and the affection became divided, some stubbornness and a slight petulance, evident perhaps in photographs of Eakins as a child, may have begun to set in (Figs. 7 and 8).

Before he entered grammar school at the age of nine in 1853, Thomas was taught at home. He learned writing and probably drawing of some sort from his father, and perhaps other subjects from other members of the family. This practice was not uncommon among Philadelphia children of the time, although most went to public school at an earlier age, with an average of five or six years' schooling before high school. Until 1836 attendance at public schools had been a mark of poverty, since children of families of position went to private schools. But in that year, owing in large part to the strenuous efforts in behalf of public education by Thaddeus Stevens, Lincoln's antagonist, the system of charity schools was done away with. Public school doors were now opened

Fig. 7. Eakins at about 6 years, c. 1850. Collection Mr. and Mrs. Daniel Dietrich II, Philadelphia. Daguerreotype.

Fig. 8. Eakins at about 8 years, c. 1852. Author's collection. Carte de visite.

to all children, rich and poor, and the difference between them was obscured. "The stigma of poverty, once the only title of admission . . . has . . . been erased from our statute books, and the schools of this city and country are now open to every child that draws the breath of life within our borders." [2]

Eakins' grammar school was located on the north side of Zane Street, west of 7th, and was thus known as the Zane Street School (Fig. 9). (Zane later became Filbert, and in this century the building was torn down and the land bought by Lit Brothers' Department Store.) Zane Street School was a three-story brick building, with wood finishing, a tin roof, brick yard, sidewalk paving, and, according to the official account, "detached unheated toilets." [3] When Eakins attended it, there were about three hundred boys and, in separate quarters, nearly the same number of girls.

There is no exact record of what Eakins studied at the Zane Street School. An 1868 report of the Committee on Revision of Studies indicates what subjects were recommended and which ones were introduced in that year. According to the committee, the principal fault with the Philadelphia grammar schools was not the curriculum, but the tremendous pressure exerted on the pupils by teachers and principals to get them into high school. The subjects being taught and, to a large extent, the books from which they were taught seem to have been left as they had been for years, presumably since the time Eakins attended. The fourth-year drawing curriculum, for example, recommended outline maps of the countries of Europe. This coincides with what is known of Eakins' grammar school drawing (CL-29,* Figs. 10 and 11).

* CL- refers to Checklist numbers beginning on page 315.

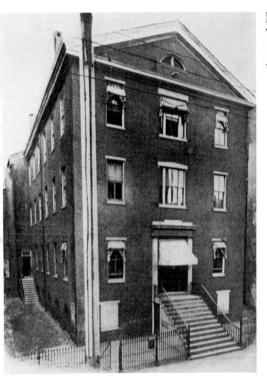

Fig. 9. Zane Street School, Philadelphia. From John Trevor Custis, *The Public Schools of Philadelphia* (Philadelphia, 1897). Zane Street School was on what is now Filbert, between Seventh and Eighth.

Fig. 10. *Map of Switzerland,* 1856–1857. Ink and watercolor on paper, 20″ × 16″ (50.8 × 40.7 cm). Hirshhorn Museum and Sculpture Garden, Smithsonian Institution.

Fig. 11. *Map of Southern Europe,* 1856–1857? Watercolor on paper, 11⅛″ × 14¼″ (28.2 × 36.2 cm). Collection Mr. and Mrs. Francis Walters, Roanoke, Virginia.

Spelling was evidently taught from Worcester or Wilson's *Spellers;* reading from Wilson's and Hilliard's readers; geography from *Common School* or Mitchell's *Intermediate,* with the texts of these books used as reading lessons; history was from Goodrich's *American Youth* and the same author's *Pictorial;* grammar was from books by Hart or Parker; parsing from Hart's *Class Book of Poetry;* arithmetic was from Vogdes' or Greenleaf's texts, with considerable attention given to business arithmetic, interest, brokerage, insurance, profit and loss, "and the extraction of roots, with mental exercises." [4] In addition there were lessons in singing, composition, "defining of words," "morals and manners," and physical exercises.

The attention given to spelling, reading, and writing was reflected in Eakins' later life: his reading experience was wide from his youth, and his spelling errors were very rare. Eakins wrote in 1875 to Earl Shinn that he wrote poetry when he was in grammar school, "all about sweethearts. I guess they were madrigals. When I had them bad my mother used to give me a vermifuge." [5] During physical exercises, the 1868 committee recommended, the windows should be opened, "if found *prudent,*" and they should also be opened between sessions. Lessons in "morals and manners" were to follow the reading of the Bible by the principal, and should be remarked upon whenever the teacher thought the occasion was ripe. "Respectfulness to teachers, obedience to parents and teachers, honesty and truthfulness," the committee felt, would be "powerful auxiliaries" to school discipline.

During the early part of the summer, before summer vacation, school ran from 8:30 A.M. to noon, with thirty-minute recesses, and during the rest of the year school was in session both morning and afternoon. Only the two top grades could take their books home to study.

Eakins graduated from grammar school in 1857, the year he entered high school. "There is no excellence without great labor," his diploma read, and it is likely that the future artist earned his excellence by hard work. His Zane Street average was 76.8, nearly the best of all the grammar school pupils entering Central High that year. Competition to get into Central was keen, and his meeting the entrance requirements there—which were "rather more than for West Point and rather less than for [Harvard]"—as well as his record after he arrived, suggests that he had done his lessons well.

He was admitted to Central High School, a few blocks away from home at 505 Greene Street, on July 11, 1857 (Fig. 12), coincidentally on the same day that his father bought the new house on Mt. Vernon Street.

The four years at Central High were divided into eight divisions, designated A, B, C, D, E, F, G, and H. When a boy entered he was put in Division H; the second half of the first year he was put in Division G, and so on until, by the time he left school, he had reached Division A. Algebra, Latin, phonography (shorthand), science, history, and German were the first year's fare. (The daughter of Max Schmitt, a former grammar school classmate of Eakins, remembered that Eakins was not very good at German and had difficulty talking in the language to Schmitt, who was fluent

Fig. 12. Central High School, Philadelphia. From Franklin Spencer Edmonds, *History of the Central High School of Philadelphia* (Philadelphia, 1902). Central High School was on the southeast corner of Broad and Green streets.

in it.) German gave way to French in the last half of the third year, and phonography to philosophy, chemistry, and civil engineering. Latin grammar graduated to Horace and was supplemented by Greek, which included Xenophon for the last term. Algebra was supplanted by trigonometry, calculus, and finally astronomy; and science was replaced by "moral science," political economy, and "mental philosophy." One of the items in the last course was a particularly grim lecture on delirium tremens. The notebook of a fellow student is covered with drawings of the various imaginary creatures the victims of this curse were said to have encountered.

Drawing was taught in the second half of the first year—in Division G—and the text was Rembrandt Peale's *Graphics*. This book, or series of books, ran through a number of editions from 1834 to 1867. It started out as a "Manual of Drawing and Writing, for the Use of Schools and Families," and by the time Eakins began to use it in school it had become also an "Auxiliary to Writing, Geography and Drawing." Peale had been Professor of Graphics in Central High School itself, and was, of course, a distinguished member of the distinguished Philadelphia family of artists founded by Charles Willson Peale. "Try," the title page admonished. "Nothing is denied to well-directed industry."

The edition Eakins used contained first, second, third, fourth, and fifth "books" of drawing, the fifth being a study of "drawing applied to writing." "The Art of Drawing," Peale wrote, "sufficiently simple in its nature, has been a mystery in the hands of a few, not many of whom are able to explain the principles upon which they practise. In the System which is here offered to the public, these principles are explained, in a manner so simple, that every student may readily acquire a competent proficiency." Practice exercises were given in, among other things, perspective script, the perspective of the egg, "parallel condensation," the angles of the human face and hands, general perspective and shading—in all of which Eakins did, indeed, acquire a "competent proficiency."

For this class Eakins produced a number of drawings. Several still exist. Among these are drawings of a bridge (CL-35), gears (CL-33, Fig. 13), a lathe belonging to his father (CL-32, Fig. 14), and two drawings after another artist (CL-30 and CL-31, Figs. 15 and 16)—all of which show considerable, even remarkable talent.*

At the end of the second year, Division E, Eakins was on the "Distinguished" list of Central students with an average for the term of 94.6. This was a bit behind Charles Fussell, an artist friend, and a bit ahead of Max Schmitt and W. J. Crowell,

* The originals of Figs. 15 and 16 were evidently prints used by Eakins' drawing class for copying. But efforts to identify them with Samuel Prout, J. D. Harding, John Frederick Lewis, David Roberts, or others have been unsuccessful. They do not depict a particular site, and are therefore not travel drawings. They do not appear in any book cited by the best authority on travel-book art, J. R. Abbey, *Travel in Aquatint and Lithography 1770–1860* (London, 1956).

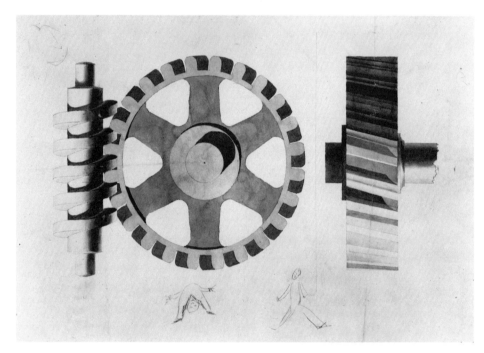

Fig. 13. Drawing of gears, c. 1860. Ink and watercolor on paper, 11⅜″ × 16⅞″ (28.9 × 42.9 cm). Hirshhorn Museum and Sculpture Garden, Smithsonian Institution.

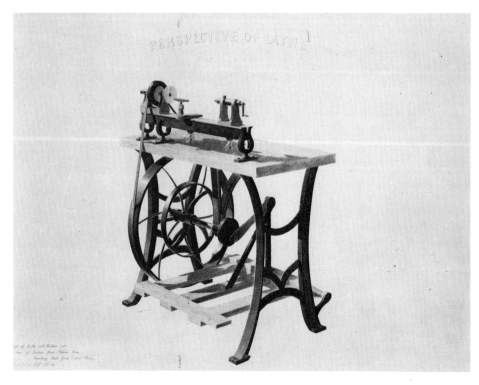

Fig. 14. Drawing of a lathe, 1860. Ink and watercolor on paper, 16¼″ × 22″ (41.2 × 55.9 cm). Hirshhorn Museum and Sculpture Garden, Smithsonian Institution.

whose sister he was soon to start escorting and who later married Eakins' sister Frances. His friend William Sartain did not even rate. The average, incidentally, was made by combining the average for scholarship with the average for conduct.

At the end of the third year Eakins had slipped from the "Distinguished" list to the "Meritorious," with a term average of 88.4. Studies or conduct—or both—had declined.

When Eakins entered Central High, the principal was John S. Hart, a man evidently much respected generally, but considered a "fool" by Eakins. Hart resigned shortly after, and the new principal, Nicholas H. Maguire, was less successful. There were a number of aspirants among the Central faculty for Hart's vacant post, but Maguire was brought in over their heads from the principalship of a grammar school.

Fig. 15. Drawing of a Spanish scene after an unidentified original, Fall 1858. Pencil on paper, 10″ × 14½″ (25.4 × 36.8 cm). Hirshhorn Museum and Sculpture Garden, Smithsonian Institution.

Fig. 16. Drawing of a Spanish scene after an unidentified original, March 1858. Pencil on paper heightened with white, 11½″ × 17″ (29.3 × 43.2 cm). Hirshhorn Museum and Sculpture Garden, Smithsonian Institution.

He was "kind, tolerable, and affable," an alumnus of Eakins' time later recalled,[6] but he could not control the frustrated teachers—let alone the boys. Maguire's administration during the time Eakins was there was the "stormiest period in the history of the High School, and is the least pleasant for the historian to contemplate." Maguire got along with the students better than he did with the faculty. The students, the Central High historian wrote, welcomed him as a friend and "even as a playmate. . . . The Faculty was not harmonious, . . . the principal was not able to do his best work, and hence grave doubts as to his competency arose; politics continued to play an important part in the management; and, worst of all, there was a captious and bitter spirit shown by all that led to personalities of the most flagrant type. Over all these details," the historian concludes, ". . . let time draw its veil." One of the well-liked and successful professors who came during Eakins' time was Dr. Benjamin Howard Rand, a Jefferson Medical College alumnus, whose portrait Eakins was to paint fifteen years later (CL-325, Plate 19).

During Eakins' last year at Central the Civil War began, and as soon as it became clear that the war was not just a summer campaign, a number of the older students left school and enlisted. In February 1861 a class of sixty-three was graduated, but five months later, with so many joining the army, there were only twenty-four graduates.

Eakins was among these twenty-four (Fig. 17). The Commencement of the Forty-sixth Term of the Central High School, Eakins' class, was held at the Academy of Music at Broad and Locust on the morning of July 11, 1861. Fourteen students had

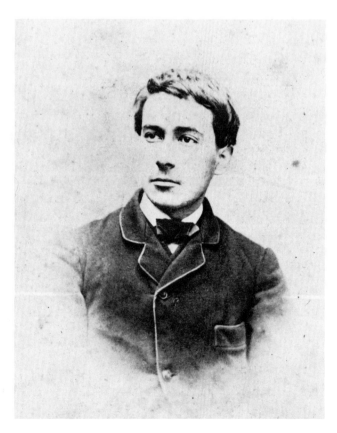

Fig. 17. Eakins at about 17, c. 1861. Author's collection. 4″ × 2⅜″ (10.2 × 6 cm). Carte de visite. Possibly the Central High School graduation photograph.

completed the four-year course for the degree of Bachelor of Arts, and Eakins was fifth among these with a four-year average of 88.40. Max Schmitt was sixth, Will Crowell was tenth, and William Sartain twelfth. The Reverend Phillips Brooks gave an opening prayer, and Richard Ludlow the Introductory Address. The *Public Ledger* reported that Eakins had given a "scientific address," but the principal's report, made the following year, did not name him. Evidently the *Ledger* followed an announcement released by the school, which reported only that Eakins had been *chosen* to make a speech.

Besides his studies at Central High School Eakins' first drawing work on a semiprofessional level now began. Before he went to Europe to study five years later, in 1866, he did a considerable amount of work at the Pennsylvania Academy of the Fine Arts, and possibly also at the classes sponsored by the Philadelphia Sketch Club. The Sketch Club had been organized on November 20, 1860, and included among its first members Thomas Sully, Thomas Nast, J. Q. A. Ward, and George Bispham. In its beginning years the Philadelphia Sketch Club did not have life sketching, and Eakins was not a regular member, although he may have attended some of the classes. He was later to teach classes there, and they were to become immensely popular. But at this time Sketch Club meetings were often largely social, and it was only Eakins' eagerness to draw that would have persuaded him to brave the social atmosphere.

The Pennsylvania Academy was another matter (Fig. 18). It had been founded in 1806, but it was not until 1855 that very substantial efforts were made to establish art classes. There were classes for drawing from the antique by the time Eakins had left Zane Street Grammar School, and shortly afterward classes in life were introduced. Students could draw from casts every day throughout the year and, for six months in the year, on three evenings a week as well. In a cellar lecture room, from October to April, advanced students could also draw from life. There was no teacher, but the older students helped the younger ones as much as they could. There was also a weekly anatomy lecture by a physician. The Academy board, *The Art Amateur* reported, was made up of bankers and merchants—with the exception of John Sartain, an engraver—and they "took much credit to themselves for conducting a free school of art and . . . resented suggestions for improvements with as much bitterness as they did complaints about their deficiencies." [7] The students were told, according to *The Art Amateur*, "that it was unbecoming in beggars to be choosers." The result was that aspiring Philadelphia artists usually went off to Europe to get their education.

In the Academy's first antique classes were such familiar figures as George W. Brown, William T. Richards, Lucien Crépon (with whom Eakins later stayed in Paris), William J. Clark (later the critic for *The Evening Telegraph*, a director of the Academy, and a stout champion of Eakins' unconventional art), Xanthus Smith, Daniel Ridgeway Knight, and Earl Shinn (who was also in Paris with Eakins). Life class members were also well-known in Philadelphia: William H. Furness, George C. Lambdin, Christian Schussele (later Eakins' teacher) (Fig. 19), Peter F. Rothermel,

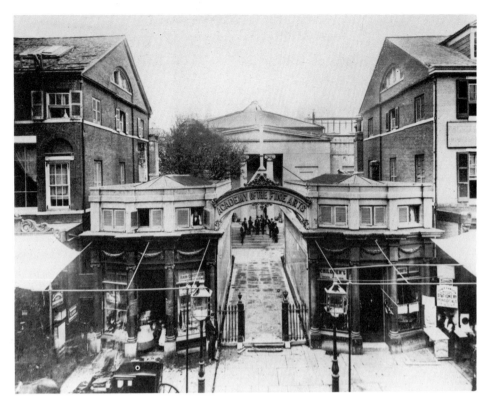

Samuel B. Waugh, John Sartain (a well-known engraver and father of William and Emily, with whom Eakins had strong friendships) (Fig. 20), Samuel Sartain (William's brother), and again, Lucien Crépon. There were life classes on Monday, Wednesday, and Friday evenings between seven and nine thirty, with the Monday and Friday sessions designated as "male," which evidently meant that the model was male on those evenings, and Wednesday sessions designated as "female." All of this would be changed when Eakins took charge fifteen years later. But now everything was calm, conventional—and dull. The average attendance for life classes was not large during these early sixties, averaging about ten for each session.

Eakins did not at first attend these life classes. On October 7, 1862, he was given a pass to draw from casts and to attend lectures at the Academy, but not until shortly before he left for Paris—probably in 1865—was he allowed to go to the life classes. (In 1865 he would have been twenty-one, and it seems possible that that may have been considered an appropriate age, although I have not found any such rule recorded.) Eakins' friend William Sartain (Fig. 21) had planned to attend the Academy classes also, but finally decided to volunteer for service in the Civil War, and, along with a number of other Central High boys, including Max Schmitt and three Central professors, went off to camp. Eakins did not volunteer. Why he did not is not known; perhaps his Quaker heritage was a factor; perhaps he thought he had more important things to do; or perhaps he was just afraid of getting killed.

"The rebels are taring [sic] up the railroad in the Cumberland Valley," [8] Sartain wrote his sister Emily, and a few days later, "the whole of Philadelphia seemed poured into Maryland . . . three Prof's of H. S., hundreds of pupils—in fact everybody almost." [9] But let the Rebels "tare" as they might, and let the whole of Central High

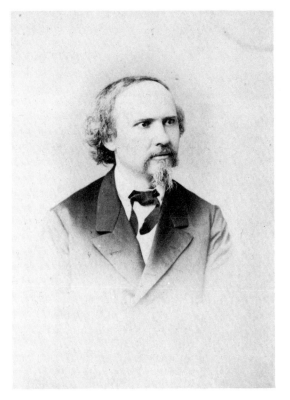

Fig. 19. Christian Schussele, Eakins' Academy teacher, 1860s. Collection Mr. and Mrs. Daniel Dietrich II, Philadelphia. Carte de visite.

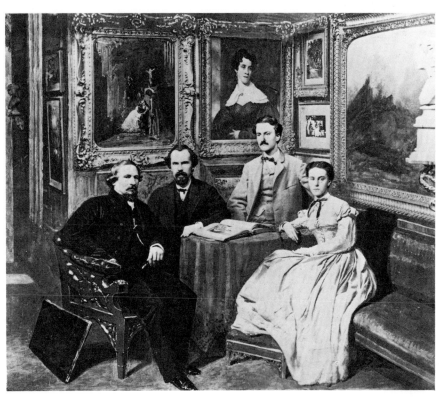

Fig. 20. From left, John, Samuel, William, and Emily Sartain in the parlor of their house at 728 Sansom Street, Philadelphia, c. 1870. The Historical Society of Pennsylvania. The photographs of John and Samuel have been pasted in from separate, different photographs to make this "official" photograph of the four engraving Sartains.

School volunteer to stop them—Eakins had other things to do.

Sartain was called up on September 12, 1862, two days after he had gone boating by moonlight up the Schuylkill with Eakins. They fished for catfish but didn't get any, and the next day Sartain had a "sweet reminder of [his] pleasures in a pair of blistered hands." [10] Eakins was then a candidate for the professorship of drawing and writing at Central High, but he was passed over for another applicant.

Eakins' first year at the Academy of the Fine Arts, 1862, was the year his

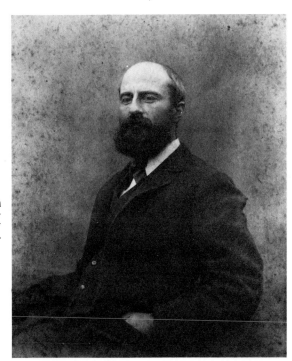

Fig. 21. William Sartain in photograph by Eakins, 1880s. 4¼″ × 3½″ (10.8 × 8.9 cm). Author's collection.

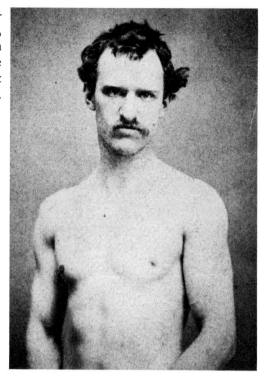

Fig. 22. Max Schmitt, c. 1868. Collection Mr. and Mrs. Daniel Dietrich II, Philadelphia. Schmitt was a champion sculler, and this photograph may have been taken near the time of his greatest success.

teacher, Christian Schussele, produced one of his major, typical works, *Men of Progress* (Plate 2).

These early Academy years were also the years of Eakins' greatest sporting activity. Sailing on the Delaware, sculling on the Schuylkill, fishing in Gloucester, which is south of Camden, and making excursions to the Cohansey in South Jersey filled the summers. In winter he gave vent to his great enthusiasm for ice-skating, and as early as the first of May, when the Schuylkill was still icy cold, he started to go swimming.

His friend Max Schmitt was a frequent companion (Fig. 22), and on one occasion, in a facetious letter to Eakins, Schmitt suggested that the three friends, Sartain, Eakins, and Schmitt, go to Jansen's newly opened natatorium in the Schuylkill (Figs. 23 and 24): [11]

> My dear Tommy
> The announcement of the opening of Jansen's Natatorium brings me to the consideration to wit: When shall we three, i.e. yourself, a sartain William and myself, again take a 'shwim" this season in the placid bosom (whew, how poetical!) of the Schuylkill. Then shall we again have belly smashers, back bumpers, side switches etc etc. Then shall we see. I II . . SUNRISE ON THE SCHUYLKILL . . . 3 . . . 4 . . . and *divers* other beautiful performances by the immortal T.E.C. Guess I'll never beat you in swimming—have given that up! . . . And other figures, too numerous to mention.
> Dont show these drawings to anybody, lest I should attain to an unenviable notoriety for my original notions of anatomy—Writing fluid is not the best material.
> We are just in that pleasant condition which precedes moving; the store

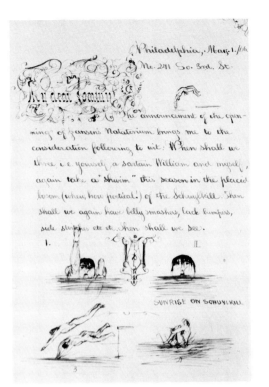

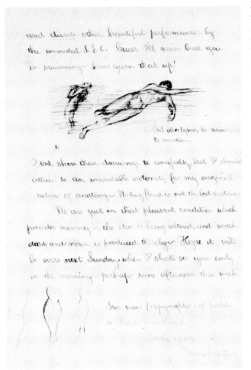

Figs 23 and 24, Illustrated letter from Max Schmitt to Eakins, May 1, 1866. Hirshhorn Museum and Sculpture Garden, Smithsonian Institution.

is being altered, and much dust and noise is produced thereby. Hope it will be over next Sunday, when I shall see you early in the morning—perhaps some afternoon this week. . . . Two views (copyrighted) of pedals or Future and Present.

<div align="right">Truly yours,
Max Schmitt.</div>

The three and a half years between Sartain's letter of September 1862, when he spoke of Eakins' trying for the Central High School teaching job, and this letter from Schmitt are the least documented of any part of Eakins' life. Apart from 1864–1865 cards of admission to Jefferson Medical College anatomy classes, no known documents tell us what his life was like from the time he was eighteen in 1862 until the time he was twenty-two in 1866. It seems clear that he did, as some have suggested, consider becoming a physician, and the Jefferson lectures may have helped him decide what to do. William Sartain also attended these lectures.

Eakins' letters in 1866 to Emily Sartain suggest that during this time his relationship with her had reached some degree of intimacy. It is not beyond reason to think that Emily's father had something to do with persuading Eakins to go to Europe to study. Surely John Sartain would not have thought the wild young Tom Eakins, with his uncertain future, a suitable match for his daughter. Eakins' relatives say that there was "something" between Tom and Emily, and letters between them suggest they may be right: [12]

> I received your second note in Italian from Willie and read it with a mingling of joy and pain. I am happy in the awareness that, although I went away, I am not forgotten, and that a dear friend grieves over my departure. Yet a great sorrow fills my heart, Emily, and I fear it will never pass. Nevertheless,

I have often heard the proverb which says that sorrow shared is only half a sorrow, which is a comfort, wherefore I beg you: do not let me die for want of this: compassion for my grief. I have not left only a friend, but everybody. My good father and my dear mother, I leave and go to a foreign land, where I know neither relative nor friend, nor even friends of friends, and I go alone.

My father awaits me. I cannot finish. I shall see you in New York. Write to Willie or to me. Thank your hostesses on my behalf. I shall not have time to do so myself.

Tom.

As is the way with young people, feeling that they are meeting on a high level of intellectual as well as emotional intimacy, Emily and Tom, together with brother Willie, had been exchanging views on fine points of language. Eakins wrote William Sartain: [13]

I have made mention of the contrast of nature and art, and of how the last synonyms depended on a passiveness of being born (for that is Nature). Yet Nature and Art are but the same words, Nature is from L. Natus, born, and this from Gnatus, and this from Gigno or Geno, to generate, bear, create; and Nature is what is created or shaped; that is the Creation. Tell Emily to look in her Dutch dictionary.

Now Art (so thinks Webster) is but a contraction of the word to create. (See Art, Create, Cry, Can [?] etc.).

It's time to go swimming. I saw the lightning bugs last night.

The day before Eakins wrote his do-not-let-me-die letter, he had written Emily a more formal note, making plans to see her and Willie in New York before he sailed for Europe to study. "I can see you Friday evening or Saturday morning," he wrote.[14]

My dear Emily,

I received your letter of Friday or Saturday, and delayed answering that I might consult with Willie. I leave here in the midnight train of Wednesday or Thursday and sail from New York in the *Pereire* on Saturday. Willie expects to spend the last of the week with you in New York where I can see you Friday evening or Saturday morning. He suggests a picture gallery as the place of our meeting and parting.

Tom.

If the three were planning to say their good-byes in a picture gallery, it is likely that Eakins' family had also come to New York to see him off.

2

First Months In Paris
1866-1867

Early saturday afternoon, September 22, 1866, Eakins sailed from pier 50, North River, on the *Pereire* for Le Havre. A first cabin cost $135 and a second $80, with free wine at both tables. Medical attention, the *Times* reported, was free, and Eakins may have needed it. The voyage lasted thirteen days, and he was sick the whole time.

The *Pereire* touched at Brest, and continued to Le Havre. Eakins took the train to Paris and registered at the Hotel Lille et Albion, across the street from the Louvre. Why he settled on this particular place to stay while he looked for a permanent address is unknown. Perhaps simply because it was convenient to the École Impériale et Spéciale des Beaux Arts—the École des Beaux Arts—where he was to present himself to study (Fig. 25). Perhaps one of the Sartains recommended it, or Earl Shinn, who had come to Paris before him to study.

Shinn had presented himself at the American legation in Paris the previous June, and was told on August 22 that his name and others had been placed on the list of the Minister of the Emperor's Household and of the Arts, at the Tuileries. It was that Minister who had to pass on all applications by foreign students for the École. It is possible that Shinn had also put Eakins' name on the list. John Hay, the legation Secretary, wrote Shinn that his name had been put on the list "with others." When Eakins got to Paris and stirred up the ponderous French bureaucracy, the names of three

Fig. 25. École des Beaux Arts as it looked when Eakins attended it. From *Paris Dans Sa Splendeur* (Paris, 1861).

other Americans besides his own and Shinn's were on the list: Conrad Diehl, H. Roberts, and Frederic Bridgman.[1]

Hay had written Shinn to report that the Minister had rejected the application, saying that "all applications will be postponed for further consideration, there being at present no vacancies in the school."[2] But Eakins got busy, and armed with a letter from John Sartain to Albert Lenoir, the Secretary of the École, he set the whole process in reverse. "The fact is," Shinn wrote his family, "while I was travelling in Brittany, young Tom Eakins was exerting himself in the heat, investigating Directors and bothering Ministers, until he got the whole list of American applicants accepted—they had decided to exclude foreigners."[3]

John Sartain's help in this process, although Eakins gave it credit for getting him into the École, was oblique. Evidently Sartain knew Lenoir, and asked Eakins to carry a letter to him, asking Lenoir for some sort of "report." It was something Lenoir wanted to do, for he told Eakins that he could not find "it" right away, but would send "it" on when he found "it." Possibly "it" was the answer to questions Sartain had asked him about the school—the number of students, and so forth—which Sartain wanted to publish in one of the numerous publishing ventures in which he was engaged. The promise of publicity, then as now, opened doors wide. Eakins later developed a friendly, personal relationship with Lenoir.

Sartain's letter stirred Lenoir at once. He wrote immediately to the Superintendent of the Fine Arts about the matter.[4] Eakins was to get a letter from the American minister, and that would be enough for acceptance. The previous year there had been no room for foreign students, but this year there was, and as soon as Lenoir heard from the Superintendent he could register Eakins for study. Then, with a letter from Gérôme, he could begin work. Now Eakins must go to John Bigelow, the American Minister to France, and he did so the same day. Bigelow's letter of approval is dated

the day after Lenoir's. How the young American could have gotten such immediate action is a puzzle, but there is no doubt that Eakins made a good impression. In any case, Bigelow's letter was highly favorable: [5] "I am calling on the good graces of your Excellency to ask on behalf of my young compatriots Messrs Thomas Eakins, Conrad Diehl, Earl Shinn, H. Roberts, and Frederick A. Bridgman, for the authorization necessary for them to be able to be admitted in their capacity as foreign students to the School of Fine Arts in Paris." Lenoir had told Eakins he must now get a letter from the professor of his choice, and Eakins was off to see Jean Léon Gérôme, the École's most celebrated teacher, and the man Eakins had long ago decided upon. Gérôme looked at the young artist's work and Eakins was in: [6] "I have the honor of presenting to you Mr. Thomas Eakins who has come to work in my studio. Please would you be so kind as to enroll him as one of my students. . . ."

Why Gérôme? The most natural—and logical—reasons are: First, Eakins, like many thousands of others in America, knew and was fascinated by the Gérôme

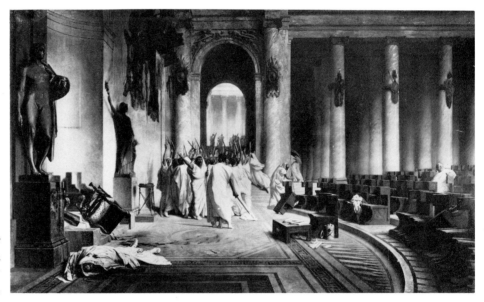

Fig. 26. Jean Léon Gérôme. *The Death of Caesar*, 1859. From a Goupil print courtesy New York Public Library.

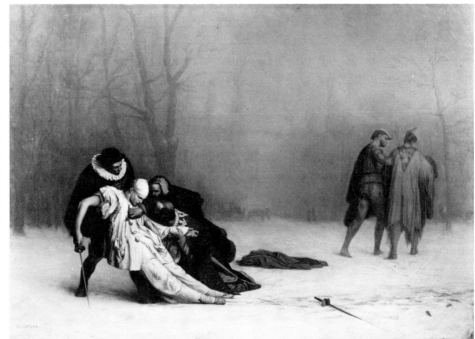

Fig. 27. Jean Léon Gérôme. *Duel after the Masquerade*. Oil on canvas, 15¼″ × 22″ (38.7 × 55.9 cm). The Walters Art Gallery, Baltimore. Gérôme's original was produced in 1857. The Walters painting may be a replica.

engravings that were so familiar in this country during the 1850s and and early 1860s. The most glamorous of these for a boy would have been *The Death of Caesar* (Fig. 26), *Caesar and Cleopatra*, and *Hail Caesar! We Who Are About to Die Salute You!* Close behind would have come *Duel after the Masquerade* (Fig. 27) and *Diogenes*. All would have appealed to Eakins in a romantic sense, and they would have prepared him for the great excitement he felt when he realized that he was going to study with the man who had created all these pictures. He must have felt as Saint-Gaudens did passing Goupil's on Broadway: "Since an early winter of our Civil War, when, as a boy, I stopped evening after evening at Goupil's window on Broadway and adored Gérôme's *Death of Caesar*." [7]

By the time Eakins had begun to study art seriously, he would have understood what a remarkable oil technique Gérôme had. Apart from the engravings, we know of only one original that Eakins could have seen before going to Europe: Gérôme's *Egyptian Recruits Crossing the Desert*, which was loaned to the Academy's 1860, 1861, and 1862 Annuals (Plate 3). James Claghorn, the leading Philadelphia collector, owned only a single drawing, and he did not acquire that until after Eakins went to Paris; Henry C. Gibson, whose collection with a magnificent Gérôme came to the Academy in 1892, did not buy any Gérômes before 1882.

Eakins probably did not move out of the Hotel Lille et Albion until he found out for sure that he was going to get into the École des Beaux Arts. He now began to make entries in his account book for such items as a shirt, handkerchiefs, rent, and although the date for the rent payment is not given, the earliest date for any entry is October 15. The place he chose for what was to be home for the next several months

was at 46 rue de Vaugirard,* across the street from the Luxembourg Palace and only a short walk from school. He described the place and its furniture in detail in a remarkable letter to his mother (Figs. 28 and 29): [8]

My dear Mother,

Having a great desire to write to you and having the time, I will tell you about my room for want of something more interesting. It is as comfortable a one as can be found in Paris as far as I know. The house is across the way from the old palace of Luxembourg, and by going out into the entry, I can look down into the garden. Besides, it is close to my school, not more than half a mile, and on the same side of the river. Besides that, there is an arsenal or some such place right back of the house, and the soldiers of this place and of the Luxembourg wake me up at the right time in the morning with their trumpets and drums. Besides that there are no bugs and not even fleas which bother the Americans very much in Paris, as I am told. So taking everything together, I am as well off, as I can be out of my home. My room is not as large as my bed chamber at home,[9] but it is large enough and has a big window in it, which gives plenty of light. The walls are papered, and the ceiling is nicely whitewashed. The floor is of stone or rather a sort of brick painted red, but a big piece of carpet in the centre of the room covers half of it.

The grand houses still have waxed wooden floors. They are very slippery, and I came near falling when I first went to the Luxembourg palace to see the pictures. Before trying to find my way in, I stopped and asked a soldier for directions. He said that depended on what I wanted to see, so I told him the pictures. Well then you must go in that door over in the corner, but have you seen the throne, it is far more worth seeing. I told him

* After a hundred years 46 rue de Vaugirard, as the Association des Étudiants Protestants de Paris, still offers rooms for foreign students at a daily rate of $2.40, including breakfast and a free shower.

Fig. 30. Detail from illustrated letter from Charles Fussell to Eakins, December 13, 1866. Hirshhorn Museum and Sculpture Garden, Smithsonian Institution.

Figs. 28 and 29. Illustrated letter from Eakins to his mother, November 8 and 9, 1866. Hirshhorn Museum and Sculpture Garden, Smithsonian Institution.

no, and then he showed me where I must enter. I represented to him that, I had rather see the pictures first, but he was eloquent for the throne. I finally told him I was going to be a painter. He didn't say another word. I fell at least a hundred degrees in his estimation. I am yet ignorant about that throne and whose it was.

My room is well furnished, and the principal piece is of course the bed. It is kept clean and tidy. The French bedsteads all seem to have curtains. They add to the beauty, and help keep out the light which would be an advantage to those who don't need to get up early. I'd like to know when you would be up if you had long curtains to your bed. There is a big flat pillow half the size of the bed which goes down at the foot and covers the legs after one is in bed. It is not a bad idea, for when the feet are right warm there's no necessity for a heavy bunch of bed-clothes. But comfortable as it is, I've spent more miserable hours in it lying awake, thinking of home during my trouble.[10] But I will not think less of my home now that it is ended, but it will be another feeling. The next thing I've drawn for you is a chair with a velvet seat to it. I have two of these besides the little one with a cane seat. These will do for my friends when any of them will come to see me. Crépon[11] has promised to come sometime, and so have one or two of my new friends.

The next thing is my bureau, and this I make that Aunt Eliza's mind will be a little eased about a place to put my clothes. The next thing is the wash stand, but I believe there is nothing worth mentioning about it. The next thing is the stove which is just in the corner of the room. It is necessary to build a fire every two or three days, to dry the room and purify it, even if you are not going to sit in it. To make a fire you take a little ball of resinous shavings. These balls are about as long as one's finger and twice as thick. You light it and put a bunch or half bunch of little sticks on top and then a couple of big pieces over them and then pull down the gate in front. After the fire is well started you can put up the gate or whatever it is called and throw some coke in on top of the wood. The next thing I've drawn is a mahogany box with a door and a drawer to it. I think you would have a good deal of trouble guessing its use if I hadn't left the door a little open. The lowness of the French bedstead has given rise to this piece of furniture, which I first saw at the Hotel of Lille & Albion. It was sometime before I thought of looking there for what I wanted. On this page I make my arm-chair. This I sit in when I have a fire.

Nov. 9th.

When I got home from school today, I sat down to draw my table for you, but it got so dark in a few minutes that I couldn't see, the days are so short here, but I guess you can make out that it is a table with a cover and some books on it. There is yet another table to write on, and this one has two little drawers in it, and completes the furniture of the room. There is no closet but there are some big wooden pegs on the wall to hang the clothes upon, and a curtain can be drawn over them which will keep them from getting smoked.

When I came home yesterday, the old doorkeeper opened her window and told me she had received a letter for me. I grabbed it and made for my room, and lit my candle as soon as I could. I had gone to Monroe's, American banker, to see a paper & had registered my name & address, and this man of business I suppose copies down all the names of all the Americans who come to Paris. Advertising is a good thing but it's carried too far when it takes a private letter form. I'll be careful never to go to that store.

Last Sunday I was invited to go dine with the Moores,[12] and they proposed we should go before dinner to the Garden of Plants. There is a splendid Menagerie there probably the finest in the world. I can never get tired of seeing elephants camels or monkeys. There is a little baby elephant there a thing I never saw before. We had a pleasant time and then visited the Museum. I was glad when we got out of that; the Moores are such lovers of relics. The old lady must have a leaf from the cedar of Lebanon. She couldn't get one for they were all too high but she managed to break off some bark. In the mineral department there is a splendid quartz crystal. They tried their best to break off a bit when they thought there was no one looking, it would be so interesting to a son in California to have a piece of stone which came from the French Museum. After this we were closely watched and a man with a soldier cap on followed us till we got out.

We went home in a carriage & they gave me a good dinner & we spent a cheerful evening talking about Philada. Old Mrs. Moore knows all the old families of our city especially the quakers. They are all very fine people & their only fault as far as I know is the intense love for relics.

When you write me don't forget about little Caddy and her progress, and tell me about Mrs. Lewis[13] & Uncle Emmor's[14] family. I am very anxious to receive my first letter from home. I expected one today, but I'm afraid I've another week to wait. It's likely when the mail comes I'll get a whole bunch of them. How is Billy Crowell? I hope he didn't go home that rainy night; for he had been very sick. Have Max and Johanna[15] taken supper at our house since I left. . . .

I have had a little darning to do and I don't think I've done it badly. The hole wasn't very big though. I see it will require more skill to mend a stocking with big ones in it. When they get beyond darning and want patch work I'll go and buy a new pair for I remember that Aunt Eliza with all her experience was not always successful in this line although always brilliant . . .

This letter, like others to his female relatives, was self-consciously simple. Letters to his father and others were extraordinarily direct, but to his mother, aunt, and sister Margaret he wrote almost as to children, being careful, of course, not to condescend. "I'd like to know when you would be up if you had long curtains to your bed" and the reference to a private joke about Aunt Eliza's darning are not the correspondence of sophisticates.

When this letter got back to Philadelphia, Eakins' fellow Academy student, Charles Fussell, saw it and wrote Eakins an illustrated letter of his own (Fig. 30):[16]

Dear Tom

Your success in illustrating the letter descriptive of your room has inspired me to try my hand at something of the same kind and having no unique furniture of such doubtful use as to require open doors I could think of nothing better than to pictorially offer for you the door that you have so often entered and let you know how we are going on in our old sanctum. The design is just sufficiently definite or indefinite for you to exercise your imagination in regard to the workers, their sayings and doings. . . .

Or you may have a conversation on our brother artists in Paris, showing how wonderfully the French Masters were impressed by the genius and power of Young America. How Bispham [17] was the favored pupil of Couture or Couturier folks didnt know which. How Miss Cassatt [18] was honored by Gerome's private lessons, how complimented Shinn felt by the notices that Gerome took of his drawing. There I have "gone and done it" Will Sartain claimed that story for himself and I told him he should have it, but since I have started and Will most probably has already written I will just say that Shinn wrote home that he had had a great compliment paid to him in the fact that Gerome took so much notice of his drawing criticising its faults &c—

I have been out skating today and yesterday and the fact of being out and the place and the ice being so like that of a certain memorable occasion when we two went out skating together and came home separately that I could not have helped thinking of you even if I had wished to and I did not *want* to it gives me great pleasure in thinking that you are making yourself a good artist as I know you will do. . . .

When Eakins included his sister Margaret as an addressee, his language was again very simple: [19]

Dear Daddy and Maggie,

Last evening after dinner I was taking a walk along the garden of the Luxemburg and when I came to the end I saw a crowd of men and little boys and girls and little babies and their nurses. I went up to see what they were looking at and found out it was a man who had a little dog and a monkey.

The little dog would stand up on his hind legs and dance for a very long time that way, while the man played on a whistle and beat a drum, and afterwards he would be horse for the little monkey and would turn to the right or left and would walk or trot or gallop just as the man would say. When any one gave the man a penny the man would throw it to the monkey and the monkey would catch it in his hand and put it in his little pocket and then turn around and take off his hat and bow to the person that had given it.

His name was Funny. His master gave him a little sword and then fenced with him for some time, but when he stopped to look round at something Funny hit him as hard as he could and made all the little children laugh. . . .

Funny had a little fiddle to play music on but it was not as good music as Fanny makes on her piano. . . . At halfpast eight o'clock it was beginning to get so dark that Funny couldn't see to catch the pennies and so the man stopped and little Funny jumped up into his master's arms and kissed him and they went away. The little dog wagged his tail and barked and ran on before, and I hope they had all a good dinner after they got home.

A letter to Eliza Cowperthwaite spoke about dressmaking, and one time when he saw the Empress Eugénie getting into her carriage: [20]

Dear Aunt Eliza:

I am sending again by mail another batch of stupid grammar stuff and I am sorry that I did not learn dressmaking as well as grammar in my Zane St. school.

I have never seen a long frock in the streets or a gaudy one, but they all dress very plain. At church the only perceptible difference between the duchess and the laborer's wife is that the duchess is the cleanest of the two. Pews are unknown but each one takes her little praying stool and all sit together. But the washwoman goes home in an omnibus and my lady in a state carriage mounted by flunkeys. These footmen and coachmen dress up like monkeys always with long white stockings and high hats with pompoms in them and they often powder their hair. They are low dogs and very insolent to honest people. They put on great airs and when they stare at me I always laugh in their faces. They are the only men I can never respect.

The ladies of the court are said to dress very grand and to wear very low dresses which commence somewheres below the breasts but I have never been there. There are not wanting too stories of immorality connected with this court.

I have seen the Empress a great many times and once when she came to the school I could have touched her had I reached out my arm. Her frock was short so that we saw her legs when she got in her carriage. I have a sneaking idea that her frock was cut bias fold.

On October 23 Eakins, armed with his letters from the American Minister and Gérôme, wrote to the office of the Minister of the House of the Emperor and the Fine Arts and three days later received a letter announcing that he had been accepted for the École. It was not until he got this letter that he was sure he would be able to enter, although the École Secretary had assured him that the letters from Bigelow and Gérôme would suffice.

It was after he had secured the first letters, however, and things began to look brighter, that he wrote Emily Sartain his first letter from Europe. It was in reply to one from her in which she wrote that she had arranged for him to get the address of Schussele, his "beloved master and teacher," [21] who was then in Strasbourg. She must have expressed concern about Eakins' reaction to criticism from Gérôme, for he ended his reply with: "many a year will pass before I experience shame at being corrected by Gérôme."

Ten days later, with admission certain, Eakins wrote his father jubilantly:

Dear Father,
I'm in at last and will commence to study Monday with Gérôme. Full particulars in my next. The mail starts directly. I haven't got my first letter from home.

T. C. E.[22]

Monday, October 29, 1866, was Eakins' first day in school. We do not know exactly what his hours of study were, although he wrote his sister Fanny that he always got to school by 7 A.M. and that in November, at least, it got dark shortly after he returned home. We know that his painting class was held in the morning, but he did not begin to paint until the following March. He took other courses, including antique study, anatomy, and perhaps sculpture and the history of art. By the time William Sartain had joined him to live in Paris, he was also going to evening school. But we do not know just when his classes began, how often they were held, or what their length was.

We do have a good idea of how and where the classes were conducted. Gérôme's classes, which may have met only twice a week, were held in what is still a large painting atelier at the École, in the right-hand corner of the second floor, facing the Quai Malaquais. Over the door from the courtyard is now inscribed: "Ateliers d'Architecture et de Peinture." Eakins, coming from the rue de Vaugirard, would not have come around the corner to the Quai entrance on the Seine, but would have entered the École through its main gate on the rue de Bonaparte, a block from the nerve center of the Latin Quarter at the Church of Saint-Germain-des-Prés.

Today the floor of what was Gérôme's atelier is flat, but in Eakins' time it was built like an amphitheater, with six rows of hard wooden benches around a raised model stand. The skylight began ten or twelve feet above the floor in the south side of the room, and the three north windows, from floor to ceiling, overlooked the courtyard and the river. William Sartain took "evening" classes there several years later, from four to six in the afternoon, and there was still enough light to work by. There was so much light, as a matter of fact, that screens had to be put up. "Every niche," Sartain wrote, ". . . is well lighted for drawing." [23]

The benches had no backs, and the drawing folios—the cardboard backings onto which the sheets were pinned—were rested against a T-shaped iron bar that rose in front of each student and balanced on the knees. Gérôme selected the best drawing done each month, and the honored student could choose where he would like to sit the ensuing month. It is not without significance that Eakins' École des Beaux Arts charcoal drawings (CL-228 and 229, Figs. 32, 33, and 34) were made from slightly below eye level—placing him, at least for these drawings, in the front row.* Sartain was to write later that Eakins was the best draftsman the École had had,

* Within the last two years a number of small c. 5″ × 6″ charcoal drawings of male and female heads have come onto the market. These have been attributed to Eakins' Paris days, but they are probably not his.

Fig. 31. Charles Fussell: *Thomas Eakins as a Young Art Student*, c. 1865. Oil on paper, 14¹¹⁄₁₆″ × 12¹¹⁄₁₆″ (37.4 × 32.2 cm). The Philadelphia Museum of Art.

Fig. 32. Drawings from Eakins' first Academy days or first Paris days, 1862–1867. Charcoal on paper, 24″ × 18″ (60.9 × 45.7 cm). The Philadelphia Museum of Art. These drawings were recently discovered on the reverse of CL-224. See CL-223.

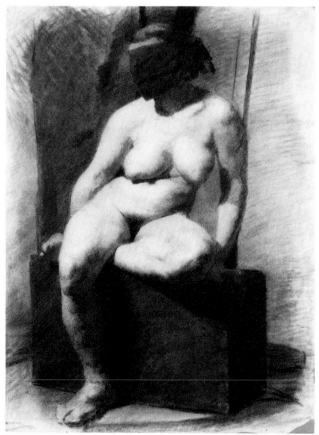

Fig. 33. *Nude Woman with a Mask, Seated, from the Front*, 1866–1867. Charcoal on paper mounted on cardboard, 24″ × 18″ (60.9 × 45.7 cm). Philadelphia Museum of Art. See CL-223.

Fig. 34. Drawing of workman, undated. Pencil on paper, 2¹⁵⁄₁₆″ × 2⅝″ (7.5 × 6.7 cm). Historical Society of Pennsylvania.

and the artist himself was to refer to the fact that he was a favorite.

The only physical item in the École des Beaux Arts archives today attesting to Eakins' presence is an 8″ × 4¼″ card, such as was filled out for every École student: "*Eakins/Thomas/*Né à *Philadelphia* le *25 Juillet 1844/*Presenté par *M. Gérôme/*P Dossier No. *Sans dossier.*" What "P" meant is lost to history, and the fact that Eakins did not have a dossier may suggest that he took less than a full course of study. Perhaps only French students had dossiers, which might have contained their school records up to the time of their entering the École.

The Gérôme atelier at the École was large, and is said to have been made even larger since Eakins' days, although present École informants do not believe this is true. Will H. Low, the American painter who studied in the room four years after Eakins left, wrote that seventy students were crowded into a room big enough for half that many. Today there is room for thirty-five, easels and all.

One of the most tantalizing facts about Eakins' first months in Paris is that he applied for and received permission to copy in the Louvre. What he copied—if he copied anything—we do not know, except that it was not a Dutch or a Flemish painting. The permit was for 1866 only: he made no further application. A register of copyists in the Louvre lists him alongside the figure "397," which is evidently the number of his pass.

Today we can find little specific information about Gérôme's methods among the florid adjectives of his nineteenth-century fans. Most of what we know about the Gérôme of Eakins' time comes from Eakins himself and is set down in letters written home, evidently now lost. Fortunately extracts from them were quoted by Lloyd Goodrich in his immensely valuable book of 1933. Eakins had begun to draw from life from the first, but it was not until March 1867 that he began to paint from life. At that point Gérôme [24]

> made no change in my work, said it was not bad, had some middling good parts in it, but was a little barbarous yet. If barbarous and savage hold the same relation to one another in French as they do in English, I have improved in his estimation. . . . Only once he told me that I was going backwards and that time I had made a poetical sort of outline. The biggest compliment he ever paid me, was to say that he saw a feeling of bigness in my modelling.

A few months later, shortly before school disbanded for the summer of 1867, with Gérôme going off to Normandy and Eakins making a trip through Switzerland with William Sartain and William J. Crowell, Eakins wrote his father that Gérôme had taken the brush right out of his hand and had painted a head over again. Eakins did not like this, but he was to do the same thing himself years later at the Academy.[25]

> I am working now from memory and composing [he wrote his father]. I make very bad things but am not so downhearted as I have been at times when I was making a drawing from the model, not good, not bad, but wishy-washy generally. When you make a thing mighty bad and see how

bad it is, you naturally hunt [?] to improve it, and sometimes find a way, but it keeps staring you in the face till you do. When after painting a model I paint it from memory, and then go back and do it again, I see things the second time I would not have seen if I had stayed at school painting on the same canvas all the week and maybe getting more and more tired.

Color is becoming less of a mystery than it was and more of a study in proportion. When it ceases altogether to be a mystery, and it must be very simple at the bottom, I trust I will soon be making pictures. . . .

Gérôme did not scold me that day you asked me about, but just painted my head right over again, and this I take as an insult to my work. . . . I had a clean canvas, clean outline, clean everything, but I am sure I would have learned more slathering around. . . . A beginner in skating may learn faster by rolling over rough ice, than by slowly studying out a complicated turn, which he may never be able to learn, but which a good skater may easily do the first time he tries it.

Gérôme complained to Count Nieuwerkerke, the Director of the École, that his students were often absent on Mondays—a not unexpected day to be absent—but he did not have many students he liked anyway. But Eakins he liked, whether or not he knew Eakins skipped his antique classes: [26]

Gérôme is very kind to me and has much patience because he knows I am trying to learn, and if I stay away he always asks after me. In spite of advice I always stay away the antique week, and often I wish now that I had never so much as seen a statue, antique or modern, till after I had been painting for some time.

On Eakins' first day at school, October 29, 1866, he had a dose of the immemorial behavior of students vis-à-vis a newcomer—an initiation. Goodrich quoted a letter to his father: [27]

When I got my card of admission the officers told me I could go now into the studio, and they seemed to have a little fun amongst themselves. Asking my way of the employees, I was passed along, and the last one, looking very grave, took me in. All the way that I went along I was making up a neat little address to Professor Gérôme explaining to him why I appeared so tardy. Unfortunately for French literature, it was entirely lost, as is every trouble you take to imagine what you ever are going to say when such and such a thing arrives.

The man took me into the room and said, "I introduce to you a newcomer," and then he quickly went out and slammed the door. There was nobody in there but students. They gave a yell which would have lifted an ordinary roof up, and then crowded around me, "Oh, the pretty child!" "How gentle!" "How graceful!" "Oh, he is calling us *Musheers*, the fool!" "Isn't he tall?" "Give us twenty francs!" Half of them screamed, "Twenty francs!" and the other half, "The welcome breakfast!" When I could get them to hear me I asked what it was. Several tried to explain but their voices were drowned. They all pushed each other and fought and yelled all at

once. . . . "Where do you come from? England?" "My God no, gentlemen, I'm an American." (I feel sure that raised me a peg in their estimation.) "Oh, the American!" "What a savage!" "I wonder if he's a Huron or an Algonquin?" "Are you rich?" "No." "He lies; he's got a gold mine." They began at last to sit down one by one. I was invited by one to do the same thing. I did so, looking to see the stool was not jerked from under me. No sooner was I sat down than one of the students about thirty years old, a big fellow with a heavy beard, came and sat down with his face within a foot of mine and opposite me. Then he made faces, and such grimaces were never equalled. . . . Each new contortion of course brought down the house. I looked pleasantly on and neither laughed nor got angry. I tried to look merely amused. Finally he tired himself out. . . . Then he insisted that I should put my bonnet on to see how I looked in it. Not being a model I resisted and wouldn't until I would be ready to go away. . . . I had determined to keep my temper even if I should have to pitch into them, and to stay there and have as much of it through with as possible. When they got not quiet but comparatively quiet, I took my leave. I thanked them for their kind attention, and giving warning to the big fellow that I was now about to put on my bonnet, I thanked him for his politeness and then left. I think the last was a good stroke, and the first thing I did next day was to make friends with the big booby.

There was a dispute in the studio between two of the fellows as to which was the strongest. It was decided they should wrestle as soon as the model rested. So they stripped themselves and fought nearly an hour, and when they were done, they were as dirty as sweeps and bloody. Since then there has been wrestling most every day, and we have had three pairs all stripped at once, and we see some anatomy. The Americans have the reputation of being a nation of boxers. Max Schmitt taught me a little about boxing, which I have forgotten. A French student squared off at me, offering to box; I jumped in nothing loth for a little tussle, but another student jerked my opponent away, saying, "My good man, let me give you a piece of counsel: never box with an American."

They are an ill-mannered set when together, but easy to make friends with one at a time. I will be sorry if I ever have an enemy amongst them. . . . There is no one in all the school who knows English and I am glad of it.

Eakins had another story of his hazing. According to Adam Emory Albright (father of the celebrated painter Ivan Albright), it involved two revolvers: [28]

He always leaned toward the wild west and in the Paris school hazing was started by a group of French students. When it came Eakins' turn they called him from an upper floor. A group waited for him below. He came down sliding on the bannister,—I have seen him do this trick, from the dissecting room to the hall a dozen times, only this time he had two revolvers. I don't know that either one was loaded. Down he came yelling like an Indian, but quick as his descent was, that group of Frenchmen were equally quick. There wasn't a Frenchman there when he landed with a Comanchee

yell. The students went into a huddle and made all Americans exempt from initiations.

Earl Shinn, at the same school at the time, had a slightly different experience: [29]

An old and sacred custom of the Ecole makes new pupils the victims of every device of teasing that can be thought of by raprascals very ingenious that way—so I began under the heaviest fire of jokes—"Chine! Chine! Vue chausson Chinoise! Ecoutez la chanson du Nouveau"—and so on; it is a rule for every Nouveau to sing a song for the rest to laugh at: I wouldn't sing; but I had to go out for their milk and black soft-soap; this will be my duty until the coming of the next apprentice, but I know of one who will be in next week, so the trial will be short. I had heard endless stories of their insults to the nouveaux; they have painted some of them all over Prussian-blue. Only lately they made a young German take off all his clothes. But the real insults are only put on those who deserve them; I managed by complete good nature, coupled with a certain display of self-respect, to steer about right, and am by this time on the best of terms with the whole set. I had to take today the breakfast purchased with my "Bienvenu"—a tax levied on newcomers; I made mine a pretty liberal one, thinking that as I was to be educated out of Frenchmen's taxes it did not behoove me to shut my fist with Frenchmen. . . .

When Eakins got home from all this, his first thoughts were to write the Sartains. He wrote John a thank-you note for helping him get into school, William a somewhat empty letter of commonplaces, and Emily what young people attached to each other generally write. John he wrote in English, "Billy" in French, and Emily in Italian: [30]

My dear Emily:

Do not be moved to anger by the long lapse of time passing before you receive my note; and do not say that I have forgotten you. Every time I look at Dante, I recall the wonderful evenings spent with you, reading the "Inferno" (although the task of a book is not precisely that); and I read it often. Then why haven't I written? to tell you the truth, with due apologies, after my sojourn in Paris, although I hoped from day to day, I had nothing but setbacks and it was not until last Friday that this ceased, so I did not want to sadden a friend with melancholy. Now, however, thanks to your father, I am among the students accepted by the Imperial Institute of Fine Arts which delights me, and this being the case, to my immeasurable joy, and I hope all my friends will rejoice with me, I can begin writing to them. Although I have already been in Paris a month, I have not found any of my companions; to tell the truth, I have not looked for them; but though I may not have companions, I do have some friends and they are Crépon who is also a comrade or he would be if he were not married, and already he has been very kind to me.

Doctor Hornor is another friend. He is an old man, a dentist, the best in Paris, and I have become firm friends with him. The third friend (and I

do not say third out of any ingratitude), is Lenoir, the Secretary. In his great goodness of heart he has done much for me, and I could not possibly tell how greatly I esteem him.

But now that I am attending school, I shall look for some fitting good comrades worthy of your brother, so that melancholy does not take hold of us, or so that at least in part, its weight will be alleviated. I for my part, have already experienced it enough, to know that it is no minor thing.

T. C. E.

There is more than a hint of homesickness in this letter to Emily. Eakins missed Philadelphia, his friends and his family, and the beauty of the country. Fall, which he particularly liked, was turning the leaves along the river into gold, and he wished he could be there to see them. He wrote his family: [31]

Have you been out on the river? It must be very beautiful now with the red and yellow leaves of the trees. The leaves are all changing here too, but they do not grow bright; they only fade and die. Since I left America I have not seen the sun except two or three days in mid ocean, and although the weather is not positively bad, it is far from good. It is always cloudy, sometimes it drizzles a little, sometimes it is foggy. Crépon says the winter is commencing and this is a specimen of it.

It never gets very cold here. The Seine does not freeze. We sometimes see such days at home in November. The spring however is said to be very beautiful here and I shall await it with some impatience.

Emily Sartain sent him a photograph of herself, and he thought it the best he had ever seen: [32]

My dear Emily,

I can't begin to tell you the pleasure I had on receiving a letter from you and Willie. I was anxiously looking for my first one. I got it Saturday and Sunday (next day) I had yours and a second one from home. Your photograph is far the best I have ever seen of you and I am very thankful for it. I will soon have mine taken and will send it to you. I am pleased with your German arrangements as they will tend to keep my friends together, and often will imagine the pleasure I would have in studying with you all.

I envy you your drive along the Wissahickon among those beautiful hills with which are connected some of my most pleasant reminiscences. You say you had a slight sensation somewhat resembling pride in your native city. I feel like scolding you for such a weak avowal of your real sentiments. You should hear me tell the Frenchmen about Philadelphia. I feel 6 ft. & 6 inches high whenever I only say I am an American; but seriously speaking Emily Philadelphia is certainly a city to be proud of, and has advantages for happiness only to be fully appreciated after leaving it. I am comfortable here, and like Paris much more than I expected to when I left home. Many young men after living here a short time do not like America. I am sure they have not known as I have the many reasonable enjoyments to be had there, the skating, the boating on our river, the beautiful walks in every direction.

I am glad you already have an invitation to go skating, and glad you have learned to skate so well that you will be likely to receive more.

Do you know which of Charley Fussell's sisters you saw, he has three.

You ask me a question I find very hard to answer; do I appreciate politeness when away from home. We may have different ideas of the word. An incivility or supposed incivility in a strange land cuts very deep and even a great or unlooked for kindness almost brings tears for one is apt to say to himself you are very good but maybe it's because I'm a stranger, and he is forcibly reminded of home where kindness is taken thoughtlessly as a matter of course. Impressions are stronger away from home as you have discerned. If by politeness then is meant goodness, it is appreciated by me and I trust it always has been, but if it is to mean the string of ceremonies, generally used for concealing ill nature, and which have been found necessary to the existence of every society whose members are wanting in self respect and morality I detest it more than ever.

I have often used the word in both these acceptations, but I don't like it. My prominent idea of a polite man is one who is nothing but foolish. It is an unenviable reputation. If there was anything else in him the polish would never be noted. He is a bad drawing finely worked up, and Gérôme says that every attempt at finish on a bad design serves only to make the work more contemptible.

I know nothing of Miss Casat [sic], but from what I know of Gérôme I think the whole story extremely probable. . . .

I don't know Helmick. I asked some of Cabanel's boys if they knew him and they did not.

I will not write you about Paris which you know yourself, and I know of nothing else that will interest you.

<div style="text-align: right">

Thomas Eakins
46 rue de Vaugirard
Paris
France.

</div>

Now Eakins' passion for Emily—whatever it was—was beginning to cool: "I know of nothing else that would interest you." And Emily herself seems to have been making conversation with her abstract, perfunctory questions about what Tom thought of politeness away from home. In a letter of the following May the casualness increased: [33]

My dear Emily,

I received your sweet Italian letter and despite my deep gratitude for your kindness, I am unable to answer it (except to tell you how much it delighted me), because I do not have the time, nor any news to give you, for nothing of any importance has occurred.

Among all the things you told me none were more pleasing than your friendship with a friend of mine.

. . . The mail is about to leave.

<div style="text-align: right">

T. C. E.

</div>

By the time the summer of 1868 came, and Emily came for a visit, the correspondence between the two had deteriorated into scolding from Emily, with Eakins answering her criticisms carefully, but evidently caring less and less whether she found his ideas acceptable or not. The two remained friends for much of their lives, however, at least through the Academy crisis of 1886, although by that time Emily seems to have thought that Eakins was rather beyond the pale of respectable Philadelphia. Her father had long since given up on Tom Eakins, and her brother Will, at least partly out of jealousy, had ceased being as friendly as he had been before.

Eakins wrote his sister Fanny from Paris that Emily was a "maiden," [34] and considering that it was written in the nineteenth century and by Eakins, he may have meant just that. He was writing Fanny about a "medical matter" concerning a girl friend whom he did not want his sister to see. He thought "a modest virgin" like Fanny should not make friends with the girl. Emily, he thought, was "a noble girl & a good companion for you & you cant see her too often." But Emily had a strong will, and would go to see whom she pleased, and, in any case, he had no right to tell her what to do. In the course of this letter he asked Fanny to say nothing to Emily about the other girl. Emily, he wrote, was "also a maiden," and he did not want to start trouble between friends.

Emily's letters to Eakins and to her brother Will were "full of society news &c & she would no doubt now like to know the Bonheurs & Europeans etc This may seem ridiculous but it is not to a girl who has perversed herself like Emily." She seemed always to want to run things, and late in 1868 apparently intruded herself upon the Eakinses in such a way that Eakins, "who was always a good friend to her," now thought she had become simply ridiculous: [35]

> My dear Mommy, I am sorry to see by Fanny's last letter & Poppy's too that Emily is at her old tricks again. However the simplest plan & best is not to notice her & I guess she will tire herself when she finds it brings her no good. She has lost Fanny's friendship for always & that of the rest of the family. . . . She hurt herself long ago by her folly in the eyes of her father & brother. She broke with me who was always a good friend to her & now with a confidence to my father would force him to rule not only Fanny to her will, but . . . begin to suspect me too. This I take to be so high handed that it is certainly no more than ridiculous, & when she breaks with my father & she must do so by her excessive claims, for Will has often told me she never could keep a friend, she will have to seek a new field for conquest.

In a letter to his sister Fanny of the same time, Eakins was even more outspoken. Emily had evidently written his father concerning something she had heard about Tom from a New York friend of hers. Benjamin advised his son to let the matter ride and not try to check on the source of the gossip. But whatever it was, it bothered Tom, who called the New Yorker a "dirty crook," and added some succinct remarks about Emily:

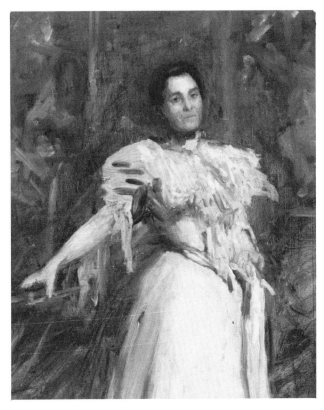

Fig. 35. *Unfinished Portrait of Emily Sartain* (detail), 1890s? Oil on canvas, 23½″ × 17½″ (59.7 × 44.5 cm). Collection Mr. and Mrs. Daniel Fraad.

There are some women who want to rule over everything and especially over men and especially those who are weak and incapable of running themselves. And once a woman gets this notion, she knows no limits or modesty and sticks her nose into everything, interferes in other people's business, spreads family secrets, lays her plans and thinks of others as belonging to her, as her personal tools for her success and not as people who have a good idea.

In the same letter Emily may also have written Benjamin that Schussele, with whom she and William studied, was a greater teacher than Gérôme, that Paris was "a damnable place to study painting," and that Philadelphia was a good place. But Benjamin urged his son not to weaken, and not to worry about Emily and her brother—they only copied, copied, copied.

By the time Eakins painted her portrait in the 1890s, Emily Sartain had grown rigid (Fig. 35). And by the time she had taught many years in the Philadelphia School of Design for Women, of which she was principal, her students thought of her, "Oh, my God! What a dragon!" and she seemed to have earned this description.

Eakins' letter to Fanny about Emily was written on the second anniversary of his École matriculation, and it is interesting to note that he wrote that he had been studying for "only two years." He obviously did not count his Philadelphia study. He was not yet "a great painter," but was studying "with all the strength and wits the Good Lord gave me and I am progressing no slower than the others."

During Eakins' first winter in Paris he saw quite a lot of Harry Moore's family, and Earl Shinn had an interesting thing or two to say about the artist vis-à-vis the Moores: [36]

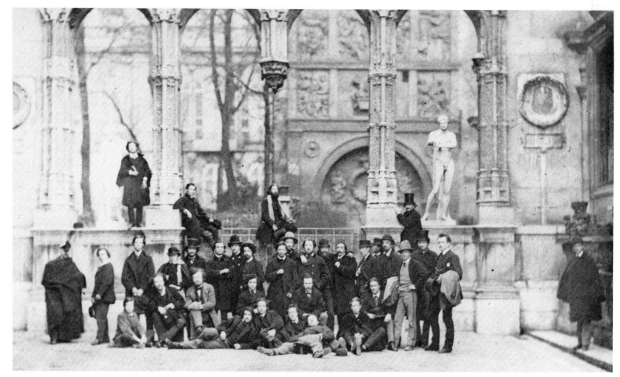

Fig. 36. Students in courtyard of École des Beaux Arts, 1866–1869. Collection Mr. and Mrs. Daniel Dietrich II, Philadelphia. Eakins does not appear in this photograph. He was probably only coincidentally absent when it was taken.

Fig. 37. Thomas Eakins at about 24, c. 1868. Collection Mr. and Mrs. Daniel Dietrich II, Philadelphia.

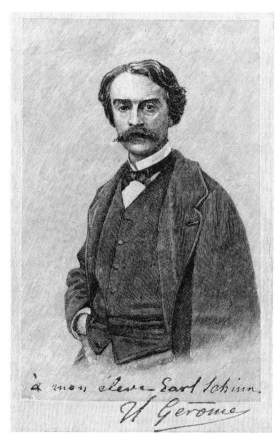

Fig. 38. Jean Léon Gérôme, c. 1866. From Earl Shinn (pseud. Edward Strahan), *Gérôme* (New York, 1881). "To my pupil Earl Shinn." Since Shinn began his study with Gérôme at the same time Eakins did, Eakins' photograph of Gérôme must have been very like this one.

Eakins visits them, and they fool with him and treat him like a little child, thee-and-thou-ing him in fun. He is 21, converses in Italian, French and German, with the manners of a boy. Restricts his conversation pretty much to stories of the Schuylkill boating club. Is the son of the writing master, tall, athletic, black hair and splendid eyes. Look out, young widow, treating the dangerous young Adonis as a boy.

Just as Shinn rhetorically warns the Moores about liking Eakins too much, Eakins later had occasion to warn his sister Fanny about liking Shinn too much. After nearly two years in France Shinn was on a visit back home, and went to see the Eakinses. "I am glad you treated Shinn well," Eakins wrote Fanny, "but be sure you dont admire him for anything but his good heart & want of vices for he is very very silly." [37] Years later, when Eakins was in his middle sixties, it was said of him that he got "very silly" about young girls. He seems to be using the word "silly" in the same way here.

By the time of this letter Shinn had been writing letters from France to *The Philadelphia Bulletin*, and Eakins had little but scorn for these:

> Shinn signs himself enfant perdu in his letters which he writes for the Bulletin & makes French in them & although he never connects more than two of the foreign words together he sometimes still manages to get them wrong. I wonder what per cent the sprinkling of such trash enhances the money value of newspaper correspondent. If a Frenchman put foreign words in his writing I am sure there is not a paper in Paris would print his stuff even for nothing.

During the remaining months of this first winter in Paris Eakins' account books show expenditures for Spanish lessons, Madeira, an occasional photograph, and gymnasium visits. One of the photographs may have been the picture of a group of students in the École courtyard (Fig. 36). He was always physically powerful, and tried to remain so at least through his youth (Fig. 37). The first day Gérôme criticized Eakins' work Eakins went out and bought his teacher's photograph. This photograph is now lost, but one that Shinn bought at the same time must be just like it (Fig. 38). Gérôme had a "beautiful eye and a splendid head," Eakins wrote. He treated everyone alike, "the oftener I see him the better I like him." [38]

The great Paris Exposition of 1867 opened early in the year, and Eakins went often, buying two catalogues—one to send home. In the Exposition's Art Gallery he saw a number of paintings, but we know little of what he thought of them: [39]

> I send by mail a catalogue of the Exhibition of Fine Arts. The great painters don't care to exhibit there at all; about twenty pictures in the whole lot interest me. The rest of the pictures are of naked women, sitting, lying down, flying, dancing, doing nothing which they call Phyrnes, Venuses, nymphs, hermaphrodites, houris, and Greek proper names. The French court has become very decent since Eugénie had fig leaves put on all the statues in the Garden of the Tuileries. When a man paints a naked woman he gives her less than poor Nature did. I can conceive of few circumstances

wherein I would have to paint a woman naked, but if I did I would not mutilate her for double the money. She is the most beautiful thing there is—except a naked man, but I never saw a study of one exhibited. It would be a godsend to see a fine man painted in a studio with bare walls, alongside of the smiling, smirking goddesses of many complexions, amidst the delicious arsenic green trees and gentle wax flowers and purling streams a-running up and down the hills—especially up. I hate affectation.

Eakins admired Gérôme of course, and later his teacher Bonnat. But just now, with the beginning of impressionism seething about him, and everyone in Paris getting involved in what was going on, Eakins might just as well have been taking a walk along the Wissahickon as along the Latin Quarter streets in which Manet, Cézanne, and Renoir were weaving their tormented way. Courbet was by now an established painter, and the Salon des Réfusés was several years in the past. But Eakins, so far as he has let us know, cared little of what they were doing. His work seems to have been done in another world and another century.

There are those who must see the influence of impressionism everywhere. But it is difficult to recognize any new points of view regarding light or the philosophy of art in the work of Eakins. It is likely he saw much impressionist work in Paris during his students days: those days encompassed the significant beginnings of the work of Monet, Renoir, Pissarro and others—and it is fair to say that it would have been difficult to avoid becoming aware of impressionism in Paris in 1866–1867. Later he knew Degas charcoals (see page 134). But historians generally agree—and I count myself among these—that the course of Eakins' art was remarkably—almost uniquely—independent of the influence of new movements.

3

Gérôme, Bonnat, and Dumont
1867-1869

In june 1867 Eakins' friends William Sartain and William J. Crowell, fellow members of his Central High School class and good friends of the family, came to visit him in Paris and to see something of Europe. Five years later Will Crowell was to marry Eakins' sister Frances, and develop into quite a prig. Sartain was something of a prig already, as his letters demonstrate.

Now, in June 1867, Paris was humming. Crowned heads and sundry were arriving for the International Exposition with considerable pomp, circumstance, and, in the case of Alexander II of Russia, with peril. Shortly after Crowell arrived, an attempt was made on Alexander's life, on the spot where Eakins and Crowell had been five minutes earlier. The King of Prussia and Bismarck were in Paris; the Sultan of was to arrive shortly.

The boys continually borrowed money from each other, with Eakins generally being the most borrowed from. This was partly because he was a bit better fixed than his friends and partly because he did a better job of keeping accounts. There is a long list of items spent, items charged to Sartain or Crowell, and items paid back when accounts were settled. Only a few of these have dates, but it can be deduced that the three left Paris sometime in July for their trip: Geneva, Villeneuve, Martigny, Col de Baume, Mer de Glace, Chamonix, Interlaken, Zurich, Lauterbrunnen, the Grindelwald,

Muringen, Grimsel, Andermatt, Lucerne, Weggis, Rigi, St. Gallen, St. Gall, Constance, Schaffhausen, Basle, Freibourg, Strasbourg, and back to Paris on September 2.

In Strasbourg they visited Christian Schussele, Eakins' and Sartain's Academy teacher, who had returned to his native city to get medical help for his palsy. Sartain talked to Schussele privately about how neither of them liked Gérôme. There must have been quite a lot of jealousy in their feeling, since neither was fit to hold Gérôme's brushes when it came to the quality they chiefly criticized—his "bad drawing": [1]

> Schussele thinks as I do (in spite of Tom's protests and laughs) that Gérôme's color is tame & flat and monotonous, that his drawing is poor, very poor in comparison with the Belgian artists (whom S. thinks better than the French in art). I see the greatest monstrosities in Gérôme's drawing—every time I go to the Exposition. . . . The conclusions I have come to are—not to return to live in Paris as an art student, but if I come to Europe again I shall go to Belgium, Holland, or Italy. There are some pictures here by Alma Tadema of Holland, that I admire enthusiastically, & WHEN [sic] Schussele, whom I took to see them for the first time, admires very much. He said they are like Gérôme's in subject but how beautiful in color & drawing. . . .

Gérôme was "too little a man," to study with, Schussele remarked, leaving us to wonder about the size of a man who painted such turgid works as *Men of Progress*. He told Sartain that he saw no advantage in coming to Europe to study art.

Schussele was in Paris a few days after he saw the Philadelphia boys in Strasbourg. He had come to consult a quack about his palsy, Sartain wrote. Sartain and Eakins met him at the Exposition, and he was worse than ever.

Sartain was placid about Switzerland, except such places as Zurich and Constance, which he thought had better railroad depots than any town in America. Eakins, however, was repelled by much of Swiss life, and particularly by the inbreeding which then and now often puts a visitor off: [2]

> the most God forsaken place I ever saw or hope to see. The people are all either cretins or only half cretins with the goiter on their necks. They live in the filthiest manner possible the lower apartment being privy and barn combined and they breed by incest altogether. Consequent goiters and cretins only. If I was a military conqueror and they came in my way I would burn every hovel and spare nobody for fear they would contaminate the rest of the world. When you ask them a question they grin and make idiotic motions. Jesus Christs on the cross are at every 50 yards with lots of blood and agony. We saw a congregation waiting for church. The women were laughing as usual and picking the lice off the children's heads till the priest came. The hats the women wear are as stupid as possible, a band with gold or silver edge surrounding the crown. They all have big faces and the heads run lower than those of the flat head Indians but don't stick out behind like theirs. They are dirty as they can be and so have become contented as they can never become dirtier. The women aforsesaid are

not contented no more than the men. Their minds are not even capable of this sentiment. I mean to say their ancestors were contented to be as dirty as possible and they are as dirty as possible only because their ancestors were and they never would think of a change even if no trouble to make. Even the children are frightfully ugly. When a woman comes along leading a cow or sheep of ordinary intelligence you ought to see how intellectual looking and spirited the animal is alongside of the woman by contrast. They stink their houses stink worse, the water of the valley stinks, and the valley itself stinks except in a few places for instance the big French hotel we are now in. Out in Poland and down in Italy they have the cholera. It is to be hoped it will get up some of these valleys. An earthquake some years ago was a godsend in destroying half of them. The rocks thrown down the mountain sides are the biggest loose rocks I ever saw almost young mountains in themselves. We meet of course crowds of Englishmen. The only bearable ones are those who have lived in Australia a long time and were fetched up at Cape of Good Hope in Africa or the little girls too young to be prudish and English. The latter might be tamed if got away from the disagreeable associations, but it would not be worth the trouble unless to one who could find neither an American, French Italian Spanish or Chinese. Now it is raining worse than ever and the hotel is full of English. They are great hogs, so different from the French. . . . Chamonix is in French Switzerland nothing like this dutchvalley we're in now.

On the way from Strasbourg back to Paris on September 2, 1867, they traveled in a third-class compartment, and Sartain's sensibilities were destroyed: [3]

> We were as dirty, tired, and uncomfortable as possible, as you may imagine when I say we came *third* class & that the car was filled with common people, very dirty and their children even dirtier. To add to our comfort, the child in our compartment, having eaten too many pears, met with an accident, that anything but improved the air. Excuse this disagreeable minutia—but it is perfectly French & therefore fashionable to mention it. The whole triple compartment in our car discussed it without reserve . . . another party washed their faces with water they carried with them in a bottle & wiped them on a towel which was subsequently devoted to wrapping up the bread & meat. . . .

The following Friday, up at 6 A.M., Sartain wrote his sister Emily while Eakins and Crowell were still in bed, "with apparently no intentions of getting up." At seven o'clock Eakins got up and began to amuse himself with a doll Crowell had bought that talked and cried when it was laid down. "Bye the bye," Sartain wrote, "Crowell dont want anyone to know that he has got the doll baby—either at Eakins' or at his own house. So don't anyone mention it." [4] When Crowell got up, they settled their accounts. "W. S. owes Tom E. 36.65," Eakins wrote, "W. C. owes Tom E. 18.80." [5] Soon Sartain was off for a visit to England—he liked the English better than other Europeans —and Crowell was off with him, but directly for America.

After his friends had left, Eakins must have felt lonely, for he decided to move to

Fig. 39. 62–64 rue de l'Ouest, Paris, 1971. Author's collection. Eakins lived or had his studio here from 1867 to 1869. The two-story building in the center is 62, next left is 64.

what he thought would be a more homelike atmosphere, as indeed it eventually turned out to be. His friend Crépon had had as a tenant another École student who had moved out, and Eakins decided to move in. The new address was at 62 rue de l'Ouest, a building that still stands (Fig. 39). A letter to his father in about November 1867 describes the place, and his move to a more comfortable room next door at number 64, though in the same building: [6]

> So I will tell you about my housekeeping for I have again moved. My first studio was on the pavement one step below the ground paved with brick and the walls with dark bluish color. It was a nice large studio and I thought I could live there very well, but it was impossible to keep it clean. I bought a big broom but the way the dirt would stick in those bricks was a caution. I had spread a piece of carpet down by my bed to tread on for if I trod on the bricks I had to go wash my feet. Then I had to be very careful to tuck in the bed clothes well at night for if they touched the bricks they were soiled too. One day I found that the wall had the same effect on them and then I made up my mind to wash the wall where my bed was. Sculptors had had my studio before me and a sort of dust had settled all over the wall. It took me nearly all day to scrub a place big enough for my bed and I think that after I had worked for about two hours right hard and had skinned my little finger that if any one had come to me and offered to clean house for me and all for nothing I would not even have got mad. Crépon came in and put up a big curtain all around my bed for me so that I was

not on the whole very uncomfortable, but my trouble after all was to keep dry. I thought it would be very easy with a fire, but the fire would go out sometimes at night or I would be away all day and although I never got a cough or other sickness I was apt to have a cold in the head. Crépon's little baby got sick and the doctor told him he must get away from his quarters to an upstairs place, that beside the danger to his wife and child he might find himself some day with rheumatism. Crépon told the doctor how he kept fire going all the time but the doctor said that that did not do much good although some one told him no one ought to live on a ground floor. When I heard all this I began to think of myself and concluded that I had better leave my quarters too. So I have taken in place of my old studio an upstairs in the same building. I am now rather more 64 than 62 rue de l'ouest. Crépon is looking around for a new house but has not yet been as lucky as I was. Having a child it is very hard to rent a room in Paris. Children interfere with the comforts of close neighbors and children seem to have no business to be in Rues for it is not the fashion. They should be given to common ignorant strange women to nurse, one of whom has just been sentenced to prison for killing little babies and keeping on charging for them weekly months after their death when she pretends they are just dead.

The place I am in now is perfectly dry and comfortable. It has a nice wooden floor of oak which may be waxed if one likes it but I'm sure I'll never take that trouble; but what is so good about it is that when one takes the broom the dirt dont stick fast but slips easy along the floor and is put all in a pile. The studio is not so large as the other one but plenty large enough for my bed and then another place for my clothes and writing materials. I go to bed up a little ladder and there is a door and balcony which will prevent me from falling down into the studio if I should take to sleep walking. This little room is papered and I can easily keep my bed and everything perfectly nice.

His studio was comfortable and he had a taste of home living, but his work made him unhappy. "I am perfectly comfortable," he wrote, "and would be happy if I could make pictures." [7] He was well and hard at work, but downhearted because Gérôme had called one of his things "not bad," but said, "Now I will mix your colors which you will put on." But Eakins could not make them "gee," and made a "devil of a mess." He was sure he would get a "good scolding" from Gérôme the next day.

At Christmastime in 1867 he was particularly depressed and perhaps short-tempered, for when Emily Sartain accused him of writing her trivia he answered her strongly: [8]

. . . Happy New Year Emily to you & all the family who by this time must again be all together. If as you say you have felt hard sometimes toward me I have never returned that sentiment. If ever I said it has been a long time since I had a letter from you or your last letter was so short it was not to find fault with you but tell you the pleasure I still got from your letters. Some of your reproaches make me think you want me to answer them: for

instance—"It seems to me that if you had taken so much trouble to remember to tell me each time you had seen Father etc what you had talked about &c as you have to give all the particulars of the way in which different Americans make fools of themselves I should have etc." I always sent general news of your family to my family. Particular conversations could not possibly have been interesting but I would surely have written to you direct at any time of their whereabouts for the month hence if I could have known it better than themselves. They were very erratic had no plans very fixed except general ones that I wrote home in my home letters that any one can read.

I have thought over your reproach of my being cynical. I think it unjust. Understand me I do not think you unjust for making it, but am thankful to you for speaking so free. I think I easily forgive any amount of folly which springs only from want of sense and is not mixed with ill nature. But what I hate is imposition & hypocrisy and affectation, of which I saw a big share last week. Dear Emily Please excuse me from writing more. I feel so stupid & prosy from having been sick & it is getting dark so I want to hurry to the post office. I'll try write you [sic] more at length next time. There is one thing though very funny in your letter I insist that the duties & responsibilities of men & women are equal etc. Tell me truly how hard did you set down your pretty little foot after writing that. You never learned that from yourself Emily or my mother or your mother or next door at your sister Helen's. Happy New Year to you. Go to our house and eat a big piece of mince pie for me & an extra slice of plum pudding at your own house

Thomas Eakins.

Eakins' depression and unrest continued through the winter. He started hiring models to pose for him—one a girl named Anne—and before the winter was out he made at least two visits to a house of prostitution, not apparently for the purpose of finding models. Gérôme had gone to the Orient for a four months' trip, and Eakins' principal reason for being in Paris went with him. He attended the opera and theater with fair regularity—a surprising program for one as frugal as himself—and he started horseback riding. He was also beginning to have serious thoughts about the philosophy of painting. Ideas as to what painting was all about and what he wanted to do about it were surging through his mind. He wrote his father about these: [9]

The big artist does not sit down monkey-like and copy a coal-scuttle or an ugly old woman like some Dutch painters have done, nor a dung pile, but he keeps a sharp eye on Nature and steals her tools. He learns what she does with light, the big tool, and then color, then form, and appropriates them to his own use. Then he's got a canoe of his own, smaller than Nature's, but big enough for every purpose. . . . With this canoe he can sail parallel to Nature's sailing. He will soon be sailing only where he wants to, . . . but if ever he thinks he can sail another fashion from Nature or make a better-shaped boat, he'll capsize or stick in the mud, and nobody will buy his pictures or sail with him in his old tub. If a big painter wants to draw a coal-

scuttle, he can do it better than the man that has been doing nothing but coal-scuttles all his life. . . . The big painter sees the marks that Nature's big boat made in the mud and he understands them and profits by them. . . . The big artists were the most timid of themselves and had the greatest confidence in Nature, and when they made an unnatural thing they made it as Nature would have made it, and thus they are really closer to Nature than the coal-scuttle painters ever suspect. In a big picture you can see what o'clock it is, afternoon or morning, if it's hot or cold, winter or summer, and what kind of people are there, and what they are doing and why they are doing it. The sentiments run beyond words. If a man makes a hot day he makes it like a hot day he once saw or is seeing; if a sweet face, a face he once saw or which he imagines from old memories or parts of memories and his knowledge, and he combines and combines, never creates— but at the very first combination no man, and least of all himself, could ever disentangle the feelings that animated him just then, and refer each one to its right place. . . .

Then the professors, as they are called, read Greek for inspiration and talk classic and give out classic subjects, and make a fellow draw antique, not to see how beautiful those simple-hearted big men sailed, but to observe their mud marks, which are easier to see and measure than to understand. I love sunlight and children and beautiful women and men, their heads and hands, and most everything I see, and some day I expect to paint them as I see them, and even paint some that I remember or imagine, . . . but if I went to Greece to live there twenty years I could not paint a Greek subject, for my head would be full of classics, the nasty, besmeared, wooden, gloomy, hard, tragic figures of the great French school of the last few centuries, and Ingres, and the Greek letters I learned at the High School, and my mud marks of the antique statues. Heavens, what will a fellow ever do that runs his boat, a mean old tub, in the marks not of Nature but of another man that run after Nature centuries ago? . . .

A good painting has a very high money value which it always brings, and beyond that a fancy price that runs up and down very irregularly. This fancy price is gambling, and an artist that pays attention to it instead of the real price, must lose in the end as sure as insurance. The big painters understand this, and whether their aim is reputation or the comforts of money or even social position, they look on painting as their heaviest tool and work through it. A prince or anyone at all could not get in to Gérôme or Meissonier or Couture at work. No one but a student can ever get in to Gérôme. So everything I see around me narrows my path and makes me more earnest and hardworking. That Pettit or Read get big prices does not in the least affect me. If I had no hope of ever earning big prices I might be envious, and now worthy painting is the only hope of my life and study. . . .

I could even now earn a respectable living in America, I think, painting heads but there are advantages here which could never be had in America for study. . . .

Eakins' correspondence with his sister Fanny continued steadily. He spoke very

frankly to her on a variety of matters. Now, in the spring of 1868, he wrote her about his disgust with the Christian religion. It was Good Friday—April 10—and he could not find any meat to eat for breakfast. All that was to be had was a piece of codfish that was so salty he could not eat it. The servant assured him that it was for the good of his soul. This set him off: [10]

> Most people think they will go to hell if they eat meat on good Friday & others that dont believe in it at all never ate it before & dont like to begin & would rather take a dose of castor oil than a nice piece of beef.
>
> Of all religions the christian is the most intolerant & inconsistent & no one without living here can know what a frightful war it wages against anything that is good.

The following year, after praising the religion of the Near East, that Gérôme had painted so admirably, he zeroed in on the Catholic religion: [11]

> There's no God but God & Mahomed is his prophet. How simple & grand. How Christ like . . . the contemptable catholic religion the three in one & one in 3 $3 = 1$ $1 = 3$ $3 \times 1 = 3$ which they call mystery & if you dont believe it be damned to you & the virgin's mother that afterwards married a man look at it isn't it ridiculous & the virgin's grandmother for his grandmother was made so recently by Pope Pius IX don't you remember the stone the solemn conclave the date in gold letters. Either I am stark mad myself or the people are fools beside me.
>
> I won't believe I'm wrong. A healthy religious [*sic*] will always affect you like a Turk. You would go out into the big quiet, the desert or the top of the house. You wont go to church to see their little parades their gildings & tinsel their little bells to hear the money clinking for the Society of Jesus for the new chapel the bad close damp air the nasty low priests who live without work. When I see genuflexions & crossings & clap trap & wood virgins gilt & statues in clay with gold crowns all jewelled on their heads I want to laugh always & I pity those who believe in them & I look down on them as my inferiors. The Turk dont pray like a Christian nor he dont pay anyone to pray for him. We will now sing the 917th Psalm the 1st & 5th verses 1st 3 & 5 my brethren omitting the 2d & 4th.
>
> Let us pray page 100 near the bottom of the page. My God. Fanny if you ever will make a habit of going to church I'll think less of you for it.

Perhaps his father sensed that his son was depressed, and needed the cheering up that the sight of his family would give him. In any case, early in the summer, on June 12, 1868, Eakins' father and sister Frances left Philadelphia for a visit to Tom. The same month Emily Sartain, with friends named the Howellses (whom Eakins could not tolerate) also left America for a trip to Europe. "I will be very glad to see you," Eakins wrote Emily. ". . . It has been a long time since we were together." [12]

Fanny's list of things to take along on her trip included German and French dictionaries, sheet music (which she practiced a little on the boat going over), Confucius, Thoreau, *John Halifax, Gentleman*, and a pair of gloves for Tom. On the boat

she expressed herself in her diary about the "English snobs" she met, agreeing with her brother that the English were far from being her favorites among foreigners (page 50). She had a long quarrel with two Englishmen about Anglo-American relations, and one of them got very angry. One of their table companions was an Englishman who did not want to talk to them: "He dont know who our great grandfather was and has not been regularly introduced." [13]

When Fanny and "Poppy" got to Cork, a letter from Emily was waiting for them. They stayed overnight in Liverpool, and after getting to London collected a letter from Tom. The two saw sights for several days. On June 26 they visited the exhibition of the Society of Painters in Water Colors, and "then spent the rest of the evening in search of a drink." Fanny saw the Royal Academy show, but did not like the pictures—"they were all modern." The paintings in Hampton Court Palace were "excreble." After receiving two more letters from Tom, they made a rough crossing to Boulogne and arrived in Paris at 9:35 A.M. on the Fourth of July. Tom was at the station to meet them, and Fanny thought he was "the finest looking fellow I've seen since I left Philadelphia": [14]

> On the Fourth of July we saw Tom; he was waiting at the station for us. He is much thinner than when he left home, but his complexion is clear and he looks right strong. The excitement of seeing us had kept him awake for a couple of nights and had made him pale, but by yesterday he had regained his color and looked fine. Anybody would take him for an Italian, his face and figure are so very Italian.
>
> Yesterday morning we went to his studio. He had not yet finished any of his paintings (that is lady's work, he says) and of course they are rough looking, but they are very strong and all the positions are fine and the drawing good. He thinks he understands something of color now, but says it was very discouraging at first, it was so hard to grasp.
>
> He has changed very little, he's just the same old Tom he used to be, and just as careless looking. His best hat (I don't know what his common one can be) is a great big gray felt steeple, look's like an ashman's; his best coat is a brown sack, and his best pantaloons are light, with the biggest grease spot on them you ever saw. And then he most always wears a colored shirt. But he's the finest looking fellow I've seen since I left Philadelphia. We told him he was a little careless looking and he evinced the greatest surprise. "Good gracious," he said, "why I fixed up on purpose to see you, you ought to see me other days." You ought to see him bow; imagine Tom making a French bow. But I tell you he does it like a native.

Max Schmitt's wife sent along some cakes for them to celebrate the Fourth with, and after walking through the Luxembourg Gardens, the three enjoyed a bit of Philadelphia cooking away from home. The next day they met Emily Sartain and her traveling companions, the Howellses. Fanny didn't like them any better than Tom did. But Emily liked them and wrote her father that she thought Tom was "absurd": [15]

I had a most absurd letter today from Tom Eakins, talking against Mr.

Howells ridiculously. He took a prejudice against him,—I suppose because he is well dressed,—fancied he was a dandy etc. I tell you this, for probably he will write home in the same strain, and I do not want you to let them think, that I am anything but satisfied. I do not think I could have pleasanter companions. I am sorry Mrs. H. gets tired so easily, but that is better than being with some one so strong that I should get worn out. . . .

Fanny and her father met Tom's friends, Curé and Sauvage, and Fanny liked them very much.[16] On July 10 Tom and his father and friends "went to some place of amusement," leaving Fanny home, and the next day Tom and his father went swimming in the Seine. The Crépons, Tom's landlords, were in Fontainebleau for the summer, and the three went to visit them. The following day, July 13, Fanny and her father were off to Cologne, to "do" the central Continent and meet Tom in Genoa at the end of their trip on August 1. In Constance, meanwhile, Fanny had another "long argument with an Englishman."

Tom decided to take a trip to Turin before he met his family at Genoa on the first of August, and bought a ticket and a guide book to the Turin Museum. At Genoa he learned "Poppy" had walked all day at the Grindelwald and that they had "bought our watches" while in Geneva. From Genoa the three sailed for Naples via Leghorn and Pisa, arriving in Naples on August 5. There they visited Virgil's tomb, Vesuvius, and Pompeii. Three days' sight-seeing in Rome—during which time they saw the Pope —and they started back for Paris via Florence (where the Palazzo Vecchio "smelled very bad"), Padua, Venice, Verona, Munich ("the fine picture gallery containing Rembrandt, Rubens, & Murillo & other fine paintings" and a beer garden), Stuttgart, Heidelberg, Mainz, Düsseldorf, Brussels, Verviers ("the ugliest town we ever saw"), and finally back to Paris on August 31. In Paris they heard *Zampa*, visited the Bois de Boulogne, went down the river to St. Cloud, visited Sèvres, dined with Crépon, and left for Le Havre on September 9, leaving a lonely Thomas Eakins at the Gare du Nord. Fanny and her father sailed for America on September 10. Two days later Emily Sartain and her friends followed them on a Cunard liner from England.

Either before or after his family arrived, Eakins moved to 116 rue d'Assas (Fig. 40), but kept a studio at Crépon's, on rue de l'Ouest. Perhaps the Crépons had given up their address on the rue de l'Ouest to go to Fontainebleau. His new building still stands, across the street from the University of Paris and across the Luxembourg Gardens from his first Paris address at 46 rue de Vaugirard.

Late in September 1868 Eakins arranged for a collection of art objects to be sent to Philadelphia to Edward T. Cope, and told Cope that he would probably not be in Paris when the money got there. This suggests that he may have been planning his Christmas trip to America, or a return to America for good. Cope passed the letter on to Benjamin Eakins, who may have been urging Tom to come home for a Christmas vacation. Goodrich quotes part of a letter from Eakins to his father which betrays some degree of homesickness: [17]

I do not know exactly what made me betray an uneasiness in my letter of which you speak. It was probably a rainy day or I had been seeing some disagreeable person or thing. But certainly it was a momentary affair like that and not a homesickness that could be dispelled by a momentary visit. I love my home as much as anybody and never see the sun set that I do not think of it, and I often feel lonely, but I can learn faster here than at home, and stay content, and would not think of wasting the expense of a voyage for a few weeks' pleasure. You miss but one from the family. I miss all.

Eakins was yearning for the day when he could come home to stay. He was beginning to think he had gotten all he could from Gérôme, but he felt that he would probably never return to Europe and that he should do everything he could before he left. Nevertheless, by the time winter came, he could stand being away no longer, and early in December sailed from Havre for home on the *St. Laurent*. Some time before he left he wrote his little sister Caroline a Christmas letter: [18]

Dear little Caddy. When you get this letter there will be only a month to Christmas time when all the good little boys & girls hang up their stockings & as I expect you will be very good & deserve a great deal of goodies I hope you will think to hang up your Mamas stocking instead of your own for a little girl's stomach is I am sure bigger than her foot.

Eakins stayed at home until March 6, 1869, when he and William Sartain, who had decided to study in Paris for a while, sailed from New York on the *Ville de Paris*. Soon after getting back to France he wrote his father: [19]

Fig. 40. 116 rue d'Assas, Paris, 1971. Author's collection. Eakins lived here from 1868 to 1869.

One terrible anxiety is off my mind. I will never have to give up painting, for even now I could paint heads good enough to make a living anywhere in America. I hope not to be a drag upon you a great while longer.

In Paris Sartain, who had thought Gérôme drew poorly, began to study with Yvon, who had been Schussele's teacher. He met a lot of Eakins' friends, and until he saw Léon Bonnat's *Assumption* (Plate 4) in the Salon of that year and decided that this was the man for him, he lived with Eakins at his house in the rue d'Assas. Then he moved to Montmartre to a hotel on the rue de Laval to be near Bonnat.

The two had intended to share Eakins' old studio with Crépon on the rue de l'Ouest, and live together at 116 rue d'Assas. But one day after they came Eakins went to Crépon's to cover some canvases, and Crépon made it clear that he wanted them to move out, and especially clear that he did not want Sartain to use the place. The smell of paint, he complained, would give his little boy the colic. So Eakins told him that "it was indifferent to us whether we staid with him or took a studio to ourselves," [20] and it was agreed that they had better move. The move, to a studio on the rue de Rennes, had been made by the middle of April 1869. Correspondence, including issues of *The New York Tribune*, which were occasionally forwarded from home, could be sent either to his new studio or to his living quarters on the rue d'Assas.

Both Sartain and Eakins caught colds when they got back to Paris, and Eakins, possibly from tap water he added to his wine, also got diarrhea, "another natural exit" for the cold.[21] Eakins kept Sartain away from the "unpleasant" parts of Paris and introduced him to the Bonheurs and other friends. They were better, Eakins thought, than Sartain's American friends at Yvon's. To celebrate his having been rejected for military service, Bonheur had a party where he served punch. Sartain saw "a little cutting up which seemed to please him." [22] Eakins didn't like punch, so he "took care" to spill all of his on the floor.

By mid-April the weather was [23]

> bright & clear & warm like summer. The leaves are all out, & in the evening we sit out on the balcony looking on the delicate sky & new moon till dark & without a bit of chilliness. Green peas & strawberries & asparagus are come but are too dear to buy but in a week or so they will be plenty. We are fixing our studio up nicely. We have bought some good photographs & prints to hang on the walls & besides some plaster casts that are nice & useful to draw from once in a while.
>
> Last Sunday Bill & I took a long walk in the country & in coming home we saw one of the horse races.

Eakins' love of men and horses in motion took the two to the circus more than once. "The circus is the finest thing I know of in Paris," Eakins wrote his sister Fanny. "Men & horses in motion. If Paradise is prettier than this part of the circus I want to see it." [24] He bought photographs of works of art: a Gérôme, life studies, and a landscape. He went to hear *Martha, Faust,* and *The Daughter of the Regiment.* He was

also having trouble with his teeth, having as many as nine replacements or "plugs" put in that spring. His Aunt Eliza Cowperthwaite sent him the equivalent of a hundred francs on the Fourth of July, and he bought a barometer with the money. The Paris weather, which was finally to send him off to the south of Spain that fall, was beginning to get him down.

There was much rioting in the Paris streets in the summer of 1869. Napoleon III moved hysterically from one domestic alliance to another, trying to recoup his waning power, and, under the influence of his wife Eugénie, just as hysterically from one foreign alliance to another. Meanwhile the country lurched inevitably toward a confrontation with Prussia. It must have been both politics and weather that helped Eakins to make up his mind to leave France.

He had been interested in Spanish painting for some time, had seen the work of Velázquez, Ribera, and others in the Louvre. Now he also became interested in Bonnat. Bonnat had lived in Spain, and admired the Spanish masters very much. He was also strongly influenced by them. It is perhaps his *Assumption* with its strong Spanish aura that helped Eakins make up his mind to try Sartain's new teacher himself. So for a few months beginning possibly in the summer of 1869, he worked in Bonnat's studio. Gérôme was constantly flitting about, and on October 1 he was given leave from the École for two months to attend the Suez Canal opening celebration. It may have been this continuing irregularity of his master's teaching schedule that helped Eakins make up his mind to turn to Bonnat.

His admiration for Gérôme was as great as ever, but he was beginning to see the end of his European sojourn and the necessity of settling down to an artist's life of his own. He wrote his sister Fanny about a new picture by Gérôme, one showing Dante walking along the street. Only Gérôme could do it—Gérôme, who had "raised himself above his fellow men as man had raised himself above the swine." [25] He had sent home a photograph of Gérôme, and he asked his sister to "look at Gérôme's head again"—

> It is like Shakespeare's & Cervantes just as large but a great deal more beautiful. You are superior to any girl I know of Fanny or I never would have written you to think of Gérôme as I do. If Billy Crowell knew him as well as I do he would never have spoken against him & I wonder at it still. . . .
>
> Some painters paint beautiful skin, some find happy bits of color, some paint soldiers clothes, & costumes of Louis 15, 16, 17, 18, 20 & puppets & mawkish unnatural of sickish sentiment, some tin & earthen ware, some flowers always beautiful & sometimes too on canvas some make moonlights & some candle lights some make ships & some paint water & some paint allegories or fiddles or landscapes angels or horseradishes but who can paint men like my dear master, the living thinking active men, whose faces tell their life long story. Who ever has done so but him & who will ever do it again like him. . . . But he never made from choice a dollbaby or a weak man or a hen-pick unless to show off a strong minded woman. . . . He

never presented vice in a form to make ony one like it but rather shudder
at it. . . .

Couture, whose *Decadence* was still the talk of Paris, he also admired. He
thought some examples of Couture's color at an American banker's the most beautiful
he had ever seen. But he tells us more about himself than Couture when he speaks of
Couture's pre-eminent success in putting nature and beauty on canvas: [26]

> Who that has ever looked in a girl's eyes or run his fingers through her soft
> hair or smoothed her cheek with his hand or kissed her lips or their corners
> that plexus of all that is beautiful in modelling but must love Couture for
> having shown us nature again & beauty on canvas.

Eakins' last summer in Paris, with Gérôme off to the country and Bonnat,
whether in the country or not, still in the offing, was filled with work. But he found
time to visit friends and, when Max Schmitt's mother came to Paris, to show her
around. He lent his friends and fellow École student Germain Bonheur, the brother of
Rosa, forty francs, and wrote his mother that he could write her "a whole French novel
about that." [27] Sartain wrote of two other friends, Dagnan-Bouveret and "his inseparable
companion" Courtois,[28] and gave an interesting account of a visit to the Bonheurs: [29]

> I should have mentioned another companion of Tom's—Germain Bonheur.
> From this acquaintance we were invited to his parent's home. His sister Rosa
> Bonheur was there on a visit from her home in Fontainebleau and as she sat
> at the table she strikingly resembled Henry C. Carey the political economist
> of Philadelphia. Below she wore skirts but her upper attire resembled that of
> a man. She was very bossy and dictatorial, with the family, and when Ger-
> main differed from her on any point she would tell him to go to bed! Tom was
> speaking of our national mechanical skill and to illustrate his point he pulled
> out from his pocket his Smith & Wesson revolver. (I know of no other
> person in Paris who carried one!) Rosa put *her* hand into her pocket and
> pulled out one of the same make. She acquired the habit of carrying it
> during her sketching at Fontainebleau.

At some time during Eakins' stay in Paris—it may have been during this last
summer there—he studied with the sculptor Augustin Alexandre Dumont (1801–
1884). Dumont was a professor at the École from 1852 onward, and Eakins must have
seen his *Blanche of Castille* in the Luxembourg Gardens many times. The more explicit
portrait bust illustrated here shows considerable technical skill, though something less
than psychological penetration (Fig. 41).

In November the decision had been made. Eakins would go to Seville, see some
Spanish art, and, in the process, escape the execrable Paris weather. He wrote his father
his decision: [30]

> I have a cold that set me coughing today. I will try to get it well. It has
> been raining now for two weeks every day, and sometimes it pours and is
> very dark, so that I feel anxious to get away. . . . Rain, dampness, and

Fig. 41. Augustin Dumont; *Marquis de Pastoret*. Marble. Palais du Luxembourg.

French fireplaces—no color even in flesh, nothing but dirty grays. If I had to live in water and cold mist I had rather be a cold-blooded fish and not human. . . . I have a good fire that warms my back and I hold my feet up on a chair to keep them from the draught that blows in from under the doors and sashes and up the chimney. The French know no more about comfort than the man in the moon. . . . I feel now that my school days are at last over and sooner than I dared hope. What I have come to France for is accomplished, so let us look to the Fourth of July, as I once looked for it before and for Christmas after. I am as strong as any of Gérôme's pupils, and I have nothing now to gain by remaining. What I have learned I could not have learned at home; for beginning, Paris is the best place. My attention to the living model even when I was doing my worst work has benefited me and improved my standard of beauty. It is bad to stay at school after being advanced as far as I am now. The French boys sometimes do and learn to make wonderful fine studies, but I notice those who make such studies seldom make good pictures, for to make these wonderful studies they must make it their special trade, almost must stop learning, and pay all their attention to what they are putting on their canvas rather than in their heads, and their business becomes a different one from the painter's, who paints better even a study if he takes his time to it, than those who work in the schools to show off, to catch a medal, to please a professor, or to catch the prize of Rome.

I do not know if you understand. An attractive study is made from experience and calculations. The picture-maker sets down his grand landmarks and lets them dry and never disturbs them, but the study-maker must keep many of his landmarks entirely in his head, for he must paint at the first lick and only part at a time, and that must be entirely finished at once, so that a wonderful study is an accomplishment and not power. There are enough difficulties in painting itself, without multiplying them, without searching what it is useless to vanquish. The best artists never make what

is so often thought by the ignorant, to be flashing studies. A teacher can do very little for a pupil and should only be thankful if he don't hinder him, and the greater the master, mostly the less he can say.

What I have arrived to I have not gained without any hard plodding work. My studies and worries have made me thin. For a long time I did not hardly sleep at nights, but dreamed all the time about color and forms, and often nearly always they were crazinesses in their queerness. So it seems to me almost new and strange now, that I do with great ease some things that I strained so hard for and sometimes thought impossible to accomplish. I have had the benefit of a good teacher with good classmates. Gérôme is too great to impose much, but aside from his overthrowing completely the ideas I had got before at home, and then telling me one or two things in drawing, he has never been able to assist me much, and oftener bothered me by mistaking my troubles. Sometimes in my spasmodic efforts to get my tones of color, the paint got thick, and he would tell me that it was the thickness of the paint that was hindering me from delicate modelling or delicate changes. How I suffered in my doubtings, and I would change again, make a fine drawing and rub weak sickly color on it, and if my comrades or my teacher told me it was better, it almost drove me crazy, and again I would go back to my old instinct and make frightful work again. It made me doubt of myself, of my intelligence, of everything, and yet I thought things looked so beautiful and clean that I could not be mistaken. I think I tried every road possible. Sometimes I took all advice, sometimes I shut my ears and listened to none. My worst troubles are over, I know perfectly what I am doing and can run my modelling, without polishing or hiding or sneaking it away to the end. I can finish as far as I can see. What a relief to me when I saw everything falling in its place, as I always had an instinct that it would if I could ever get my bearings all correct only once.

4

Spain
1869-1870

O<small>N NOVEMBER</small> 29, 1869, "in a pouring rain of course," Eakins and Harry Moore left Paris for Madrid. The next afternoon at two thirty they crossed the border and were in Madrid, at the Hotel de Peninsular, by nine thirty that evening.

It had passed through Eakins' mind that he would go to Algiers. The hotter a place seemed in the middle of the cold rain in Paris the more it lured him. "Open air painting is now important to me," he wrote his father, "to strengthen my color and to study light." [1] He also had diarrhea, which "the good sunlight of Madrid" soon cured.

Every day in Madrid Eakins went to the Prado and was overwhelmed by what he saw. He was repelled by Rubens, and *The Three Graces* and *The Judgment of Paris* disgusted him. But at the sight of *The Birth of the Milky Way* (Fig. 42) his Philadelphia gorge must have risen beyond any reasonable prospect of quite settling ever again: [2]

> Rubens is the nastiest most vulgar noisy painter that ever lived. His men are twisted to pieces. His modelling is always crooked and dropsical and no marking is ever in its right place or anything like what he sees in nature, his people never have bones, his color is dashing and flashy, his people must all be in the most violent action must use the strength of Hercules if a little watch is to be wound up, the wind must be blowing great guns even in a

Fig. 42. Peter Paul Rubens. *The Birth of the Milky Way*, c. 1636–1637. Oil on canvas, 71½″ × 96″ (181 × 244 cm). Prado Museum, Madrid.

chamber or dining room, everything must be making a noise and tumbling about there must be monsters too for his men were not monstrous enough for him. His pictures always put me in mind of chamber pots and I would not be sorry if they were all burnt.

But Velázquez was another matter: [3]

I have seen big painting here. When I looked at all the paintings by all the masters I had known, I could not help saying to myself all the time, "It's very pretty but it's not all yet. It ought to be better." Now I have seen what I always thought ought to have been done and what did not seem to me impossible. O, what a satisfaction it gave me to see the good Spanish work, so good, so strong, so reasonable, so free from every affectation. In Madrid I have seen big work every day and I will never forget it. I was sick when I left Paris. I think the good sunlight of Madrid set me up.

The Fonda del Peninsular was on the Calle Mayor, halfway between the railroad station and the Prado. At the Prado there were sixty works by Velázquez, including a large number of portraits of both aristocrats and commoners (Fig. 43). The great series of royal portraits—Philip III and IV, Philip IV's heirs and wives and relatives—must have had a special appeal. Ribera's portraits of assorted saints, taken as they were from Spanish common people, must have affected Eakins strongly (Fig. 44). He saw in them a directness and strength that were rarely seen in the Louvre, and then largely in other paintings by these same masters.

Eakins also enjoyed Madrid itself. Everything was so clean, and the Spaniards were so attractive and colorful. How he must have reveled in their dark beauty! [4]

Madrid is the cleanest city I ever saw in my life. The ladies walk the promenades with long trains like in Philadelphia and just as rich dresses what is never seen in Paris, and I don't think they are much more soiled when they come home than if they had been to a ball. The hotels are clean the privies

Fig. 43. Diego Rodríguez de Silva y Velázquez: *Los Borrachos*. Oil on canvas, 65″ × 88⅝″ (165 × 225 cm). Prado Museum, Madrid.

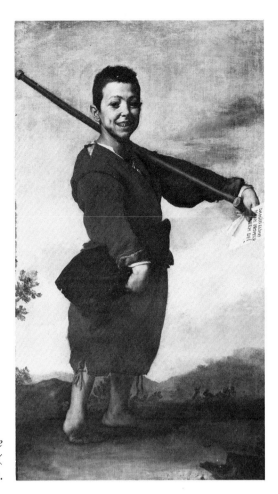

Fig. 44. José de Ribera, *Le Pied Bot* (*The Club Foot*, 1642. Oil on canvas, 64⅝″ × 36¼″ (166.7 × 92.1 cm). Louvre, Paris.

are large commodious and built on the American not French pattern and the floors are everywhere covered with carpet or thick matting even in the picture galleries. The peasants and muleteers have very bright pretty colored dresses sometimes though they are dressed entirely in skins with the wool left on or worn off by age. There are a great many ink shops in Madrid and where a man sells a great many kinds of things he still advertises and pays most attention to his ink. What in the world the Spaniards want with ink I don't know unless for their generals to write pronouncements and proclamations with. I went to church this morning to hear mass. The music on the organ is the queerest I ever heard. It is the quickest dance nigger jig kind of music then its echo in the distance. Then another jig and it comes so sudden each time or you can't get accustomed to it. The whole cathedral floors are covered with thick matting and there are no seats. The people all keep on their knees men and women and from time to time fall their face on the ground like a Hindoo sticking the backside up in the air and then back on the knees again.

The ladies of Madrid are very pretty, about the same or a little better than the Parisians but not so fine as the American girls. A good many of them are fair but the proportion is not so great of fair ones as in America. The country women are often coarse with that ugly hanging of the eye that is often supposed to represent the whole Spanish type. I have been going all the time since I have been here and I know Madrid now better than I know Versailles or Germantown and tonight I leave for Seville. I have seen the big work every day and I will never forget it. It has given

me more courage than anything else ever could. The cooking is very nice here with one exception I don't like stinking fish cooked in garlic egg and oil with fresh lemon juice squeezed over it although the Spaniards even the delicate ladies seem very fond of it. The Spaniards as far as I have seen them seem to be a very good average sort of people, with good ideas or none at all.

On Friday evening, December 3, Eakins and Moore boarded the train for Seville. Today the trip takes ten hours, so it is likely that Eakins pulled into Seville's Cordoba station during the morning of December 4. He registered at the Fonda de Paris on the Plaza Magdalena, the city's second-best after the Hotel Madrid, the best in Spain in those pre-Ritz days (Fig. 45). It was a short walk from the city's civic center and from Seville's great cathedral, which Eakins sketched (Fig. 46). A bit farther away was the Museo de Bellas Artes, where Eakins could see a magnificent collection of Murillos and Zurburans, and a *St. Jerome* carving by Torregiano, whose face must have stayed with him for the rest of his life.

From the front door he could see the entrance to Las Pobres, a street lined with houses of prostitution. Just around the corner were two other *calles*, in one of which, from time immemorial, a visiting debaucheé could have a "nice French girl."

William Sartain followed Eakins to Spain, leaving Paris on January 5, 1870. He too was depressed by the weather—it had rained every day since October 10. He had been in Spain before and claimed to have been responsible for Eakins' decision to go. Sartain described the Fonda de Paris, where he moved in with Eakins: [5]

At the Fonda de Paris Tom and I have a splendid large room, looking out on two streets, and also on the hotel court yard which was planted with orange and other fruit trees, and had a fountain in its center. In the morning before getting up we rang and said to the waiter who came what we would have for breakfast—and were offered any game or other delicacy that the markets afforded, generally heavy steak and game and elaborate Spanish

Fig. 45. Fonda de Paris, Seville. Author's collection, courtesy Sr. Casañes Carruana, Seville. Eakins stayed here while living in Seville.

Fig. 46. *Sketch of the Interior of the Cathedral of Seville*, 1869–1870. Oil on canvas, 16″ × 18″ (40.7 × 45.7 cm). Hirshhorn Museum and Sculpture Garden, Smithsonian Institution. Painted over a study of fabric.

dishes. At six in the afternoon we had a superb table-d'hôte of many courses and then there were four desserts. Our bill at this hotel was $1.50 per diem & a good pour boire was added for the servants.

Eakins and his friends reveled in more than the culinary aspects of Seville life. They went to cafés—one of their programs for the Café Lope de Rueda still exists— and to the theater for Easter festivities. These places still stand: the café as the Cinema Cervantes, and the Theatre Fonda—recently closed—not two blocks from the Hotel de Paris. Sartain had seen a bullfight before and did not want to see another. But Eakins and Moore went and the three of them often rode into the city's environs to watch bulls being trained for the ring.

Sartain seems never to have gotten the point of the country. He tells us more of himself than he knows in his memories of an encounter with his landlady and a young boy, from which he must have walked away triumphantly: [6]

> Among the beggars that abounded was a young boy to whom we nightly gave some small coins. He would always reply Dios lo pagara (God will pay it back to you) one night I said to him "Do you know God has never paid back to us a cent" He looked concerned & disappointed–evidently believing what he had said–and never asked us for alms again!
>
> But our sojourn at Seville was now drawing to a close. On leaving my lodgings my landlady expressed many regrets at my departure, no doubt largely owing to her pecuniary interests. She gave me the truly oriental compliment of saying "Oh Don Guglielmo you are a cup of gold, a pearl beyond price."

Eakins met a family of street performers, and asked the little girl, Carmelita Requena, to sit for him (Plate 5). She was only seven, he wrote to his own little sister Caroline, and he put a little card on the floor for her to look at while he painted her. He gave her candy to eat and she put that down on the floor so that she could look at it while she posed. He painted all morning and into the afternoon until three, after which he and Moore took walks into the country: [7]

> I am very well, and it seems to me when I breathe the dry warm air, and look at the bright sun, that I was never so strong, and I wonder if I can ever be sick or weak again. The Spaniards I like better than any people I ever saw. . . . We walk every day into the country, One day we went up along the river. At every quarter of a mile there would be little groups of men and women, much like our old picnic parties, family affairs, and they would be dancing. We stopped a long while with one party, the girls were so beautiful, and one man came with a little pigskin full of very fine wine and gave us all to drink, making us take first because we were strangers. How different a reception we would have got in England and even at home!

Three of his paintings of the Requenas have come down to us, the major one being the artist's first large composition, *Street Scene in Seville* (Plate 6). He made his studies on the roof of the Fonda de Paris, and had a great deal of discouraging trouble

with the composition and getting sunlight onto his canvas. He wrote his father of the difficulty he was having: [8]

> My student life is now over and my regular work is commenced. I have started the most difficult kind of picture, making studies in the sunlight. The proprietor of the hotel gave us permission to work up on top of the roof where we can study right in the sun. Something unforeseen may occur and my pictures may be failures, these first ones. I cannot make a picture fast yet, I want experience in my calculations. . . . Sometimes it takes me longer to do a thing than I thought it would, and that interferes with something ahead, and I have a good many botherations, but I am sure I am on the right road to good work and that is better than being far in a bad road. I am perfectly comfortable, have every facility for work, especially sunshine, roof and beautiful models, good-natured natural people desirous of pleasing me. If I get through with what I am at, I want a few weeks of morning sunshine. Then I will make a bullfighter picture, and maybe a gypsy one.

The bullfight picture apparently never materialized: the artist got no further with that milieu than the rough sketches on the wall in *Street Scene in Seville*.

Evidently up to the time the three of them went south on a nine-day excursion to the remote town of Ronda, he was working and struggling with his picture. He kept his father informed of his agony, and now as in the preceding years made of him a virtual father confessor: [9]

> The trouble of making a picture for the first time is something frightful. You are thrown off the track by the most contemptible little things that you never thought of, and then there are your calculations all to the devil, and your paint is wet and it dries slow, just to spite you, in the spot where you are the most hurried. However, if we have a blue sky, I think I can finish the picture and it won't be too bad if not too clumsy. . . .

Two weeks later he wrote:

> I have been lately working very hard and often in much trouble. . . . If all the work I have put on my picture could have been straight work, I could have had a hundred pictures at least, but I had to change and bother, paint in and out. Picture-making is new to me; there is the sun and gay colors and a hundred things you never see in a studio light, and ever so many botherations that no one out of the trade could ever guess it.

A month later he wrote:

> I am not in the least disheartened. . . . I will know so much better how to go about another one. My picture will be an ordinary sort of picture, with good things here and there, so that a painter can see its at least earnest clumsiness.

Sartain wrote that the Ronda trip was made toward the end of their stay in

Seville, and since that was about the first of June, they may have set out about the middle of May (Fig. 47). Sartain wrote of the trip in his typically subjective way: [10]

> Finally, toward the end of our sojourn in Seville we decided to take a trip to Ronda. Attaching ourselves, but not too closely except when needed for finding our way or for safety, to the ordinario or expressman who carried his goods to [*sic*] the backs of mules we started on our journey. It took three days to arrive at Ronda, part of the way over mountains where there were no roads—only occasional tracks made in the previous journeys. It was thus for long stretches over hills & mountainsides, a vast solitary waste. At night we would sleep in the inns, consisting of one long cobble stone paved room— at the further end our horses and the mules & baggage, nearer the part devoted to cooking & eating. I remember that out of one bowl or dish of mixed salad & pieces of meat we three, the ordinario his brother & son and the host helped ourselves each with his particular spoon. At night they laid on the cobble stone floor for each of us a mattras [*sic*] not over five feet long, a foot wide & perhaps an inch thick—through which the stones were plainly felt. . . . In Ronda we remained three days taking excursions into the surrounding country. There is an old church there built by Ferdinand and Isabella on the conquest of this stronghold of the Moors. In it, we saw a large painting, rather high up on the gloomy walls to properly see but apparently a fine thing. It was hanging in rags at places & with holes through it. I remarked in Spanish (which by this time I was able to talk) that they ought either to sell it or repair it. The next day the priest sent word that he would sell it—would I buy it? I agreed to do so for $200.00 and thought I had secured a marvelous bargain. I found out that out of this money they employed a local artist (?) to make a copy to replace it on the walls! Later they were to send it to Philadelphia. . . .

In Ronda the three stayed at 40 Calle Molinas. The church where they found the painting—which turned out to be a copy of a Rubens and which ended up at St. Charles Seminary near Philadelphia [11]—was the Church of the Holy Spirit, built by

Ferdinand the Catholic to celebrate the taking of Ronda from the Moors. The round trip to Ronda even today can scarcely be made in a day, and the narrow highway hugs many a precipice on the ninety-mile journey southeast of Seville.

Back in Seville, Eakins and Moore moved into another, more Spanish hotel, the Posada Lobo, and Sartain took his meals there, staying in a parlor and bedroom at the corner of Espejo and Cid streets.

The three left Seville and Spain at the beginning of June and arrived back in Paris in time to see the new Salon. About the middle of the month Eakins sailed for home, possibly on the *Russia* from Liverpool, which sailed on June 18. Although he shared his sister Fanny's dislike of the English, it is scarcely credible that he did not stop in London and look at paintings on his way home. He knew that the collections were rich and contained many works by several of his heroes.

The passenger list of the *Russia* and of any other ship arriving during this time failed to list Eakins. But such a listing was optional, and Eakins may not have wanted anyone but his family to know he was getting back. "I would not tell anyone about my coming home," he had written his father. "Bill Sartain thinks best too. I would not want anyone to make plans hanging on my coming, and I do not care for Schussele or the young artists to know of it." [12]

Eakins may have exaggerated the danger of anyone's knowing, but he knew that by keeping his name off the passenger list at least that little risk was obviated. It is curious that he was apparently successful in keeping his name off the published lists of arriving passengers, and even more curious that he was able to do the same for the captains' manifests: none of these shows his name. And the curious becomes the paradoxical when we realize that each captain was required to produce a complete list for customs records. An assumed name is scarcely likely, since he would have had to produce his passport.

When he went home for his three months' visit in the winter of 1868–1869, he had also traveled in secrecy—no published list showed his name. He particularly did not want Schussele to know. He had ignored his teacher's advice in the choice of his European teachers, and he probably did not want to risk the frustration of having Schussele say, "I told you so."

He also wanted to find himself anew, a new artist in the milieu he was going to make his own for the rest of his life. He did not want to stick out his artistic neck until he had decided what sort of neck he would stick out. Now he must plan his first public exhibition.

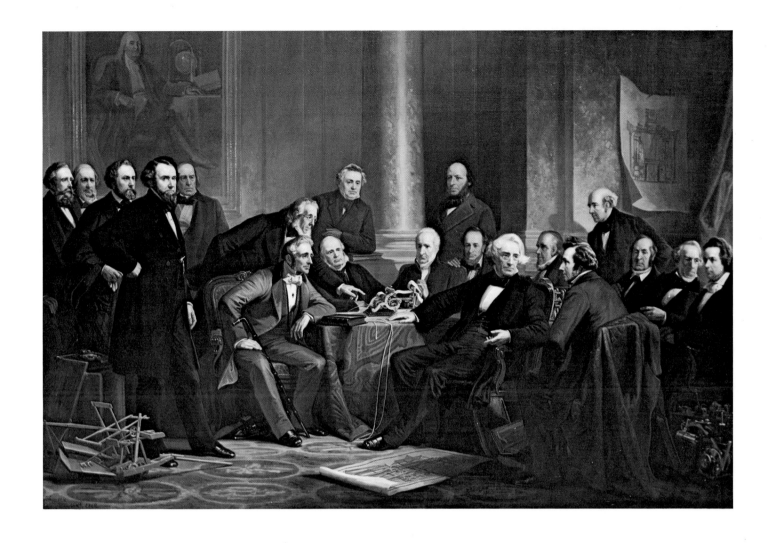

Plate 2. Christian Schussele: *Men of Progress*, 1862. Oil on canvas, 51″ × 76½″ (129.5 × 194.3 cm). The National Portrait Gallery, Washington, D.C. Left to right: William T. G. Morton, James Bogardus, Samuel Colt, Cyrus McCormick, Joseph Saxton, Charles Goodyear, Peter Cooper, Jordan L. Mott, Joseph Henry, Eliphalet Nott, John Ericsson, Frederick E. Sickels, Samuel F. B. Morse, Henry Burden, Richard M. Hoe, Erastus B. Bigelow, Isaiah Jennings, Thomas Blanchard, Elias Howe.

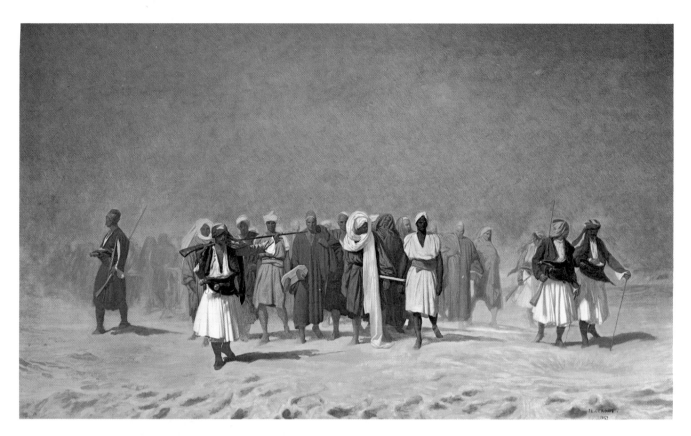

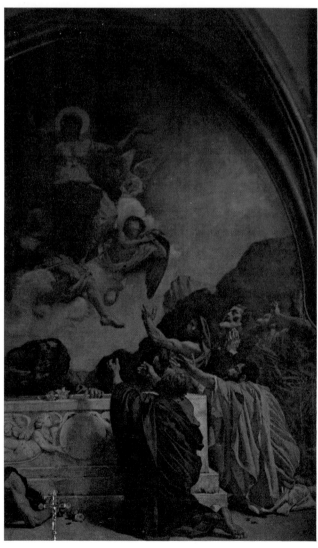

Plate 5 (above). *Carmelita Requena*, 1870. Oil on canvas, 21″ × 17″ (53.3 × 43.2 cm). Collection Mr. and Mrs. James Fosburgh, New York.

Plate 3 (opposite). Jean Léon Gérôme: *Egyptian Recruits Crossing the Desert*, 1857. 14⅞″ × 24¼″ (37.8 × 61.6 cm). Courtesy Gerald Ackerman and Schweitzer galleries.

Plate 4 (opposite). Léon Bonnat: *Assumption* (detail), 1869. Eglise Saint-André, Bayonne, France.

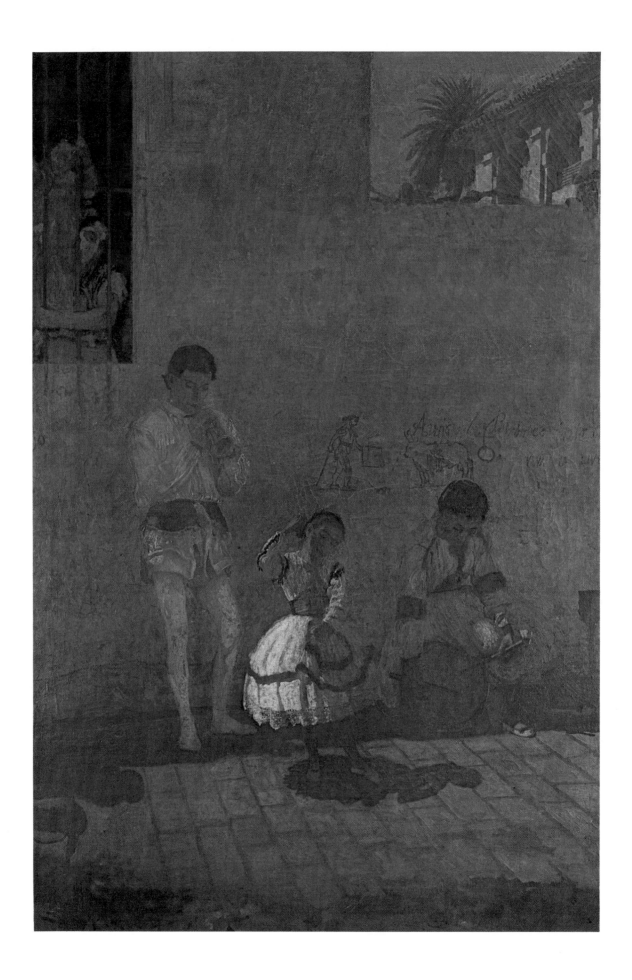

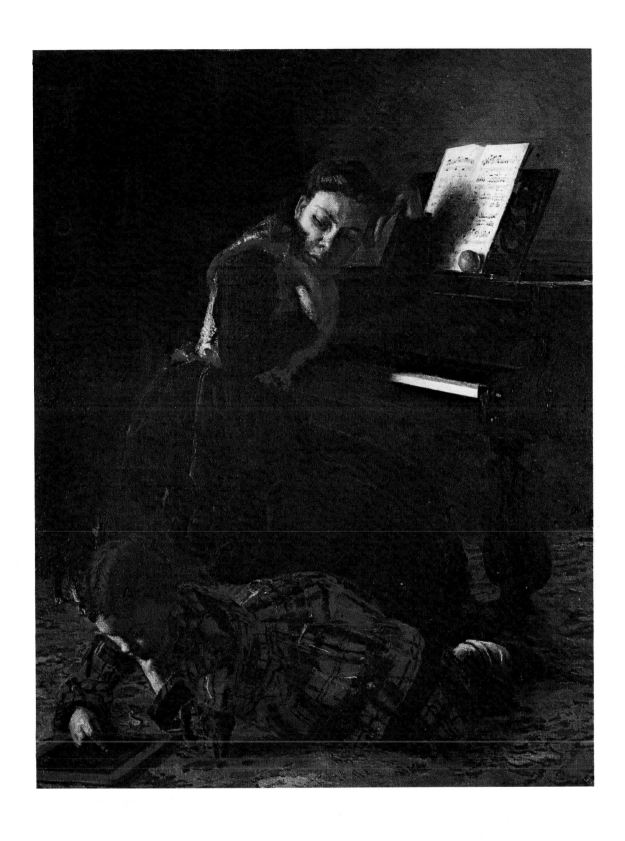

Plate 7 (above). *Home Scene*, c. 1871. Oil on canvas, 22″ × 18¼″ (55.9 × 46.3 cm). Brooklyn Museum. Margaret and Caroline Eakins, with Margaret at the piano.

Plate 6 (opposite). *Street Scene in Seville*, 1870. Oil on canvas, 63″ × 42½″ (160 × 107.9 cm). Collection Mrs. John Randolph Garrett, Roanoke, Virginia.

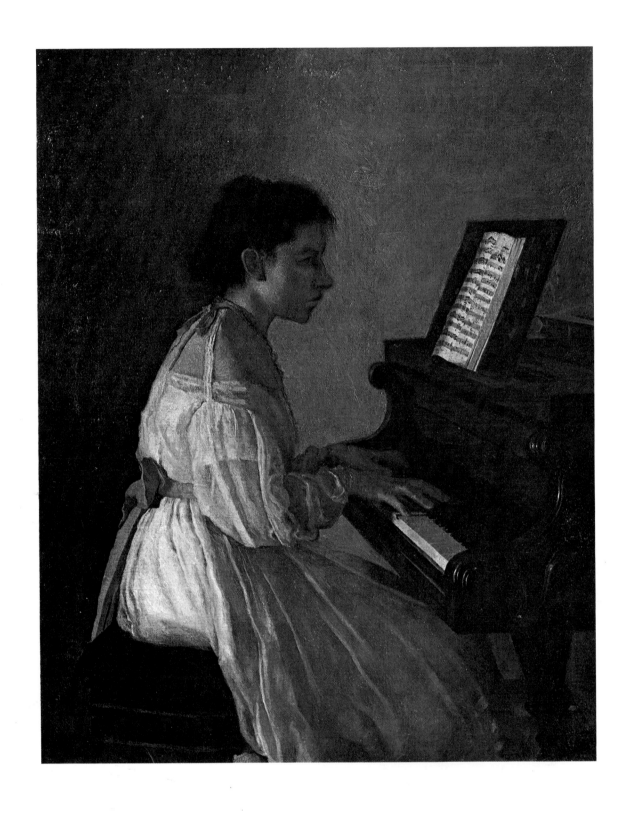

Plate 8. *Portrait of Frances Eakins*, c. 1870. Oil on canvas, 24″ × 20″ (60.9 × 50.8 cm). William Rockhill Nelson Gallery of Art, Kansas City, Missouri.

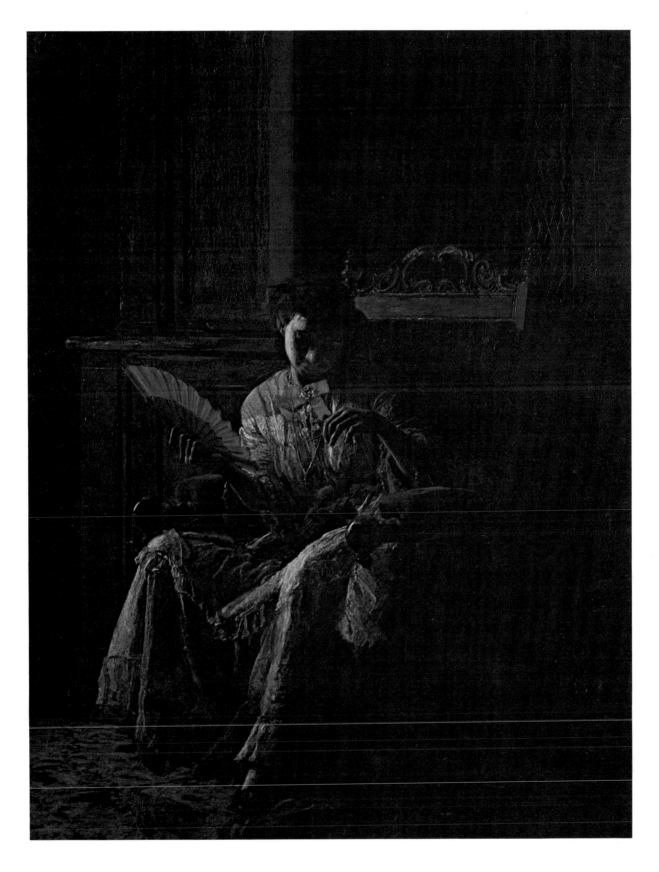

Plate 9. *Girl with a Cat—Katherine*, 1872. Oil on canvas, 62¾″ × 48¼″ (159.4 × 122.6 cm). Yale University Art Gallery. Kathrin Crowell.

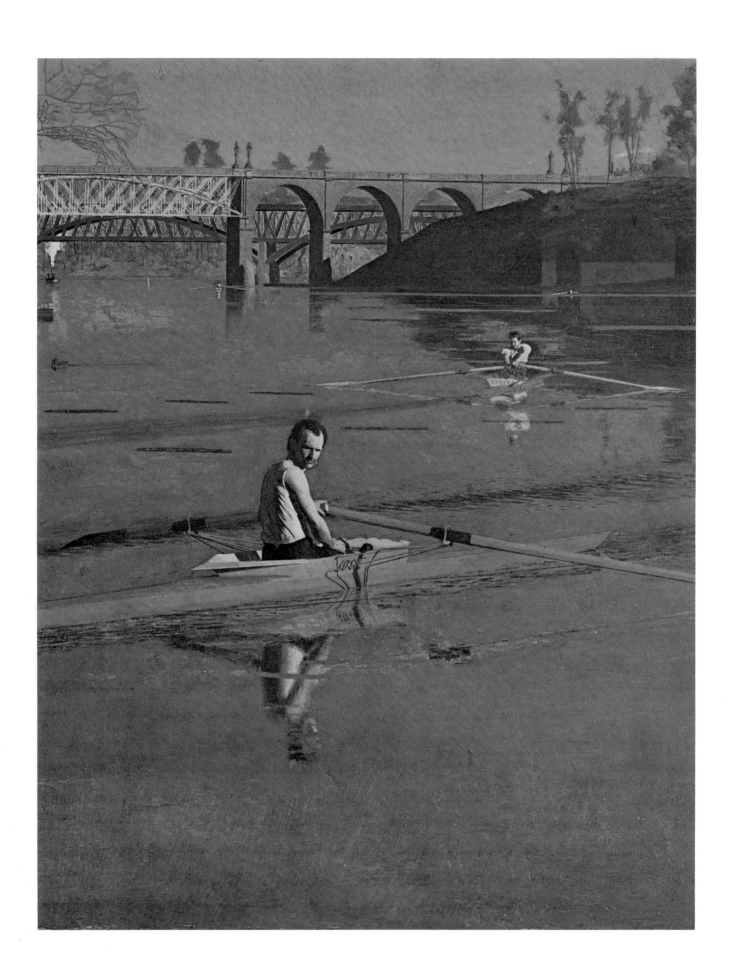

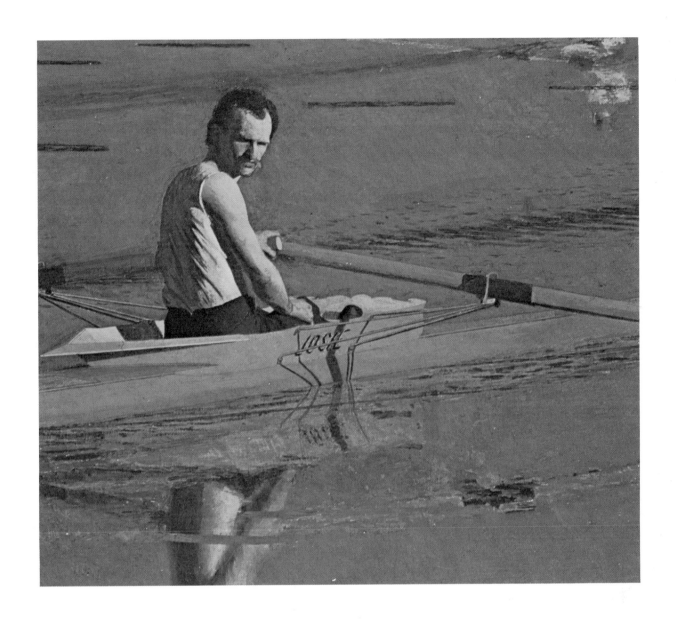

Plate 11 (above). *The Champion Single Sculls* (detail).

Plate 10 (opposite). *The Champion Single Sculls (Max Schmitt in a Single Scull)* (detail), 1871. Oil on canvas, 32¼″ × 46¼″ (81.9 × 117.5 cm). Metropolitan Museum of Art. Max Schmitt is in the foreground, and the artist himself is in the scull at the right. Schmitt's scull is named after his sister Josie.

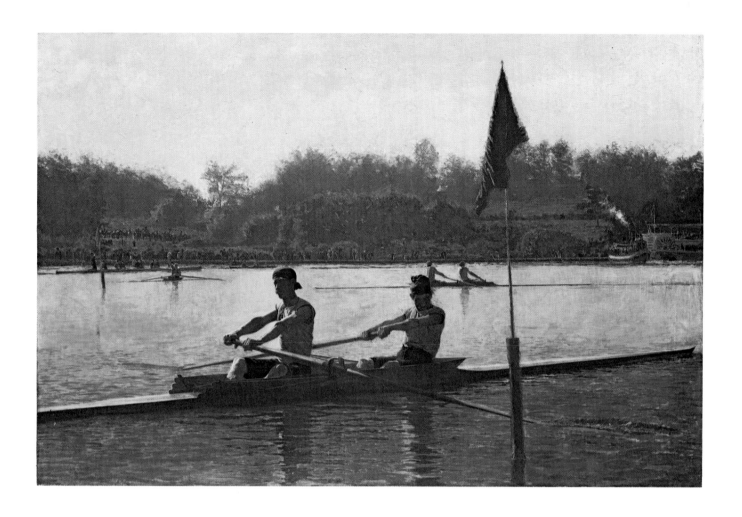

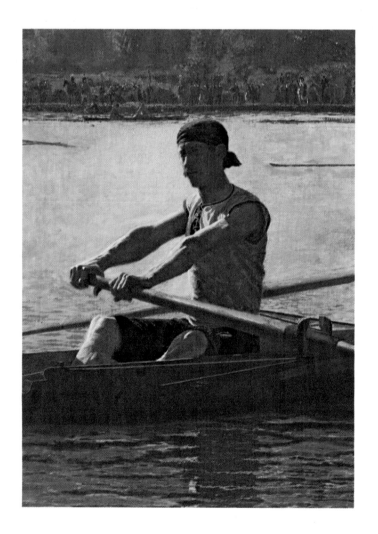

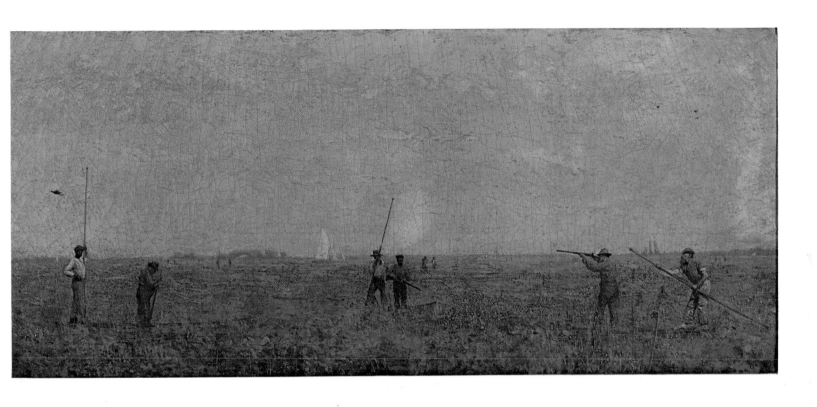

Plate 14 (above). *Pushing for Rail*, 1874. Oil on canvas, 13″ × 30⅟₁₆″ (33 × 76.3 cm). Metropolitan Museum of Art.

Plate 12 (opposite). *The Biglin Brothers Turning the Stake*, 1873. Oil on canvas, 50¼″ × 60¼″ (102.2 × 153 cm). Cleveland Museum of Art.

Plate 13 (opposite). *The Biglin Brothers Turning the Stake* (detail).

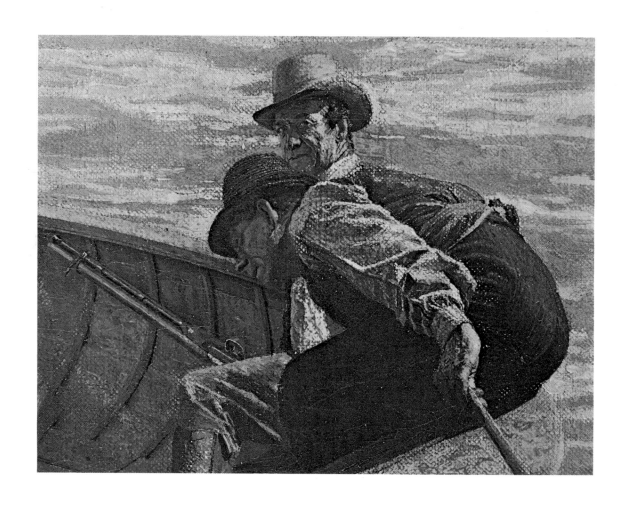

Plate 15. *Starting Out after Rail* (detail), 1874. Oil on canvas, 24″ × 20″ (60.9 × 50.8 cm). Boston Museum of Fine Arts.

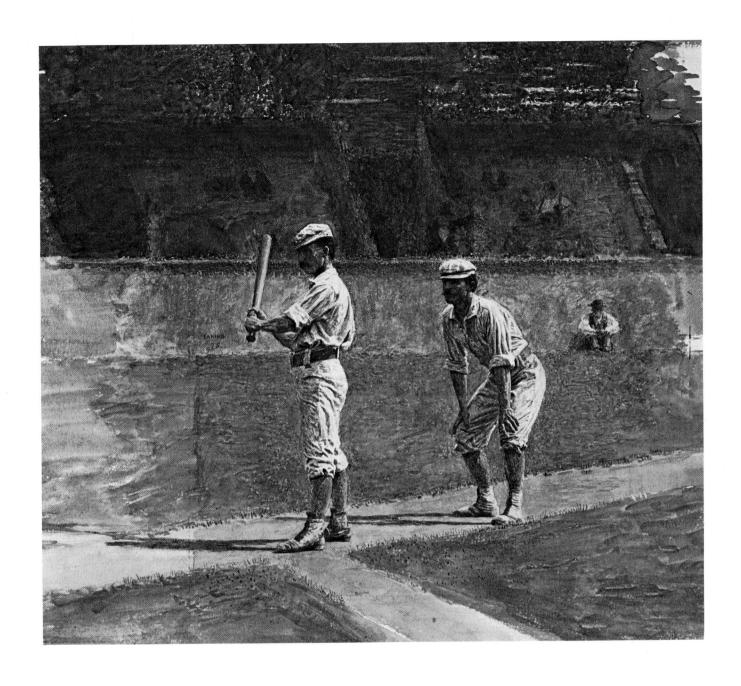

Plate 16. *Baseball Players Practicing*, 1875. Watercolor and pencil on paper, $10^{13}/_{16}'' \times 12^{7}/_{8}''$ (27.5 \times 32.7 cm). Museum of the Rhode Island School of Design, Providence.

Plate 17. *Sketch for "Portrait of Professor Gross,"* 1875. Oil on canvas, 24" × 20" (60.9 × 50.8 cm). Philadelphia Museum of Art.

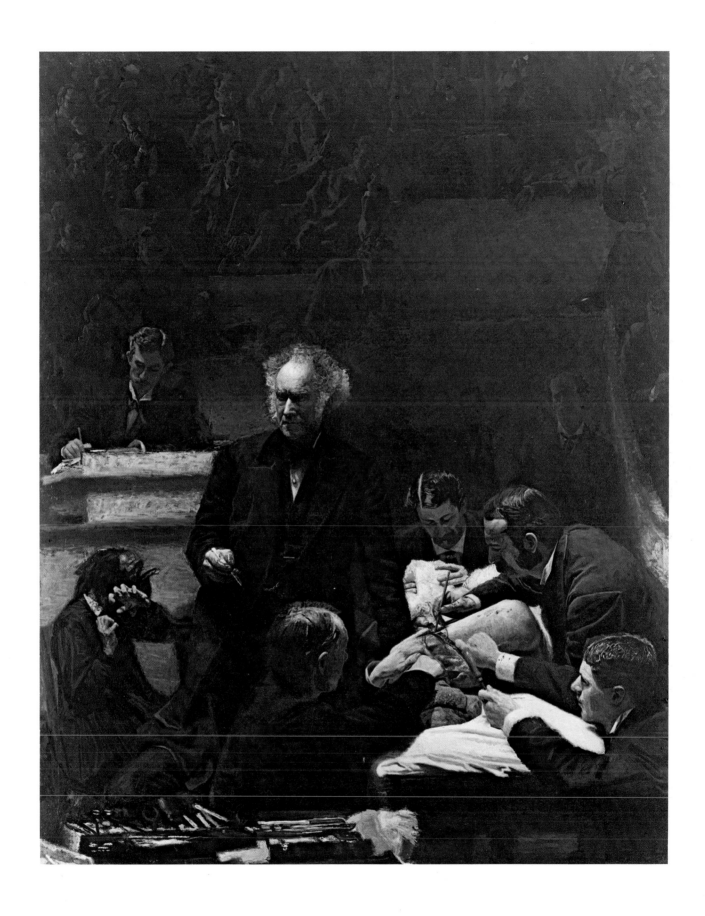

Plate 18. *Portrait of Professor Gross (The Gross Clinic)*, 1875. Oil on canvas, 96″ × 78″ (243.8 × 198.2 cm). Jefferson Medical College, Philadelphia. The artist himself is at right center.

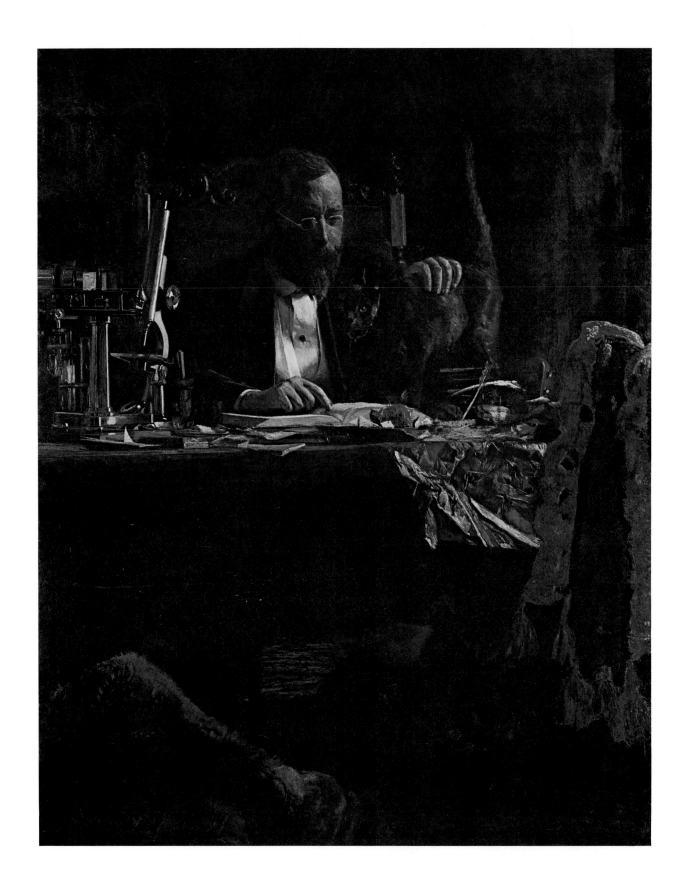

Plate 19. *Portrait of Benjamin Howard Rand*, 1874. Oil on canvas, 60″ × 48″ (152.4 × 121.9 cm). Jefferson Medical College, Philadelphia.

5

Back in Philadelphia
1870-1875

WHEN EAKINS got back to the house on Mt. Vernon Street, he found his family much as he had left them, only older: Caroline, now age seven, Margaret, age seventeen, Fanny, age twenty-two, his mother and father, and Aunt Eliza Cowperthwaite, age sixty-four. But now there was a new problem: where was Tom to have his studio? He was embarking on a full-fledged career as a professional painter, and he needed a place with a skylight, if possible, where he could work with models, teach, and so on. Above all, it must be private.

Soon after his son returned home, Benjamin Eakins (Fig. 48) fitted up a studio at the top of the rear of the house. There is some confusion as to what room it was. McHenry wrote that it was "the third floor back," [1] but the remarkable agreement made by Eakins and his father and put into writing thirteen years later says that it was the fourth story: [2]

> This paper made double, witness and agreement between Thomas Eakins (painter and sculptor, Director of the schools of the Pennsylvania Academy of the Fine Arts) and Benjamin Eakins his father, owner of the premises 1729 Mount Vernon St. In consideration of the sum of Twenty dollars per month (this until changed or broken by sufficient notice) paid by Thomas Eakins to Benjamin Eakins. Thomas Eakins receives his board, lodging, and the exclusive use of the 4th. story studio. Thomas Eakins will have the

Fig. 48. Benjamin Eakins, c. 1870. Author's collection. This photograph was taken by the Schreiber brothers, and evidently shows Eakins' father in the cloak bought for him by his son in Paris. Print by Rolf Petersen.

Fig. 49. *At the Piano*, c. 1870. Oil on canvas, 22″ × 18¼″ (55.9 × 46.3 cm). University of Texas Museum.

right to bring to his studio his models, his pupils, his sitters, and whomever he will, and both Benjamin Eakins and Thomas Eakins recognizing the necessity and usage in a figure painter of professional secresy [*sic*], it is understood that the coming of persons to the studio is not to be the subject of comment or question by the family.

<div align="right">B. Eakins
Thomas Eakins.</div>

This agreement without date was entered into in the presence of the family shortly after my son's return from his studies in Europe but was put into writing in 1883. B. E.

Evidently in 1883, possibly during the time that Eakins was having his trouble with the Academy, it was thought expedient to confirm that whatever was going on in the artist's studio was accepted by the family.

The present fourth-floor-north mansard-roof room at 1729 Mt. Vernon Street apparently acquired its present appearance shortly after Eakins returned from France. There is some difference of opinion among specialists, however, as to what was there before. Was there an attic, a crawl space, or nothing?

With a proper studio fitted up, the artist turned to his family and friends for models. Four paintings of his sister Margaret—one with Caroline called *Home Scene* (CL-169, Plate 7), one with Fanny called *At the Piano* (CL-321, Fig. 49), and two

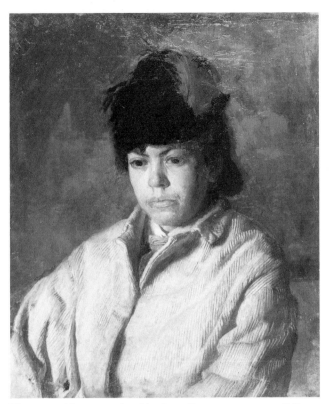

Fig. 50. *Margaret in Skating Costume*, 1871. Oil on canvas, 24″ × 20½″ (60.9 × 52.1 cm). Philadelphia Museum of Art.

Fig. 51. *Benjamin Eakins*, c. 1870. Watercolor on paper, 3½″ × 3½″ (8.9 × 8.9 cm). Private collection, Texas.

alone, including the famous *Margaret in Skating Costume* (CL-235, Fig. 50), were among the first he completed after arriving home. The picture of Margaret and Fanny at the piano is less successful than *Home Scene*, with Margaret and Caroline, a later, similar project. Curiously, Eakins did not return to his sister Margaret as a model for another ten years, but he continued to paint other members of the family, for example, Fanny, at the piano (CL-148, Plate 8), and his father, in a tiny watercolor (Fig. 51).

Will Crowell's sisters Elizabeth and Kathrin—generally spelled Katherine but according to the family Bible Kathrin—were also painted, Kathrin with her cat (CL-12, Plate 9) and Elizabeth with her dog (CL-2, Fig. 52) and, four or five years later, at the piano (CL-129, Fig. 53). Kathrin's and Elizabeth's mother, Mrs. James W. Crowell, was also painted at about this time. This portrait is in too poor a condition to reproduce, but a remarkable photograph, which may have been taken by Eakins, shows the suffering this lady is supposed to have gone through (Fig. 54). Her first daughter, Mary Ella, born in 1848, died of yellow fever when her mother, without thinking, covered her with a blanket that had been used for another sister suffering from the same disease. The sister recovered, but Mary Ella died because of her mother's thoughtlessness.

It was probably about this time that Eakins produced one of his few attempts at a romantic or sentimental theme. He himself thought little of it and intended to do a better job of the project, but he never got around to it. The oil painting *Hiawatha*

Fig. 52. *Elizabeth with a Dog*, c. 1874. Oil on canvas, 13¾″ × 17″ (34.9 × 43.2 cm). Fine Arts Gallery of San Diego.

(CL-38, Fig. 55) illustrated eight lines from Longfellow's poem:

> Suddenly upon the greensward
> All alone stood Hiawatha,
> Panting with his wild exertion,
> Palpitating with the struggle;
> And before him, breathless, lifeless,
> Lay the youth, with hair dishevelled,
> Plumage torn, and garments tattered,
> Dead he lay there in the sunset.

McHenry wrote that Eakins also did a watercolor on the Hiawatha theme, but that it was accidentally ruined. In a letter to Earl Shinn, Eakins remembered the venture with disgust, and said that Margaret pretended it made her sick to her stomach—a picture of sophistication that is not apparent in Margaret's photographs (Fig. 56).[3]

> I went seriously to work also at my Hiawatha also to put into this ex-hibition intending to make a big watercolor. The corn angel was down & Hiawatha standing over & other angels as corn shocks were all around. And the sky was a corn field & a buffalo & deer & possum and squirrel & rabbit &c &c &c. It got so poetic at last that when Maggy would see it she would make as if it turned her stomach. I got so sick of it myself soon that I gave it up. I guess maybe my hair was getting too long, for on having it cropped again I could not have been induced to finish it.

But painting his family and friends and creatures from literature was not what

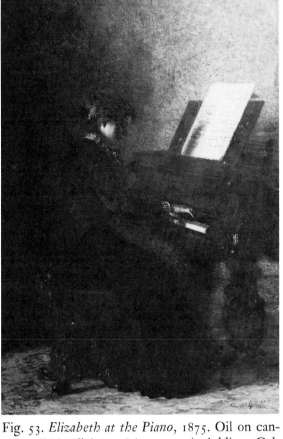

Fig. 53. *Elizabeth at the Piano*, 1875. Oil on canvas, 72" × 48" (182.9 × 121.9 cm). Addison Gallery of American Art, Andover, Massachusetts.

Fig. 54. Mrs. James W. Crowell, c. 1872. Author's collection. Print by Rolf Petersen.

Fig. 55. *Hiawatha*, c. 1871. Oil on canvas, 20" × 30" (50.8 × 76.2 cm). Hirshhorn Museum and Sculpture Garden, Smithsonian Institution.

Fig. 56. Eakins' photograph of his sister Margaret, c. 1881. 4" × 3" (10.2 × 7.7 cm). Author's collection. Print by Rolf Petersen.

was closest to Eakins' heart. They were mere practice runs for what had been in his mind since he first decided to become an artist, and what must by now have become something of an obsession—his first public exhibition.

He had two portraits in mind for this, one that might have been his very first commission, a painting of a friend of the family, M. H. Messchert; and the other of himself and his friend Max Schmitt portrayed in a milieu in which they both reveled: rowing. The Messchert picture is unlocated, but the Schmitt-Eakins painting, *The Champion Single Sculls*, commonly known as *Max Schmitt in a Single Scull* (CL-175, Plates 10 and 11), is in the Metropolitan Museum of Art in New York City.

Schmitt's daughter thinks she remembers her father saying he posed for the painting on the roof outside Eakins' studio. But she may be confusing this memory with another story with which she was familiar—that the model for Eakins' *Crucifixion* (Fig. 140) was posed on the roof outside the studio. In any case we know that the artist could not have painted Schmitt from where he is shown in the picture, at a considerable distance from the left bank of the Schuylkill, upstream from the Girard and Connecting Railroad bridges. That vantage point is now part of a filled-in park, and considerable trees now grow where once the Schuylkill's waters flowed. Other landmarks, however, are still in evidence.

In 1870 the Pennsylvania Academy was being "torn out" and a new building was being planned for the corner of Broad and Cherry. Meanwhile the Union League of Philadelphia sought to fill the gap and late in 1870 began a regular series of art exhibitions. The first of these was in December 1870 and the second in February 1871. The third, in which Eakins exhibited, opened on April 26, 1871, and ran through April 29.

Both the *Inquirer* and the *Bulletin* found something to say about Eakins' work. The *Inquirer* reported that though it showed "marked ability," the whole effect was "scarcely satisfactory": [4]

> Thomas Eakins shows two, a portrait and a river scene, entitled, "The Champion Sculls." While manifesting a marked ability, especially in the painting of the rower in the foreground, the whole effect is scarcely satisfactory. The light on the water, on the rower and on the trees lining the bank indicates that the sun is blazing fiercely, but on looking upward one perceives a curiously dull leaden sky.

The *Bulletin* ignored the Messchert portrait, but was not so condescending about *The Champion Single Sculls* as the *Inquirer* had been. It predicted a "conspicuous future" for the artist, and pinpointed a crucial factor—he was working on solid, tested principles: [5]

> There are other portraits, by Sully, Rehn, Mrs. Holmes, Street and Thomas Eakins. The latter artist, who has lately returned from Europe and the influence of Gérôme, has also a picture entitled "The Champion Single Sculls" (No. 137), which, though peculiar, has more than ordinary interest. The Artist, in dealing so boldly and broadly with the commonplace in

nature, is working upon well-supported theories, and, despite a somewhat scattered effect, gives promise of a conspicuous future. A walnut frame would greatly improve the present work. . . .

This April 1871 Union League showing was Eakins' world première, a fact confirmed by *The Philadelphia Evening Telegraph* five years later: [6]

> The most noteworthy picture . . . is Mr. Eakins' water-color entitled the Zither Player, No 335. This is in many respects the best performance of a thoroughly accomplished artist who has, during the four or five years that have elapsed since he first exhibited in Philadelphia at one of the Union League art receptions, been steadily growing. . . .

The point should be made here and stressed that *The Champion Single Sculls* is primarily a portrait and only secondarily a genre or anecdotal picture. Eakins has often been called a genre painter, but he was only rarely so, and sometimes only coincidentally so, even though he sometimes gave a painting a genre-sounding title. In *The Champion Single Sculls* he set out with the primary idea of painting a portrait of his friend Max Schmitt, not to paint a picture of sculling. The result is a magnificent picture of sculling, of course, but it is also what the artist initially and perhaps finally intended it to be—a portrait of Max Schmitt and of himself. The artist had the same motivation later on when he painted his picture of Samuel David Gross and called it *Portrait of Professor Gross* (Plate 18), not as genre enthusiasts would call it, *The Gross Clinic*. Such pictures as *Mending the Net, Ships and Sailboats on the Delaware, Drawing the Seine,* and *Hauling the Seine* are, of course, genre pictures (see Plate 28, Figs. 67, 123, and CL-198). But the Gross portrait, the boxing, wrestling, and most of the hunting and sailing pictures are not, any more than the artist's first publicly exhibited picture, *The Champion Single Sculls*, was.

The subject of the other Union League painting, M. H. Messchert, came from —and ended up in—the neighborhood of Reading, Pennsylvania, but no trace of his portrait has been found. Messchert was a lawyer, and a tortuous trip through family sources, legal records, and cemeteries led to a great-great-grandson, who knew nothing of Eakins or the painting. The single additional bit of information we have about the Messcherts is that they once had trouble with shad flies! Emily Sartain had complained to Benjamin Eakins about the trouble her family was having with shad flies, and Benjamin wrote her that he had talked to Mrs. Messchert, and Mrs. Messchert had said not to bother, because they would soon "take their leave." [7]

From Max Schmitt in sculling scenes Eakins now turned to other figures and produced several of the sculling works for which he is most famous. These depicted the world-famous sculling champions Barney and John Biglin (usually misspelled Biglen) practicing and racing in their sculls. Three pictures show the two together— *A Pair-Oared Shell* (CL-236, Fig. 57), *The Biglin Brothers Turning the Stake* (CL-199, Plates 12 and 13), and *The Biglin Brothers Racing* (CL-110, Fig. 58). For each of these the artist did elaborate perspective drawings, and a number of these have survived (Cl-209, Fig. 59).

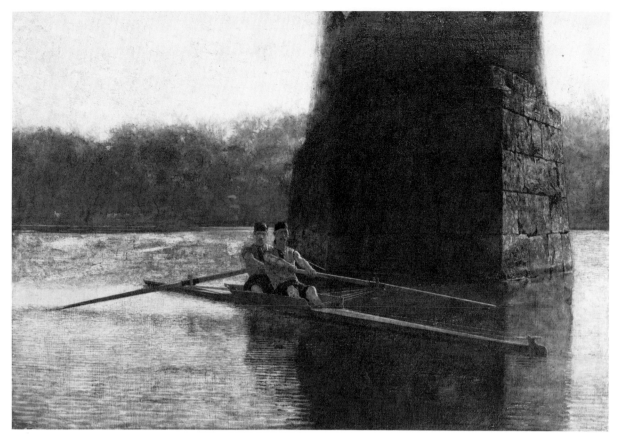

Fig. 57. *A Pair-Oared Shell*, 1872. Oil on canvas, 24″ × 36″ (60.9 × 91.9 cm). Philadelphia Museum of Art. Left to right, Barney and John Biglin.

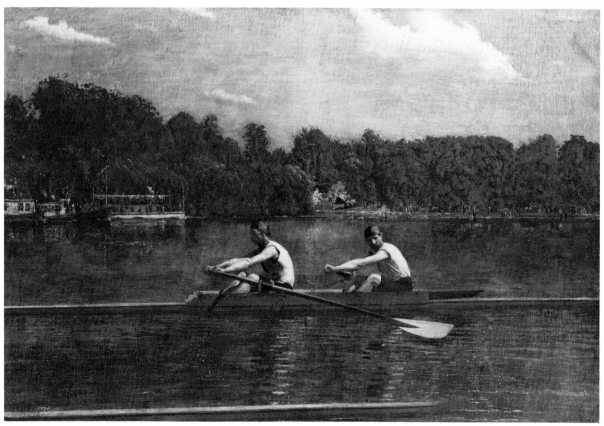

Fig. 58. *The Biglin Brothers Racing*, c. 1873. Oil on canvas, 24⅛″ × 36⅛″ (61.2 × 91.8 cm). National Gallery of Art.

Fig. 59. *Perspective Drawing for The Schreiber Brothers* (detail), 1872. Ink and pencil on paper mounted on cardboard, 28″ × 48″ (71.1 × 121.9 cm). Pennsylvania Academy of the Arts.

Fig. 60. *Drawing of The Biglin Brothers Turning the Stake*, c. 1880. Pencil on paper, 13 15/16″ × 17″ (35.4 × 43.2 cm). Cleveland Museum of Art, Mr. and Mrs. William H. Marlett Fund. Apparently a drawing by the artist—with additions by his pupil Charles Bregler—for an engraving in *Scribner's Monthly*.

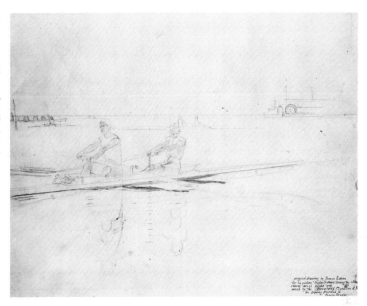

Fig. 61. *The Schreiber Brothers*, 1874. Oil on canvas, 15″ × 22″ (38.1 × 55.9 cm). Collection John Hay Whitney, New York. Likely an exercise for Fig. 57.

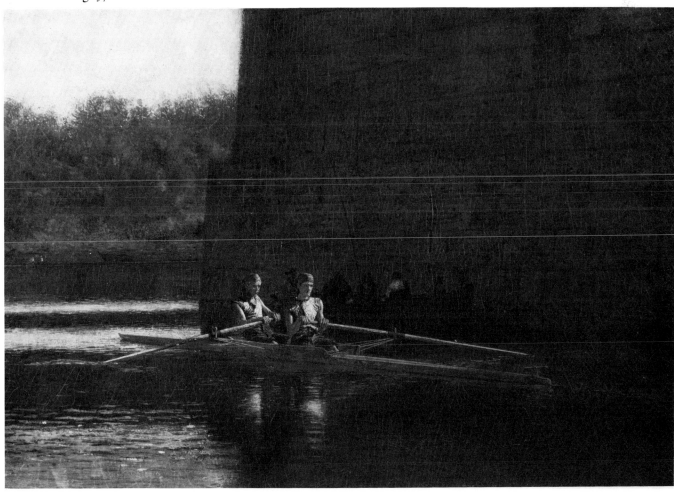

The Biglin Brothers Turning the Stake was later used for an engraving in *Scribner's Monthly*.[8] Alice Barber, one of Eakins' best pupils, who later married Eakins' colleague Charles Stephens, did the engraving, evidently from the original in Eakins' studio. A drawing with pencil shading for transfer on the reverse and tracing around the figures is in the Cleveland Museum (CL-200, Fig. 60). It is evidently something Eakins did and Charles Bregler, a student of his, worked over.

The Yale and Metropolitan museums each have a painting of John Biglin alone, and the Boston Museum has a perspective drawing for the Metropolitan's painting. The Brooklyn and Philadelphia museums have other paintings of sculls with variously identified occupants, and John Hay Whitney has a picture of Eakins' friends the Schreiber brothers, who were photographers of animals as well as sculling enthusiasts (Fig. 61). The Hirshhorn Collection has two perspective drawings for the National Gallery painting (CL-42 and CL-43), the Pennsylvania Academy has one for the Whitney painting (CL-209), and the Portland museum has an oil study for a possibly projected but uncompleted work (CL-208). At about this time Eakins also painted the Schreibers' dog (Fig. 62).

The sports publications of the time are full of news about the Biglins, and the particular Philadelphia visit that gave rise to *A Pair-Oared Shell* was celebrated as the first pair-oared race in America. Eakins caught the Biglins under a Schuylkill bridge (it has been called the Columbia Bridge, but it does not qualify for that definition) one morning during their visit. "They are both dapper fellows," the *Press* of May 21, 1872, reported, "about the medium height, well formed, and with a very determined cast of countenance." They were "delighted with our park and our magnificent river Schuylkill." In the race, which the Biglins won, they wore approximately what Eakins showed them wearing in his picture—blue shirts and shorts and light blue kerchiefs around their heads.

A Pair-Oared Shell was not known publicly for seven years, until it was shown in 1879 in New York. *The New-York Herald* thought it was "decidedly photographic,"[9] and it impressed *The American Art Review* as a "scientific statement of form, rather than as embodiment of movement and color."[10] Eakins' pupil and friend, William Clark, of *The Philadelphia Evening Telegraph*, who was soon to give the artist a rave review for his painting of Dr. Samuel David Gross, reminded his readers that *A Pair-Oared Shell* was one of the pictures that "gave such a shock to the artistic conventionalities of Philadelphia when it was first shown."[11] But it was the reliable *New York Times* that put its critical finger on several crucial points:[12]

> Scant justice has been done a genre picture by Thomas Eakins, of Philadelphia, which hangs in the West Room. It is so far above the line that its great merits can scarcely be appreciated except on a brilliant day. Then it will be found remarkable for good drawing, natural and quiet composition, and a pleasant feeling in the color. . . . In a less technical sense, it is also an entrance into a sphere of human activity where one might have expected artists would have sought for subjects long ago. . . . If it

Fig. 62. *Grouse*, 1872. Oil on canvas, 20″ × 24″ (50.8 × 60.9 cm). Private collection. Grouse belonged to the Schreiber brothers.

were possible to conceive that an artist who paints like Mr. Eakins had a poetic impression, we would like to think that in this composition he had tried to express the peculiar charm that everyone has experienced when rowing out of the sunlight into the shadow of a great bridge.

Eakins painted his friend Max Schmitt again as the second rower in the Brooklyn Museum's *Oarsmen on the Schuylkill* (CL-170), and also as the single oarsman in the Philadelphia Museum's painting *Oarsman in a Single Scull* (CL-239), although Mrs. Eakins herself identified this oarsman as Henry Schreiber, one of the two men in *The Schreiber Brothers*. Max Schmitt was one of Philadelphia's best scullers, one of the Pennsylvania Barge Four, whom the Brooklyn painting has been said to depict.

On June 4, 1872, while Eakins was painting *A Pair-Oared Shell*, his mother died, at the age of fifty-two. Now the house and children had to be managed by Fanny and Aunt Eliza, and if the arrangements Eakins and his father made in 1871 and other accounting records we have are any indication, the two did a good job. Fanny got married shortly afterward to Eakins' Central High School classmate William J. Crowell. Crowell moved in with the Eakinses, and he and Fanny promptly began to raise a family. First Ella came along in December 1873, Margaret in January 1876, and finally Ben in October 1877. At this time Benjamin Eakins loaned Will Crowell $5175 without interest to buy a farm outside Philadelphia in Avondale, where he could have as many children as he wanted. Crowell had been going to law school while living at the Eakinses', and Benjamin had promised the money if he would finish law school. Crowell abided by the letter if not the spirit of the agreement, for when he got his law certificate he never again went near a law book. He "didn't like the people you had to deal with," he said, and so he became a desultory farmer.

From sculling, which for some reason he never painted again, Eakins turned to hunting. The Eakinses knew or were related to the Samuel Hall Williams family of Fairton, Cumberland County, New Jersey. The Williamses lived in a house at Tindall's Landing on the south bank of the Cohansey, a little west of the center of Fairton.

Boats from Philadelphia, filled with rail and reed bird hunters, made regular excursions down to the Cohansey, and the Fairton neighborhood was a favorite haunt.

Since 1861 there had been a railroad from Camden, across the river from Philadelphia, to Bridgeton, a rig ride from Fairton. The Fairton railroad spur opened in 1876. So after the steamer had been abandoned as unprofitable—it took too long— Eakins and his father took the railroad. Later the artist bicycled it with his friend and pupil Samuel Murray.

An early map shows a "storage house" between the Williams place and the river, and it is possible that this was the "fish house" that the Eakinses, father and son, used as a retreat from the early 1870s nearly to the end of the son's life. The Williams daughters were Addie and Annie. While he was still in Paris Eakins commended Addie to the good graces of his sister Fanny: "[Addie] is a pretty little girl & I guess as good as she is pretty. . . . We owe a great deal to her father & mother for their unvarying and disinterested kindness to us, whenever we have been there and to little Addie too." [13]

Addie, who stayed unmarried, later came to live with Eakins and his wife, and Eakins painted two remarkable portraits of her (Plates 44 and 45). Annie married a man named Gandy—a well-known name in the Fairton area—and was immortalized by a portrait Eakins made and gave to her sister Addie, now in the National Collection of Fine Arts (CL-109). McHenry wrote that the Eakinses and the Williamses were related, but I have found no record of any such connection, or of any Eakinses in this region of South Jersey.

McHenry wrote that Eakins would go down to Fairton, pass by the Williams house on his way to the fish house, and call out, "What's for supper tonight?" to Abbie, Mrs. Samuel Hall Williams.[14] Abbie is buried in the yard of the "old Stone Church" near Fairton (the Fairfield Presbyterian Church), and her gravestone gives her death date as April 13, 1873. Eakins' visits to the Williams fish house, therefore,

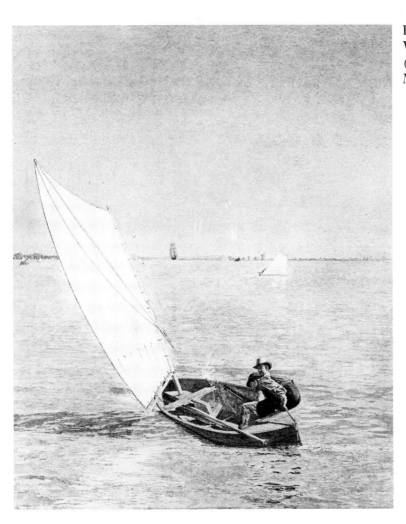

Fig. 64. *Starting Out after Rail*, 1874.
Watercolor on paper, 25″ × 20″
(63.5 × 50.8 cm). Wichita Art
Museum.

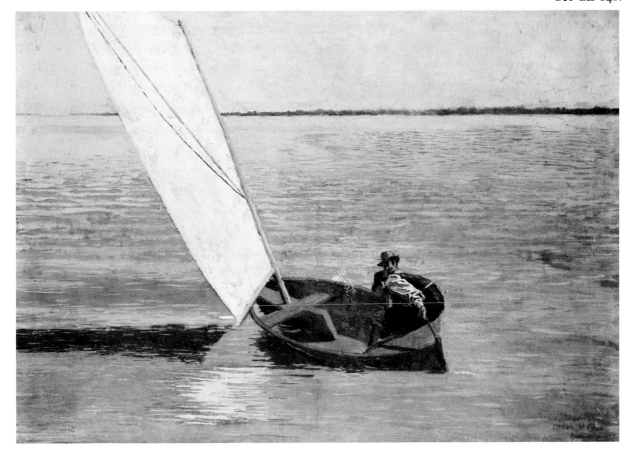

Fig. 65. *Sailing (Starting Out after Rail)*,
1873. Oil on canvas, 32″ × 46⅜″ (81.3 ×
117.8 cm). Philadelphia Museum of Art.
See CL-242.

began not later than April 1873; he probably started coming down soon after he got home from Paris. The fish house has long since disappeared, in spite of the insistence of various local historians that it is still there.

The salt marshes near the site of the fish house, however, still look as though they might have been taken directly from Eakins' paintings of the place. *The Artist and His Father Hunting Reed Birds* (private collection), *Pushing for Rail* (CL-177, Plate 14), and *Whistling for Plover* (CL-171, Fig. 63) could all have been painted within a block of where the Williams fish house stood. Three other works, showing hunters with push poles in their boats starting out on hunting excursions, are known. Two are called by logical names—*Starting Out after Rail* (CL-133, Plate 15, and CL-123, Fig. 64), but a third, an unfinished experiment with the palette knife, has been called *Sailing* (CL-242, Fig. 65), although it is a clear parallel with the other two. Further, it would be impossible to sail in the boat pictured in *Sailing* since nearly all the sheets are missing. All three pictures are portraits of two of Eakins' friends, Harry Young, of Moyamensing, a section of south Philadelphia, and Sam Helhower, "the pusher." Again, they are only incidentally genre subjects; Eakins was painting his friends in a milieu in which he often saw them. (Later, when he painted such portraits as that of Benjamin Howard Rand, showing Rand in his study surrounded by his scientific instruments, he was doing the same thing, although no one has ever called the Rand portrait a genre painting or anything but a portrait.)

There were hunting marshes closer to Philadelphia than Fairton on the Cohansey, and it was to these that the men in the boats in the *Starting Out after Rail* pictures are headed. These were near Chester, Pennsylvania, and south of Gloucester, a place that was later to be celebrated by the artist in a series of shad-fishing pictures. Reed birds are small, nearly inedible wild birds that were hunted then—and are to this day—from early September to well into October. Rail are similar though somewhat larger. "Reed birds may be shot with impunity, or anything else, after the first of September," the *Press* once quipped.[15] A few years later it detailed the procedure: [16]

> The gunner always stands in the fore part of the boat, piece in hand, patiently waiting a rise, while the pusher who is standing on the back seat, moves it with a pole. If a bird should happen to rise at the side, or behind the gunner that is not seen by him, the pusher calls out "mark," when the gunner turns round, fires, and brings the bird down. The pusher, seeing where it has fallen, goes and takes it up. . . . Rail are often fired at as soon as they leave the water, which frequently tears them so badly as to leave them unfit for use. The sportsman always permits the bird to get off at a sufficient distance before he fires, and the result is he inevitably secures it. . . . As long as the tide will float the boat rail can be shot, after which reed-bird shooting is in order. For the latter the inlets, or "guts," are sought, where the water remains deep enough for an hour or two longer. In days gone by gunners did not regard the reed bird as being worthy of much attention, inasmuch as they always desired to get two or three at a shot, but now it has become general

to shoot at a single bird, and one thus secured is prized the more. Rail birds are superior because of their flavor and in the month of October they are considered to be in their best condition.

Pushing for Rail and *Whistling for Plover* are dated 1874, and it is likely they were both finished in the studio late in the spring from studies made in the fall of 1873. Eakins also painted the birds themselves (Fig. 66). One of the two *Starting Out after Rail* pictures (Fig. 64), the one that Eakins exhibited at the January–February exhibition of the American Society of Painters in Water Color in New York, is now in the Wichita Museum, after having been lost for many years. It was evidently traded by Eakins to James C. Wignall, a shipwright, in exchange for a boat. Until recently the Boston Museum's version had been folded under, to cover up the ragged edges. Now, with the painting restored, the name "EAKINS" can be seen at the lower left.

The Wignall watercolor got varied reactions when it came back from New York to Philadelphia for an exhibition in 1881. *The Art Amateur* remarked on the crystal-like pale-blue water, but spoke of Eakins' lack of "felicity of touch," and the "brutal exactitude which holds in a vise-grip the scientific facts of wave-shape and wave-mirroring." Nevertheless, the painting as a whole bordered on the "miraculous." [17] Eakins' friend Clark, on the *Evening Telegraph*, brushed such nonsense aside and added some nonsense of his own: [18]

> It is worth noting . . . how many of our artists have taken to interpreting pure white daylight. . . . This picture is notable for the reason that Mr. Eakins so frequently and, as we think, so needlessly sacrifices the light in his pictures to other considerations. . . . The radical effect of the work is that it has absolutely no color quality although color is just what it needs to give it real vitality. This is a splendid little picture, however, despite its shortcomings. It bears upon its face the fact that it is the work of a man who

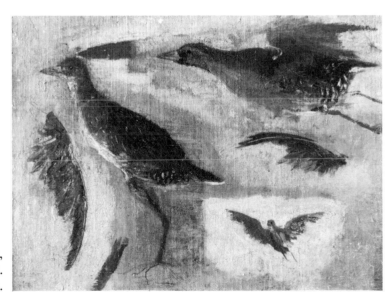

Fig. 66. *Plover*, c. 1872. Oil on canvas, 9⅝″ × 13¾″ (24.4 × 34.9 cm). Private collection, Ohio.

is an eager, exhaustive, and conscientious student of Nature, who cares for nothing that Nature cannot tell him, and who is profoundly convinced that what Nature cannot tell him is not worth telling.

In 1881, when Clark wrote this, he had been a director of the Pennsylvania Academy for some years, and Eakins had just become Director of the Schools there. Clark's magnificent championship of Eakins' *Portrait of Professor Gross* was five years past, and by this time more than the artist's unconventional painting methods were bothering him. A lot of people were continually getting upset by Eakins' life-class behavior, his easy, natural way with both "his boys" and "his girls," the regular dissection, and the seemingly constant odor of formaldehyde that swept through the august halls of the Academy. Clark and others began to find less and less to admire in the artist's work, although its quality and range were continually growing.

In the spring of 1873 Eakins had sent his old teacher Gérôme a watercolor of a sculler—evidently a study for or a copy of *The Sculler* or *John Biglin, of N. Y., the Sculler*, both of which he exhibited at the New York watercolor show in 1874 along with *Starting Out after Rail*. Gérôme replied in a letter now unlocated, but recorded by Goodrich: [19]

> My dear student:
>
> I received the watercolor that you sent me, and I accept it with pleasure and thank you for it. It has been all the more pleasurable for me as I have been able to observe in it a remarkable progress and, above all, a method of working that can only lead you to improvement. I won't hide from you the fact that previously in the studio I was not without worry about your future as a painter on the basis of the studies I saw you making. I am really very pleased that my advice, although applied later, has finally borne fruit and I don't doubt that, with perseverance along the good road that you are now following, you will surely achieve really serious results. I am now going to criticize the work, having noted progress.
>
> There is in all prolonged gestures, such as rowing, an infinity of rapid phases. . . . There are two moments to choose for us painters—the two extreme phases of action. . . . You have taken an intermediary moment and from that comes immobility. The general quality of tone is very good, the sky is firm and light, the backgrounds in their proper plane and the water has been done in a charming fashion, very properly, which I can't praise enough. What especially pleases me, and this looks toward the future, is the construction and composition together with the honesty that prevails in the work, and that is why I am sending you my compliments with my encouragement, which I am very happy to do. Please keep me apprised of your work and feel free to consult me at any time you need to, for I am very interested in the work of my students and yours in particular.

The following May, 1874, Eakins sent another watercolor, evidently incorporating some of Gérôme's suggestions. This one was, Gérôme thought, "entirely good." [20] Along with this new watercolor he sent other paintings, including *Pushing*

for Rail. The following spring, 1875, he sent four oils to Gérôme. One was *Sailing*, now at the Philadelphia Museum (Fig. 65); another was an oil version of *Negro Whistling Plover*, which is now unlocated; another was a painting he called *Drifting*, showing ships becalmed on the Delaware; and the fourth is unidentified. Gérôme and his colleagues thought the figures in all the paintings were "splendid," but the water in the unidentified one was "painted like the wall," and the composition of *Starting Out after Rail* was "too regular." "The nigger," Eakins wrote Shinn, "they had nothing against." [21]

These pictures were intended for the 1875 Salon, but they were delayed en route, and Gérôme decided to put the pictures Eakins had sent the previous year into the exhibition. The new ones managed to arrive in the nick of time, but Gérôme decided to leave the earlier works in after all, and send the four new ones to Goupil's in London.

There is little doubt that Gérôme was much taken with the work of his American pupil. "I am very interested in the work of my students," he had written, "and yours in particular," and was soon to say that he thought Eakins could do as he pleased—he had technique enough. "Gérôme calls me his favorite pupil," Eakins wrote, "& is proud of having in the New World one doing him so much honor. . . . Gérôme told Billy I was one of his most talented pupils and that he was most particularly anxious about me." [22]

Sartain, who was still in Paris, later wrote that Eakins' pictures attracted "a good deal of attention" at the Salon.[23] Some of this attention was recorded in *L'Art:* [24]

> There is a whole mass of names from the United States in the catalogue. They are still only students, but full of promise. Among those having already fulfilled their promise, I didn't find any but Mr. May, the well-known portraitist who has been living in Paris for some time, and Mr. Thomas Eakins, a disciple of Mr. Gérôme's, who has sent from Philadelphia a mighty strange painting, but which is far from having no good points. *Une Chasse aux Etats-Unis* (no. 757)* is a work of genuine precision; it is rendered in a way that is photographic. There is a veracity of movement and details which is truly great and singular. This exotic product teaches you something, and its author is not one to be lost sight of. We are dealing with a seeker, a man of will. We can assume that he will find what he is seeking, and that his discoveries may be worthwhile, to say the least.

In the midst of all these projects, William Sartain, hearing of Eakins' industry from his family, wrote from Paris, where he was helping Gérôme gather Eakins' pictures for the 1875 Salon: [25]

> I am glad Tom Eakins is progressing. I never had the slightest doubt of his success eventually. Success can be reckoned more surely from one's character than from anything else. Besides he did work here at Paris that is still quoted as the best in many of the highest qualities of anything that they

* "A Hunt in the United States" evidently refers to the painting *Pushing for Rail.*

have done at the Beaux Arts school. With one strong quality education can advance the others sufficiently for success. Besides all artists are very one-sided in their merit.

When you see any of the Eakins tell them (it may be of interest to Tom) that this year they receive 3 pictures from an artist instead of 2 at the "Salon."

Sartain, in the midst of endless years of study in Paris, was beginning to get defensive. He gave Eakins credit for "one strong quality," and conceded that that one alone could give him success. Eakins' "one strong quality" was exactly one more than Sartain had.

Meanwhile, back in America, Eakins submitted a painting to the National Academy Annual opening on April 8, 1875. His letter to Shinn concerning this project is a paradox: [26]

I sent on my little picture. It is better than those Biglin ones. I did not care to exhibit the Biglin ones for that reason. They are clumsy & although pretty well drawn are wanting in distance & some other qualities. . . . I did not varnish it. . . . If you are in the neighborhood and want an excuse to go in you can rub a little linseed oil with your finger on any part of the shadows that are soaked in or on the whole of the picture except the light of the red handkerchiefs & and the sky.

. . . Don't put yourself out. The picture dont please me altogether. I had it too long about I guess. The drawing of the boats & the figures the construction of the thing & the peculiar swing of the figures rowing pair oared the twist of the starboard oarsman to one the one side [*sic*] & the port to the other on account of the long sweeps are all better expressed than I see any New Yorkers doing but anyhow I am tired of it. I hope it will sell and I'll never see it again. . . .

Eakins is describing an unidentified work which was little, a pair-oared sculling picture, a non-Biglin picture, and a picture in which the oarsmen are wearing red handkerchiefs.

Pushing for Rail came back from Europe, and Eakins submitted it to the National Academy of Design's 1876 Annual, which opened on March 28. But it was sent back. Eakins wrote Shinn: [27]

The reason my oil picture was not exhibited in New York I do not know. It was sent on in due time by Mr. Haseltine.

About 2 weeks ago I got a polite circular from T. Addison Richards president saying he had dispatched my picture to my address and hoping it would arrive safe-*ly*.

It arrived safe soon after the note. I supposed the exhibition to be over but it had not commenced. I guess therefore my picture was simply refused.

It is a much better figure picture than any one in N. Y. can paint.

I conclude that those who judged it were incapable of judging or jealous of my work, or that there was no judgment at all on merit, the works being hung up in the order received or by lottery.

Anyhow I am mulcted in the price of frame, & double expressage, & boxing.

A gentleman & lady came to see me Tuesday. They told me they were commissioned to buy one of my pictures. It must have 2 or 3 or more figures in it and so large as not to need a magnifying glass. I had none such but showed them what I had at their request.

I showed them the oil picture I had intended for the N.Y. exhibition. They liked it but feared the distant figures might fall in the magnifying glass limits. I feared it too & showed them their best plan would be to wait till our fall exhibition when I would likely have something larger.

I felt flattered by their visit. They came evidently to buy. They were strangers to Philadelphia but seemingly less so to N.Y. where they had seen my water colors. They were educated spoke good English, neither arrived safely nor felt badly nor looked beautifully nor betrayed any other vulgarity of speech or of manner.

I believe [*Pushing for Rail*] had better go to London. In selling things on merit only your object is to put them in comparison with the best ones in the largest market. I think by this course I will gain in the end.

Besides, the anxiety I once had to sell is diminishing. My works are already up to the point where they are worth a good deal and pretty soon the money must come. Just now I am making rapid & heavy progress & old things of mine already made that would now bring less than they are worth for want of a reputation will soon fetch more than they are worth on account of the reputation that will have come.

I dont like Englishmen but I would like to get their gold. I have seen artists bore their friends to buy their pictures but I had rather sell to my enemies.

"I supposed the exhibition to be over," Eakins wrote Shinn, "but it had not commenced." It is surprising that Eakins would not have known when the most conspicuous art exhibition in the United States would have begun or ended. It is likely that, since he had indeed sent *Pushing for Rail* in time for the exhibit, he was being facetious.

He did not get a painting into a National Academy Annual until 1877, when *Pushing for Rail*, catalogued as *Rail Shooting on the Delaware*, finally made it.

In one of the Shinn letters Eakins referred to a sport watercolor he exhibited at the 1875 watercolor show in New York. This was his *Ball Players Practicing* (CL-320, Plate 16).[28]

The moment is when the just after [*sic*] the batter has taken his bat, before the ball leaves the pitcher's hand. They are portraits of Athletic boys, a Philadelphia club. I conceive that they are pretty well drawn.

Ball players are very fine in their build. They are the same stuff as bull fighters only bull fighters are older and a trifle stronger perhaps. I think I will try make [*sic*] a base ball picture some day in oil. It will admit of fine figure painting. . . .

One of the watercolors sent to the 1875 exhibition in New York, along with *A Negro Whistling Plover*, was a painting called *No Wind—Race Boats Drifting* by the

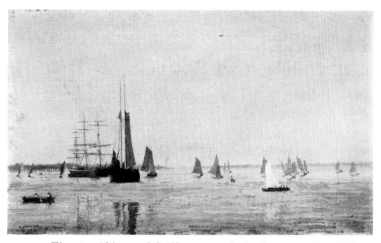

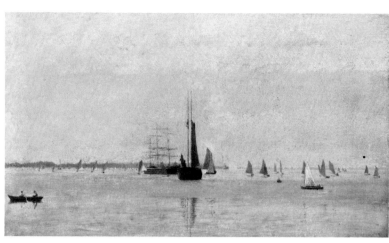

Fig. 67. *Ships and Sailboats on the Delaware*, 1874. Oil on canvas, 10⅛″ × 17¼″ (25.7 × 43.8 cm). Philadelphia Museum.

Fig. 68. *Ships and Sailboats on the Delaware* (*On the Delaware*), 1874. Oil on canvas, 10⅛″ × 17¼″ (25.7 × 43.8 cm). Wadsworth Atheneum.

exhibition catalogue and *Drifting Race* by the artist. This was one of four or five important pictures of sailing on the Delaware the artist produced during this time. Two of these, *Sailboats Racing* (CL-240), and *Ships and Sailboats on the Delaware* (CL-241, Fig. 67), are in the Philadelphia Museum; another, closely parallel to the latter, is in the Wadsworth Atheneum (CL-8, Fig. 68). Eakins had bought a boat by this time and was a regular, enthusiastic sailor. "Tom Eakins is off to Newport Monday," William Sartain wrote his mother a few years later. "On his return I suppose will [*sic*] commence our regular Sunday sails on the Delaware." [29]

Although *Sailboats Racing* is close to being a genre picture, the occupants of the principal boat are nevertheless painted as portraits and must have been men Eakins knew. "The river [was] dotted with hikers," the *Press* reported of an 1874 race, the year of this picture.[30] That race was from Thompson's wharf in Gloucester, New Jersey, to the first red buoy below the Block House and return, and it included first- and second-class yachts, as in *Sailboats Racing*. But considering the large number of boats in the picture, Eakins may have had in mind the later regatta of August 31, 1874, while painting the picture. No other race seems to have had so many boats in it. Goodrich wrote that this painting was shown at Goupil's branch in Paris, probably in 1874.

Sailboats Racing, like *Starting Out after Rail*, was not exhibited in Philadelphia until some years later. During the early 1880s Eakins was too busy with his Academy teaching to do as much painting as formerly, so from time to time he dragged out one or another of his older paintings and put them on exhibit. Clark of the *Evening Telegraph* had little good to say of *Sailboats Racing*. It was, he wrote, "a picture painted several years ago, and in rather too low a key." [31]

The Philadelphia Museum and Wadsworth Atheneum paintings of ships and sailboats are evidently oil parallels to *Drifting Race*, a watercolor the artist exhibited in 1875. "You can see the least little breeze this side of the vessels at anchor," Eakins wrote Shinn. "It turns up the water enough to reflect the blue sky of the zenith. The . . . boats in the foreground are not the racers but starters, & lookers on." [32] Goodrich wrote that Eakins' records, which are now lost or unavailable, indicate that the

1875 watercolor was donated to the Christian Schussele benefit sale in 1880, and that no one knows who bought it from there.

By 1874 Eakins had begun his first regular teaching at life classes sponsored by the Philadelphia Sketch Club. These classes were very popular and perhaps contributed to the "success" of which Sartain had heard. The exact date on which Eakins started teaching is not clear. He wrote in 1893 that he had been teaching for twenty years—that is, since 1873—but it is possible that this teaching began in 1874, not in 1873. The *Press* reported in 1876 that the classes had been in progress for three years and that Eakins was in charge of them, but it did not say that Eakins had been in charge from the beginning. A letter the artist wrote to Earl Shinn on April 2, 1874, indicates that he was yet to begin: [33]

> If your friends of the Sketch Club really want my corrections of their drawings they can have them for the asking, that is, if the *majority* of the club desire them. I cannot of course act on the suggestion of one of them to my friend.
>
> I don't know them as you say. I only fear some of them are of the kind who would believe themselves more capable of teaching me than I them, but of this, you know best & I will make no account. It is always a pleasure to teach what you know to those who want to learn.

The vacuum left by the closing of the Pennsylvania Academy of the Fine Arts in anticipation of its new building lasted six years. This vacuum had been recognized by the Union League and its exhibitions, and was now recognized by the Philadelphia Sketch Club. The life classes it sponsored were an important addition to the city's artistic life. Classes were held on Wednesday and Saturday evenings at 10 Northwest Penn Square. "If the rooms were four times as capacious as they are," the *Telegraph* reported, "they would scarcely accommodate the students who are anxious to avail themselves of the facilities which the class affords." [34] William Clark, who wrote this report, added that the classes would stay open until the Academy reopened—and likely afterward, since the Sketch Club classes offered advantages that the Academy probably could not offer, "unless its management is much more intelligent and appreciative of the true end and aim of art study [than] it has been in the past." Friday evening classes in watercolor were also organized in the season of 1875–1876, evidently under Eakins' tutelage. All of this kept him busy three nights a week.

A number of Sketch Club students went also to Jefferson Medical College, where they audited lectures on anatomy, and we know that Eakins himself often attended these lectures. Teaching at Jefferson was his old teacher from Central High School, Benjamin Howard Rand, and Eakins asked Rand to sit for him. This was a portrait with which he had considerable difficulty—X-rays show many trials and errors—but it ranks among the most attractive works of the artist's early career (CL-325, Plate 19). Perhaps in preparation for this, he painted a copy of an old daguerreotype of his late mother (Figs. 69 and 70) and made a portrait of his friend Harry

Fig. 69. Mrs. Benjamin Eakins, c. 1866. Author's collection. Carte de visite.

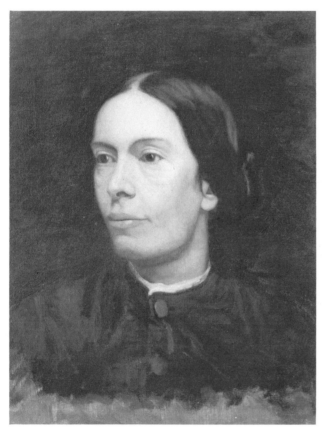

Fig. 70. *Portrait of Mrs. Benjamin Eakins*, c. 1874. Oil on canvas, 24″ × 20″ (60.9 × 50.8 cm). Collection Mr. and Mrs. Daniel Dietrich II, Philadelphia. Copied from the photograph of Fig. 69, after her death.

Fig. 71. *Portrait of Harry Lewis*, 1876. Oil on canvas, 24″ × 20″ (60.9 × 50.8 cm). Philadelphia Museum of Art.

Lewis (CL-247, Fig. 71).

Now he was on the threshold of the greatest work of his career, and he began to plan the painting that many consider the masterpiece of American art.

6

Portrait of Professor Gross
1875-1876

"BUT WHAT ELATES ME more," Eakins wrote Earl Shinn on April 13, 1875, "is that I have just got a new picture blocked in & it is very far better than anything I have ever done. As I spoil things less & less in finishing I have the greatest hopes of this one."

Earlier in the year Gérôme had told Eakins that he had now, in his own hands, the ability to do what he wanted to do—"*le côte d'exécution*." The great, nearly life-size *Portrait of Professor Gross*, often called *The Gross Clinic* (CL-326, Plate 18), is what he wanted to do.[1]

It was different from anything he had tried before. In *The Champion Single Sculls* he had caught Max Schmitt in the midst of activity, resting on his oars between stints of rowing. In *Pushing for Rail* he had caught the hunters in the midst of their activity, with one or two stooping in expectation of a start of birds, and others in the act of shooting. In his portrait of Benjamin Howard Rand he had caught the sitter in the midst of *his* activity, shuffling through notes in his study. And now, in *Portrait of Professor Gross*, he was to catch Gross in a sharp edge of incident, poised above a patient in an operating theater, with scalpel in hand, explaining his procedure.

There is a crucial difference, however, between the Gross painting and those that had gone before. Schmitt and Rand and the hunters in the hunting pictures are in an everyday confrontation—Schmitt with the river, Rand with the problems of science, the hunters with their game. Gross, too, is involved in what was an everyday

confrontation for him. But he is dealing with the vital elements of life and death, playing the role of champion of humanity, and he is performing an incident of the highest drama, in a theater where the world can see him. It is this difference, as well as the nearly life-size figures with the commanding figure of Gross in their midst, that sets *Portrait of Professor Gross* on a higher plane.

Jefferson Medical College, the leading medical school in Philadelphia, was familiar ground to Eakins. He had attended lectures there back in 1864 and 1865, when he may have had thoughts of becoming a physician, and he continued to do so after his return from Paris.

He had undoubtedly seen Samuel David Gross, who held the Chair of Surgery, in action in both the lecture room and the clinic. Gross had been at Jefferson since 1856, and was, at six feet two, weighing two hundred pounds, a commanding figure. Eakins' new painting may have been gestating since the artist returned to Jefferson in 1873. Two admission cards exist, one signed by Dr. William Pancoast dated 1874–1875, and another signed by Dr. Joseph Pancoast, undated. Jefferson catalogues fail to list Eakins as a student, but the manuscript register from which these catalogues were drawn evidently listed only those who intended to take a full course and to make medicine their profession.

It has often been said that Eakins' portrait of Gross was commissioned by the Jefferson Alumni Association, but this is incorrect. The Association did, indeed, commission a portrait of Gross, but this was the banal picture by Samuel B. Waugh (Fig. 72), not Eakins' portrait. Three years later, when *Portrait of Professor Gross* came to rest at Jefferson—from which it has yet to be dislodged in spite of recent vigorous efforts to do so *—it was reported that the picture had been painted "for the faculty." [2] This claim also is preposterous. In painting *Portrait of Professor Gross* Eakins worked completely on his own and was dependent only on the cooperation of his various sitters—Gross, S. W. Gross, Hearn, Barton, Appel, Briggs, West, "Hughie" the janitor, and those of his students who were willing to pose as spectators. He also painted himself at the center right, sketching this dramatic confrontation between life and death (Fig. 73).

Surely a number of these students were from the Sketch Club classes. They would have felt delighted—and privileged—to participate. Some of the painting's background figures are probably also the boys in the burlesque photograph (Fig. 74); one figure is Eakins' friend Robert C. V. Meyers, the poet who wrote "If I Should Die Tonight." [3] We know that the background figures were not filled in until the fall of 1875: the sketch of Meyers, the only one we have, is dated October 10 (Fig. 75).

Eakins evidently began working with Gross earlier in the year. Gross was not very enthusiastic about posing, which was done under the skylight in the studio of Eakins' house. Mrs. Eakins told Goodrich that on one occasion Gross got tired and said

* Efforts have recently been made by the National Gallery to acquire this monument of American art for the United States. But successive offers of $500,000, $750,000, a million, and finally a million and a half have been refused by Jefferson.

Fig. 72. Samuel B. Waugh: *Portrait of Samuel David Gross*, 1874. Oil on canvas, 30″ × 25″ (76.2 × 63.5 cm). Jefferson Medical College, Philadelphia.

Fig. 73. *Wash Drawing for Autotype of Portrait of Professor Gross* (detail), c. 1875. Ink wash on paper, 22″ × 28″ (55.8 × 71.1 cm). Metropolitan Museum of Art. Eakins at right with sketch pad.

Fig. 74. Burlesque photograph of *Portrait of Professor Gross*, 1875 or 1876. Philadelphia Museum of Art. Eakins may be the seated figure at the left.

Fig. 75. *Study of Robert C. V. Meyers for Portrait of Professor Gross*, 1875. Oil on paper, 9″ × 8½″ (22.9 × 21.6 cm). Collection Mr. and Mrs. Daniel Dietrich II, Philadelphia.

to Eakins: "Eakins, I wish you were dead!" He was immensely occupied, and the demands on his time must have been considerable. It is likely, however, that he liked both the magnificent study (CL-243, Plate 17) and the finished work. He, Samuel David Gross, was the center of the universe, glorified as never before, defending mankind against the forces of darkness and disease. The blood, which put nearly everyone else off, did not bother him. It was an everyday experience.[4]

> Persons have often come to me [Gross wrote] saying they had understood that I was very fond of using the knife . . . nothing could be more untrue, or more unjust. I have never hesitated to employ the knife when I thought it was imperatively demanded to relieve or cure my patient; but that I have ever operated merely for the sake of display or the gratification of a selfish end is as base as it is false. I have always had too much respect for human life, for my professors, and for my own dignity, to be guilty of such an outrage. No man ever had a greater or more unmitigated contempt for the knife's-man, or mere mechanical surgeon and operator, than I, and I have never hesitated, in season and out of season, to denounce him in the most unmeasured terms.

The patient in *Portrait of Professor Gross* is lying on his right side, with his left thigh and buttock bare, and his feet, in their cheap charity socks, crossed as they would be if he were under ether, the anesthetic Gross used. The operation is for the removal of a piece of bone diseased because of osteomyelitis, and today it would be considered as simple as a tooth extraction. In the 1870s, however, even in the clinic of the great Dr. Samuel David Gross, no surgical operation was simple.

We know the patient was a charity case because there is a woman present, possibly a sister or mother since most surgeons did not want wives in the operating

Fig. 76. *Drawings of Heads of Drs. Gross and Barton for Autotype of Portrait of Professor Gross*, c. 1875. Ink by pen and brush on paper, 11¾" × 14¾" (29.8 × 37.5 cm). See CL-244.

Drawing in India Ink by Thomas Eakins 1876

Fig. 77. *Portrait of Charles F. Haseltine,* c. 1901. Oil on canvas, 24″ × 20″ (60.9 × 50.8 cm). Montclair Art Museum, Montclair, New Jersey. Haseltine was Eakins' dealer in the early years.

room. The law required that in charity cases a relative of the patient, when available, must be present and most doctors wished to avoid malpractice suits. The figure of the woman, incidentally, was criticized by the reviewer of *The New-York Tribune* as being an unnecessarily melodramatic element. Assuming she must be there, the reviewer went on, why must she be writhing about in horror? But he exaggerated her reaction —the woman is merely covering her face.

Work on the painting progressed through the summer to the point where, in August 1875, John Sartain could write his daughter Emily that "Tom Eakins is making excellent progress with his large picture of Dr. Gross, and it bids fair to be a capital work." [5]

After *Portrait of Professor Gross* was finished, Eakins decided that he wanted to have an autotype of it. An autotype is a carbon photograph, a reproduction in black and white of very high quality. To be sure that the proper values would be reproduced in black and white, Eakins made a wash drawing of his painting and sent it to Adolph Braun and Company in Alsace. In the process of trying to decide whether to do it in wash, line, or a combination of the two, he produced drawings of the heads of Gross and the chief assisting surgeon, Dr. Barton (CL-244, Fig. 76). These drawings, as well as the wash drawing done for Braun (CL-178), still exist. Although the artist must have ordered a number of the autotypes, I know of the existence of only one, in the Philadelphia Museum (CL-245). This example had been given by Eakins to his friend Florence Einstein. He also gave one to Emily Sartain, and perhaps another to his alma mater, Central High School, when they were forming a library some years later, but neither of these has been found. It is probable that they were considered mere "prints" and were not treated with much respect.

It was through one of these autotypes that Philadelphia, outside the artist's friends and family, got its first look at the painting that it would find so shocking and disgusting. The Penn Art Club put an autotype on exhibition on March 7, 1876, and William Clark reported on its appearance: [6]

> The most striking works were the two contributions by Mr. Thomas Eakins, a young artist who is rapidly coming into notice as the possessor of unusual gifts. One of these was a photograph from his large portrait of Dr. Samuel D. Gross—representing that eminent surgeon holding a clinic. The original of this picture has never been out of the artist's studio, but reports of it have gone abroad and much curiosity has been excited because of it. It is a work of great learning and great dramatic power, and the exhibition of the photograph last night will certainly increase the general desire to have the picture itself placed on exhibition at an early day. Mr. Eakins' other work was a water color representing *A Negro Whistling down Plover*, and, like the photograph, was a masterly performance.

Eakins was proud of his new painting and wanted as many people as possible to see it. But the exhibition of the autotype in advance of the original suggests that he wanted to break them in gradually. He knew that the painting—and especially the red blood—would shock everyone, and perhaps he felt that the autotype would prepare them.

One of the autotypes also found its way into the Academy Annual opening on April 24, at about the same time the original of the painting began its public exhibition at Haseltine's at 1125 Chestnut (Fig. 77). Haseltine's was the leading local gallery, to which a number of Philadelphia artists regularly sent their works for public debuts.

Late in the following month *Portrait of Professor Gross* left Eakins' studio for Haseltine's. Clark of the *Telegraph* gave it the best review Eakins ever received. For all its superlatives, however, the review failed to do the painting justice: [7]

> Eakins' Portrait of Dr. Gross.
>
> There is now on exhibition at Haseltine's galleries, No. 1125 Chestnut street, Mr. Thomas Eakins' portrait of Dr. Samuel D. Gross, in which that eminent surgeon and teacher is represented as attending a clinic at the Jefferson Medical College. This picture until within a few days past has only been visible in the studio of the artist, but the reports of those who have seen it with regard to its many very striking qualities have stimulated the curiosity not only of art lovers but of people who do not under ordinary circumstances take much interest in art matters. Mr. Eakins has been living and working in Philadelphia for the last four or five years—ever since his return from Europe, after completing his artistic education—but he has exhibited very seldom, and such of his works as have been placed on view here have not been of a character to attract general attention, although their great technical merits have received ample acknowledgement from competent judges. The fact is, Mr. Eakins has been in the habit of sending his

best things to Paris, where they have found a ready sale, and where his delineations of American sporting scenes especially have been greatly admired. The public of Philadelphia now have, for the first time, an opportunity to form something like an accurate judgment with regard to the qualities of an artist who in many important particulars is very far in advance of any of his American rivals. We know of no artist in this country who can at all compare with Mr. Eakins as a draughtsman, or who has the same thorough mastery of certain essential artistic principles. There are men who have a knack of choosing more popular and more pleasing subjects, who have a finer feeling for the quality that can best be described by the word picturesqueness, and who are more agreeable if not more correct in color. For these reasons it is not difficult to understand that the pictures of men who cannot pretend to rival Mr. Eakins as masters of techniques should find more favor with the general American public than his have been able to do. With regard to Mr. Eakins' color, however, there is this to be said—and it is a point that must be considered by those who may be disposed to regard his color as odd, not because it does not represent nature, but because it does not look like what they have been accustomed to in other pictures—his aim in color, as in drawing, is to represent, as near as is possible with the pigments at command, the absolute facts of nature, and a misrepresentation of facts for the purpose of pleasing the eyes of those who do not know what nature looks like is something that his method does not contemplate. The genuineness of Mr. Eakins' method is abundantly exemplified in the picture under consideration, and on a sufficiently large scale for a just opinion with regard for it to be formed. . . . The picture being intended for a portrait of Dr. Gross, and not primarily as a representation of a clinic, the artist has taken a point of view sufficiently near to throw out of focus the accessories, and to necessitate this concentration of all his force on the most prominent figure, Dr. Gross is delineated as standing erect, one hand resting upon the bed, while with the other, which holds the instrument with which he has been operating, and which is stained with blood, he is making a slight gesture, as if to illustrate the words he is uttering. To say that this figure is a most admirable portrait of the distinguished surgeon would do it scant justice: we know of nothing in the line of portraiture that has ever been attempted in this city, or indeed in this country, that in any way approaches it. The members of the clinical staff who are grouped around the patient, the students and other lookers-on, are all portraits, and very striking ones, although from the peculiar treatment adopted they do command the eye of the spectator as does that of the chief personage. The work, however, is something more than a collection of fine portraits; it is intensely dramatic, and is such a vivid representation of such a scene as must frequently be witnessed in the amphitheatre of a medical school, as to be fairly open to the objection of being decidedly unpleasant to those who are not accustomed to such things. The only objection to the picture that can well be made on technical grounds is in the management of the figure of the patient. The idea of the artist has obviously been to obtrude this figure as little as possible, and in carrying out this idea he has fore-

shortened it to such an extent, and has so covered it up with the arms and hands of the assisting surgeons, that it is extremely difficult to make it out. It is a mistake to introduce a puzzle in a picture, and this figure is, at first glance, a decided puzzle.

Leaving out of consideration the subject, which will make this fine performance anything but pleasing to many people, the command of all the resources of a thoroughly trained artist, and the absolute knowledge of principles which lie at the base of all correct and profitable artistic practice, demand for it the cordial admiration of all lovers of art, and of all who desire to see the standard of American art raised above its present level of respectable mediocrity. This portrait of Dr. Gross is a great work—we know of nothing greater that has ever been executed in America.

It is impossible to know whether or not *Portrait of Professor Gross* was conceived and executed with the thought that it would be Eakins' principal contribution to the Art Gallery for the upcoming celebration of the centennial of Independence. Probably it was. He began to work on it about the first of April 1875, at the time American artists were being urged to submit an example of their work to the Committee of Selection. As early as March 5, 1875, local artists as well as others were given some of the ground rules: [8]

All works of art must be of a high order of merit, and those produced by citizens of the United States will be admitted to the exhibition only with the approval of the Committee of Selection. . . . All pictures . . . should be placed in square frames. Glass over oil paintings will not be permitted. . . . All works of art must be in Philadelphia prior to April 1, 1876; and after having been admitted under the rules, shall not be removed before the close of the exhibition.

A month later the artists of Philadelphia appointed a committee to have "a general oversight of the interests of American and foreign artists in the Art Department of the Centennial Exhibition." [9] This was an unofficial, informal organization which worked hard to whip up enthusiasm for art at the Fair. William Trost Richards of Germantown, a well-known marine painter, was chairman, and other members included the illustrator F. O. C. Darley, John Sartain, and Eakins' Academy teacher, Christian Schussele. They sent out circulars to painters in every important city in America, but received not a single answer. Later artists complained they had never seen the circular, which may have been the case; possibly with the Fair approaching, they had changed their minds about the importance of the exhibition.

The Committee of Selection was a separate official body formed largely through the recommendations of John Sartain, who had as much as or more than anyone else to say about art matters in Philadelphia at this time. Sartain had been offered the job of Superintendent of the Art Department early in the summer of 1875, but he declined, probably because he felt the Fair authorities would interfere too much with his decisions. Later, when it appeared that the authorities were prepared to turn the matter

over to a committee, he wrote his daughter Emily that he "might occupy that honor-able position after all." [10] The job would give him the power to organize a Committee of Selection to decide what would hang at the Fair. The Selection Committee members chosen by Sartain were Daniel Huntington, President of the National Academy of Design, Jervis McEntree, Thomas Hicks, J. Q. A. Ward, H. K. Brown, W. H. Wilcox, Richard M. Staigg, and Thomas Robinson. Sartain acted as an *ex officio* member. This committee was a veritable pantheon of conservatism. The Hanging Committee members, to be in charge of installing the paintings, were three: Worthington Whit-tridge, James Smillie, and Schussele.

Sartain became Superintendent of the Art Department, or Chief of Bureau, as he generally referred to himself, on September 8, 1875. It was part of his job to try to straighten out the constant dissension among the Selection Committee members. This one or that one would resign, another would be chosen to replace him after all other members had been consulted, then the old one wanted to rejoin, the new member would be found unsatisfactory, and so on. Sartain's methods were often dictatorial and presumptuous. In the case of Albert Bierstadt, for example, Sartain promised the artist a wall space of 12 by 54 feet without consulting any of the other members. "Pictures like yours need no passing on by the Committee," he wrote Thomas Moran, "only 'tell it not in Gatt, nor publish it by the Gates of Ascalon.' " [11] On March 17, 1876, with the Fair's opening just around the corner, he wrote Huntington: "Permit me to remind you that it is understood that the office of your Comee. is *simply to reject work of insufficient merit.*"

By the fall of 1875, everyone was beginning to sit up and take notice of the forthcoming exhibition. A correspondent of *The New-York World* thought that although few Philadelphia artists had national reputations, some were worthy, and "Thomas Aiken," who was teaching the Sketch Club classes, was a star among them: [12]

> There is another—Thomas Aiken [*sic*]—who is called by his admirers here the best draughtsman of the figure painters of the United States. He was a favorite pupil of Gérôme, who still takes a keen interest in his success. He is a very modest man, but is now acting as instructor of the life class of the Philadelphia Sketch Club.

On April 5, 1876, three weeks before Eakins' *Portrait of Professor Gross* had been taken down to Haseltine's, the Committee of Selection began to look at the paintings upon which they would pass—except, of course, those John Sartain had already decided would be accepted, an honor he did not confer upon Eakins. The Fair was to open on May 10, and there were already so many paintings in prospect that an immense Annex had been built to house the overflow. It is possible that Sartain, who may sometimes have decided what the committee would see, did not even show them Eakins' painting. Nevertheless, we know that decisions were still being made up to and beyond the time the galleries were opened to the public, and *Portrait of Professor Gross* was on display at Haseltine's from April 25, where anyone who wanted to see it

could do so. The Committee of Selection, which was next door to the new Academy at Broad and Cherry streets, would have had only five or six blocks to walk to see the picture, if they had not already seen it in their selection rooms. According to Clark, the painting had been in the artist's studio until just a few days before it went on display at Haseltine's, but he does not tell us whether or not it went to the committee in the interim. Presumably, however, the committee members had plenty of opportunity to examine the work and to decide they didn't like it.

When the Fair opened on May 10 in a state of utter confusion—"workmen . . . cleaning floors, tumbling out stacks of straw, removing boxes, unpacking statues, hanging pictures, joining frames, upholstering sofas" [13]—Eakins' painting was not there. Nor was it ever to be there. His *Elizabeth at the Piano* (CL-129),* *Dr. Rand* (CL-325), *Chess Players* (see Plate 21), *Ball Players Practicing*, and *Negro Whistling Plover* were there, but not *Portrait of Professor Gross*. The Committee had turned thumbs down on such a horror. But it was suffered, instead, to be hung in the First Aid Hospital of the Fair, presumably in the staff room, so that Fair visitors coming to get a scratch or a bruise tended to would not take fright at the sight of this blood-spattered monster towering above them.

Eakins' friend Clark, the *Evening Telegraph* critic, thundered his rage: [14]

> In commenting upon Mr. Eakins' portrait of Dr. Gross when it was on exhibition at Haseltine's galleries . . . we said that nothing finer had been done in this city. There is nothing so fine in the American section of the Art Department of the Exhibition, and it is a great pity that the squeamishness of the Selecting Committee compelled the artist to find a place for it in the United States Hospital Building. It is rumored that the blood on Dr. Gross' fingers made some of the committee sick, but, judging from the quality of the works selected by them we fear that it was not the blood alone that made them sick. Artists have before now been known to sicken at the sight of pictures by younger men which they in their souls were compelled to acknowledge was beyond their emulation. The figure of Dr. Gross in this picture is the representation of a man and not of a shadow. . . .

The American art at the Centennial aroused little enthusiasm. Occasionally a reporter would write about West, Copley, Allston, or Stuart, but would lament the apparent fact that most contemporary artists had not sent the best they could do now, but their best of five, ten, or twenty years ago. In none of the dozens of reviews I have found were even Eakins' five "acceptable" paintings mentioned. John Sartain, incidentally, was publicly excoriated for his mismanagement, and the catalogue was said to be a "useless and irritating performance." [15]

From Eakins' exhibitor's pass (which is in the Hirshhorn Collection) it is possible to determine when he went to the grounds: May 26 and 28; September 12, 14, 21, 25, and 29; October 10, 12, 16, 27, and 28; and November 1, 4, 6, 8, and 10. The

* The catalogue of the exhibition listed this as "Lady's Portrait," but the *Telegraph* of June 16 reported that this was a picture of "a young lady playing upon the piano," which evidently refers to *Elizabeth at the Piano*, painted the previous year.

dates close together at the end suggest that he was seeing to the removal of his paintings; the hiatus during June, July, and August suggests that he may have been somewhere trying to forget his frustration—perhaps in South Jersey, down along the banks of the Cohansey.

The Centennial came and went, and *Portrait of Professor Gross* passed into limbo. Then, on March 9, 1878, *The Philadelphia Press* announced that the painting had been acquired by Jefferson Medical College. Other sources indicate that the price paid was $200.

A year later Eakins borrowed his painting and sent it to the exhibition of the Society of American Artists in New York, which opened on March 10. Two years before, in Philadelphia, the city had refrained, in its genteel fashion, from publicly expressing the revulsion it felt at the painting. But vulgar New York was something else. Reviewers from the *Herald, Tribune, Times,* and *Daily Graphic* all went to "varnishing day," the day prior to the opening when artists customarily gave a final touch of brilliance to their works, and each critic could scarcely wait to outdo the others with fascination and repulsion.

The *Herald* thought the work "decidedly unpleasant and sickeningly real in all its gory details, though a startlingly lifelike and strong work." [16] The *Tribune* thought it "one of the most powerful, horrible, and yet fascinating pictures that has been painted anywhere in this century. . . . But the more we praise it, the more we must condemn its admission to a gallery where men and women of weak nerves must be compelled to look at it. For not to look at it is impossible." [17]

Two weeks later the *Tribune* critic went back to look at the picture again. He'd had time to mull things over a bit, and wrote a clearer analysis, but confirmed his lack of understanding: [18]

> The more we study Mr. Thomas Eakin's "Professor Gross," No. 7, the more our wonder grows that it was ever painted in the first place, and that it was ever exhibited in the second. As for the power with which it is painted, the intensity of its expression, and the skill of the drawing, we suppose no one will deny that these qualities exist. With these technical excellencies go as striking technical faults. There is no composition, properly so called; there is of course no color, for Mr. Eakins has always shown himself incapable of that, and the aerial perspective is wholly mistaken. The scene is in the lecture room of a medical college. The Professor, announced as a portrait, and said to be an excellent one, has paused in an operation, apparently one of great difficulty, and is making a remark to his class. The patient lies extended upon the table, but all that we are allowed to see of the body is a long and shapeless lump of flesh which we conclude to be a thigh because, after eliminating from the problem all the known members, there seems nothing but a thigh to which this thing can be supposed to bear any likeness. We make out that one of the Professor's assistants is holding a cloth saturated with chloroform over the patient's face, meanwhile two students hold open with flesh-hooks a longitudinal cut in the sup-

posed thigh; another assistant pokes in the cut with some instrument or other, and the Professor himself, holding up a bloody lancet in bloody fingers, gives the finishing touch to the sickening scene. A mile or so away, at a high-raised desk, another impassive assistant records with a swift pen the Professor's remarks, and at about the same distance an aged woman, the wife or mother of the patient, holds up her arms and bends down her head in a feeble effort to shut out the horror of the scene. She is out of all proportion small compared with the other figures, and her size is only to be accounted for on the impossible theory that she is at a great distance from the dissecting table. This is the subject of a picture of heroic size that has occupied the time of an artist it has often been our pleasure warmly to praise and that a society of young artists thinks it proper to hang in a room where ladies, young and old, young girls and boys and little children, are expected to be visitors. It is a picture that even strong men find it difficult to look at long, if they can look at it at all; and as for people with nerves and stomachs, the scene is so real that they might as well go to a dissecting room and have done with it.

It is impossible to conceive, for ourselves, we mean, what good can be accomplished for art or for anything else by painting or exhibiting such a picture as this. It was intended, we believe, for a medical college; but surely, the amorphous member we have spoken of would create such doubts in the minds of neophytes, and such sarcasm in the minds of experts, as to make it a very troublesome wall ornament. As a scientific exposition, it is on this, as well as on other grounds of no great value. The Professor's attitude and action are apparently very unusual, and give an uncomfortable look of "posing" to the principal figure, which of course could never have been intended by the artist. Then, again, is it usual for the relatives of a patient who is undergoing a serious operation to be admitted to the room? And, whether it be or be not, is it not unnecessary to introduce a mel-odramatic element—wholly hostile to the right purpose of art—into the scene, to show as this old woman writhing her body and twisting her hands as the Professor details the doings of the scalpel to the house of life of some one dear to her? Here we have a horrible story—horrible to the layman, at least—told in all its details for the mere sake of telling it and telling it to those who have no need of hearing it. No purpose is gained by this morbid exhibition, no lesson taught—the painter shows his skill—and the spectator's gorge rises at it—that is all. It will be seen that we admit the artist's skill, and that skill would be more telling if he had known to confine himself to the main group. The recording scribe in the distance is well painted; no matter how slight the thing Mr. Eakins's people are doing, they always are doing it as effectually as if their painted bodies were real ones. And the old woman is well painted too; but neither the recording scribe nor the old woman has any right at all to be in the picture. They are only here for the sake of effect.

The *Times* agreed with the *Tribune* that the old woman should not have been there, and made a curious cavil: the outside of a grown man's thigh was indecent: [19]

[Eakins] has terribly overshot the mark, for, although his method of painting is not disgusting in colors, as that of some foreign artists is, but rather wooden and academic, yet the story told is in itself so dreadful that the public may well be excused if it turns away in horror. The ugly, naked unreal thigh, the pincers and lancets, the spurting blood, and the blood on the hands of the Professor and his assistant are bad enough, but Mr. Eakins has introduced, quite unnecessarily, an additional element of horror in the shape of the woman, apparently the mother of the patient, who covers her face and by the motion of her hands expresses a scream of horror. Above and in the background, are the students in their seats in a surgical amphitheatre. The composition is rather confused. This violent and bloody scene shows that at the time it was painted, if not now, the artist had no conception of where to stop, or how to hint a horrible thing if it must be said, or what the limits are between the beauty of the nude and indecency of the naked. Power it has, but very little art.

Only the *Daily Graphic* among the New York papers understood a little of what *Portrait of Professor Gross* was about: [20]

"The Clinic," by Thomas Eakins, is a large and important canvas which commands attention both from its subject and treatment. It is a work which will attract as much comment as any picture in the collection. The painting represents a surgical operation in the amphitheatre of a medical college. Grouped around the central figure—which is a striking portrait of Dr. Gross, the well-known physician of Philadelphia—are the students [*sic*] who assist in the operation. The patient lies upon the table, nearly covered from sight, the face being hidden under a cloth saturated with ether, held by one of the attendants. The light is arranged to throw out the central group in bold relief. The entire picture is a serious, thoughtful work, and we can readily understand what a fascination a subject like this must have for an artist who is himself a profound student of anatomy. There is thought and feeling of a high order in this painting, and in this respect it is in marked contrast with many of the works that surround it.

Portrait of Professor Gross, however, for the *Daily Graphic* critic, did not compare with John Singer Sargent's *Capriote*, "a delicate little Mediterranean idyll," that carried off the honors of the exhibition.

Shortly after the New York exhibition closed, Eakins' painting traveled back to Philadelphia and was exhibited at the Academy of the Fine Arts' Fiftieth Annual, opening on April 28, 1879. The New York show had been invited to come down *en masse*, and the Society accepted the invitation. But the Academy refused to hang Eakins' picture. Later, when the Society threatened to withdraw all their pictures if Eakins' was not included, the Academy protested that they had intended to hang it all along, but the Society had not furnished the "necessary information." [21] Thomas Moran's *Ponce de Leon in Florida* had been hung where Eakins' picture was to have been, and this was taken down. But still the Academy could not bring itself to put up

Portrait of Professor Gross in its place. Instead, they rehung much of the show, and Eakins' picture was put in an obscure corner of the East Corridor.

The Philadelphia North American was glad it was in the corner, and predicted that that corner would be "severely left alone" while *Portrait of Professor Gross* was there: [22]

> In the same corridor is a large and pretentious production by Mr. Thomas Eakins—a "Portrait of Professor Gross." It is well but blackly painted, and is no doubt a good portrait; but as the learned professor and his assistants are represented as engaged in the thick of a serious surgical operation— the crimson evidences of which are more than obtrusively presented—it may be seriously doubted whether the walls of Jefferson College have been denuded without any sufficiently good reason. There is an especially objectionable finger and thumb, which will go far to cause the corner in which this grisly picture is hung to be severely left alone during the duration of the exhibition.

The shock created by *Portrait of Professor Gross*—apart from the fact that it was original and therefore impossible for most to understand—may have resulted in part from its appearance at the height of the vivisection controversy, which may fairly be said to have been raging at this time. When Eakins' work appeared at Haseltine's in 1876 a bill was pending in the Pennsylvania legislature to outlaw the practice, and Philadelphia itself was the headquarters of the American Anti-Vivisection Society. The majority of medical men—and surely Gross—favored vivisection, but generally refrained from expressing their views. "Murder in the name of science," was the battle cry of their opponents. The patient in Dr. Gross's clinic is not a lower animal, but he is, nevertheless, "helpless," bleeding, and "at the mercy" of the scientifically detached surgeon towering above him. The blood on the hands and cuffs of the doctors and on the coarse hospital sheet, the pitifully crossed feet of the patient in their cheap socks, and the thin, undernourished look of the thigh itself—all did not help to cool the public passion. Perhaps, if the audience had not been there, the painting would not have seemed so bloodthirsty.

First Academy Years
1876-1879

DURING THE EARLY 1870s the Union League had its art exhibitions, for a while at least, and the Philadelphia Sketch Club had its life classes. But everyone was waiting for the Academy. The old building had long since been torn down, and the new one, at the southwest corner of Broad and Cherry, was slowly, ever so slowly, rising. The years passed. Philadelphia was "sadly deficient," the *Press* editorialized, "in facilities for study." [1]

Admittedly the new Academy building was an elaborate, expensive edifice (Fig. 79). It was substantially underwritten by prominent citizens. John Sartain was chairman of the Building Committee, and his principal objections to the various architects' plans were that they did not sufficiently take into account the fact that the building was to be used for both galleries and a school. It seemed to him that "the external forms should grow out of, and be subordinate to, the essential internal uses and purposes of a building, and not the reverse." [2] One set of plans was rejected outright, because the uses were sacrificed to architectural effect; in Frank Furness' plan, many of the difficulties rose from the same cause—"subordinating interior uses to external forms." Only Thomas Richards' plan seemed acceptable. But evidently strings were pulled, and Furness' plans were put into effect. Sartain's chief objection to Furness' ideas were that they indicated several sources of light. To adopt such a plan, he wrote, would violate

Fig. 78. Eakins in backyard of 1729 Mt. Vernon Street, c. 1876. Collection Mr. and Mrs. Daniel Dietrich II, Philadelphia.

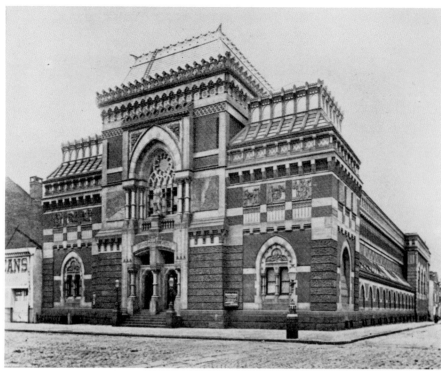

Fig. 79. Photograph of the Pennsylvania Academy of the Fine Arts, c. 1876. Pennsylvania Academy of the Fine Arts.

"the immutable principle of light from a single source," and would make "the judicious grieve."

Slowly the furbelows were added, one by one, until the building looked as it does today, when there are still some details to be set in place. Construction had begun in May 1872, but by 1874 it was not ready for reopening. The delay added fuel to another resentment—the Academy had never produced a good artist anyway. "If a painter or sculptor of any fame ever graduated from that seminary the world has yet to be informed of the fact." [3] The good artists had gone to the "wiser or more liberal New York." [4] In fact, years later, when Eakins was having trouble over the raise that had been promised but not given him, he reminded the Academy authorities that if it had not been for such prospects he would have gone to New York long since.

In June 1874 Fairman Rogers, chairman of the Building Committee and later a friend and patron of Eakins (Fig. 80), told the Academy board of directors that the building "could probably be urged forward to completion by next spring," [5] and late that summer eighty men were finishing the walls.

Finally, at noon on April 22, 1876, the new building was opened to a "private view" on the new red moss-patterned carpet. Eakins had on exhibition oils, a watercolor (*The Zither Player*, CL-118, Fig. 81), and his Gross autotype. The directors did not want to detract attention from the Fair, and had decided that there would be no special, crowd-drawing exhibitions in the Academy during the Centennial. They also decided to put off decisions about classes, teachers, and so on, until fall. "There

must be a competent Professor for guiding the studies of the human form," the Committee on Instruction reported, but the job "may in fact be regarded as already filled by Professor C. Schussele, who was the instructor in this department when the operation of the school was suspended." [6]

The Academy announced that life classes would be held only three times a week, and Clark, the *Telegraph* critic, thought this was dreadful: [7]

> Exactly why there should not be a life class and a drapery painting class in operation [in the Academy] not only every evening, but every day, from one year's end to the other, it is difficult to understand. . . . Why spend so much . . . to the injury of the only feature of the institution that entitles it to the name it bears? . . . Matters are to go on in the same old-fashioned unsatisfactory style that they did in the old Chestnut Street building.

Clark, ever a champion of Eakins, also had some fine words for Eakins' contribution to the Academy exhibition: [8]

> The most noteworthy picture after Mr. Moore's . . . is Mr. Eakins water-colors [*sic*] entitled the *Zither Player*, No 335. This is in many respects the best performance of a thoroughly accomplished artist who has, during the four or five years that have elapsed since he first exhibited in Philadelphia at one of the Union League art receptions, been steadily growing in the regards

Fig. 81. *The Zither Player*, 1876. Watercolor on paper, 12⅛" × 10½" (30.8 × 26.7 cm). Chicago Art Institute. William Sartain (left) and Max Schmitt.

Fig. 80. Fairman Rogers in the box of his four-in-hand coach, c. 1879. Author's collection. From Rogers' *A Manual of Coaching* (Philadelphia, 1900).

of those who know what fine artistic workmanship really is. It has a freedom of handling and a color quality that his previous productions have to some extent lacked. As a piece of drawing it is thoroughly fine, and the "movement" of the principal figure—a man in his shirt sleeves playing upon a zither—is expressed with a refinement of skill that no American artist that we know of can begin to equal. This little masterpiece is better worth the consideration of visitors who desire to know what good work really is than whole galleries full of such canvases as those which compose the bulk of the exhibit. . . .

In October the Academy classes opened. Schussele was there (at $1200 a year), along with Dr. W. W. Keen, Professor of Artistic Anatomy (at $10 a lecture), a J. C. Bailly, Professor of Modeling in Clay (at $15 a lecture), and James H. Kirby, Lecturer and Instructor in Perspective and Architecture (also at $15 a lecture). Eakins was going to take over Schussele's evening classes for no payment. Six weeks later, in the face of all this prodigality, the Academy spent $20,000 on a painting by Hans Makart, *Venice Paying Homage to Catherine Cornaro*. There might be little money for a museum's "nonessentials," but there was always plenty for the "important" things.

From the beginning Eakins was restive. In spite of his devotion to his old teacher Schussele, he was frustrated by Schussele's methods. His old teacher insisted on the old methods—forcing a student to draw interminably from antique casts before he was allowed into the life classes, and even refusing to allow him to draw anything *but* casts. A request from a girl student to draw from a painting was refused because Schussele did not think she was sufficiently advanced "to engage in such work with profit to herself."[9] On another occasion a student from the Art Students' Union class (p. 105) submitted a drawing from life, with Eakins' recommendation, as an entrance requirement for the Academy. No exception, the Board decided. It had to be a full figure from the antique. This rejected student was Francis Ziegler, later a pupil at the Philadelphia Art Students' League, and art critic for *The Philadelphia Record*. Eakins painted his portrait in about 1890 (CL-137, Fig. 82).

Eakins could do little as yet to change these practices. But he could at least do something with his own classes at night. Soon he became bumptious, and the Academy authorities, like proper Philadelphians, slapped him down. Life models had always been hired from houses of prostitution, and Eakins wanted to change that, thinking such a procedure was degrading and unworthy of the school:[10]

Gentlemen,

The Life Schools are in great need of good female models.

I desire that an advertisement similar to the following be inserted in the Public Ledger.

"Wanted Female Models for the Life Classes of the Pennsylvania Academy of the Fine Arts.

Apply to the Curator at the Academy Broad & Cherry at the Cherry St. entrance.

Applicants should be of respectability and may on all occasions be accompanied by their mothers or other female relatives. Terms $1 per hour.

<div align="center">

John Sartain
Chairman of Com. on Instruction"

</div>

The privilege of wearing a mask might also be conceded & advertised.

The publicity thus given in a reputable newspaper at the instance of an institution like the Academy will insure in these times a great number of applicants among whom will be found beautiful ones with forms fit to be studied.

The old plan was for the students or officers to visit low houses of prostitution & bargain with the inmates.

This course was degrading & would be unworthy of the present academy & its result was models coarse, flabby, ill formed & unfit in every way for the requirements of a school, nor was there sufficient change of models for the successful study of form.

<div align="center">

Thomas Eakins

</div>

Needless to say, no such advertisement ever graced the pages of the *Ledger* or any other Philadelphia newspaper. The directors referred the matter back to the Committee on Instruction, and John Sartain, the Committee Chairman, not unexpectedly felt that the proposal was too far out for the Philadelphia of the time—as it was, and still is.

William Sartain tells a story of his and Daniel Ridgeway Knight's going out into the streets to get a male model for the life classes. The man they found and brought back to the Academy did not know that he was expected to model in the nude, and when he was told of this, Sartain wrote, he "squared off" at them.

It got so unconventional in the evening life classes, thanks to Eakins, that on May 14, 1877, the directors decided that Schussele must not allow "any other person" (i.e., Eakins) to take over his duties, and that he must be personally present at all the evening classes. His palsy had gotten much worse, and to the point that he could not hold a brush steady. But sick or not, it was better to have a teacher who could not hold a brush than one who wielded it like a madman. So Eakins left the classes and set up his own school on March 30, 1877, in a Juniper Street building, under the aegis of the newly formed Philadelphia Society of Artists.

The Philadelphia Society of Artists was evidently organized for the purpose of giving Eakins a place to teach. The official name of the classes was the Art Students' Union, and through much of the winter of 1877–1878 a number of those who were dissatisfied with what the Academy was offering carried out "the Sketch Club class idea in a commodious room on Juniper Street, above Arch." [11] There had been only nine hours per week of daylight life classes at the Academy, and in the new school there were nine-to-twelve-o'clock classes three days a week, and one-to-four-o'clock classes every day, a total of twenty-four hours of life drawing a week. "All of these classes," the *Telegraph* reported, "are superintended by Mr. Eakins, who gives his services as

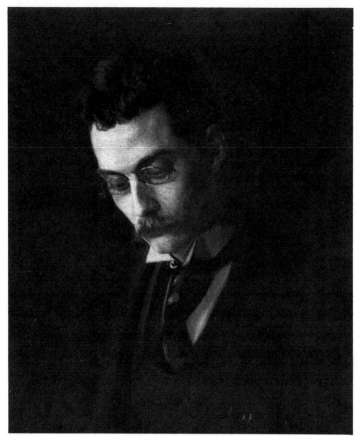

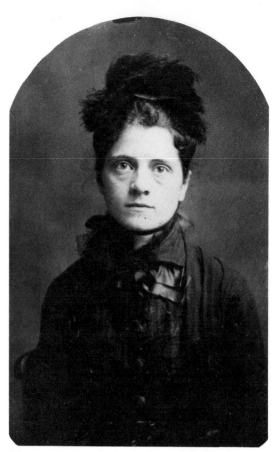

Fig. 82. *Portrait of Francis Ziegler*, c. 1890. Oil on canvas, 24″ × 20″ (60.9 × 50.8 cm). Fogg Art Museum, Cambridge, Massachusetts. Ziegler was a pupil of Eakins at the Art Students' League.

Fig. 83. Hannah Susan Macdowell, c. 1878. 3½″ × 2⅜″ (8.9 × 6 cm). Collection Walter Macdowell, Roanoke, Virginia. Tintype.

instructor gratuitously, as he did when superintending the Sketch Club classes and night classes . . . at the Academy." [12] There was a registration fee of two dollars, and for a dollar a week a student could go to as many classes as he wanted. Eakins' new students even went so far as to exhibit their works. On December 12, for example, they opened a show in Wilmington to, it must be said, something less than resounding public approbation. But that may have been Wilmington's fault.

Back at the Academy, dissatisfaction with the state of affairs was boiling, and it was not long before the directors themselves realized that something had to be done about Schussele—not his methods—they were safe and solid—but he couldn't teach because he was not physically able. Attendance in Schussele's life classes had fallen to a daily average of seven men and ten women. The other students were all over on Juniper Street. In an effort to make things better for the women at least, the morning life class was changed to seven thirty for those who went to work at nine. But that was too early, and anyway it did not give the girls enough time. They wanted more life study, and they got up a petition.

Their leader was a young woman named Hannah Susan Macdowell (Fig. 83) —or Susan Hannah Macdowell as she sometimes wrote it—who is said to have been inspired by Eakins' work when she saw *Portrait of Professor Gross*. Now she and seventeen others urged the Committee on Instruction to give them more life study: [13]

We desire to submit the enclosed petition for an additional life class. . . . Our desire in having this class, is to offer an additional opportunity of studying from life at a very convenient time, for those students whose private work prevents them from having the full benefit of the early morning class, added to this the great advantages to all the students of having more opportunity to study from the nude.

On presenting our petition to Mr. Claghorn we learned that Mr. Thomas Eakins has no longer a position as instructor in the Academy. We are sorry for this, as, his good work of last winter at the Academy, proved him to be an able instructor and a friend to all hard working students.

Professor Schussele's work at the Academy is already heavy. Therefore if this extra class be granted us we desire the privilege of inviting both Prof. Schussele and Mr. Eakins to overlook our work, using their own judgement as to the amount of instruction necessary.

We are earnest, and without any desire or intention of dictating, ask only, that whatever may be done by the Academy for the Students, will be in the direction of the life classes, which means of study, we understand to be the most important to those, who wish to make painting a profession

Very respectfully
Miss S. H. Macdowell
2016 Race Street
Philada.

Three days later the Academy directors, knowing that something must be done to keep its students interested, established an evening life class for women, "as might be recommended by Prof. Schussele after consultation with the ladies." [14] They would still have nothing of Thomas Eakins. He had dared to leave them, and now he could stew in his own juice.

He didn't stew there long. It may have been Fairman Rogers, after John Sartain resigned, who decided that things had gone on long enough. Academy pique was one thing, but the school was about to fall flat on its face because Eakins was not there. He asked Eakins to write to the board reminding them of their May 1877 decision to bar him from Schussele's classes and saying that Rogers had asked him to come back again. Eakins asked the board to give Schussele the necessary authority to ask Eakins' assistance. He would then, he wrote, "be happy to give him any assistance he may choose to avail himself of." [15] On March 11 the board rescinded its May 1877 resolution, and as of March 22, 1878, Eakins—and the Academy school—were back in business. He was still taking no salary, which probably was not the least reason the directors changed their minds. At the end of the term, when the school closed for July and August, they passed a resolution thanking Eakins for his "free services." [16] They also decided to cut out the perspective classes for the following term and use the money they saved for more life study. Eakins, helped by the progressive influence of Fairman Rogers, was turning the Academy about and forcing it reluctantly into modern times.

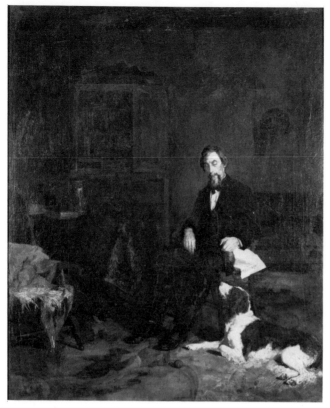

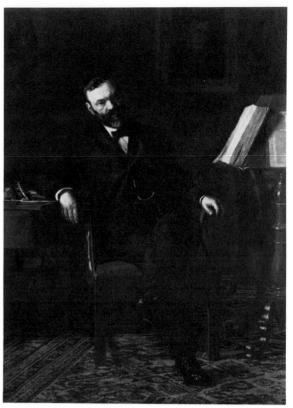

Fig. 84. Susan Macdowell: *Portrait of William H. Mac-dowell*, 1878. Oil on canvas, 22¼″ × 18″ (56.5 × 45.7 cm). Collection Mr. and Mrs. Francis Walters, Roanoke.

Fig. 85. *Portrait of Dr. John H. Brinton*, 1876. Oil on canvas, 78⅝″ × 57⅛″ (199.7 × 145.1 cm). Armed Forces Institute of Technology, Washington, D.C., on loan to the National Gallery.

The Academy archives meanwhile recorded another instance of Rogers' liberality. The Committee on Instruction questioned whether or not the female model should be required to "be covered" during their rest periods. After some discussion it was decided to leave the decision to each model, "with a preference for entirely dispensing with the mask and other covering." [17] The new spirit of the Academy was also reflected in a project the students organized for the 49th Annual, which opened on April 22, 1878. They designed and produced a six-page parody in French on the Academy's catalogue, reproducing, in caricature, several of the Annual's offerings, and adding a facetious line or two in French about them. Susan Macdowell's portrait of her father was among them (Fig. 84).

In this Annual Eakins had only a *Rail Bird Shooting*, which had been bought by a G. D. McCreary and which may have been the painting used for a *Scribner's* illustration, *Will Schuster and Black Man Going Shooting for Rail* (CL-14). But in the two years since the Gross travesty his muse had been far from somnolent. William Sartain had come back to Philadelphia from his study with Bonnat in Paris, and Eakins had painted him listening to Max Schmitt playing the zither, *The Zither Player*. This had been completed in early 1876, after work on *Portrait of Professor Gross* had been finished. It was a warm, cozy home scene, and now the artist did another like it—*The Chess Players* (CL-180, Plates 21, 22, 23) showing his father watching a game of chess

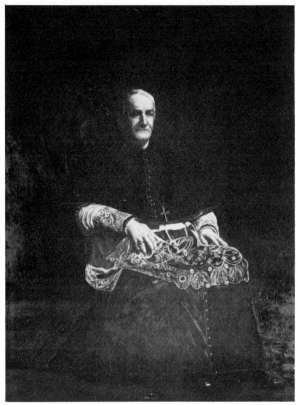

Fig. 86. *Portrait of Archbishop James Frederick Wood*, 1877. Oil on canvas, 82″ × 60″ (208.3 × 152.4 cm). St. Charles Borromeo Seminary, Overbrook, Pennsylvania.

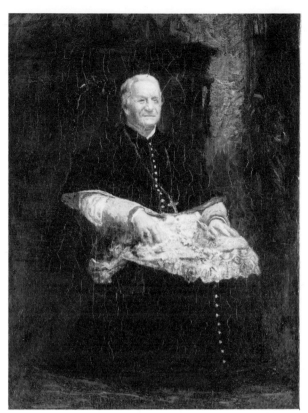

Fig. 88. *Study for Portait of Archbishop James Frederick Wood*, 1877. Oil on canvas, 16″ × 12⅛″ (36.8 × 25.7 cm). Yale University Art Gallery.

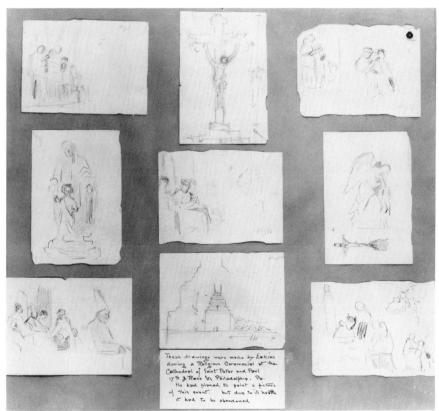

Fig. 87. *Sketches in Cathedral of SS. Peter and Paul, Philadelphia*, c. 1875. Pencil on paper, each sketch 3½″ × 5″ (8.9 × 12.7 cm). Hirshhorn Museum and Sculpture Garden, Smithsonian Institution.

Fig. 89. *The Brinton House, Chester County, Pennsylvania*, c. 1878. Oil on panel, 10½″ × 14½″ (26.7 × 36.8 cm). Private collection, Beirut, Lebanon. Painted from imagination. This house, much altered from this original, still stands near the road Eakins often took to visit his sister in Avondale, Pennsylvania.

Fig. 90. *Columbus in Prison*, c. 1876. Oil on canvas, 5⅝″ × 7¾″ (14.3 × 19.7 cm). Kennedy Galleries, New York. A study for a project never carried out.

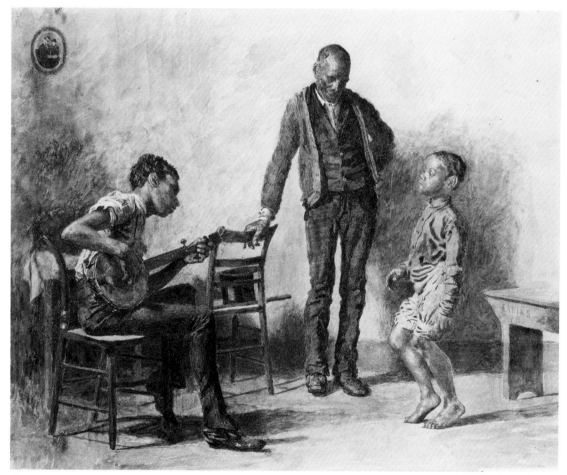

Fig. 91. *Negro Boy Dancing*, 1878. Watercolor on paper, 18⅛″ × 22⅝″ (46 × 57.5 cm). Metropolitan Museum of Art. This painting was titled *Study of Negroes* by the artist.

between Mr. Gardel, a French teacher, and George Holmes, an art teacher. He also posed his niece Ella Crowell, the two-year-old daughter of his sister Fanny, on the red brick of the side yard at 1729 Mt. Vernon Street (*Baby at Play*, Plate 20). In 1876 he also painted the portrait of another Jefferson professor, Dr. John H. Brinton (Fig. 85), and in the same year Archbishop James Frederick Wood (CL-328, Fig. 86), who had been installed as the first archbishop of Philadelphia in April 1875 and was having every artist in sight paint or sculpt him. Sketches in a church, likely the Cathedral of SS. Peter and Paul, may have been made during these ceremonies (CL-44, Fig. 87). It was a brilliant affair; the papal nuncios' arrival with the pallium was an event of considerable celebrity in Philadelphia. The Wood portrait has been disgracefully treated by the St. Charles Seminary authorities, who had charge of it for many years. It is in such bad condition, indeed, that a restoration is now thought to be impractical. A study for the work, fortunately, has been better kept (CL-15, Fig. 88), and from it we can see more of the artist's genius than we can in the finished portrait.

Perhaps during the time he was painting Brinton, or in 1878 when he painted Mrs. Brinton, Eakins did a particular favor for the couple. He painted, *from a description*, a painting of the Brinton house in Chester County (Fig. 89) as it was said to have been early in the eighteenth century. He also sketched *Columbus in Prison* (Fig. 90), but as with his *Hiawatha* venture, he got disgusted with it and never carried the idea out.

The Brinton and Wood portraits, along with *The Chess Players*, were shown at the Academy Annual in 1877, but they attracted little attention. *The Chess Players* was "admirably manipulated" but had "a tendency to blackness." *The Art Journal*, which made these remarks, thought the Wood portrait had unsatisfactory flesh painting, but thought the Brinton was, "in some important respects, the finest work that Mr. Eakins has yet executed. It is especially good in color." [18]

At the American Society of Painters in Water Color exhibition in New York in February 1878, Eakins showed *Study of Negroes* (CL-182, Fig. 91) and *Seventy Years Ago* (CL-160, Fig. 92), a project he had given his pupils and a theme to which he returned again and again—olden times. *Study of Negroes*, now at the Metropolitan and insured for $25,000, was offered for $250; *Seventy Years Ago*, now at the Princeton Museum and valued at $15,000, was offered for $150. The artist also produced several other paintings in this "olden times" genre at this stage of his life, among which is a watercolor of his sister Margaret.

It may have been the "olden times" theme that inspired Eakins' next great work after *Portrait of Professor Gross*. Or it may have been the Gross portrait that inspired the group of "olden times" pictures. In any case, at some point in 1876, after the Gross painting had been rejected, Eakins began work on his William Rush theme, and before a year had passed, presented to the public view *William Rush Carving His Allegorical Statue of the Schuylkill* (CL-250, Plate 24).[19]

Rush was a Philadelphia sculptor who produced a great deal of what Eakins believed to be elegant, refined work. Besides numerous figureheads for ships and other

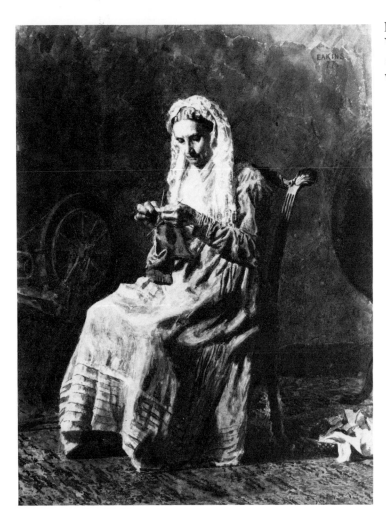

Fig. 92. *Seventy Years Ago*, 1877.
Watercolor on paper, 15⅝" × 11"
(39.7 × 27.9 cm). Princeton University Art Museum.

carvings, he had done the remarkable statue of Washington now in Independence Hall, and two allegorical wheelhouse figures representing the Schuylkill, all of which Eakins knew well. But he had also done, in 1809, an allegorical figure of a nymph carrying a bird on her shoulder—a bittern—from whose marble mouth water poured in a fountain. Rush had done this for Center Square in Philadelphia, but the figure was later moved to what was called the Forebay, in Fairmount Park. It has since decayed into oblivion, with only a bronze cast remaining. But the cast, now in the Philadelphia Museum (Fig. 93), was skillfully made when the original wooden figure was in good shape, so we can still see much of the beauty of Rush's original.

For his model Rush used Louisa Van Uxem, the daughter of a fellow civic leader. Miss Van Uxem, according to legend, was asked to pose nude, but this is not necessarily what happened. The scandal that was said to have been caused could certainly have been caused by the clinging Greek gown, which is revealing enough. The legend—of which Eakins was certainly aware—was that Rush was strongly condemned and suffered considerable ill-repute because of his audacity. Eakins, with *Portrait of Professor Gross* rejected, may have identified with Rush and was inspired to honor another Philadelphia martyr, perhaps to point out that he was not the first American —or Philadelphian—to work against convention.[20]

There are a number of preliminary, alternate, and corollary *Rush* works from

Fig. 93. William Rush: *Nymph of the Schuylkill.*
Bronze cast of wooden original (now lost)
made in 1809. Philadelphia Museum of Art.

Fig. 94. *Abandoned Version of William Rush Carving His Allegorical Statue of the Schuylkill*, 1876. Oil on canvas, 20″ × 24″ (50.8 × 60.9 cm). Collection Mr. and Mrs. James W. Fosburgh, New York.

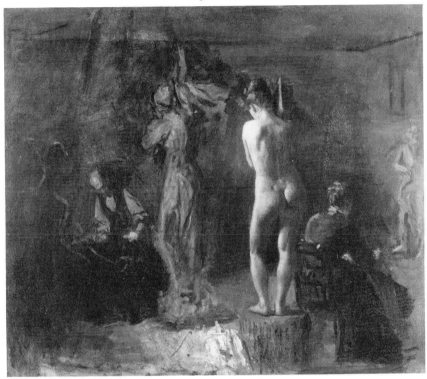

Fig. 95. *Study of Nude for an Abandoned Version of William Rush Carving His Allegorical Statue of the Schuylkill* (?), c. 1876. Oil on wood, 10⅜″ × 14⅝″ (26.4 × 31.1 cm). Collection Mr. and Mrs. Daniel Dietrich II, Philadelphia.

Fig. 96. *Plaster Casts of Wax Models for William Rush Carving His Allegorical Statue of the Schuylkill*, 1876. Left to right: *Head of Rush*, 7¼″ (18.4 cm); *Head of Nymph*, 7½″ (19.5 cm); *Washington*, 8½″ (21.6 cm); *Figure of Nymph*, 10½″ (26.7 cm); *The Schuylkill Harnessed*, 5½″ (14 cm). Philadelphia Museum of Art.

Eakins' hand. One of the more interesting is one he evidently abandoned (Fig. 94); another is of a nude that may or may not have been related to the *Rush* painting, but which nevertheless is an attractive study (Fig. 95). In preparation for the painting Eakins made wax models of the six principal figures. What has become of the model of the nymph is a mystery, but the other five wax models (CL-249) as well as plaster casts (Fig. 96) are in the Philadelphia Museum. Numerous plasters have been made, and the molds, which were sold at the estate sale in 1938, are still unlocated—so we have probably not seen the last of the *Rush* plasters.

Into the pink welter of Bouguereau, Alma-Tadema, and Sir Frederick Leighton, Eakins' *William Rush* nude burst like the proverbial bombshell. Nothing like it had been seen before in American art; little, as a matter of fact, has been seen to equal it since. Beside this nude, Vanderlyn's *Ariadne* is a peach-blossom *dolce far niente*. *The New York Times* thought the picture improper because the clothes had been thrown carelessly over the chair, implying that the model had undressed in front of Rush and mounted the model stand without going behind a screen to put on a wrap. The arrangement of clothes, which so distracted the *Times* critic, is, incidentally, a small masterpiece—moral consideration aside (Plate 25). Several critics thought Eakins' nude was ugly, and one said, "If belles have such faults as these to hide, we counsel them to hide them." [21]

Once more Clark, the critic of the *Evening Telegraph*, came forth to champion this new work of his friend and teacher: [22]

> Whatever difference of opinion there may be with regard to the relative merits and demerits of other performances it is certain that, considering it simply as a specimen of workmanship, there is not a picture in the display at Kurtz's that is at all up to the high standard of Mr. Thomas Eakins' *William Rush Carving His Allegorical Statue of the Schuylkill*. This represents the interior of Rush's shop, with the artist hard at work putting the

finishing touches upon the beautiful statue which all Philadelphians know so well. His model is posing for him with a large book on her shoulder to aid in enabling her to keep the exact position required, while at her side is an elderly woman engaged in knitting and in preserving the proprieties. The comments made on the picture are curious and amusing. One person objects to the subject; another allows the subject, but thinks that the artist might, with advantage, have treated it in a different manner; a third admits that the workmanship is clever, very clever, but suggests that it lacks refinement; a fourth concedes the refinement, but disputes the color-quality; and so on, and so forth. The substantial fact is that the drawing of the figure in the picture—using the word drawing in its broadest sense to indicate all that goes to the rendering of forms by means of pigments on a flat surface—is exquisitely refined and exquisitely truthful, and it is so admitted by all who do not permit their judgement to be clouded by prejudices and theories about what art might, could, would, and should be were it something else than, in its essence, an interpretation of nature, and of an order of ideas that must find expression through the agency of the facts of nature if they are to find any adequate expression. The best comment on this picture was that made by a leading landscape artist of the old school, and who, being of the old school, certainly had no prejudices in favor of works of this kind. This was that he had not believed there was a man outside of Paris, certainly not one in America, who could do painting of the human figure like this.

In the few years from 1875 to 1877 Eakins had done genre works better than any before him and a portrait that is still at the summit of American art. And now, in his *William Rush* nude, he had produced one of America's finest figure studies. Two years later, in *A May Morning in the Park* (Plate 26), he would master yet another challenge—the problem of showing rapid motion.

But first he became involved in another portrait project, one that was only less frustrating than the Gross imbroglio because it was less significant. But the sitter was the most conspicuous man in America, and Eakins' portrait, now lost to posterity, became the center of another swirl of controversy for political as well as artistic reasons.[23]

In June 1877 various members of the Union League of Philadelphia decided they wanted a portrait of their Republican hero, Rutherford Birchard Hayes, then in the White House—contrary to the wishes of a substantial majority of the American people. They cast about them and came up with Eakins as the recent painter of Archbishop Wood, Dr. Brinton, *et al.* And although they must have known of the Gross portrait and were as disturbed by it as anyone else, they probably thought that Eakins would behave himself in painting the President of the United States. Besides, they wanted him to paint the portrait from a photograph, so how could things go wrong?

They reckoned ill. Eakins would have none of this plan and, in what most thought of as his importuning way, insisted on Hayes sitting for him:[24]

It may at first sight seem ill befitting me to commence offering suggestions

to those who have just gratified me so by their choice of me to paint the president, but I would neverthless ask of you to represent to Col. Bell and your Committee one of my ideas with the excuse that I am even more anxious than they for the success of my portrait.

I do not intend to use any photographs but the president must give me all the sittings I require. I will take a chance to watch him and learn his ways and movements and his disposition.

If I find him pressed or impatient, or judge that he can ill afford a great number of sittings, I would like to confine myself to the head only, painting it with the greatest care, and this I could finish during a few hours in a week's time.

If he is disposed, however, for full-sized portrait similar to the Dr. Brinton composition, I would undertake it with equal spirit, but of myself I would not select the size you mentioned. A hand takes as long to paint as a head nearly, and a man's hand no more looks like another man's hand than his head like another's, and so if the president chose to give me the time necessary to copy his head and then each of his two hands (for I would not be induced to slight them), then it would seem a pity not to have the rest of him when I know how to paint the whole figure. The price in either case can remain the same as you mentioned. In comparison with the importance of the work, the money and time do not count.

So I would beg your influence with the gentlemen to urge postponement of the question of size only, until I can get acquainted with the president himself, and then I would want to consult with them before commencing. I wish very much to make them a picture which may do me credit in my city and which if I may be allowed to exhibit in France may not lessen the esteem I have gained there.

But Hayes had little time, and reminded Eakins that another "eminent" artist had done a fine job in just a few minutes. The result was that Eakins, to use his own shattering words, had to construct Hayes as he would "a small animal" (p. 69). While he was sitting in the stifling heat of the President's reception room (now the private dining room) waiting for Hayes to give him a few minutes, he turned to Lafayette Park outside the window and sketched it. This is the only tangible result we have of the Hayes project (CL-251, Fig. 97). The portrait has since been lost, perhaps burned or destroyed, through carelessness or intent.

When the portrait got back to Philadelphia, and before its brief career on the august walls of the Union League, it was shown at Haseltine's. Clark, the *Telegraph* critic, thought it "one of the most severely literal works" that Eakins had yet done: [25]

Eakins' Portrait of President Hayes.
Mr. Thomas Eakins' portrait of President Hayes—painted for the Union League—is now on exhibition at Haseltine's galleries, No. 1125 Chestnut Street. The pre-eminently realistic qualities of Mr. Eakins' art are well known, and this portrait is one of the most severely literal works that he has yet produced. . . . This portrait gives a very different idea of the President

Fig. 97. *Sketch of Lafayette Park, Washington*, 1877. Oil on wood, 10½″×
14½″ (26.7 × 36.7 cm). Philadelphia Museum of Art. Eakins made this sketch from a north window of what is now the family dining room of the White House while he was waiting for President Hayes to pose for his portrait. In the center is Clark Mills's statue of Andrew Jackson; at the right is Latrobe's St. John's Church.

from that given by any of the photographs of him or by any of the painted portraits that have yet come under our notice. . . .

This portrait was painted last summer, just after the President had returned from his Southern trip. The artist originally intended to make a full-length, but was unable to obtain the necessary sittings, and the work at present under consideration was painted with the expectation that opportunities in the future would be afforded for the execution of a larger work. While it is complete in itself, it is also a preliminary study, and the fact that it is a preliminary study accounts for the rather awkward introduction of the right arm and hand—the only feature of the work that calls for unfavorable criticism. The President is represented as seated, in an easy and unconstrained attitude, at his office table, but the pose is such a peculiar one that it needs a larger canvas than the one adopted to account for it. In a full length, what now appears awkward in the picture would be easy, natural, and obvious. . . . Mr. Hayes has been very badly maltreated by the portrait-makers of all orders and degrees, and there is some satisfaction in seeing at least one truthful likeness of him from the hand of a thoroughly honest and thoroughly competent artist . . . there is certainly nothing of the mock-heroic in this representation of the President in his old alpaca office coat, with the stump of a lead pencil in his fingers, and with his sunburned face glistening with summer perspiration; there is, however, that which is of a good deal more worth.

Clark did not mention, however, if indeed he perceived it, what the real trouble was with Eakins' work. Two months later he still did not see the trouble—or if he did, he kept quiet about it.

But it all came out when the painting was hung at the Union League. Hayes had been elected with the considerable help of the teetotalers of America. His wife was even called "Lemonade Lucy," and with a single exception, when the Grand Duke Alexis visited the White House, not even wine was served. On that occasion it had taken the intervention of the Secretary of State to effect the presence of a bottle

or two. Russo-American relations were being threatened, he said.

It must be remembered that the heat in Washington the previous August, when Eakins' portrait was done, averaged 74 degrees day and night, and during the day not the least little breeze could have penetrated the Victorian stuffiness of the Presidential office. As a result, Hayes was red-faced and he was made to *look* red-faced. But it didn't look like heat to his admirers at the League, and it was not long before the portrait disappeared—gone, finally, to the White House basement, never to be heard of again. The *Press* quoted *The Delaware County Republican* about the matter, not wanting to get involved itself: [26]

> The Union League of Philadelphia has recently hung on its walls a portrait of President Hayes, which represents him with a rubicund countenance far removed from that supposed to characterize a temperant, not to say a temperance man. As such a "counterfeit presentment" is likely to create erroneous impressions, prejudicial to our Chief Magistrate, it is hoped that it will be either removed or "turned to the wall," at the earliest possible moment.

Years later, when Eakins and his wife walked by the League, Mrs. Eakins went in to inquire about the portrait. She wrote later that she was sorry she had done so, for Eakins was not well, and the news that nobody knew anything about his picture upset him.

In 1912 or 1913 Eakins painted another portrait of Hayes (Fig. 299), and this time, of necessity, he did use a photograph, Hayes having died many years before. It is not the artist's best work, but it is also not his worst, and his worst is often better than the best of others.

Late in 1878 another project loomed. The photographer Eadweard Muybridge, later to be called "the Father of the Motion Picture," had been pursuing his experiments in the photography of rapid motion in California. He had achieved amazing results and published and sold hundreds of cabinet-size series photographs of various gaits of the horse. Eakins and Fairman Rogers had seen these and were fascinated by them. "Professor Eakins, what about taking my four-in-hand carriage and painting it in motion, so that everyone can see what motion really is, instead of what it's supposed to be?" Early the next year Eakins began to work on this project, and before the year was out had managed to set the artistic world on its ear once again with another consummate work, *A May Morning in the Park* (CL-260, Plates 26 and 27) often called *The Fairman Rogers Four-in-hand*.[27]

What he had done, *The Philadelphia Daily Times* thought, was "impossible to accept as true, unless it be that Mr. Eakins' perceptions are right and those of everybody else are wrong." [28] The point is, of course, that the artist was not concerned with his "perceptions"; he was concerned with nature, which he saw in Muybridge's photographs. Nature had been so obscured by generations of artists that she could not be recognized when Eakins unveiled her in his painting.

In *A May Morning in the Park* Eakins also unveiled a paradox. Three of the horses are trotting, as they would be doing in life. But the fourth, the near-wheeler—the horse at the right in the painting—is walking. This is obviously impossible: a walking horse, hitched to three trotters, would quickly be forced to a trot as well. And Eakins knew, from Muybridge's photographs, that he was painting a walker. Why did he do it? Eakins never explained, nor can we. Perhaps he felt that no one would notice and intended it as a private joke.

The *Evening Bulletin* thought "the spirit of swift motion was admirably caught," and that the painting was "one of the gems of the collection so far as good painting is concerned."[29] But the *North American* and the *Press*, although expressing admiration for the skill which produced *A May Morning in the Park*, made an interesting moot point. This is how motion really is, but do we want to see it as it is? Do we not rather want to see what *looks* like rapid motion?

The *Press* reporter stated the proposition as well as any other:[30]

> Mr. Eakins is a builder on the bed-rock of sincerity, and an all-sacrificing seeker after the truth, but his search is that of a scientist, not of an artist. . . . As an example, to make this meaning plainer, let us consider Mr. Eakins as a student of the figure, the highest walk of study an artist can enter upon.

Fig. 98. *Study of Off-Lead Horse for A May Morning in the Park*, 1879. Oil on wood, 13½″ × 9⅝″ (43.3 × 24.4 cm). Hirshhorn Museum and Sculpture Garden, Smithsonian Institution. This is probably Rogers' favorite mare, Josephine.

In this walk he has advanced further than any other man in America. . . . He has acquired this knowledge and skill by arduous study, study not confined to outward phenomena, but dealing with constituents, from the skeleton to the skin . . . But suppose these studies, instead of being held as means, become an end, knowledge being pursued for its own sake? Then such pursuit may develop a good demonstrator of anatomy, but never an artist.

No. 349, a drag and four-in-hand, with figures, is simply a puzzle to an ordinary observer. . . . The instantaneous photograph has demonstrated that with all our looking at horses we have never seen how they move their feet, and in view of this discovery Mr. Eakins has formulated certain theories, mathematical and anatomical, which this work purports to illustrate. As a mechanical experiment it may be a success; on that point we express no judgment, but as to the matter of framing the experiment, hanging it in a picture gallery, and calling it A Spring Morning in the Park, we have to express a judgment decidedly adverse.

Eakins gets the same criticism today. He is "too scientific," "too literal," "too unimaginative." But it is still a matter of taste and, to me, sophistication. What is scientific or literal for some is truth for others; and what seems unimaginative is really quite the opposite—the highest level of imagination.

$$8$$

In Charge at the Academy
1879-1886

A$_T$ ONE FIFTEEN on the morning of August 21, 1879, Christian Schussele died at the age of fifty-five. The next day the Academy board of directors held a special meeting and resolved, among other things, that Schussele's "character and gentleness of manner endeared him to all." [1] And whatever may be said of his conservatism in teaching, considering the loyalty Schussele inspired among his students—particularly Eakins—this was not an empty tribute.

Every young person at the Academy who had anything to do with Schussele must have felt frustrated at his rigidity; everyone was made to draw endlessly from antique casts before being allowed to draw from life. And some of the board realized that he was too ill to teach properly. Fairman Rogers himself had written the previous October: [2]

> Much as I like Mr. Schussele personally and much as I value his knowledge
> of the subjects that he teaches I cannot help seeing that he requires some one
> in his place who is physically able to attend to a general technical supervision
> of the schools which is in my opinion all that we require or can afford to have
> at present.

Three months later, in January 1879, one of the directors suggested that they

try to get a friend of Schussele to persuade him to quit. "The Committee," the *Minutes* read, "engaged to try."[3]

Although Eakins was impatient with what he thought was a great waste of his own time and talent, as well as the time and talent of the students, he was still unwilling to urge Schussele's removal, palsy or not. And Schussele's illness, coming on top of the fact that he was very modestly situated financially, something his $1200-a-year salary did little to alleviate, made the problems more difficult. There had been a benefit sale of donated paintings for Schussele the previous year. On August 21, 1879, however, the Lord managed the affair. Emily Sartain, who had been a pupil of Schussele (and who agreed with him that Gérôme was a poor teacher), wrote the obituary for the *Inquirer*. She also gave a brief résumé of his career, and her father, John, a plug or two:[4]

> Christian Schussele was born at Guebvillers, Haut-Rhin, Alsace (then a French province), in the year 1826*. At the age of fifteen he began the study of lithography at Strasburg, and at seventeen went up to Paris, where he studied painting under Adolphe Yvon—himself a pupil of Delaroche and a grand medalist. Four years later, in 1847, he came to America, selecting Philadelphia as his home. Here he painted his first American picture, "Clear the Track," a coasting scene, now in the possession of Mr. James L. Claghorn. This work was engraved for the long since defunct Art Union of Philadelphia. Orders flowed in upon him. Among his many productions during the ensuing twenty-five years may be mentioned: "The Iron Worker and King Solomon," painted to the order of the late Joseph Harrison, Jr., and now in the Harrison collection, engraved: "Franklin before the Lords in Council," engraved by Whitechurch; "Zeisbarger Preaching to the Indians," painted to the order of and owned by the Moravian Society of Bethlehem; "The Dying Soldier," an episode of Gettysburg, now in the Baird collection; "Morton before Claverhouse," some time in the possession of Mr. James S. Martin; "Men of Progress," a group of inventors, well known by the fine engraving by Mr. John Sartain; "Queen Esther Denouncing Haman," and "An Alsatian Fair." The two last named are in the possession of the Academy of the Fine Arts—the Alsatian fair scene being one of the artist's latest as well as one of his best works.
>
> In the year 1868 Mr. Schussele was elected to the Professorship of Drawing and Painting in the Academy of the Fine Arts. Trained under a great French artist, possessing naturally a singularly true artistic taste combined with exceptionally acute powers of criticism and direction and, above all, being of a most gentle, generous disposition, he was rarely well fitted for the discharge of the responsible duties to which he was called. Than Professor Schussele, never has a preceptor been more sincerely respected or held more warmly in affectionate regard, and by all who have been his pupils—either privately in his studio or at the Academy—his death will be mourned as that of a most helpful and patient master, who was also a dear friend.

The Academy students met *en masse* on August 25 and adopted a resolution of

* There is a difference of opinion as to whether Schussele was born in 1824 or 1826.

appreciation, and on September 3, with the opening of school approaching, the Committee on Instruction met and appointed Eakins "Professor of Drawing and Painting," at a salary of $600, half that of Schussele's. He was to take charge of the Life and Antique classes, and he was given a leave of absence during the month of September, with William Sartain substituting for him for that month. The purpose of this leave was probably so that he could go up to Newport with his superior at the Academy, Fairman Rogers, stay at Rogers' magnificent Tudor revival house, and complete his preliminary work on *A May Morning in the Park*. He had been there in June, but had not had time to do all the work. He might have wanted to put the four-in-hand in a Newport setting—such a study exists (CL-258)—and he also had to paint Mrs. Rogers and a relative or two on the top of the coach.

John Sartain had resigned from the Academy board some time earlier, because, he wrote, not enough voice was given artists in the running of the place. This was a noble reason, but whether or not it was true, he and Eakins had been at odds for some time, particularly since the Gross episode. William Sartain was now more or less on Eakins' side, and his autobiography is filled with the greatest scorn for his father and the penurious and arbitrary way the Sartain house was run.

About this time Eakins became attached to Hannah Susan Macdowell, the student who had petitioned for his reinstatement at the Academy the year before. At the height of the controversy at the Academy about the hanging of *Portrait of Professor Gross*, on April 6, 1879, Kathrin Crowell, who was said to have been Eakins' fiancée, died of meningitis. Now it was to Susan Macdowell that Eakins wrote of his jubilation about the Academy job: [5]

> Dear Sue,
> I am just going off to Newport. I learned this morning that the Directors on the recommendation of the Committee on Instruction have appointed me

Fig. 99. Eakins at Manasquan, New Jersey, c. 1880. 3⅞″ × 2¼″ (9.9 × 5.8 cm). Metropolitan Museum of Art.

Professor of Drawing and Painting. They did this last night & Mr Rogers wanted me to wait here so as to give the first lesson. I found 4 antique fellows whom I instructed & introduced to Billy Sartain whom I substitute till I come back.

When old Sartain learns not only that I have the place, but that the other young firebrand Billy is keeping it for me, I fear his rage may bring on a fit.

I hope you are all well and having a mighty good time.

Thomas Eakins.

The Macdowells, possibly, were having their "mighty good time" at Manasquan on the Jersey shore, where they had been the summer before and where they were to be the following summer (Fig. 99).

When Eakins got back to Philadelphia, he found that eighty-three new students had registered, a substantial increase over the previous term. Now their mentor was at the top of his profession in Philadelphia. The Establishment had put its imprimatur upon him, and he was a principal spokesman for art matters of any variety—*Portrait of Professor Gross* notwithstanding.

The Academy school was the most famous in the country, and that distinction was confirmed for it in a *Scribner's Magazine* article in September 1879. (*Scribner's* had hired Eakins to illustrate an article of the preceding June [CL-172, Fig. 100], and in the same issue had berated him for the unnecessary horror of the Gross picture.) The magazine originally planned two articles on the Academy and its methods. But this project was abandoned, and William C. Brownell—who was probably responsible for the idea in the first place—wrote a single piece.

Brownell's article was illustrated by ten black-and-white oils by students of the

Fig. 100. *Illustration for "Mr. Neelus Peeler's Conditions," Scribner's Magazine*, June 1879. Ink wash and Chinese white on paper, 11″ × 16½″ (27.9 × 41.9 cm). Brooklyn Museum.

Academy. Nine of these showed various school activities—life sketching (Fig. 101), Dr. W. W. Keen's anatomy lecture, and so on. The tenth painting was by Susan Macdowell (see Fig. 84), the same painting that was caricatured in the 1878 burlesque, evidently considered among the best examples of Academy students' work. It is possible that Eakins, the man who was largely responsible for choosing the illustrations and the students to do them, was somewhat biased in favor of Susan Macdowell. It is, in any case, an excellent painting.

The students were paid a small sum for their work—so small, in fact, that Fairman Rogers thought that the fee covered only the use of the illustrations, not the purchase price. All the paintings ended up at the Academy, where, with the exception of two, they can be seen to this day. It was agreed that one of these two was *Scribner*'s property; the other was Susan Macdowell's painting, which she kept for herself. Alice Barber's painting of the women's life class, one of the best of the group, shows both Miss Barber and Susan Macdowell (Fig. 102). Alice Barber later married Charles Stephens, one of Eakins' opponents in the Academy rift in 1886, and she became a well-known illustrator. Some of her work is scarcely distinguishable from Eakins'.

Brownell began the *Scribner*'s article [6] by saying that although Philadelphia had remarkable art collections and a fine tradition involving such men as Stuart, West, and the Peales, the city was nevertheless somewhat provincial when it came to art. "Its 'leading men,'" he wrote, "manage everything." In New York the artists managed things, but in Philadelphia it was these "leading men." They were enthusiastic about their calling, and they paid "for their enthusiasm, liberally, and without the least grumbling at the price." They provided the most elaborate art school in America, or anywhere else, but permitted no outsider to meddle. It was their Academy and must be left well enough alone.

When the article was written, Schussele was still in official charge. But when it appeared in September 1879 he was dead. So Brownell's remarks about the contrast between Schussele and Eakins were especially timely. "Professor Schussele, who is conservative, prefers a long apprenticeship in drawing. . . . He insists on a long preliminary study of the antique. Mr. Eakins, who is radical, prefers that the pupil should paint at once, and he thinks a long study of the antique detrimental." "Don't you think a student should know how to draw before beginning to color?" Brownell asked Eakins in an interview for the article. "I think he should learn to draw with color," was the reply.

The article pointed out that dissection classes were a regular part of the Academy curriculum, and that nowhere else in the United States was this true. Although the Art Students' League in New York had lectures on anatomy, not even at the École des Beaux Arts, where Eakins had been taught, were there classes in dissection. Students were encouraged to do this work themselves, and some of them did, in hospitals and slaughterhouses. But there was nothing of the sort within the walls of the École. Eakins at the Academy, on the other hand, conducted regular dissections and took his students

Fig. 101. Walter M. Dunk: *The Men's Life Class*, 1879. Oil on cardboard, 10¼" × 12¾" (26 × 32.4 cm). Pennsylvania Academy of the Fine Arts. This painting, along with Figs. 102, 103, and 104, were used for illustrations in *Scribner's Magazine*, September 1879.

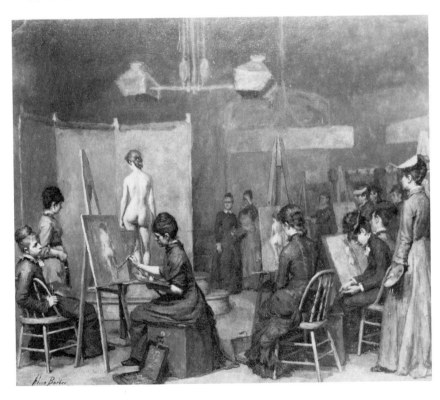

Fig. 102. Alice Barber: *The Ladies' Life Class*, 1879. Oil on cardboard, 12" × 14" (30.5 × 35.6 cm). Pennsylvania Academy of the Fine Arts.

to slaughterhouses where they dissected animals on the spot. One of the *Scribner* illustrations, by Eakins' old-time classmate Charles Fussell, showed them doing this (Fig. 103).

Brownell asked Eakins: "Don't you find this sort of thing repulsive? At least, do not some of the pupils dislike it at first?" "I don't know anyone who doesn't dislike it," Eakins answered. "Every fall, for my own part, I feel great reluctance to begin it." Brownell then asked if he was not afraid that such scientific work would affect the students' work, that it would make their painting more "scientific" than "aes-

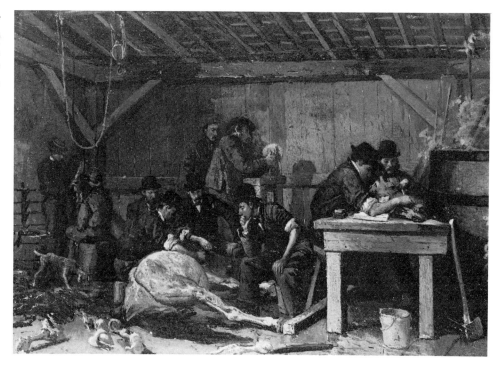

Fig. 103. Charles Fussell: *Academy Students Dissecting a Horse*, 1879. Oil on cardboard, 7¼″ × 10¼″ (18.4 × 26 cm). Pennsylvania Academy of the Fine Arts.

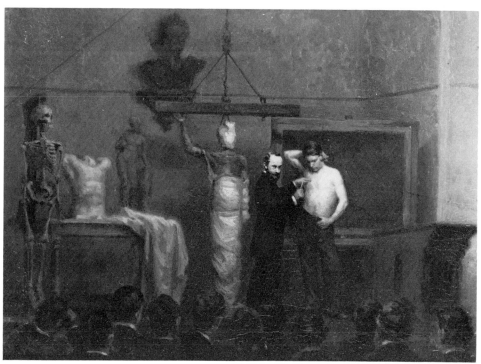

Fig. 104. Charles H. Stephens: *Anatomical Lecture by Dr. Keen*, 1879. Oil on cardboard, 8¾″ × 11″ (22.2 × 27.9 cm). Pennsylvania Academy of the Fine Arts.

thetic." "No," replied Mr. Eakins, smiling, "we turn out no physicians and surgeons. And about the philosophy of aesthetics, to be sure, we do not greatly concern ourselves, but we are considerably concerned about learning to paint!" "But the atmosphere of the place, the hideousness of the objects!" Brownell rejoined. "I can't fancy anything more utterly—utterly—inartistic." Eakins' reply is a classic:

> Well, that's true enough. We should hardly defend it as a quickener of the aesthetic spirit, though there is a sense in which a study of the human organism is just that. If beauty resides in fitness to any extent, what can be more

beautiful than this skeleton, or the perception with which means and ends are reciprocally adapted to each other? But no one dissects to quicken his eye for, or his delight in, beauty. He dissects simply to increase his knowledge of how beautiful objects are put together to the end that he may be able to im tate them. . . .

"Do you imagine that the pupil will be able to draw a leg better for knowing all that?" I asked Mr. Eakins.

"Knowing all that will enable him to observe more closely, and the closer his observation is the better his drawing will be," he returned; and the whole point of such instruction is there.

Then Brownell described the "artistic anatomy" lectures of Dr. W. W. Keen. A skeleton, a cadaver—hung by a truss suspended from the ceiling—and a living model were placed side by side on the platform of the Academy lecture room (Fig. 104). Movements were demonstrated, and "in less than two hours every pupil probably knows as much about the leg as will be of service to him in drawing and painting it."

"It quite takes one's breath away, does it not? Exhaustive is a faint word by which to characterize such a course of instruction." But Brownell went on to say that what may be all right for Eakins and his students would not be all right for such painters as LaFarge and Corot.

Not only male students were involved in dissection. Elizabeth Macdowell, a strong-willed, talented girl who would become Eakins' sister-in-law, was avid for it (Fig. 105). An interesting letter survives in which she asks Eakins what can be done about the fact that after the boys had gotten through with a cadaver everything left had dried up: [7]

Fig. 105. Eakins' photograph of Elizabeth Macdowell, Mrs. Eakins' sister, c. 1880. 8¾" × 6½" (22.3 × 16.5 cm). Metropolitan Museum of Art.

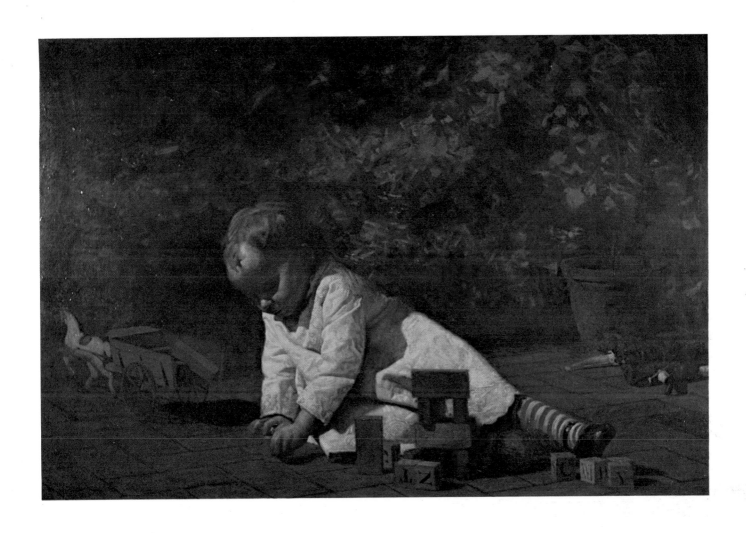

Plate 20. *Baby at Play* (detail), 1876. Oil on canvas, 32¼″ × 48″ (81.9 × 121.9 cm). Collection John Hay Whitney, New York. Ella Crowell, Frances's daughter, in side yard of 1729 Mt. Vernon Street, Philadelphia.

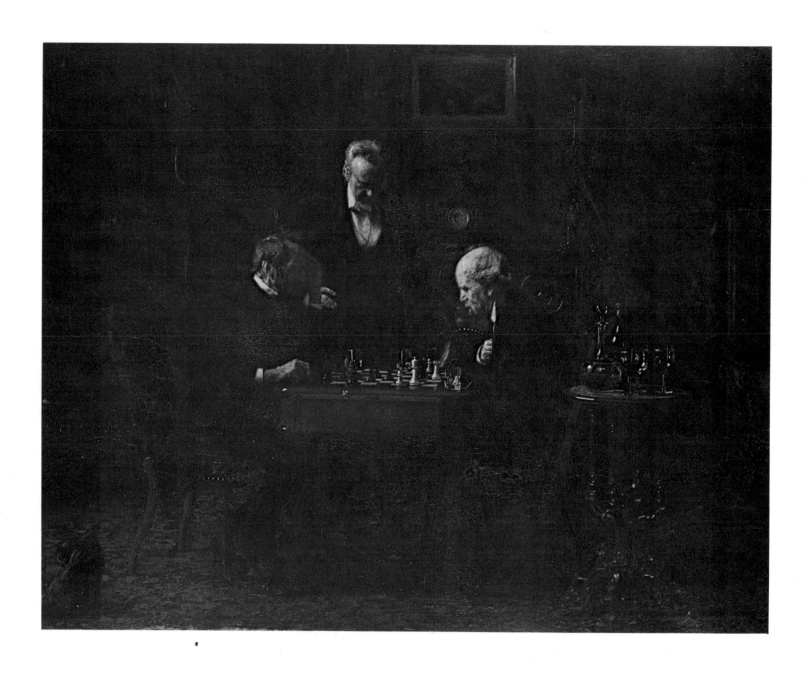

Plate 21 (above). *The Chess Players*, 1876. Oil on panel, 11¾" × 16¾" (29.9 × 42.5 cm). Metropolitan Museum of Art. Left to right: Bertrand Gardel, Benjamin Eakins, George Holmes.

Plates 22 and 23 (opposite). *The Chess Players* (details).

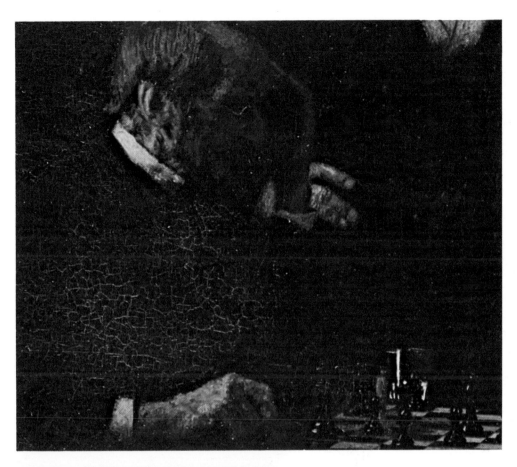

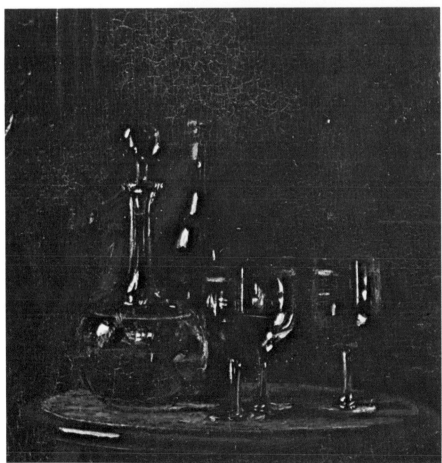

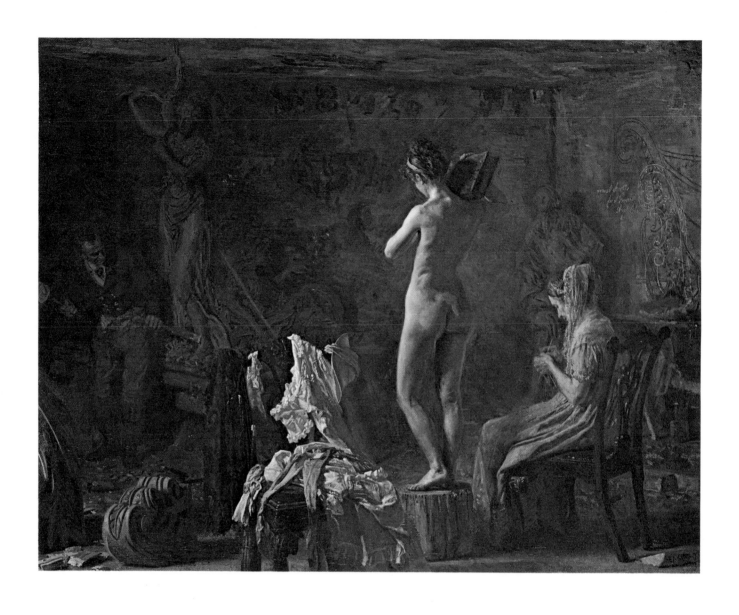

Plate 24 (above). *William Rush Carving His Allegorical Statue of the Schuylkill*, 1877. Oil on canvas, 20⅛″ × 26⅛″ (51.1 × 66.3 cm). Philadelphia Museum of Art.

Plate 25 (opposite). *William Rush Carving His Allegorical Statue of the Schuylkill* (detail).

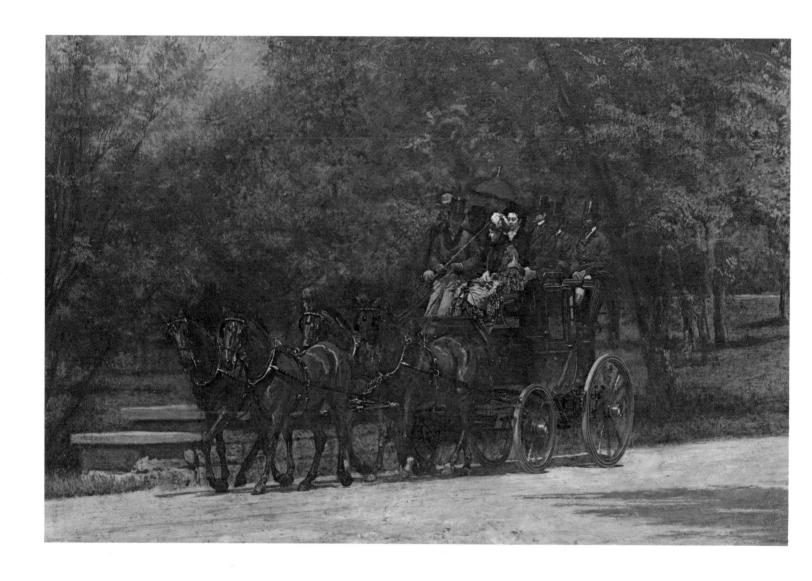

Plate 26 (above). *A May Morning in the Park (The Fairman Rogers Four-in-Hand)*, 1879. Oil on canvas, 24″ × 36″ (60.9 × 91.4 cm). Philadelphia Museum of Art. The first known time in the history of art that animals in rapid motion were shown as they actually move—not as they were believed to move.

Plate 27 (opposite). *A May Morning in the Park* (detail). Left to right: George Gilpin, Mrs. Rogers' brother; Fairman Rogers; Mrs. George Gilpin; Mrs. Fairman Rogers; Mrs. Franklin A. Dick, Mrs. Rogers' sister; Franklin A. Dick; grooms.

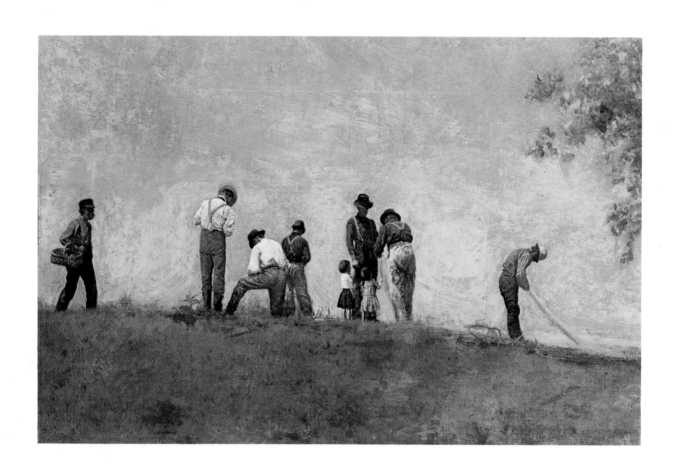

Plate 28. *Mending the Net* (detail), 1881. Oil on canvas, 32″ × 45″ (81.3 × 114.3 cm). Philadelphia Museum of Art. (See Fig. 119 for complete painting.)

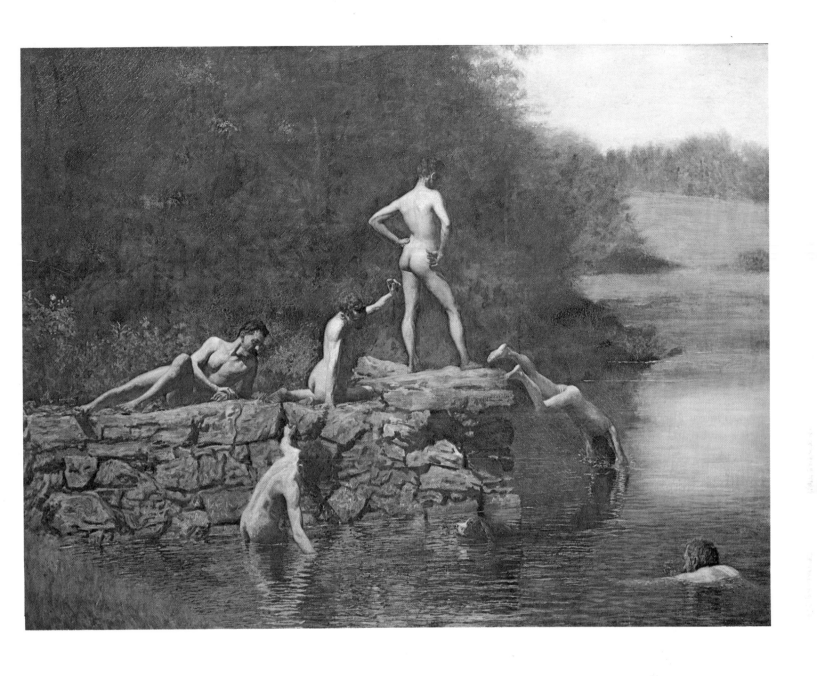

Plate 29. *The Swimming Hole*, 1883–1885. Oil on canvas, 27″ × 36″ (68.6 × 91.4 cm). Fort Worth Art Center.

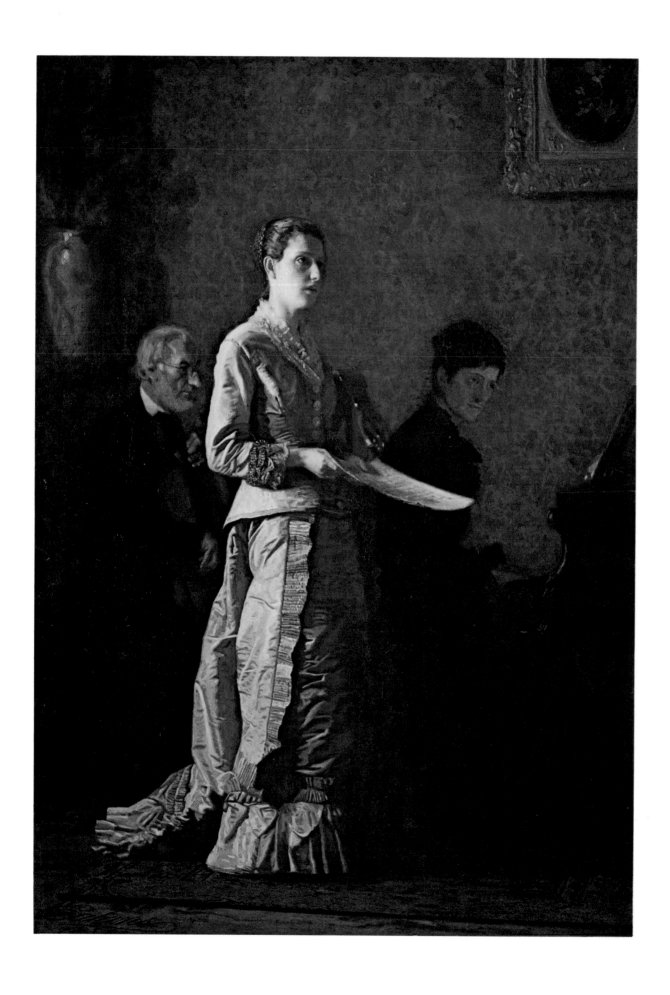

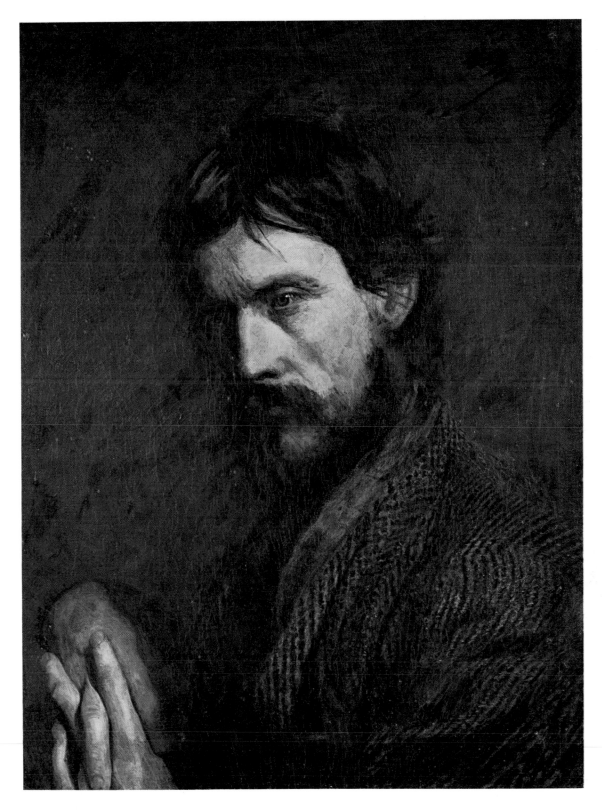

Plate 31 (above). *The Veteran*, c. 1884. Oil on canvas, 22¼″ × 15″ (56.5 × 38.2 cm). Yale University Art Gallery. George Reynolds, a pupil of Eakins.

Plate 30 (opposite). *The Pathetic Song*, 1881. Oil on canvas, 45″ × 32¼″ (114.3 × 82.6 cm). Corcoran Gallery of Art, Washington, D.C. Left to right: Mr. Stolte, Margaret A. Harrison, Susan Macdowell.

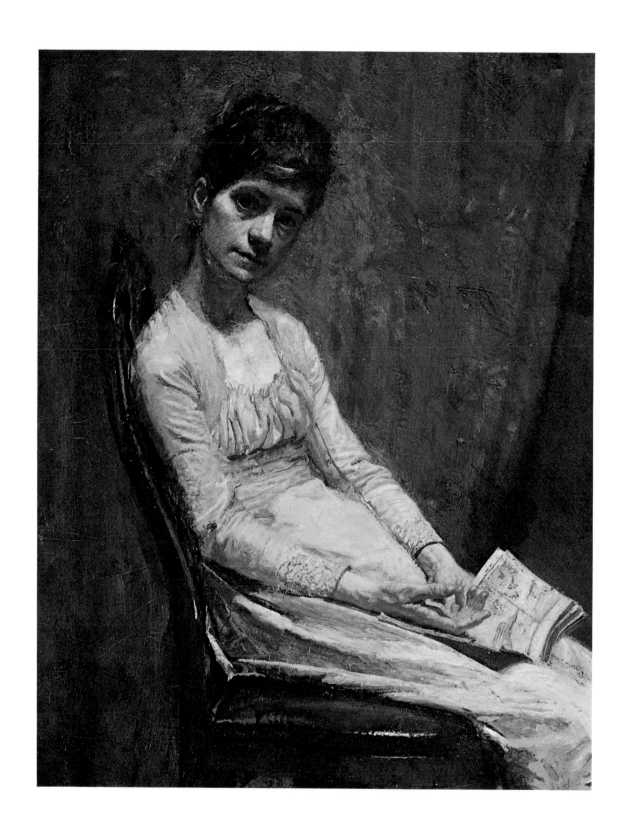

Plate 32. *Lady with a Setter Dog* (detail), 1885. Oil on canvas, 30″ × 23″ (76.2 × 58.4 cm). Metropolitan Museum of Art. Mrs. Thomas Eakins and Harry.

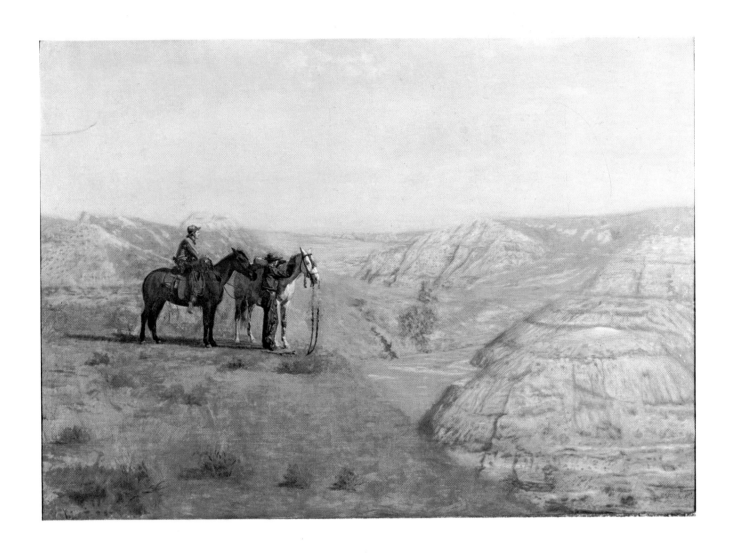

Plate 33. *Cowboys in the Badlands*, 1888. Oil on canvas, 32¼″ × 45″ (82.6 × 114.3 cm). Private collection.

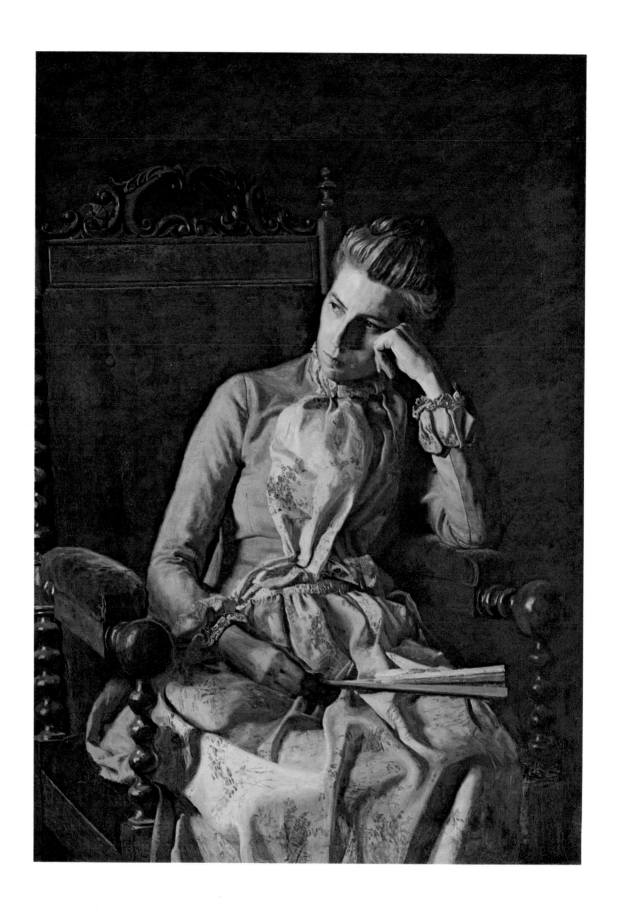

Plate 34 (above). *Portrait of Amelia Van Buren*, c. 1891. Oil on canvas, 45″ × 32″ (114.3 × 81.3 cm). Phillips Collection, Washington, D.C.

Plate 36 (opposite). Death mask of Walt Whitman, 1892. Plaster, 15½″ × 5″ (39.4 × 14 cm). Houghton Library, Harvard University. This was essentially Murray's work, done with Eakins' advice.

Plate 35 (opposite). *Portrait of Amelia Van Buren* (detail).

Plate 37 (above). *Portrait of Franklin Schenck*, c. 1890. Oil on canvas, 24″ × 20″ (60.9 × 50.8 cm). Delaware Art Center, Baltimore.

Dear Tom:—

I write to know if the mornings of our days in the dissecting room can be secured to us exclusively at once. Up to the present the boys have worked on the new subject, while we were at ours: but now beside the fact that ours is dried up completely, they have cut off the head, arms and scapulii so the back, about the freshest part, is about useless. This was done without consulting us and Miss Roberts and I had just prepared it for study . . . the other girls are losing a great deal of valuable time having had no previous study to assist them with the old subject. . . .

Dissection occasionally went on into the summer. (A letter of Thomas B. Clarke establishes that Eakins and others were working at the Academy on August 14, 1883.) And Thomas Anshutz wrote J. Laurie Wallace on August 7, 1884, that they were "about winding up horse dissection for the season." [8]

In the same letter Anshutz wrote of the Academy perspective study. It was now "the all-engrossing topic," he said. Eakins' interest and skill in perspective is evident in his many remarkable perspective drawings (CL-179, Fig. 106). And Eakins' manuscript on perspective, possibly dating from the time of Anshutz's letter, is in the Philadelphia Museum.

In his anatomy course Keen gave eight lectures on the skeleton, twelve on the muscles, one on the nose, one on the ear, one on the eye, two on the skin, and two on

"the influence of sex on the development of the body." [9] All the lectures were given to both boys and girls, except the last two. For these two Keen had a male and female model stand in front of classes of first men and then women, and pointed out the "differences in the various regions, omitting only the generative organs." [10] At the beginning of the lectures there were only about seventy-five listeners, but by the time Keen had gotten around to sex, there were considerably more than two hundred. Lectures were open to the public at ten dollars per course, but students and artists got in free, with the front seats reserved for them, though as Keen told the director, "the use of opera glasses renders the back seats practically just as good as the front." [11] Beginning with the term of 1880–1881, the lectures on sexual differences were omitted. The Committee on Instruction "feared that it might give rise to unfavorable criticism." [12]

Two years later the number of "Artistic Anatomy" lectures had been increased to thirty-seven, and Keen demonstrated the skeletons of the lower animals as well as man. The Philadelphia Academy of Natural Sciences supplied the skeletons of animals, and in 1883 the University of Pennsylvania helped Keen to get dissecting subjects. Keen suggested to the directors that each institution should be given a set of the excellent new series of anatomical dissections Eakins had made during the 1878–1879 term. Eakins was Keen's "Chief Demonstrator," along with six assistants, including James P. Kelly and Thomas Anshutz, who were later to become Eakins' rivals for Academy promotion. The gelatine molds for anatomical casts were kept, and casts were given to such students as wanted them for study. In 1880 Eakins was promoted to the Professorship of Drawing and Painting, and Kelly was made Chief Demonstrator, with Anshutz and Frank Stephens (Figs. 107 and 108), soon to become Eakins' enemies, and David Wilson Jordan, who became his good friend (Fig. 109), as assistants. A new skeleton was

Fig. 107. Thomas Anshutz, c. 1895. Photograph courtesy James Graham Gallery, New York.

Fig. 108. Frank Stephens, Eakins' brother-in-law (date unknown). Photograph courtesy Donald Stephens.

Fig. 110. *Plaster Cast of Écorché Cat*, 1877. 13¾″ × 25⅝″ (34.9 × 65.1 cm). Pennsylvania Academy of the Fine Arts.

Fig. 111. *Plaster Cast of Male Torso*, 1878–1879. 32″ × 19″ × 8″ (81.3 × 48.2 × 20.4 cm). Pennsylvania Academy of the Fine Arts.

needed, as well as new male and female pelvises, but Keen was glad to have Eakins' new casts, as the Houdon ones they were using were inaccurate. During the term of 1876–1877 Eakins also made casts of a cat and a dog. Like the casts of the human body, said to be that of a muscular stevedore killed in a boiler explosion, these casts are still at the Academy (CL-215, Figs. 110 and 111). Eakins later gave them to his friend Samuel Murray; Murray took them with him to the Moore School, and they were rescued just as the Moore School was about to throw them out.

The Academy dissecting classes took place in the pump room, and the tables that were used, clearly visible in Anshutz's painting, are said to be those still at the Academy. Later, dissections were evidently done in an adjoining room, for Adam Emory Albright, who came to the Academy as a student in 1883, remembered that it was at the top of the rear stairs, and that there was a tank set into the floor into which the bodies were dumped. Today at the Academy what is evidently the support for this tank can be seen in the southwest corner of the ceiling of the room underneath, which is now the school store. Albright remembered having been left alone one Christmas: [13]

> I was left alone in the Academy Christmas week, class rooms deserted, pupils had gone elsewhere for the holidays. Strolling through the halls, Old Henry, the darkey who was almost a part of the Cherry Street entrance, came cautiously out of his little den and unlocked the back door, slipped back

Fig. 109. *Portrait of David Wilson Jordan*, 1899. Oil on canvas, 60″ × 28″ (152.4 × 71.1 cm). Kennedy Galleries, New York.

again and shut himself in. An ugly hulk of a man opened the door and came in with a huge burlap wrapped bundle and dropped it on the floor. Then another, and then a third, larger than the others, all closely wrapped. Seeing me he called, "Keep back." He opened a trap door in the front of our life class I had never noticed before, ripped off the burlap and dropped one human body after another into the hole. "Pickles," he said, as I heard a splash. He closed the trap door, locked it, gathered up the burlap and drove away. "Pickles," he said again, as he closed the back door. A meaner looking man I had never seen. These were the cadavers we had in the dissecting room.

The Academy students, like art and medical students from time immemorial, took great delight in playing practical jokes. McHenry wrote of an occasion when a paper sack being carried on a bus got wet and various grisly objects spilled out on the floor. Albright wrote that when he was a demonstrator he prepared a skull by boiling a head, and that the woman who took care of his room was "shocked and frightened" when she found an arm and a hand on his window sill.

One episode certainly lowered our status and created an entirely false notion of our characters [Albright continued]. Carried outside [the rumor] was spread by a plumber, after cleaning out a clogged toilet. To prepare a male stiff for the women's dissecting class, we removed the part that made a man a man. We all declared it was an accident that the part was found in some fellow's smock pocket as he took it down before leaving. Be that as it may, it had to be dodged several times and finally followed some one down the back stairs and into the washroom, landing in the flush toilet. "Say," said the plumber, and his assistant verified the story, "some of those artists are rotten and I know what I am talking about. . . ."

To demonstrate head bones we filled a skull with beans, put it in a bucket of water overnight and a display of the most beautiful dovetailing one ever saw was shown by the bones being forced apart by the swelling beans.

Albright, like many of Eakins' students, had an almost idolatrous regard for his teacher. "Why don't you call Eakins Mr. Eakins," asked a new student from Toronto. "Do you say Mr. Jesus in Canada?" was the answer.[14]

Albright described Eakins' methods in a *Harper's Bazaar* article of August 1947. "Go paint an egg," Eakins would say, believing that an egg was an almost impossible subject. He also described Eakins' personal appearance in the years he was at the Academy, 1883–1886:

Tommy was never well dressed by the standards of those days. He usually wore a flannel shirt, nondescript suit, and a round felt hat, the brim of equal length all around, a good rain shedder. I don't recall that he ever carried an umbrella, but he seemed always to wear a rain coat and often rubber boots, for it rained all winter in Philadelphia. He created something of a stir when he appeared at a smart Philadelphia reception, wearing those boots, his trousers tucked in the tops. Why not, it was raining outside, wasn't it?

Fig. 112. Modeling class at the Pennsylvania Academy of the Fine Arts, 1882. Archives of American Art.

On one occasion James L. Claghorn, the Academy president, a prominent collector and one of the "leading men" who took an interest in Philadelphia art in general and in Academy affairs in particular, asked Eakins if Dr. Keen's lecture could be changed to the daytime. Eakins replied that daylight was "very precious to the art student," [15] and that his pupils painted from the nude from nine to twelve in the morning, had lunch, and were back in his painting class at one. "Between modelling & painting, & the men's and women's hours, the classes are so constantly in session that no time really would be found for a daytime lecture which would not interfere with one or more of them." He thought that if Keen's lecture time was changed, half or three-fourths of those who went to them in the evenings would drop out because they would prefer the other classes.

Eakins' students not only worked hard within the Academy walls; they often went on excursions into the countryside, making landscapes and other studies. On at least one occasion they went as far afield as New York, where they saw a Rembrandt newly come to America, and a Théodore Rousseau landscape. Anshutz did not like Rousseau, but, he conceded, the Rembrandt "certainly grows on you wonderfully." [16] On another New York visit Eakins saw Rembrandt's *Old Woman Paring Her Nails*, and when he returned home told his pupil Charles Bregler that it reminded him of a painting Bregler had done of his grandmother. On one of his New York excursions, perhaps at a later time, Eakins startled people on a trolley by saying "New York is a hell of a place to live in." *

* Quoted by Samuel Murray in the McBride papers. Nevertheless, Eakins still liked New York better than Boston. "New York is composed largely of rowdies prize fighters jail birds swindlers pickpockets," he wrote his sister Fanny, "& Boston of scientific ladies & gentlemen who know professors intimately. The New Yorkers are the most intelligent & least pretentious & I like them the best. The sweetest young man I ever knew came from Boston. I have also met several in Europe. They all tell you the first thing, that they are graduated out of Harvard." (Letter of July 9, 1869, in a private collection.)

Bregler took notes in his Academy classes and published many of them in 1931, when Eakins' reputation had begun to rise, following the Museum of Modern Art exhibition of Eakins, Homer, and Ryder. Many of his notes quoting Eakins' statements we would expect from what we know of Eakins' life and work. Others are more surprising: [17]

> There are men in Paris in the schools, they paint day after day from the model. They never try to paint anything else. They are waiting until they know something. They are now old men. They cannot paint as well as they could twenty years ago.
>
> If I had known what I know now, I would have been a painter in half the time it took me.
>
> A boat is the hardest thing to put into perspective. It is so much like the human figure, there is something alive about it. It requires a heap of thinking and calculation to build a boat.
>
> If you see any photograph of Gérôme's works, notice that he gets the foot flat on the floor better than any of them.
>
> Draw the chair first and put the figure in the chair. It will be a guide to draw the figure.
>
> Take an egg or an orange, a piece of black cloth, and a piece of white paper and try to get the light and color.
>
> *Respectability in Art is appalling.*
>
> Mathematics is . . . so *much like painting.*
>
> Get the character of things. I detest this average kind of work. There is not one in the class that has the character.
>
> I'd rather see an exaggeration . . . than not enough. Go to the full extent of things.
>
> If I were painting an arm I would finish the elbow and then the wrist, then I would finish in between until the two ends meet. Joints are always a good thing to start from.
>
> You don't try to get anything right at first. You guess at it, then correct it.
>
> When I came back from Paris I painted those rowing pictures. I made a little boat out of a cigar box and rag figures, with the red and white shirts, blue ribbons around the head, and I put them out into the sunlight on the roof and painted them. . . .
>
> Feel the model. A sculptor when he is finishing has his hand almost continually on the model.
>
> Don't paint when you are tired. . . . Get the thing built up as quickly as possible before you get tired.
>
> There is mystery in shadow.
>
> Did you see those charcoal drawings by Degas? . . . That fellow knew what he was about.
>
> A chair and all common things are hard to draw.
>
> There is a limit in relief, if you keep inside of it it is a powerful instrument to work with . . . The frieze of the Parthenon by Phidias is the highest perfection of relief. There are horses and men, and that is all there

is to it . . . In the works of the Greeks, you can feel the moisture of the skin.

On January 10, 1881, a new dimension was added to the Academy curriculum: a live horse was brought in for the modeling class, and the class in the dissecting room had, for the first time, also an entire horse carcass to work on. There is some evidence that the carcass was Josephine, Fairman Rogers' favorite mare, who had been a stellar attraction of *A May Morning in the Park*. Now, besides being worked over by the Academy students, she was the model, before her postmortem dismemberment, of a number of sculptures by Eakins (CL-216).

For all of Fairman Rogers' liberality, he insisted, as Chairman of the Committee on Instruction, over Eakins' objections, that the requirements for entry into the school and its life classes should be drawings from the antique. In June 1881 he published an account of the Academy school and propounded his philosophy: [18]

> At the student's pleasure, he makes application for admission to the second antique class, sending in a drawing made for the purpose in the first antique; should that show satisfactory progress, he is advanced, and in this class draws from the whole figure. In these examinations, more weight is given to the grasp of the subject and appreciation of its character, than to finish or smoothness. The students spend more time in the second than in the first antique,—on an average, six months before entering the life class. The present Professor of Painting has a strong feeling that a really able student should go early into the life class, and, if he deems best to do so, go back to the antique, from time to time, later, to compare his work with it, on the principle that work from nature is more useful than that from a copy of nature, however great. This is, in fact, the key-note of all the present instruction.
>
> Admission to the life class is made much more difficult than to the antique, for several reasons. It is not well for the life classes to be too crowded, not more than thirty-five or forty being able to work conveniently from a single model, no matter what the size of the room may be, and it is not worthwhile to waste expensive models upon those who will evidently never make artists of any power; so that many who enter the second antique never go into the life class. Minors are not permitted to enter the life class without the written permission of parents or guardians.

Rogers strongly supported Eakins, however, in the feeling that the study of art at the Academy could begin and end with the figure. He saw little lost with the exclusion of still-life or draped figures. Picture-making, he wrote, is "better learned outside, in private studios, in the fields, from nature, by reading, from a careful study of other pictures, of engravings, of art exhibitions." [19] "Great stress," he continued, "is laid upon the weight and solidity of the figure; it must stand on its legs . . . and must look as if made from a real living body, and not from a paste-board silhouette."

Attendance at the school was not compulsory, but rolls were signed by the stu-

dents, and if much absenteeism was noticed they were required to give reasons or be dropped.

On January 10, 1881, a matter came up at the meeting of the board of directors which was a turning point in the Academy school, and which was, in a way, the beginning of the end of Eakins' teaching career there. Tuition was free at the Academy, but at this meeting John G. Johnson, a director, and the founder of the remarkable Johnson Collection at the Philadelphia Museum of Art, proposed that the Academy should start charging tuition. It would not, he thought, endanger the Academy's tax-exempt status. Nothing visible was done about the proposition for a year, but the idea remained in the mind of the Chairman of the Committee on Instruction, and the following January he announced that he "expected to propose some important changes in the School regulations" at the next board meeting, on February 13, 1882.[20]

The proposed changes were sweeping ones, and they were readily accepted. For a start the directors resolved to charge fees and to put the school "on a paying basis." At the next meeting, in March, they decided to change Eakins' title from "Professor" to "Director," and to double his present salary of $1200 (it had been raised from $600 to $1200 at some point between 1879 and 1882) "as soon and as rapidly as the income of the School will permit."[21] When school opened the following October 2, students were charged $48 for a season ticket, $8 for a monthly ticket, and $4 for a weekly ticket. There were sixty-two new students, and most of the former ones stayed, so the result was comfortable. After only a year and a half, in January 1884, the schools were reported to be "largely self-supporting."

But business is never as good as it should be, and fifteen months later Eakins drew the directors' attention to a fact that he evidently hoped would be embarrassing:[22]

> Gentlemen,
>
> At the reorganization of the school as a pay school of which I was made the director, my salary was fixed at $2500, but as there were many doubts as to the probable number of scholars under the pay system, I was asked to temporarily serve at a much reduced salary. The chairman of the Instruction Committee Mr. Rogers, confident of the success of the new plan, assured me he believed my temporary salary would be much raised during the first year and probably paid in full thereafter, and that it was not contemplated that the expenses of the whole school would be paid by the pupils, the price for tuition being kept very low.
>
> The number of classes has increased, the school is full: probably as full as it should be, its pupils are becoming known, its reputation is wide, and its standard of work is very high. My promised salary was a large factor in my determination to remain in Philadelphia.
>
> Yours truly
> Thomas Eakins.

Since 1882 Eakins had also been teaching at the Brooklyn Art Guild in New York, and the Guild paid him $100 a month for two weekly lectures, plus all expenses,

which included sleeping-car tickets back and forth to Philadelphia. He pointed out to the Academy directors that J. Alden Weir was getting $2000 a year at Cooper Union, and that his friend William Sartain was getting $75 a month from the Art Students' League of New York as well as "surplus accumulated profits" at the rate of about $1600 a year.

But Eakins' chief supporter Fairman Rogers had resigned on the first day of 1883, and was now cruising southern waters in his fifty-foot steam yacht *Magnolia*. (For the rest of his life Rogers was a gentleman of the most dignified leisure, dividing his time between the great house on Rittenhouse Square, the farm in Delaware County, the house in Newport, and various addresses abroad. He died in Vienna in 1900, mourned by all—and especially Eakins.)[23] And with Rogers gone, the Academy directors were a phalanx of conservatism. Even William Clark, the *Telegraph* critic, who was now an Academy director, tended to side with the conservative members of the Board, as did the art historian Charles Henry Hart, who was also a director. Why should they pay something they didn't have to? Mr. Eakins should be glad he had such an important job. It was their Academy and they would run it as they liked. Besides, Eakins was getting to be almost more trouble than he was worth.

The formaldehyde smell, the throwing of a dead horse down the stairs in the middle of an important social function, all-nude frivolity in the countryside (see Fig. 142), as bad as they were, were not the only things that were getting on the nerves of such men as Edward H. Coates and John G. Johnson. There were rumors that something was going on with all those naked models and with the students modeling for each other. Even as far back as the spring of 1882 a mother wrote James Claghorn, the Academy President, what must have been one of several protests about the demoralizing effect of Eakins' free and easy ways. "I allude to the Life Class Studies," she wrote Claghorn, "& I know where of I speak":[24]

> Dear Sir,
> . . . Would you be willing to take a young daughter of your own, into the Academy Life Class, to the study of the nude figure of a woman, whom you would shudder to have sit in your parlor clothed & converse with your daughter? Would you be willing to sit there with your daughter, or know she was sitting there with a dozen others, *studying* a nude figure, while the Professor walked around criticising that nudity, as to her *roundness in this part*, & swell of the muscles in another? That daughter at home had been shielded from every thought that might lead her young mind from the most rigid chastity. Her mother had never allowed her to see her young naked brothers, hardly her sisters after their babyhood & yet at the age of eighteen, or nineteen, for the culture of *high Art*, she had entered a class where both *male* & female figures stood before in their horrid nakedness. This is no imaginary picture. . . .
> Do you wonder why so many art students are unbelievers even infidels? Why then is often so much looseness of morals among the young men? To them anything so effective in awakening licentiousness as this daily &

nightly study of woman's nudity! Can't be helped! Can Christian men, members of the Church deliberately aid in demoralizing the young in this manner & not be guilty? . . .

Now Mr. Claghorn, does this pay? Does it pay, for a young lady of a refined, godly household to be urged as the only way of obtaining a knowledge of true art, to enter a class where every feeling of *maidenly* delicacy is violated, where she becomes so hardened to indelicate sights & words, so familiar with the persons of degraded women & the sight of nude males, that *no possible art* can restore her lost treasure of *chaste & delicate thoughts?* There is no use in saying that she must look upon the study as she would that of a wooden figure! That is an *utter impossibility.* Living moving flesh & blood, is not, & cannot be studied thus. The stifling heat of the room, adds to the excitement, & what might be a cool unimpassioned study in a room at 35°, at 85° or even higher is dreadful.

Then with all this dreadful exposure of body & mind not one in a dozen could make a respectable *draped* figure. Spending two years in life study of *flesh color*, that a *decent* artist would never need, & then have to begin over again for the draped figure. Where is the elevating enobling influence of the beautiful art of painting in these studies? The study of the beautiful in landscape & draped figures, & the exquisitely beautiful in the flowers that the Heavenly Father has decked & beautified the world with, is ignored, sneered at, & that only made the grand object of the Ambition of the student of Art, that carries unholy thought with it, that the Heavenly Father himself covers from the sight of his fallen children. Pray excuse this liberty in writing to you but I have been made to feel that the subject is one of such vital importance to the morals of our young students I could not refrain. Very truly yours.

R. S.

By the time Eakins asked for his raise such troubles as these had been brewing for years. He felt that the raise was his by right, and most would agree that it was, and that the Academy directors were wrong in denying it. But it was unrealistic of him not to realize that these same directors did, after all, effectively own the school, and they could do what they pleased so far as changing its policy or closing its doors was concerned. Their Professor of Painting had built it up to the point where it was easily the most distinguished in America, and, in some ways, the world. But it was still their school, and Eakins was getting to be a bit too much. It is likely that Eakins knew this, and he may have wanted things to turn out as they did.

According to a legend that has the ring of truth, the final straw that broke the directors' back was the protest someone had made when Eakins removed the loincloth from a male model in the ladies' life class. He wanted to show the origin of a muscle, it is said, perhaps the oblique, and how else could he show it than to take off the model's covering?

On February 8, 1886, the Committee on Instruction, now comprising the most conservative elements in a conservative board of directors, tired of the dissension and the

Fig. 113. Eakins' letter of resignation from the Pennsylvania Academy of the Fine Arts, February 9, 1886. Pennsylvania Academy of the Fine Arts. The Academy's letterhead imprint has been cropped.

inconvenience, asked for Eakins' resignation. This request must have been handed to him personally at the Academy the next day when he came down to classes. For on February 9, on the Academy's own stationery, he made his reply (Fig. 113): [25]

> Dear Sir,
>
> In accordance with your request just received, I tender you my resignation as director of the schools of the Pennsylvania Academy of the Fine Arts.
>
> > Yours truly
> > Thomas Eakins.

Instantly there was an uproar. The men students immediately circulated a petition asking that the board "prevail on Mr. Eakins to withdraw his resignation:" [26]

> Gentlemen
>
> We the undersigned students of the academy of fine arts, have heard with regret of the resignation of Thomas Eakins, as head instructor of the school.
>
> We have perfect confidence in Mr Eakins competency as an instructor, and, as an artist; and his personal relations with us have always been of the most pleasant character.
>
> We therefore respectfully and earnestly request the Board of Directors, to prevail upon Mr Eakins to withdraw his resignation, and continue to confere [sic] upon us the benefit of his instruction.
>
> We are very respectfully yours,

The list of student petitioners contains many familiar names, names well-known in the story of Eakins' life and in the story of American art: Charles Grafly, Charles Cox, Thomas Eagan, Charles Bregler, James Wright, James Wood, Alexander Stirling Calder, Edward W. Boulton, and George Reynolds. There were only a few girls' names

on the list, but most of the boys were there, and it was obvious that they were to be somehow placated if the Academy school was not to be gutted.

Not on the list were the names of Eakins' fellow teachers, men he had himself raised from the ranks to help him in his radical way of teaching art. On March 12 five of these, having seen a newspaper report that seemed to incriminate them, presented a collective letter to the board of directors: [27]

> Gentlemen:
>
> In the absence of any official statement as to the cause of Mr. Eakins' resignation from the Academy rumors have spread, of which the enclosed clipping is a specimen, (see Feb. 15), resulting in the general belief that he has suffered without cause.
>
> This is unjust to those who have brought Mr. Eakins' offenses to the notice of your Board and still more to those who come under his influence now, or who may hereafter, believing that he is, as he claims, the innocent victim of a conspiracy.
>
> We who are acquainted with the case cannot defend ourselves except by detailing the facts and that being in every other sense undesirable we bring the matter to the attention of your Honorable body & appeal, most earnestly, for an official statement from your Board to the effect that Mr. Eakins' dismissal was due to the abuse of his authority and not to the malice of his personal or professional enemies.
>
> Respectfully

The letter was signed by James P. Kelly, Colin Campbell Cooper, Charles H. Stephens, Thomas Anshutz, and Frank Stephens.

The clipping these men enclosed may have been from *The Philadelphia Press:*

> "The whole thing, in my opinion," said one of the directors, last night, "is rather a tempest in a teapot. Professor Eakins is an excellent teacher. He is a pupil of Gérôme and a thorough artist. He loves art for art's sake. But you know artists never agree among themselves. He had a number of enemies who made trouble for him and the committee thought it best for the interests of the school that he should resign."

This director's meaning is clear—Eakins' "enemies" were his fellow artists, not his students. And James Kelly *et al.* were correct in assuming that the finger was pointing to them. While denying their culpability, however, they made damaging admissions: "This is unjust to those who have brought Mr. Eakins' offenses to the notice of your Board," and "the malice of his personal or professional enemies." They were, in this last phrase, not denying the existence of such enemies, but only saying that Eakins' dismissal was not the result of the machinations of such enemies. Who else, indeed, would have brought Eakins' "offenses" to the attention of the Board except the signers of this letter?

Time and time again, in the presence of statements that Anshutz and the others wanted Eakins' job and were therefore less than enthusiastic about helping him to keep it, Anshutz's supporters have pointed to something that was simply not true—that

Anshutz's name was on the petition to retain Eakins. Recent discoveries in the archives of the Philadelphia Sketch Club, of which Eakins, Anshutz, Charles Stephens, and Frank Stephens were members, clearly establish that the latter three, at least, were part of a movement to oust their colleague from the Sketch Club and, by clear inference, from the Academy. They apparently convinced the other members that the Philadelphia Sketch Club, which owed so much to Eakins, would now be better off without him: [28]

> In the early part of the year [1886], a delicate and disturbing problem engaged the serious attention of the members, which was carried through to a satisfactory conclusion. Charges were preferred against a prominent member of the Club, signed by Thomas Anshutz, Charles H. Stephens and G. Frank Stephens, on March 6th, and President Cariss in pursuance of a resolution, appointed . . . a committee to investigate these charges, which they painstakingly and conscientiously did, examining a number of witnesses . . . making a report in a very long and carefully worded document, with full specifications on April 17th, they found the member guilty of the charges preferred and recommended his expulsion from the Club. All former privileges granted this member were withdrawn and his name erased from the Club roll. . . .

Needless to say, this "long and carefully worded document," with its lengthy testimony to Eakins' moral corruption, is not now available. Eakins' answer—I have been told that at one time there were Eakins' letters at the Club—is also unlocated. It is difficult to decide which of the two documents would be more interesting—or depressing.

Frank Stephens had recently married Eakins' sister Caroline and persuaded her that her brother was a wicked, wicked man. For the rest of her life Caroline scarcely spoke to him.

Eakins wrote about all his distress to his old friend Emily Sartain, sending her a "Statement" on March 25, 1886: [29]

> Dear Emily,
> I send you a statement which I leave entirely to your discretion. It is comprehensive, & shown to some persons might do a deal of good. It is carefully written & covers all the ground
> Anshutz is teaching in all my classes at the Academy, having given one class to Kelly the class formerly taught by himself.
> Statement.
> Philadelphia
> March 25,
> 1886.
> In pursuance of my business and professional studies, I use the naked model.
> A number of my women pupils have for economy studied from each others' figures, and of these some have obtained from time to time my criticism on their work.
> I have frequently used as models for myself my male pupils: very rarely

female pupils and then only with the knowledge and consent of their mothers.

One of the women pupils, some years ago gave to her lover who communicated it to Mr. Frank Stephens a list of these pupils as far as she knew them, and since that time Mr. Frank Stephens has boasted to witnesses of the power which this knowledge gave him to turn me out of the Academy, the Philadelphia Sketch Club, & the Academy Art Club, and of his intention to drive me from the city.

Thomas Eakins.

Adam Albright tells a parallel story. Among the girls who posed nude in the women's life class was an unusually talented girl who had an uncanny ability to paint a likeness. So when this girl's sketch book was "accidentally" left behind for the men's class to see, they all knew exactly who had done the posing.

William Sartain was not exactly fervent in his support of Eakins during this time of crisis. The Academy had written him about a successor to Eakins, and he got the idea that they wanted him for a professorship. Sartain wrote to the director of the Academy: [30]

In regard to seeing you I should perhaps state that if I were in view as one of the professors of the Academy, I do not see how I could be available.

I am very much engaged for next year and I do not think the Academy would be willing to make it worth my while to take a position there. . . . I can at any time have a class in Phila. [which] is more profitable & more independent. I refused one there this year which netted for one day as much as Mr. Eakins' salary.*

I would be very glad to be consulted in regard to it. I am anxious for the School to be worthy of the Academy. I think it important *now* to make it so, for Mr. Eakins was a man of great qualities if of great shortcomings also. . . .

One wonders what Sartain thought Eakins' "great shortcomings" were. A substantial part of these, perhaps, was the fact that Eakins, from the same city, the same grammar school, the same high school, and the same art schools in both America and Europe, made Sartain look like a pale shadow as a painter. Eakins' pupil Samuel Murray told Henry McBride many years later that Sartain "was not especially kind to Eakins. On the contrary when he heard of any portrait commission being given to Eakins [he went] to the people and [tried] to persuade them to have it done by others." [31]

Eakins' students, family, and friends were not the only ones stirred up by his resignation. The art world, both locally and nationally, took varyingly jaundiced views of the affair. But the Philadelphia press, mindful of the side upon which its bread was buttered, sided with the Academy directors. The *Inquirer* was particularly condescending: [32]

* It is impossible to know what Sartain means here. He could not have gotten Eakins' salary for any single day's teaching anywhere. And if he is referring to a pro rata scale for Eakins' salary, there would have been nothing remarkable about that.

The action of the directors of the Pennsylvania Academy of the Fine Arts in accepting the resignation of Mr. Thomas Eakens [*sic*] as principal instructor, has been the occasion of considerable excitement among the younger students of the boys' classes. Mr. Eakens' retirement resulted from the fact that he was at variance with the Instruction Committee of the board respecting certain details of instruction, and a number of the boys, mostly new pupils, sided with their teacher with rather more eagerness than discretion. They have discussed the matter with youthful ardor for several days past, held meetings, passed resolutions, drawn up a petition to the directors to reconsider their action, solicited Mr. Eakins to withdraw his resignation, and have variously ventilated their sentiments.

Yesterday morning the directors very properly put an end to this disturbing agitation by giving the dissatisfied students to understand that the action of the board was final and could not be reviewed. On receiving this announcement they hurriedly decided that they would withdraw from the Academy and form an Art Students' League, similar to that in New York. The more enthusiastic were for taking immediate action and going off at once in a body, but more deliberate counsels finally prevailed, and it was proposed to hold a meeting at some later time to consider the matter. It is more than probable that if any movement of withdrawal is eventually made it will be confined to a small number of the younger boys who have not advanced far enough in their studies to understand what unexampled advantages the Academy offers them.

The *Bulletin* reported that Eakins' women students had also drawn up a petition, which all but a dozen had signed, and described a nighttime rally organized by a number of the men students: [33]

Upwards of forty art students, members of the life class of the Academy of the Fine Arts, marched down Chestnut Street about 10 o'clock last night from Seventeenth Street to the studio of Mr. Thomas Eakins, which is situated just below Broad Street and opposite the United States Mint. Each man wore a large E on the front of his hat as a symbol that he was for Eakins first, last and all the time. On reaching this point they came to a halt and cheered lustily for their head instructor. After waiting a reasonable length of time for him to appear, and seeing no sign of his appearance, they departed for their homes. Prior to this demonstration they met at the rooms of one of their number and drew up a petition requesting the Board of Directors of the Academy to endeavor to persuade Mr. Eakins to withdraw his resignation, which was recently sent in, and return to his old place. . . . It is said that should the directors refuse to comply with the request thus made, the students, with a few exceptions, will leave the Academy and accept Mr. Eakins's offer to teach them outside the institution.

An editorial in the *Bulletin* summed up the Establishment view of the matter: Eakins was wrong, the directors were right, it was the directors' school, and that was that: [34]

The Academy Life School

The resignation of Mr. Thomas Eakins, who has been for a number of years the teacher of the Life School at the Academy of the Fine Arts, has become a subject of much interest in both art and social circles. It is as well that the general facts of the case should be clearly understood. Some well-written communications have been received at this office, devoted to expositions of Mr. Eakins's rare abilities as an artist and teacher, which have not been brought in question by the directors of the Academy. The directors are not responsible for Mr. Eakins's resignation and are altogether right, in every point of view, in declining to reconsider their action in accepting the resignation.

The directors of the Academy are wholly responsible for the conduct of all work that is prosecuted under their auspices. They established the Life School some years ago, not for the benefit of the Academy, but for the promotion of an art education which may almost be called a free education. They furnished their school upon the most liberal scale, provided it with an able conductor in the person of Professor Eakins and have carried it on at an annual loss to the Academy, but with the most admirable results in the way of art education. . . .

In any such differences of opinion, the will and judgment of the directors is supreme. It is their school and nobody's else. It is for them to determine what shall and what shall not be done in it. The persons whom they employ are their subordinates and are as much bound to accept their directions as is any other subordinate. With the pupils the directors are to deal through the instructors and through such general rules as they may prescribe. It is for the pupils to accept these rules or to study elsewhere; the directors are responsible only to their constituents. . . .

Suffice it to say, at present, that, no matter how much may be conceded to the theory that there is no sex in Art, such a Life School as that at the Academy of Fine Arts is no fit place for pushing the theory to its extremes. The pupils in that school, both men and women, can be taught all that they really need to be taught without any such sacrifice of personal instinct and principles as was demanded of them. The directors are right, and the young men who are talking about establishing an Art Students' League upon no broader platform than it will have to rest upon in this case will do well to reconsider their hasty conclusions and not throw away their present rare advantages, for which they can obtain no equivalent from any such enterprise.

That was the final Philadelphia word on the matter. But the art world in general held a different view, as the following article in *The Art Interchange* makes clear: [35]

Professor Thomas Eakins, who for several years past has been instructor in charge of the classes in painting and sculpture at the above-named institution, has resigned his position, much to the regret of the majority of his pupils. It seems that there is a small faction of students in the professor's classes who are opposed to his methods of study, and they have been eagerly seeking for an opportunity to place their own favorites in power. Gratitude

for the good results which have been attained by Mr. Eakins does not seem to have been thought of by his opponents, and a feeble charge was trumped up that he had insisted upon an excess of nudity in study from the life model, and made an unnecessary exposure of the "subject" in the anatomical class! Art students who attend the classes at the Pennsylvania Academy are supposed to understand that it is a school intended for professionals and those amateurs who may have the good sense to avail themselves of the advantages of study from the nude model. If Mr. Eakins offended the modesty of the women and men of his class by an excess of realism, it was intended for their benefit, and they should not have overlooked the well-known fact that he always had their welfare at heart. When the study of nude models met with so much opposition some years ago, he procured a room at his own expense and there gathered a little band of students around him whose rapid progress in art soon proved to the public the error of wasting time by attempting to teach drawing and painting in any other than on those true principles which he himself had learned from his master, Gérôme. Many of Mr. Eakins' pupils say that if he is not reinstated at the Academy they will leave it and form an Art League similar to that which has been so successful in New York. The best wishes of all who love truthful study will attend the formation of the students' class, and whatever Mr. Eakins' errors may have been, we most earnestly wish that he may be forgiven by his enemies, whom [sic] it is to be hoped will never commit any greater sins than those of which he has been accused.

9

Work During the Academy Years
1876-1886

Eakins' schedule at the Academy had been a full one, but it still left him considerable time for his own painting. "I doubt if Eakins ever spent more than thirty minutes in a review twice a week," Adam Albright remembered.[1] And the directors expected him to do no more than this. He would occasionally enter the room, which would become suddenly silent, often accompanied by Harry, his red setter, walk about among the easels, make remarks to the students, and, when he saw something particularly good, make an "E" in the corner. The work would then become the property of the Academy, and the students thus singled out for the Academy collection were exhilarated. Evidently not all of the works given Eakins' imprimatur stayed at the Academy. Charles Bregler acquired one such study by J. Laurie Wallace and later gave it to George Barker, Wallace's pupil.

Among the paintings Eakins produced during his teaching career at the Academy were five illustrations commissioned by the art director of *Scribner's Magazine*. In November 1878 he produced two illustrations for Bret Harte's poem "The Spelling Bee at Angel's" (Figs. 114 and 115), one illustration for "Mr. Neelus Peeler's Con-

Fig. 114. *Illustration for "The Spelling Bee at Angel's," Scribner's Magazine,* November 1878. Photograph New York Public Library.

Fig. 115. *Illustration for "The Spelling Bee at Angel's." Scribner's Magazine,* November 1878. Photograph New York Public Library.

Fig. 116. *A Pusher.* Illustration for *Scribner's Magazine,* July 1881. Photograph New York Public Library.

ditions" (Fig. 100) for the June 1879 issue, and two more illustrations for the July 1881 issue, *Rail-Shooting* and *The Pusher* (Fig. 116). Lloyd Goodrich, who saw Eakins' records, wrote that *Rail-Shooting* and *The Pusher* were not engraved from paintings, but were made from separate drawings, for which Eakins got fifty dollars. A painted version of *Rail-Shooting* (CL-17), which was donated to a benefit for George W. Holmes (Fig. 117), is now in the Yale University Art Gallery. A study for *Mr. Neelus Peeler's Conditions* (CL-10) is in the New Britain Museum of American Art.

The Academy school usually closed for vacation late in June and reopened early in September, and Eakins evidently did much of his work then. Though not a member of the Philadelphia elite, which packed up and left town for the summer, Eakins occasionally took a trip to the Jersey shore, a favorite haunt of the Macdowells, or down to Cumberland County and the Cohansey River. Excursions to places near

Fig. 117. George W. Holmes in photograph by Eakins, c. 1890. 10⁷⁄₁₆″ × 8¹⁄₁₆″ (26.5 × 20.5 cm). Metropolitan Museum of Art. Holmes was a blind teacher of art. He was the right-hand figure in *The Chess Players*, Plate 21.

Philadelphia were more frequent, either with students and friends or family. His sister's farm in Avondale was a regular resort, where Eakins could revel in the fresh air, the sunlight, and the warmth of Crowell family life. But he always had a picture or two on the easel in his studio, and always a project or two in his mind for the immediate future.

During the Academy summers he often went across the Delaware to Gloucester, where the shad-fishing industry had its center, sometimes joined by the whole family. One such occasion gave rise to *Shad Fishing at Gloucester on the Delaware* (CL-267, Fig. 118), in which the artist depicted his mother, two of his sisters, and his father, together with Harry, watching the activity of the fishermen. At other times he went to Gloucester with William Sartain, and perhaps with Walt Whitman and others, for planked shad at Thompson's Hotel; the figure sitting on a pile of capstan spools beneath a plane tree in *Mending the Net* (CL-266, Plate 28, and Fig. 119) is probably Sartain. *Mending the Net*, incidentally, elicited the artist's first known German review. It was shown at a Munich exhibition in 1884 and the *Allegemeine Zeitung* critic thought it "an exquisite conception."[2]

Other shad-fishing works and a rare landscape showing the meadows nearby (CL-271, Figs. 121 and 122) also date from this time. A shad-fishing watercolor (CL-268, Fig. 123) in the Johnson Collection of the Philadelphia Museum, made at about the time Johnson was beginning to think the Academy should charge tuition, was copied from a photograph (Fig. 124).

Eakins' pupil John Laurie Wallace was the subject of several photographs Eakins took while he was working on his *Arcadia* series of paintings and sculpture (Figs. 126, 127, and 129). This series, presenting single figures and groups of figures

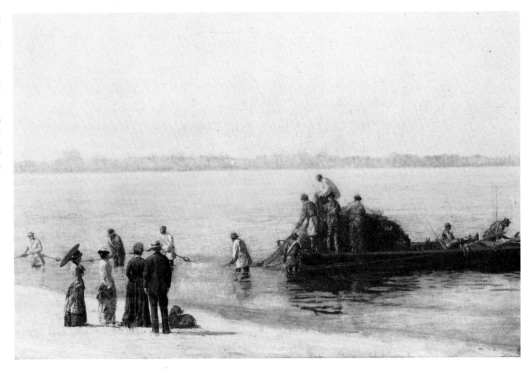

Fig. 118. *Shad-Fishing at Gloucester on the Delaware*, 1881. Oil on canvas, 12⅛″ × 18¼″ (30.8 × 46.3 cm). Philadelphia Museum of Art. The figures suggest two of Eakins' sisters, his mother posthumously, his father, and his dog Harry on the banks of the Delaware in Gloucester, New Jersey.

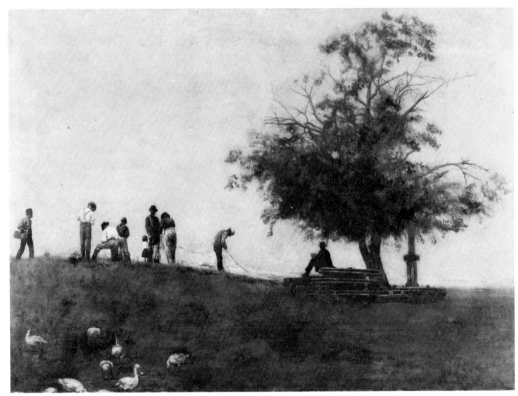

Fig. 119. *Mending the Net*, 1881. Oil on canvas, 32″ × 45″ (81.3 × 114.3 cm). Philadelphia Museum of Art. Fishermen on a ridge overlooking the estuary of Big Timber Creek, Gloucester, New Jersey.

Fig. 120. Eakins' photograph used for documentation of *Mending the Net*, 1881. 3¹⁵⁄₁₆″ × 7¼″ (10 × 18.4 cm). Hirshhorn Museum and Sculpture Garden, Smithsonian Institution.

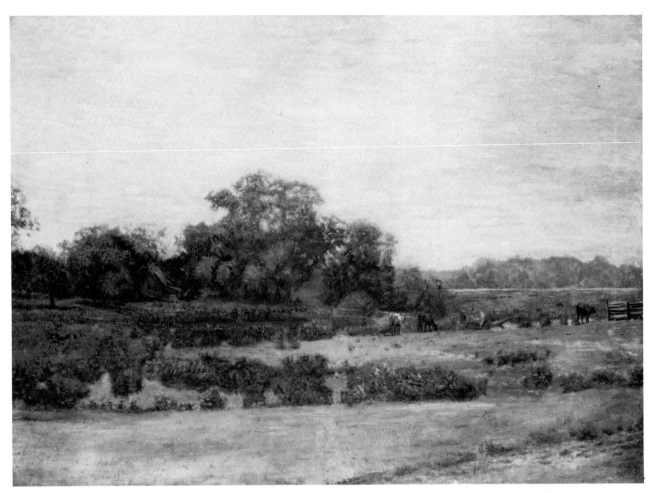

Fig. 121. *Meadows, Gloucester*, c. 1882.
Oil on canvas, 32¼″ × 45¼″ (81.9 ×
114.9 cm). Philadelphia Museum of Art.
Evidently a view to the left—eastward—
from the ridge in *Mending the Net*.

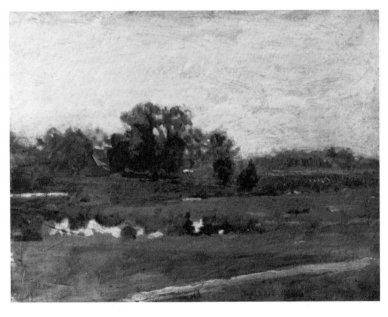

Fig. 122. *Study for Meadows, Gloucester*,
c. 1882. Oil on wood, 10½″ × 13¾″
(26.7 × 34.9 cm). Collection of
Roy Davis, New York.

in idyllic, sylvan settings, is less successful than most of the artist's work. This is
evidently because he was working with imaginary situations—nude boys playing pan
pipes with girls in flowing Greek gowns languorously listening. The two oils, *Arcadia*
(CL-186, Fig. 128) and *An Arcadian* (Fig. 131), with the latter probably an unfin-
ished or abandoned version of *Arcadia*, were produced in the early 1880s, before Wal-

lace left Philadelphia. Chalkmarks originally at the right in *An Arcadian* indicate that the young woman on the greensward was initially intended to be listening to such a figure as the standing youth in *Arcadia*. But the artist became so involved in the figure of the woman that when he finished it he knew that any possible introduction of the youth would have been disjointed: to get him into the proper perspective he would have had to have been a midget. A photograph of the youth planned for *An Arcadian* and actually introduced into *Arcadia*, and a photograph for the reclining pipes player of *Arcadia*, were taken by the artist (Figs. 129 and 130). Bas-reliefs of an *Arcadia*

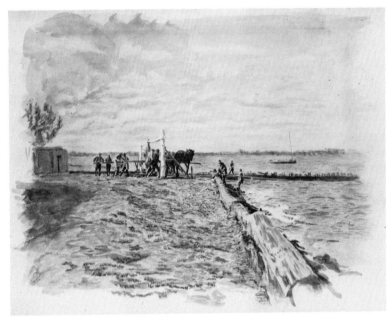

Fig. 123. *Drawing the Seine*, 1882. Watercolor on paper, 8″ × 11″ (20.3 × 28 cm). The Johnson Collection of the Philadelphia Museum of Art. Perhaps the most literal example of a transcription from a photograph (Fig. 124) known in American art.

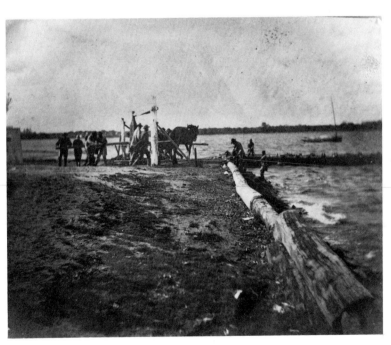

Fig. 124. Eakins' photograph from which *Drawing the Seine* (Fig. 123) was copied. 3⁷⁄₁₆″ × 4⁵⁄₁₆″ (8.8 × 11 cm). Author's collection.

Fig. 125. Thomas Anshutz's (?) photograph
of Eakins, c. 1883. Metropolitan Museum of Art.

Fig. 126. Thomas Anshutz's (?) photo-
graph of Eakins and J. Laurie Wallace,
c. 1883. Archives of American Art.

Fig. 127. Eakins' photo-
graph of J. Laurie Wallace,
c. 1883. 3¼″ × 4½″ (8.3 ×
11.4 cm). Philadelphia
Museum of Art.

Fig. 128. *Arcadia*, c. 1883. Oil on canvas, 38¾″ × 45½″ (98.4 × 115.6 cm). Metropolitan Museum of Art. See CL-186.

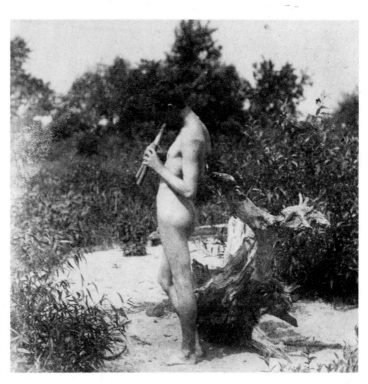

Fig. 129. Eakins' photograph of unidentified model (Wallace?) for *Arcadia*, c. 1883. 3⅜″ × 3⅜″ (8.6 × 8.6 cm). Hirshhorn Museum and Sculpture Garden, Smithsonian Institution.

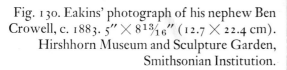

Fig. 130. Eakins' photograph of his nephew Ben Crowell, c. 1883. 5″ × 8¹³⁄₁₆″ (12.7 × 22.4 cm). Hirshhorn Museum and Sculpture Garden, Smithsonian Institution.

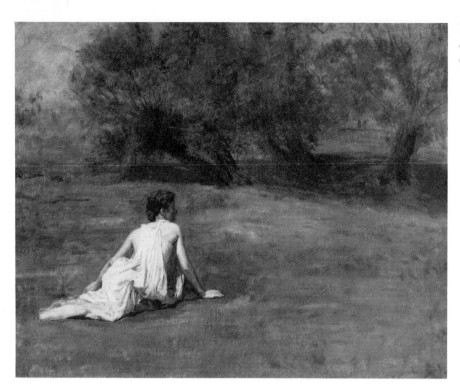

Fig. 131. *An Arcadian*, c. 1883. Oil on canvas, 14″ × 18″ (35.6 × 45.7 cm). Collection Lloyd Goodrich, New York.

Fig. 132. Eakins' photograph of trees on his sister Fanny's farm, c. 1833. 3⁹⁄₁₆″ × 4⁷⁄₁₆″ (9.1 × 11.3 cm). Author's collection.

Fig. 133. *Arcadia*, 1883. Bronze bas-relief, 11½″ × 24″ (29.2 × 60.9 cm). Hirshhorn Museum and Sculpture Garden, Smithsonian Institution.

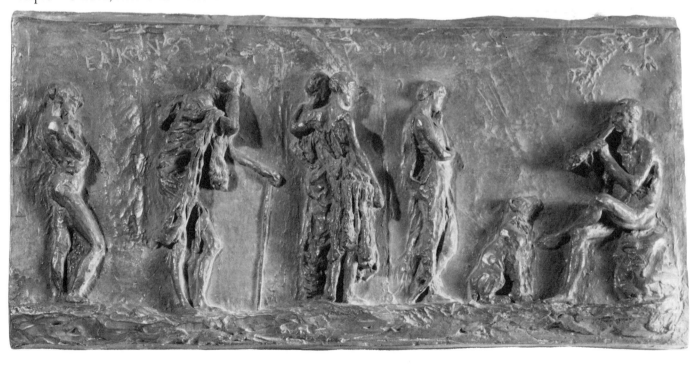

quite different from the oil of the same name, and a separate relief of the pipe-playing youth were also produced (CL-64, Fig. 133; CL-63, Fig. 134).

Albright has described Wallace (Fig. 135), who had been something of a figure at the Academy before Albright entered: [3]

> The star student had completed his class work just before I entered, but his reputation lingered. He, it was said, could set up the best figures on canvas of any one who had ever studied in the school. Eakins was very proud of him . . . his personal habits were ultra Bohemian. He wore a celluloid collar, only took off his shoes and coat when he went to bed. Washed his face in the morning without removing flowing tie or celluloid collar or shirt. Chewed tobacco, and in Chicago, girls in his class complained because he squirted tobacco juice back of the pedestals on which their antique models rested. . . . He looked the part of an artist, long curly black hair and full beard. We never knew his nationality, he was dark with black eyes and a mannered speech. As a student he was great, as an artist he never rose to fame.

Wallace was, as a matter of fact, still around at the Academy when Albright got there, for he wrote a greeting in Albright's sketchbook, along with other students.

Wallace left Philadelphia about 1883 to try to make a living painting portraits farther west. The Art Institute of Chicago needed a teacher, and Albright was asked if anyone at the Academy would suit. He recommended Wallace, and the director received a confirmation from Eakins so that Wallace began to teach in Chicago. In 1892 he went to Omaha, where he spent the rest of his days, painting a number of portraits of local celebrities and noncelebrities which are remarkable for their technical

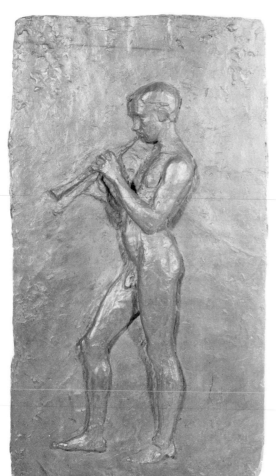

Fig. 134. *Youth Playing Pipes*, c. 1883. Bronze bas-relief, 19¾″ high (50.2 cm). Hirshhorn Museum and Sculpture Garden, Smithsonian Institution.

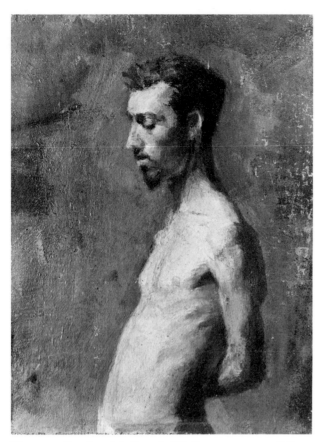

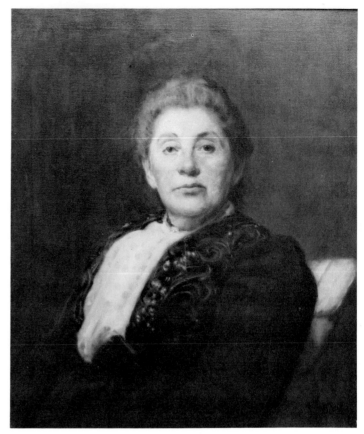

Fig. 135. *Study of J. Laurie Wallace*, c. 1882. Oil on canvas, 8″ × 6″ (20.3 × 15.3 cm). Kennedy Galleries, New York.

Fig. 136. J. Laurie Wallace: *Portrait of Fannie Teweles Brandeis*, 1901. Oil on canvas, 30″ × 25″ (76.2 × 63.5 cm). Joslyn Art Museum, Omaha.

skill, if not their psychological penetration (Fig. 136). Wallace never married. Like Walt Whitman, he claimed to have a lover in far-off climes, where his statement could not be checked.

Eakins painted a portrait of Wallace (CL-152, Figs. 137 and 138) either before he left Philadelphia or later when Wallace came back for a visit. The portrait has been dated 1885 by Wallace, but the exact date is not known.

Wallace also sat for *Professionals at Rehearsal* (CL-274, Fig. 139), a reworking of *The Zither Player*, showing Wallace playing the zither and William MacLean, who became Eakins' Chief Demonstrator of Anatomy at the Academy, playing the guitar. MacLean was a better anatomist than he was a draftsman; one of the little sketches in Adam Albright's sketchbook shows barely more than a talented amateurism. *Professionals at Rehearsal* was a commission for Thomas B. Clarke, the New York collector. It became the subject of an engraving by William Miller and Miller's only known etching.

In 1880 Eakins had also painted Wallace as Jesus in a *Crucifixion* (CL-261, Figs. 140 and 141), strapped, according to legend, on the roof outside his Mt. Vernon Street north studio. Here was a painting utterly devoid of what William C. Brownell would have defined as poetry, or as having "a sweet and tender" sentiment.[4] Few of Eakins' American colleagues made *Crucifixions*, but his European masters had done so. Gérôme made a "poetic" one, with only the shadows of the crosses showing, and Bonnat painted one that was harrowing, using as a model a real cadaver nailed to a cross by guardsmen

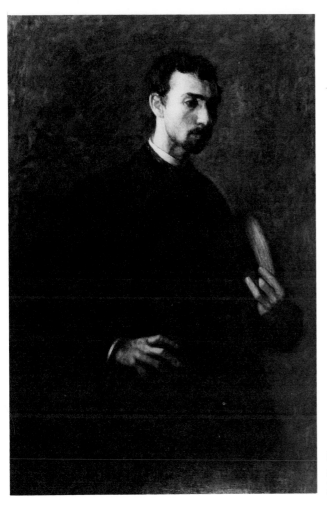

Fig. 138. George F. Barker(?): Tracing of Eakins' *Portrait of J. Laurie Wallace*. Charcoal on paper, 49½″ × 32″ (125.7 × 81.3 cm). Joslyn Art Museum, Omaha.

Fig. 137. *Portrait of J. Laurie Wallace*, c. 1885. Oil on canvas, 50¼″ × 32½″ (127 × 82.6 cm). Joslyn Art Museum, Omaha.

Fig. 139. *Professionals at Rehearsal*, c. 1883. Oil on canvas, 16″ × 12″ (41.2 × 30.5 cm). Philadelphia Museum of Art. J. Laurie Wallace playing the zither, with William MacLean or Robert Reid listening.

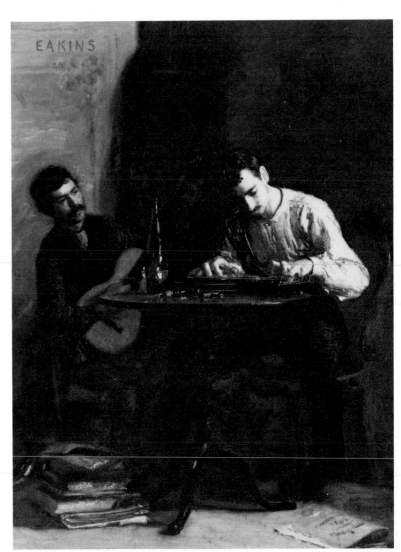

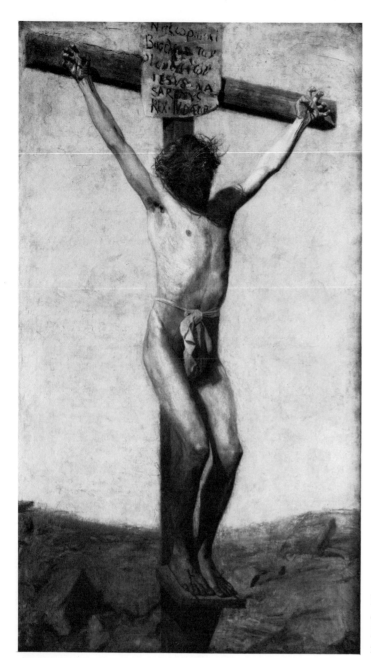

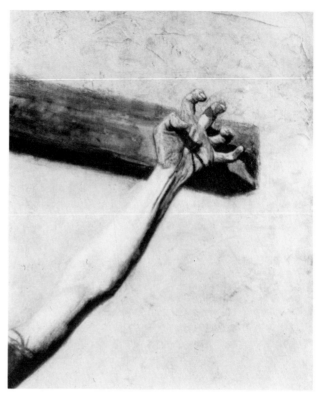

Fig. 141. *Crucifixion* (detail).

Fig. 140. *Crucifixion*, 1880. Oil on canvas, 96″ × 54″ (243.8 × 137.2 cm). Philadelphia Museum of Art. J. Laurie Wallace was the model for this painting.

and hung up in the Invalides courtyard. Eakins' has little "poetry," but it is full of power, desolation, and agony. Eakins had a crucifix in his house, and when Beatrice Fenton sat for her portrait and kept looking at it, he was careful to explain to her that he was not a Catholic, but he liked it anyway.

The critics were again unable to understand what Eakins was about, and they harped on the "scientific" quality of *Crucifixion*. The *Art Amateur* review is a good example of the narrow response the painting got in New York during its first public showing: [5]

> Mr. Eakins's "Crucifixion" is of course a strong painting from the scientific side, but it is difficult to praise it from any other point of view. At this stage of the world there can be only one reason for an artist's choosing such a subject—he must treat it as a poet. The physical aspect of the case

ought to be sunk; the mere presentation of a human body suspended from a cross and dying a slow death under an Eastern sun cannot do anybody any good, nor awaken thoughts that elevate the mind. We are told that Mr. Eakins painted his picture out of doors, his model having been suspended on a cross erected on the roof of the artist's house in Philadelphia. No doubt Mr. Eakins would spare no pains to be correct, and no doubt we may trust implicitly to what he tells us about a body so suspended as we see this one, but there is nothing artistic in this realism because it does not stir any noble emotion. It is not meant for beauty, of course; but it does not move us to wonder, pity, or awe. Nobody, so far as we can learn, is moved by it to do more than comment on the artist's technical skill, or to criticize some of his details. Should the legs and feet be so full of blood while the rest of the body is so vacated? Should the hand be so constricted? Could the face in nature be so concealed? Is the shadow on the left shoulder darker than it should be? These, and other questions, one hears, but such questions belong to the studio or to the class-room, not to the presence of a completed work of art.

When the picture went back to Philadelphia for the Academy's Annual opening on October 23, 1882, Clark, the *Telegraph* critic, put his finger again on the critical point: If you believe that the crucifixion of Jesus was a real event, then you must believe in the realism of Eakins' painting: [6]

This artist is the greatest draughtsman in America. He is a great anatomist as well, and both in his own practice and in his conduct of the Academy's classes he has had very unusual opportunities—opportunities of which he has fully availed himself—of studying the human figure both analytically and synthetically. We can, therefore, dismiss certain elements of the picture in question with very few words—it is a superb piece of drawing, while in brushwork, color, and other matters it is up to the artist's very best standard of excellence. But how does it figure the true sentiment of the theme? This is an important query, for Mr. Eakins has commonly been accounted an extremely unsentimental sort of a person, and there are, doubtless, many who will look upon this particular picture who will still so account him. What he has done primarily has been to conceive the Crucifixion as an actual event. He has hung his figure on the cross in the exact position in which he believed that such a given figure must hang under the given circumstances. His Christ is dead, the struggle of dissolution is over, the head has sunk on the shoulders, and has fallen forward, and the whole weight of the body is carried by the nailed hands. The artist, contrary to the usual custom, has not sought to gain anything in the way of effect by relieving the cross against a dark background, but he has rather flooded it with a full burst of sunshine. The atmosphere palpitates with light and the heat—the rays of the sun beating on the crown of the bowed head and throwing the face into shadow. Exactly how much in the way of symbolism may have been intended by the lighting of the picture we cannot undertake to say. There are doubtless some who will see a significance in the illumination, just as others see the same in the dark backgrounds of Bonnat and others. The

important fact is that the full, uncompromising light reveals everything of the uncompromising realism with which the subject has been treated. Whether or no Mr. Eakins' picture is not approved, in comparison with other treatments of the same subject, would appear to depend upon whether the spectator has ever conceived, or is willing to conceive, of the Crucifixion as an event which actually occurred under certain understood conditions. Certainly, if that event meant all that Christendom believes and has for centuries believed it to mean, it would seem that, if it is to be represented at all, the most realistic treatment ought to be the most impressive. It is undoubtedly the case, however, that many who believe themselves to be good Christians fail altogether to appreciate their religion or the events upon which it is based as realistic; and to such, a picture like this has no message to deliver.

Years later Eakins told Cardinal Dougherty that he did not believe in the divinity of Christ. "Yet," the Cardinal wrote, "he seemed an amiable man." [7] James L. Wood wrote Samuel Murray that "Eakins used to smile superciliously when anyone spoke about future life, it was contrary to the knowledge of science he possessed." [8] But atheist, agnostic, or whatever, Eakins had broken new ground in religious art, as he had done in portraiture, the painting of nudes, genre, and the depiction of motion.

J. Laurie Wallace—and A. B. Frost, George Reynolds, Jesse Godley, the setter Harry, and Eakins himself—were all pictured in another major work from Eakins' Academy years, *The Swimming Hole* (CL-322, Plate 29). Preparatory or attendant to this work Eakins went into the woods one day and took a remarkable series of nude photographs of his students wrestling and boxing (Fig. 142). [9] Some have considered such photographs as evidence that Eakins, if not homosexual or bisexual, was at least homoerotic. But the artist would undoubtedly have done the same thing with his women students if such a thing had been possible. Adam Emory Albright's remark that he never knew Eakins to like anyone but "tall, well-built people" [10] may or may not be relevant.

Other photographs and studies for *The Swimming Hole* have also been found (CL-58, Figs. 143 and 144). Both Bregler and Albright wrote that Eakins made wax models for the figures, or at least for the diving figure, which was George Reynolds.

Until 1961, when *The Swimimng Hole* was cleaned for an Eakins' retrospective exhibition, the date of the painting was not known, although a Thomas Anshutz letter of August 1884 stated that Eakins was working on it at that time. It was discovered after cleaning that 1883 was painted on the rock pier. The artist continued to work on it, however, until late in 1885, perhaps changing figures in accordance with the ideas of Edward Coates, who had originally commissioned the picture. After Coates had had the painting for a while, he changed it for *The Pathetic Song* (CL-26, Plate 30) instead, for which he paid Eakins eight hundred dollars.

George Reynolds, the diver in *The Swimming Hole*, was also the subject of a remarkable portrait, *The Veteran* (CL-18, Plate 31). Reynolds also posed for a num-

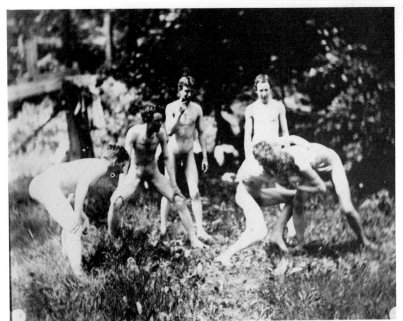

Fig. 142. Eakins' photograph of students wrestling, c. 1883. Modern enlargement from copy negative. Metropolitan Museum of Art.

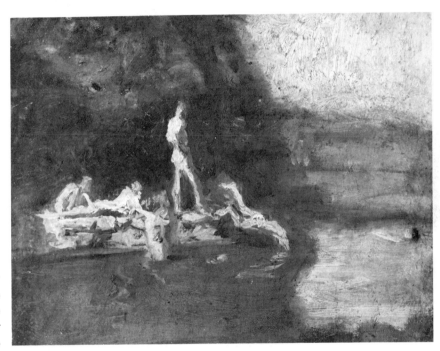

Fig. 143. *Study for The Swim-ming Hole*, 1883. Oil on board, 8¾″ × 10¾″ (22.2 × 27.3 cm). Hirshhorn Museum and Sculp-ture Garden, Smithsonian Institution.

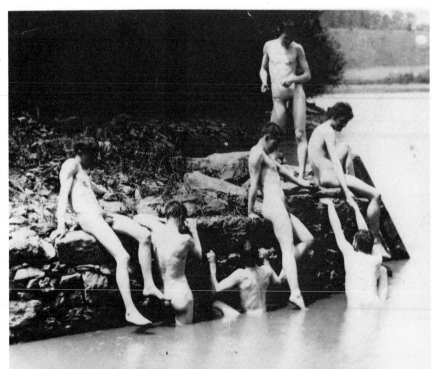

Fig. 144. Photograph of students at site of *The Swimming Hole*, 1883. Hirshhorn Museum and Sculpture Garden, Smithsonian Institution. Eakins is probably the lower right figure.

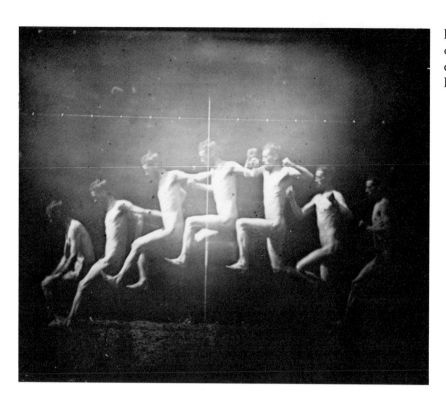

Fig. 145. Eakins' motion photograph of George Reynolds, 1884. Modern enlargement. Franklin Institute, Philadelphia.

ber of Eakins' motion photographs (Fig. 145),[11] and it was Reynolds who added what was possibly a self-portrait to Adam Albright's sketchbook.

Arthur B. Frost, the redhead in *The Swimming Hole*, who was always reluctant to give Eakins credit for teaching him anything, was the subject of two portraits. One of them (CL-278, Fig. 146), of about 1886, now in the Philadelphia Museum, is finished, or perhaps over-finished, and the other (CL-143, Fig. 147), in the Detroit Institute of Arts, is unfinished.

The latter painting now hangs beside another portrait also ascribed to Eakins. But this other portrait (Fig. 148) is evidently a copy of Eakins' Philadelphia portrait made by Frost's son John, perhaps during the time it was on loan to The Museum of Modern Art for the Eakins–Homer–Ryder exhibition in 1930. It was in 1930 that Henry Lanier published this copy in his biography of Frost, and ascribed it to Eakins,

apparently thinking that it was an exact reproduction and thus, effectively, an Eakins! J. Laurie Wallace had seen this copy in Frost's home, and an eyewitness tells us that he thought so little of it that he pretended not to see it. Mrs. Eakins and Charles Bregler, along with numerous Philadelphia Museum staff members, saw it in 1934, when it was shown in a Chestnut Street bookstore as part of a display for the Frost biography. "It is a very poor copy," Mrs. Eakins wrote Fiske Kimball, the Museum director, and Kimball agreed with her. He assured her that in accordance with his promise, no copy had been made of the Museum's portrait. Perhaps it had been copied from a photograph.

Mrs. Eakins knew only the Philadelphia Museum's Frost portrait by her husband, but there is little doubt that another was produced. Eakins records how he got $150 for a portrait of Frost in 1887—and the Detroit portrait fills the bill. The price paid would have been reasonable for an unfinished portrait at a time when finished portraits were costing $500. The size (27″ × 22″) is too large for a sketch for a portrait, but appropriate for the first stage of a finished, full-size portrait. The quality of the Detroit portrait, although we know of no other Eakins' portrait at this stage of completion, is high. And X-rays of the picture show an underlying sketch for *The Courtship* (Fig. 149 and CL-6, Fig. 150) theme that Eakins was working on at this time.

Another student painted by Eakins, although the picture is more of a study than a finished portrait, was Harry Barnitz. When Barnitz left the Academy for the summer of 1883, he wrote Eakins that he had had an offer to do a portrait. "I should accept the portraits by all means and try to please the lady," Eakins wrote him, and continued: [12]

> I am sure you will learn a great deal doing them under the peculiar circumstances only peculiar & new to you though. As for sunlight studies that is new too for you & I regret for a good many older fellows in the life school. The whole of the tones have to be transposed into another key as you would say in your music, transposed so that what you do for out of doors must

Fig. 148. John Frost(?): Copy of Eakins' *Portrait of Arthur B. Frost* (no date). Oil on canvas, 26¾″ × 22″ (68 × 55.9 cm). Detroit Institute of Arts.

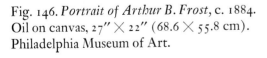

Fig. 146. *Portrait of Arthur B. Frost,* c. 1884. Oil on canvas, 27″ × 22″ (68.6 × 55.8 cm). Philadelphia Museum of Art.

Fig. 147. *Unfinished Portrait of Arthur B. Frost,* 1886. Oil on canvas, 26″ × 18″ (66 × 45.8 cm). Detroit Institute of Arts.

look like out of doors only when in doors in the gallery or house light. When you get back you will hear a lot about sunlight from Tommy Anshutz & the crowd that went sketching with him & you will see their work and that of others in the exhibition. So dont get the blues. You draw and paint very well extremely well for your age. I know no one who has a better start.

During this time the artist was invited by an architect friend, Theophilus Parsons Chandler, to do two bas-relief chimney pieces for the new house Chandler was building for James P. Scott, around the corner from Rittenhouse Square on Walnut Street. Scott did not like Eakins' designs of a girl spinning and of a woman knitting,

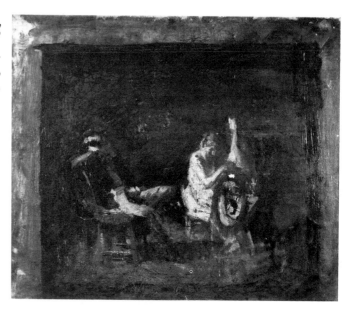

Fig. 149. *Sketch for The Courtship*, 1878. Oil on canvas, 13½″ × 16½″ (34.3 × 41.9 cm). Collection Mrs. John Randolph Garrett, Roanoke, Virginia.

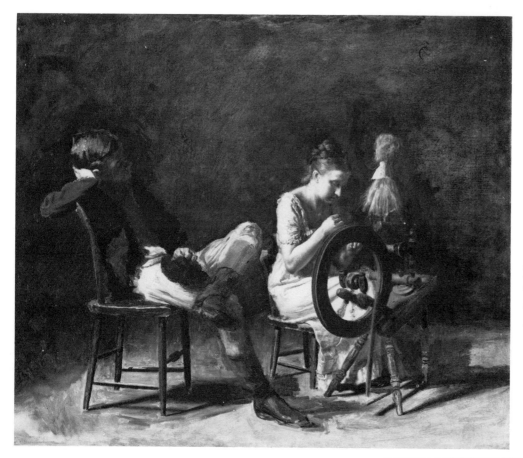

Fig. 150. *The Courtship*, 1878. Oil on canvas, 20″ × 24″ (50.8 × 60.9 cm). DeYoung Memorial Museum, San Francisco.

and there was a remarkable exchange of letters between artist and patron. Goodrich, who had access to original accounts, tells the story as follows: [13] Eakins was "easily induced" to take the commission, for the work was "much to my taste." Eakins even had his model take spinning lessons, and after she became adept, he saw that what he had done before was not right, and recommended the whole job. When Eakins showed his patron the clay models, Scott thought the price of four hundred dollars each was too high, and intimated that he might not accept them. Eakins reminded him that he had already done a lot of work and that the work had been specifically commissioned.

> Nor am I an obscure artist [he continued]. Relief work too has always been considered the most difficult composition and the one requiring the most learning. The mere geometrical construction of the accessories in a perspective which is not projected on a single plane but in a variable third dimension, is a puzzle beyond the sculptors whom I know.
>
> My interest in my work does not terminate with the receipt of my bill. Thus I have heard with dismay that a stone-cutter had offered to finish these panels in a week's time. I have been twenty years studying the naked figure, modeling, painting, drawing, dissecting, teaching. How can any stone-cutter, unacquainted with the nude, follow my lines, especially, covered as they are, not obscured by light draperies? How could the life be retained?

Then Scott suggested that the reliefs be left unfinished, but Eakins demurred. He invited Scott to stop by the Academy and look at the plasters of Phidias' Parthenon frieze, "the most celebrated in the world." Then Scott would understand that "un-

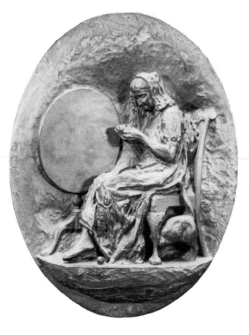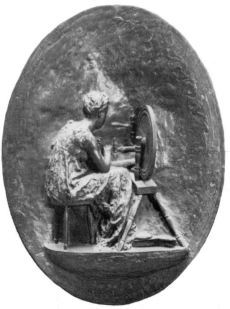

Fig. 151. *Bas-relief of Knitting*, c. 1883. Bronze, 18″ × 14½″ (45.7 × 36.8 cm). Pennsylvania Academy of the Fine Arts. See also Fig. 92.

Fig. 152. *Bas-relief of Spinning*, c. 1883. Bronze, 18″ × 14½″ (45.7 × 36.8 cm). Pennsylvania Academy of the Fine Arts.

finished sketches by a good artist . . . would be appropriate in an artist's studio or his home, but hardly in a fine house like yours . . . you would come to wish them completed."

But Scott refused to pay, and Eakins, after trying to collect the bill, suggested the matter be submitted to arbitration (one wonders what Chandler was doing all this time). Eakins was left with the reliefs (CL-273, Fig. 151, and CL-272, Fig. 152) and received $500 for his pains in June 1885.

Some reviewers did not like Eakins' sculptures any better than Scott did, although Clark of the *Evening Telegraph* came through again: [14]

> Mr. Eakins has long been known to his scholars and his intimates to be exceedingly skillful with the sculptor's instruments, but we believe that the two pieces in this exhibition are his first attempts to produce anything in the line of sculpture outside of the range of academic exercises. . . . Mr. Eakins is easily the first of American artists, in certain very important particulars, and those beautiful bas-reliefs ought to do much to advance his reputation with a general public which has been rather slow in showing its appreciation of his great merits, for they ought to be—what perhaps some of his paintings have not been—easily and entirely comprehensible to the least instructed understanding. The making of these pieces will be a happy augury if it means that there is a prospect of a really great artist like Thomas Eakins being in

Fig. 153. Eakins' photograph of William H. Macdowell, his sister Margaret, and two boys at Clinch Mountain, Virginia, c. 1881. 10⅞″ × 7⅞″ (27.7 × 20 cm). Metropolitan Museum of Art.

Fig. 154. *Young Girl Meditating,* 1877. Watercolor on paper, 8¾″ × 5½″ (22.2 × 14 cm). Metropolitan Museum of Art.

Fig. 155. Eakins' photograph of Susan Macdowell, 1880–1882? 3³⁄₁₆″ × 4¹⁵⁄₁₆″ (8.1 × 12.1 cm). Hirshhorn Museum and Sculpture Garden, Smithsonian Institution.

the future called upon by the architects who are engaged in constructions of importance to aid them in their labors.

On December 22, 1882, or thereabouts—we know only the burial date, December 24—Eakins' sister Margaret died. There are conflicting reports about Margaret's relationship to her brother. Many people, including Mrs. Eakins and others who knew the family, have said that Margaret was Eakins' favorite sister. But by the time Susan Macdowell began to know much about Eakins' family life, his sister Fanny had gone to live at Avondale and his sister Caroline was being influenced against her brother by Frank Stephens. A baby brother, Benjamin, had died in infancy. So there was, practically speaking, no one else available for the designation of "favorite."

There are contradictions also in the photographs we have of Margaret. The Clinch Mountain photograph (Fig. 153) shows her alert and happy, but another (Fig. 56) makes her look almost dull. Thomas' account of her reaction to his *Hiawatha* may suggest sophistication on her part—or wishful thinking on his (see page 68). There is no question that she shared much of her brother's life, both in the studio, where he did several portraits of her, and outside, such as the time she visited the Jersey shore with her brother and a gaggle of Macdowells, or when she and Elizabeth and Susan Macdowell had "gorgeous" times on Fanny's farm near Avondale.[15]

When Margaret died, there was hanging on the walls of the Academy Annual

Fig. 156. Susan Macdowell Eakins:
Portrait of Thomas Eakins, c. 1889.
Oil on canvas, 50" × 40" (127 × 101.6
cm). Philadelphia Museum of Art.

a watercolor showing her spinning, which her brother was offering for $150. Another
painting at the same exhibition, *Study*, evidently the one now called *Young Girl
Meditating* at the Metropolitan Museum (CL-181, Fig. 154), belonged to Margaret,
according to the catalogue.

As we have noted, Eakins' personal interest in Hannah Susan Macdowell dates
from not later than 1879. The date of his nude photograph of her (Fig. 155) is un-
certain. It was to her that he expressed his pleasure in being appointed professor at
the Academy in September 1879. She was a good painter and she must have been a good
listener. Eakins often talked about his art to his friends and family, but Susan Macdowell
was a favorite confidante.

Eakins' account book shows an increasing number of charges to "Pleasure &
Presents" in 1883, which may indicate that the courtship had begun in earnest. When
the two were married on January 19, 1884, Susan was in her thirty-third year, having
been born on September 28, 1851, and Eakins was in his fortieth. McHenry wrote
that they moved into Arthur B. Frost's studio at 1330 Chestnut Street. There Eakins
kept a studio for about sixteen years, until 1900 when his father died and he fitted
up the fourth floor front attic into a studio. Mrs. Eakins may have moved out of the
Chestnut Street studio a year or so after the marriage.

In 1885, shortly after they were married, Eakins produced the remarkable por-
trait of his wife with his dog Harry (CL-187, Plate 32), and the following year a wash
copy of it for reproduction in Lippincott's *Book of American Figure Painters*. There
are interesting variations between the original and the copy. His wife painted Eakins in
a portrait (Fig. 156) said to have been done in 1921 from photographs, but likely done
at the time of *The Agnew Clinic*.

Eakins' habits were relatively undisturbed by his marriage. An account book shows several pages of entries for the very day of his wedding. Five weeks later he wrote Wallace: [16]

> My dear Johnny:
>
> I have just received today your second letter and I am mortified to think how I have delayed answering you for I myself know well the pleasure of a letter from home when away. Of course you are very much missed by the whole gang.
>
> Wagner became our prosector and chief demonstrator of anatomy on your retirement, and gave satisfaction to all the school. Dr. Keen having commenced his lectures so early this year finished sooner that my course might commence and I am now already on my third lecture on perspective and composition. The school is fuller than ever. There was a great deal of careful work on the horse made in the dissecting room this year, Tommy Anshutz, Harmer Godley, Maclean and McCormick working every night.
>
> A good class worked from the live horse in the modelling room and we will follow up the horse with a cow as last year. A new life modelling class has been started at night for the girls on the boys painting nights and we have at least our still life class going on in the little room. There is solid work going on there all day. I am glad to say the oldest and best pupils patronize it largely and they are painting from eggs to learn nicety of drawing and from pure colored ribbons and muslins the range of their colors.
>
> I have been carpentering and tinkering ever since I have been here but hope to get at pictures again.
>
> Sue sends her love with mine and although I approve very much of the course you have marked out for yourself, that is to earn money at portraits, yet I still hope you will pay us an occasional visit and when you do there is no place barring your mother's where you will find so hearty a welcome as here.
>
> Yours truly,
> Thomas Eakins.

Eakins' portraits of his sister Margaret and of his wife excited little critical attention. But when the artist grouped Susan with two others in a painting he referred to as *Singing a Pathetic Song* (now known as *The Pathetic Song*, Plate 30) the reaction was more enthusiastic. It remains one of his most ingratiating works. It has, for me, a distinct nostalgia for a warm Victorian parlor I never entered, and for a simple girl singing a quiet song.

Early the following year, 1882, Eakins produced another portrait of his father, the first since *The Chess Players* (1876). This is the painting known as *The Writing Master* (CL-185, Fig. 157). The facial expression, *The Art Amateur* commented with characteristic superficiality, was "well-seized, but the picture is mainly a pair of well-drawn and well-colored hands." [17]

Other portraits were produced during Eakins' Academy years, several of which were on a high level: the great Barker and Marks portraits (Fig. 158 and CL-150, Fig.

161), two versions of General George Cadwalader (CL-205), and an unfinished portrait of Mrs. William Shaw Ward. Two other portraits, of E. M. Lewis and Sophie Brooks, now unlocated, are referred to in the account book.

As Schendler points out, Mrs. Ward was the only woman Eakins had painted for several years except for his new wife.[18] He always seemed more sympathetic in painting men than women. A classic example of this is in the Husson portraits in the National Gallery: Louis Husson (CL-111, Fig. 159) was painted with much sympathy, while his wife (CL-113, Fig. 160) appears to be a tight-lipped, narrow, small-souled woman. There is no doubt that Mrs. Husson looked the way he painted her, or that Addie Williams looked like her first portrait (Plate 44). Amelia Van Buren with her tight mouth (Plate 35), Letitia Wilson Jordan Bacon and Miss Harrison in *The Pathetic Song* with their empty expressions, Mrs. Gillespie and Mrs. Gilbert Lafayette Parker with their rigidity (Fig. 270 and Plate 54), or Suzanne Santje and Mrs. Talcott Williams (Plate 53 and CL-289) with their looks of impatience and boredom, are all represented as they were, living the "Victorian horror of their lives," in Leonard Baskin's apt phrase. Eakins did not soften what this Victorian horror had done to them. Men were generally less oppressed by the glacial conventions of the time, and this may be why, however conventional, rigid or shallow men sometimes are in Eakins' portraits, the artist's conceptions of men are on the whole more ingratiating. It is possible that he felt more comfortable with men. It is curious that he did not paint certain men whom he knew well, such as his brother-in-law William J. Crowell and William Sartain, whom he never painted in a formal portrait. It may be only coincidental that both were unsympathetic to Eakins as a person, and, in the case of Sartain, as an artist as well.

Apart from the fact that he made a trip to Lake Champlain, little is known of

Fig. 157. *The Writing Master*, 1882. Oil on canvas, 30″ × 34¼″ (76.2 × 87 cm). Metropolitan Museum of Art. The artist's father, Benjamin Eakins, was the model.

Fig. 158. *Portrait of Professor George F. Barker* (detail), 1886. Oil on canvas, 24″ × 20″ (60.9 × 50.8 cm). Private collection. This painting was cut down from 60″ × 40″ to make it more salable.

Fig. 159. *Portrait of Louis Husson*, 1899. Oil on canvas, 24″ × 20″ (60.9 × 50.8 cm). National Gallery of Art.

Fig. 160. *Portrait of Mrs. Louis Husson*, c. 1905. Oil on canvas, 24″ × 20″ (60.9 × 50.8 cm). National Gallery of Art.

Fig. 161. *Portrait of Professor William D. Marks*, 1886. Oil on canvas, 76″ × 53½″ (193.1 × 135.9 cm). Washington University Gallery of Art, St. Louis.

Fig. 162. *Portrait of Dr. Horatio C. Wood*, c. 1889. Oil on canvas, 64″ × 50″ (162.6 × 127 cm). Detroit Institute of Arts.

the summer of 1886 in Eakins' life. In the fall he went back to the League's students—he may have worked with them a bit during the summer—and began his tenure at the Art Students' League of New York. But apart from the portraits of William D. Marks and George F. Barker, both signed and dated 1886, no work except the Dakota studies is known to have been produced. The Marks and Barker portraits may well have been done before the Academy rupture. The unfinished Frost portrait may have been unfinished for the very reason that the artist left the Academy.

It is unfortunate that we do not have recourse to the papers of Dr. Horatio C. Wood, whom Eakins painted at about this time (CL-144, Fig. 162). Wood was a professor of nervous diseases at the University of Pennsylvania, and considering the fact that Eakins, the most energetic of artists, scarcely laid a brush to canvas for a year and a half, Wood's private manuscripts might be of great interest. Further, Wood had part interest in a Dakota ranch where Eakins was about to go, and where he began to work again regularly. It is possible that Eakins was treated by Wood, and that Wood recommended the ranch vacation.

Despite the *Bulletin*'s blind confidence that they would soon come back, sixteen or so of the forty young men who protested Eakins' leaving the Academy by leaving themselves did not, in fact, return. One week after their nocturnal march up Chestnut

Street, they set up shop on the second floor of a three-story building near the northwest corner of Market Street and West Penn Square.[19] Eakins or one of the boys wrote J. Laurie Wallace about the debacle almost immediately after it happened, for on February 23, the day after the Arts Students' League was founded, Eakins replied to a letter of condolence from Wallace: [20]

> My dear Johnny,
> Your good letter came to me betimes, and I thank you very much for it. Your confidence in me and my good intentions has not been displaced. I have often thought differently from others but my heart was open to my friends.
> I never deceived any one or tried to. I have put myself out to help along in their work my worthy students. Such as you have always known me, such I am now and will be.
>
> <div align="right">Yours truly,
Thomas Eakins</div>
>
> Susie was as pleased as I was with your letter.

Four months later, in reply to the letter answering this, Eakins wrote again: [21]

> My dear Johnny,
> I am ashamed to see the date of your letter to me. I was very busy when I received it, and so Susie commenced to answer it for me, but her letter seemed to me not good and she tore it up to let me write instead. I am very glad you want something of mine, & shall send you the first sketch I may make that may seem to me worth your having.
> As regards the infamous lies that were circulated and which imposed upon some people who should have known better, any of them are easily disproved to any one who takes the trouble to find out.

At the end of the first term on June 1, the sixteen faithful got together and sent Eakins a letter of appreciation: [22]

> Dear Sir,
> We, the undersigned, have assembled this day, to thank you for your appreciation and kindness shown us during the past school season.

Chas. B. Cox	J. P. McQuaide	James Wright
Edw. W. Boulton	Albert W. Baker	Geo. Reynolds
Henry A. Nehmsmann	Eldon R. Crane	Chas F. Fewier
G. H. Merchant	Rudolph Spiel	August Zeller
James J. Cinan	Thos. Eagan	Alex. Duncan
	Charles Bregler	

Later that summer, on July 14, perhaps because her husband was out of town and perhaps because he could not bring himself to have any contact, however formal, with anyone at the Academy, Mrs. Eakins wrote the Academy asking for *Crucifixion*, now called *Ecce Homo*, for the Louisville Exposition.

Except for the Academy, however, Eakins continued to exhibit. In addition to *Crucifixion* he sent to the Louisville show, which opened on August 28, 1886: *The*

Swimming Hole, which Coates, friend or not, loaned him; the George Reynolds portrait, now called *The Veteran*; and his *Mending the Net* and *Drawing the Seine*, of a few years back. He also sent a still unidentified "strong female head," [23] *A Lady with a Setter Dog*, called *Portrait of Lady and Dog*, and his Scott bronzes to the Society of American Artists' exhibition which opened in New York on April 25, 1887. There they had the usual effect—quibbling reviews by critics who did not know that art could still be good even though it was unconventional. In his sculpture, the *Art Amateur* critic wrote, Eakins pushed in or pulled out his "field" according to his convenience, and in Mrs. Eakins' portrait, although the dog was rendered in accordance with a good theory of painting, the lady's figure was "unfortunate." [24]

In January 1887 John Sartain, who never liked Eakins much, and William Sartain, who was now willing to give him a good kick, with perhaps an "I-told-you-so," organized an exhibition of American art at Earl's Court in London and failed to invite Eakins to contribute, although everyone else was there. There were six galleries, each forty feet square, but not a single Eakins. It was as though he had not done any painting whatever in the past several years, as though he had not been one of the most conspicuous American artists of the past decade and a half, in both Europe and America.

Exile. The Philadelphia Art Students' League
1886-1892

By the summer of 1886 Eakins was seized with a new, exciting project. He was going to take a trip of several weeks into the Wild West. He wrote Wallace of his plans: [1]

> Dear Johnny:
>
> I am glad to think of the pleasure I promise myself of seeing you if you are at leisure on Tuesday morning July 26. I am going to take a little trip to the West, & shall pass through Chicago, arriving at 7 A.M. and leaving at 2:15 P.M. I am very glad to hear that you are well established socially and artistically. . . .
>
> I do not forget your sketch. Only I haven't got one now that I care to give you. My best ones were all given away, some to unworthy people, others were covered up. When I give you a sketch I want it to be good.

Walt Whitman, whom Eakins visited soon after he returned from his trip, said to Horace Traubel, his biographer–amanuensis, that Eakins was "sick, run down, out of sorts; he went right among the cowboys; herded; built up miraculously . . . he needed the converting, confirming, uncompromising touch of the plains." [2]

The site of this miracle was the Badlands of the Little Missouri, in what is now

southwestern North Dakota. In Eakins' time it was simply Dakota Territory. It was country that Theodore Roosevelt had visited to improve his health a few years earlier, and is said by Roosevelt's biographer to be "wild and fantastic in its beauty." [3]

Between the prairie lands of North Dakota and the prairie lands of Montana there is a narrow strip of broken country so wild and fantastic in its beauty that it seems as though some unholy demon had carved it to mock the loveliness of God. On both sides of a sinuous river rise ten thousand buttes cut into bizarre shapes by the waters of countless centuries. The hand of man never dared to paint anything as those hills are painted. Olive and lavender, buff, brown, and dazzling white mingle with emerald and flaming scarlet to make a place of savage splendor that is not without an element of the terrible. The buttes are stark and bare. Only in the clefts are ancient cedars, starved and deformed. In spring there are patches of green grass, an acre here, a hundred acres there, reaching up the slopes from the level bottom-land; but there are regions where for miles and miles no green thing grows, and all creation seems a witch's caldron of gray bubbles tongued with flame, held by some bit of black art forever in suspension.

Eakins may have visited two ranches during his stay. Charles Bregler, his pupil, wrote that one belonged to the Badger Cattle Company, located on Beaver Creek about fifty miles north of Medora, North Dakota. McHenry, who talked with Bregler, Thomas Eagan, Samuel Murray, and George Wood (Horatio Wood's son, who was at the ranch with Eakins), wrote that Eakins also visited the B-T Ranch in the same territory. McHenry also wrote of Wood's financial interest in the ranch Eakins visited, but she or her informants may have been mistaken about which ranch Wood had an interest in. It is more likely to have been the Badger, since another Philadelphian, Bush Shippen Huidekoper, a colleague of Wood's at the University of Pennsylvania, who collaborated with Eakins and Muybridge in their motion studies there, was the backer of Howard Eaton, founder of the Badger Ranch.

McHenry wrote of various nineteenth-century high jinks at the ranch: [4]

. . . if it had not been for [Eakins'] geniality and generosity his ignorance of the customs of the country would have made him an open mark for the cowboys' sense of humor. For example, once a cowboy who didn't belong to the B-T Ranch remarked that he had laid his gun down somewhere and asked Eakins to lend him his. Eakins was naive enough to have handed over his own gun if he hadn't been prevented by his more experienced friends. George Wood remembered Eakins constantly went painting, and sometimes Wood went along. . . . Eakins would hand Wood canvas and paint and tell him to go ahead. . . . Wood couldn't remember that Eakins ever went out to work the cattle, but Eakins wrote back to Sue [5] that he had taken part in the round ups, one time riding all of sixty miles in one day; had taken part in all the work a cowboy does in the life on a ranch, so much so that he hadn't been permitted to pay his board, though he'd wanted to. . . .

Eakins also wrote to Wallace from Dakota, saying that he was sorry to have missed him coming through Chicago on the way out, but that he hoped they could get together on the way back. He was in perfect health, he told Wallace, and "moderately happy." He slept on the ground with the other boys, frequently between wet blankets, but he had nevertheless not caught a single cold, and he had not had one bilious spell. He had bought two horses, an Indian pony named Baldy and a broncho named Billy, and he was going to ride with them in a cattle car to Chicago. He would help take care of the cattle, and as a result he could take his horses along. Cattle trains, he wrote Wallace, had air brakes and could go faster than passenger trains.

Eakins wrote his wife that he had bought the pony for the Crowell children in Avondale, and that he would come home riding down Mt. Vernon Street on one horse, leading the other. He asked her not to tell Harry he was coming. "Don't tell him about me," he wrote, "until I am almost home." [6]

In the Chicago stockyards on the way back home on October 4 Eakins wrote Wallace again. He had arrived "all safe and sound" with the broncos, and was staying at the Transit House. He was waiting for a chance to ship his horses with someone else's animals, and he couldn't leave the neighborhood. He hoped Wallace could come to see him for a few minutes in the morning, at least, and would at any rate save Sunday for him. Sunday, from October 4, 1887, was October 9, which means that Eakins was planning to wait over Sunday in Chicago, whether or not he had a chance to ship his horses before that time. He must really have been eager to see Wallace.

It was not until December that Eakins found time to write Wallace again. Apparently he had seen his pupil and was now telling him what happened on the way back to Philadelphia. He was plunging into work now that he felt better, and had not had time to write before: [7]

> Dear Johnny,
> . . . I had a splendid time coming on, meeting with no accidents and no unpleasantness except a little delay around Baltimore. I was entirely comfortable, more so than in a sleeper. I could lie down or go back into the caboose or climb up on the top of my car to enjoy the scenery. I came through as pretty a country as ever I saw especially around Harper's Ferry that I passed soon after sunrise. . . .
> My trunk arrived long before my clothes, so I stabled the horses and then went into the bath tub and to bed and next day rigged up in a boiled shirt, etc. On Saturday I got my father to ride down in the cars to Media and wait there for me to pass through on my way to the farm 40 miles down the road, W. S. W. from Phila, where my sister's husband's farm is. I started down on the broncho leading the pony. At Media where the prettiest country begins, my father got on Baldy and we had a ride down to the farm. At Kennett Square, six miles this side of the farm, we met Susie on horseback and all the little children and their father in the wagon coming out to meet us. Then my father got in the wagon and little Ben got on the

pony, and little Ella on Susie's horse, and we scampered home like cowboys.

Little Baldy is ridden every day to school by one of the children at least an hour before school and then the school children are allowed to ride him by turns until Mr. Crowell returns with the milk wagon. Then he leads Baldy home unless another child coming in the milk wagon rides him home and in the village he is met by another crowd of children who would like to ride him as far as the farm. So I have been a public benefactor with the little beast besides giving the children the greatest happiness they have ever had. Nor is the pleasure confined to the children only. My sister is very fond of the little beast and often rides him in the afternoon when she has finished her work and Susie rides him whenever we go down to the farm.

The other horse, the broncho, had a bad cold the first week he was here but got over it all right. He has the sweetest disposition that a horse ever had. He follows my sister around and the greatest trouble is to keep him from coming into the house after her. When the door is shut he puts his nose against the pane in the kitchen window. They wheel the baby coach under his nose for the baby to play with him.

Although so rough gaited the children ride him too, but not so well as little Baldy the mustang. I hope when you come on you will find time to go down to the farm for a day or so and we can ride over and see Benny McCord * the farmer artist or anywhere else. . . .

<div align="right">

Yours

T. E.

</div>

Eakins brought back with him many sketches and photographs from his trip (CL-281 and Figs. 163 and 164). One of these, *Cowboys Circling,* previously unknown to history and now unlocated, belonged to John Hemenway Duncan, the architect for two of Eakins' sculpture jobs (page 223). But the central *oeuvre,* a curious, strangely surrealistic landscape, was *Cowboys in the Badlands* (Plate 33). In 1971 it broke all auction records for an American painting when it sold for $210,000 at a Parke-Bernet sale.

Besides going to work on new paintings, Eakins looked about him for a work painted before February 1886 that had not been publicly shown, and he lighted upon his portrait of George Barker (Fig. 158) to be sent to the Annual of the National Academy of Design. The painting won the Thomas B. Clarke prize for "the best American figure composition painted in the United States," and received great acclaim from the New York critics. The *Sun* led off: [8]

> A more frank piece of realism, it would hardly be too much to say a more brutal piece of realism, than Mr. Eakins's portrait of a Philadelphia professor it would be hard to imagine. Yet it would not be easy to find a much clearer piece of portraiture or a more vigorous and, for its purpose, adequate technical method. The man is painted as though with a scalpel instead of a brush or palette knife, so unerringly, we feel so ruthlessly we see, has the work been accomplished.

* One of Eakins' Assistant Demonstrators of Anatomy at the Academy.

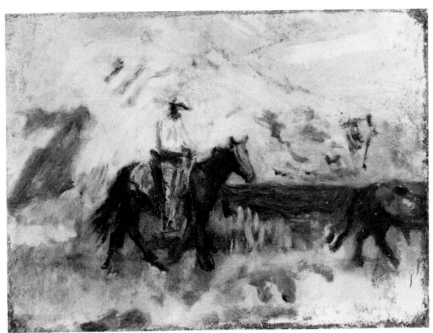

Fig. 163. *Sketch of Cowboy in Cowboys in the Badlands,* 1887. Oil on canvas, 24″ × 30″ (60.9 × 76.2 cm). Philadelphia Museum of Art.

Fig. 164. Eakins' photograph of unidentified man in Dakota Territory, 1887. 4½″ × 3⅝″ (11.5 × 9.2 cm). Collection of Mr. and Mrs. Daniel Dietrich II, Philadelphia.

The *Times* generally agreed. Barker was painted as he *was:* [9]

> Philadelphia contributes one of the best portraits, that of Prof. George F. Barker, of the University of Pennsylvania, by Thomas Eakins. Here is another strong artist who differs from Sargent, Eaton, Weir, Chase, and the rest. It is not elaborated in a soft or winning style, but painted ruggedly, yet with the utmost truth to nature. We see the intent scholar, the Professor of Chemistry, careless of dress, anxious that his pupils shall learn the exact truth, and at the same time possessed with ideas of original research that take his mind off the daily drift. It is a picture which may be readily overlooked, though it holds a place of honor, for it has no adventitious or picturesque details to attract the eye.

Three other portraits, of Blanche Hurlburt (CL-277), a former Academy student, of Letitia Wilson Jordan Bacon (CL-173, Fig. 165), the sister of David Wilson Jordan, and of Douglass Hall, a Philadelphia Art Students' League student, were also painted about this time.

But the portrait masterpiece of the two or three years following Eakins' return from his ranch trip was that of Walt Whitman (CL-219, Fig. 166), who had been living across the river in Camden, New Jersey, since 1882. Although the chronology of the Whitman portrait is complicated,[10] the artist probably started the work soon after he returned from Dakota, having been introduced to Whitman by "Talk-a-lot"

Fig. 165. *Portrait of Letitia Wilson Jordan Bacon*, 1888. Oil on canvas, 60″ × 40″ (152.4 × 101.6 cm). Brooklyn Museum.

Williams (Talcott Williams, whom Eakins painted in about 1890 with his mouth open [Fig. 167]).*

Whitman said that once Eakins got started on the portrait he "painted like a fury." [11] On April 15, 1888, it was "about finished," and hung on the wall the following day. Judging from Traubel's account of Whitman's life, which recorded almost day-by-day minutiae, there seems not to have been a great number of sittings. We know of no other work besides the Whitman portrait that was completed during the winter of 1888. Only two portraits exist that are even dated 1888. Eakins was having trouble getting back into his old schedule.

Eakins also took photographs of Whitman during the time the portrait was underway. Their chronology is complicated, and I have discussed it in some detail in my book on Eakins photographs. As far as I know there are ten Eakins photographs of Whitman that still exist, as well as one of Whitman's housekeeper (Figs. 168 and 169).

*Eakins also painted Williams' wife (CL-289), but she got angry and left before the sittings were over, and her portrait—although the *Inquirer* raved about it (page 273)—was never finished. One day while she was posing, Eakins had a gentleman caller. When the caller left, Eakins poked Mrs. Williams in the stomach and told her that now she could relax.

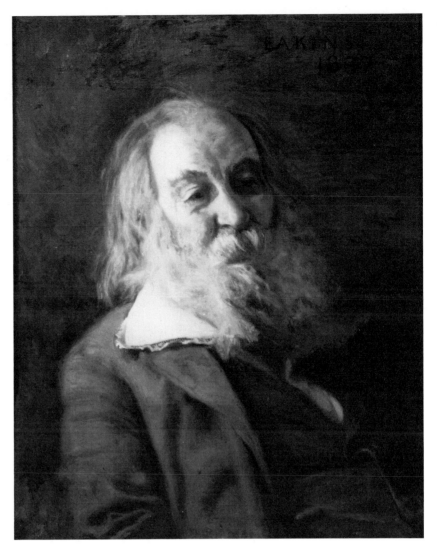

Whitman remembered well his first meeting with Eakins. Eakins seemed "careless, negligent, indifferent, quiet; you would not say retiring, but amounting to that." "Indifferent" is the word that would seem most likely to apply to Eakins at this point. He had given everything to the Academy and his students, and he must have had numerous doubts about whether or not it had been worth it. Eakins apparently never asked Whitman to sit, but heard from someone else—probably Talcott Williams—that Whitman would be willing to do so. So he went over to Camden, as Whitman tells it, canvas under his arm, and announced that "he had understood I was willing he should paint me." A painted study for the portrait, which was not taken from a photograph, but from Whitman himself as he sat at the downstairs parlor window, is remarkable (CL-134, Fig. 170), and the final portrait became Whitman's favorite. He had had others done, but he liked Eakins' best. He thought it made him look like "a poor old blind despised & dying king," but he stuck to it "like molasses to a jug." [12]

> Of all the portraits of me made by artists [Whitman wrote], I like Eakins's best. It gets me there—fulfills its purpose, sets me down in correct style, without feathers, without fuss of any sort. I like the picture always—it never fades or weakens. It is not perfect, but it comes nearest being me. . . . Eakins errs just a little—a little—in the direction of the flesh.

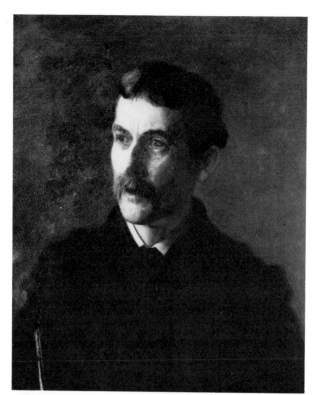

Fig. 167. *Portrait of Talcott Williams*, c. 1890. Oil on canvas, 24½″ × 20½″ (62.2 × 52.1 cm). Private collection, New York. Williams was nicknamed "Talk-a-lot" Williams; Eakins has painted him with his mouth open.

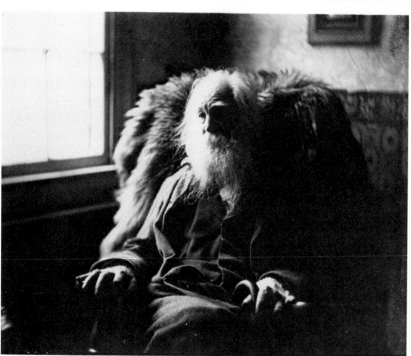

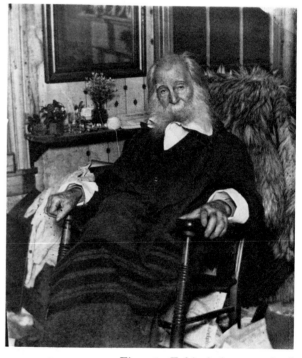

Fig. 168. Eakins' photograph of Walt Whitman, c. 1891. 4″ × 5″ (10.2 × 12.7 cm). Philadelphia Museum of Art, bequest of Mark Lutz.

Fig. 169. Eakins' photograph of Walt Whitman, c. 1892. 7¾″ × 6¾″ (19.7 × 17.2 cm). Collection Mr. and Mrs. Daniel Dietrich II, Philadelphia.

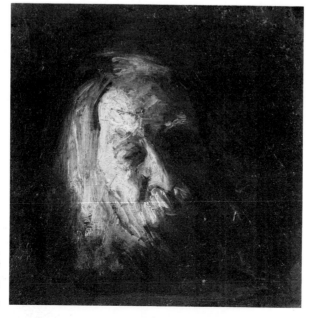

Fig. 170. *Sketch of Walt Whitman*, c. 1887. Oil on panel, 5¼″ × 5¼″ (13.3 × 13.3 cm). Boston Museum of Fine Arts.

Whitman and Eakins hit it off at once, perhaps because they were alike in so many ways. It is glib but true to say that they were both rejected by society in spite of having done their best for it, because what they had done was unconventional. Eakins, Whitman thought, was "a good comrade." He delighted in a story about Eakins and a girl model: "The girl had appeared before the class, nude, with a bracelet on—Eakins, thereupon, in anger, seizing the bracelet and throwing it on the floor. 'It was just like Eakins, and oh! a great point in it too!' " [13]

Whitman's health grew steadily worse after 1888. More than once his numerous friends in and around Philadelphia hurried over to Camden on a report that he was dying. But in spite of a great number of things the autopsy showed were wrong inside him, Whitman lingered until March 26, 1892. The day after he died Eakins and Samuel Murray, his young friend and pupil, made a death mask of his face and shoulders (Plate 36).

Eakins had met Murray (Fig. 171) in about 1886 or 1887 in a cemetery—an appropriately melancholy place for the artist at this time of his life. Murray's father was a stonecutter (Fig. 172), and Murray may have been helping him in his work when he ran into Eakins. How Eakins must have delighted in Murray's youth and innocence! Murray immediately joined Eakins' class at the Art Students' League, and although he apparently studied painting for a while, he soon switched to sculpture and became, in time, an artist of considerable interest.

In April 1888 Earl Shinn's nephew, Richard T. Cadbury, wrote Eakins to ask if he would make a drawing of some sort of plaster or metal hand Cadbury owned. He

Fig. 171. Eakins' photograph of Samuel Murray, c. 1890. 3⁵⁄₁₆″ × 3″ (8.4 × 7.6 cm). Hirshhorn Museum and Sculpture Garden, Smithsonian Institution.

Fig. 172. *Portrait of William Murray*, c. 1890. Oil on canvas, 20″ × 16″ (50.8 × 40.7 cm). Private collection.

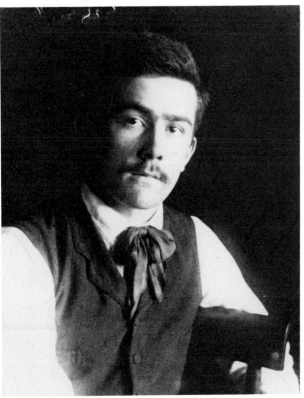

must have been a very young man, for his request that Eakins make the drawing was naïve, but Eakins answered him directly and gently: "I am not an illustrator, and I fear you will be disappointed. . . . However you seem to know just what you want in the drawing, and I am willing to help you to this extent. . . . I shall be happy to make the drawing under your direction and free of charge." [14] It was not until a year later that Cadbury followed up on Eakins' offer. "I shall do [it] with pleasure," Eakins wrote him. "Let us say some day next week but not Tuesday or Wednesday." [15]

Tuesdays and Wednesdays may have been the days that Eakins had set aside for work on his next conspicuous painting, *The Agnew Clinic* (Fig. 173).

"Conspicuous" and "elaborate"—but not "great"—are words for *The Agnew Clinic*. It was not what Eakins hoped it would be, not another *Portrait of Professor Gross*, not even another *Champion Single Sculls* in its compositional effect. It contains magnificent, brilliant parts; the portrait of Agnew, for instance, is a masterpiece. But these parts do not cohere into a successful whole. The artist seems still not to have recovered from his shock of February 1886, and I believe that he was trying a kind of work no longer close to either his skill or his heart. From now on his best paintings were straightforward, uncomplicated portraits, with sitters accompanied by elements from their milieus, and these elements few in number. Only in his portrait of Mrs. Frishmuth (Plate 48) did the artist add much accompanying detail. Henceforward —after *The Agnew Clinic*—his portraits were to be only portraits, and very little more. In these works, however, he reached the summit of his art.

The Agnew Clinic was commissioned by members of Agnew's class in the medical school of the University of Pennsylvania. Agnew was resigning from a long and brilliant career, and his students wanted to show their appreciation by this painting, designed for presentation to Agnew at the 1889 commencement, and eventually destined for the University as a memorial to the famous surgeon. Goodrich implies that Eakins had been expected to produce a painting of the single figure of Agnew for $750. But for some reason (perhaps because the rejection of his Gross picture still rankled) he decided to enlarge the work to a view of the whole clinic. He included numerous identifiable portraits among the figures helping Agnew with his operation, an operation for the removal of a breast cancer, and among the spectators. Again the artist himself appears, but this time, some critics believe, he was painted by his wife. Dr. J. William White, who succeeded Agnew in the University's Chair of Surgery, and Dr. Joseph Leidy II, whom Eakins painted again the following year (CL-158), are attending Agnew, and these are brilliant portraits. The study for Agnew (CL-19, Fig. 174), incidentally, was the only work by Eakins acquired by the notorious Dr. Albert Barnes, who thought that Eakins "created nothing that can be said to have been truly original." [16]

The artist is said to have attended Agnew's lectures numerous times, in order to get the feel of the situation and to know the amphitheatre. The portrait sittings were held in Eakins' third-floor studio at 1330 Chestnut Street. It is said that Agnew's portrait took ninety-six hours, which is scarcely credible. "I can give you just one

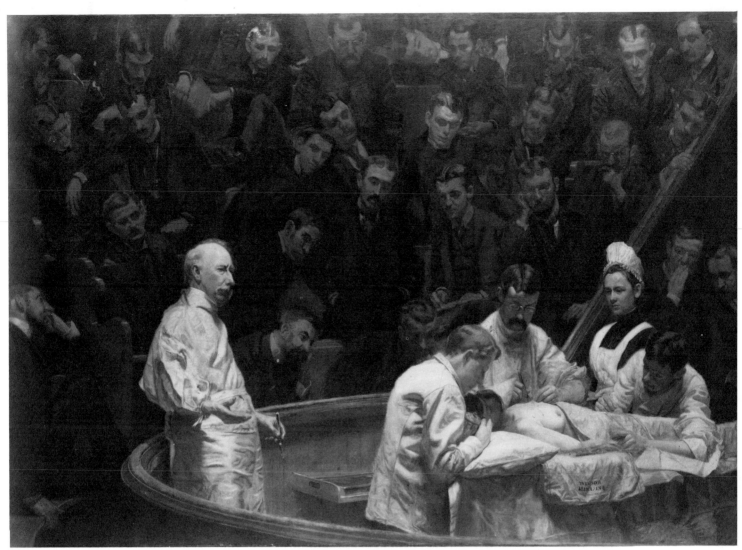

Fig. 173. *The Agnew Clinic*, 1889. Oil on canvas, 74½″ × 130½″ (189.2 × 331.5 cm). University of Pennsylvania. In the operating arena, left to right: Dr. D. Hayes Agnew, Dr. Ellwood R. Kirby, Dr. J. William White, Nurse Clymer, Dr. Joseph Leidy II; in passageway: Dr. Fred H. Milliken and the artist, who is said to have been painted by Mrs. Eakins. The students are identified in *The Old Penn Weekly Review*, October 30, 1915.

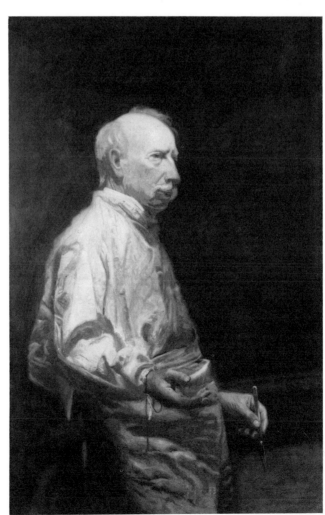

Fig. 174. *Study of Agnew for The Agnew Clinic*, 1889. Oil on canvas, 49″ × 31½″ (124.5 × 80 cm). Yale University Art Gallery. This is the single Eakins work acquired by Dr. Albert Barnes.

Fig. 175. Mrs. Thomas Eakins: Photograph of Eakins in his 1330 Chestnut Street studio, c. 1892. 3⁹⁄₁₆″ × 2¾″ (9 × 7 cm). Author's collection.

hour," Agnew is quoted as saying each time he arrived in the studio,[17] and as having demanded, on seeing the final painting, that the blood should be taken off his hands. Eakins took some of it off, but left some on. This may have been partly responsible for Agnew's not having any comment to make about the portrait when he saw it finished.

It has been said that for the three months in which Eakins had to complete *The Agnew Clinic*, he got up at 4 A.M. and worked as long as the light lasted. McHenry wrote that since the picture was too big for an easel, Eakins painted it on the floor, sitting cross-legged, and that one night a student came in and found him stretched out in front of the painting, asleep. Perhaps it was during this period that Samuel Murray got the idea for his statuette of Eakins sitting cross-legged with a palette and brush in his hands (Fig. 176). There is, in fact, in the Hirshhorn Collection, a photograph of Murray's statuette placed in front of a large reproduction of *The Agnew Clinic*.

The Agnew Clinic was presented to Agnew at the commencement of the University of Pennsylvania Medical School at the Academy of Music on May 1, 1889. According to University records, however, it was not paid for in full for another ten years, when 3 per cent interest was added to the original amount.

More successful than *The Agnew Clinic* were several portraits Eakins produced these years of his Art Students' League students—Franklin Schenck, Amelia Van Buren (CL-114, Plates 34 and 35), and Samuel Murray (Fig. 179). He painted Schenck in two formal portraits, now called simply *Portrait of Franklin Schenck* (CL-24, Plate 37), and *The Bohemian* (CL-290, Fig. 180), both of which are among his most attrac-

Fig. 177. Thomas Eakins, c. 1888. Hirshhorn Museum and Sculpture Garden, Smithsonian Institution.

Fig. 176. Samuel Murray: *Thomas Eakins*, c. 1890. Plaster, 9″ (22.9 cm) high. Pennsylvania Academy of the Fine Arts, gift of Malcolm Sausser.

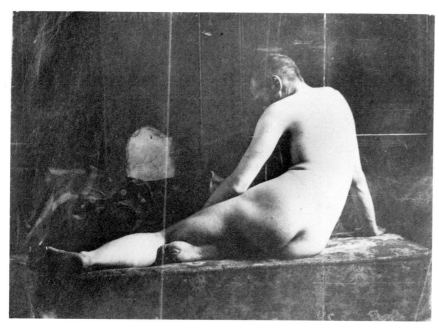

Fig. 178. Thomas Eakins, c. 1888. Hirshhorn Museum and Sculpture Garden, Smithsonian Institution.

tive works. He also painted Schenck in a cowboy suit brought back from Dakota, playing the banjo in *Cowboy Singing* (CL-291), and playing the guitar with Murray listening in *Home Ranch* (CL-292, Fig. 181). He also painted his pupil Edward Boulton in this cowboy suit, in a portrait that is now unlocated.[18] In the course of this work he also painted Schenck's father (Fig. 182), and took many photographs of Schenck (Fig. 183).

The Red Shawl (CL-286), probably picturing a professional model at the League, was also painted about 1890. Portraits of Francis Ziegler, the Art Union student who tried unsuccessfully to get into the Academy (p. 104) and who was secretary of the Art Students' League (CL-137), and of James Wright (Fig. 184), another student, who went off with Schenck when the League closed to live the pure life of barter and trade on Long Island, were also produced at this time.*

One of the models at the Art Students' League was Mrs. Eakins' father, William H. Macdowell. More than one portrait of Macdowell, later attributed to Eakins, is still with us. But three or four that are unquestionably Eakins' tower above the efforts of the students (CL-195, Fig. 186). It may also have been at this time that the artist took photographs of his father-in-law (Figs. 187 and 188), although it is likely that these had been taken a few years earlier, when he set up a backdrop in the side yard at Mt. Vernon Street and took many photographs of members of the family and friends (see Chapter 11).

A work that numbers among the artist's least successful projects was produced at this time: a study for *Phidias Studying for the Frieze of the Parthenon* (Fig. 190). Like *Hiawatha* and *Columbus in Prison* and the *Arcadia* oils—not the *Arcadia* sculptures—this painting was one of Eakins' occasional efforts at portraying the imaginary. Eakins, with both feet, head, and heart solidly in Nature, did not find such work com-

* Years later, still painting and playing the guitar (Fig. 185), Schenck wrote Murray that he was "externally getting like an old oak, internally the Perennial fires of youth burn as bright as ever." Like other Eakins students he did not like the abstract paintings that were beginning to take over, and was glad that Eakins' work, then at a Brummer exhibition, burned brighter "every show down." (From a letter of December 5, 1925, in the Hirshhorn Collection.)

Fig. 179. *Portrait of Samuel Murray*, 1889. Oil on canvas, 24″ × 20″ (60.9 × 50.8 cm). Private collection.

Fig. 180. *The Bohemian*, c. 1890. Oil on canvas, 24″ × 20″ (60.9 × 50.8 cm). Philadelphia Museum of Art. This painting was called simply *Portrait* when it was first exhibited; it is of Franklin Schenck.

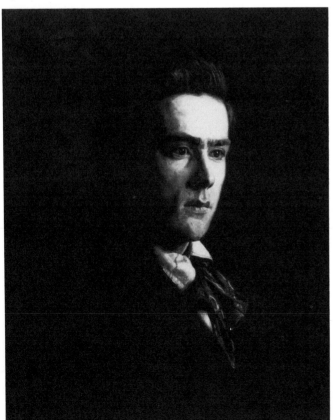

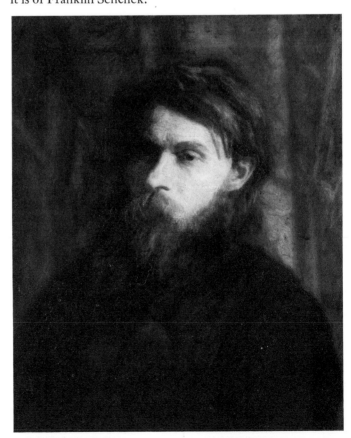

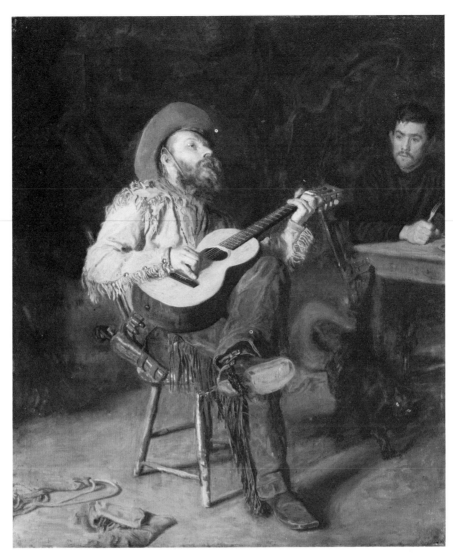

Fig. 181. *Home Ranch*, 1892. Oil on canvas, 24″ × 20″ (60.9 × 50.8 cm). Philadelphia Museum of Art. Schenck and Murray.

Fig. 182. *Portrait of Franklin Schenck's Father*, c. 1890. Oil on canvas, 24″ × 20″ (60.9 × 50.8 cm). Collection Nelson C. White, Waterford, Connecticut.

Fig. 183. Eakins' photograph of Franklin Schenck, c. 1890. 4⅝″ × 3¹⁄₁₆″ (11.7 × 7.8 cm). Hirshhorn Museum and Sculpture Garden, Smithsonian Institution.

patible with his talent. Adam Albright remembered that Eakins was very much impressed by the Parthenon frieze (Fig. 190):[19]

The one shining example of absolute correctness blazed out from antiquity in the marbles of Phidias for the frieze of the Parthenon. These, which had long puzzled students and scholars because the poses seemed strange from

(left) Fig. 184. *Portrait of James Wright,* c. 1890. Oil on canvas, 42″ × 32″ (106.7 × 81.3 cm). Private collection.

(right) Fig. 185. Photograph of Franklin Schenck, c. 1925. Collection Nelson C. White, Waterford, Connecticut.

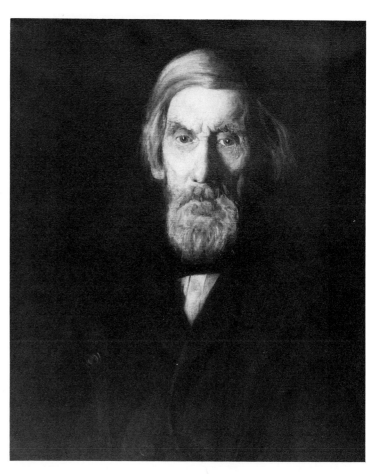

(*left to right*)

Fig. 186. *Portrait of William H. Macdowell,* c. 1891. Oil on canvas, 24″ × 20″ (60.9 × 50.8 cm). Memorial Art Gallery of the University of Rochester, Rochester, New York.

Fig. 187. Eakins' photograph of William H. Macdowell, 1884? 11⅝″ × 9″ (20.1 × 22.9 cm). Author's collection.

Fig. 188. Eakins' photograph of William H. Macdowell, c. 1884. 3½″ × 2½″ (8.9 × 6.4 cm). Author's collection.

the standpoint of ordinary observation, were now proved [by the invention of motion pictures] to be amazingly accurate and gave rise to a speculation by Eakins that Phidias might have dissected horses and made little jointed and movable models from his findings.

Samuel Murray told Margaret McHenry that Eakins "dreamed" of making a painting of Phidias working on the frieze, and made sketches for it showing Phidias pointing out to two nude youths two others riding horses, the movements he was putting into his sculpture.[20] Some of the sketches, Murray remembered, were very similar to two in the frieze.

At some time during the Whitman days Eakins also produced a portrait of Dr. Thomas B. Harned, later one of Whitman's executors, and a regular participant in Whitman celebrations.

Now Eakins was back in stride. The Schenck, Macdowell, and Van Buren portraits are as good as any he had done before the Academy shock. And his portrait of Weda Cook, now known as *The Concert Singer* (CL-288, Plates 38 and 39), is near the peak of his art. Miss Cook was a faithful friend of the Art Students' League, and helped entertain them in their annual February 22 celebrations of the League's founding. On their third anniversary the object—or victim—of the students' sense of humor, she sang for the school. A program for this occasion is in the Hirshhorn Collection, and the part reproduced here gives us a good idea of the League's way of life.

<div align="center">

PROGRAM

</div>

SPECIAL NOTICE—The Audience are requested to restrain their indignation, and not to assault the alleged performers with deadly weapons.

Fig. 189. Model with cast of Greek torso, undated. Oil on paper, 11¼″ × 8″ (28.6 × 20.3 cm). Private collection.

Fig. 190. *Phidias Studying for the Frieze of the Parthenon,* c. 1890. Oil on panel, 10⅝″ × 13¾″ (27 × 34.9 cm). Private collection.

Fig. 191. Samuel Murray (?): Thomas Eakins at about 65, c. 1909. Hirshhorn Museum and Sculpture Garden, Smithsonian Institution.

(*left*) Fig. 192. *Portrait of Maud Cook,* 1895. Oil on canvas, 24″ × 20″ (60.9 × 50.8 cm). Yale University Art Gallery. Maud was Weda's sister.

(*right*) Fig. 193. *Portrait of Weda Cook,* c. 1895. Oil on canvas, 24″ × 20″ (60.9 × 50.8 cm). Columbus Gallery of Fine Arts, Ohio.

1. The Orchestra under the able bat of the renowned Th----re Th---s, will begin the torture with one of Bakeoven's Moonlight Snorters.
2. Brer Barrows will add to the misery with a song.
3. Brer Schenck will intensify the audience's longing to go home with the Prophecy of Calchas.
4. Brer Pollock will empty the room with a tenor solo.
5. The Orchestra will perform the Serenade by Titl.
6. Brer Spiel will perform a Fantasie by Singelee (Not of "The Record")
7. Brer Murphy will sing a pathetic song.

N.B. During this number sheets will be provided to wipe off the tears and tubs to wring 'em out in; also, we have thoughtfully caulked the floors to prevent the lower stories from being flooded, and one of Cox's shoes will be moored handily as a life boat.

Miss Weda, the Favorite Contralto, has kindly promised to sing for us.

"Th----re Th---s" is Theodore Thomas, who was then giving regular concerts in Philadelphia; "Brer Schenck," Franklin Schenck; "Brer Spiel," Rudolph Spiel.

Weda Cook was also a friend of Walt Whitman, who had once asked her if she had taken singing lessons. He was glad when she told him she had not, and advised her never to get started. After Whitman's funeral, according to legend, she was stood up on a table and "commanded" to sing Whitman's "O Captain! My Captain!" which she had set to music, and which is now lost.

Eakins is said to have taken two years to finish the painting, for which Miss Cook often sang "O Rest in the Lord," from Mendelssohn's *Elijah*. Eakins carved the frame for the picture, which still surrounds it, and has carved a few bars (incorrectly) from the *Elijah* aria. The note Miss Cook is holding in her portrait is evidently the one on "for" in the phrase "wait patiently for him." Eakins also took photographs of Miss Cook and her sisters at this time and painted her sister Maud (CL-21, Fig. 192) and another

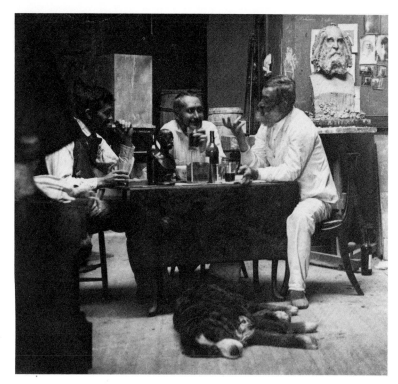

Fig. 194. Left to right: Samuel Murray, Eakins, and the sculptor William O'Donovan in Eakins and Murray's studio at 1330 Chestnut Street, Philadelphia, c. 1892. Eakins' dog Harry is on the floor, O'Donovan's bust of Walt Whitman and various Whitman photographs upper right, O'Donovan's bust of Winslow Homer is on the table.

portrait of Weda (CL-201, Fig. 193). In one of the 1330 Chestnut Street studio photographs (Fig. 194), Weda's name is chalked on the wall, indicating that she was expected for a sitting.

Years later, in 1914, when Eakins was old and sick, Weda Cook, now Mrs. Stanley Addicks—Eakins also painted Addicks (CL-121)—asked him for the portrait. Then and for many years afterward, as visitors to the house at 1729 Mt. Vernon Street remembered, *The Concert Singer* was hanging in the honored place above the mantel in the first-floor front parlor. Eakins, loath to part with what was evidently one of his own favorites among his works, politely declined the honor of giving it to the sitter: [21]

> Dear Weda
> I was glad to have your note. I cannot however part with the picture.
> It must be largely exhibited yet.
> I have many memories of it, some happy, some sad.
> Your boy can see it at any time. Probably it will be his some day but not now.
> I have been very sick but the physician assures me that I will recover.
> Yours
> truly
> Thomas Eakins

An important part of Eakins' continuing recovery from his 1886 psychological and artistic setback was due to the constant love and support he got from his family, friends, and students. His visits to Fanny's farm near Avondale, for example, continued regularly. His niece Ella was one of his students at the Art Students' League and may have managed to turn out an interesting portrait or two (Plate 40). She was unstable mentally, however, and was later the cause of Eakins' being banned from the farm and

his name forbidden for years (see page 236). But now everything was rosy, and the visits to the farm were happy occasions for most of those involved. The children remember that Uncle Tom did not pay much attention to them. Their chief memory involved some mild kind of punishment he inflicted on one occasion when they were pulling feathers out of a chicken. A fonder memory was when Uncle Tom noticed a fly in a glass of beer he was drinking, and to the amazement and amusement of all, especially the children, he drank the beer—fly and all. He took many photographs of the Crowells up until the time his brother-in-law forbade his visiting them (Figs. 196 and 197). In the summer of 1890, with all of Fanny's and Will's children but one (Caroline was not yet born), he lined them up on the front steps in something less than saturnalian hilarity (Fig. 198).

He occasionally took his students out to the farm. Among them were Charles Fromuth, from both the Academy and the League, and Franklin Schenck, from the League, who was alone in Philadelphia. Curiously, none of the children remember Murray, but Schenck they remembered well. McHenry wrote about the Schenck visits and quoted from Will Crowell, Jr., about the various emotions they elicited among the children and their father: [22]

> Schenck visited us first during the Christmas holidays I think of 1888. Uncle Tom probably had written to Papa asking him if Papa would write to Schenck and invite him down. Evidently Papa would have preferred no guests for the holidays for he spluttered and fussed about strangers at Christmas being like a nail in one's shoe, but then he wrote to Schenck and read aloud to us what he had written—an utterly courteous invitation.
>
> I think of Schenck as having a happy time with us, with happiness entering the life of the family, without doing anything well, during the day skating on the Goose Pond and telling us of his own skating adventures with wolves, which we did not believe, and during the evening singing Gounod's Ave Maria and other songs with Papa and Mama at the organ and piano.

At some point during one of these visits (but certainly not at Christmas) Eakins photographed Schenck nude beside the pony Baldy.

When he left Philadelphia about 1892, Schenck moved to Long Island and painted little landscapes, somewhat on the order of Ralph Blakelock. He tried for the rest of his life to live as nearly completely without money as possible, bartering food and goods on his Hauppauge farm.

Meanwhile, late in 1890, two years before the Art Students' League went out of existence, a *rapprochement* between Eakins and the Academy of the Fine Arts began. Arrangements were made for Eakins to exhibit in the 1891 Annual, which opened on January 29, 1891. Who or what caused this easing of a tense situation is unknown: it may have been the appearance on the horizon of Harrison Morris, who became director the following year. A December 1890 article in *The Art Amateur*, evidently prepared with the cooperation of the Academy, had a sympathetic tone and

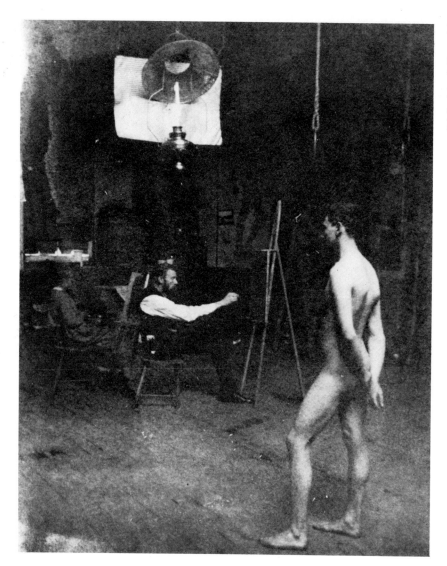

Fig. 195. Eakins(?): photograph of (left to right) Ella Crowell(?), Charles Brinton Cox, and James Wright in Art Students' League, Philadelphia, c. 1890. Modern enlargement. Metropolitan Museum of Art.

(*left*) Fig. 196. Eakins' photograph of Frances Crowell and three of her children in Avondale, Pennsylvania, c. 1888. 6⅝″ × 6¼″ (16.9× 15.9 cm). Author's collection.

(*right*) Fig. 197. Eakins' photograph of Frances Crowell and three of her children in Avondale, Pennsylvania, 1890. Author's collection. The children are, left to right: Katie, Jim, and Fanny.

gave Eakins credit for establishing the mode of instruction at the school. "All the present professors," *The Art Amateur* reported, "were formerly students at the Academy, which they attended while it was under Mr. Eakins's direction. They may be said to carry out with some few modifications the method formulated by him."

The reporter wrote, however, that things were not as prosperous or as energetic as they used to be, owing largely to the institution of tuition. He pointed out that Eakins' three "friends," Thomas Anshutz, James Kelly, and Charles Stephens, were in charge of the classes:

> Prior to February, 1886, the school was under the supervision of that excellent painter, Mr. Thomas Eakins. During his regime the plan of study was systematized. Much attention was given to anatomy, and the dissection of animals and of the human figure formed an important feature of the course. This is not given so much prominence now, although it is still an obligatory part of the work done. . . .
>
> During Mr. Eakins's superintendence, painting from the antique and from life took the place of drawing. The instructor expressed himself on this point to the following effect: "I think a student should learn to draw with color. The brush is a more powerful and rapid tool than the point or stump.

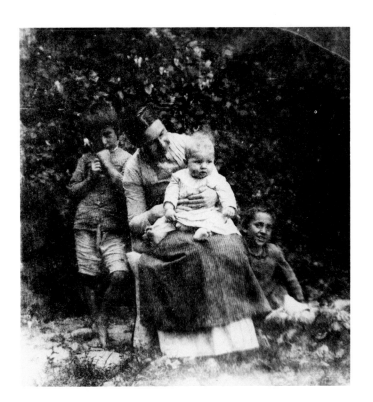
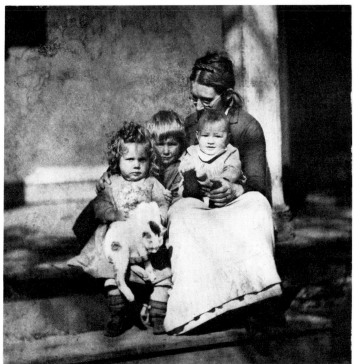

Very often, in practice, before the student has had time to get in his broadest masses of light and shade with either of these, he has forgotten the purpose he had in view. Charcoal would be better, but it is clumsy and rubs off too easily for students' work. The main advantage of the brush, however, is the instant grasp it secures on the construction of the figure . . . there are no lines in Nature, but only form and color . . . the most difficult to catch, as it is the most liable to change, is the outline . . . if the model moves a hair's breadth, already the whole outline has been changed . . . Moreover, the outline is not the man; the construction is. . . . I prefer the brush and do not at all share the fears entertained by some that the charms of color will intoxicate the pupil and cause him to neglect form. I have never known anything of this kind to happen. . . ."

Now, however, the pupils use charcoal and crayon, as in most schools, until they become "strong" draughtsmen, when color is taken up. The school is conducted upon a conservative plan—conservative, that is to say, as contradistinguished, not from progressive, but from radical or revolutionary methods.

"No distinctly original, or 'new' methods are employed," said one of the professors. "No rigid order of study is enforced. Our students stay with us for so short a time—a year or eighteen months, generally going to New York or Paris—that it is not practicable for us to demand that any certain amount of time should be spent upon any one branch of study . . . We do not say 'you must paint, and not draw.' . . . We endeavor to teach our students to see as well as to draw; to learn to look at Nature properly, and to regard it in its fullest, broadest meaning."

Since leaving the Academy Eakins had been teaching at the National Academy of Design in New York. He began a course in "Art Anatomy" there in the fall of 1888,

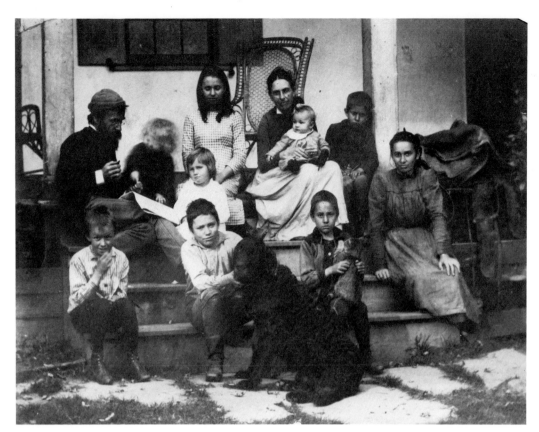

Fig. 198. Eakins' photograph of the Crowell family on the steps of their farm in Avondale, Pennsylvania, in the summer of 1890. Modern enlargement. Author's collection. Left to right, first step: Artie, Ben, Peiro, and Will; second step: Ella; third step: W. J. Crowell and Jim; fourth step: Katie, Margaret, Frances Eakins Crowell, Fanny, and Tom.

and taught each year thereafter through the season of 1894–1895. His stint at the Brooklyn Art Guild had been brief: he began in 1882, and in 1884 Anshutz wrote Wallace that Eakins was no longer there.

In the 1891 Academy exhibition Eakins showed the portraits of Marks, James Wright, Letitia Wilson Jordan Bacon, Walt Whitman, and Samuel Murray, which were designated, respectively, "Portrait of an Engineer," "Portrait of an Artist," "Portrait of a Lady," "Portrait of a Poet," and "Portrait of a Student."

But although his pictures were back on the Academy's walls, relations with the directors were still cool. There was an imbroglio about how the Annual's pictures, including Eakins' contribution as well as others, were to be hung, and Eakins wrote a slightly sarcastic letter to Edward Coates, who was apparently just as dictatorial as he had been when Eakins was forced to leave the Academy. Now it must have been a pleasure for Eakins to tell him off—something he could not have done a few years before: [23]

> My dear Sir,
>
> I thank you very much for putting into writing your conversation with me.
>
> I still beg leave to say, that in order to call the Hanging Committee's notice to a fact already well known, it was hardly necessary to have a controversy extending over many days until wearied with the great labor of hanging pictures, the artists in a moment of weakness ceded to the importunity, and asked to be relieved of a responsibility they had no right to surrender.

Fig. 199. The Crowell children sixty-one years later, in 1951. Collection James W. Crowell, California. Left to right: Jim, Tom, Fanny, Ben, Caroline, Will, and Artie. Katie, Margaret, and Ella were dead; Caroline had not yet been born at the time of the 1890 photograph.

When the Marks and Bacon portraits traveled up to New York for the National Academy of Design Annual a few weeks later, installation problems again caused trouble for the Marks portrait. "[It] suffers from bad hanging," the *Times* reported, ". . . and enough of it can be detected to warrant the belief that it deserves a better place." [24] The Bacon portrait was in a better place, however, and the critic liked that also.

By about 1892 the Philadelphia Art Students' League had dissolved. The students had dropped away one by one until there was no longer sufficient reason to invest the time and effort that had been put into it back in the days when enthusiasm ran high. Now Eakins decided to break off another bond, one that had irritated him for some years. The Society of American Artists, which had so bravely championed his Gross portrait, and which supplied him for a number of years with an auspicious New York showcase, had for the previous three years rejected the artist's work, including *The Agnew Clinic*. Now Eakins resigned: [25]

> I desire to sever all connection with the Society of American Artists.
>
> In deference to some of its older members, who perhaps from sentimental motives requested me to reconsider my resignation last year, I shall explain.
>
> When I was persuaded to join the Society almost at its inception, it was a general belief that without personal influence it was impossible to exhibit in New York a picture painted out of a very limited range of subject and narrow method of treatment.
>
> The formation of your Society was a protest against exclusiveness and served its purpose.

For the last three years my paintings have been rejected by you, one of them the Agnew portrait, a composition more important than any I have ever seen upon your walls.

Rejection for three years eliminates all elements of chance: and while in my opinion there are qualities in my work which entitle it to rank with the best in your Society, your Society's opinion must be that it ranks below much that I consider frivolous and superficial. These opinions are irreconcilable.

The Society's Committee of Selection for the previous year had contained such people as J. Carroll Beckwith, William Merritt Chase, F. S. Church, Kenyon Cox, Thomas Dewing, Childe Hassam, Thomas Hovenden, Will Low, Augustus Saint-Gaudens, Abbott Thayer, Louis Tiffany, Dwight Tryon and J. Alden Weir. Scarcely one of these men, from the beginning of their lives to the end, produced work approaching the directness of Eakins. It is scarcely surprising that the majority did not like—or understand—him.

11

Work in Photography
c. 1880-c. 1905

For purpose of discussion and analysis Eakins' use of photographs can be divided into three groups.[1] First, the photographs he took that have no apparent relationship with his painting. They may have told the artist something he wanted to know, but so far as we can see, they have no direct connection with any of his works. Most of these are interesting, and a number are beautiful. Typical of this group are the portraits of Amelia Van Buren and of Mr. and Mrs. MacDowell (Figs. 201 and 202).

The second group comprises the photographs the artist made with the intention of using them in his work. These include the several he transcribed more or less literally onto canvas, as well as those he used as memoranda when he sat down to work. Typical of this group is the photograph he took of the pollard on his sister's farm, which he used in *An Arcadian* (Figs. 131 and 132).

To the third group belong those photographs the artist took to help him understand his work better. None of these, so far as we know, was used in any painting or sculpture. But it is evident that they were not taken casually, as were those of the first group. Typical of this group would be one of the photographs of wrestlers he took, but did not use, for his *Wrestlers* (Fig. 203, and see Fig. 260).

Many of the artists of Eakins' time had cameras, and all of them more or less obviously used these cameras in the course of their work. Generally they were ashamed

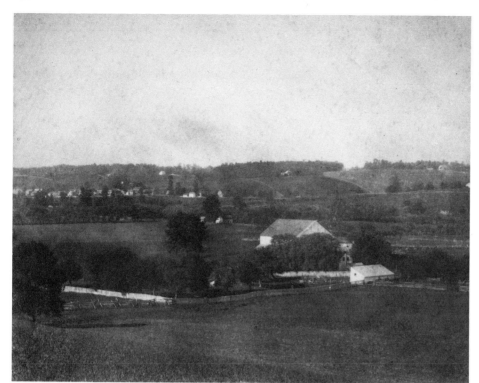

Fig. 200. Eakins' photograph of his sister's farm in Avondale, Pennsylvania. 3⅜″ × 4¼″ (8.6 × 10.8 cm). Author's collection.

Fig. 201. Eakins' photograph of Amelia Van Buren, c. 1891. 3⅜″ × 5⁵⁄₁₆″ (8.6 × 13.5 cm). Philadelphia Museum of Art.

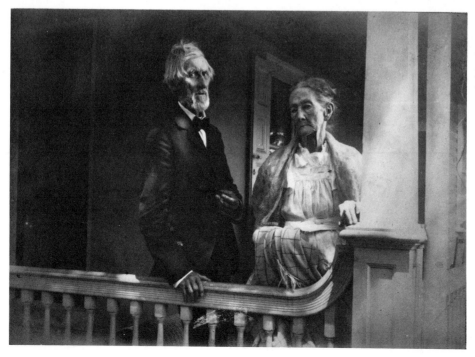

Fig. 202. Eakins' photograph of Mr. and Mrs. William H. Macdowell. 4½″ × 6⅜″ (11.5 × 16.7 cm). Collection of Walter Macdowell, Roanoke, Virginia.

Fig. 203. Eakins' photograph of wrestlers at his studio, 1330 Chestnut Street, c. 1899. Modern enlargement. Metropolitan Museum of Art.

Fig. 204. Eakins' photograph *History of a Jump,* with Eadweard Muybridge notations, 1884 and 1885. Modern enlargement. From *The Burlington Magazine,* September 1962. Eakins gave a lecture for the Philadelphia Photographic Society late in 1885 and asked Muybridge to supply technical data.

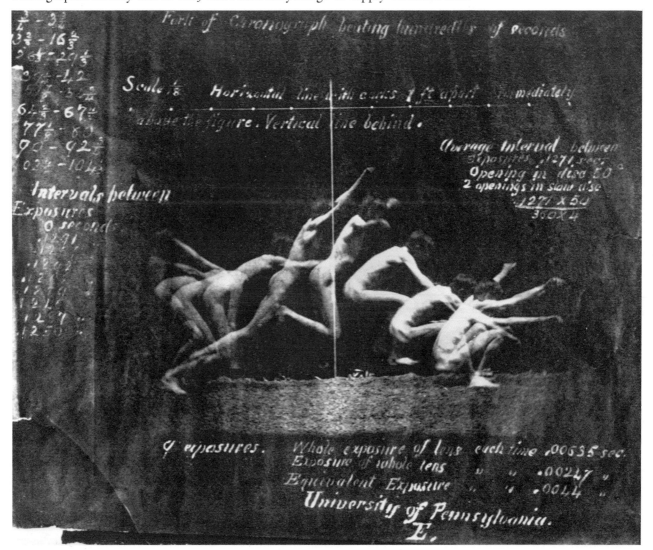

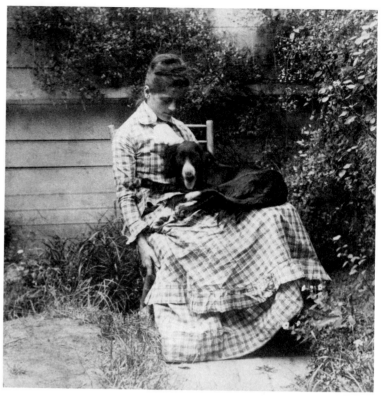

(*left to right*)

Fig. 208. Eakins' photograph of unidentified sitter in 1729 Mt. Vernon Street yard, c. 1884. 3$\frac{13}{16}$" × 2$\frac{11}{16}$" (9.7 × 6.7 cm). Author's collection.

Fig. 209. Eakins' photograph of unidentified sitter in 1729 Mt. Vernon Street yard, c. 1884. 4$\frac{1}{8}$" × 3$\frac{3}{16}$" (10.5 × 8.1 cm). Author's collection.

Fig. 210. Eakins' photograph of his sister Fanny in 1729 Mt. Vernon Street yard, c. 1884. 4$\frac{1}{8}$" × 2$\frac{3}{4}$" (10.5 × 7 cm). Author's collection.

to have anyone know it. Photography was a real threat to realistic painting, and painters pretended to scorn it as merely mechanical—which it often was, both then and today—while giving the name "art" to a hardly less mechanical skill. But in Eakins' time photography threatened to do away with portrait painting, and it was hated and feared, and rarely mentioned in "artistic" circles.

(*left to right*)

Fig. 205. Eakins' photograph of his sister Margaret on the beach at Manasquan, New Jersey, 1880. 4⅛″ × 3⅛″ (10.5 × 8 cm). Author's collection.

Fig. 206. Eakins' photograph of Susan Macdowell and Dinah(?) in 1729 Mt. Vernon Street yard, 1880–1881? 3⁷⁄₁₆″ × 3⁵⁄₁₆″ (9 × 8.4 cm). Author's collection.

Fig. 207. Eakin's photograph of Susan Macdowell, later Mrs. Thomas Eakins, 1883–1884. Blue print, 3¾″ × 2⅝″ (9.5 × 6.7 cm). Author's collection.

Eakins' use of the new medium was not influenced by this fear and hatred. He had one overriding object in mind in using photography—to express what he saw as he saw it. And whatever means he had to achieve this end he used freely. His camera was one of these means; his study of anatomy and perspective were others. So far as we know he never published a photograph he had taken, but he exhibited at least one, talked

Fig. 211. Eakins' photograph of his sister Caroline, 1882. 4½″ × 3½″ (11.4 × 8.9 cm). Author's collection.

Fig. 212. Eakins' photograph of Caroline Eakins in 1729 Mt. Vernon Street studio, c. 1883. 2½″ × 3⅞″ (6.4 × 9.9 cm). Author's collection.

Fig. 213. Susan Macdowell. Caroline Eakins in 1729 Mt. Vernon Street studio, c. 1883. Collection Walter Macdowell, Roanoke, Virginia.

about it, and described in detail his method of taking it (Fig. 204). Putting aside the question of whether or not another artist of his time could have produced *The History of a Jump*, another artist would undoubtedly have kept it under his hat, lest he should become known as having prostituted his art to mere science.

A camera Eakins apparently used is now in the Hirshhorn Collection. It was an American Optical Company 4 x 5 so-called view camera, which meant that it was designed to take pictures of landscapes, rather than pictures of people or close-ups. It became popular in about 1880, and it was at about this time that Eakins began taking pictures. Either or both of the two burlesque photographs of the *Portrait of Professor*

Gross may have been taken by Eakins in 1876, and if so, they are the first we know from the artist's hand (see Fig. 74).[2] But we do not know what camera he could have used or, more important, why he did not continue to use it. It is probable that if he did take these two photographs he borrowed a camera from someone else.

Not long after Eakins got his camera he acquired lenses that would bring his subjects up closer. The photographs of his sister Margaret on the Manasquan beach, which I have dated about 1880, could have been taken with the view camera as he got it from the manufacturer, with only its distance lens (Fig. 205). But the pictures of others, taken in the side yard of the Mt. Vernon Street house, were shot with a closer lens (Figs. 206, 208, and 209). And such photographs as the portrait of Fanny were taken with a portrait range lens (Fig. 210).

Rarely did Eakins go in for "artistic" photographs, although many of his photographs are certainly works of art. In 1882, the summer before Margaret died, he took several "artistic" photographs of his sister Caroline, posed somewhere other than the side yard of the Mt. Vernon Street house (Figs. 211 and 212).

Earlier the same year he had taken a photograph of Gloucester, New Jersey, fishing and transcribed it literally into watercolor, probably the most literal such transcription in the history of American art (see Figs. 123 and 124). The watercolor he made from this photograph is now in the Johnson Collection at the Philadelphia Museum. Johnson was a director of the Academy in 1882, and he must have thought that it would be appropriate for him to have something by the Academy's professor of Painting and Drawing. He bought nothing else from Eakins, and very little, indeed, from any American artist. (Eakins may have been getting even with philistinism by giving Johnson a painting into which he had put as little of himself as possible.)

From about 1880 to past 1900, Eakins continued to take remarkable portrait shots with his camera. An early example is the one he took of his wife's mother, Mrs. William H. Macdowell (Fig. 214). This photograph invites copying, as other Eakins photographs do; in 1970 at the Chicago Art Institute during an exhibition of Eakins photographs, the portrait was copied by a Chicago painter and offered in Omaha for sale.[3] Eakins occasionally used some of his portrait photographs as *aides mémoire* for his own paintings, others for what we might call self-amusement.

Three photographs I have called the "tormented" photographs may be self-portraits. They are direct, apparently unposed, and reveal more of Eakins than any other self-portraits we have. It is possible that the artist, who was becoming important during his first years at the Academy, felt the need of an official photograph and decided to take one himself. The result would hardly pass for an official photograph. Fig. 215, with the background screen filling the negative, may have been the one he offered to the Academy, but such a photograph would scarcely have attracted pupils to the Academy schools. The photograph finally used was bad enough (Fig. 216).

Eakins did little manipulating with his photographs, though occasionally he enlarged them with the solar enlarger which we know he owned. Some of this work was

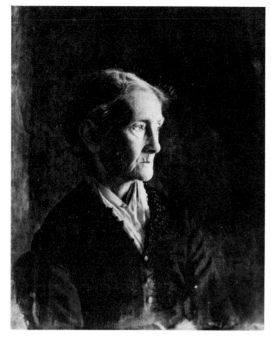

Fig. 214. Eakins'(?) photograph of Mrs. William H. Macdowell, 1880–1882? 9^{15}⁄$_{16}$″ × 8″ (25.3 × 20.3 cm). Metropolitan Museum of Art. This has been claimed by Elizabeth Macdowell.

Fig. 215. Eakins, 1881 or 1882? 4″ × 4^{1}⁄$_{16}$″ (10.2 × 10.3 cm). Collection Mr. and Mrs. Daniel Dietrich II, Philadelphia.

Fig. 216. Photograph of Eakins taken for use in an engraving in *Harper's Monthly*, February 1882. 5″ × 4″ (12.7 × 10.2 cm). Philadelphia Museum of Art, bequest of Mark Lutz.

Fig. 218. Eakins' photograph of Mary (Dolly) Macdowell, 1880–1885. 13^{15}⁄$_{16}$″ × 8^{13}⁄$_{16}$″ (35.4 × 22.4 cm). Metropolitan Museum of Art.

Fig. 217. Eakins' photograph of, left to right: Frances Eakins Crowell, Artie Crowell, Tom Crowell, and Susan Macdowell at Frances's farm in Avondale, Pennsylvania, 1883. 3^{7}⁄$_{16}$″ × 4^{9}⁄$_{16}$″ (8.8 × 11.6 cm). Author's collection.

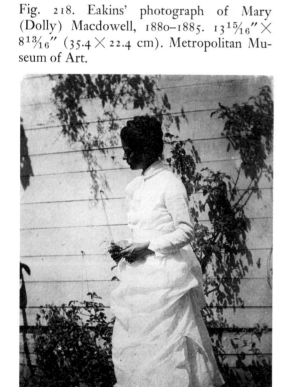

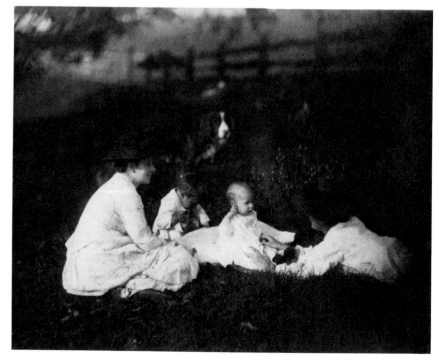

Fig. 219. Eakins at about 35, c. 1879.
Carte de visite. Archives of
American Art.

Fig. 220. Eakins' photograph of two of his nephews at his sister Fanny's farm in Avondale,
Pennsylvania, 1885–1890. 8⅚6″ × 9⅚6″ (21.1 × 24.3 cm). Author's collection.

Fig. 221. Eakins' photograph of two of his nephews at his sister Fanny's farm in Avondale, Pennsylvania, 1885–1890. 3½" × 4⅜" (8.9 × 11.1 cm). Author's collection. Not an enlarged detail of the preceding, but a different negative.

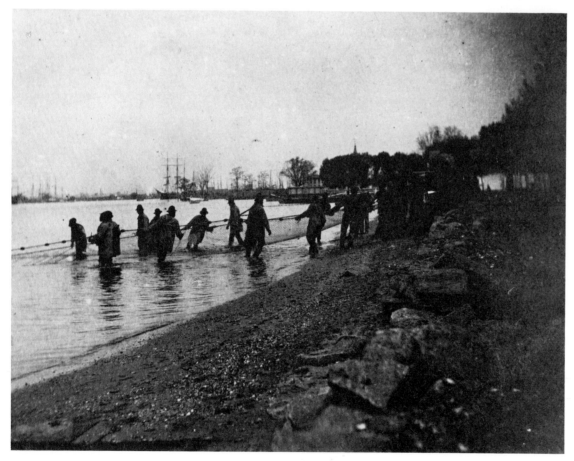

Fig. 222. Eakins' photograph of a Gloucester, New Jersey, fishing scene, c. 1881. 3" × 4" (7.7 × 10.2 cm). Author's collection. See CL-198.

done rather crudely, not because he could not have done better, but because he did not want to bother. Some of the casual efforts of this sort are the photographs of his students boxing and wrestling in the woods (see Fig. 142). Examples of fine, careful enlarging are the photographs of his family (Fig. 217), his sister-in-law Mary Macdowell (Fig. 218), a photograph of an unidentified model (Fig. 224), and several of his father-in-law, William H. Macdowell (see Figs. 187 and 188). It is possible that some of this work was done by Mrs. Eakins.

Once in a while Eakins enlarged a detail of a negative. One case of apparent enlargement looks at first glance like a similar process. His two nephews were posed by the pond of their farm in a distant shot, and posed again with such exactness for a second, closer shot that the close-up looks very much like an enlarged detail (Figs. 220 and 221).

Eakins took few "views" with his view camera, but when he did, the results were felicitous. A Gloucester fishing scene is very attractive (Fig. 222), and the distant view of his sister's farm shows sensitive framing, which must have come very easily to a painter (see Fig. 200).

On at least two occasions—the two last photographs of Walt Whitman[4] and the photograph of Franklin Schenck in the Art Students' League rooms (Fig. 223)—Eakins used artificial light. He may also have used supplementary artificial light to photograph a nude (Fig. 224). Although the model is lighted mostly from windows and perhaps also a skylight, there is some indication that additional light was used. It is possible, however, that this appearance of light may have been achieved by longer exposure or processing or both.

As a result of Eakins' work in motion photography, it has often been said that he

Fig. 223. Eakins' photograph of Franklin Schenck at the Art Students' League rooms, Philadelphia, 1890–1892? Modern enlargement. Metropolitan Museum of Art. A tug-of-war rigging is on the floor, a gymnast's bar upper right, palettes and photographs on the wall.

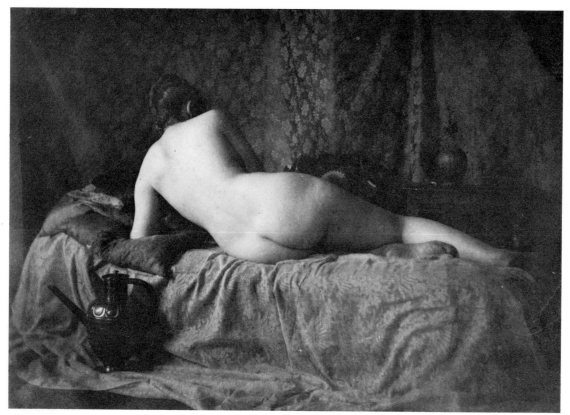

Fig. 224. Eakins' photograph of an unidentified model, c. 1883. 4¼″ × 6″ (10.8 × 15.2 cm). Metropolitan Museum of Art.

Fig. 225. Eakins' photograph of, left to right: Susan Macdowell, unidentified girl, Elizabeth Macdowell, and Mary (Dolly) Macdowell(?) in the Macdowell yard at 2016 Race Street(?), Philadelphia, 1880–1882? 5½″ × 11⁄16″ (14 × 17 cm). Hirshhorn Museum and Sculpture Garden, Smithsonian Institution.

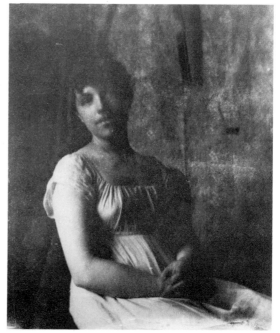

Fig. 226. Eakins' photograph of an unidentified model, c. 1883. 9″ × 7½″ (22.9 × 19.1 cm). Metropolitan Museum of Art. The model moved, probably inadvertently, but Eakins liked the effect and made an enlargement.

made a significant contribution to the development of the motion picture, but this is not true. What he did was useful to himself and significant in his work, but it did not affect the development of the motion picture as either an art or a science. The design of his motion picture apparatus, with minor mechanical alterations which may well have been suggested to him by one of the skillful mechanics or scientific men with whom he worked, was given to him by others—Jules Etienne Marey, the French physiologist whose work Eakins may have seen in print, or Eadweard Muybridge, "the father of the motion picture," whose work Eakins became aware of about 1878, when Muybridge's photographs had been widely distributed (Fig. 229).

Before his remarkable series of motion studies, the artist's photographic work shows considerable interest in the photography of motion. The work for *A May Morning in the Park* is a case in point. And the photograph of Susan Macdowell playing ring-around-a-rosy with her sister and two others is at least expressive of a curiosity as to what motion would look like in a photograph (Fig. 225). In another case he did not intend to show motion, but liked the accident enough to keep the print and even enlarge it (Fig. 226).

Eakins' contact with Muybridge occurred when Muybridge published his celebrated photographs of horses in motion in 1878.[5] Eakins probably wrote Muybridge about his photographs late in the same year, for *The San Francisco Alta California*, published near where Muybridge's experiments were made in Palo Alto, reported on November 21, 1878, that "a lecturer in anatomy in an art school wants a series showing the changes in the position of the muscles while running." Later Eakins became so interested in these 1878 photographs that he suggested that Muybridge draw the trajectories for the horses' hooves. Muybridge evidently did not do so, but published trajectories Eakins had sent him without giving Eakins credit. Eakins had also suggested certain changes in Muybridge's method:[6]

> Dear Muybridge, I pray you to dispense with your lines back of the horse in future experiments. I am very glad you are going to draw out the trajectories of the different parts of the horse in motion. . . .
>
> Have one perpend[icular] centre line only behind the horse marked on your photographic plate. Then after you have run your horse and have photographed him go up and hold a measure perpendicularly right over the centre of his track and photograph it with one of the cameras just used.
>
> Do you not find that in your old way the perspective [is] very troublesome? The lines being further off than the horse a calculation was necessary to establish the size of your measure. The horses being a little nearer or a little farther off from the reflecting screen deranged and complicated the calculation each time.

The following year Fairman Rogers, now deeply involved with Eakins' plans for *A May Morning in the Park*, wrote in a magazine article that Eakins himself had "constructed, most ingeniously, the trajectories":[7]

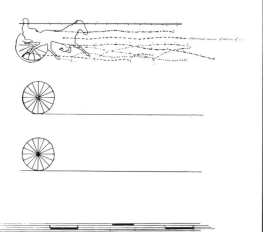

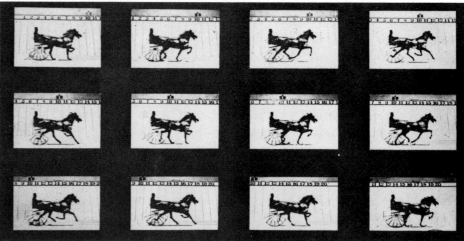

Fig. 227. Glass slide of a Muybridge trotting horse photograph, showing the trajectories of the hooves, 1883. 3¼″ × 4″ (8 × 10.2 cm). Franklin Institute, Philadelphia. Eakins drew the trajectories, and an Academy pupil, Ellen Wetherald Ahrens, drew the horse and sulky.

Fig. 228. Eadweard Muybridge's photographs of Leland Stanford's trotter Abe Edgington, June 11, 1878. Library of Congress. Eakins' slide (Fig. 227) was evidently taken from the upper right photograph.

Fig. 229. Eadweard Muybridge at about 50, 1881(?). Author's collection.

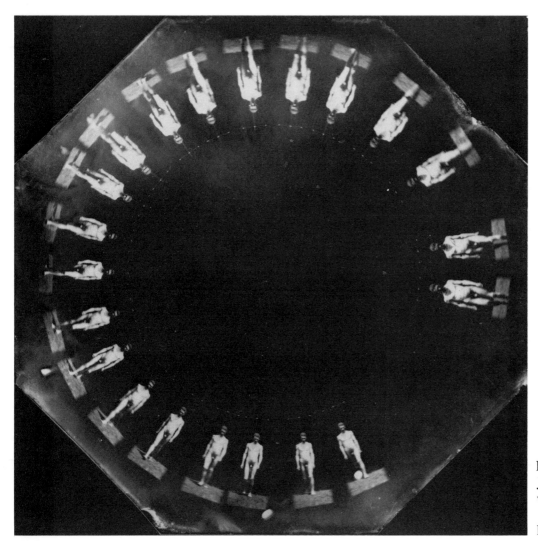

Fig. 230. Eakins' photograph of J. Laurie Wallace in Eakins' first version of the Marey Wheel, 1884. 10³⁄₁₆″ × 10″ (25.9 × 25.5 cm). Franklin Institute, Philadelphia.

Shortly after the appearance of the photographs, Mr. Thomas Eakins of Philadelphia, instructor in the Pennsylvania Academy of the Fine Arts, who had long been studying the horse from an artistic point of view, and whose accurate anatomical knowledge fitted him especially for the investigation, took them up for examination. . . . To obtain a perfectly satisfactory result, drawings must be based upon the information given by the photographs. To do this, Mr. Eakins plotted carefully, with due attention to all the conditions of the problem, the successive positions of the photographs and constructed, most ingeniously, the trajectories, of paths, of a number of points of the animal, such as each foot, the elbow, hock, centre of gravity, cantle of the saddle, point of cap of the rider, &c.

Eakins made glass slides of these trajectories, combined with copies of Muybridge's horses made by his Academy pupil Ellen Wetherald Ahrens, and used them in his Academy classes (Figs. 227 and 228). He also fitted Muybridge's photographs into a zoetrope, or "wheel of life," which he set up on the library table at the Academy. More than one of his pupils made prints from copy negatives of the Muybridge photographs, doing the work in the Academy's darkroom.

Joseph Pennell told members of the London Camera Club in 1891 that Eakins made photographs of Rogers' horses in his work for *A May Morning in the Park*, but he was wrong. Pennell was at the Academy at about this time, and knew that Eakins was using photographs for the horses' position. He must have assumed that the photographs were taken by Eakins, but actually Eakins used Muybridge's photographs and not his own to transcribe accurately the relative positions of Rogers' trotting horses.

In 1883, four years after the painting was completed, Muybridge came to Philadelphia and lectured twice at the Academy, on February 12 and 16. There "a large and interested audience" saw motion pictures of men and all sorts of animals in all sorts of gaits, pictured on the screen "in the most natural and life-like way." [8] By the following August Muybridge had been invited to continue his experiments in Philadelphia at the University of Pennsylvania, for which several Philadelphians had agreed to guarantee the money. Eakins, as the Academy's official art spokesman, was a member of the so-called Muybridge Commission, and was avidly interested in the project.

By the time Muybridge got to the University to begin his regular work, Eakins had built an ingenious camera of his own, a camera designed for very short exposures, which he demonstrated before the Photographic Society of Philadelphia on December 5, 1883. The Society's official organ, *The Philadelphia Photographer*, reported the demonstration as follows: [9]

Mr. Thomas Eakins, who was present, showed the Society an ingenious exposer for instantaneous work. Two equal weights attached to cords of different lengths, were dropped simultaneously. When the weight of the short cord had fallen as far as the cord allowed, the tension released a slide which uncovered the lens. The exposure continued while the other weight

was falling. When the end of its string was reached, it in turn released a second slide which covered the lens. By altering the length of the second cord, in accordance with a table he has prepared, changing thereby the distance the weight is allowed to fall, Mr. Eakins can accurately vary his exposures from one-quarter to one-hundredth of a second.

It is a wonder that Eakins, with all he had to do at the Academy and with all the painting he was doing during this period, could have found time to work on such a project as this. This early apparatus was even more original than the motion apparatus he devised under Muybridge's suggestions at the University. If it had not been original, the Photographic Society members, eager readers of the latest developments in the field of photography, would have known so at once, and Eakins would have been disgraced. Indeed, a careful search of contemporary photographic literature reveals no comparable device.

An account book the artist kept during this time records that in June of 1884 he had begun to build "a quick shutter for Marey & Muybridge photos." [10] By the end of the year he had spent $179.63 on the project, and by the time his "Marey Wheel" expenditures were complete, the Academy owed him $814.85 for them. Obviously the Academy was underwriting the project, although Eakins did make good use of what he had discovered through Muybridge in his Academy work in the zoetrope fitted with Muybridge photographs. But the Academy must not have known the extent to which it was getting involved financially when it appointed Eakins to work with Muybridge in his experiments. It is quite possible that these expenditures, which took place in 1884 and 1885, as well as the time Eakins spent away from his regular Academy duties, caused some of the friction that was growing now between Eakins and the Board.

Eakins built two different devices for his motion photographs. One was evidently made in the spring or early summer of 1884 while J. Laurie Wallace was still in Philadelphia, since Wallace is the model for the two series taken with this apparatus (Fig. 230), in which the negative moved behind the shutter. In the second device the negative was fixed, with two wheels with rapidly coinciding slots moving in front of it. Most of the Eakins motion photographs we know were made with this latter machine. Some of the shots are remarkable both as objects of beauty and as displays of technical excellence.

Thomas Anshutz, who worked with Eakins—and spoke of the experiments that "we" had done—wrote Wallace about them shortly after Wallace had left town: [11]

> Muybridge has also a machine for taking views on one plate, of moving objects, by opening and closing the camera rapidly at the rate of about 100 exposures per second. This shows the moving object not as a continuous smear but shows one clear view at every 2 or 3 inches of advance. The exposures are made by two large discs with openings cut around their circumferences. They run in opposite directions and are geared to run very fast, the exposure is while two openings meet. The lens remains until the object

has reached the edge of the plate. . . . Eakins had made one of the above design except he had only one wheel. We sewed some bright balls on Godley and ran him down the track. The result was not very good although you could see the position of the buttons at every part of the step. But afterwards Muybridge took him with his machine and got a very good result even showing his black clothes.

This letter was written in June 1884. By August Eakins had built a better machine, and Anshutz wrote Wallace again: [12]

Eakins is still interested in it and gives most of his time to it I imagine. He has made a drop shutter which is light in weight and is opened and shut by two long rubber bands pulling down, each, a piece of silk. They are touched off by electricity the first pulls the silk down from the lens and the second pulling another piece down to cover it. It works rapidly but is troublesome to set. The shutter is placed in front of his lens and in front of this again is the revolving disc with the hole in it which can be run by hand or by electric motor. Well the animal comes running by, the wheel is started and when the animal has reached the point where he comes on the plate the shutter is opened. The images are received every time the hole in the disc passes the lens until the animal has reached the end of the plate when the shutter is closed. The exact time has been registered by a separate electrical apparatus.

The "separate electrical device" Anshutz mentioned for measuring the exposure was developed by William D. Marks, the University professor whom Eakins painted (CL-150) in 1886. Marks's portrait shows this apparatus, and Marks later described its use as one of the authors of *The Muybridge Work*, published by the University. Eakins virtually wrote the essay for him, and Eakins' manuscript exists today in the Philadelphia Museum. Marks added a comment or two here and there in the midst of Eakins' text, and managed in the process to obfuscate Eakins' direct, simple explanation.

Though Eakins' work in motion photography does not deserve a place in the pantheon of original contributions to the invention of the motion picture, his work was interesting and often beautiful in its own right. Also, it helped the artist with his work, and was thus, like his still photography, a significant contribution to the history of American art.

One of Eakins' series photographs was exhibited at the Academy Annual opening on January 11, 1886, just three weeks before Eakins was forced to resign from the Academy. There it was called *History of a Jump* (Fig. 204), and it is probably the photograph reproduced here. To help Eakins with a lecture on *History of a Jump*, Muybridge took a print of the photograph, which corresponds to the picture we have, and made numerous notations on it.

Eakins' interest in—and contribution to—photography is at once more conspicuous and more notable than that of any other painter in the history of American art. He is America's greatest artist, and, at least, one of her excellent—perhaps great—photographers.

12

The Great Portrait Period, I
1892-1900

Although eakins exhibited in the 1891 Academy Annual, his relationships with the Academy remained cool until, whether by coincidence or not, Harrison S. Morris became its director. "Out of Schussele came Eakins," Morris wrote, "who grew the flower that all might have the seed." [1]

Somehow Morris seems to have been the sort of man Talcott Williams was—a man who made it a point to become friendly with anyone he thought might add to the sophisticated image he had of himself. There is no question that he appreciated Eakins beyond most of those associated with the Academy when he came to it in 1892. But there is also no question that his understanding of what Eakins was all about, just as his understanding of Walt Whitman—he had also been a friend of Whitman and was to write a biography of him—was superficial. "Eakins, the simple-minded, almost disingenuous Thomas Eakins—the noble, manly spirit, without guile, almost without a sense of self-protection." These are Morris' words, and they reflect an imperfect understanding of the artist. Morris also spoke of "the force" of Eakins' intellect, and in support of this thesis wrote that Eakins could speak Latin, and that he knew French, German, and Italian. Knowing languages, like a facility for working crossword puzzles, often has little to do with intellect, and citing such an accomplishment as an intellectual attribute is naïve.

Morris thought that trying to run the Academy without Eakins was like trying to run a wagon with three wheels. And so he re-established a measure of cordial relations with him, not by getting him back in the schools—the resistance to that would have been too great—but by seeing him socially, making gingerly visits to Fanny's farm, and, a few years later, sitting for his portrait (Fig. 231). He describes these visits in the style of the journalist writing for effect and careless with facts:

> One sunshiny day—perhaps it was August or September—I went down there by train to be met by Eakins on my arrival at the station. My attire was of the usual style for a visit. I had a stiff hat, and good clothes, with no idea of any rough travel. When I got off, there was Eakins on the back of a lean Western pony, leading a white one by the bridle. Before I knew it, I was mounted on this led broncho, and Eakins started off on the other. I protested that I knew very little about riding—tried to stop him; but he took for granted that anybody ought to stick on a horse, and he looked back without a flicker of sympathy at my plight. He was dressed as a robust cowboy . . . and he looked to me in his fringed leggings and sombrero hat like the attendant of a circus. All he told me, when mounting, was to steer the beast by throwing the bridle to the left and right on his neck. Then he galloped off under the trees, and I, like John Gilpin, galloped after. I soon saw that my broncho was trained to do whatever he did, and he wickedly led me a mad race—always just behind him, with no control of the rudder, no knowledge of the road, no security in my seat, trying to hold on by what I might call mane-force.
>
> We must have galloped miles on those primitive Delaware roads, Eakins entirely satisfied that I could take care of myself—which was far more than I was—hardly ever looking back, enjoying the break-neck pace; while I was shouting to him to stop for Heaven's sake—and every minute expecting to be hurled to the road.

Fig. 231. *Portrait of Harrison Morris*, 1896. Oil on canvas, 54″ × 36″ (137.2 × 91.4 cm). Private collection, Swarthmore, Pennsylvania.

Somehow, I held on; and we reached the farm of his brother-in-law, perpetuated in the canvas called "The Thinker," at a gallop so wild that I nearly ran into the rail fence of the barnyard—my good stiff hat, I believe, did pitch over it.

As a guest, I had to be pleased with the experience; but I thought it was a miracle I had come through it alive. Eakins was a serious person, but he enjoyed a sly inward chuckle at me, and his sister was very sympathetic.

It was not Delaware, of course, but Pennsylvania, and the gallop from the Avondale station to Will Crowell's farm was not more than two miles at the most. And it was Will Crowell's farm, and not Louis Kenton's. Kenton, the model for *The Thinker* (Fig. 264), was Elizabeth Macdowell's husband.

Morris was glad to "have the favor" of Eakins' presence, "to see him often, and to feel his passive influence." Eakins gave him "so much a share of his regard" that before long he was up in the top-floor no-elevator 1330 Chestnut Street studio having his portrait done. It was

> a vast, narrow floor-space with hardly adequate north light, and messed up with clay and paint and canvas in what he thought delightful disorder. Here, too, he was akin to Walt Whitman.
>
> I stood day after day while he patiently transcribed me—for his method stuck closely to the object; and I watched his large underlip, red and hanging; his rather lack-luster eyes, with listless lids; his overalls of blue, I think; and his woolen undershirt, the only upper garment, which was the American equivalent of the velveteen of my Lord Leighton or of Carolus Duran. . . .
>
> I posed on my feet for so many hours that I was seized of an irruption [*sic*] on my weary legs and had to go to a doctor for a remedy. But to me it was no ordinary compliment to be painted by Eakins, and a little lack of ease was worth it. The portrait won by such waiting is a precious return in full for all suffering. It will endure, like Dr. Tulp, long after its counterpart is forgotten—such is fame, such was the innocent modesty of Eakins who never dreamt that he would outlive his day.

To ascribe "innocent modesty" to Eakins, and to say that he "never dreamt he would outlive his day" is shallowness indeed. This shallowness, not unexpectedly, Eakins put onto canvas.

Samuel Murray, meanwhile, had been working on his bust of Whitman, which he had taken from the death mask (Plate 36) and from photographs like the ones pinned to the studio wall (Fig. 194). A few months after Whitman's death, with Morris newly established in the Academy, Murray gave Morris a copy of the bust. A few days later Emily Sartain, having seen the bust Murray had done of his little nephew, asked Murray his price for another such for a friend of hers.

In the short time he had been with Eakins Murray had learned a great deal about sculpture. It is possible and even likely that he had learned some stone carving from his father before he met Eakins. But Eakins was a master sculptor, if an unconventional

one, and he helped Murray with his craft with devotion and assiduity. The relationship between the two was close. Each inspired the other to work and to live joyously. We do not know whether their relationship was partly a sexual one, and it may be significant that Murray did not marry until a few months before Eakins died, and neither had children. And that Eakins and he, when Eakins was fifty and Murray was twenty-five, went on long trips together, often for a matter of weeks, into the wilderness. In the nineteenth century such a close association between two men was not uncommon, but such a difference in ages was less typical. It is possible, of course, that their relationship was simply a father-and-son association.

Eakins had not produced any sculpture since the days of his Scott reliefs and the *Arcadia* friezes back in the early 1880s. Now, in 1891, the fifth year of the Philadelphia Art Students' League, his friend William O'Donovan arranged for him to help with the new Brooklyn Civil War Memorial Arch. There were to be equestrian figures of Lincoln and Grant, and O'Donovan was to do the riders. Would Eakins do the horses?

He would. We do not know just how Eakins and O'Donovan got acquainted, but we know that they both knew Walt Whitman, and that they both were at one of Whitman's birthday parties. In any case, O'Donovan knew better than most that good horse sculptors were scarce, and that Eakins was the "very man" to do the horses for the new commission. *McClure's Magazine*, four years later, when the job was completed, described this decision: [2]

Experts have said that American sculpture cannot boast a single good horse in bronze, except perhaps the one by H. K. Brown which cavorts in spirited though rather conventional fashion, under the weight of Washington, on the monument in Union Square, New York. Mr. O'Donovan determined that no such reproach should be made against his work; and although himself a practical horseman, being a Virginian and an old soldier, he decided to associate himself with some artist who possessed such expert knowledge of a horse's anatomy as would render impossible any error in the modelling. His ambition from the first was to show in these two statues real men on real horses.

Casting about him for an artist of such special talent as was needed, Mr. O'Donovan found the very man he wanted in his old friend Thomas Eakins, for many years at the head of the art school in the Pennsylvania Academy of Fine Arts, and lecturer on demonstrative anatomy at the National Academy of Design.[3] . . . Since establishing himself in Philadelphia he had gained wide reputation among the best surgeons as an anatomist, and for years it had been his habit to take his pupils regularly to the horse "heaven" for practical demonstrations. There is probably no man in the country, certainly no artist, who has studied the anatomy of the horse so profoundly as Eakins, or who possesses such intimate knowledge of its every joint and muscle. He was therefore called into collaboration with O'Donovan, and the statues as they stand to-day are the work of these two artists.

Billy the pony would do for Lincoln, who "never cared for a showy charger." But what to do about Grant's horse? Grant chose his horses carefully. Eakins and O'Donovan looked everywhere, including West Point, where Jesse Grant, Ulysses' son, was stationed. Eakins took many photographs and spent many days watching the cavalry train. He also took photographs down on the Avondale farm, of Murray and himself nude astride standing horses and running ones (Figs. 232 and 233). Eakins and O'Donovan also went to Newport, where Fairman Rogers may have been, and to Long Branch, the center of Monmouth County horse breeding. But all of this was to no avail, except to teach them that what they had to do was not as simple as they had thought it would be.

Finally, at Alexander J. Cassatt's farm in Devon near Philadelphia—almost in their own backyard—they found in Cassatt's horse Clinker what they wanted. They took Clinker to Fanny's farm where Billy already lived, and Eakins set to work. First he made one-sixteenth-size wax models, then one-fourth models in clay and in plaster, which were then scratched with lines for enlargement. There were ten frames built for the models of each horse, one for each of ten different parts of the body. After he had built his armatures, Eakins modeled the clay, using the living horse as a model. When each of the ten clays was finished, it was cast in plaster, and when all ten were finished they were fitted together. *McClure's* photographer—or someone else at *McClure's* instigation—took photographs of all this work (Fig. 234).

In April 1892 the horse plasters were sent to O'Donovan's studio in New York, where they were fitted with their riders. The castings were done in the summer of 1895 and were fitted into place in what is now the plaza at the entrance to Prospect Park in Brooklyn. There they can still be seen by anyone foolhardy or expert enough to brave the traffic maelstrom that surrounds the monument (Fig. 235).

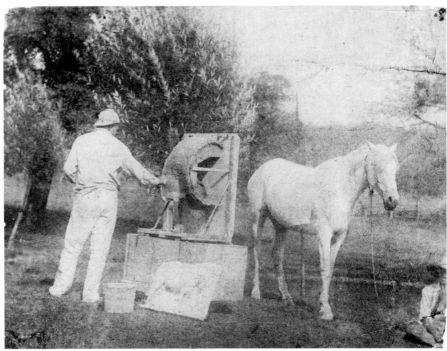

Fig. 232. Eakins' photograph of Samuel Murray astride Eakins' horse Billy, near Eakins' sister Fanny's farm in Avondale, Pennsylvania, c. 1892. 3¾₁₆″ × 3⁷₁₆″ (8.1 × 8.8 cm). Hirshhorn Museum and Sculpture Garden, Smithsonian Institution.

Fig. 233. Samuel Murray's(?) photograph of Eakins astride his horse Billy, near his sister Fanny's farm in Avondale, Pennsylvania, c. 1892. Modern enlargement. Philadelphia Museum of Art.

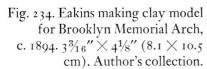

Fig. 234. Eakins making clay model for Brooklyn Memorial Arch, c. 1894. 3¾₁₆″ × 4⅛″ (8.1 × 10.5 cm). Author's collection.

The architect for the Brooklyn Memorial Arch was John Hemenway Duncan, who was also the architect for Grant's Tomb, then rising on the banks of the Hudson in upper Manhattan. Duncan had also been commissioned to design another project, and decided to give his Brooklyn team a crack at that. That was the Battle Monument to be erected in Trenton, New Jersey, to celebrate the 115th anniversary of the Battle of Trenton in the Revolutionary War.

Many sculptors were too busy with their work for the 1893 Chicago World's Fair, but Eakins was not, so he agreed to do three reliefs depicting scenes from the battle. These were to be fixed at the base of a high column surmounted by a figure of Washington to be made by O'Donovan. In December 1892 Duncan told the Trenton Committee Eakins was engaged in "preparing some new, and if possible, some historically accurate sketches of the Crossing of the Delaware, the Opening of the Fight, and the Surrender of the Hessians." [4] Eakins, incidentally, while not too busy with World's Fair projects to take the Trenton job, nevertheless had ten works in the

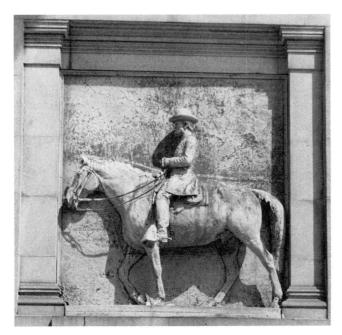

Fig. 235. Brooklyn Memorial Arch, Grand Army Plaza, Brooklyn, New York, showing Eakins' bas-relief for Grant's horse. Photograph by Rolf Petersen. Lower left: W. R. O'Donovan & Thomas Eakins Sculptors, 1893–1894.

Fig. 236. *Cast of The Continental Army Crossing the Delaware for Trenton Battle Monument.* Bronze, 55″ × 93½″ (139.7 × 237.5 cm). In bow of left-hand boat, left to right: Colonel William Washington, Alexander Hamilton, and Lieutenant James Monroe; in middle boat, left to right: George Washington, a Jersey farmer, and Colonel Knox. The right-hand figure is unidentified. New Jersey Museum, Trenton.

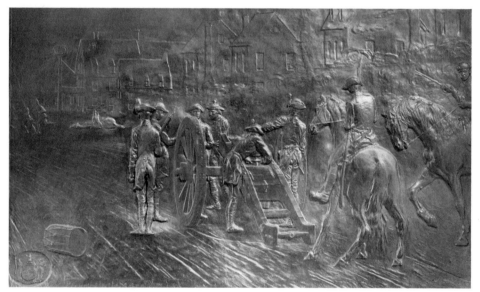

Fig. 237. *Cast of The Opening of the Fight for Trenton Battle Monument,* 1893 (date of original). Bronze, 55″ × 93⅛″ (139.7 × 237.5 cm). New Jersey State Museum, Trenton. At right, mounted, is Alexander Hamilton.

Fig. 238. The Trenton Battle Monument, Trenton, New Jersey, 1971. Eakins' originals have been removed, and bronze copies are present here.

Fair's art collection. None was new, however, the most recent evidently being the painting showing Schenck playing the guitar, called by the Fair catalogue *Cowboys at Home Ranch* (Fig. 181). In Chicago, as someone put it, they aroused wide public apathy.

When the Battle Monument dedication was held on October 19, 1893, O'Donovan's *Washington* was atop it, but Eakins' three reliefs were present only in staff, the paper-and-plaster material that was used so extensively in the Chicago Fair. They

had been bronzed, however, and must have looked nearly as they would when the bronzes themselves were inserted. One of the three reliefs, *The Surrender of the Hessians*, was not liked, and the sculptor Karl H. Niehaus was asked to do another to replace Eakins' version.

Eakins' two remaining casts have recently been taken from their location on the monument, refurbished, and set in an attractive site in the New Jersey State Museum (CL-161 and CL-162, Figs. 236 and 237). One of the two new sets of casts, which were underwritten by the Hirshhorn Collection, has been put back into the monument, which now stands in what is known as an "impossible" neighborhood (Fig. 238). The other of the two sets is in the Hirshhorn Collection.

Soon after he finished his work on the Brooklyn and Trenton sculpture commissions, Eakins painted a portrait of the Philadelphia physician Jacob Mendez da Costa (Fig. 239). Da Costa did not like the portrait, and legend has it that the painting was destroyed and that Eakins painted another. But the letter Eakins wrote to Da Costa about the criticism that had been made suggests that he was not prepared to change the picture in any way and was not even sorry that Da Costa did not like it. At fifty, with so much behind him, Eakins had little patience left: [5]

> It is, I believe, to your interest and to mine that the painting does remain in its present condition. . . . I do not consider the picture a failure at all, or I should not have parted with it or consented to exhibit it.
>
> As to your friends, I have known some of them whom I esteem greatly to give most injudicious art advice and to admire what is ignorant, ill-constructed, vulgar, and bad; and as to the concurrent testimony of the newspapers, which I have not seen, I wonder at your mentioning them after our many conversations regarding them.
>
> I presume my position in art is not second to your own in medicine, and I can hardly imagine myself writing to you a letter like this: Dear Doctor,

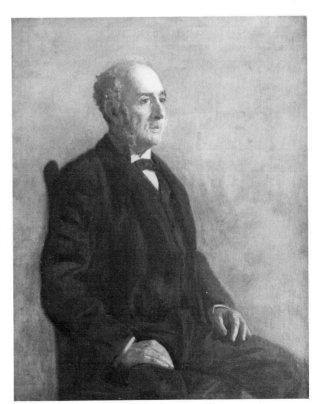

Fig. 239. *Portrait of Dr. Jacob Mendez da Costa*, 1893. Oil on canvas, 42″ × 34″ (106.7 × 86.4 cm). Pennsylvania Hospital, Philadelphia.

The concurrent testimony of the newspapers and of friends is that your treatment of my case has not been one of your successes. I therefore suggest that you treat me a while with Mrs. Brown's Metaphysical Discovery.

Eakins had not seen the newspapers' comments on Da Costa's portrait, nor have I been able to find them. It is difficult to imagine an occasion for a public showing, unless it was a social affair, in which case the newspaper reporter would probably not have been an art critic.

About this time, in reply to the writer of a biographical dictionary,[6] Eakins took a parallel stand: [7]

I was born July 25, 1844. My father's father was from the north of Ireland of the Scotch Irish. On my mother's side my blood is English and Hollandish. I was a pupil of Gérôme (also of Bonnat and of Dumont, sculptor). I have taught in life classes, and lectured on anatomy continuously since 1873. I have painted many pictures and done a little sculpture. For the public I believe my life is all in my work.

The following spring, in a letter to Harrison Morris, he wrote another short autobiography, this one slanted to a man who was now director of the Academy that had treated him so shabbily: [8]

I was born in Philadelphia July 25th 1844. I had many instructors, the principal ones Gérôme, Dumont (Sculptor), Bonnat.

I taught in the Academy from the opening of the schools until I was turned out, a period much longer than I should have permitted myself to remain there.

My honors are misunderstanding, persecution, & neglect, enhanced because unsought.

In 1894 Eakins read a paper at the Philadelphia Academy of Natural Sciences entitled "On the Differential Action of Certain Muscles Passing more than One Joint." He had spent much of the summer working on the paper, experimenting with the reactions he was going to talk about and refining his language to make it "scientific." In this he was helped by Dr. Harrison Allen, his colleague of the old Muybridge days. "In [some] cases," Eakins wrote Dr. Edward J. Nolan, "[Allen] approved of expressions which at first he disliked." [9] Eakins had photographed some of his experiments against a background very like the one he had used in his motion photographs in 1884, which suggests perhaps that the experiments had been done ten years before and were only now being compiled and organized for the lecture. Allen points out, in fact, in a footnote to the lecture, that they were taken earlier.

The lecture itself can be read in the published proceedings of the Academy for 1894. Suffice it to say that it was characterized by intense treatment of an area in which little was known. Again the artist was reaching into another field, and doing original, significant work in it. During his work on this lecture he may have produced his portrait of Dr. Nolan, with whom he had correspondence about it (CL-302). The slides

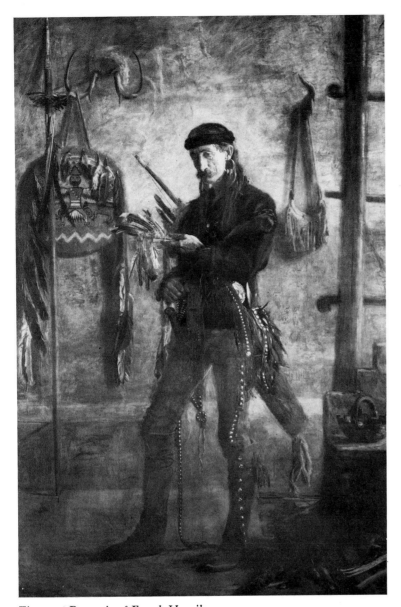

Fig. 240. *Portrait of Frank Hamilton Cushing*, 1895. Oil on canvas, 90″ × 60″ (228.6 × 152.4 cm). Gilcrease Institute, Tulsa, Oklahoma. Cushing was ill, and Eakins used a photograph for the head and upper body (see Fig. 241).

Fig. 241. Eakins' photograph of Frank Hamilton Cushing, 1895. 5⅝″ × 4¾″ (14.3 × 12.1 cm). Hirshhorn Museum and Sculpture Garden, Smithsonian Institution. Transcribed by Eakins for the Cushing portrait (Fig. 240).

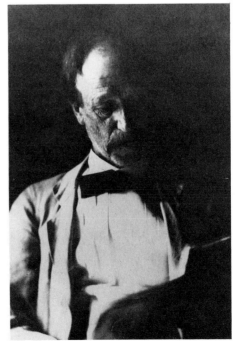

Fig. 242. Eakins' photograph of Frank Hamilton Cushing, c. 1895. 6¾″ × 4¾″ (17.2 × 12.1 cm).

he used, with a single exception, are unlocated.

The following summer Eakins painted Frank Hamilton Cushing (CL-207, Fig. 240), the famous anthropologist who had become an authority on American Indians, particularly on the Zuñis, with whom he had lived, and from whom he had experienced unbelievable tortures in his efforts to gain their acceptance. Eakins may have met Cushing at the 1876 Centennial, and the two had become good friends. Cushing was ill in 1895 (as he had been in 1876), and his health was growing worse. Eakins' portrait is a close transcription of a photograph (Fig. 241) because Cushing was too ill to pose for long. Another photograph of Cushing (Fig. 242), not related to the portrait, is in the Hirshhorn Collection.

Eakins wrote to Cushing on July 14, 1895, about posing:

> My dear Mr. Cushing,
>
> Your letter duly received and my late acknowledgement is from a bad habit of putting off writing till Sundays . . .
>
> I hope sincerely you may be able on coming back to Philadelphia to prolong your stay beyond a few days.
>
> I think I could paint the whole picture in a couple of weeks if you would help me with the background and accessories, and in so helping me, I could teach you perspective. . . .
>
> I wish you were here now. Murray is just starting a statuette of me to go with that of my wife.
>
> He is modelling my naked figure before putting on the clothes and I wish you were modelling alongside of him.
>
> Bobby is quite unfriendly with the cats. If one comes within his reach, he runs & pinches it or bites it & quickly retreats. He entices the cats by holding back of the full length of his chain ready to dart forward.
>
> If the cat is just beyond his reach, he gets one of his numerous war clubs, & then whacks her with that. In case the cat is too far even for that, he then hurls his war club at her and shows a fiendish delight if he hits. The first time we saw this done we felt there might be chance; but now we have seen it so frequently as to eliminate all the factors but those of pure intention.
>
> I have bought myself a new bicycle, the latest Columbia, and my father has besides his own bought one for my wife, so there are now four new bicycles in the house, so that when you come back you shall not want for a wheel. Could you not stay at our house while I paint you? Or whether I paint you or not.

The two Murray statuettes of Eakins and his wife are well-known today; Bobby is a monkey, and the context implies that Cushing knew him, and may indeed have given him to Eakins.

It is probable that Eakins' portrait of Mrs. Cushing also came into existence at this time (CL-296). Murray told McHenry something about this occasion: [10]

> Murray remembered her as "a peach" [McHenry writes] but also as cantankerous. She hadn't been able to stand the dirt and curiosity of the Indians when Cushing took her down to New Mexico to live; she was a "baby doll". . . . Cushing hated his own stiff hat because he had headaches and

he admired Murray's panama so much that Murray took him to the hatter's and had a big one made for Cushing. His wife was horrified; she liked him to dress in style. "When he came in with that hat, she just kinda danced a tattoo." Cushing said Murray wore one. She said, "Murray's a slouch." Murray said she didn't need to tell him; he knew that.

In 1895 Eakins also began his portrait of Mrs. James Mapes Dodge (CL-297, Fig. 243). Mrs. Dodge's daughter has told me that her mother was nursing her during the time the portrait was being painted, and that the painting had to be interrupted occasionally for the nursing. Another source has said that Mrs. Dodge was pregnant with her daughter while she was sitting, and it is likely that the sittings began during the pregnancy and continued for a while after it. The portrait is dated 1896, and Mrs. Dodge's daughter was born on December 22, 1895. Seven years later, when Mrs. Dodge's son Kern was a young man going to prep school, Eakins painted his portrait (CL-308). It is unfinished because Kern got too busy with his school to continue posing.

McHenry wrote of Eakins' and Murray's visits to the Dodges in their Germantown home. Evidently James Dodge was a good friend and often invited Eakins and Murray to join him sailing. He too was a director of the Academy of the Fine Arts, and like Harrison Morris appears to have seen quite a lot of Eakins.

It must have been during the time that Eakins and Murray started taking their bicycle trips up to Overbrook to visit St. Charles Seminary that the two would stop at the Dodges' on Sundays for a visit. Fifteen or eighteen people were sometimes there for dinner, McHenry wrote, and the Dodges always had to call in extra help. One time Eakins arrived with a little sailor cap on his head (Fig. 244), carrying three turtles in a paper bag. The Dodge children loved his coming. And so did Dodge himself, "always

Fig. 243. *Portrait of Mrs. James Mapes Dodge*, 1895. Oil on canvas, 24¼″ × 20¼″ (61.6 × 51.4 cm). Philadelphia Museum of Art.

Fig. 244. Samuel Murray(?): Eakins at about 55, c. 1899. Metropolitan Museum of Art.

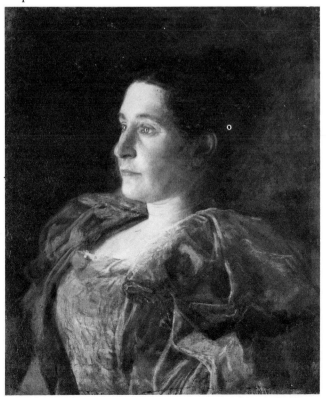

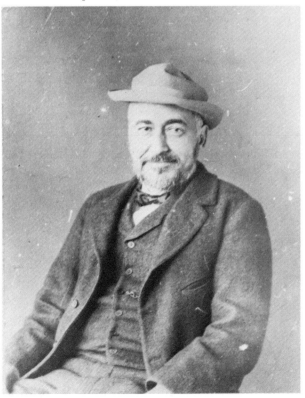

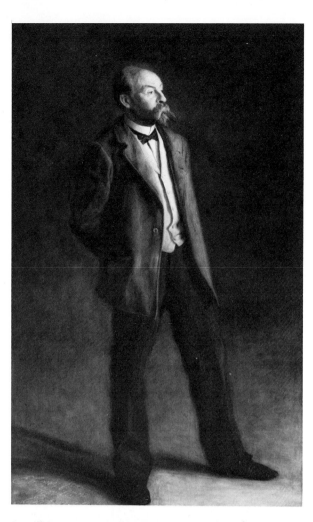

Fig. 245. *Portrait of John McClure Hamilton*, 1895. Oil on canvas, 79 1/16″ × 49″ (200.9 × 124.5 cm). Wadsworth Atheneum, Hartford, Connecticut.

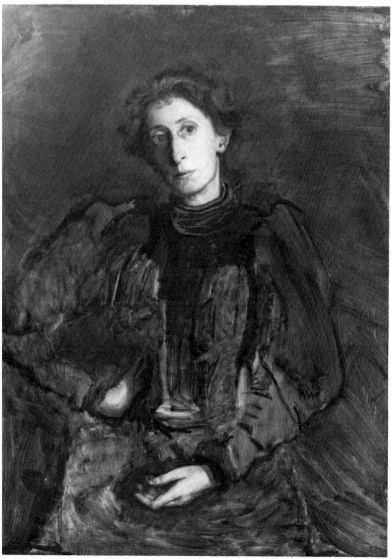

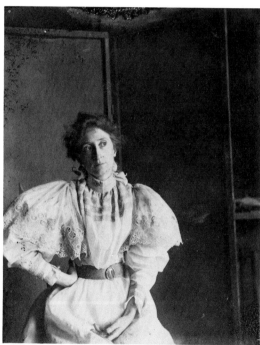

Fig. 247. Eakins' photograph of Jennie Dean Kershaw, c. 1897. 5″ × 4″ (12.7 × 10.2 cm). Hirshhorn Museum and Sculpture Garden, Smithsonian Institution.

Fig. 246. *Portrait of Jennie Dean Kershaw* (later Mrs. Samuel Murray) c. 1897. Oil on canvas, 40″ × 30″ (101.6 × 76.2 cm). University of Nebraska Art Galleries. Miss Kershaw did not become Mrs. Samuel Murray until 1916, twenty years after this portrait was painted.

full of fun."[11] Dodge once called to his wife when he saw Eakins sitting cross-legged on the lawn, wearing his sailor cap, sweater, and pants: "Josie, Josie, come here, see Tom. Doesn't he look just like a great big baby?"

Other portraits dating from 1895 and thereabouts are those of Riter Fitzgerald, the friendly critic of *The Philadelphia Item* (CL-119) and of John McClure Hamilton (CL-9, Fig. 245), the painter, who was eventually to call Eakins the greatest painter of nineteenth-century America. Eakins also painted Samuel Murray's sister that year and Jennie Dean Kershaw (CL-151, Fig. 246), Murray's future wife, who worked at the Moore College of Art where Murray taught for so long, and who "everyone thought would never get married." During this work Eakins took photographs of Miss Kershaw (Fig. 247), and he may also have painted and photographed her mother, Mrs. Anna M. Kershaw (Figs. 248 and 249) at this time. In the photograph Mrs. Kershaw looks like a frightened bird, which, indeed, she may have been. It is said she kept her sons and probably Jennie from marrying for an unusually long time. Her portrait is inscribed on the back, "Jennie Dean Kershaw from Thomas Eakins 1903," but that may be the year he gave the portrait away, rather than the year he painted it. He wrote a similar inscription on the back of the portrait of Jennie Kershaw's niece, Ruth Harding (CL-115, Fig. 250), when he gave it to the girl's mother: "Laura K. Harding from Thomas Eakins 1903." This portrait, incidentally, is the single example of Eakins' work in the

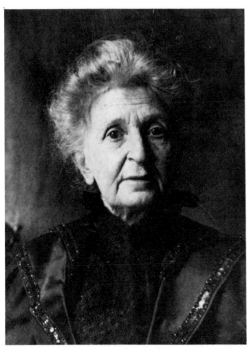

Fig. 248. Eakins' photograph of Mrs. Anna M. Kershaw, Jennie Dean's mother, c. 1903. 8⁷⁄₁₆″ × 6³⁄₁₆″ (21.5 × 15.7 cm). Hirshhorn Museum and Sculpture Garden, Smithsonian Institution.

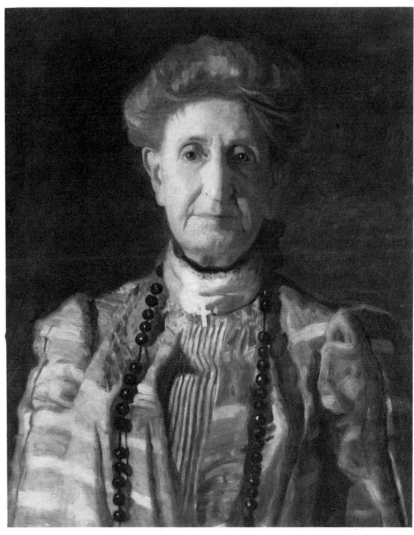

Fig. 249. *Portrait of Mrs. Anna M. Kershaw,* 1903. Oil on canvas, 24″ × 20″ (60.9 × 50.8 cm). Private collection.

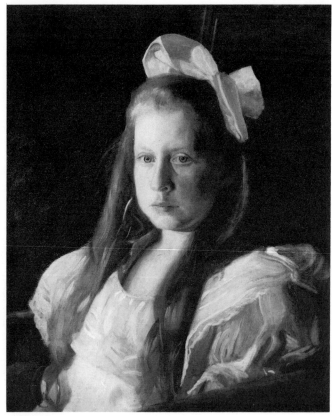

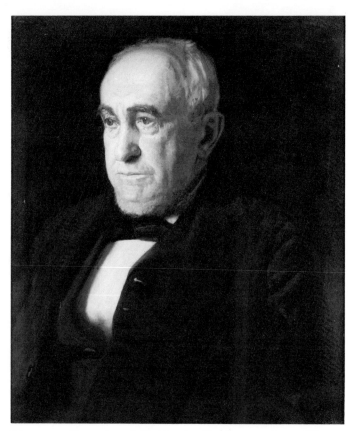

Fig. 250. *Portrait of Ruth Harding*, 1903. Oil on canvas, 24⅛″ × 20⅛″ (61.2 × 51.1 cm). The White House. For an Eakins photograph of Ruth Harding, see Fig. 235 in *The Photographs of Thomas Eakins* (New York, 1971.)

Fig. 251. *Portrait of Benjamin Eakins*, c. 1895. Oil on canvas, 24″ × 20″ (60.9 × 50.8 cm). Philadelphia Museum of Art.

White House, a gift of the Hirshhorn Collection.

On February 18, 1895, Eakins gave the first of a series of fifteen "Lectures on Artistic Anatomy" at the Drexel Institute in Philadelphia, but again his insistence on the nude resulted in another resignation.

On December 23, 1895, with Harrison Morris in charge at the Academy and determined to "rehabilitate" Eakins, the artist had four works at the opening of the Annual: *Portrait of Riter Fitzgerald, Esq.*, *Portrait of John McClure Hamilton, Esq.*, *Portrait of a Lady*, and *Panel for Trenton Monument*. The Trenton panel had been intended for the preceding Annual, but never got there. The Cushing portrait was refused.

In May 1896 Eakins gave Philadelphia an opportunity to make up halfway for its rejection in 1886. He gathered together twenty-eight of his works, including recent portraits of James MacAlister (CL-189), Harrison Morris, his father (CL-298, Fig. 251), and the Cushing portrait—a total of fourteen—grouped them with some of his earlier fishing or sailing scenes and photographs of the two *Clinics*, and invited the public to the only one-man show he ever gave. It was at Earle's Galleries, and the preview was on the afternoon of May 11, 1896. To his friend Riter Fitzgerald, the critic of the *Item*, it was a front-page event; to the other papers it was an occasion for a stultified, icy indifference.

Fitzgerald thought Eakins painted his subjects as he found them, "imperfections,

blemishes and all." [12] He thought the detail in the Cushing portrait detracted from the effect, although he acknowledged that that was the way Cushing wanted it. The portrait, he thought, indicated that Eakins was either in advance of his time or was very misunderstood, whereas he was misunderstood *because* he was in advance of his time. Fitzgerald liked the portrait of Lucy Lewis, although he thought the background was too yellowish. He hoped that a number of commissions would result from the exhibition. It had become "quite the fad," he wrote, "for painters to go to the houses of sitters, and quoted Eakins' agreement with this procedure:

> I think it an excellent idea. The home surroundings have the effect of giving a natural look to the picture. . . . The discomfort attending a hasty dress, a trip up three or four flights of stairs to an artist's studio who waits in vain for his subject are all avoided. It is somewhat of an innovation, but I am sure it will become popular and be a great saving of time, both to the sitter and artist.

The *Ledger*, the *Evening Bulletin*, and the *North American* failed to take any notice whatever of the exhibition, even though they regularly announced Philadelphia art events. The *Record* reported only that Samuel Murray would exhibit some of his work in connection with Eakins'. The *Inquirer* named several of the portraits, all "brutally like his models." [13] Such was the city's total response to the most comprehensive, self-revealing offering Eakins ever gave it. The *Item* reported on May 12:

> It is the fashion to say that Eakins is "brutally frank"; that he has too high a regard for Art to idealize or etherealize his subjects.
> All of which translated into plain every day English means that he paints his subjects as he finds them imperfections, blemishes and all.
> This is all very well from "an Art for Art's sake" standpoint, but in the progressive work-a-day world of the present time, the portrait painter, the same as everyone else, must trim his craft to the trade winds.
> It is easy to comprehend what fate would befall the fashionable photographer who neglected to doctor his negatives and paint out all imperfections.
> The people demand idealization, and if they don't get it at one shop they will bend their footsteps to another.

At the next Academy Annual, which opened on December 21, 1896, Eakins showed his new *Cello Player* (CL-220, Fig. 252), an uncharacteristically romantic work. The Academy bought it for its own collection for $500, evidently through the influence of Harrison Morris. During this exhibition Eakins was invited to give a talk to a workingman's club: [14]

> With regard to the matter of your letter of the 2d; I do not see my way very clear to comply.
> The artist's appeal is a most direct one to the public through his art, and there is probably too much talk already.
> The working people from their close contact with physical things are apt

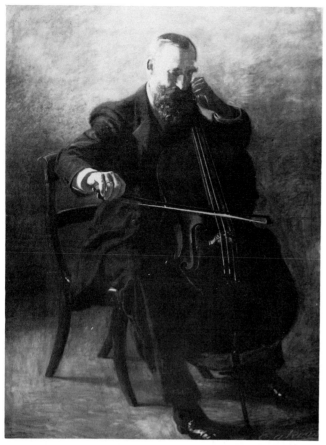

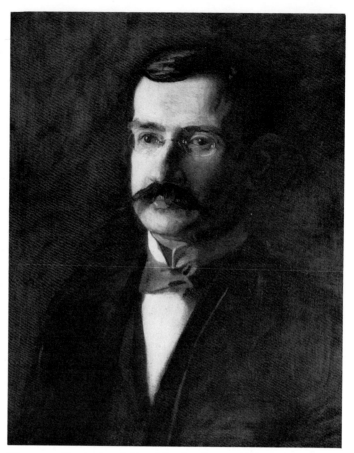

Fig. 252. *The Cello Player*, 1896. Oil on canvas, 64½″ × 48½″ (163.8 × 123.2 cm). Pennsylvania Academy of the Fine Arts. Rudolph Hennig.

Fig. 253. *Portrait of Dr. Charles Lester Leonard* (detail), 1897. Oil on canvas, 24″ × 20″ (60.9 × 50.8 cm). University of Pennsylvania.

to be more acute critics of the structural qualities of pictures than the dilettanti themselves, and might justly resent patronage.

In my own case, I have not found time to examine the Academy exhibit, and would be puzzled indeed to tell anybody why most of the pictures were painted.

I have however the greatest sympathy with the kindly and generous spirit which prompts the action of your club.

In 1897 Eakins produced one of his most banal works, the portrait of Dr. Charles Lester Leonard (Fig. 253). Leonard was a pioneer in X-ray and had been badly burned. He died at the comparatively early age of fifty-one, a "martyr to science." Martyr or not, Eakins could not work up any enthusiasm either for Leonard or his portrait, and his boredom shows.

Also during this time, somehow or other, Eakins became acquainted with Dr. Henry F. Rowland, a Johns Hopkins professor of physics, and painted him (CL-131). Another of the same year, taken from a photograph after the death of the subject, Joshua Ballinger Lippincott, was as bad as the Rowland was good (CL-294, Figs. 254 and 255). The portrait of Mrs. Matilda Searight (Fig. 256) is one of several examples of Eakins' less successful portraits painted during this period.

Fig. 255. Photograph of Joshua Ballinger Lippincott. Used to paint the preceding portrait.

Fig. 254. *Portrait of Joshua Ballinger Lippincott*, 1892. Oil on canvas, 30″ × 25″ (76.2 × 63.5 cm). Philadelphia Museum of Art. From a photograph (Fig. 255) after Lippincott's death.

Fig. 256. *Portrait of Mrs. Matilda Searight*, c. 1904. Oil on canvas, 22″ × 18″ (55.9 × 45.8 cm). Private collection. Possibly 1904 is the year this portrait was given to the sitter's daughter.

On July 2, 1897, tragedy struck the Crowell family. Ella, who had studied with Eakins at the Philadelphia Art Students' League, shot and killed herself. Ella, according to her family, seems never to have been "right." As a nursing student she once gave a patient the wrong medicine, and in expiation took the same dose herself. Shortly before she killed herself she had been released from a mental hospital and was kept in an upstairs room at the farm. But somehow she got out, found the gun, and turned it on herself. I have spoken to more than one relative who heard the shot. It was a sound they never forgot. They also never forgot how beautiful Ella looked in death.

From that time on, Ella's father, W. J. Crowell, Eakins' old friend of Central High and Paris days, refused to allow Eakins to visit the farm. Indeed, he told his children never to use their uncle's name again. One relative has told me that Eakins' sister Fanny knew none of this, but it is unlikely that she would not have tried to find out why her brother never came back. She must not have approved of her husband's interdiction, but decided to cleave to his wishes to keep peace in the family, however unbending or puritanical she may have thought him to be. Another has said that Uncle Tom made Ella put her hands on his "private parts," whatever she may have meant by that. It was possibly no more than Eakins' freedom about the human body in his teaching at the Art Students' League, where Ella was a student. Being unstable, and no doubt capable of fantasy, she may have told her father or another member of the family something that led them to believe that Uncle Tom had taken untoward liberties with her. There seems to be little doubt that her father was self-righteous. Crowell's sister Elizabeth had a long-standing feud with him which began when she heard him criticize someone at the supper table for what he thought was adultery. In any event, not until three years after Ella's death, when Fanny got a telegram saying, "Your father dangerous ill," [15] did Fanny hear from her brother Tom. He, on his part, was cut off from a favorite source of relaxation—not to mention the loving company he always enjoyed.

In 1898 Eakins and Murray, who was teaching modeling at the University of Pennsylvania, began to go to prizefights in the Arena, diagonally across Broad and Cherry streets from the Academy. Eakins' first work in this series was *Taking the Count* (CL-23, Fig. 257), now at the Yale Art Gallery, an interesting, attractive sketch for which is in the Hirshhorn Collection (CL-79, Fig. 258). Next was *Salutat* (CL-132, Fig. 259), now at the Addison Gallery. Finally the last of the three prize-ring pictures, *Between Rounds* (CL-301, Plate 41), came along in 1899.

The fighter for *Salutat* and *Between Rounds* was Billy Smith, who years later wrote a delightful letter about his association with Eakins. Walker Galleries of New York had sold Eakins' *Between Rounds* study of Smith (CL-124) to the Wichita Art Museum. Smith owned the painting and wrote Walker "something about Mr. Eakins" for Walker to pass along to the new owners: [16]

> You want to know something about Mr. Eakins, and the picture. First, as Mr. Eakins would say, when asked to speak of himself, My all is in my work. But, what I know. It was 1898, when Mr. Eakins came to a Boxing Club, to get a model for his first fight picture, titled *Between Rounds*. He choose Me. I posed first for the picture you just sold. Then, for the Between Rounds and next for the one titled salutat. Mr. Eakins, to Me was a Gentleman and an Artist, a Realist of Realists. In his work he would not add or subtract. I recall, while painting the portrate you just sold, I noticed a dark smear across my upper lip, I asked Mr. Eakins what it was, He said it was my mustache; I wanted it off; He said it was there, and there it stayed. You can see he was a Realist. The purchaser of My painting may want to know a little about me? I boxed over 100 times made a living at it for ten years, in My time I fought

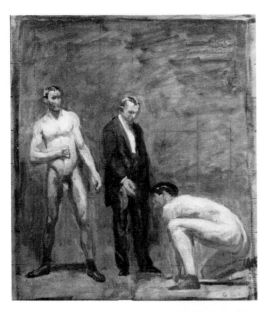

Fig. 258. *Study for Taking the Count*, 1898.
Oil on canvas, 18″ × 16″ (43.7 × 40.7 cm).
Hirshhorn Museum and Sculpture Garden,
Smithsonian Institution.

Fig. 257. *Taking the Count*, 1898. Oil on canvas,
96⁵⁄₁₆″ × 84⁵⁄₁₆″ (244.6 × 214.1 cm). Yale University
Art Gallery. Left to right: Charlie McKeever, H.
Walter Schlichter, and Joe Mack. Mack is painted
twice—again at lower right; Benjamin Eakins is second
from left on the bottom row of spectators. See CL-23.

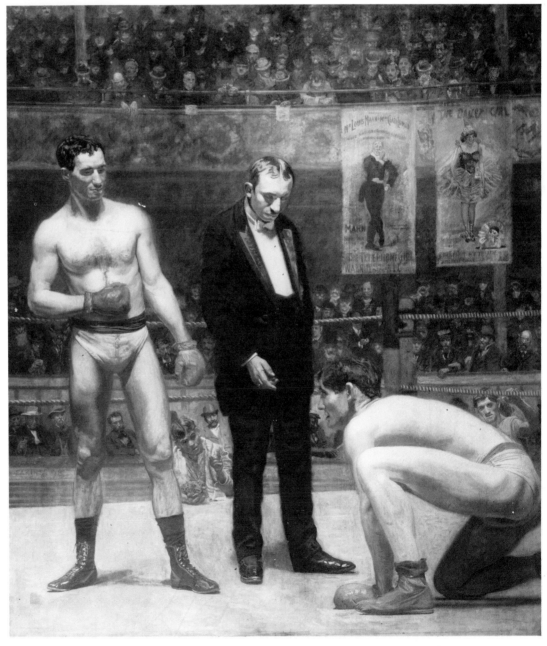

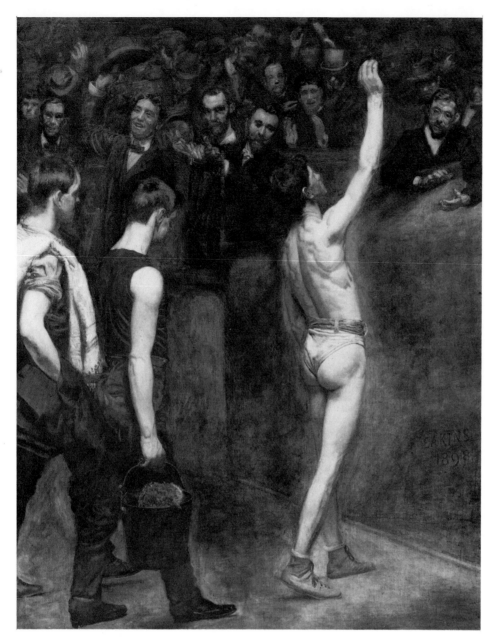

Fig. 259. *Salutat*, 1898. Oil on canvas, 49½″ × 39½″ (125.8 × 100.4 cm). Addison Gallery of American Art, Andover, Massachusetts. The fighter is Billy Smith; the man waving his hat is Clarence Cranmer; right of Cranmer is David Wilson Jordan; leaning over rail at right is Samuel Murray; and above Murray's left shoulder is Benjamin Eakins.

two Feather weight champions Tommy Warren and Terry McGovern. and Harry Forbes of Chicago, who won the Bantam weight championship in think in 1901.

I was known then as Turkey Point Billy Smith.

I am now past 66 years of age.

> I am William Smith
> 3946 Market st
> Phila Pa

Actually, *Taking the Count*, not *Between Rounds*, was Eakins' first fight picture. The nickname "Turkey Point Smith" comes from the name of a locality in Southwark, in South Philadelphia.

Clarence Cranmer, the local newspaperman who was to become Mrs. Eakins' agent for the sale of her husband's pictures after his death, is the timekeeper in *Between Rounds*. "It should be a good go," the *Inquirer* prophesied on April 21, 1898, and gave

us a complete *dramatis personae* of Eakins' picture:

> The preliminaries will bring together several of the most popular of the local punchers. Kid Maddern of Fairmount, will meet Frank Fisher who recently made so good a showing against Steve Flanagan: Harry Berger, who is one of Billy McLean's most promising pupils, will meet Ellwood McCloskey, the "Willinun"; and Martin Judge is to meet Jack Smith, of Norfolk. The semi-wind-up is creating no end of interest among the local sports. It will be between Tim Callahan and Billy Smith, two of the cleverest 115-pound lads in the State.

The posters Eakins put into *Salutat* are again in *Between Rounds: The Telephone Girl* opened at the Walnut Street Theatre on April 11, 1898, with Louis Mann and Clara Lipman, presented by George W. Lederer and George B. McLellan; *The Ballet Girl* opened at the Walnut Street Theatre on April 18 presented by Edward E. Rice. Nearly all of these names can be seen in *Salutat*. The fight in *Between Rounds* was fought in the Arena on April 22, 1898, and Smith lost the match.

The *Inquirer* tells us why a policeman is so conspicuously present in *Between Rounds:* [17]

> During the evening Tom O'Rourke and Hugh Kennedy had a run-in at the door, the result of an argument over the outcome of the Ziegler-Green fight at Frisco. A few passes were made and the two were taken into custody, but released without leaving the building. And yet there are those who will say that Philadelphia is slow!

Salutat was Eakins' only picture in the Academy's 1899 Annual, but it got little attention.

Of *Between Rounds* at the Academy's 1900 Annual, *The Critic and Art Collector* wrote, "You all know . . . that he can do better." [18] The painting was offered for $1600. Evidently Morris asked Eakins if he would take less, but Eakins refused. [19] As a result, it remained in the artist's possession until his death in 1916. Then his will listed its value as fifty dollars, perhaps one seven-thousandth of what it would demand today.

There is a suggestion that arrangements for *Between Rounds* and Eakins' next sporting pictures, the *Wrestling* series, were made at the Quaker City Athletic Club. Cranmer, a member there, wrote that he and another newspaperman had been responsible for getting the fighters to model for *Between Rounds* and the wrestling pictures. He seems to have been correct, for Eakins wrote him a letter about beginning the work on his wrestling picture "on Monday at half past ten. I wish you could find it convenient to be at the studio and help us with advice as to positions and so forth." [20]

The top man in *The Wrestlers* (CL-202, Fig. 260), Cranmer wrote, was Joseph McCann. "I had to pose him in the winning position, with a half nelson and crotch hold . . . Tho not a champion wrestler he was a very good one and a fine, most modest upstanding chap as well." [21]

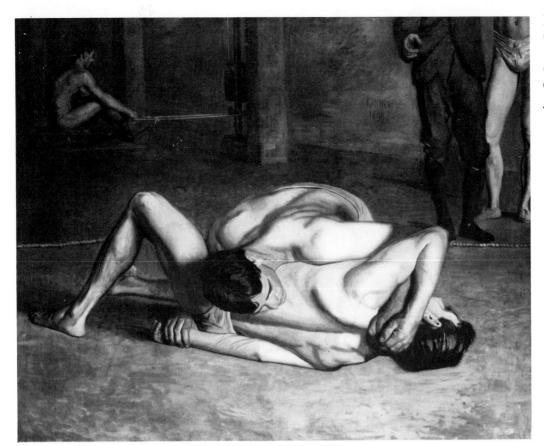

Fig. 260. *The Wrestlers*, 1899.
Oil on canvas, 48¾" × 60"
(123.8 × 152.4 cm). Columbus
Gallery of Fine Arts, Columbus,
Ohio. The man on top is
Joseph McCann.

Fig. 261. Eakins' photograph
for *The Wrestlers*, 1899.
3½" × 4¾" (8.9 × 12.1 cm).
Hirshhorn Museum and Sculp-
ture Garden, Smithsonian
Institution.

The Philadelphia Museum has an unfinished alternate version of *The Wrestlers*
which Fiske Kimball, as Museum director, pointed out as evidence of his interest in
Eakins when he was trying to persuade Mrs. Eakins to give her husband's work to the
Museum (CL-299). The Los Angeles County Museum has a sketch for the finished
work (CL-1), which until recently was in the National Academy of Design and is
now in Columbus, Ohio. Eakins had been elected an associate member of the Academy
after so many years of distinguished production, and this was his "diploma picture."

Photography played an important role in the preparation for *The Wrestlers*.

Eakins took several photographs, and finally one (Fig. 261) that was transcribed almost exactly for the finished work.

Years later Samuel Murray wrote that Eakins' fighter friends were always borrowing money from Eakins and never paying it back. Billy Smith, on the other hand, after a career in which he became a "fighting evangelist," on the order of Billy Sunday, engaging the Devil in fistfights on the platform, was a great comfort to Eakins when he was an old, sick man. Smith would come regularly to the house and massage Eakins, something for which Mrs. Eakins and Murray were very grateful.

During his work on *Taking the Count* Eakins also produced portraits of Mrs. Maybelle Schlichter (CL-324), wife of the referee, and of John N. Fort, one of the spectators. Fort's portrait is unlocated, but Goodrich wrote that he is the man at the extreme right end of the first row.

In faraway Vienna, Eakins' old friend Fairman Rogers, publishing his *Manual of Coaching*, wanted to reproduce *A May Morning in the Park* as one of two frontispieces. Eakins, thinking that a black-and-white version would show the values better in a photographic reproduction, made him one (CL-149).

In 1899 Eakins painted his friend and pupil David Wilson Jordan (Fig. 109), whose sister he had painted some years before. Along with the Martinelli portrait (Fig. 274), it is one of the rare full profiles the artist produced. The Husson portraits (Figs. 160 and 161) were also done this year, and possibly also the portrait of William Merritt Chase (CL-84, Fig. 262), who was now teaching at the Academy, and who Murray thought never liked Eakins much, steering prospective sitters another way when they mentioned Eakins: [22]

Chase did not really appreciate Eakins. Why once when Chase had just come

Fig. 262. *Portrait of William Merritt Chase*, c. 1899. Oil on canvas, 24″ × 20″ (60.9 × 50.8 cm). Hirshhorn Museum and Sculpture Garden, Smithsonian Institution.

from Eakins studio where Eakins had given him some pictures [*Starting Out after Rail?*], he spoke against Eakins publicly in one of his lectures to students at the Academy. "Modelling," he cried, "Don't model. Look at Eakins, there's a man that's hide-bound by modelling." Words not exact.

Eakins now also painted a portrait that was near his zenith, *The Dean's Roll Call* (CL-135, Plates 42 and 43), a portrait of Professor James W. Holland of Jefferson Medical College. It was of this portrait that Leslie W. Miller wrote that Eakins asked Holland to wear old shoes, such as he would not possibly have worn on the distinguished occasion depicted—reading the College's roll call for degree candidates at a Commencement.

On the next-to-the-last day of the century, another tragedy struck the Eakins family. On December 30, 1899, Benjamin Eakins died, and three days later was buried beside his wife in Woodlands Cemetery, overlooking the Schuylkill River. He was eighty-one years old, and had been a constant support in adversity through all his son's life.

13

The Great Portrait Period, II
1900-1908

On the day Eakins declined to take less than $1600 for *Between Rounds,* his father's will was entered into probate in the Philadelphia Orphans' Court. His personal property amounted to $80,000 and his real estate to $10,000 [1]—a tidy sum for 1899, when a dollar could buy perhaps six times as much as it can now. He had $2000 in cash in the bank at the time of his death, and $31,000 worth of stocks and bonds, nearly all of which was invested in the Pennsylvania and Norfolk and Western Railroads. The Norfolk and Western was the company in which his son Tom's wife's relatives in Roanoke, Virginia, were highly placed.

In a typical year Benjamin Eakins had grossed $4822.29, $3307.54 interest on investments, $1012.80 from fees for teaching, and $501.95 for "ornamental writing" jobs, and he had expenses which left him a net of $2446.55.

His will gave his gold watch and chain to Fanny's son Ben, his namesake; his household goods and wearing apparel to his son Thomas; and the remainder equally to Thomas, Fanny, and Caroline. Thomas was to have, if he wished—and he certainly wished it—1729 Mt. Vernon Street as part of his share at a valuation of $7500. W. J. Crowell, having been loaned "various sums of money," was to have that taken off his wife Fanny's share, without interest. All of this was signed in a very shaky hand by Benjamin on April 19 of the year of his death.

There are two other familiar names on the will: Ellwood Potts and John B. Gest. Potts handled the Eakins real estate, and Gest was president of the Fidelity Insurance and Safe Deposit Company. Eakins had painted Potts' portrait by the time of his father's death, and five years later he was to paint Gest's (Plate 46), one of his finest works.

The size of his father's estate—about half a million according to present-day standards—enabled Eakins to do as he pleased about selling paintings and setting prices. It must have had its effect on the very day of the probate, when he wrote Morris in an elevated tone, "I think I shall not change the price of *Between Rounds*, to wit, $1600." For the rest of his life he was comfortably off, as was his wife after him.

Now, with Benjamin gone, the Eakinses, with an extra room and knowing that their old friend Addie Williams, of Fairton days, was alone and probably lonely, invited her to come and live with them. Addie had lived in Chicago for a while, but had recently come back to Philadelphia. Letters that McHenry saw show Eakins urging her to bring her sewing and sit with Susie for the afternoon. He wanted to photograph her head. Other letters invited Addie to New Year's dinner, to a "show," to a motion picture display that James Mapes Dodge had arranged, to the circus, and to a meeting at Fifteenth Street on the way to see John Singer Sargent's *Asher Wertheimer*, an immensely celebrated painting that had just arrived in America.

Eakins did two portraits of Mary Adeline Williams. The one in the Chicago Art Institute is sometimes called *The Black Dress* (CL-120, Plate 44), and it is a picture of the classic old maid—tense and unyielding. A short time later he painted another portrait of Addie (CL-303, Plate 45). The difference is remarkable indeed. Now Addie is relaxed, human, and warm. We can feel the warmth emanate from her eyes and the gentleness of her smiling face.

Why the difference? This question has vexed people for many years. Something happened to Addie or to Eakins' concept of her between the two portraits. Assuming that the first portrait was done shortly before she came to live with the Eakinses or soon thereafter, and that the second was done not long after the first— and that assumption seems to be correct—the difference is stunning. The natural thing to believe is that love came into Addie's life. That idea is taken for granted by one relative I met: "You know, of course, that Uncle Tom made love to Addie Williams." And this theory is not contradicted by the portrait Eakins made of his wife at about this time (CL-83, Plate 47). The artist was a difficult man to live with at times, but he would have had to have been something more than just difficult to produce the effect shown in the portrait. It is painted with a love that neither of them probably ever doubted, but that must have taken curious turns upon occasion.

Possibly Eakins and his wife showed Addie attention and affection she had not known for years. The family environment may have affected her enough to explain the difference between the two portraits.

Fig. 263. Mary Adeline Williams in side yard of 1729 Mt. Vernon Street, Philadelphia, c. 1915. The dog is the same as in Fig. 301, which Charles Bregler, Eakins' pupil, has called the artist's last photograph. Thus the estimated date.

For the World's Fair in Paris in 1900 Eakins borrowed his *Cello Player* from the Academy and sent that along with *Salutat*. The American jury, which convened in Paris and awarded the prizes, was composed of eight men: Edwin Austen Abbey, John W. Alexander, William T. Dannat, Alexander Harrison, Gari Melchers, F. B. Millet, John Singer Sargent, and Jules Stewart. Abbey, Alexander, and Harrison had been associated with Eakins at the Academy; Melchers, Millet, and Sargent were well-known and popular American artists. But the result, even considering the taste of the turn of the century, was shocking: Eakins received an "Honorable Mention" along with thirty-eight others, two-thirds of whose names are unknown today even to specialists. Bronze medals were awarded to forty-seven others, among whom only a few names are not lost in the history of American art—Robert Blum, J. Carroll Beckwith, Howard Chandler Christy, Bruce Crane, Howard Pyle, Edward W. Redfield (who is chiefly remembered because he sat for Eakins), Charles Schreyvogel, Robert W. Vonnoh (who had pleased da Costa much more than Eakins had with his portrait), and J. Alden Weir. Silver medals were given to a select group of twenty, including F. A. Bridgman, who had studied with Eakins in Paris, and Charles H. Fromuth and Henry O. Tanner, both of whom had studied under him at the Academy. This group also included Charles Dana Gibson, whose "Gibson Girls" were becoming popular, and tells us all we need to know about how Europeans condescended to American art.

Harrison Morris and Thomas B. Clark, both of whom owned Eakinses, were on the National Advisory Board for the Exposition, but the others were Cecilia Beaux (who thirty years later was to modify her opinion of Eakins to the point where

Fig. 265. Key to instruments in *Antiquated Music*. Identification chiefly by Cynthia Coolidge; drawing by Guido Castelli.

1. serpent, likely early 18th century; 2. double reed, probably African; 3. esrar (lute), Indian; 4. cornemuse, 18th-century French; 5. late 18th-century English piano (the nameboard inscription, "Geo. Astor/1771/Cornhill London," is incorrect, since Astor did not go to England until 1778); 6. viola d'amore, possibly 18th-century German; 7. drum, possibly African; 8. muet; 9. pochette or kit, a small fiddle used by dancing masters; 10. apparently a northwest American Indian instrument; 11. zampora, a south Italian bagpipe; 12. an east African kissar or bowl lyre; 13. pan-pipes; 14. hurdy-gurdy; probably late 18th- or early 19th-century French; 15. lute; 16. double bell, probably Congolese; 17. straight trumpet, probably Chinese; 18. barrel drum, probably Japanese. There is also a group of flutes below the zampora. No. 4 is now in the Smithsonian Institution; Nos. 9 and 12 are probably those now in the Philadelphia Museum.

Fig. 266. *Antiquated Music* (detail).

Fig. 264. *The Thinker*, 1900. Oil on canvas, 82″ × 42″ (208.3 × 106.7 cm). Metropolitan Museum of Art. The model is Louis B. Kenton, Eakins' brother-in-law, who married Elizabeth Macdowell.

she begrudgingly gave him credit for "sincerity," "originality," and "rock-bottom methods"), William Merritt Chase (who steered customers away from Eakins), and Robert Vonnoh (who outrivaled him in the da Costa commission). When the committee decided to accept *Cello Player* and *Salutat*, it is possible that they knew on accepting the paintings in America that they did not have a chance for a prize in Paris.

Paris kudos or not, Eakins continued to paint life as he saw it. From the death of his father until 1910 he painted an average of nine portraits a year, and in each of these years he produced work on a very high level. Twenty-five of these portraits are near or at the peak of his portrait art.

Three outstanding portraits, along with an unfinished example that promised to be equally excellent, were done in the first year of the decade: a portrait known as *The Thinker* (CL-190, Fig. 264), of Eakins' brother-in-law Louis B. Kenton, who was married to Elizabeth Macdowell for a brief, storm-ridden period; the portrait of Mrs. William B. Frishmuth (CL-304, Plate 48), which the artist named *Antiquated Music;* the portrait of Clara Mather, *Clara* (Plate 49), which is now in France; and the unfinished portrait of Mrs. Joseph H. Drexel with her collection of fans (CL-85, Plate 50).

Mrs. Frishmuth was posed among her collection of ancient and antique musical

instructions, some of which survive today (Fig. 265). Her solid index finger, solidly pressed upon a key of her Astor piano (Fig. 266), tells us more about the sitter than any number of words from those who knew her.

Clara was given to the Luxembourg Museum by the Philadelphia Museum, with the agreement of Mrs. Eakins, in 1933; it hung in the Luxembourg Museum until 1939, when it was removed for safekeeping during the Second World War. It has not been seen since on any wall outside a vault. It is now in storage at a provincial museum in Compeigne, fifty miles north of Paris, where it is nearly inaccessible except to persevering applicants. Thus the only painting by America's greatest painter on the continent of Europe has not been seen for more than thirty years by the French people, to whom it was given. It is also likely that people will not see it for another few years; it will be hung, I have been told, on the walls of a museum in Paris for which the plans have not been made, and for which the ground has not been cleared.

Mrs. Drexel's portrait seems to have been planned as a companion piece to Mrs. Frishmuth's. In fact, the portraits of the two Philadelphia ladies surrounded by their collections were evidently intended for the places where their collections finally came to rest. Mrs. Frishmuth's portrait was hung at the University of Pennsylvania Museum until her collection was scattered among the Smithsonian Institution, the Philadelphia Museum, Yale University, and some carelessly kept storage rooms in Philadelphia, where, I have been told, the pieces are in dilapidated condition.

The Drexel portrait is unfinished because Mrs. Drexel could not spare the time for more than a few sittings. After that she sent her maid to sit, which upset Eakins and elicited the following letter: [2]

Fig. 267. *Portrait of Frank St. John*, 1900. Oil on canvas, 24½″ × 20½″ (62.3 × 52.1 cm). Private collection, New York.

Fig. 268. Photograph by Samuel Murray(?) of Eakins painting *Portrait of Frank St. John*, 1900. 3¹¹⁄₁₆″ × 4⅝″ (9.4 × 11.1 cm). Hirshhorn Museum and Sculpture Garden, Smithsonian Institution. Above St. John's head are Murray sculptures of Billy Smith and Mrs. Eakins.

I cannot bring myself to regard the affair in the light of a business transaction. The commission was sought by me, because even long before I was presented to you I felt that a worthy and beautiful composition picture could be made of the giver of fans to the Museum, but a portrait of you that did not resemble you, would be false, have no historic value, and would not enhance my reputation.

Your other alternative is not agreeable. I cannot accept money for which I give no equivalent. I would prefer to look upon my attempt as an unfortunate one and a trespass upon your complacency.

I enjoyed my visits to you very much, and beg your pardon sincerely. May I ask that your people will at their convenience send to me my belongings?

Also in 1900 Eakins portrayed Henry O. Tanner (CL-167), perhaps America's foremost Negro artist. For the portrait of Frank St. John (Fig. 267), there exists a photograph (Fig. 268), showing Eakins actually painting the portrait.

The following year brought forth two more of the artist's best, his portrait of Leslie W. Miller (CL-306, Fig. 269) and his portrait of Mrs. Elizabeth Duane Gillespie (CL-307, Fig 270), a great-granddaughter of Benjamin Franklin.

Charles Sheeler was a student at the School of Industrial Art, of which Miller was principal, and wrote of Miller's posing:[3]

One day a stocky little man, gray-haired and gray-bearded, passed

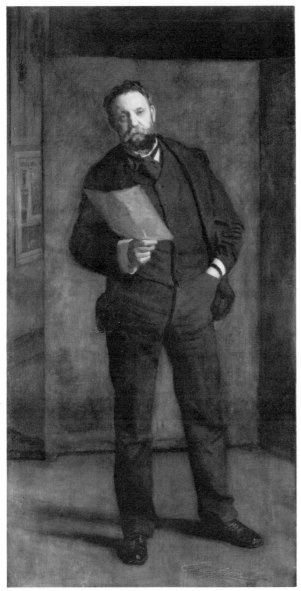

Fig. 269. *Portrait of Professor Leslie W. Miller*,
1901. Oil on canvas, 88⅛″ × 44″ (223.8 × 111.8
cm). Philadelphia Museum of Art.

Fig. 270. *Portrait of Mrs. Elizabeth Duane
Gillespie*, c. 1901. Oil on canvas, 45″ × 30″
(114.3 × 76.2 cm). Philadelphia Museum of
Art. A great-granddaughter of
Benjamin Franklin.

Fig. 271. *Sketch for Portrait of Mrs.
Elizabeth Duane Gillespie*, c. 1901. Oil on
canvas, 20″ × 16″ (50.8 × 40.7 cm). Hirsh-
horn Museum and Sculpture Garden,
Smithsonian Institution.

through our workroom. His trousers were tucked into short leather boots and fitted so snugly as to make the braces over his dark sweater superfluous. Neither his appearance nor his manner offered a clew as to the reason for his visit. A few days later he returned and passed to the life-class room, just beyond where we were working. Knotholes in the board partition were used at intervals to satisfy our curiosity. The stocky little man was beginning a portrait of the principal of the school, Leslie Miller, and before long the plan of the picture was indicated. The subject was to be portrayed standing easily with one hand in his trouser pocket and the other holding a manuscript from which he raised his eyes as if to direct them toward an audience. As the artist's work continued we witnessed the progress of a perspective drawing that was made on paper and then transferred to the canvas, to account for charts of ornament receding into the background—those charts which we knew only too well. This careful procedure led us to the conclusion that the man, whoever he was, couldn't be a great artist, for we had learned somewhere that great artists painted only by inspiration, a process akin to magic.

Several months were thus consumed; then came a day, as we discovered through the convenient knotholes, when another perspective drawing was made and transferred to the canvas, on the floor and to one side. The letters spelled Eakins. The name was not familiar to us.

Miller himself described his sittings to Goodrich: [4]

When he painted my portrait, he not only wanted me to wear some old clothes, but insisted that I go and don a little old sack coat—hardly more than a blouse—that he remembered me in in my bicycle days, and which I certainly never would have worn facing an audience, which the portrait represented me as doing. He did much the same thing with Dean Holland. He made the poor Dean go and put on a pair of old shoes that he kept to go fishing in, and painted him shod in this way when he faced a distinguished audience on a very impressive occasion.

A thread of perversity, here exemplified by Miller's coat and Holland's shoes, runs through Eakins' work. The walker among the trotters in *A May Morning in the Park*, the impossible bridge in *A Pair-Oared Shell*, the anachronistic *Washington* and the wheelhouse sculptures in *William Rush*, the double portrait in *Taking the Count*, and the skull-headed spectators in the Forbes portrait (Fig. 286) are other cases in point. Likely he thought they would never be discovered, and such mockeries of common sense comforted him in the knowledge that he was, in a way, having the last word after all.

When the Miller portrait was shown at the 1904 Annual of the National Academy of Design, it won the Thomas R. Proctor prize. "The face and attitude are realism itself," the *Times* commented.[5] The Miller portrait also impressed Robert Henri. Henri was a pupil of Anshutz, Eakins' successor at the Academy, and a member of the famous Ash-Can group, on which Eakins' teaching had perhaps its most significant influence. Henri wrote: [6]

Look, if you will . . . at the portrait of Miller for a man's feeling for a man. This is what I call a beautiful portrait; not a pretty or a swagger portrait, but an honest, respectful, appreciative man-to-man portrait.

The Frishmuth portrait, incidentally, had an even more powerful effect on another member of the Ash-Can School. George Bellows wrote that it was "the most monumental work I have ever looked at." [7]

Leslie Miller also wrote Goodrich about Eakins' portrait of Mrs. Gillespie. Mrs. Gillespie was a classic example of a woman with a mind of her own. She was the long-time widow of a young lieutenant of the U. S. Marines, for whom she claimed the almost single-handed winning of the State of California for the Union. On one occasion, hiking in the mountains of Europe, she "asked for my room, and a hot bath, into which I poured a quantity of alcohol, I then ate half a chicken and drank half a bottle of champagne." [8] As president of the Women's Committee of the 1876 Fair, she was constantly in hot water with the other ladies, although she was evidently a strong helping hand. Some of her colleagues thought she had slighted Mrs. Ulysses S. Grant, the President's wife, in favor of the Empress of Brazil, on the Fair's opening day. "She is a woman of great talent," one wrote, "but it did not take long for those who had business with her to find out that she was dictatorial and disagreeable." [9]

Mrs. Gillespie later became one of the founders of the School of Industrial Art, of which Leslie Miller was principal, and it was evidently at Miller's instance that she sat for her portrait with Eakins. The portrait was to be a gift for the school, and it was to the school that Eakins gave it, although it was unfinished. Mrs. Gillespie was apparently too upset by the artist to go on. Miller writes of this sad occasion as follows: [10]

> Mrs. Gillespie refused to go near [Eakins] again after he received her one blistering hot day in his studio up three or four flights of stairs, dressed only in an old pair of trousers and an undershirt. He wanted her to give him one or two more sittings, but she not only refused them, but wanted me to destroy the portrait after it came into my possession—which of course I didn't do.

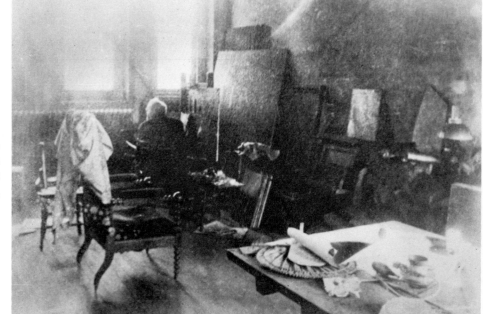

Fig. 272. Eakins in his 1729 Mt. Vernon Street studio, c. 1910. Modern enlargement. Metropolitan Museum of Art.

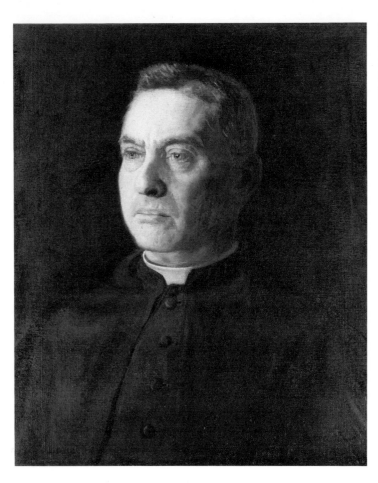

Fig. 273. *Portrait of Monsignor Patrick J. Garvey*, 1902. Oil on canvas, 24″ × 20″ (60.9 × 50.8 cm). St. Charles Borromeo Seminary, Overbrook, Pennsylvania.

Fig. 274. *Portrait of Sebastiano Cardinal Martinelli*, 1902. Oil on canvas, 79¼″ × 60″ (201.3 × 152.4 cm). The Armand Hammer Foundation, Los Angeles, California.

Fig. 275. *Portrait of Monsignor Diomede Falconio*, 1905. Oil on canvas, 72⅛″ × 54¼″ (183.2 × 137.8 cm). National Gallery of Art.

The Hirshhorn Museum owns a sketch for the portrait (CL-86, Fig. 271).

By now Eakins had given up his studio at 1330 Chestnut Street and had had the attic in the front of the house fitted up roughly—rough compared to the relative elegance of the 1871 studio with its mansard windows—into a studio. He had a skylight cut in; this time, unlike the other, it was on a true north and south axis, and not parallel with the street or the property line. A number of the sitters remember climbing the precipitous stairs to this studio, but there is only one photograph of it as it was when the artist was alive (Fig. 272). In this photograph he sits in the dim light near the northeasternmost window, bent over his palette. On a table in the foreground is a tray with the remnants of a light refreshment, and a fan, which he must have needed in this hot room.

Charles Bregler wrote that this studio had been an attic that Eakins had fitted up with all sorts of woodworking and metalworking apparatus. When he made the room into a studio he apparently gave up that work. He must have decided to re-establish himself at 1729 Mt. Vernon Street when his father died. Murray moved out of the 1330 Chestnut Street Studio at the same time, and into number 2219 on the same street. Eakins offered to lend him $2500 to fit it up, but Murray refused. "Eakins swore," Murray wrote, so he finally took the money and paid it back in a year.[11]

These first years of the new century also produced a magnificent series of clerical portraits. Eakins' trips to St. Charles Borromeo Seminary in Overbrook with

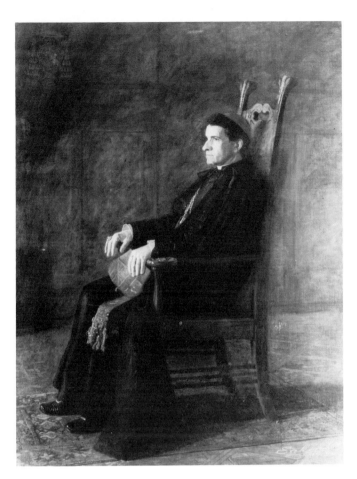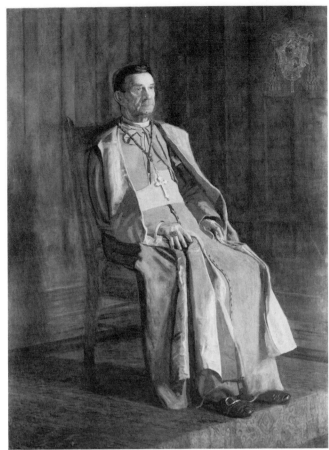

Murray seem to have gone on unabated during these years. He was now a bit heavy, and not what could be called athletic, although he could still hold one ankle and jump through the loop without losing his balance, a neat trick even for an athlete. A chalk drawing of a portly Eakins and Murray on bicycles, from the 1729 dining room blackboard where Eakins and his family and guests used to write topics for discussion, is reproduced by McHenry.

At Overbrook Eakins may have met Monsignor James P. Turner, of whom he painted two portraits (CL-329); the Reverend Philip R. McDevitt (CL-122); the Very Reverend John J. Fedigan; the Right Reverend Monsignor Patrick J. Garvey (CL-333, Fig. 273); the Right Reverend Monsignor Hugh T. Henry (CL-330); Monsignor James F. Laughlin (CL-332); and James A. Flaherty (CL-331). Garvey did not particularly like his portrait. He asked for changes, which Eakins refused, so Garvey hid the portrait under his bed, where it stayed until his death several years later. Then it went into the hands of Garvey's nephew, who hid it in a closet, where it stayed until the nephew's death in 1959. Eventually it came back to St. Charles. It was the hard eyes, according to legend, that Garvey did not like. But more than one of his seminarians agreed with Eakins that his eyes *were* hard.

Eakins' three best clerical portraits are his portraits of three men who were considerably higher in the Catholic hierarchy. The first was a portrait of Sebastiano Cardinal Martinelli (Fig. 274), Apostolic Delegate to the United States, which was begun at the Cardinal's residence in Washington in 1902 and finished in Philadelphia.

Fig. 276. *Sketch for Portrait of Mother Mary Patricia Joseph Waldron*, 1903. Oil on canvas, 14⅜″ × 10½″ (36.5 × 26.7 cm). Philadelphia Museum of Art. The finished portrait was not liked, was given away, and was probably destroyed.

Fig. 277. *Portrait of Signora Gomez d'Arza*, 1902. Oil on canvas, 30″ × 24″ (76.2 × 60.9 cm). Metropolitan Museum of Art.

Fig. 278. *Portrait of Robert C. Ogden*, 1904. Oil on canvas, 72″ × 48″ (182.9 × 121.9 cm). Hirshhorn Museum and Sculpture Garden, Smithsonian Institution, Washington, D.C.

Fig. 279. *Portrait of William R. Hallowell*, 1904. Oil on canvas, 24″ × 20″ (60.9 × 50.8 cm). Collection Dr. and Mrs. Irving Levitt, New York.

It was recently sold for $130,000 in auction at Parke-Bernet. The second was a portrait of the Archbishop of Cincinnati, William Henry Elder (Plate 51), painted possibly in Cincinnati in 1903. This portrait won the Temple Gold Medal for Eakins in 1904, a medal which Eakins marched in to collect, and marched down to the U.S. Mint to have melted into something useful. The third of the three was the portrait of Diomede Falconio (CL-112, Fig. 275), the Third Apostolic Delegate to the United States and later Cardinal. This was painted by the artist in 1905, and was, like the Martinelli portrait, evidently posed for in the Apostolic Delegate's residence in Washington. Data concerning the two Apostolic Delegate portraits are not available either in the archives of George Washington University, which owned the portraits, or in the archives of the Apostolic Delegation. Whatever papers there were have recently been shipped to the Vatican, where they are now inaccessible.

The single female member of Philadelphia's Catholic hierarchy who sat for Eakins was Mother Mary Patricia Joseph Waldron, whose portrait has been lost, with only a sketch remaining (CL-310, Fig. 276). Mother Waldron was the Superior of the Order of the Sisters of Mercy when Eakins painted her, evidently at the Order's seat in Merion, Pennsylvania. She did not like the portrait, nor did anyone else among those who paid her court. Eakins' portrait was at the Convent at the corner of Broad and Columbia streets in Philadelphia until 1916 or 1917, but has since disappeared. Why it disappeared was a mystery until Frances Lichten, an able, assiduous Philadelphia Museum and Academy aide, was told in the 1930s by William Antrim that he had been called in to paint "a more pleasing" portrait. Eakins' portrait was given to Antrim who took it off its stretcher and "tossed" it into the attic of his studio at 1305 Arch Street. This building has long been down, and no one knows where the portrait is now.

In 1902 Eakins painted Signora Gomez d'Arza (CL-192, Fig. 277), the wife of the impresario of a small Italian theater in Philadelphia. Eakins is said to have liked the d'Arzas and to have visited them often.

Occasionally in these years Eakins served on Academy and other juries. He exhibited the Martinelli portrait at the Carnegie exhibition which opened on November 5, 1903, and served on a number of Carnegie juries. While on one of these visits, in 1904, he painted a portrait of Joseph R. Woodwell (CL-318), the chairman of the Carnegie Fine Arts Committee. In the same year he borrowed his *Cello Player* from the Academy again for the St. Louis Exposition, and also *The Agnew Clinic*. In the same year, one of the artist's most productive, his Ogden (CL-97, Fig. 278), Hallowell (Fig. 279), Mrs. Mahon (CL-140, Plate 52), and Melville (Fig. 280) portraits were painted. We would expect, from the expression on Mrs. Mahon's face, that she was a sympathetic sitter. She told John Ireland years later, however, that she did not like the portrait, but sat for it and accepted it as a favor.

In 1904 Eakins produced his portrait of Mrs. Kern Dodge, which has suffered extraordinary outrages from a "restorer." It was also in 1904 that young Beatrice Fen-

Fig. 280. *Portrait of Rear Admiral George Wallace Melville*, 1905. Oil on canvas, 40″ × 27″ (101.6 × 68.6 cm). Private collection, New York.

Fig. 281. *Portrait of Col. Alfred Reynolds*, 1902. Oil on canvas, 24″ × 16″ (60.9 × 40.7 cm). Photograph by Wayne Newcomb. Collection Walter Macdowell, Roanoke, Virginia. Reynolds was Mrs. Eakins' cousin.

ton (CL-206), afterward a distinguished sculptor, sat for her portrait. *Music* (CL-164) and *The Violinist* (CL-93) were also painted in 1904.

Sometimes Eakins would go with Murray and Melville to the theater: Mrs. Eakins, McHenry wrote, wanted Tom to "get out more." One of the actresses they saw was Suzanne Santje, a native Philadelphian, who, by her own account, swept the leading Paris teachers of drama off their feet, and brought them to tears (Fig. 283): [12]

> I began with my heart in my mouth, but . . . I forgot everything. When I had finished M. Vernon [the head of the Institute] got up slowly from the sofa. The cigarette was still between his teeth but it had gone out. He had tears in his eyes, and he said, "Mademoiselle, I shall be glad to have you for a pupil."

Miss Santje, as might be expected in so modest a young woman, needed "pursing and pleading," according to Murray, but finally she consented to sit for a portrait (CL-309, Plate 53). Murray said the two had seen her in *Beau Brummel*, but there was no *Beau Brummel* in Philadelphia at the time of Eakins' portrait. *Camille* was there, and there is an open book of *Camille* on the floor in the portrait. But although *Camille* was in Philadelphia at the appropriate time, Suzanne Santje was not in it. Most

Plate 38 (opposite). *The Concert Singer*, 1892. Oil on canvas, 75″ × 54″ (190.5 × 137.2 cm). Philadelphia Museum of Art. When this portrait of Weda Cook was first exhibited, it was called simply *The Singer*.

Plate 39 (opposite). *The Concert Singer* (detail).

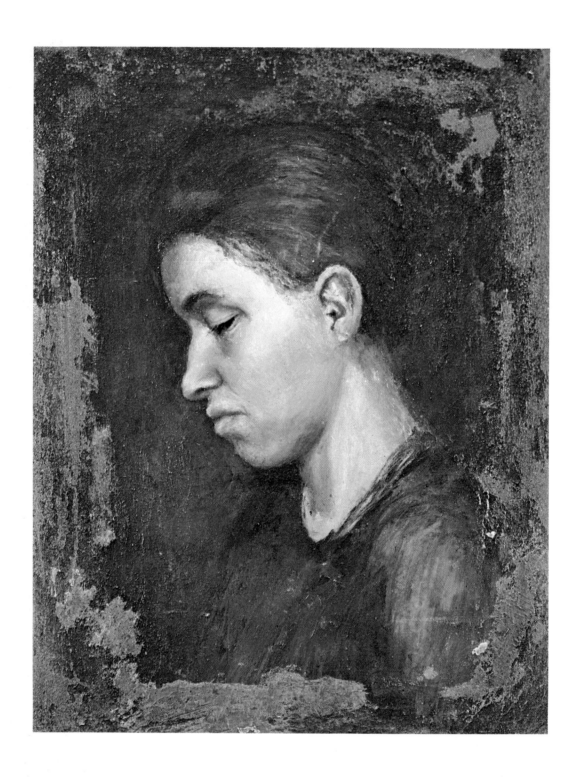

Plate 40 (above). *Portrait of Margaret Crowell*, c. 1892. Oil on canvas, 19″ × 15″ (48.2 × 38.1 cm). Private collection. Margaret Crowell was sixteen in 1892. This portrait, possibly by Eakins, is generally attributed by the family to Margaret's sister Ella, who studied with Eakins, but no other work by Ella is known.

Plate 41 (opposite). *Between Rounds*, 1899. Oil on canvas, 50¼″ × 40″ (127.7 × 101.6 cm). Philadelphia Museum of Art. The fighter is Billy Smith, the timekeeper is Clarence Cranmer, the second is Elwood McCloskey, and the towel waver is Billy McCarney.

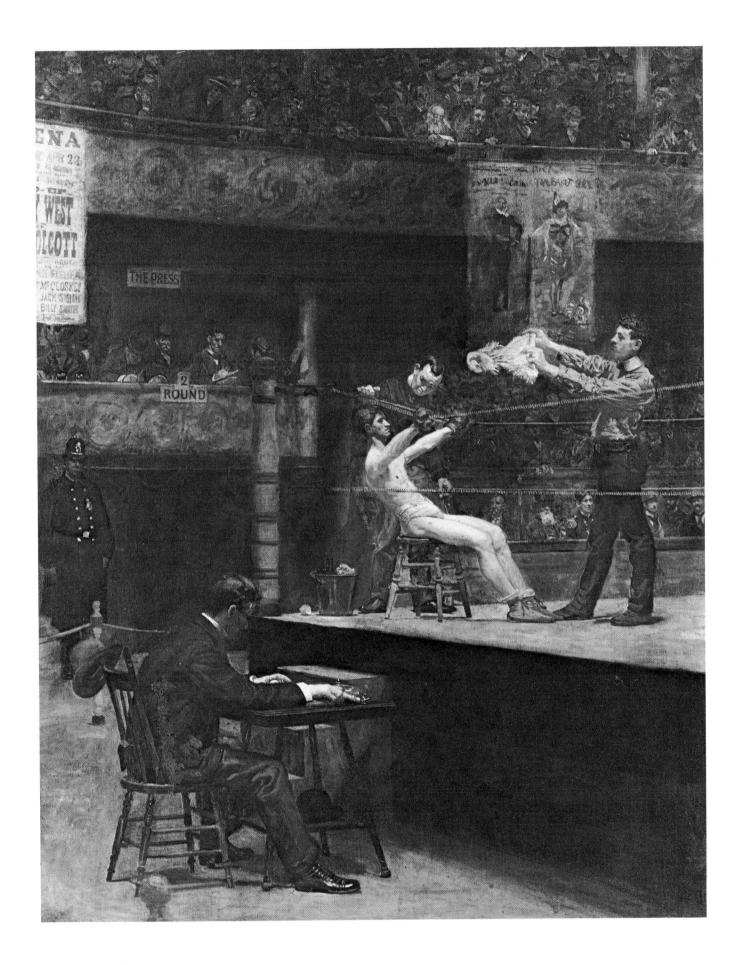

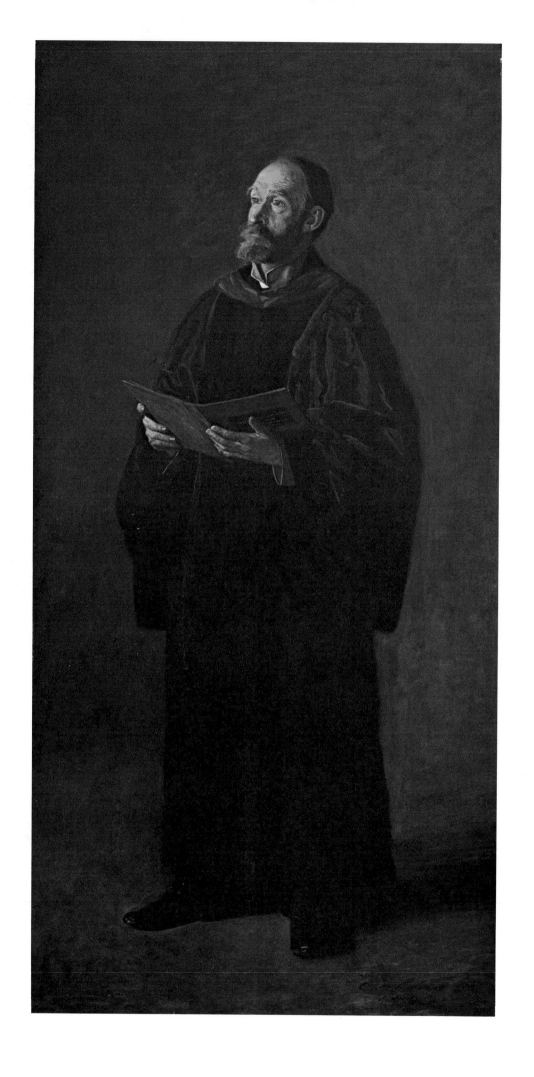

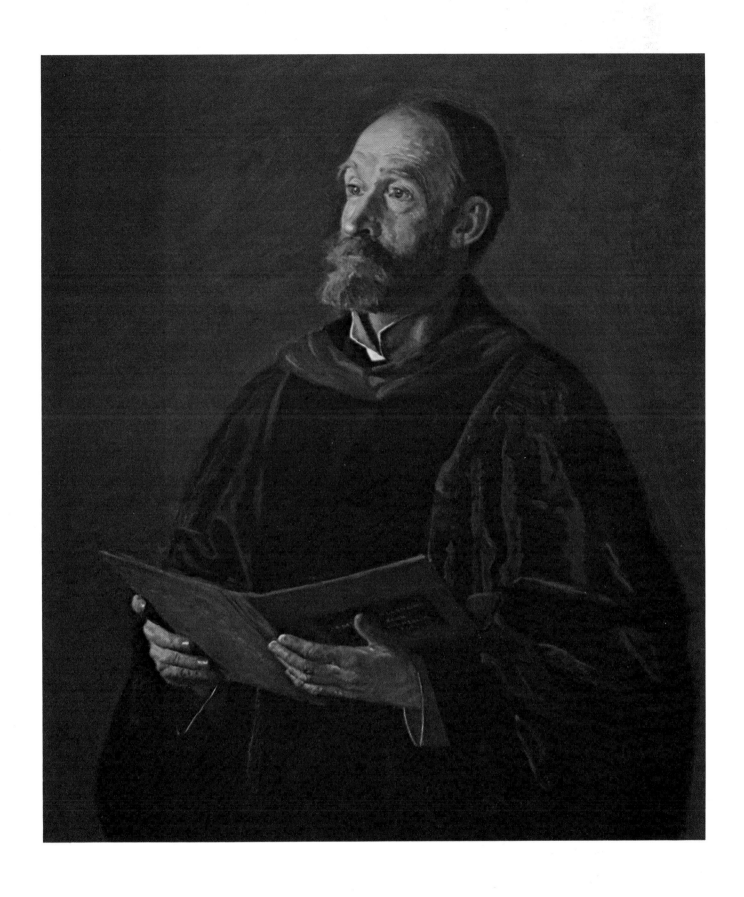

Plate 43 (above). *The Dean's Roll Call* (detail).

Plate 42 (opposite). *The Dean's Roll Call*, 1899. Oil on canvas, 84″ × 42″ (213.4 × 106.7 cm).
Boston Museum of Fine Arts. Portrait of Dr. James William Holland.

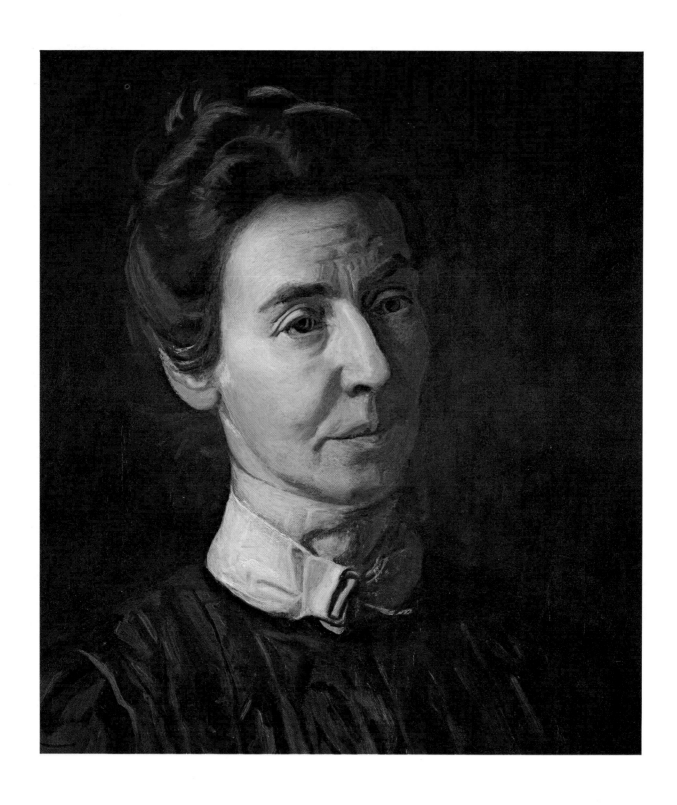

Plate 44. *Addie, Woman in Black* (detail), c. 1899. Oil on canvas, 24″ × 20″ (60.9 × 50.8 cm). Chicago Art Institute. Portrait of Mary Adeline Williams.

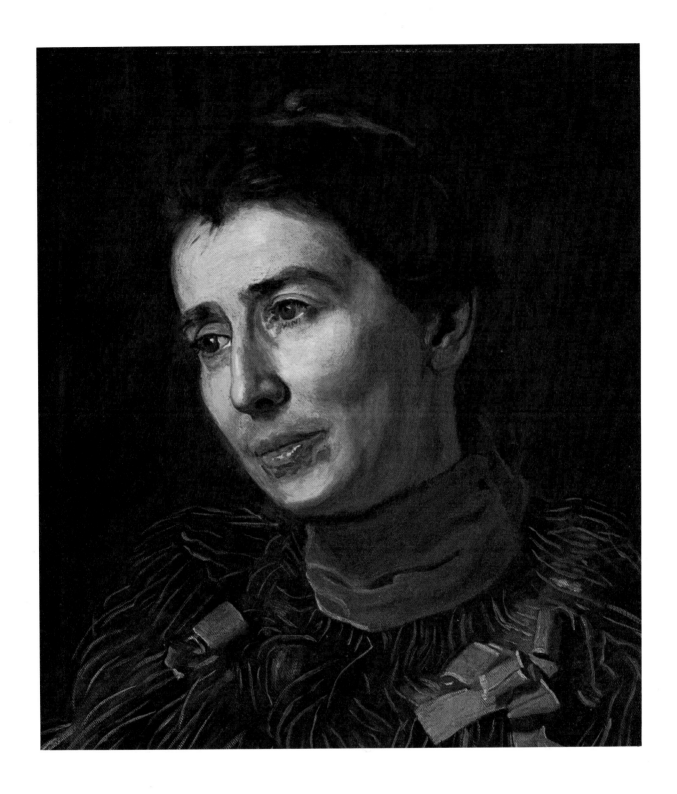

Plate 45. *Addie* (detail), c. 1900. Oil on canvas, 24″ × 18″ (60.9 × 45.6 cm). Philadelphia Museum of Art. Portrait of Mary Adeline Williams.

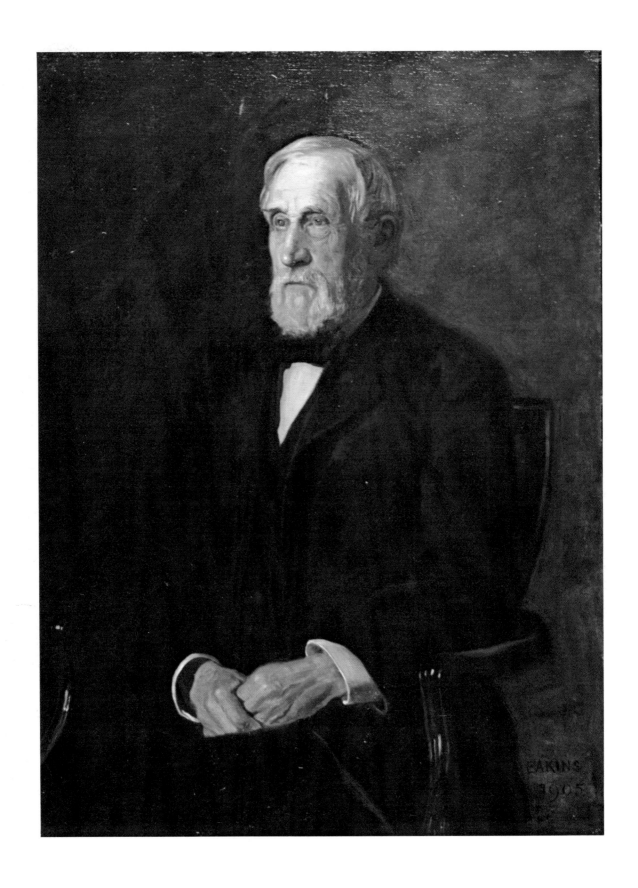

Plate 46. *Portrait of John B. Gest*, 1905. Oil on canvas, 40″ × 30″ (101.6 × 76.2 cm). Fidelity Bank, Philadelphia.

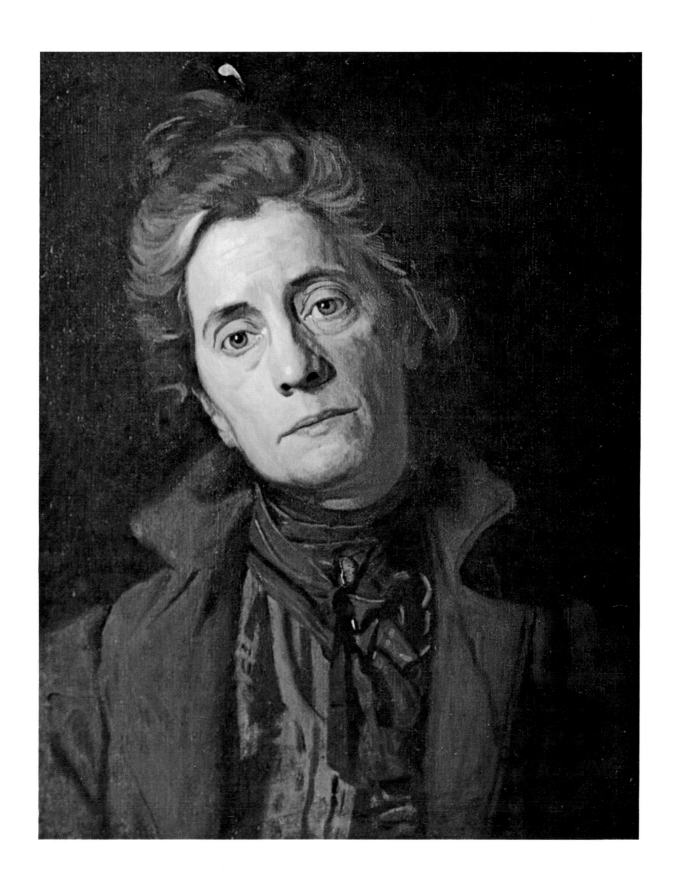

Plate 47. *Portrait of Mrs. Thomas Eakins*, c. 1899. Oil on canvas, 20″ × 16″ (50.8 × 40.7 cm). Hirshhorn Museum and Sculpture Garden, Smithsonian Institution, Washington, D.C.

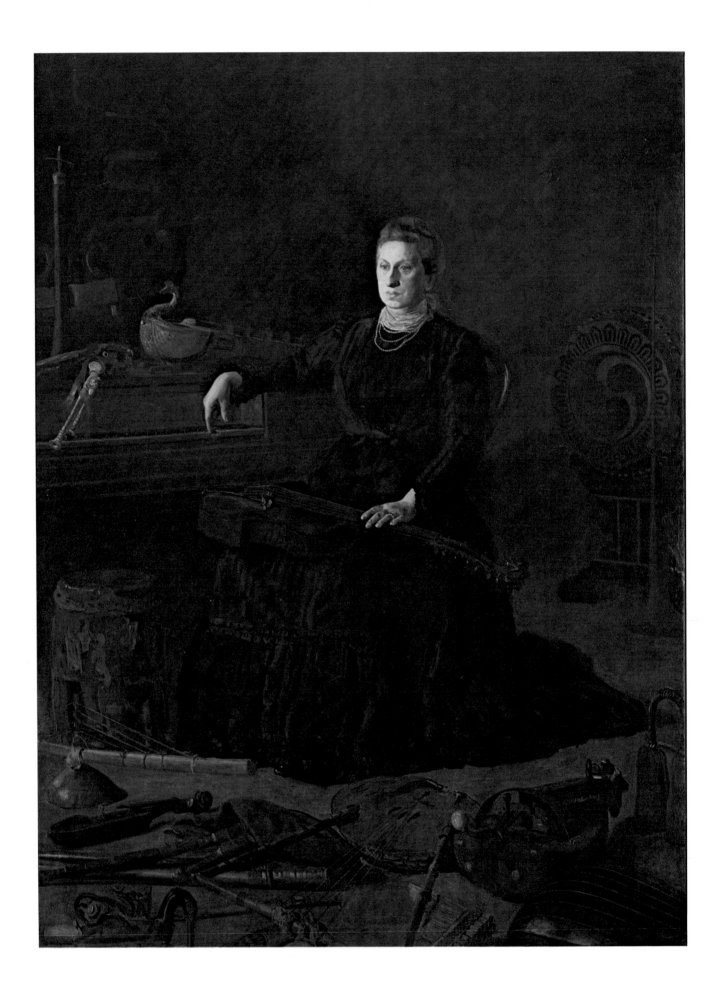

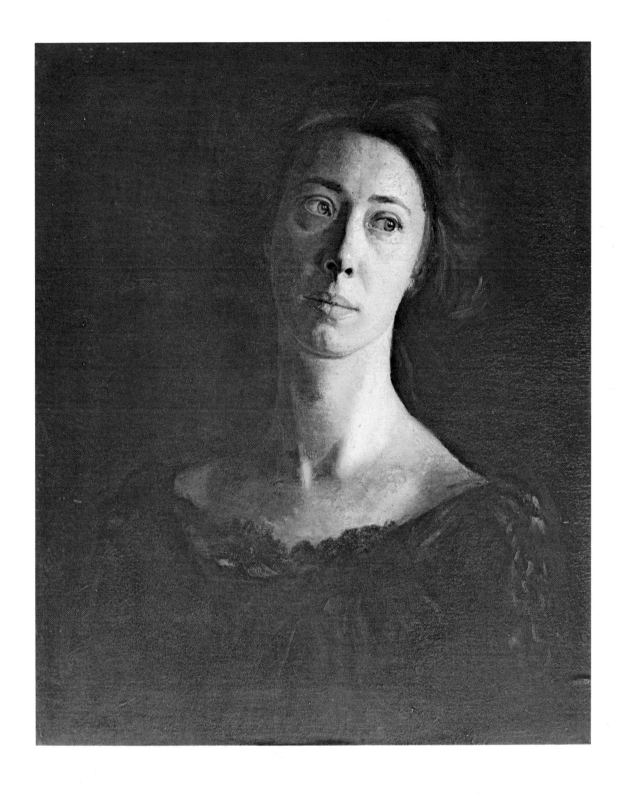

Plate 49 (above). *Clara*, c. 1900. Oil on canvas, 24″ × 20″ (60.9 × 50.8 cm). Musée d'Art Moderne, Paris. Clara J. Mather.

Plate 48 (opposite). *Antiquated Music*, 1900. Oil on canvas, 96″ × 72″ (243.8 × 182.9 cm). Philadelphia Museum of Art. Mrs. William D. Frishmuth. (See Fig. 265 for key to instruments.)

Plate 50. *Portrait of Mrs. Joseph H. Drexel* (unfinished), 1900. Oil on canvas, 47″ × 37″ (119.4 × 93.9 cm). Hirshhorn Museum and Sculpture Garden, Smithsonian Institution, Washington, D.C. Mrs. Drexel was a collector of fans. This painting was cut down from an original size of 72″ × 53″ (182.9 × 154.6 cm).

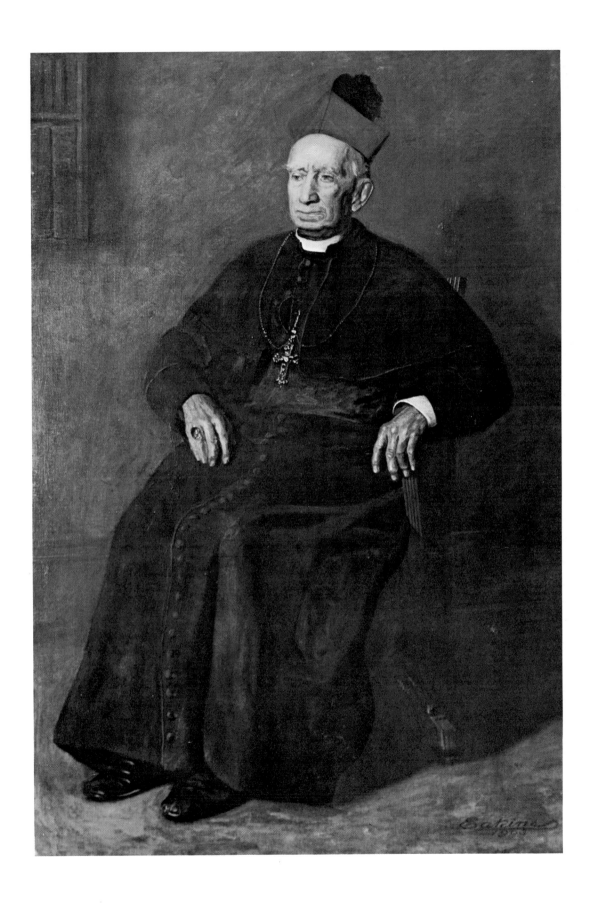

Plate 51. *Portrait of Archbishop William Henry Elder*, 1903. Oil on canvas, 66½″ × 45½″ (168.9 × 115.6 cm). The Archdiocese of Cincinnati.

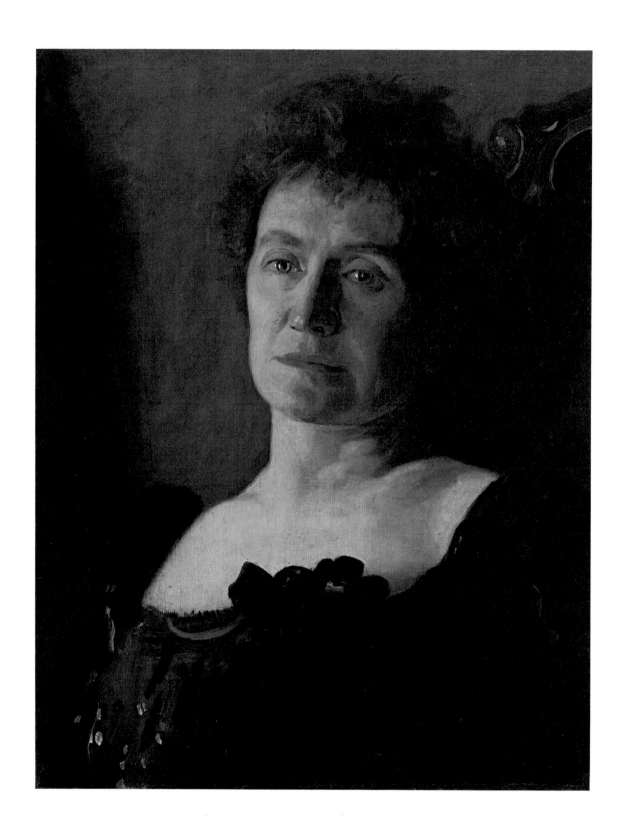

Plate 52 (above). *Portrait of Mrs. Edith Mahon*, 1904. Oil on canvas, 20″ × 16″ (50.8 × 40.7 cm). Smith College Museum of Art, Northampton, Mass.

Plate 53 (opposite). *Portrait of Suzanne Santje* (unfinished), 1903. Oil on canvas, 80″ × 59½″ (203.2 × 151.2 cm). Philadelphia Museum of Art. Sometimes called *The Actress*.

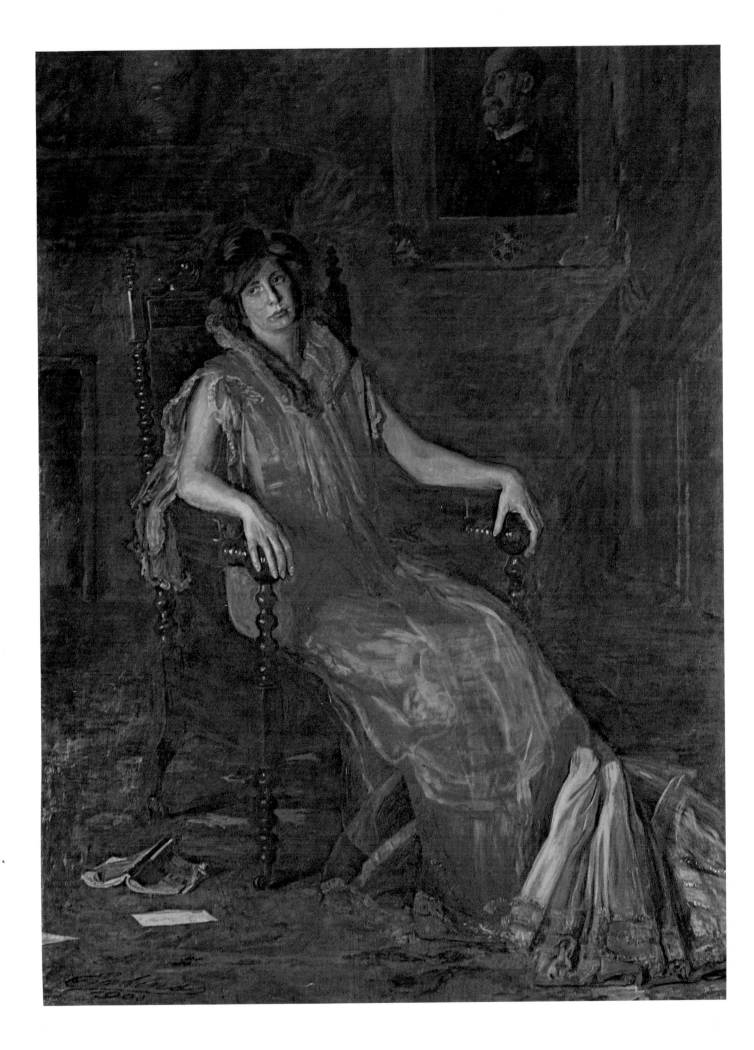

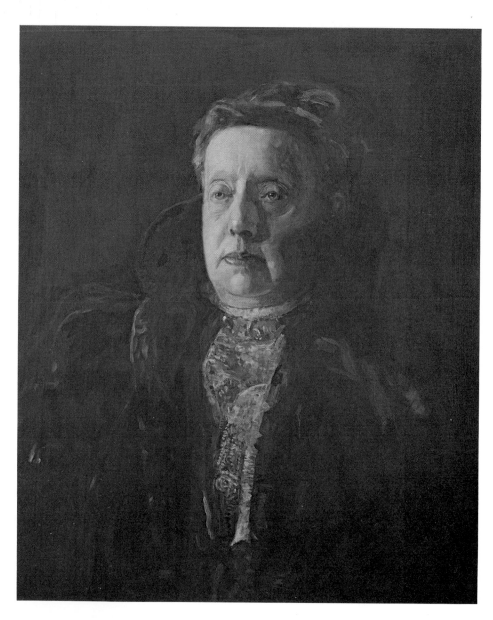

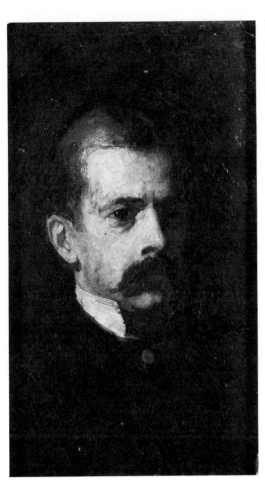

Fig. 282. *Study of Walter Macdowell,* c. 1886. Oil on wood, 7" × 4" (17.8 × 10.2 cm). Photograph by Wayne Newcomb. Collection Walter G. Macdowell, Roanoke, Virginia.

Fig. 283. Suzanne Santje, c.1900. Author's collection.

probably, like the informal portrait on the wall of the room, the *Camille* is a genre touch. McHenry wrote that the portrait was of David Wilson Jordan, Eakins' pupil. But it is not like Jordan. More likely it is of Miss Santje's husband, Al Roth, a theatrical agent.

The Ogden portrait resulted in another of Eakins' frequent disagreements with his sitters. Again we must rely on Goodrich for a portion of Eakins' letter to Ogden: [13]

> I remember speaking very frankly to you of my affairs, telling you that a very large proportion of my important works had been given away or sold at nominal prices. My work has been so divergent in character and so novel, and so much of it has gone directly to institutions, that its commercial value is indeterminate, and I admit I was sorely puzzled to know just what to charge you. I asked some of the best figure painters and reduced considerably the sum mentioned by them. I also learned the prices of Madrazo and Chartran, both painting in New York. They get $6,000 for full-lengths, and certainly do not paint better than I do. My reputation among artists is very good. I am a member of the National Academy and have had awards by international juries in the last three World's Fairs, including Paris. . . . May I suggest what I think to be your duty? It is to inform yourself at your leisure as to the value of large portraits. The best painters in the country belong to your club, and there are many picture stores along Fifth Avenue which would take orders for portraits. If after consultation you still believe I have overcharged you, I will give you back so much of the money as will bring the sum within your own opinion of propriety and honesty.

Plate 54 (opposite). *Portrait of Mrs. Gilbert Lafayette Parker,* 1910. Oil on canvas, 24" × 20" (60.9 × 50.8 cm). Boston Museum of Fine Arts.

Plate 55 (opposite). *Portrait of Mrs. Gilbert Lafayette Parker* (detail).

Ogden paid the price Eakins asked, $1500, only under protest, and offered to return the portrait "with his compliments."

Besides the Falconio portrait, 1905 brought forth two more of the artist's best: the portraits of A. W. Lee (CL-197, Fig. 284) and John B. Gest (Plate 46). Gest was, like Ogden, a high official in a local institution; in Ogden's case it had been the New York branch of John Wanamaker, in Gest's the Fidelity Bank in Philadelphia. The Gest portrait, in my view, has scarcely been exceeded by the artist. His sitter sits tensely and arrogantly, clenching between his hands the first nickle he ever made.

Elizabeth Burton, a student of the artist, was also painted in this year (CL-147, Fig. 285). Years later she had fond memories of her association with Eakins. She wrote to the Minneapolis Institute of Art, which had acquired her portrait, about a letter she had received from Eakins: [14]

> The distinguished penmanship . . . is interesting and unusual, and all friends of Mr. Eakins will recognize the sweet, simple, thoughtfulness of nature the letter reveals.
>
> His way of giving the portrait was equally characteristic of his generous, loving heart. After I had gone so far away to live, Mother wrote me that Mr. Eakins appeared at our home one afternoon with the picture under his arm, handed it to her and said with his usual gentle simplicity—"I thought you might like to have it Mrs. Burton, now that Elizabeth has gone."
>
> "Elizabeth had gone." There could be no more poses. In November 1913 my Husband and I came home from the Far East for a brief visit, and saw Mr. and Mrs. Eakins at their home, 1729 Mount Vernon Street, Philadelphia.

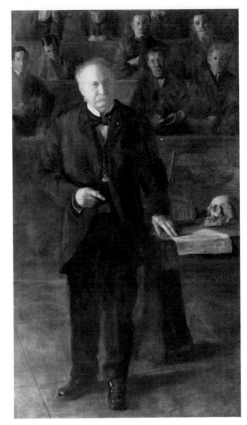

Fig. 286. *Portrait of Professor William Smith Forbes*, 1905. Oil on canvas, 84″ × 48″ (213.4 × 121.9 cm). Jefferson Medical College, Philadelphia.

Fig. 284. *Portrait of A. W. Lee*, 1905. Oil on canvas, 40″ × 32″ (101.6 × 81.3 cm). Reynolda House, Winston-Salem, North Carolina.

Fig. 285. *Portrait of Elizabeth L. Burton*, 1906. Oil on canvas, 30″ × 25″ (76.2 × 63.5 cm). Minneapolis Institute of Art.

He had failed so that I was deeply shocked and grieved. He kissed me, said a few words about the "old days," and fell asleep in his chair. I never saw him again.

In 1905 Eakins also painted a portrait of Professor William Smith Forbes (CL-327, Fig. 286) for Jefferson Medical College. He wrote William Sartain on March 13, 1905, that he was working on the Forbes portrait, and as soon as he finished it he was going down to Washington to work on the Falconio portrait. "Murray has a good many nice orders," he wrote, "so we are both very busy." [15] In Washington on May 7 he wrote Morris that he would again serve on the jury for the Academy's Stewardson Prize.

As friendly as his relations were with Harrison Morris, the Academy director, Eakins still could not bring himself to be anything but cold to Edward Coates, who had been Academy president in that fateful February 1886. There had evidently been some sort of circular sent to Academy stockholders, in which a quotation concerning Morris' abilities appeared over Eakins' name. Coates, in his dictatorial way, wrote Eakins a demur, scolding him for presuming to write such a thing. Eakins' answer is in the Academy archives: [16]

Dear Sir,

In answer to your inquiry, I did not promulgate the circular bearing my name.

On the contrary, I refused to sign my name to it.

While putting a high estimate on the ability I have seen in Mr. Morris

as a Fine Art manager, and while allowing him to repeat my opinion of him
to his friends or inquirers, I would certainly not have thrust my opinions
unasked for on stockholders or on others with whom I have no relations.

<div align="right">
Yours truly

Thomas Eakins.
</div>

Early the next year Eakins received a letter from a pupil of J. Laurie Wallace,
now teaching in far-off Omaha. George Barker, Wallace's pupil, wanted to go ahead
with his art study, and Wallace had evidently suggested he write to Eakins for advice.
Eakins' answer was far from encouraging: [17]

Dear Sir,

I am sorely puzzled to answer your letter. If you care to study in
Philadelphia, you could enter the life classes of the Pennsylvania Academy
of the Fine Arts and I could give you advice as to your work and studies,
or you might go to Paris and enter some life classes there. Nearly all the
schools are bad here and abroad.

The life of an artist is precarious. I have known very great artists to
live their whole lives in poverty and distress because the people had not
the taste and good sense to buy their works. Again I have seen the fashion-
able folk give commissions of thousands to men whose work is worthless.

When a student in your evident state of mind went to Papa Corot for
advice, the old man always asked how much money he had. When the boy

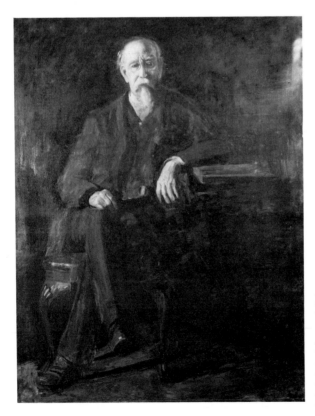

Fig. 287. *Unfinished Portrait of Dr. William Thomson*, c. 1907. Oil on canvas, 68″ × 48″ (172.7 × 121.9 cm). Photograph by Wayne Newcomb. Collection Mrs. John Randolph Garrett, Roanoke, Virginia. The College of Physicians of Philadelphia owns a finished portrait of Thomson.

offered to show him sketches and studies the old man gently pushed them aside as being of no consequence.

<div align="right">Yours truly
Thomas Eakins.</div>

P.S. I am not connected with the Pennsylvania Academy and my advice would be contrary to nearly all the teaching there. I have no classes of my own.

Barker was probably too young to have thought Eakins anything but soreheaded when he got this answer. Fortunately he lived to know better, and when I spoke to him late in his life he wished he had gone to Philadelphia and taken Eakins' offer to give him advice.

In 1907 Eakins' old acquaintance Talcott Williams wrote an article for *Book News Monthly* in which he set himself up, after the manner of journalists of his style, as an art critic. He reviewed the 1907 Academy Annual, where one of Eakins' clerical portraits and his *Dr. Thomson* (Fig. 287) were shown. A Philip Hale picture had "an excessive modernity," but was "full of charm and flexile grace."[18] A Mr. Adams had a picture with a "somewhat vulgar title," the "vulgar title" being "A Young Jewess." He liked the Mary Cassatt: "here is sheer executive ability carried to its utmost," and thought Sargent's portrait of Endicott Peabody was "solid, blotched and unsatisfying." He quoted Bernard Berenson's snobbish remark that the best Sargents are signed Cecilia Beaux. He flattered other portraits of the Philadelphia elite, and must have been thinking of Mary Cassatt's brother, Alexander J., president of the Pennsylvania Railroad, when he spoke of her "executive ability." Eakins, however, in all this verbiage, is not even mentioned.

A few months later Eakins, in his letter to Elizabeth Burton, wrote about Murray and exposed his prejudice in favor of Murray's technical, somewhat heavy work.[19]

> Murray's nine foot statue of Commodore Barry the father of the American navy was unveiled on St. Patrick's day the 17th of March with great ceremonies followed by a banquet.
>
> The statue is planted in the very centre of Independence Square, where the old commodore walked many a time smoking his pipe at the close of the revolutionary war. The statue is a gift to the city by the Friendly Sons of St. Patrick a very rich society dating away back of the revolution.
>
> George Washington was one of its members. As nobody can belong except he has Irish blood in his veins the members were hard put to it to find an expedient. Finally George Washington was legally adopted by a very Irish member as his son and then all trouble ended.
>
> Artistically the statue is I believe the best in the country and I am proud to have assisted Murray in its execution.
>
> As soon as I can get hold of a good photograph of the statue I shall send it to you.
>
> I take it that the portrait I painted of you is half mine and half yours. I have given my half to your mother.

I wish I had had two or three more sittings on it so that I might have pulled it together more, but your mother will excuse any artistic short comings, and will only consider the likeness. . . . Our whole Spring has been wet and cold, but now it is real summer. I suppose your climate is hot, perhaps hot and moist.

I suppose you might go in to swim without much of a bathing suit . . . Susie wishes to be remembered.

According to the records of the School of Design for Women, of which Emily Sartain was principal, Murray began teaching there in 1895. But in January 1894 Eakins wrote that Murray had already been teaching there "for some time." Murray was soon to become quite deaf. He did not follow his teacher's practice of using the complete nude. Once it happened accidentally, and some of the ladies had hysterics.

In 1907 Eakins also painted a portrait of his long-time friend and pupil Thomas Eagan, who had been one of those who left the Academy with him, and who helped form the Art Students' League (Fig. 289).

At about this time—the evidence wavers between the summer of 1906 and the summer of 1907—Eakins painted a portrait of his young friend Helen Parker (CL-316, Fig. 290), the daughter of the well-known Philadelphia silhouette artist, Kate Parker, who had done a cutout of the artist himself. This portrait, now in the Philadelphia Museum, has come to be known as *The Old-Fashioned Dress*. (The dress itself, incidentally, is also in the Museum.) McHenry wrote of the circumstances: [20]

> Eakins was fascinated by a dress which had belonged to her grandmother. Helen Parker would leave it at his studio between sittings, and Eakins and Susie and Addie Williams would pour [*sic*] over the dress, studying it. The dress had been remade and the seams were sewed by machine with a chain stitch. Eakins called his portrait of Helen Parker "The Old Fashioned Dress." She had been disconcerted while she was posing because he would not make her "just a little pretty" but kept saying, "You're very beautiful, you're very beautiful" while reveling in her neck bones and making her "really small and dainty nose more and more bulbous" according to Helen Parker. She remembered too that she and Eakins used to check their bicycles in the baggage car up to Chestnut Hill and ride the wheels back down the Wissahickon Drive.

McHenry also quoted Kate Parker's memories of the occasion: "Mr. Eakins painted Helen's picture in about 1908 and put on it a world of work. She posed about thirty-five times, two and three hours at a time and wore my grandmother's old white silk and pearls." If what Mrs. Parker said about the time the portrait took is true, some sort of record was established for Eakins. He was getting tired or bored or a bit of both.

A remarkable photograph of Helen Parker, not by Eakins, is a fascinating comparison with the Eakins portrait (Fig. 293). Which came first, the photograph or the portrait? Likely Eakins asked Helen how she wanted to pose, and she remembered the recent photograph, and he told her to bring it along and he would see. In *The Old-*

Fig. 288. Eakins at about 55, c. 1900. Modern enlargement. Collection Leonard Baskin, Northampton, Mass.

Fig. 289. *Portrait of Thomas J. Eagan*, 1907. Oil on canvas, 24″ × 20″ (60.9 × 50.8 cm). Collection Thomas M. Evans, New York.

Fashioned Dress the artist again used the famous Victorian Elizabethan chair that he had used in *The Zither Player*, Mrs. Brinton's portrait, and the portraits of Amelia Van Buren, Edith Mahon, Joseph Leidy, Benjamin Howard Rand, Suzanne Santje, and others. It also appears in the photograph of the artist's sister Caroline (Fig. 212) in his studio.

Helen Parker had met Eakins at one of Frank A. B. Linton and Samuel Myers' musicales, as Eleanor Pue, another of Eakins' sitters (CL-323) from this time, had done. Miss Pue remembered that Eakins had followed her around at the party, and that when she sat for him he poked her and exclaimed, "Beautiful bones, beautiful bones!" [21] Miss Pue and Mrs. Evans both recalled Eakins' interest in their bodies, and Mrs. Evans spoke to me of his having wanted her to pose nude. The same story is told by another young woman sitter of this time, Rebecca Macdowell, Mrs. Eakins' niece, who visited the Eakinses often, and who is now Mrs. John Randolph Garrett (Figs. 295 and 296). "He always wanted us to pose in the nude," Mrs. Garrett remembers.

Sylvan Schendler wrote of an interview he had with another Eakins sitter, Alice Kurtz, now Mrs. John B. Whiteman (CL-138), who was a young girl at the same time: [22]

> . . . her mother and father had met in the Macdowell home, and Thomas
> Eakins attended her wedding to John Whiteman. Eakins spent a good part
> of the summer of 1903 working at her portrait. He did not photograph her.

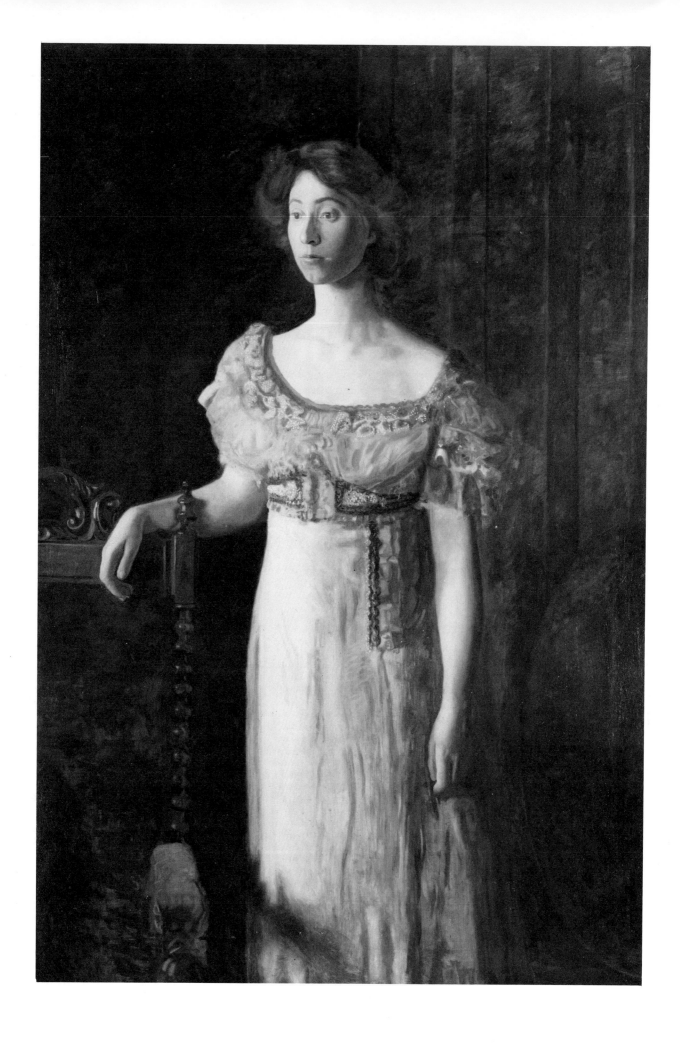

Fig. 290. *The Old-Fashioned Dress*, c. 1907. Oil on canvas, 60⅛" × 40¼" (152.7 × 102.3 cm). Philadelphia Museum of Art. Helen Montanverde Parker.

Fig. 291. *Study for The Old-Fashioned Dress*, c. 1907. Oil on cardboard, 11⅛" × 7" (28.2 × 17.8 cm). Originally squared-off for enlarging. Collection Mr. and Mrs. Daniel Dietrich II, Philadelphia.

Fig. 292. *Study for The Old-Fashioned Dress*, c. 1907. 36" × 22" (91.4 × 55.9 cm). Collection Mr. and Mrs. Daniel Dietrich II, Philadelphia.

She had been playing tennis that summer in a long-sleeved high-necked blouse which she removed when she posed for him; her arms and neck were pale, her face sunburned, and he painted her that way.

"Mr. Eakins," she told him during one sitting, "my collar button has gone down my back and it hurts sitting here." He reached down to retrieve it, and told her, "Your back is more like a boy's than a girl's." He told her he would like to paint her in the nude, and she said she would ask her mother about it. Her mother said it would be perfectly alright if she did. "Tom is an old fool about the nude. He would look at you as if you were an anatomical specimen." But she thought it would be just as well not to, and Eakins did not ask her again.

Mrs. Whiteman is evidently the sitter who is quoted by another historian as saying that "Tom Eakins was somewhat hipped on nudes." [23]

Since 1900 Eakins had confined himself to portraits in oil. Before that he occasionally stepped into other milieus—a genre or a landscape or two, photography, sculpture, watercolor. But by the turn of the century he had settled snugly into his forte: the depiction in oil on canvas of the physiognomy and psychology of his fellow human beings. There had been great portraits before 1900—the Holland, Barker, Rowland, Cook, and Marks portraits among them. But the full flood surged most consistently in the first years of the new century, and ebbed steadily thereafter. Left to him, on the level of the past, were only the Dr. William Thomson portrait and the portraits of the Parker family.

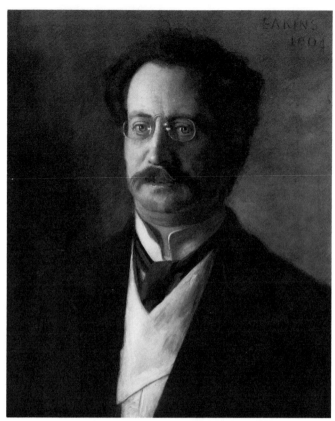

Fig. 293. Helen Montanverde Parker, 1906 or 1907. Courtesy Helen Montanverde Parker Evans, Minneapolis, Minnesota.

Fig. 294. *Portrait of Samuel Myers*, 1904. Oil on canvas, 24″ × 20″ (60.9 × 50.8 cm). Hirshhorn Museum and Sculpture Garden, Smithsonian Institution.

Fig. 295. *Portrait of Rebecca Macdowell*, c. 1908. 20″ × 16″ (50.8 × 40.7 cm). Kennedy Galleries.

Fig. 296. Mrs. John Randolph Garrett (née Rebecca Macdowell), 1971. Author's collection.

14

Decline and Death
1908-1916

AFTER *The Old-Fashioned Dress*, the last comparably penetrating and attractive portrait was one of a group of four Eakins made in 1910 of the Parker family of Philadelphia: Dr. Gilbert Lafayette Parker (Fig. 297), Mrs. Gilbert Lafayette Parker (CL-136, Plates 54 and 55), and their sons Gilbert Sunderland and Ernest Lee, both successively curators of the Pennsylvania Academy of the Fine Arts.

Eakins had generally had his greatest success with portraits of men rather than women. In his portrait of Mrs. Parker, however, with her marvelous rigidity and a face both expressive and consummately expressionless at the same time, he achieved one of the heights of his career. Mrs. Parker's husband is a dub beside her, more of a dub than he perhaps actually was. His wife apparently interested Eakins very much more, and the result is a depiction of character that can stand beside a Rembrandt or a Velázquez without embarrassment. A dowager of dowagers; a cold right eye, and a flaccid mouth that no defendant would ever like to see in a jury box or on a judge's bench.

Before Eakins' final fling at greatness, in the half dozen years before his death in 1916, he had shown symptoms of a decline. The downward direction was taken in about 1908, with the complex of works surrounding his return to the *William Rush* theme of 1876. The central work in this group, now in the Brooklyn Museum, shows fatigue, carelessness, and boredom, and little of the spirit that made the painter the great

Fig. 297. *Portrait of Dr. Gilbert Lafayette Parker*, 1910. Oil on canvas, 24″ × 20″ (60.9 × 50.8 cm). Private collection, Denver.

Fig. 298. *William Rush Carving His Allegorical Statue of the Schuylkill*, 1908. Oil on canvas, 35¹⁵⁄₁₆″ × 47¾″ (89.7 × 121.3 cm). Brooklyn Museum.

artist he showed himself to be in the earlier work (CL-174, Fig. 298). A parallel work (CL-116), evidently an abandoned version of the plans he had for the Brooklyn picture, has a little more ease and life. But neither can match even the artist's recent portraits of Helen Parker or A. W. Lee, and both are mere shades of his earlier achievements.

Such portraits as the Parker portrait, the Borie portrait at Dartmouth (CL-153), and the Dr. Thomson portrait at the Philadelphia College of Physicians indicate that Eakins was not finished, the Brooklyn *William Rush* notwithstanding. But so far as his influence and significant work are concerned, the portrait of Mrs. Gilbert Lafayette Parker is the final highlight.

In 1912 there was a final effort, another portrait of President Hayes, and the result, though a bit dull, is interesting (Fig. 299). Alexander Smith Cochran, the carpet manufacturer, was collecting Presidential portraits, and Charles Henry Hart, the art historian who had not exactly been a help and a comfort to Eakins back in 1886 when he needed such help on the Academy Board of Directors, was helping Cochran collect the pictures. Hart was evidently aware of the portrait Eakins had made of Rutherford B. Hayes early in his career, and this may have led him to ask Eakins to do a new portrait. He may have discovered that Eakins' earlier portrait of Hayes had been destroyed, or he may have seen it somewhere and decided the red face was still too unconventional for the sedate array his patron wanted. In any case, he asked Eakins about the earlier Hayes portrait, and received the following reply: [1]

Dear Mr. Hart,
I received from the Union League a commission to paint President Hayes. The portrait was finished accepted delivered paid for and hung and I never saw it again.

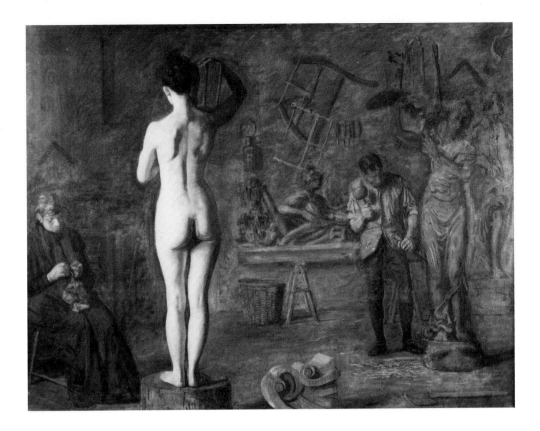

The portrait was far from the conventional. Mr. Hayes knew nothing
of art and when I asked for time for sittings, he told me that he had already
sat for a distinguished artist who had required only 15 minutes of sitting.
I saw work by this distinguished artist. His method was to make a rapid
sketch for the color and then use the photograph altogether.

I told Hayes this, but all I could get out of him was permission to be
in the room with him as he attended affairs of state and received visitors.

As I was very anxious to please my patrons, I accepted the President's
terms foolishly perhaps, but determined to do my best.

The President once posed, I never saw him in the same pose again. He
wrote, took notes stood up, swung his chair around.

In short, I had to construct him as I would a little animal.

I believe with you that mine is the only portrait from life. I do not
believe it was destroyed. It is probably coarse but not without merit and
might serve as a basis for something better

The "distinguished artist" who had pleased Hayes was, evidently, W. Garl Browne,
whose monstrous parody of life is still resplendent upon the walls of Philadelphia's
Union League, which had taken Eakins' work down and banished it to a cellar
(Fig. 300). Eakins' statement that he thought his portrait was the only one made from
life is curious. We know, as a matter of fact, that besides Eakins' portraits and Browne's
there were several other likenesses of Hayes taken from life.

The note to Hart was written in an uneven, shaky hand. By now Eakins' age
and illness were taking a toll. He exhibited at the Academy regularly, but only paintings
he had produced years before. In the 1914 Annual, for example, he showed his study
for Agnew in *The Agnew Clinic,* and his Leonard and Dana portraits, the most recent
of which had been produced twelve years before. He had wanted to show his George

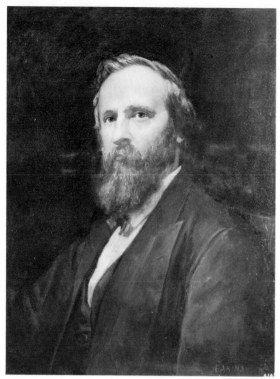

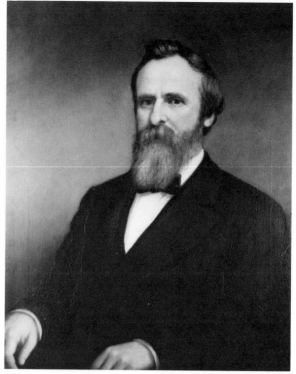

Fig. 299. *Portrait of Rutherford Birchard Hayes,* 1912. Oil on canvas, 29″ × 24″ (73.7 × 60.9 cm). Philipse Manor Hall, Yonkers, New York.

Fig. 300. W. Garl Browne: *Portrait of Rutherford Birchard Hayes,* 1878. 36½″ × 29¼″ (92.7 × 74.2 cm). Union League of Philadelphia.

Barker portrait, but the Academy's Secretary, John Andrew Meyers, refused it. Eakins had written Meyers that the portrait had been exhibited once before but he knew that "you some times violate your rule for previous exhibition," [2] as, indeed, they did. "I am very sorry that this is the case," Meyers replied, "for it is, on this account, ineligible much to our regret." [3]

The January letter was very unsteady, with lines sloping downward, unevenly spaced, and with letters of unequal and inconsistent sizes. Two weeks later another letter to Meyers, apologizing for a late entry by Samuel Murray, shows more deterioration. "Mr. Murray among other things things [sic] entered at the Academy a bust of Monsignor Heiran. An accident happened in casting I told Mr Murray you would doutless [sic] extend his time The bust is now ready Yours truly Thomas Eakins." [4]

Albert Barnes bought the Agnew study from the Academy walls, and this purchase caused a furor, because the price Barnes paid was $4000, leaving the artist $3400 after the Academy had taken its 15 per cent commission. It was a small sum compared to what other painters were getting, but it was nearly three times as much as Eakins had ever gotten. And in 1914 it was gratifying, particularly since Barnes did not make a habit of buying American art. In this case he had evidently been advised by Robert Henri, who had been so enthusiastic about the Leslie Miller portrait. Henri wrote Barnes his congratulations: [5]

Dear Dr Barnes

Congratulations! I was cursing the luck that no big museum was forth

coming with the sense or courage to buy Eakins' great masterpiece and was very much tempted to get into print about it, hopeless as the case might be. Now I am happy that you have it and that it has found place in a collection in which there are so many of the best works by men who like Eakins have seen the way before them and have dared to follow it.

Eakins has pursued his course no matter what the fashion has been.

I think your purchase of his work is more significant than the purchase of a hundred old masters

Yours Henri

The celebrity surrounding the Barnes purchase induced a Philadelphia newspaper to send a reporter up to the house on Mt. Vernon Street to interview Eakins, now "the dean of American painters." [6] He was asked the perennial question: "Who do you think is the greatest American painter?" and in the course of his reply Eakins named Winslow Homer and had apt words for his Philadelphia public and for us:

If America is to produce great painters and if young art students wish to assume a place in the history of the art of their country, their first desire should be to remain in America, to peer deeper into the heart of American life, rather than to spend their time abroad obtaining a superficial view of the art of the Old World. In the days when I studied abroad conditions were entirely different. The facilities for study in this country were meagre. There were even no life classes in our art schools and schools of painting. Naturally one had to seek instruction elsewhere, abroad. Today we need

Fig. 301. Eakins at about 70, in rear doorway of 1729 Mt. Vernon Street, Philadelphia, c. 1915. 4⅜″ × 3½″ (11.7 × 8.9 cm). Hirshhorn Museum and Sculpture Garden, Smithsonian Institution.

Fig. 302. Eakins at about 70 with Mrs. Eakins in side yard of 1729 Mt. Vernon Street, Philadelphia, c. 1915. 4³⁄₁₆″ × 3⁵⁄₁₆″ (10.7 × 8.4 cm). Collection Mr. and Mrs. Daniel Dietrich II, Philadelphia.

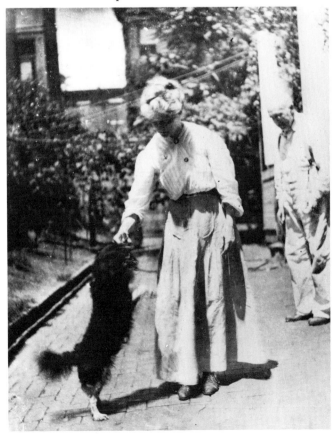

Fig. 303. Left to right: Charley Boyer(?), Eakins, and Samuel Murray in Cohansey River behind Eakins' fish house, Fairton, New Jersey, c. 1910. 4⅜″ × 6¹⁄₁₆″ (11 × 15.4 cm). Hirshhorn Museum and Sculpture Garden, Smithsonian Institution. Boyer, an organist of neighboring Bridgeton, helped with the housekeeping.

not do that. It would be far better for American art students and painters to study in their own country and portray its life and types. To do that they must remain free from any foreign superficialities. Of course, it is well to go abroad and see the works of the old masters, but Americans must branch out into their own field, as they are doing. They must strike out for themselves, and only by doing this will we create a great and distinctly American art.

Unlike many other painters Eakins knew what was best in the art of others, and when he named Winslow Homer as the greatest American artist, he was only one step away from the truth.

On November 23, 1912, an exhibition illustrating the "Evolution of Portraiture in Lancaster County" opened in Lancaster, Pennsylvania. D. Hayes Agnew was a Lancasterian and thus Eakins' *Agnew Clinic* was eligible for display. Mrs. Eakins told Henry McBride, the critic of *The New York Sun*, that her husband then had the best reception of his life. He was ill, and was advised not to go, but go he did, and, as McHenry wrote, had "a grand good time." McHenry makes much of this visit—she evidently interviewed more than one of those concerned with it—and it was a rare occasion for Eakins. He was the center of much attention and consideration, both for his art and for himself, and sick or not, he and everyone who knew him were glad he had gone.

By the end of the winter of 1913–1914 Eakins was no longer able to write, and his wife assumed the role of secretary. Soon he was confined to his room, with Samuel Murray or Billy Smith or another helping him move from one part of the house to another. The halcyon Cohansey days were over. No longer could he ascend the steep steps to the studio. No longer could he hold a brush for long. He started a portrait of Dr. Edward Spitzka, a brain specialist, but failing eyesight prevented his finishing it. It is the last work we know from the hand of Thomas Eakins (CL-104, Fig. 304).

Fig. 304. *Unfinished Portrait of Dr. Edward Anthony Spitzka*, c. 1913. Oil on canvas, 30″ × 25″ (76.2 × 63.5 cm). Hirshhorn Museum and Sculpture Garden, Smithsonian Institution. Cut down from a larger canvas, 84″ × 43½″ (213.3 × 110.5 cm) to make it more salable. Spitzka, a brain specialist, was shown with a human brain in the original portrait. Mrs. Eakins is said to have finished the brain because her husband was too ill to continue.

Goodrich wrote that Mrs. Eakins painted the only finished part of the portrait, a human brain that Spitzka was holding in his hands. But this section, like a good share of the Barker portrait, was cut away by a dealer in order to make the portrait "prettier." This and the portrait of Eakins in *The Agnew Clinic* are the only instances in which Mrs. Eakins added to her husband's work.

In the Academy Annual of 1915 Mrs. Eakins arranged for three of her husband's pictures to hang: *Portrait of an Artist*, *Portrait*, and *Portrait of a Young Man*. *Portrait of an Artist* (CL-3) was evidently the one Eakins had done of J. Carroll Beckwith, and *Portrait of a Young Man* (CL-308) the one he had done of Kern Dodge. The one called simply *Portrait* (CL-289) was his unfinished portrait of Mrs. Talcott Williams, and Mrs. Williams' husband's colleagues in the Philadelphia newspaper world were delighted to honor this unremarkable picture. The *Inquirer*, for example, failed to mention the Beckwith and Dodge portraits, and dwelt on the offerings of such exhibitors as Cecilia Beaux, who was called "ultramodern," and William Merritt Chase, whose work was "beautiful," "sensitive," delicate," and "refined." But Eakins' third portrait was a portrait of a colleague's wife, and the critic must be his most fulsome: [7]

> It is very delightful to see Mr. Eakins' "Portrait" (of Mrs. Talcott Williams) allotted the place of honor in Gallery F. This portrait, painted about twenty-five years ago, may be numbered among the most distinguished works of a painter whose place in the history of American art cannot be too strongly insisted upon. His reputation in measure rests upon the famous portraits of Dr. Hayes Agnew, owned by the University of Pennsylvania, and the portrait of Dr. Gross, owned by Jefferson Hospital.
>
> These are known and generally accepted, but besides these Mr. Eakins has painted a long series of very important canvases whose place in the history of American painting is of utmost importance. This full length portrait is one of the finest, it has the essence of portraiture, it presents in

Fig. 305. Eakins with Murray's sculpture at about 70 in the parlor of 1729 Mt. Vernon Street, Philadelphia, c. 1915. Modern enlargement. From *The American Art Annual*, 1916.

the most beautiful manner a distinguished and charming personality. It has none of the technical fluency of the superficial painter who sets out to show one how easy it is for him to paint. It has none of the much-vaunted tone painting that comes from thick thinking, or the confusion which indicates vague thinking.

The figure is drawn with an exquisite sense of fact. Its truth appeals to one, its personality grips one, just as is the case in Titian's famous "Man With a Glove." Its simplicity is its great element of power, and its absolute sincerity constitutes its great charm. The slender woman stands holding in her two hands a black fan which makes the one deep note in the picture.

For the rest the gown is of subtle pink and the background a warm tone, reflecting the general coloring of the gown. The head is small and distinguished in its setting, the features fine and delicate, while the arms in the simple sleeves of the style of a quarter of a century ago are finely drawn like the arms of an antique statue. The portrait is profoundly impressive.

Now that Eakins was old, and near death, and the Academy rupture possibly a source of bad conscience for the *Inquirer*, it was safe and assuaging to say that Eakins' place in the history of art "could not be too strongly insisted upon." A little of such insistence might have helped back in 1886.

Unsuccessful attempts to sell the Melville portraits—for $3000 each—in June 1915, and the artist's final exhibition during his lifetime, the Academy Annual opening February 6, 1916, were the chief artistic events in the final year of Eakins' life. There were also a good many sales, which must have been a source of some gratification. *Music* and *Starting Out after Rail* were both sold, for $1500 and $500 respectively, from the Academy exhibition. More important than the money was that *Starting Out*

after Rail was sold to the Metropolitan Museum, whose curator, Bryson Burroughs, had become an Eakins enthusiast. The other sporting picture, *Pushing for Rail*, was given to the Metropolitan at the same time, a deal which was probably made when the museum bought *Starting Out after Rail*. The purchaser of *Music*, nervous because it was neither signed nor dated, asked the Academy supernumerary, John Andrew Meyers, to have Eakins put a date and a signature on it. His request for these additions, dated April 4, 1916, is the last Eakins item in the Academy archives. It was never answered.

In February 1916 Eakins' old friend of Paris days, Harry Moore, who had been living abroad for many years painting sweet, banal pictures, returned to Philadelphia. Eakins and Moore had a reunion, and had their pictures taken with Murray for a Sunday feature article in the *Press* of February 13, 1916.

Thomas Cowperthwaite Eakins died at 12:47 P.M. on Sunday, June 25, 1916, in the middle second-floor bedroom of the house at 1729 Mt. Vernon Street where he had spent nearly all his life. Although the manuscripts of his physician are now missing, his death was said to have been due to "heart failure." Murray was with him for the last two weeks, day and night. During that time he held Eakins' hand—"he didn't seem to want me to leave," Murray wrote McBride.[8] Only Murray could feed him. The women around him tried to give him patent medicine, but he would not take it

He is said to have been blind in the final months, and this was said to have been caused by the continuous, prolonged intake of formaldehyde, which was then widely used as a milk preservative. Formaldehyde does not cause blindness, however, but gastric irritation, and ulcers, liver damage, or congealed tissue, none of which was known to trouble Eakins. Eakins probably died of arteriosclerosis, brought on by the high blood pressure and hypertension that he must have had.

The terms of the artist's will were simple. He left an estate of $64,481.17, having reduced, by his unprofitable profession, the estate that had been left him sixteen years before. His personal and household effects were left to his wife, and the "rest, residue and remainder" was left to his wife and Addie Williams, three-fourths and one-fourth respectively. His wife was named executrix.

There was $1453.07 in the bank, $29,352.54 worth of stocks and bonds, a house at 2340 St. Albans Street in Philadelphia, which he had inherited from his Aunt Eliza Cowperthwaite, a house at 111 Olive Street in Media—and $2860 worth of oil paintings. These are what he had in his studio on May 10, 1915, when he drew his will. Today they would be worth several million:

Number

1	Oil painting	*Marine*	Framed	$ 25
2	Oil painting	*Mending of the Nets*	Framed	35
3	Oil painting	*The Bathers*	Framed	25
4	Oil painting	*Cowboy*	Unframed	20
5	Oil painting	*Woman at Piano*	Framed	200

6	Oil painting	*Professor Barker*	Framed	150
7	Oil painting	*Between Rounds*	Framed	50
8	Oil painting	*Admiral Melville*	Unframed	75
9	Oil painting	*H. Lewis*	Unframed	20
10	Oil painting	*Dr. Gross–sketch*	Framed	30
11	Oil painting	*Rush carving the Spirit of Schulkill* [sic]	Framed	25
12	Oil painting	*Professor Rowland*	Framed	250
13	Oil painting	*Hauling the Net*	Framed	10
14	Oil painting	*Cowboy*	Framed	25
15	Oil painting	Portrait—*Boy*	Framed	35
16	Oil painting	*Salutat*	Framed	50
17	Oil painting	Portrait	Framed	65
18	Oil painting	Portrait	Unframed	20
19	Oil painting	Portrait	Unframed	20
20	Oil painting	Portrait—*Mrs. Frishmuth*	Framed	400
21	Oil painting	Portrait—*McLure Hamilton*	Framed	100
22	Oil painting	Portrait—*Miss Parker*	Framed	35
23	Oil painting	Portrait—*Talcott Williams*	Unfinished	125
24	Oil painting	*Study of a Head—Spanish Girl*		40
25	Oil painting	*Single Scull*		50
26	Oil painting	*The Wrestlers*		25
27	Oil painting	*A Sketch*		15
28	Oil painting	*Santzje* [sic]—Study Unfinished		100
29	Oil painting	*Study of Head*		20
30	Oil painting	Portrait		20
31	Oil painting	Portrait—*Charles Hazeltine*	Framed	50
32	Oil painting	*Crucifixion*		400
33	Oil painting	Portrait—*Soldier*		200
34	Oil painting	*The Singer*		150
			Total	$2860

The *Ledger*, along with the conventional errors of detail attendant upon a hastily prepared biographical sketch (Eakins had studied with the sculptors Chapeau and Barye, his Hayes portrait was in the National Portrait Gallery, he had designed the figure on the U.S. dollar.) ranked him as "one of the foremost of American artists in the last half century," [9] a modest tribute indeed.

The American Art News reprinted the *Ledger* obituary almost verbatim, but added a significant item. Eakins had left an estate of "less than $100,000"—no particular surprise. But of what he had left, a fourth of it was to go to Addie Williams. It is this fact that accounts for the inscription on Mrs. Eakins' gift to the Philadelphia Museum: "Gift of Mrs. Thomas Eakins and Miss Mary Adeline Williams."

The will records no specific bequest to his friend, pupil, and companion Samuel Murray. Murray owned at least five works by his master: a portrait of his wife's mother, the portrait of himself, and three sketches—for *The Cello Player, The Crucifixion,* and the portrait of Walt Whitman. But whether they came to him after Eakins' death, and Mrs. Eakins invited him to make some choices, or whether they had come to him before, we do not know.

Eakins' body was cremated at the columbarium at the Chelton Hills Cemetery, brought back to Mt. Vernon Street, and placed in an urn on the mantel. In 1938 his wife died, and the following spring the ashes of both were buried together in the Eakins' family plot overlooking the Schuylkill in Woodlands Cemetery.

15

Posthumous Recognition

SHORTLY AFTER Eakins' death a movement was started among the art world of Philadelphia to hold a Memorial Exhibition at the Academy. This was met with a sharp rebuff by John Frederic Lewis, who was then President of the Board of Trustees. His reaction and his reasons are recorded in a remarkable letter from Helen Henderson, art critic of the *Inquirer*. New York had beaten Philadelphia to the punch, a Memorial Exhibition was under way at the Metropolitan. New York had shown Philadelphia what should have been Philadelphia's "immediate impulse": [1]

> My dear Mr. Lewis:
>
> I am sending you the page in the New York Sun devoted to a consideration of the Memorial Exhibition to Thomas Eakins at the Metropolitan Museum, also my own article, fearing that they may otherwise escape your attention.
>
> I hope you know that the initiative with regard to this splendid showing of the master's work came entirely from the management of the Metropolitan Museum. Mr. Bryson Burroughs having gone personally to call upon Mrs. Eakins in her home to beg her to allow the Metropolitan the privilege of showing her husband's work.
>
> I remember very clearly and painfully our conversation on the subject of a memorial exhibition to Eakins at the Academy last February in the corridor upstairs a few days before the opening of the Academy Annual. You then said that you had told Mrs. Eakins that she could have the gallery at some time when there was nothing else there, as you had "no doubt that the

poor woman needed money," and when I explained to you that Mr. Eakins' will amply provided for her welfare you said that in that case you took no further interest in the matter.

I have felt this attitude on the part of the Academy management very deeply. You should understand that the management is not there to *patronize* artists, but to recognize ability, and that such a memorial exhibition of the work of, as McLure Hamilton said to me to-day, the *greatest artist of the nineteenth century in America*, brings more honor upon the institution than it ever can upon the dead artist. You forget that without the artists Academies would not exist.

I believe that there is nothing that the Academy can ever do now to wipe out the memory of its negligence in this particular instance—as well as in many others—You have allowed New York to show you what should have been our immediate impulse. What I do hope is that the big lesson of such a disgrace will not utterly escape you.

I speak frankly as one who spent the best years of her life in service to the Academy—as one of hundreds who love the institution unselfishly and long to see it hold its place as the oldest of its kind in this country. However little you may regard my opinion I beg you to note that it is backed by the action of the Metropolitan Museum, and take it kindly.

New York had indeed shown Philadelphia its duty. Bryson Burroughs, the Metropolitan curator, admired Eakins' work and had acquired two pictures the year before the artist's death. Now the Metropolitan decided to mount a Memorial Exhibition, and gathered sixty works for an opening on November 5, 1917. A number of the best and most characteristic works were selected: several sculling and sailing pictures, the 1876 *William Rush*, and the portraits of Harry Lewis, Rand, Barker, Whitman, Weda Cook, Schenck, Mrs. Frishmuth, Falconio, Mrs. Parker, Gest, and the Gross and Agnew pictures.

The page of *The New York Sun* that Helen Henderson sent to John Frederic Lewis was undoubtedly page 12 of the *Sun*'s edition of November 4, 1917. There Henry McBride, the *Sun* critic, spent nearly the whole page in his review of the Metropolitan's Memorial, and fairly chortled his admiration for Eakins, "one of the three or four greatest artists this country has produced."[2]

He was probably grouping Eakins with Homer and Ryder. By this time this triumvirate had been set up as America's greatest. All were now comfortably dead—the last of the three, Ryder, had died the previous March, and no one needed to back up praise with action, or get involved in the artist's personal life, or use his influence to see that the artist received praise or sold paintings when he was alive and needed it. All now delighted to praise America's "greatest," and luxuriated in the process, healing their consciences. Helen Henderson had gone overboard for Eakins in the 1914 Academy Annual, but she had praised the wrong portrait for the wrong reasons and to the complete neglect of far greater works.

All three—Burroughs, McBride, and Henderson—took up the cudgel when it

was too late to do Eakins himself any good. They helped lay a foundation for a convention that echoes still today—that Eakins, Homer, and Ryder are America's greatest painters. But they praised none of the three to any extent while they were alive. With an occasional exception—in Eakins' case the William Clark reviews were notable—all three artists died believing they had been scorned and neglected, as indeed, in comparison with what they deserved, they had.

McBride reproduced three paintings in the *Sun* article: *Portrait of Professor Gross, Katherine*, and the 1876 *William Rush*. He could not say enough in praise of the Gross painting which, incidentally, he properly called a portrait, not a genre picture. It was "not only one of the greatest pictures to have been produced in America but one of the greatest pictures of modern times anywhere." It was "great from any point of view, impeccably composed, wonderfully drawn, vividly real." *The Agnew Clinic* he did not like so well. The grouping, he wrote, was not "so happily arranged" as in the Gross painting, and there was no such overpowering climax. He had visited Mrs. Eakins and had learned from her that the only time Eakins had gotten a really "comforting experience" was when Lancaster, Pennsylvania, gave him an exhibit in 1912.

Not all New York critics were as laudatory as McBride. *The Outlook* was as superficial as could be: Eakins' portraits, though "always strong," were often "muddy," his surfaces were "inelegant," and "a few of his pictures were certainly extravagantly ugly." [3] The critic spoke of the artist's "integrity and sincerity," which were, of course, complimentary terms, but so trite by now in terms of Eakins' work that they lacked force. *The Outlook* critic especially liked *The Chess Players, The Writing Master, The Thinker*, and the J. Carroll Beckwith portrait. *The Thinker* he liked best of all. One would almost think the critic worked for the Metropolitan—or wanted to, for three of his four favorites had been or were shortly to be owned by the Museum: *The Chess Players, The Writing Master*, and *The Thinker*.

Mrs. Eakins went to New York, saw the hanging several days before the opening, and wrote Burroughs a graceful, gentle letter of appreciation: [4]

> Dear Mr. Burroughs
>
> At home again, I want to write to you, how wonderful the visit to the Museum and to you, was to me. I think I can hardly express, the impression that filled me and remains with me, of the beauty and elegance of your arrangement of my husbands pictures in that splendid room. I know that Miss Baldwin [5] would love to join me in writing to you.
>
> I read in tonights paper, with much regret the death of Mr. Beckwith. Some time ago he wrote me of the pleasure he would have in seeing his portrait again.
>
> I shall remember always the kind reception I received from all whom I had the pleasure of meeting on that memorable day.
>
> With kindest regards and best wishes for your health
>
> > Very truly yours
> > Susan M. Eakins.

Burroughs, in his introduction to the catalogue, pointed out that Eakins had grown up in the tradition of the Hudson River School, whose members had been "circumscribed by the lack of foundation and experience." But Eakins, among other young Americans, overcame these defects by study abroad. "It is the work of the best of these," he continued, "who were technically competent, even judged by foreign standards, and who still kept something of the quality of the rugged and homely America of their prime, which represents most significantly our artistic accomplishment. Of this group was Thomas Eakins. . . ."

Thus went contemporary criticism at the time of Eakins' death. He was sometimes praised, and for the right reasons, and sometimes denigrated for the wrong. But as was natural so soon after his death, no one knew how good he was or how much he should have been praised.

Meanwhile, the Helen Henderson letter and reviews, along with obscurer sources, induced the Academy of the Fine Arts to give in and mount an Eakins show in Philadelphia, where it should have been in the first place—even though Mrs. Eakins didn't "need" it. Miss Henderson had been pounding at the Academy in her *Inquirer* column until the pressure built up intolerably. To this woman must be given a large part of the credit for persuading the Academy and Philadelphia to dislodge itself from its lethargy and defensiveness and honor its foremost painter. She pulled no punches— "Now that we have buried one great Philadelphia artist without recalling his importance until New York points it out to us." [6]

She went up to the Metropolitan's preview and came back and devoted most of her column to the exhibition and what she thought of how Philadelphia had treated the artist: [7]

> . . . The Eakins Exhibition takes precedence as honoring the greatest American painter of our day by the greatest art institution of the country . . . the most dignified and appropriate tribute to the memory of a great artist that the writer has ever seen. . . .
>
> To the Philadelphian making the pilgrimage to New York to see the memorial exhibition of the art of a man who was born, lived and died in our midst, it must be inevitably apparent that he has never seen Eakins really well hung before. The prophet was never honored in his own country. . . .
>
> There is not one insincere canvas upon the walls. In each we see the conscientious performance of a master. . . . He was without pose of any kind, made no pretentions whatever, and for that reason was much overlooked and neglected in his native town. . . .

The critic singled out for particular praise *Portrait of Professor Gross, The Agnew Clinic, The Cello Player,* and *The Concert Singer,* which she called "without doubt the most purely beautiful thing that Eakins did." "Poor Eakins," *The American Art News* commented, "he had to die to get a page in the Sunday papers."

Loan arrangements for the Academy Memorial got under way within a month

after the Metropolitan exhibition opened. Among those solicited were Eakins' old *bête noir* Edward Coates, the Academy president in 1886. Coates was asked to loan *The Pathetic Song*—which Meyers, the Academy Secretary, thought was the same as *At the Piano.*

The Academy wrote Burroughs about loaning *The Thinker* and *The Writing Master*, which the Metropolitan now owned, and was told in reply that although Burroughs did not feel free to tell them the insurance valuation of these particular pictures, the whole Metropolitan show was insured at $110,000. "The Exhibition," he closed, "continues a splendid success." [8]

The Academy Memorial opened on December 23, 1917, with forty-three more works than had been in New York, perhaps the largest collection of Eakins' works "ever brought together or that ever will be," the catalogue preface said. The preface was written by Eakins' friend and protagonist Gilbert Sunderland Parker. It was as laudatory as Burroughs' had been for the Metropolitan, although somewhat less sophisticated.

> "No painting should be out of perspective," he frequently remarked, and was wont to term "cowardly" those paintings that left much to the imagination, in spite of which he was a most tolerant man when on a jury of artists.
>
> But not alone was it his knowledge of drawing, composition, anatomy and perspective that made Eakins great; his constructive ability was wonderful,—he fairly modelled in paint, if one may so express it. He built up the whole form, giving every plane its proper relation and value so that the feeling of being able "to go all around" one of his figures, the Gross or the Agnew, for instance, is experienced, as when viewing a great Velasquez, but more important even than these was his marvellous insight into character and his power to analyze and portray it, and when one compares most of the portraits of our time with an Eakins' from the Eakins' viewpoint, they look weak and thin,—the Eakins' stands out full of life and character.
>
> Illustrative of this talent was the amusing reply made by the late Edwin A. Abbey, when asked as to why he did not have Eakins paint his portrait. "For the reason," he answered, laughing, "that he would bring out all those traits of my character I have been trying to conceal from the public for years." . . . While a few art lovers have always known and realized the remarkable work of this great man, they were necessarily few, for he was not and could not be a popular portrait painter. Insipid prettiness did not appeal to him, neither would he endeavor to flatter his subject in any way, nor was he attracted by the sensuous or unclean, but it was always character, character, character. . . . It mattered not the cost, Eakins did what he felt and believed to be right even though the whole world were against him.
>
> An incident that will show his lack of fear and also his spirit toward his fellowman happened soon after his return from the West, where he had been living among the cow-boys. He had occasion to cross Walnut Street bridge, which was infested with thugs in those days, late one night, and

therefore took his large revolver along. Two toughs were waiting for a possible victim, and, as Eakins walked across the bridge, he cocked his revolver in his pocket. The thieves evidently heard it, for one said to the other, "Let him go by, we'll get the next." After Eakins had passed the men, he waited for the man following and escorted him the rest of the distance over the bridge.

To those of us who knew him intimately for a quarter of a century or more and have always esteemed his work, one and all, we must say, "Here was a man."

Now that the Philadelphia exhibition had opened, Helen Henderson felt somewhat better: [9]

In Honor of Eakins

It has long been the custom in this country for Philadelphia to produce the artists, but for New York to support them. Generally the artists have left for Gotham, but in any event have expected to sell their pictures there. Thomas Eakins never deserted his artistic home. He loved the city and he loved to help develop young artists, even if they soon flew from the maternal nest. In any other city of the country Eakins would have been one of its best-known citizens; in any other country he would have been decorated. Instead, Philadelphia, outside the small artistic colony and the few real lovers of art, knew him rather as a name than as standing for high achievement.

It is therefore gratifying that this distinguished artist is being honored by a large exhibition at the Academy of the Fine Arts, where the whole range of his abilities is shown and where those who love and can appreciate good art may have an opportunity to get a good perspective of the results of a long life of industry. It is a little late, considering that the exhibition is of a memorial nature, but appreciation now is better than never.

While the Academy show was running, *The Art World*, in its issue of January 1918, published a biographical sketch of Eakins written by William Sartain. Sartain had submitted his manuscript to Mrs. Eakins, who had suggested changing a paragraph that contained error—Sartain had written that Eakins taught in the *Brooklyn* Art Students' League (did he still not want to give his old friend credit for a New York school?). But Mrs. Eakins was overruled in the final copy, Eakins was said to have taught in the "Brooklyn Art Students' League," an organization that so far as I have been able to discover never existed. Mrs. Eakins also modestly wanted Sartain to take out the following sentence: "He married Susan Macdowell, an artist of talent whose portrait of Prof. Schussele is a very notable work." [10] Someone, Sartain or an editor, agreed, and the sentence did not appear in the magazine.

In February *The Nation*, in a review by "N. N," was a strong dissenter from even the relatively mild praise Eakins had evoked from other critics. The Gross portrait had the "cheap trick" of falsely concentrating light; [11] the clerical portraits showed "characterless" people; such portraits as *The Thinker* and *John McClure Hamilton* showed "superficiality" and "clumsiness." Eakins was not a great artist, and "no

amount of booming will make him one. To exalt him to a seat among the mighty is to bring him with a crash to the earth. . . . In a word," *The Nation* concluded, "Eakins was a sufficiently important painter in his generation to justify the Memorial Exhibition . . . , even if eventually the world jury may not endorse today's critics."

Mrs. Eakins' income, as she had written Burroughs, was not large, and the money from the paintings she had sold the Metropolitan had come in handy. Burroughs now gave her some advice as to how she could occasionally sell paintings. Perhaps he had told her she could get a friend of the family to act as her agent: [12]

> Dear Mr. Burroughs,
>
> I am following your advice—you are certainly my friend, and also a good Dutch uncle, which pleases me very much. No, I am not rich, or I would not have sold "The Writing Master," but I feared that nothing would sell. I was in debt, and when the handsome sum was realized, I felt that I would like to spare a little, and my Dutch uncle has shown me how. And your ancient niece is grateful and will not trouble you further about it.
>
> Wishing you a most happy New Year,
>
> > Yours sincerely,
> > Susan M. Eakins.

In September 1919, evidently feeling the pinch again, Mrs. Eakins approached her husband's old friend Clarence Cranmer, of the *Ledger*, and asked him to help her sell two more paintings. Cranmer wrote the Academy asking for "a small list of Art Academies in the country, who might be interested." [13] It is also possible, of course, though less likely, that it was Cranmer who needed the money, and had asked Mrs. Eakins if he might use this means of making a commission or two. In any case, Cranmer's solicitation had little effect, and in 1923 the first of a series of frankly commercial exhibitions was held at the Joseph Brummer Galleries in New York. Burroughs, who was one of three writing the catalogue preface, said that "We are catching up to [Eakins] at last and an ever-increasing number hold that American art has produced nothing greater than the work of Thomas Eakins." [14] The Metropolitan bought *Lady with a Setter Dog* from the exhibition.

There were thirty works in the first Brummer exhibition, including seven watercolors. Two and a half years later Brummer held another Eakins' one-man show, having decided, as he wrote in the catalogue, that Eakins was "the most important artist America has produced." [15] He had thirty-nine more to sell, including six "small studies in oil," eight drawings, and an enigma, "Head of 'Slick' (Study)." Who "Slick" was is a mystery—possibly a dog. In the spring of the next year the Brummer exhibition went up to the Albright Art Gallery in Buffalo, where the catalogue indicated that *Becalmed* and one of the small oil studies had been disposed of. Mrs. Eakins was also having contacts with the Macbeth Galleries—perhaps eager ones, since a letter she wrote to Macbeth in November 1926 seems oversolicitous, even granting her characteristic kindness. Macbeth had come across a portrait of a Miss Van Buren, and sent Mrs.

Eakins a photograph of it, thinking it might be one of her husband's. It was not, she replied, but she would do her best to find out more about whose it might be, and whether or not the sitter was a relative of her husband's sitter, Amelia Van Buren, of Tryon, North Carolina.

In the process, also, she made a remarkable statement:[16] "I never knew Mr. Eakins to sign his pictures in any place, but the lower right-hand corner—the usual way with most artists, and always with dark paint." Considering the fact that such Eakinses as *A May Morning in the Park*, *The Pathetic Song*, *The Concert Singer*, and at least thirty others are signed elsewhere than in the lower right-hand corner, this is a curious remark.

By the time of this letter Clarence Cranmer had gotten a little expertise, which he did not have when he asked the Academy of the Fine Arts for a list of "Art Academies" that might want an Eakins. Now he wrote the Carnegie Public Library in Fort Worth, Texas, which had bought *The Swimming Hole*, about other paintings he was selling—this time those belonging to the collector named Pfeiffer, who had no Eakinses. In the process Cranmer claimed that he had sold thirteen Eakinses to the Metropolitan (a considerable exaggeration), one to the Brooklyn Museum, one to Fiske Kimball personally, and one each to Portland, Oregon, and Los Angeles. The Brooklyn painting was the watercolor *Whistling for Plover;* the Fiske Kimball was *The Wrestlers* study. But neither the Portland nor Los Angeles museums had bought any. Evidently Cranmer thought that Fort Worth would not be liable to check out the facts.

Cranmer also wrote Fort Worth of a movement that was "now gaining impetus here to try and arrange to purchase the entire collection for our new Art Museum, which, if consummated will make it nearly impossible to obtain an Eakins at any price."[17] This was merely a come-on, to try to stampede Fort Worth into buying another Eakins. But it was what Cranmer had been writing to others for some months, and it was having an interesting effect.

On July 7, 1927, Bryson Burroughs wrote Mrs. Eakins a letter that reveals a plan to acquire the bulk of her Eakins works for New York:[18]

> Mr. C. W. Cranmer has written me asking if the Museum would be interested in acquiring any more of Thomas Eakins' paintings. He also tells us that a movement is under way to try and acquire a collection of Eakins' paintings for the city of Philadelphia which I am very glad indeed to hear. I hope Philadelphia has at last waked up to the appreciation of her greatest artist.
>
> I do not believe that the trustees would feel able to buy any more of Eakins' paintings just now but Mr. Cranmer's letter brings up a long cherished ambition of mine which I want to write you about.
>
> When more space is allotted to the paintings galleries I am very anxious to install three special galleries, one to be devoted to your husband's work, one to Winslow Homer and one to John Sargent. I foresee no difficulties in the way of the accomplishment of this plan but had postponed writing you until the necessary space had been allotted and the trustees had approved

of the plan. But other matters depend on the enlargement of the picture space and no decision has yet been reached.

Mr. Cranmer's letter reminds me that I ought to write you so that the possibility of the Thomas Eakins Gallery in the Metropolitan Museum may enter into your consideration in the ultimate placing of Thomas Eakins' works which belong to you.

I am astonished and disappointed that the public recognition of his genius has not yet taken place. That it will come some day I am as sure as that morning follows night but it may not be during your or my lifetime. The danger to these magnificent paintings should they be thrown helter-skelter on the market before they are appreciated fills me with apprehension and I want to suggest to you that if you could arrange your will so that a number of his pictures could become the property of this Museum after your death we could be sure that the usefulness of his work would be perpetuated.

I am proud to think that the Metropolitan was the first institution to recognize the full import of the art of Thomas Eakins and want to feel that other generations may have something of the privilege which those of us had who saw the Memorial Exhibition in our big gallery.

I should be delighted to go to Philadelphia to talk over the matter if you think it worth considering.

During 1928 such a plan—or the bigger one evidently now gestating in the mind of Fiske Kimball, director of the Philadelphia Museum—did not surface. But in November 1929 Mrs. Eakins wrote Kimball, after he had suggested calling on her to talk about giving the Museum an Eakins collection: [19]

It will give me much pleasure to have you call. I will like very much to talk over the situation of how best to arrange for the care of my husband's paintings.

Your assurance that the pictures owned by the Museum have not been cleaned or touched, comforts me, as I have only lately been disturbed by information that the pictures owned by the Jefferson Hospital, among them the "Gross Clinic" have been sent to be restored. . . .

I will phone you, and will be very glad to . . . arrange for a call here at your convenience.

Although this letter is reserved, reserve is not what Mrs. Eakins felt. She was jubilant, and wrote Samuel Murray, her husband's pupil, of her excitement: [20]

Dear Mr. Murray,

Mr. Fiske Kimball has offered to place all of the Eakins works. Pictures, sketches, Drawings, sculpture in the Penna. Museum.

Do not tell anyone, it is not settled yet, but the offer is exactly what I want, and had hoped to accomplish some day. Mr. Kimball is very interested, and presents fine ideas, as his purpose—he admired so much your figure of Tom. . . .

I just send you a short note, as I want you particularly to know about

it, Addie and I think it the finest opportunity, and glad we can keep the pictures in Philadelphia—

Yours
S. M. E.

On November 20 Mrs. Eakins wrote Kimball that she and Miss Williams had decided to accept his offer of "safe-keeping" of her husband's paintings, and enclosed a list of those she wanted to give. Until the recent gift of Edward Hopper's works to the Whitney Museum it was the largest such in the history of American art.

Mrs. Eakins had written Kimball that she was going to New York, evidently in connection with the exhibition of Eakins' works at the E. C. Babcock Gallery. When Carmen d'Alesio heard of the Philadelphia gift he was "nearly overcome." [21] An Eakins exhibition was being planned, a three-man show along with Winslow Homer and Albert Pinkham Ryder, at the Museum of Modern Art, and d'Alesio, hearing that Philadelphia planned a big exhibition of Eakinses, was sure that the Philadelphia exhibition would compete with his. And, of course, his standing as the "official" Eakins dealer would be impaired.

Meanwhile a rash of Eakins articles appeared, praising the artist's work and giving him a new celebrity: *The Arts*, December 1929; *International Studio*, January 1930; *The Bulletin of the Worcester Museum*, January 1930 (the museum had just bought *The Spinner*); and *The Bulletin of the Philadelphia Museum*, March 1930. This latter article contained a checklist of Eakins' works, naming three hundred and fifty, but containing a number of errors, and virtually transcribing the list Alan Burroughs had made for *The Arts* in 1924.

Years passed, with regular Eakins exhibitions being held at Babcock and occasionally elsewhere. Prices were kept high. A sketch for *The Cello Player*, for example, was priced at $2200 in 1933, the pit of the Depression. Typical portraits went—if they went at all—for four or five thousand. As Hudson Walker of the Walker Galleries said, no one could afford them. But Mrs. Eakins was determined not to undersell her husband's work.

In December 1936 the Baltimore Museum of Art held an Eakins retrospective, and the accompanying catalogue was the most serious work on the artist since Lloyd Goodrich's extraordinarily useful book had appeared in 1933.

On December 27, 1938, Mrs. Eakins died. Her will had been written in a shaky hand—she was eighty-six years old—the previous August: [22]

. . . In accordance with the Will of Thomas Eakins, made 10th of May 1915—The income from some Bonds and a few stocks and the possible sale of two houses, the addresses given here—

1729 Mount Vernon Street and 3108 North 15th Street Philadelphia, Penna. The income derived to be shared by his wife Susan Macdowell Eakins ¾—and by his friend Mary Adeline Williams ¼. . . . For my personal benefit, I receive a sum, varied every year, from the Estate of my brother Wm. Gardner Macdowell and his wife Harriette Baldwin Mac-

Fig. 306. Carl Van Vechten's photograph of Mrs. Thomas Eakins at 1729 Mt. Vernon Street, Philadelphia, March 5, 1938. Philadelphia Museum of Art.

dowell. . . . In my husband Thomas Eakins Will he states "I give devise and bequeath my personal and household effects to my wife Susan Macdowell Eakins, absolutely.

I desire that Francis G. McGee will assume the entire care and division of household effects if I become incapable.

In a letter to McGee Mrs. Eakins expressed her regret that the house would not sell for much. "I am so sorry not to keep and repair this old house," she wrote, and closed as follows: "Having no debts, not obligated to anyone, I desire that such loans I have made to persons I trusted, shall be treated as gifts, and not indebted to my Estate in any way."

Shortly before she died Mrs. Eakins was visited by Carl Van Vechten, and a series of interesting photographs resulted (Fig. 306). One who knew Mrs. Eakins, however, Hobson Pitman, thinks the Van Vechten photographs made Mrs. Eakins look aloof, which she was not. To Pitman she was like "a dusty piece of china."

Babcock sold the bulk of remaining paintings, and Freeman, the Philadelphia auctioneer, sold all other effects.

The Freeman list is interesting. It lists various pieces of furniture, bric-a-brac and miscellaneous items that were in the house at Mrs. Eakins' death. There were also several paintings, including Charles Fussell's *Young Art Student*, assumed to be of Eakins himself (Fig. 31), several other Fussells, several by Mrs. Eakins, several by David Wilson Jordan, one by Edward Boulton, one by Leroy Ireland, and four unframed pictures by Thomas Eakins. These latter four were sold for $28. The list also included the following: "Thos Eakins plaster molds 5 pcs in case," which sold for $50. Whether these were casts or molds for casts, or what they were, is a mystery.

On April 15, 1944, an exhibition honoring the one hundredth anniversary of Eakins' birth opened at Knoedler Galleries in New York. From there it traveled to the Philadelphia Museum and continued, in a reduced version, to many other museums in America. Sporadic attention from museums and galleries has followed regularly, until now, more than a century after Eakins' first exhibition at the Union League in Philadelphia, his name is foremost in the history of American art.

CHAPTER 1 *Birth, Childhood, Youth*

1 I am grateful to Margaret Tinkcom, Historian, Philadelphia Historical Commission, and her assistant, Beatrice Kirkbride, for help with the problem of locating Thomas Eakins' birthplace.

2 John Trevor Custis, *The Public Schools of Philadelphia* (Philadelphia, 1897), page 18.

3 Franklin Davenport Edmunds, *The Public School Buildings of Philadelphia* (Philadelphia, 1913), page 137.

4 This information is drawn from the 1868 Committee report, pages 32–33.

5 From a letter of January 30, 1875, Swarthmore College.

6 This quotation, effectively repeated in subsequent editions of *Graphics*, is from page 10 of the Introduction of the 1841 edition (Philadelphia, Sherman and Company).

7 This quotation and the following are from pages 169ff of Franklin Spencer Edmonds, *History of the Central High School of Philadelphia* (Philadelphia, 1902). The writer Edmonds quotes is George Alfred Townsend.

8 *The Art Amateur*, January 1884, page 32. The point should be made that this article was written two years before Eakins was forced out of the Academy. Evidently, regardless of the Eakins imbroglio, it was generally thought that the Academy directors were rigid and reactionary.

9 From a letter of September 12, 1862, Sartain Collection, the Historical Society of Pennsylvania.

10 From a letter of September 27, 1862, Sartain Collection, the Historical Society of Pennsylvania.

11 From a letter of September 10, 1862, Sartain Collection, the Historical Society of Pennsylvania.

12 A letter of May 1, 1866, in the Hirshhorn Collection.

13 Letter of September 18, 1866, Academy archives (Eakins' Italian and French contain errors of both spelling and syntax. These have not been corrected.):

Da Willie, il tuo secondo viglietto ed italiano ricevuto ho e con piacere di molta pena miscolato letto; e addiviene il piacer d'un sentimento che m'assicura che andato via non sarò dimenticato e che una cara amica della mia partenza si dorrà. Ma qui nel animo mio surge grande tristizia, triztizia avendo Emilia; e credo che non passerà giammai. Nondimeno dacchè io abbia sovente udito dire un cotal proverbio, maggiore è la ventura stata divisa e diviene per compassione il dolore minore, e conciosiacosa che mi sia gran mestier di consolazione, ti prego, accioche non m'uccida il mancar di questa, di compianger del mio dolore. Io mè parto non che da uno amico, ma da tutti. Mio buon padre e la dolce mamma mia lascio e vo in una contrada straniere, certo non Inghilterra, ma ancora straniere, assai, non essendovi o parente, o amico, o dei miei amici, amico, e vo solo.

Mio padre m'aspetta: non posso finire. Vedrotti a New York. Scrivi a Willie od a me. Ringrazia da mia parte le tue ostesse. Non avro il temp di farlo io.

Tom.

14 From an undated letter in the Sartain Collection, the Historical Society of Pennsylvania.

15 From an undated letter, probably written in September 1866, Academy archives.

CHAPTER 2 *First Months in Paris*

1 Howard Roberts was a fellow Philadelphian who had studied at the Academy, became a sculptor, and remained in Paris, where he died in 1900. Frederic Arthur Bridgman studied in New York before going to Paris, did many Oriental and archaeological pictures, and became known as "the American Gérôme." I have found nothing about Conrad Diehl.

2 Hay's letter to Shinn is dated September 25, 1866, and is in Swarthmore College.

3 From a late 1866 letter at Swarthmore.

4 From a 5½″ x 3¾″ leather-bound notebook in the Philadelphia Museum of Art, gift of Seymour Adelman. This letter, like the following, was carefully copied from the original by Eakins:

<div align="center">

Ecole impériale & spéciale
des
Beaux-Arts
</div>

<div align="right">

Paris 11 Octbre 1866
</div>

Monsieur

J'écris dans ce moment à Monsieur le Surintendant des Beaux Arts qui nous a demandé il y a peu de jours un reseignement a ce sujet qui nous avons de la place les ateliers de l'école pour les étrangers qui demandent à y entrer, et qu'il peut leur accorder permissions; vous pourrez en consequence réclamer une lettre de votre ambassade pour soliciter du surintendant la permission d'étudier a l'école, ce qu'il vous accordera sur la présentation de votre lettre. L'année dernière toute les places étant prises on a du refuser plus d'un étranger ce dont sans doute on a gardé le souvenir a votre ambassade.

Mais aujourd'hui le il n'y plus de raisons pour y mettre obstacle. Aussitôt que M. Le Surintendant nous écrira de vous admettre je vous ferai inscrire sur la liste de tel atelier que vous voudrez choisir. Vous aurez cependant a voir le professeur de votre choix qui vous donnera une lettre pour le secretariat. Alors vous pourrez commence a travailler.

<div align="right">

Agrées l'expressions de mes senti-
ments distingués,
Albert Lenoir
Secrétaire de l'école des
Beaux Arts.
</div>

5 *Ibid.*

<div align="right">

Légation des Etats-Unis
Paris le 12 Octobre 1866
</div>

Monsieur le Ministre

J'ai recours a la bonté de Votre Excellence, pour demander en faveur de mes jeunes compatriotes

	Messieurs	Thomas Eakins
		Conrad Diehl
		Earl Shinn
		H. Roberts
		Frederick A. Bridgman

les autorisations qui leur sont nécessaires pour pouvoir être admis en qualité d'élèves étrangers a l'école des Beaux Arts de Paris.

Je profite de cette occasion pour vous renouveller Monsieur le Ministre les assurances de la haute considération avec laquelle j'ai l'honneur d'être

<div align="right">

Votre très humble et très obéissant
serviteur
John Bigelow
</div>

A Son Excellence Monsieur le Ministre
le Maréchal Vaillant de la
Maison de L'empereur et des Beaux Arts

6 *Ibid.*

École impériale et spéciale des Beaux Arts

<div align="right">

Paris le 15 Oct. 1866
</div>

<div align="center">

Monsieur le Directeur
</div>

J'ai l'honneur de vous présenter Mr. Thomas Eakins qui se présente pour travailler dans mon atelier, veuiller je vous prie le faire inscrire au nombre de mes élèves.

Veuillez agrées l'expressions de mes sentiments distinguées

<div align="center">

J. L. Gérôme
[E has evidently imitated Gérôme's signature.]
</div>

7 Fanny Field Hering, *Gérôme*. (New York, 1892), Foreword.

8 This letter of November 8 and 9, 1866, is in the Joseph H. Hirshhorn Collection, New York. Quoted with permission of the Hirshhorn Collection.

9 Which of the rooms at 1729 Mt. Vernon Street was Eakins' is an intriguing mystery. It was not until he was a married man and brought his wife home that relatives remember him as having the second floor front. Later, when he was a sick old man, the room immediately behind this was his.

10 Evidently his anxiety about getting into the École des Beaux Arts.

11 Lucien Crépon was one of the Academy of the Fine Arts' first students. Eakins later went to live with him. I have found no mention of him in any dictionary of artists. He attended the École des Beaux Arts, where he was a fellow student of Bonnat, Eakins' teacher.

12 The family of Harry Humphrey Moore, the deaf mute whom Eakins looked after in Paris. The Moores lived at 43 rue de Galilee.

13 Perhaps the mother of Harry Lewis, whom Eakins painted in 1875 (Fig. 71), Lucy Lewis, whom he painted about 1897, and Anna Lewis, whom he painted at about the same time. There is a suggestion that Lewis was a writing specialist like Benjamin Eakins: Benjamin Eakins wrote a letter to the University of Pennsylvania recommending a Mr. Lewis for writing commissions (University of Pennsylvania archives).

14 *I.e.*, Emmor Cowperthwaite, Eakins' mother's brother (Fig. 2). The text of this letter is taken from *The Bulletin of the Philadelphia Museum*, March 1930. The original is now illegible, so there may be other errors.

15 Max Schmitt and his wife.

16 A letter of December 1, 1866, in the Joseph H. Hirshhorn Collection, New York. Quoted by courtesy of the Hirshhorn Collection.

17 Henry C. Bispham, a fellow Academy student. Unlike Eakins he studied with Thomas Couture, the famous French romanticist who was enjoying the particular favor of Napoleon III. Emily Sartain later chose Couture as her teacher.

18 Mary Cassatt, who was to go to Paris in 1868, where she studied for a time with Gérôme and became a particular friend of Degas. Eakins was later to write Emily Sartain about some gossip concerning Miss Cassatt and Gérôme (page 35).

19 Margaret McHenry, *Thomas Eakins/Who Painted* (Oreland ?, Pennsylvania, 1946). Hereinafter referred to simply as McHenry. Page 5. Letter of May 1876.

20 *Ibid*, pages 3–4. Letter of July 17, 1867.

21 Letter of October 16, 1866, Pennsylvania Academy of the Fine Arts archives. Quoted by permission of the Academy:

> Parigi, ai 16 1obre 1866
>
> Mia cara Emilia,
>
> M'era piacevelo il riceverla tua ultima lettera e tanto piu quanto mi inaspettata, avendone una fra pochi giorni ricevuta, e non mi credendo bentosto un altra avere dovere: ma leggendola al suo fine mi sento un dolore esser reimaso percioche non dici mente della cattiva tosse nella lettera precedente mostrata. Hai trapassato che che hai chiamato il mio regolamento ed un altro adoperato cosi guardando silenzio dopo avermi avvertito d'un male.
>
> Siccome to hai immaginato il contarmi di tutte le occorrenze ed alle mie amice ed agli amici miei addivenute mi sempre farà piacere.
>
> Molto ti ringrazio dell'aver alla moglie del mio caro signor maestro scritto acciochè egli mi mandi il di lui indirizzo, e altri sono a Parigi fuor di me che troveranno felicità nel rivederlo e niun altro più di Crepon.
>
> Che hai cominciato ad aver percezione delle qualità nobili di un mio carissimo amico non più essermi se non eccessivamente grato.
>
> L'esposizione in quanto apparare posso si cominciarà la primavera vemente e niuna mondana cosa si potrebbe trovare che facesse cambiamento nelle internione se non fosse la morte medesma dell'imperadore, il quale siccome è generalmente creduto sta male assai ma non per morire. In poche mesi sarà giunta al fine.

Son certo che Fannie non riderà giammai cosá che non è da ridire e molti anni ed addiveranno e trapasseranno avantiche mi vergogni di esser corretto da Gerome.

<div align="right">T. C. E.</div>

22 Letter of October 26, 1866, the Joseph H. Hirshhorn Collection, New York. Quoted by courtesy of the Hirshhorn Collection.

23 From an undated but evidently 1874 letter from Sartain to his father in the Historical Society of Pennsylvania. Sartain wrote the address of the École Dessin—École Impériale de dessin, mathématique, architecture, etc.—in his notebook in the Historical Society of Pennsylvania. It was in the rue de Médicine, not far away from the center of the Latin Quarter. He may have taken classes there, but there is no indication that Eakins did.

24 Lloyd Goodrich, *Thomas Eakins* (New York, 1933). Hereinafter referred to simply as Goodrich. This letter, like others quoted by Goodrich, is no longer available. Accents were regularly added in his book, although Eakins frequently omitted them. For the sake of consistency I have added them elsewhere.

25 *Ibid.*, page 14.

26 *Ibid.*, page 16.

27 *Ibid.*, pages 11–13.

28 *For Art's Sake* (Philadelphia, 1953), page 65. Privately printed. Quoted by courtesy of Ivan Albright.

29 From a late 1866 letter at Swarthmore.

30 Letters of October 29 and 30, 1866, in the Sartain Collection, the Historical Society of Pennsylvania:

<div align="right">Paris, le 30, 8bre, 66.</div>

Mon cher Billy,

Puisque tu m'as promis d'étudier français, et puisque j'en ai bien gardé le souvenir, et puisque tu as du l'avoir dejá commence, il ne faut pas t'étonner de recevoir cette lettre. Combien va lentement le temps aux esseulés, et que je serai fort content de te revoir. Il me semble qu'il y a des années que je suis ici, et je t'aurais écrit auparavant, mais je n'avais rien à dire de moi-même, et je n'ai pas voulu te faire, description des belles choses que tu dois bientôt visiter toi-même, ni n'ai-je désire non plus prévenir tes jugements; mais sitot que nous nous trouvions ensemble il nous fera plaisir de comparer les premières impressions que nous ont données ces oeuvres.

Tu vois qu'enfin je suis admis dans l'école imperiale, et j'ai commencé mes études dans l'atelier Gérôme.

moi connaissance des événements qui ont en lieu depuis mon art. Je ne pretends point que tu prennes la peine de m'écrire mais tu pourras dire ce que tu veux a ma soeur ou à mon père. Comment se portent nos amis? Avez-vous eu des figueniques ensemble? Est-ce que tu te promines les dimanches avec eux? Mon père, vous accompagne-t-il quelquefois. As-tu vu recemment Mr. [*sic*] Gardel? Qui est ton professeur? Ton père songe-t-il encore a voyager en Espagne? Mais que de questions! Je, m'arreterai sur-le-champ. N'oublis point de visiter nos chers amis. Il faut que nous séparions le moins que possible.

<div align="right">T. C. E.</div>

<div align="right">Parigi, ai 30 Ottobre, 1866</div>

Mia cara Emilia,

Non ti muova a sdegno contro a me il lungo tempo che trapassera avanti di ricever il mio viglietto; e non ravionare di cio che dimenticata t'ho. Tutte le fiate che vedo il Dante, mi vienero memoria le belle sere avute teco l'inferno leggendo (benche non sia mestier di un libro per farlo), e lego sovente. Allora perche non ho scritto? e venendo al fatto, iscusandomi derotti; che dopo il mio dimorare in Parigi, sperando io di giorno in giorno non ho che mala fortuna avieta se non benerdi pussato e che non ho voluto che istorie triste ad una mia amica pervenissero: ma al presente, m'e la gran ventura di esser, mercè al tuo padre, al numero dei studenti ricevuto della Scuola Imperiale delle Belle Arti, e questo

essendo, e piacendomi egli oltre ad ogni misura, e con fermissima opinione credendo io che i miei amici ed amice per la loro benivolenza ne saranno lieti meco, incomincio il scriver loro.

Contuttoche sia in Parigi stato un mese, non ho ancora trovato compagno alcuno, non avendo per lo cercare il temp avuto, ma se non compagno, ho amici e son eglino questi: Crépon, e sarebbe parimente compagno se non era ammogliato, e ho gia da lui benefici molti ricevuti.

Il Dottore Horner è il secondo. E vecchione e dentista ed il migliore di Parigi ed lo contratto grand amicizia con lui.

Il terzo (e mon pergratitudine terzo), e il Segretario Lenoir. Molto son le cose le quale mosse della di lui bonta si son, praticale per me, e sarebbe impossibile il contare per parole quanto lo stimo.

Ma oro, che son nella Scuola, andrò cercando lieti e costumati compagni e del tuo fratello degni che arriverà accioche nelle nostre anime non sopravanza la malinconia, o se ci addiviene ella accioche. sieno levute via in parte le sue gravezze, le quale da me gia sentite non son piccola cosa. T. C. E.

31 McHenry, page 3.
32 A letter of November 16, 1886, archives Pennsylvania Academy of the Fine Arts.
33 *Ibid.*
34 From an undated letter in a private collection.
35 This and the following quotations are from letters of October 29, 1868, in a private collection.
36 From a January 3, 1867, letter at Swarthmore College.
37 This and the following quotation are from a letter of April 10, 1868.
38 Goodrich, page 14.
39 *Ibid., loc. cit.*

CHAPTER 3 *Gérôme, Bonnat, and Dumont*

1 From a letter of c. September 2, 1867, the Sartain Collection, the Historical Society of Pennsylvania.
2 McHenry, pages 13–14.
3 From a letter of September 4, 1867, the Sartain Collection, the Historical Society of Pennsylvania.
4 From a letter of September 6, 1867, on the same paper as the preceding.
5 From the account book in the Philadelphia Museum of Art.
6 McHenry, pages 6–8.
7 This and the following quotations are from McHenry, page 9.
8 A letter of December 20, 1867, Academy archives.
9 Goodrich, pages 17ff.
10 Private collection.
11 From a letter of April 1, 1869, in a private collection.
12 Letter of June 10, 1868, Academy archives.
13 From Frances Eakins' diary in the author's collection. The following quotations are from this diary.
14 Goodrich, page 24.
15 From a late August letter in the Sartain Collection, the Historical Society of Pennsylvania.
16 Auguste Albert Georges Sauvage was also a pupil of Gérôme at the École. He exhibited works at the Salons until 1913. Museums in Caen and Havre have works by him. I have found no appropriate Curé in either Bénézit (E. Bénézit, *Dictionnaire . . . des Peintres, Sculpteurs, Dessinateurs et Graveurs,* Paris, 1960) or in Thieme-Becker (*Allgemeines Lexikon der Bildenden Kunstler,* Leipzig, 1913).
17 Goodrich, page 21.

18 From an undated but evidently November 1868 letter in a private collection.

19 Goodrich, page 22.

20 From a letter of April 26, 1869, in a private collection.

21 From a letter of April 1, 1869, in a private collection.

22 *Ibid.*

23 From a letter of April 14, 1869, in a private collection.

24 From a letter of April 1, 1869, in a private collection. This was probably the American circus in Paris that Frederic Bridgman, whom Eakins helped to get into the École des Beaux Arts, painted, and which was a popular success at the National Academy Annual in 1875.

25 *Ibid.*

26 *Ibid.*

27 McHenry, page 12.

28 Pascal Adolphe Jean Dagnan-Bouveret was a fellow student of Eakins under Gérôme at the École des Beaux Arts. He also studied with Corot, and Eakins may have gotten the Corot anecdote he told George Barker from Dagnan-Bouveret.) Dagnan-Bouveret was prolific, and his works are in many French museums. For some time he was one of the fashionable portrait painters of Paris. Gustave Claude Etienne Courtois was also a student of Gérôme at the École. He exhibited widely and had a large class of pupils.

29 From the manuscript of an autobiography at the Philadelphia Museum of Art.

30 Goodrich, pages 25–27.

CHAPTER 4 *Spain*

1 Goodrich, page 27.

2 McHenry, page 17.

3 McHenry, *loc. cit.* There are slight differences between the Goodrich and McHenry transcriptions. Both evidently saw originals which are now unlocated.

4 McHenry, pages 18–19.

5 From the Sartain manuscript at the Philadelphia Museum of Art.

6 *Ibid.*

7 Goodrich, page 29.

8 Goodrich, pages 32–33.

9 Goodrich, pages 29ff.

10 From the Sartain manuscript at the Philadelphia Museum of Art.

11 There are today two copies of Rubens' *Descent from the Cross* at St. Charles Seminary, and no other Rubens copies. One is clearly signed and dated "Farasyn / 1865 / Paris," making it unlikely that this is the one Sartain bought—the signature is bold, and five years is too short a time for the damage Sartain described. The other copy is more likely. It is a tryptych, and has been recently resurrected through the perspicacity of Father John Shellem, the St. Charles librarian, to whom I am grateful for help with this research.

12 McHenry, page 19.

CHAPTER 5 *Back in Philadelphia*

1 Page 20.

2 The Hirshhorn Collection.

3 From a letter of January 30, 1875, at Swarthmore College.

4 April 27, 1871. I have discussed this exhibition in *The Bulletin of the Metropolitan Museum of Art*, March 1968, pages 306–307.

5 April 28, 1871.

6 April 29, 1876.

7 A letter of May 20, 1871, in the Sartain Collection, the Historical Society of Pennsylvania.

8 June 1880, page 165.

9 April 28, 1879.

10 Volume 3, page 122.

11 April 6, 1881.

12 April 20, 1879.

13 An undated letter in answer to one Fanny wrote on April 22, probably 1876. Private collection.

14 McHenry, page 132.

15 August 13, 1870.

16 August 18, 1877.

17 May 1881.

18 April 6, 1881.

19 Pages 48–49. It is dated, according to Goodrich, May 10, 1873:
Mon cher Élève:

J'ai reçu l'aquarelle que vous m'avez envoyé, je l'accepte avec plaisir et vous en remercie. Elle m'a été d'autant plus agréable que dans ce travail j'ai pu constater des progrès singuliers et surtout une manière de procéder qui ne peut vous mener qu'à bien. Je ne vous cacherai pas que jadis à l'atelier je n'étais pas sans inquiétudes sur votre avenir de peintre, d'après les études que je vous voyais faire. Je suis bein enchanté que mes conseils, appliqués quoique tardivement, aient enfin portés leurs fruits, et je ne doute pas qu'avec de la persérvérance, dans la bonne voie où vous êtes maintenant, vous n'arriviez à des résultants vraiment sérieuses. Je passe à la critique après avoir constaté les progrès . . .

Il y a dans tout geste prolongé, comme l'action de ramer, une infinité de phases rapides . . . Deux moments sont à choisir pour nous autres peintres, les deux phases extrêmes de l'action; . . . vous avez pris un point intermédiaire, de là l'immobilité . . . La qualité générale du ton est très bonne, le ciel est ferme et léger, les fonds bien à leur plan, et l'eau est exécutée d'une façon charmante, très juste, que je ne saurais trop louer. Ce qui me plaît surtout, et cela en prévision de l'avenir, c'est construction et l'établissement joints à l'honnêteté qui a présidé à ce travail, c'est pourquoi je vous envoie mes compliments avec mes encouragements, et cela je suis très heureux de la faire. Tenez-moi je vous prie en courant de vos travaux et consultez-moi toutes les fois que vous croyez devoir le faire, car je m'intéresse beaucoup aux ouvrages de mes élèves et aux vôtres en particuliers.

20 Goodrich, page 165.

21 From a letter of April 13, 1875, at Swarthmore College.

22 From letters of January 30, 1875, and April 13, 1875, at Swarthmore College.

23 From a letter of June 1, 1875, in the Sartain Collection, the Historical Society of Pennsylvania.

24 Volume 2, page 276:

Il y a une foule de noms des Etats-Unis au catalogue; ce ne sont encore que des élèves, mais pleins de bonnes promesses. Parmi les arrivés, je ne vois que M. May, le portraitiste bien connu qui habite depuis longtemps Paris, et M. Thomas Eakins, un disciple de M. Gérôme, qui envoie de Philadelphie un bien étrange tableau; c'est loin toutefois d'être sans mérite. *Une Chasse aux Etats-Unis* (no. 757) est un véritable ouvrage de précision; c'est rendu comme une photographie; il y a là une vérité de mouvement et de détails vraiment grande et singulière. Ce produit exotique vous apprend quelque chose, et son auteur n'est pas à oublier; on a affaire à un chercheur à une volonté; il faut s'attendre à ce qu'il trouve, et ses travailles peuvent être interessantes et mieux encore.

25 From a letter of February 1, 1874, in the Sartain Collection, the Historical Society of Pennsylvania.

26 From a letter of March 26, 1875, at Swarthmore College.

27 From a letter of c. March 15, 1876, at Swarthmore College.

28 From a letter of January 30, 1875, at Swarthmore College.

29 From a letter of June 14, 1879, in the Sartain Collection, the Historical Society of Pennsylvania.

30 July 7, 1874.

31 November 7, 1883.

32 From a letter of January 30, 1875, at Swarthmore College. I have discussed these paintings more fully in *The Bulletin of the Wadsworth Atheneum*, Fall 1968, pages 4off.

33 At Swarthmore College.

34 February 21, 1876.

CHAPTER 6 *Portrait of Professor Gross*

1 I have discussed this matter in some detail in *The Art Bulletin*, March 1969, pages 57ff. I felt strongly that *Portrait of Professor Gross* should have been used in that article instead of *The Gross Clinic*, but I was overruled. The picture is a portrait, not a genre painting. If there is any doubt about the matter, William Clark, who was closely associated with Eakins during the time the picture was under way, wrote that it was "intended for a portrait of Dr. Gross, and not primarily as a representation of a clinic." (The *Telegraph*, April 28, 1876.)

2 *The Philadelphia Press*, March 9, 1878.

3 An account of Meyers vis-à-vis the Gross painting and the poem are in *The Pennsylvania Magazine of History and Biography*, April 1931, pages 187ff.

4 Samuel W. Gross and A. Haller Gross, M.D.s, *Autobiography of Samuel D. Gross* (Philadelphia, 1893), page 175.

5 Undated letter in the Sartain Collection, the Historical Society of Pennsylvania. In the *Art Bulletin* article I theorized that this letter had been written in August 1875 because Sartain told his daughter in the same letter that the General Committee of the Centennial Fair would meet "next month," which I thought would probably be September. I have now found this to be correct: the General Committee did meet on September 8.

6. *The Philadelphia Evening Telegraph*, March 8, 1876.

7 *Ibid.*, April 28, 1876.

8 *The Philadelphia Press*, March 5, 1875.

9 *Ibid.*, April 6, 1875.

10 From the letter cited in Note 5.

11 From a letter of October 29, 1875, in the Sartain Collection, the Historical Society of Pennsylvania.

12 Quoted in *The Philadelphia Evening Bulletin*, September 10, 1875.

13 *The New York Daily Graphic*, May 11, 1876.

14 June 16, 1876. The date of this report, more than a month after the Art Galleries opened, may suggest that there was some behind-the-scenes struggling about whether or not to hang *Portrait of Professor Gross*. Eakins was a highly regarded painter and teacher, and had highly placed friends.

15 *The New-York Tribune*, June 1, 1876.

16 March 8, 1879.

17 March 8, 1879.

18 March 22, 1879.

19 March 8, 1879.

20 March 8, 1879.

21 From the *Minutes* of the Academy's Board of Directors' meeting of May 3, 1879, in the Academy archives.

22 April 29, 1879.

CHAPTER 7 *First Academy Years*

1 October 19, 1871.

2 From *The Report of the Chairman of the Building Committee of the Pennsylvania Academy of the Fine Arts*, dated November 7, 1871, Academy archives.

3 The *Press*, March 20, 1873.

4 *Ibid.*, March 19, 1873.

5 *Minutes* of the directors' meeting of June 8, 1874, Academy archives.

6 *Ibid.*, meeting of September 13, 1875.

7 March 23, 1876.

8 *Ibid.*, April 29, 1876.

9 *Minutes* of the Committee on Instruction meeting of March 20, 1878, Academy archives.

10 A letter of January 8, 1877 (misdated 1876), Academy archives.

11 *The Philadelphia Evening Telegraph*, February 23, 1878.

12 *Ibid., loc. cit.*

13 A letter of November 2, 1877, Academy archives.

14 *Minutes* of the Committee on Instruction meeting of November 4, 1877, Academy archives.

15 From a letter of about March 1, 1878, Academy archives.

16 *Minutes* of the directors' meeting of June 10, 1878, Academy archives.

17 *Minutes* of the Committee on Instruction meeting of January 9, 1877, Academy archives.

18 Volume for 1877, page 190.

19 The name of this work has many variations. This one is the name Eakins gave it. For a fuller discussion of this work and its nomenclature, see my article in *The Art Quarterly*, Winter 1968, pages 383ff. I theorized in this article that Eakins had probably done his studies for this work before he left the Academy early in 1877. This was because *William Rush* suggests access to the Academy's file of prints, which he would not have had when he became, briefly, *persona non grata*. It has now come to my attention that a watercolor study for the chaperon, in the Princeton Museum, was matted with a newspaper dated May 3, 1877, inclining us toward the theory that Eakins' painting had been finished by that date.

20 *Ibid.*, page 383.

21 *The New-York Herald Tribune*, March 9, 1878.

22 March 13, 1878.

23 I have discussed the Hayes commission in detail in *The American Art Journal*, Spring 1969, pages 104ff, and a later development in the same magazine's Winter 1971 issue, page 103, which brought the disappearing point of the portrait a step closer.

24 Goodrich, pages 55ff.

25 December 10, 1877.

26 June 15, 1878.

27 I have discussed this painting and Eakins' work leading up to it in detail in *The Bulletin of the Philadelphia Museum of Art*, Spring 1965, pages 49ff.

28 November 24, 1880.

29 October 28, 1880.

30 November 25, 1880.

CHAPTER 8 *In Charge at the Academy*

1 *Minutes*, August 22, 1879, Academy archives.

2 From a letter of October 7, 1878, Academy archives.

3 *Minutes* of the directors' meeting of January 30, 1879, Academy archives.

4 *The Philadelphia Inquirer*, August 22, 1879.

5 A letter of September 9, 1879, the Hirshhorn Collection.

6 The quotes that follow are all from William C. Brownell's article in *Scribner's Magazine*, September 1879.

7 From a letter of January 31, 1882, Academy archives.

8 From a letter in the Wallace Collection, the Joslyn Art Museum, Omaha.

9 From Keen's report to the Academy board of directors, April 7, 1877, Academy archives. It was this same Dr. W. W. Keen who years later performed the celebrated secret operation on President Cleveland, removing half the roof of the President's mouth while he sat in a chair tied against the mast of a yacht steaming up the river.

10 *Ibid.*

11 From Keen's report to the board of directors, May 19, 1881, Academy archives.

12 *Ibid.*

13 Adam Emory Albright, *For Art's Sake* (Chicago, 1953) page 62.

14 *Ibid.*, page 68.

15 From a letter of May 28, 1880, Academy archives.

16 From a letter of August 7, 1884, in the Wallace Collection, the Joslyn Art Museum, Omaha. Eakins' photograph of his father-in-law is said to have been inspired by a Rembrandt he saw. It is pleasant but idle to speculate on which one inspired him, Rembrandt painted so many men with wide-brimmed hats.

17 *The Arts*, March 1931, pages 383ff.

18 "The Schools of the Pennsylvania Academy of the Fine Arts," *The Penn Monthly*, June 1881, pages 453ff.

19 *Ibid.*, page 458.

20 *Minutes* of the directors' meeting of January 9, 1882, Academy archives.

21 *Ibid.*, March 13, 1882.

22 Letter of April 8, 1885, Academy archives.

23 More about the life of this enlightened patron of the arts can be found in a memorial by H. H. Furness, *Fairman Rogers* (Philadelphia, 1906).

24 Letter of April 11, 1882, Academy archives. This letter is quoted in Sylvan Schendler, *Eakins* (Boston, 1967), pages 90–92.

25 Academy archives.

26 Letter of February 15, 1886, Academy archives.

27 Academy archives.

28 Sidney C. Lomas (?), *A History / of / The Philadelphia / Sketch Club / Volume 1 / 1860–1900*, page 144, Sketch Club archives.

29 Academy archives.

30 Letter of May 5, 1886, Academy archives.

31 From Henry McBride papers dated November 23, 1917, Archives of American Art.

32 February 19, 1886.

33 February 16, 1886.

34 February 19, 1886.

35 *The Art Interchange*, February 27, 1886.

CHAPTER 9 *Work During the Academy Years*

1 *The Art Interchange*, February 27, 1886, page 64.

2 Quoted by *The Art Amateur*, September 1884.

3 *Op. cit.*, pages 64–65.

4 "The Younger Painters of America," *Scribner's Monthly*, May 1880, page 12.

5 June 1882, page 2.

6 November 1, 1882.

7 From a letter of April 10, 1948, in the Chancery archives, Philadelphia.

8 From a letter of March 14, 1925, in the Hirshhorn Collection.

9 See also my *The Photographs of Thomas Eakins* (New York, 1972), pages 90–94.

10 *Harper's Bazaar*, August 1947, page 184.

11 See *The Photographs of Thomas Eakins*, pages 70–75.

12 Photocopy of a letter of apparently May 1883 in the Academy archives.

13 This quotation and the following are from Goodrich, pages 64–65.

14 November 7, 1883.

15 From an inscription by Elizabeth Macdowell on the reverse of the photograph.

16 A letter of February 27, 1884, in the Wallace Collection at the Joslyn Art Museum, Omaha.

17 May 1883.

18 Sylvan Schendler, *Eakins* (Boston, 1967) page 12.

19 This specific information is from McHenry, who got it from Thomas Eagan or Charles Bregler, both of whom were charter members of the Philadelphia Art Students' League. After two years they moved to 1338 Chestnut, a few doors away from Eakins' studio at 1330 Chestnut. This block was a hotbed of artists' studios. Between these two addresses, for example, at 1334 Chestnut, Cecilia Beaux and Stephen Parrish had studios.

20 McHenry, page 54.

21 Letter of June 26, 1886, Wallace Collection, Joslyn Art Museum, Omaha.

22 McHenry, page 67.

23 *The New-York World*, April 23, 1887.

24 June 1887.

CHAPTER 10 *Exile. The Philadelphia Art Students' League*

1 A letter of June 23, 1887, Wallace Collection, Joslyn Art Museum, Omaha.

2 Horace Traubel, *With Walt Whitman in Camden* (Philadelphia, 1953), volume 3, page 135.

3 Herman Hagedorn, *Roosevelt in the Badlands* (New York, 1921) page 109.

4 McHenry, page 83.

5 Eakins' letter to his wife is unlocated; perhaps it is in the Bregler collection, which is inaccessible.

6 Goodrich, page 102.

7 This letter, without date, but with an envelope dated December 1887, is quoted in part by McHenry, page 90. The original is in the Wallace Collection, Joslyn Art Museum, Omaha.

8 April 1, 1888.

9 April 8, 1888.

10 I have discussed this matter in relation to the photographs of Whitman in *The Photographs of Thomas Eakins*, page 10.

11 Traubel, *op. cit.*, page 155.

12 From a letter from Whitman to Herbert Gilchrist, April 13, 1888, Rare Book Room, University of Pennsylvania. This letter was written at just the time the portrait was finished. The following quotation is from Traubel, *op. cit.* (Boston, 1906), page 131.

 Whitman's portrait came back to the Academy of the Fine Arts several years after Whitman's death. Evidently then Eakins was asked to sign and date it, which he did, making an error of "1897" and then compounding the error by erasing the "9" and substituting an "8." We know from Whitman's records that it should have been 1888.

13 Traubel, *op. cit.*, volume 3, page 144.

14 From an April 13, 1888, letter at Swarthmore College.

15 From a February 27, 1889, letter at Swarthmore College.

16 Albert C. Barnes, *The Art in Painting* (Merion, Pa., 1925), page 300.

17 McHenry, page 144.

18 Boulton, incidentally, later became the father-in-law of Eugene O'Neill.

19 *Harper's Bazaar*, August 1947, page 184.

20 Page 98.

21 A letter of February 17, 1914, in the collection of Weda Cook Addick's son, who has kindly allowed its reproduction. Sylvan Schendler wrote that *Elizabeth at the Piano* was the picture Eakins kept above the mantel (Boston, 1967) page 27. Weda Cook evidently supplanted Elizabeth Crowell.

22 Page 103.

23 A letter of February 6, 1891, in the Academy archives.

24 April 6, 1891.

25 Goodrich, pages 130–131.

CHAPTER 11 *Work in Photography*

1 For a fuller discussion of Eakins' work in photography the reader is referred to my *The Photographs of Thomas Eakins* (New York, 1972).

2 *Ibid.*, pages 209–210.

3 This exhibition, *Thomas Eakins: His Photographic Works*, was organized in 1969 and opened at the Pennsylvania Academy of the Fine Arts on January 7, 1970, supplanting, for the first time, the Academy Annual. It subsequently toured the country. There were 215 exhibits, including a number of original photographs. (See also *Life* magazine, July 23, 1971, pages 54–59.)

4 See *The Photographs of Thomas Eakins*, page 10.

5 I have discussed this work in detail in *The Bulletin of the Philadelphia Museum of Art*, Spring 1965, pages 49ff.

6 From the article cited in the preceding note.

7 *The Art Interchange*, July 9, 1879.

8 *The Philadelphia Record*, February 13, 1883.

9 January 1884.

10 Page 48 of the account book, collection of Mr. and Mrs. Daniel Dietrich II, Philadelphia.

11 From a letter of June 1884 in the Wallace Collection, Joslyn Art Museum, Omaha.

12 From a letter of August 1884 in the Wallace Collection, Joslyn Art Museum, Omaha.

CHAPTER 12 *The Great Portrait Period, I*

1 This and the following quotations are from Harrison S. Morris, *Confessions in Art* (New York, 1930) page 8.

2 October 1895, pages 420–421. The following quotations are also from this article, "Grant and Lincoln in Bronze."

3 Eakins began lecturing at the National Academy in 1888.

4 From the *Minutes* for the Trenton Battle Monument Association meeting for December 26, 1892, in the New Jersey State Library, Trenton, New Jersey. I am grateful to George F. Korn for help with this work.

5 Goodrich, page 118.

6 Possibly *The National Cyclopedia of American Biography*, which contains information that had not been publicly known before.

7 Goodrich, page 99.

8 A letter of April 23, 1894, in the Academy archives.

9 From a letter of June 12, 1894, in the Academy of Natural Sciences.

10 McHenry, page 112.

11 *Ibid.* pages 114ff. The following quotation is also from McHenry, *loc. cit.*

12 May 11, 1896.

13 May 17, 1896.

14 Goodrich, page 99.

15 Author's collection.

16 From an undated but evidently 1939 letter in the Archives of American Art.

17 April 23, 1898.

18 February 1900.

19 A letter of January 29, 1900, Academy archives.

20 Transcription by Cranmer of a letter of May 19, 1899, in the Philadelphia Museum of Art.

21 *Ibid.*, letter of April 23, 1935.

22 The Henry McBride papers, quoted by courtesy of the Archives of American Art.

CHAPTER *13* *The Great Portrait Period, II*

1 Besides the Mt. Vernon Street house this property was as follows: 1106 Union Street, 1108 Union Street, 2647 Sartain Street, 2419 Master Street, 1101 State Street, 1736 Stillman Street, 1738 Stillman Street, and 1740 Stillman Street. All of these had a yearly total rent of $540.

2 Goodrich, page 118.

3 Constance Rourke, *Charles Sheeler* (New York, 1938). Miss Rourke does not make it clear of what year Sheeler wrote. School records are lost. The posing could have occurred in 1900 or 1901, since the portrait is dated 1901. I am grateful to Garnett McCoy of the Archives of American Art for pointing out this reference.

4 Page 115.

5 January 1, 1905.

6 Robert Henri, *The Art Spirit* (Philadelphia, 1960) page 91.

7 Charles H. Morgan, *George Bellows* (New York, 1965), page 215.

8 Mrs. E. D. Gillespie, *A Book of Remembrances* (Philadelphia, 1901).

9 From *The Louisville Courier* as quoted in *The New York Daily Graphic*, June 16, 1876.

10 Goodrich, page 193.

11 From the Henry McBride papers.

12 *The New York Dramatic Mirror*, May 9, 1896.

13 Page 119.

14 From a letter of November 30, 1935, in the Minneapolis Institute of Art.

15 From a letter in the Archives of American Art.

16 December 14, 1905.

17 A letter of February 24, 1906, in the Wallace Collection, Joslyn Art Museum, Omaha.

18 These and the following quotations are from *Book News Monthly*, February 1907, pages 385ff.

19 From a letter of June 21, 1907, to Elizabeth Burton Johnston, in the Minneapolis Institute of Art.

20 Page 130. Kate Parker's quotation is also from McHenry, *loc. cit.*

21 For a fuller discussion of the Pue portrait and quotations from Eakins letters regarding it, see my article in *Arts in Virginia*, Fall 1968, pages 35ff.

22 *Eakins* (Boston, 1967), pages 294–295.

23 Alexander Eliot, *Three Hundred Years of American Painting* (New York, 1957), page 143.

CHAPTER *14* *Decline and Death*

1 A letter of April 13, 1912, in the Archives of American Art.
2 From a letter of January 11, 1914, in the Academy archives.
3 January 15, 1914, *ibid.*
4 January 1914, *ibid.*
5 The Joseph H. Hirshhorn Collection, New York. Quoted by permission.
6 This phrase, and the following letter, are from Goodrich, pages 138–139.
7 *The Philadelphia Inquirer*, February 7, 1915.
8 Archives of American Art.
9 June 27, 1916.

CHAPTER *15* *Posthumous Recognition*

1 Letter of November 6, 1917, Academy archives.
2 *The New York Sun*, November 4, 1917.
3 November 21, 1917.
4 October 25, 1917, Metropolitan archives.
5 Then living with Mrs. Eakins, besides Addie Williams, were her sister-in-law Mrs. Louis B. Kenton, now divorced, and Miss H. L. Baldwin, soon to marry W. G. Macdowell, Mrs. Eakins' brother. Eakins photographed an Elizabeth Baldwin, but this is evidently another.
6 *The Philadelphia Inquirer*, November 4, 1917.
7 *Ibid.*, December 2, 1917.
8 Letter of December 10, 1917, Academy archives.
9 *The Philadephia Inquirer*, December 25, 1917.
10 An undated but evidently June 1917 manuscript in the Sartain Collection, the Historical Society of Pennsylvania.
11 February 21, 1918.
12 January 4, 1918, Metropolitan archives.
13 Letter of September 19, 1919, Academy archives.
14 Catalogue of exhibition opening March 17, 1923.
15 Catalogue of exhibition opening November 2, 1925.
16 From a letter of November 8, 1926, in the Archives of American Art.
17 From a letter of November 10, 1927, Fort Worth Art Center archives.
18 Metropolitan archives.
19 Letter of November 12, 1929, Philadelphia Museum archives.
20 Letter of November 30, 1929, Hirshhorn Collection.
21 Letter of January 9, 1930.
22 From the *Register of Wills in and for the County of Philadelphia*, Number 503, 1939, City Hall, Philadelphia.

Bibliography

BOOKS

This list does not include numerous catalogues consulted in the United States and Europe, and many local histories.

GENERAL REFERENCES:

Appleton's Cyclopaedia

Barker, Virgil, *A Critical Introduction to American Painting* (New York, 1931.)

Barker, Virgil, *American Painting* (New York, 1950.)

Barnes, Albert, *The Art in Painting* (Merion, Pa., 1925.)

Beaux, Cecilia, *Background with Figures* (New York, 1930.)

Bénézit, E., *Dictionnaire . . . des Peintres, Sculpteurs, Dessinateurs et Graveurs* (Paris, 1960.)

Benjamin, S. G. W., *Art in America* (New York, 1880.)

Biddle, George, *An American Artist's Story* (Boston, 1939.)

Boimé, Albert, *The Academy and French Painting in the Nineteenth Century* (London, 1971.)

Bryan, Michael, *Bryan's Dictionary of Painters and Engravers* (London, 1926–1934.)

Burt, Nathaniel, *The Perennial Philadelphians* (Boston, 1963.)

Caffin, Charles H., *The Story of American Painting* (New York, 1907.)

College Art Association, *The Index of Twentieth Century Artists*, Volume 1, Number 17 (New York, 1934.)

Cortissoz, Royal, *American Artists* (New York, 1913.)

The Dictionary of American Biography

Eliot, Alexander, *Three Hundred Years of American Painting* (New York, 1957.)

Fielding, Mantle, *Dictionary of American Painters, Sculptors and Engravers* (New York, 1965.)

Flexner, James Thomas, *Nineteenth Century American Painting* (New York, 1970.)

Gernsheim, Helmuth, and Alison, *The History of Photography* (Oxford, 1955.)

Groce, George C., and Wallace, David H., *The New-York Historical Society's Dictionary of Artists in America* (New Haven, 1957.)

Harrison, Birge, *Landscape Painting* (New York, 1913.)

Hartmann, Sadakichi, *A History of American Art* (Boston, 1902.)

Henri, Robert, *The Art Spirit* (Philadelphia, 1960.)

Isham, Samuel, *The History of American Painting* (New York, 1905.)

Larkin, Oliver, *Art and Life in America* (New York, 1949.)

Low, Will H., *A Chronicle of Friendships* (New York, 1908.)

Low, Will H., *A Painter's Progress* (New York, 1910.)

McCoubrey, John W., *American Tradition in Painting* (New York, 1963.)

Morris, Harrison S., *Confessions in Art* (New York, 1930.)

Mumford, Lewis, *The Brown Decades* (New York, 1931.)

National Cyclopedia of American Biography

Newhall, Beaumont, *The History of Photography* (New York, 1964.)

The 19th Century (various authors) (New York, 1901.)

Novak, Barbara, *American Painting of the Nineteenth Century* (New York, 1969.)

Pennell, Joseph, *The Adventures of an Illustrator* (Boston, 1925.)

Pevsner, Nikolaus, *Academies of Art, Past and Present* (London, 1951.)

Philadelphia City Directories, 1830–1972 (Philadelphia.)

Rewald, John, *The History of Impressionism* (New York, 1946.)

Richardson, E. P., *Painting in America* (New York, 1956.)

Sartain, John, *Reminiscences of a Very Old Man* (New York, 1900.)

Scharf, John Thomas, and Westcott, Thompson, *History of Philadelphia* (Philadelphia, 1884.)

Sloane, J. C., *French Painting Between the Past and Present* (Princeton, 1951.)

Stranahan, C. H., *A History of French Painting* (New York, 1888.)

Theime, Ulrich, and Becker, Felix, *Allgemeines Lexikon der Bildenden Kunstler* (Leipzig, 1913.)

Webster's Dictionaries and *Supplements* 1881–1971

Who's Who in America

SPECIFIC REFERENCES:

Titles devoted entirely to Eakins are in bold face.

Adams, J. Howe, *History of the Life of D. Hayes Agnew, M. D.* (Philadelphia, 1892.)

Albright, Adam Emory, *For Art's Sake* (Chicago, 1953.)

Allen, Gay Wilson, *The Solitary Singer* (New York, 1955.)

Bauer, Edward Louis, *Doctors Made in America* (Philadelphia, 1963.)

Beath, Robert B., *History of the Grand Army of the Republic* (New York, 1889.)

Binns, H. B., *A Life of Walt Whitman* (London, 1905.)

Caswell, James Edward, *Arctic Frontiers* (Norman, 1956.)

Cohen, Charles Joseph, *Rittenhouse Square, Past and Present* (Philadelphia, 1922.)

Craig, H. Stanley, *Cumberland County (New Jersey) Marriages* (Merchantville, New Jersey.)

Craig, H. Stanley, *Cumberland County New Jersey Genealogical Data* (Merchantville, New Jersey.)

Cunningham, William H., *The Polaris Expedition* (Philadelphia, 1873.)

Custis, John Trevor, *The Public Schools of Philadelphia* (Philadelphia, 1897.)

Davidson, Jo, *Between Sittings* (New York, 1951.)

Davis, Charles Henry (editor), *Narrative of the North Polar Expedition U. S. Ship Polaris* (Washington, 1876.)

DeLong, George Washington, *The Voyage of the "Jeanette,"* (London, 1883.)

Dunbar, Elizabeth, *Talcott Williams: Gentleman of the Fourth Estate* (Brooklyn, 1936.)

Eckenrode, Hamilton James, *Rutherford B. Hayes* (New York, 1939.)

Edmonds, Franklin Spencer, *History of the Central High School of Philadelphia* (Philadelphia, 1902.)

Edmunds, Franklin Davenport, *The Public School Buildings of Philadelphia* (Philadelphia, 1913.)

Elmer, Lucius Q. C., *History of the Early Settlement and Progress of Cumberland County, New Jersey* (Bridgeton, New Jersey, 1869.)

Gerson, Robert A., *Music in Philadelphia* (Philadelphia, 1940.)

Goodrich, Lloyd, *Thomas Eakins: His Life and Works* (New York, 1933.)

Gross, Samuel W., and Gross, A. Haller, *Autobiography of Samuel D. Gross* (Philadelphia, 1893).

Hagedorn, Herman, *Roosevelt in the Badlands* (New York, 1921.)

Harper, John C., *A Symbol of a Nation Praying* (Washington, 1965.)

Hartwig, G., and Guernsey, A. H., *The Polar and Tropical Worlds* (Springfield, Mass., 1874.)

Hendricks, Gordon, *The Photographs of Thomas Eakins* (New York, 1972.)

Hering, Fanny Field, *Gérôme* (New York, 1892.)

Hoopes, Donelson, *Eakins Watercolors* (New York, 1971.)

Hopkinson, Joseph, *The Academy of the Fine Arts* (Philadelphia, 1810.)

Joshua B. Lippincott: A Memorial Sketch (Philadelphia, 1888.)

Ingram, Henry Atlee, *The Life and Character of Stephen Girard* (Philadelphia, 1892.)

Marceau, Henri, *William Rush* (Philadelphia, 1937.)

Marks, William D., Allen, Harrison, and Dercum, Francis X., *Animal Locomotion: the*

Muybridge Work at the University of Pennsylvania. The Method and the Result. (Philadelphia, 1888.)

McHenry, Margaret, *Thomas Eakins Who Painted* (Oreland (?), Pennsylvania, 1946.)

McKendry, John J., *1968: Four Victorian Photographers* (New York, 1968.)

McKinney, R. J., *Thomas Eakins* (New York, 1942.)

Melville, George Wallace, *In the Lena Delta* (New York, 1885.)

Metropolitan Museum of Art Miniatures: *Thomas Eakins* (New York, 1956.)

Miller, Leslie W., *The Essentials of Perspective* (New York, 1887.)

Morgan, Charles H., *George Bellows* (New York, 1965.)

Mount, Charles Merrill, *John Singer Sargent* (New York, 1955.)

Nichols, Isaac T., *Historic Days in Cumberland County, New Jersey* (Bridgeton, New Jersey, 1907.)

Notes Concerning the Van Uxem Family (Los Angeles, 1923.)

Pach, Walter, *Ingres* (New York, 1939.)

Perruchot, Henri, *Cezanne* (New York, 1961.)

Pinckney, Pauline A., *American Figureheads and Their Carvers* (New York, 1940.)

Porter, Fairfield, *Thomas Eakins* (New York, 1959.)

Ritter, Abraham, *Philadelphia and Her Merchants* (Philadelphia, 1860.)

Rosenberg, Jakob, *Rembrandt* (Cambridge, 1948.)

Rourke, Constance, *Charles Sheeler* (New York, 1938.)

Schendler, Sylvan, *Eakins* (Boston, 1967.)

Smucker, Samuel M., *Arctic Explorations and Discoveries* (New York, 1886.)

Soyer, Raphael, *Homage to Thomas Eakins* (South Brunswick, New Jersey, 1967.)

Traubel, Horace, et al., *In Re Walt Whitman* (Philadelphia, 1893.)

Traubel, Horace, *With Walt Whitman in Camden* (Boston, 1906, 1908, 1914; Philadelphia, 1953.)

Mother Patricia Waldron (Philadelphia, 1916.)

The White House (Washington, 1962.)

Williams, Charles Richard, *The Life of Rutherford Birchard Hayes* (New York, 1914.)

Williams, T. Harry (editor), *Hayes: The Diary of a President, 1875–1881.* (New York, 1964.)

Works Progress Administration, *North Dakota, A Guide to the North Prairie State* (New York, 1950.)

MISCELLANEOUS AND UNPUBLISHED REFERENCES:

49th Congress, 1st Session, *House Miscellaneous Document 393* (Washington.)

Mary Henrietta, *The History of the Sisters of Mercy of Philadelphia, 1861–1916.* (Philadelphia.)

Lee, E. R., (reporter), *Dr. Levis' Surgical Clinic 1878–9* (Philadelphia, unpublished.)

Lomas, Sidney C., *A History of the Philadelphia Sketch Club, Vol. 1 1860–1900.* (Philadelphia, undated and unpublished.)

Nolan, Edward J., *The Acoccidologists* (Philadelphia, unpublished.)

The Pennsylvania Society of the Colonial Dames of America, *In Memoriam: Elizabeth Duane Gillespie, 1821–1901* (Philadelphia, 1902.)

MAGAZINE ARTICLES

I list only articles I have found useful. Many others are in *The Art Index*. Lloyd Goodrich's 1932 list to that date is thorough; I have found relatively few additional references.

When Eakins works were accessioned by various museums, articles concerning the works have often appeared in the museum publications. I have omitted such references, finding little that was useful in them apart from limited provenances, and in any case the principal ones are cited by *The Art Index*.

I have also omitted most of the numerous reviews that greeted the various Eakins exhibitions from the 1917 Memorials onward: the Brummer Galleries exhibitions of 1923 and 1925; the Babcock Galleries exhibitions of 1929, 1930, and 1939; the Museum of Modern Art exhibition of 1930; the Fifty-sixth Street Galleries exhibition of 1931; the Milch Galleries exhibition of 1933; the Baltimore Museum of Art retrospective of 1936; the Kleeman Galleries exhibitions of 1937 and 1939; the Centennial exhibition which opened at the Knoedler Galleries in 1944 and traveled extensively for several years; the Century Association exhibition of 1951; the American Academy of Arts and Letters exhibition of 1958; the retrospective that opened at the National Gallery in 1961 and traveled; the Eakins' photographs exhibition that opened at the Pennsylvania Academy in 1969 and traveled; the Eakins' sculpture exhibition at the Corcoran Gallery in 1969; and, finally, the retrospective at the Whitney Museum of American Art in 1970. Again, the principal magazine references for such reviews are listed in *The Art Index*.

"The Spelling Bee at Angel's," *Scribner's Monthly*, November 1878.

Benjamin, S. G. W., "Present Tendencies in American Art," *Harper's New Monthly Magazine*, March 1879.

"Mr. Neelus Peeler's Conditions," *Scribner's Monthly*, June 1879.

"The Art Season of 1878–9," *Scribner's Monthly*, June 1879.

Brownell, William C., "The Art Schools of Philadelphia," *Scribner's Monthly*, September 1879.

Brownell, William C., "The Younger Painters of America," *Scribner's Monthly*, May 1880.

Rogers, Fairman, "The Schools of the Pennsylvania Academy of the Fine Arts," *The Penn Monthly*, June 1881.

"A Day in the M'ash," *Scribner's Monthly*, July 1881.

Lathrop, George Parsons, "A Clever Town Built by Quakers," *Harper's New Monthly Magazine*, February 1882.

"Medical Education in Philadelphia," *Our Continent*, January 17, 1883. A reproduction, with curious changes, of *Portrait of Professor Gross*.

DeKay, Charles, "Movements in American Painting," *The Magazine of Art*, Volume 10, 1887.

The Illustrated American, January 16, 1892. Illustration of Walt Whitman after an Eakins photograph, page 393.

Moffett, Cleveland, "Grant and Lincoln in Bronze," *McClure's Magazine*, October 1895.

Bucke, R. M., M.D., "Portraits of Walt Whitman," *The New England Magazine*, March 1899.

Caffin, Charles H., "Some American Portrait Painters," *The Critic*, January 1904.

Williams, Talcott, "New Progress in American Art," *The Book News Monthly*, February 1907.

Traubel, Horace, "Talks with Walt Whitman," *The American Magazine*, July 1907.

Meyer, Annie Nathan, "Two Portraits of Walt Whitman," *Putnam's Monthly and The Reader*, September 1908.

Frankenberger, Charles, "The Collection of Portraits Belonging to the College," *The Jeffersonian*, November 1915.

N.N., "The Thomas Eakins Exhibition," *The Nation*, February 21, 1918.

Sartain, William, "Thomas Eakins," *The Art World*, January 1918.

McBride, Henry, "Modern Art," *The Dial*, February 1922.

Burroughs, Alan, "Thomas Eakins," *The Arts*, March 1923.

Pach, Walter, "A Grand Provincial," *The Freeman*, April 11, 1923.

McBride, Henry, "Modern Art," *The Dial*, May 1923.

Burroughs, Alan, "Thomas Eakins, the Man," *The Arts*, December 1923.

Burroughs, Alan, "Catalogue of Works by Thomas Eakins," *The Arts*, June 1924.

Goodrich, Lloyd, "New York Exhibitions," *The Arts*, December 1925.

McBride, Henry, "Modern Art," *The Dial*, January 1926.

Grafly, Dorothy, "Events and Portents of Fifty Years," *Art and Architecture*, April–May 1926.

Goodrich, Lloyd, "Thomas Eakins, Realist," *The Arts*, October 1929.

Mather, Frank Jewell, Jr., "Thomas Eakins' Art in Retrospect," *International Studio*, January 1930.

Marceau, Henri, "Catalogue of the Works of Thomas Eakins," *The Bulletin of the Pennsylvania Museum*, March 1930.

Taylor, Francis Henry, "Thomas Eakins, Positivist," *Parnassus*, March 1930.

Watson, Forbes, "The Growth of a Reputation," *The Arts*, April 1930.

Watson, Forbes, "Ryder, Eakins, Homer," *The Arts*, May 1930.

DuBois, Guy Pène, "The Art Galleries," *The New Yorker*, May 17, 1930.

Rothenstein, John, "A Note on Thomas Eakins," *Artwork: A Quarterly*, Autumn 1930.

Schnakenberg, Henry E., "Thomas Eakins," *The Arts*, January 1931.

White, Nelson C., "Franklin L. Schenck," *Art in America*, February 1931.

Bregler, Charles, "Thomas Eakins as a Teacher," *The Arts*, March 1931.

"Notes and Queries," *The Pennsylvania Magazine of History and Biography*, April 1931.

Bregler, Charles, "Thomas Eakins as a Teacher: Part Two," *The Arts*, October 1931.

Mumford, Lewis, "The Brown Decades: Art," *Scribner's Magazine*, October 1931.

"In the Louvre: Clara, a Portrait," *The Art Digest*, March 15, 1932.

Pach, Walter, "American Art in the Louvre," *Fine Arts*, May 1933.

"Eakins and the Passing Scene," *The American Magazine of Art*, June 1934.

"Cherchez la Femme! Thomas Eakins' Painting of Clara Disappears from the Louvre," *The Art Digest*, December 1, 1937.

Burroughs, Bryson, "Estimation of Thomas Eakins," *The Magazine of Art*, July 1937.

"Sale of Young Woman in a Pink Dress and Biddle's Letter," *Art News*, May 8, 1937.

Goodrich, Lloyd, "An Eakins Exhibition," *The Magazine of Art*, November 1939.

Barker, Virgil, "Imagination in Thomas Eakins," *Parnassus*, November 1939.

"Sketches: Oils by Thomas Eakins," *Art in America*, April 1940.

"Jefferson Medical College Refuses to Loan Gross Clinic to Carnegie," *The Art Digest*, November 1, 1940.

Bregler, Charles, "Eakins' Permanent Palette," *The Art Digest*, November 14, 1940.

Nelson, Boris Erich, "Early Musical Instruments," *The Processional*, March 1, 1940.

Bregler, Charles, "Photos by Thomas Eakins: How the Famous Painter Antedated the Modern Movie Camera," *The Magazine of Art*, January 1943.

Ormsbee, Thomas Hamilton, "Thomas Eakins, American Realist Painter," *The American Collector*, July 1944.

Baldinger, W. S., "The Art of Eakins, Homer, and Ryder," *The Art Quarterly*, Volume 9, Number 3, 1946.

Mather, Frank Jewell, Jr., "Expanding Arena," *The Magazine of Art*, November 1946.

Albright, Adam Emory, "Memories of Thomas Eakins," *Harper's Bazaar*, August 1947.

Goodrich, Lloyd, "Realism and Romanticism in Homer, Eakins, and Ryder," *The Art Quarterly*, Volume 12, Number 1, 1949.

Pearlman, B. B., "Eakins Comes of Age," *The Art Digest*, February 15, 1955.

Katz, Leslie, "Thomas Eakins Now," *Arts*, September 1956.

Schulte, Regina U., "Tom Eakins—Painter," *We Women* (Bridgeton, New Jersey), July 1944.

Smith, J. G., "The Enigma of Thomas Eakins," *The American Artist*, November 1956.

"The Metropolitan Museum's Fourteen American Masters," *The Burlington Magazine*, December 1958.

Fosburgh, James W., "Music and Meaning," *Art News*, February 1958.

Canaday, John, "The Realism of Thomas Eakins," *The Philadelphia Museum Bulletin*, Spring 1958.

Scanlon, Lawrence E., "Eakins as Functionalist," *The College Art Journal*, Summer 1960.

Aponte, Gonzalo E., "Thomas Eakins," *Jefferson Medical College Alumni Bulletin*, December 1961.

Walker, John, "Eakins in Washington," *Art in America*, Volume 49, Number 3, 1961.

Homer, William I., "Concerning Muybridge, Marey, and Seurat," *The Burlington Magazine*, September 1962.

Kessler, Charles S., "The Realism of Thomas Eakins," *Arts*, January 1962.

Homer, William I., "Eakins, Muybridge, and the Motion Picture," *The Art Quarterly*, Summer 1963.

Byrd, G., "Artist-Teachers in America," *The Art Journal*, Winter 1963–1964.

Hendricks, Gordon, "*A May Morning in the Park*," *The Philadelphia Museum Bulletin*, Spring 1965.

Aponte, Gonzalo E., "Thomas Eakins (1844–1916): Painter, Sculptor, Teacher," *Transactions and Studies of the College of Physicians of Philadelphia*, April 1965.

"The Gross Clinic," *The Jefferson Magazine*, June 1965.

Hendricks, Gordon, "*The Champion Single Sculls*," *The Metropolitan Museum Bulletin*, March 1968.

Hendricks, Gordon, "The Belle with the Beautiful Bones," *Arts in Virginia*, Fall 1968.

Hendricks, Gordon, "*On the Delaware*," *The Bulletin of the Wadsworth Atheneum*, Fall 1968.

Hendricks, Gordon, "Eakins' *William Rush Carving His Allegorical Statue of the Schuylkill*," *The Art Quarterly*, Winter 1968.

Hendricks, Gordon, "Thomas Eakins's *Gross Clinic*," *The Art Bulletin*, March 1969.

Hendricks, Gordon, "The Eakins Portrait of Rutherford B. Hayes," *The American Art Journal*, Spring 1969.

Ackerman, Gerald M., "Thomas Eakins and His Parisian Masters Gérôme and Bonnat," *Gazette des Beaux-Arts*, April 1969.

McCaughey, P., "Thomas Eakins and the Power of Seeing," *Artforum*, December 1970.

Moynihan, Rodrigo, "Odd American: Thomas Eakins," *Art News*, January 1971.

Hendricks, Gordon, (Letter to Editor) *The American Art Journal*, Fall 1971.

"The Camera Eye of Thomas Eakins," *Life* magazine, July 23, 1971.

Steinberg, Leo, "Art/Work," *Art News*, February 1972.

OTHER PERIODICALS
Where two dates are given, the first date is the one in which the first reference was found; the second, the last. The intervening years were researched extensively.

The American Journal of Medical Sciences 1903

The American Art Annual 1900–1916

The American Art Journal 1969

The American Art News 1916–1917

The American Art Review 1880–1881

Anthony's Photographic Bulletin 1886

Art Age 1885

The Art Amateur 1879–1893

The Art Bulletin 1969

The Art Interchange 1879–1886

The Art Journal 1877

The Art Quarterly 1968

Arts in Virginia 1968
The British Journal of Photography 1891
Brooklyn Museum Quarterly 1932
Bulletin of the Philadelphia Museum of Art 1930–1965
Bulletin of the Wadsworth Atheneum 1968
The Century Magazine 1881–1889
The Collector and Art Critic 1900
The Engineering Magazine 1909
Harper's Weekly 1882
Jefferson Medical College Alumni Bulletin 1961–1967
The Jeffersonian 1915
Journal of the American Society of Naval Engineers 1912
Magazine of Art 1887
McClure's Magazine 1895
The Metropolitan Museum of Art Bulletin 1916–1968
The Nation 1874–1876; 1918
National Academy of Design Notes 1882–1889
The Outlook 1917
The Pennsylvania Magazine of History and Biography 1875–date
The Philadelphia Photographer 1884
The Photographic Times 1886
Proceedings of the Academy of Natural Sciences of Philadelphia 1894
Scribner's Magazine 1879–1892
Transactions and Studies of the College of Physicians of Philadelphia 1902–1965

NEWSPAPERS

The first date after each title is the year in which the reference was found; the second, the last year. The intervening years were searched extensively.

New York City:
The New York Daily Graphic 1876–1878
The New York Daily Tribune 1878–1887
The New York Dramatic Mirror 1896
The New York Herald 1914
The New York Herald-Tribune 1927
The New York Journal of Commerce 1879
The New York Ledger 1879
The New York Post 1928
The New York Sun 1882–1917
The New York Times 1866–1972
The New York Tribune 1876–1885
The New York World 1881–1887

Philadelphia:
The Philadelphia Daily Evening Telegraph 1876–1902
The Philadelphia Daily Times 1880–1891
The Philadelphia Evening Bulletin 1871–1961
The Philadelphia Inquirer 1871–1933
The Philadelphia Evening Item 1896
The Philadelphia North American 1880
The Philadelphia Press 1870–1910
The Philadelphia Public Ledger 1861–1935
The Philadelphia Record 1880–1900

Others:

The Brooklyn Daily Eagle, Brooklyn, New York 1878–1926
The Brooklyn Union Argus, Brooklyn, New York 1878
The Sea Side, Manasquan, New Jersey, 1877–1882
The Minneapolis Star, Minneapolis, Minnesota 1958
The Newark News, Newark, New Jersey 1964
L'Art, Paris, France 1875
The San Francisco Daily Alta California, San Francisco, California 1878
The San Francisco Morning Call, San Francisco, California 1879
The Washington Evening Star, Washington, D. C. 1877
The Wilmington Every Evening and Commercial, Wilmington, Delaware, 1877–1878

ARCHIVES, LIBRARIES

Some of these repositories have much material, others have less—sometimes material concerning only a small part of Eakins' life or work. The more significant collections are starred.

Addison Gallery of American Art, Andover, Massachusetts
American Museum of Natural History, New York, New York
American Philosophical Society, Philadelphia, Pennsylvania
* Archives of American Art, Detroit, Michigan, New York City, and Washington, D.C.
Art Students' League of New York, New York, New York
Atwater Kent Museum, Philadelphia, Pennsylvania
Avery Library, Columbia University, New York, New York
Babcock Gallery, New York, New York
Baltimore Museum of Art, Baltimore, Maryland
Berks County Archives, Reading, Pennsylvania
Biblioteca Naçional, Madrid, Spain
Bibliothèque Nationale, Paris, France
Musée de Bonnat, Bayonne, France
Boston Museum of Fine Arts, Boston, Massachusetts
Boston Public Library, Boston, Massachusetts
Bridgeton Public Library, Bridgeton, New Jersey
Brooklyn Museum, Brooklyn, New York
Brooklyn Public Library, Brooklyn, New York
Camden County Historical Society, Camden, New Jersey
Camden Public Library, Camden, New Jersey
Carnegie Institute, Pittsburgh, Pennsylvania
Chester County Archives, West Chester, Pennsylvania
Chester County Historical Society, West Chester, Pennsylvania
Chicago Art Institute, Chicago, Illinois
Cleveland Museum of Art, Cleveland, Ohio
Columbia University Library, New York, New York
Corcoran Gallery of Art, Washington, D. C.
Cumberland County Archives, Bridgeton, New Jersey
Delaware Art Center, Wilmington, Delaware
Detroit Institute of Arts, Detroit, Michigan
Drexel Institute, Philadelphia, Pennsylvania
George Eastman House, Rochester, New York
École des Beaux Arts, Paris, France
Fort Worth Art Center, Fort Worth, Texas
Franklin Institute Library, Philadelphia, Pennsylvania
Frick Art Reference Library, New York, New York
James Graham Gallery, New York, New York
Rutherford B. Hayes Library, Fremont, Ohio
Hirschl and Adler Galleries, New York, New York
Hollidaysburg Public Library, Hollidaysburg, Pennsylvania
* Joseph H. Hirshhorn Collection, New York, New York

* Jefferson Medical College, Philadelphia, Pennsylvania
Joslyn Art Museum, Omaha, Nebraska
Kennedy Galleries, New York, New York
Knoedler Galleries, New York, New York
Lancaster Public Library, Lancaster, Pennsylvania
Library Company of Philadelphia, Philadelphia, Pennsylvania
Library of Congress, Washington, D. C.
Liverpool Public Library, Liverpool, England
Metropolitan Museum of Art, New York, New York
Minneapolis Institute of Arts, Minneapolis, Minnesota
Moore College of Art, Philadelphia, Pennsylvania
Musée d'Art Moderne, Paris, France
Musée de Louvre, Paris, France
Museo de Bellas Artes, Seville, Spain
The Museum of the City of New York, New York, New York
Museum of Modern Art, New York, New York
National Academy of Design, New York, New York
National Archives, Washington, D. C.
National Collection of Fine Arts, Washington, D. C.
National Gallery of Art, Washington, D. C.
New Britain Museum of American Art, New Britain, Connecticut
New Jersey Historical Society, Newark, New Jersey
New Jersey State Library, Trenton, New Jersey
New Jersey State Museum, Trenton, New Jersey
New York Academy of Medicine, New York, New York
New-York Historical Society, New York, New York
New York Parks Department, New York, New York
* New York Public Library, New York, New York
Newark Museum, Newark, New Jersey
Newport Public Library, Newport, Rhode Island
North Dakota Historical Society, Pierre, North Dakota
Parke-Bernet Galleries, New York, New York
* Pennsylvania Academy of the Fine Arts, Philadelphia, Pennsylvania
* Historical Society of Pennsylvania, Philadelphia, Pennsylvania
Pennsylvania Hospital, Philadelphia, Pennsylvania
University of Pennsylvania Archives, Philadelphia, Pennsylvania
University of Pennsylvania Library, Philadelphia, Pennsylvania
University of Pennsylvania Museum, Philadelphia, Pennsylvania
Academy of Natural Sciences of Philadelphia, Philadelphia, Pennsylvania
College of Physicians of Philadelphia, Philadelphia, Pennsylvania
Philadelphia Board of Education Library, Philadelphia, Pennsylvania
Philadelphia Central High School, Philadelphia, Pennsylvania
Philadelphia City Archives, Philadelphia, Pennsylvania
Philadelphia College of Art, Philadelphia, Pennsylvania
* Philadelphia Free Public Library, Philadelphia, Pennsylvania
* Philadelphia Museum of Art, Philadelphia, Pennsylvania
Philadelphia Orchestra, Philadelphia, Pennsylvania
Philadelphia Sketch Club, Philadelphia, Pennsylvania
Philipse Manor Hall, Yonkers, New York
Prado Museum, Madrid, Spain
Pratt Institute, Brooklyn, New York
Princeton University Museum, Princeton, New Jersey
Reading Museum, Reading, Pennsylvania
Roanoke Public Library, Roanoke, Virginia
Saint Charles Seminary, Overbrook, Pennsylvania
Smithsonian Institution, Washington, D. C.
Somerset House, London, England
South West Museum, San Diego, California
Spanish National Tourist Office, New York, New York

Stanford University, Palo Alto, California
Swarthmore College Library, Swarthmore, Pennsylvania
Union League Club, Philadelphia, Pennsylvania
Victoria and Albert Museum, London, England
Wadsworth Atheneum, Hartford, Connecticut
Walters Art Gallery, Baltimore, Maryland
Wichita Art Museum, Wichita, Kansas
Henry Francis DuPont Winterthur Museum, Wilmington, Delaware
Worcester Museum of Fine Arts, Worcester, Massachusetts
Yale University Museum and Libraries, New Haven, Connecticut

A CHECKLIST OF EAKINS WORKS IN PUBLIC COLLECTIONS IN THE UNITED STATES

INTRODUCTION

I have tried to make this list as nearly exhaustive as possible and have examined a large majority of the works listed. "Public collections" has been defined as those maintaining a regular viewing place or gallery, whether or not publicly owned. Recognition illustrations have been omitted when the work has already been illustrated in the text. In such cases the appropriate illustration number is given.

"ATT." appearing after a work indicates that I do not agree that the work is an Eakins, even though it is so attributed by the owner.

Sizes are given with heights before widths, and centimeter equivalents to within the nearest sixteenth of an inch. Information in most cases is that supplied by the owners, although specifics concerning media and markings sometime have not been forthcoming. The indication of punctuation, capitalization, and lineage, given printing exigencies, has been difficult, and may sometimes seem obscure. When the artist used a period I have used it; when he did not, I have omitted it, even though it was at the end of a sentence. I have used upper and lower case type throughout, even though the artist or another may have used capitals. This may seem arbitrary. But the reverse was insoluble: if an owner had not indicated the exact capitalization, as was frequently the case, would not the reader, if capitals were sometimes indicated, have been led to assume that when they were not indicated, they were not in the original? Such an assumption often would have been false. A half dozen inquiries to scores of museums would have been necessary to appreciably reduce such error, and even then one would have felt uncertain that the "final" information received was the correct information.

In preparing her late husband's works for sale or exhibition Mrs. Eakins often wrote "T.E." or "Thomas Eakins" on the work's face or on its reverse in a label or on the canvas, wood or paper itself. Charles Bregler, who helped Mrs. Eakins get paintings ready, was not above inscribing a complete legend on the face of a painting, either in paint or by scratching. He also rebacked paintings, often obscuring original inscriptions by the artist or another without carefully or at all recording what was there originally. Some of these omissions and additions are crucial in problems of provenance, chronology, and so on. In some cases Goodrich recorded inscriptions on reverses that have been since covered. In such cases I have indicated his readings.

Works are arranged chronologically within collections, with dates at the right of each title. Such dates may sometimes disagree with previous opinion and, indeed, with markings on the work itself. When my own work has not specifically contradicted dates given by Goodrich, I have retained those, even though further work may show these incorrect. Goodrich worked hard and long and carefully on his catalogue, had frequent talks with Mrs. Eakins and others close to the artist, and had access to records no longer available.

I have dated studies to accord with the dates of their related finished works. If recognition photographs are not present, the work listed is illustrated in the main text.

CALIFORNIA

LOS ANGELES
The Los Angeles County Museum:
1. *Study for "The Wrestlers"* 1899
oil on canvas
16″ × 20″ (46 × 58 cm.)
LR: T. E. (not by artist.)

SAN DIEGO
The Fine Arts Gallery of San Diego:
2. *Elizabeth with a Dog* c. 1874
oil on canvas
13¾″ × 17″ (34.9 × 43.2 cm.)
Elizabeth Crowell was born in 1868, thus the estimated date.

3. *Portrait of J. Carroll Beckwith* 1904
 oil on canvas
 83¾″ × 48¼″ (212.8 × 122.6 cm.)
 LL: Eakins 1904
 Goodrich wrote that this painting was originally inscribed on the back: "To Mrs. Carroll Beckwith from her friend Thomas Eakins, 1904." Goodrich has also identified the figure at the left as Mrs. Beckwith.

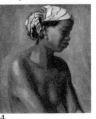

3

SAN FRANCISCO
California Palace of the Legion of Honor:
 4. *A Negress* c. 1867
 oil on canvas
 19½″ × 22¾″ (49.5 × 57.8 cm.)
 Initialed on the reverse: "T. E.", not by the artist.

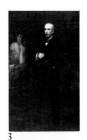

The DeYoung Memorial Museum:
 5. *Man in a Turban* 1866–1867
 graphite over stumped charcoal on green blue laid paper
 23 1/16″ × 16⅞″ (58.6 × 42.9 cm.)
 UR, by Charles Bregler. Drawing by/Thomas Eakins
 The relative naïveté of the technique suggests the artist's first months in Paris.
 6. *The Courtship* 1878
 oil on canvas
 20″ × 24″ (50.8 × 60.9 cm.)
 This work may have been planned originally as a vertical composition (see CL-142.)

4

5

SANTA BARBARA
Santa Barbara Museum of Art:
 7. *Portrait of Alfred Douty* 1906
 oil on canvas
 20″ × 16″ (50.8 × 40.7 cm.)
 Inscribed on the reverse: "To Mrs. Nicholas Douty from her friend Thomas Eakins, 1906."

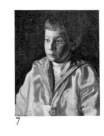

7

CONNECTICUT

HARTFORD
Wadsworth Atheneum:
 8. *Ships and Sailboats on the Delaware* 1874
 oil on canvas
 10⅛″ × 17¼″ (25.7 × 43.8 cm.)
 LR: T. E. (not by artist.)
 See my article, "On the Delaware," *The Bulletin of the Wadsworth Atheneum,* Fall 1968, pages 40ff.
 9. *Portrait of John McClure Hamilton* 1895
 oil on canvas
 79 1/16″ × 49″ (200.9 × 124.5 cm.)
 LL: To my friend/Hamilton/Eakins 95.

NEW BRITAIN
The New Britain Museum of American Art:
 10. *Study for "Mr. Neelus Peeler's Conditions."* 1879
 oil on wood
 14¼″ × 10¼″ (36.2 × 26 cm.)
 On the reverse, a sketch of a Negro boy on a bay horse. Incorrectly entitled *The Timer.*
 11. *Old Lady Sewing* c. 1879
 oil on wood
 13½″ × 9½″ (34.3 × 24.1 cm.)
 On the reverse, a sketch of an interior.

10

11

Yale University Art Gallery:

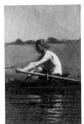

13. *Girl with a Cat—Katherine* 1872
 oil on canvas
 62¾″ × 48¼″ (159.4 × 122.6 cm.)
 LR: Thomas Eakins/1872.
 Kathrin Crowell. According to the Crowell family Bible, "Kathrin" is the correct spelling.

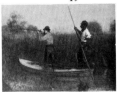

13. *John Biglin in a Single Scull* 1874
 oil on canvas
 24⁵⁄₁₆″ × 16″ (61.7 × 40.7 cm.)
 Signed on reverse: Eakins 1874.

14. *Will Schuster and Black Man Going Shooting for Rail* 1876
 oil on canvas
 22⅛″ × 30¼″ (56.2 × 76.8 cm.)
 LR: Eakins 76

15. *Study for Portrait of Archbishop James Frederick Wood* 1877
 oil on canvas
 16″ × 12⅛″ (40.7 × 30.8 cm.)
 See CL-328.

16. *Retrospection* 1880
 oil on wood
 14½″ × 10⅛″ (36.8 × 25.7 cm.)
 UR: Eakins 1880

17. *Rail Shooting from a Punt* 1881
 wash
 8⅞″ × 12³⁄₁₆″ (22.5 × 30.9 cm.)
 A copy of CL-14 for a *Scribner's* illustration.

18. *The Veteran* c. 1884
 oil on canvas
 22¼″ × 15″ (56.5 × 38.2 cm.)
 LR: Eakins
 George Reynolds

19. *Study of Dr. D. Hayes Agnew in "The Agnew Clinic"* 1889
 oil on canvas
 49″ × 31½″ (124.5 × 80 cm.)
 LR: Study for the/Agnew por-/trait/Eakins

20. *William H. Macdowell, Father of Mrs. Eakins* c. 1890
 oil on canvas
 24″ × 20″ (60.9 × 50.8 cm.)
 LR: T. E. (not by artist.)

21. *Maud Cook* 1895
 oil on canvas
 24″ × 20″ (60.9 × 50.8 cm.)
 Inscribed on reverse: "To his friend/Maud Cook [*sic*]/Thomas Eakins/1895."

22. *Sketch for "Taking the Count"* 1898
 oil on canvas
 9¾″ × 9⅜″ (24.8 × 23.8 cm.)

23. *Taking the Count* 1898
 oil on canvas
 96⁵⁄₁₆″ × 84⁵⁄₁₆″ (244.6 × 214.1 cm.)
 LL: Eakins. 98.
 Goodrich has identified the standing fighter as Charlie McKeever, the kneeling one as Joe Mack, and the referee as H. Walter Schlichter. I believe Benjamin Eakins is second from the left on the bottom row. In another of Eakins' perversities—or practical jokes—Joe Mack is painted again—at the extreme lower right, with his hand on a rope. Posters advertising "The Telephone Girl" and "The Ballet Girl" for the Walnut Street Theatre are hanging from the balcony.

These shows opened at the Walnut Street Theatre respectively on April 11, 1898, and April 18, 1898. (See *Between Rounds*, CL-301.)

23a. *Two Models for "William Rush Carving His Allegorical Statue of the Schuyl-kill"* 1876 [acquired 1972]
bronze
Head of Rush
height: 7¼″ (18.4 cm.)
Nymph
height: 10½″ (26.7 cm.)

DELAWARE

Delaware Art Center:

24. *Portrait of Franklin L. Schenck* c. 1890
oil on canvas
24″ × 20″ (60.9 × 50.8 cm.)

25. *Portrait of Dr. Thomas Fenton* c. 1905
oil on canvas
60″ × 30″ (152.4 × 76.2 cm.)

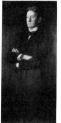

25

DISTRICT OF COLUMBIA

Corcoran Gallery of Art:

26. *The Pathetic Song* 1881
oil on canvas
45″ × 32½″ (114.3 × 82.6 cm.)
LL: Eakins./1881
The singer is Margaret A. Harrison, the pianist Susan Macdowell, and the cellist a Mr. Stolte.

27. *Knitting* c. 1883
plaster
18½″ × 14⅞″ × c.4″ (47 × 37.8 × c.10.2 cm.)

27

27a. *Knitting* c. 1883
bronze
18¼″ × 15″ × c.4″ (46.3 × 38.1 × c.10.2 cm.)

The Joseph H. Hirshhorn Museum and Sculpture Garden:

28. *Boyhood Visiting Card* c. 1853?
ink on paper
1⅝″ × 2⅞″ (4.2 × 7.3 cm.)
Center: Tom C Eakins
On the reverse, a sketch of a cottage by the water.

27a

29. *Map of Switzerland* 1856–1857
ink and watercolor on paper
20″ × 16″ (50.8 × 40.7 cm.)
LC: Switzerland/by Tom C. Eakins, Zane St/Grammar School
See page 6 for reasons for date.

28

30. *Drawing after Unidentified Spanish Scene* 1858
pencil on paper
10″ × 14½″ (25.4 × 36.8 cm.)
LR: Tom C. Eakins G' 1858

31. *Drawing after Unidentified Spanish Scene* 1858
pencil on paper heightened with white
11½″ × 17″ (29.3 × 43.2 cm.)
LL: Eakins F' 1858; TC: L' [Album] De Eakins

32. *Drawing of a Lathe* 1860
ink and watercolor on paper mounted on board
16¼″ × 22″ (41.2 × 55.9 cm.)
LR: Tom Eakins 1860 Lettered at top center: Perspective of Lathe/in possession of B. Eakins

34

35

36

39

40

41

42

43

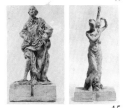

45

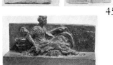

33. *Drawing of Gears* c. 1860
ink and watercolor on paper
11⅜" × 16⅞" (28.9 × 42.9 cm.)
LR: Tom Eakins R: Eakins B
The B here is evidently Eakins' grade for the drawing. At the bottom are sketches of two men; on the reverse, miscellaneous sketches of scrolls, figures, and arithmetical notations.

34. *Perspective Drawing of Three-Legged Table* c. 1860
ink on paper
23¾" × 16" (60.3 × 40.7 cm.)
At the left and top left are perspective notations. At lower center, evidently not by Eakins: Drawing 13
This table has not been identified wtih any of the three-legged tables in Eakins' paintings.

35. *Drawing of Girard Avenue Bridge Pier and Spans* c. 1860?
pencil on paper
3⅞" × 6½" (9.8 × 16.5 cm.)

36. *Study of a Young Woman's Head* 1869?
oil on canvas
21½" × 16" (53.3 × 40.7 cm.)
Could this be Anne (?) with whom Eakins may have had an artist-model liaison in 1869? The canvas maker or supplier is Parisian.

37. *Sketch of the Interior of the Cathedral of Seville* 1869–1870
oil on canvas
16" × 18" (40.7 × 45.7 cm.)
A label on the reverse by Charles Bregler, Eakins' pupil, states that he, Bregler, cut the painting down from 18" × 21¼" and rebacked it "to make secure for all time."

38. *Hiawatha* c. 1871
oil on canvas
20" × 30" (50.8 × 76.2 cm.)

39. *Sketch of General Robert E. Lee* c. 1871?
oil on canvas
13" × 10" (33 × 25.4 cm.)
UR, by Bregler: Original Sketch by Thomas Eakins

40. *Margaret* c. 1871?
oil on canvas
18" × 15" (45.7 × 38.1 cm.)
Margaret Eakins.

41. *Cast of Girl's Hand* c. 1872
bronze
12" (30.5 cm.) length
The estimated date is not the date of the casting, but the plaster from which the cast was made. The hand may be that of Kathrin Crowell, who would have been twenty-one in 1872.

42. *Perspective Drawing for "Turning the Stake"* c. 1873
ink and pencil on paper
31¼" × 47¾" (79.4 × 121.3 cm.)
A label by Bregler describing the drawing is at lower right.

43. *Perspective Drawing for "Turning the Stake"* c. 1873
ink and pencil on paper
31½" × 47¾" (80 × 121.3 cm.)
A label by Bregler describing the drawing is at lower right.

44. *Nine Sketches Made at the Cathedral of SS Peter and Paul, Philadelphia* 1875?
pencil on paper tipped onto board
each sketch: 3½" × 5" (8.9 × 12.7 cm.)
Three are vertical, six are horizontal. See page 110 for reasons for estimated date. There are several miscellaneous pencil sketches on the reverse.

45. *Three Models for "William Rush Carving His Allegorical Statue of the Schuylkill"* 1876

plaster
Washington
height: 8½″ (21.6 cm.)
Figure of Nymph
height: 9½″ (24.1 cm.)
The Schuylkill Harnessed
height: 4¾″ (12.1 cm.)

46

46. *Drawing of the Nymph in "William Rush Carving His Allegorical Statue of the Schuylkill"* 1876
 ink on paper
 9¾″ × 12″ (24.8 × 30.5 cm.)
 The figures surrounding the Nymph and the lettering are probably Charles Bregler's.

47

47. *Eight Sketches for "William Rush Carving His Allegorical Statue of the Schuylkill"* 1876
 pencil, with pencil and ink notes on paper tipped onto board
 each sketch: 7¼″ × 4⅝″ (18.4 × 11.8 cm.)
 I have identified the originals of several of these in *The Art Quarterly*, Winter 1968, pages 383ff.

48

48. *Bas-relief of Horse Skeleton with Details of Knees* 1878
 plaster
 11¼″ × 14½″ (28.6 × 36.8 cm.)

49

49. *Three Drawings of Dissection Parts with Notes* 1878
 pencil traced in ink mounted on board
 7½″ × 12″ (19.1 × 30.5 cm.), each sketch
 The left-hand drawing is inscribed "Thomas Eakins/1878" in another hand than Eakins'. The tracing may have been done at a later date, when Eakins may have wanted to photograph the drawings and notations for a slide for use in his Academy classes. A label by Charles Bregler reads: Drawings and notes by/Thomas Eakins/made while dissecting.

50

50. *Perspective Drawing for "Mr. Neelus Peeler's Conditions"* 1879
 pencil and ink on paper mounted on board
 14″ × 17″ (35.6 × 43.2 cm.)
 A reproduction of Alice Barber's engraving of this illustration in *Scribner's Magazine* is attached at the bottom of the work. A Bregler label is at the bottom right. Bregler did not know the purpose of the drawing.

51

51. *Sketch of Head and Right Foreleg of Near-wheel Horse, and Fairman Rogers' Face-drop for "A May Morning in the Park"* 1879
 oil on wood
 9⅝″ × 13⅝″ (24.4 × 34.6 cm.)

52. *Study of Off-lead Horse for "A May Morning in the Park"* 1879
 oil on wood
 13½″ × 9⅝″ (34.3 × 24.4 cm.)

53

53. *Sketches of Head, Forelegs and Right Forehoof of Near-lead Horse for "A May Morning in the Park"* 1879
 oil on wood
 9⅝″ × 13¾″ (24.4 × 34.9 cm.)

54

54. *Sketch of Body Without Head and Right Forehoof, and Right Forehoof of Near-wheel Horse for "A May Morning in the Park"* 1879
 oil on wood
 13⅝″ × 9⅝″ (34.6 × 24.4 cm.)
 See *The Bulletin of the Philadelphia Museum of Art*, Spring 1965, for a further discussion of these works.

55

55. *Study for "The Crucifixion"* 1880
 oil on canvas rebacked on panel
 22″ × 18″ (55.9 × 45.8 cm.)
 See CL-261.

56. *Sketch for "The Pathetic Song"* 1881
 oil on panel
 11½″ × 8⅜″ (29.2 × 21.3 cm.)

56

56

57

58

59

61

62

63

66

67

UR, by Charles Bregler: original sketch for The Pathetic Song by Thomas Eakins 1881

This sketch suggests that Eakins originally may have intended to have a man playing the piano. He later substitutes his wife (see CL-26.)

57. *Woman Knitting* c. 1882
oil on board
8″ × 5″ (20.3 × 12.7 cm.)
This has been cut down from a larger board

58. *Sketch for "The Swimming Hole"* 1883
oil on board
8¾″ × 10¾″ (22.2 × 27.3 cm.)
LR, by Bregler: Original sketch for Swimming Hole by Thomas Eakins.

59. *Bas-relief of "Knitting"* c. 1883
bronze
18½″ × 14½″ (47 × 36.8 cm.)
LC, not in Eakins' hand: Knitting/Thomas Eakins/1881. On side: Roman Bronze Works, N. Y. Both are the caster's markings, and the date is incorrect. The date here is that of the plaster, not of the casting.

60. *Bas-relief of "Spinning"* c. 1883
bronze
18″ × 14″ (45.7 × 35.6 cm.)
LC, not in Eakins' hand: Spinning/Thomas Eakins/1881. On side: Roman Bronze Works, N. Y. Both are caster's markings. The date, as in the preceding, is incorrect.

61. *Nude Boy Reclining, Study for "Arcadia"* c. 1883
oil on wood
10¼″ × 14½″ (26.1 × 36.8 cm.)
LR, by Bregler: Thomas Eakins
Possibly Ben Crowell, Eakins' nephew. Painted from a photograph (Fig. 132)

62. *Study for "An Arcadian"* c. 1883
oil on panel
8¾″ × 11⅛″ (22.2 × 28.3 cm.)
UL, by Bregler: study by Thomas Eakins
Study for the figure in *An Arcadian*, Lloyd Goodrich collection (Fig. 129), not to be confused with *Arcadia*, the Metropolitan Museum oil (Fig. 128, CL-186)

63. *Youth Playing Pipes* c. 1883
bronze
height: 19¾″ (50.2 cm.)
Bas-relief. A cast of a plaster copied directly from a photograph (Fig. 127) or from an oil sketch copied from the same photograph (See 33 in Fairfield Porter, *Thomas Eakins*, New York 1959.) Used in the Metropolitan Museum *Arcadia*.

64. *Arcadia* 1883
plaster
11½″ × 24″ (29.2 × 60.9 cm.)
UL: Eakins UC: 1883
Bas-relief.

65. *Arcadia* 1883
bronze
11½″ × 24″ (29.2 × 60.9 cm.)
UL: Eakins UC: 1888 [incorrect date.] Probably both by caster.

66. *Perspective Drawing of a Boy* c. 1884
oil on paper
15⅜″ × 22″ (39.1 × 55.9 cm.)
LL, probably not by Eakins: No. 16
The paper has a watermark: J. Whatman/1883. It seems possible that this work may have been used as a teaching aid at the Academy.

67. *Perspective Drawings of Baseball Players* c. 1884?
pencil on paper
13⅞″ × 16⅞″ (35.3 × 42.9 cm.)

UL, perspective notations.

This drawing seems unrelated to Eakins' watercolor of baseball players (CL-320.) It may have been produced at the same time as CL-66, thus the estimated date.

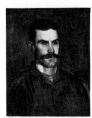

68. *Portrait of Frank Macdowell* c. 1886
 oil on canvas
 24″ × 20″ (60.9 × 50.8 cm.)
 Scratched in paint upper right by Bregler: Portrait of Frank Macdowell painted by Thomas Eakins. Macdowell was Eakins' brother-in-law. The date is the result of the estimated age of the sitter by his relatives.

69. *Portrait of Girl in a Big Hat* c. 1888
 oil on canvas
 24″ × 20″ (60.9 × 50.8 cm.)
 Lillian Hammitt, a pupil. Signed on the reverse: Eakins
 A label on the reverse states that this painting was loaned to "the New Students League" at 1324 Spruce Street, evidently the Art Students' League.

70. *Portrait of Mrs. William H. Green* 1889
 oil on canvas
 27¼″ × 22¼″ (69.2 × 56.5 cm.)
 LR: Eakins 1899
 Painted from a photograph after the sitter's death.

71. *Portrait of William H. Macdowell* c. 1890?
 oil on canvas
 15″ × 13″ (38.1 × 33.1 cm.)
 Like the portrait of Margaret Crowell (Pl. 40) this painting is one of Eakins' rare profiles. That consideration, together with the unusual sizes of the two canvases, weigh against an attribution to Eakins. On the other hand, it is difficult to settle upon another authorship: no one else in the artist's milieu had a comparable technique. Also, given Eakins' constant interest in experiment, it is logical that he would have tried profiles.

72. *Sketch of a Street* c. 1890?
 oil on panel
 5⅞″ × 7⅞″ (14.9 × 20 cm.)

73. *Study for Portrait of Joshua Ballinger Lippincott* 1892
 oil on board
 12½″ × 10″ (31.8 × 25.4 cm.)
 See Cl-294.

74. *Bas-relief of Grant's Horse for the Brooklyn Memorial Arch* c. 1892
 wax mounted on wood
 11¾″ × 6¾″ (29.8 × 17.2 cm.)
 LL: Eakins
 Framed and squared-off for enlarging.

75. *Bas-relief of Grant's Horse for the Brooklyn Memorial Arch* c. 1892
 bronze
 6¼″ × 6¼″ (15.9 × 15.9 cm.)
 UR, by caster: Thomas. Eakins./1892.

76. *Bas-relief of Horse with Rider* c. 1892?
 clay mounted on wood
 7¾″ × 11″ (19.7 × 27.9 cm.)

77. *Portrait of Mrs. Charles L. Leonard* 1895
 oil on cardboard
 13¾″ × 10½″ (34.9 × 26.7 cm.)
 LR, by Bregler?: T. E.
 Squared-off for enlarging. The finished, three-quarter-length portrait has been lost.

78. *Study for Portrait of Frank Hamilton Cushing* 1895
 oil on canvas
 24″ × 16″ (60.9 × 40.7 cm.)
 UR, by Bregler: Original sketch for painting of Frank Hamilton Cushing by Thomas Eakins.

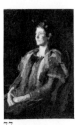

78

80

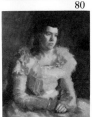

81

82

87

88

89

90

91

92

The leather-thong-bound frame is by Eakins. It has the embossed figure of a bird lower left.

79. *Sketch for "Taking the Count"* 1898
oil on canvas
18" × 16" (45.7 × 40.7 cm.)
Squared-off for enlarging. See CL-23. UR, by Bregler: Original sketch for "Counting Out" by Thomas Eakins 1898

80. *Study for Referee in "Taking the Count"* 1898
oil on canvas
20¼" × 16¼" (51.4 × 41.3 cm.)
LR, by Mrs. Eakins?: T. E.

81. *Portrait of Ann Lewis* 1898
oil on canvas
28" × 33" (71.1 × 83.8 cm.)

82. *Sketch for "Between Rounds"* 1899
oil on cardboard
5¾" × 4" (14.6 × 10.3 cm.)
LR, by Mrs. Eakins?: T. E.
There is an unidentified sketch on the reverse.

83. *Portrait of Mrs. Thomas Eakins* c. 1899
oil on canvas
20" × 16" (50.8 × 40.7 cm.)

84. *Portrait of William Merritt Chase* c. 1899
oil on canvas
24" × 20" (60.9 × 50.8 cm.)
Inscribed on reverse: To my friend William M. Chase, Thomas Eakins.

85. *Unfinished Portrait of Mrs. Joseph H. Drexel* 1900
oil on canvas
47" × 37" (119.4 × 93.9 cm.)
This canvas was reduced in size by Charles Bregler. According to a Bregler label the original size was 72" × 53". When Goodrich saw this portrait in about 1930, it was squared-off in white chalk. Since squaring-off is for purposes of enlargement, it is interesting to speculate on the size of a canvas enlarged from 72" × 53."

86. *Sketch for Portrait of Mrs. Elizabeth Duane Gillespie* 1901
oil on canvas
20" x 16" (50.8 × 40.7 cm.)
Squared-off for enlarging. See CL-307.

87. *Signatures in Perspective* 1901
pencil and ink on paper mounted on panel
13¼" × 16¼" (33.7 × 41.2 cm.)
These may be studies for the signature in the Leslie W. Miller portrait, CL-306.

88. *Sketch for Portrait of The Very Reverend John J. Fedigan* 1902
oil on canvas
24" × 20" (60.9 × 50.8 cm.)
Scratched in paint upper right by Bregler: original sketch of Rev. John J. Fedigan by Thomas Eakins 1902

89. *Sketch for "The Actress"* 1903
oil on canvas mounted on board
14" × 10" (35.6 × 25.4 cm.)
Scratched in paint lower left by Bregler: original sketch for "An Actress" by Thomas Eakins 1903

90. *Portrait of Mrs. Richard Day* c. 1903
oil on canvas
24" × 20" (60.9 × 50.8 cm.)

91. *Portrait of Mrs. Helen MacKnight* c. 1903
oil on canvas
20" × 16" (50.8 × 40.7 cm.)

92. *Portrait of Betty Reynolds* c. 1903
oil on canvas

93

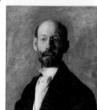

95

24″ × 20″ (60.9 × 50.8 cm.)

Also called *Girl in a Pink Dress*. The reverse inscriptions describing the paint-ing are not in Eakins' hand.

93. *Study for "The Violinist"* 1904
oil on canvas
40″ × 40″ (101.6 × 101.6 cm.)
Hedda van den Beemt. This portrait is said to have been given to van den Beemt in payment for his sitting for *Music*, in which he appears with the pianist Samuel Myers (CL-164.)

94. *Portrait of Samuel Myers* 1904
oil on canvas
24″ × 20″ (60.9 × 50.8 cm.)
UR: Eakins 1904
See CL-164

95. *Portrait of Frank B. A. Linton* 1904
oil on canvas
24″ × 20″ (60.9 × 50.8 cm.)
UL: Eakins/1904
Inscribed on reverse: "To my pupil/Frank B. A. Linton./Thomas Eakins./ 1904." Linton was a pupil of Eakins at the Philadelphia Art Students' League, and a portrait painter. For years he shared a studio with Samuel Myers, the pianist of *Music* (CL-164) and the subject of another Eakins portrait (CL-94.) It was at soirées held by Linton and Myers that Eakins met many friends and sitters.

98

96. *Study for Portrait of Robert C. Ogden* 1904
oil on canvas
19⅝″ × 15½″ (49.8 × 39.4 cm.)
LL, not by Eakins: Painted in 19___?

97. *Portrait of Robert C. Ogden* 1904
oil on canvas
72″ × 48″ (182.9 × 121.9 cm.)
LL: Eakins/1904
Painted in the New York studio of Eakins' pupil Frederick W. Stokes.

99

98. *Sketch for Portrait of Charles L. Fussell* c. 1905
oil on panel
9⅛″ × 7⅛″ (23.2 × 18.1 cm.)
UL, by Bregler: Original sketch for Portrait of Charles Fussell by Thomas Eakins.

99. *Portrait of Maurice Feeley* c. 1905
oil on canvas
24″ × 20″ (60.9 × 50.8 cm.)
LL on reverse: Eakins
Feeley was a pupil of Eakins.

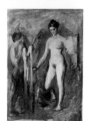

100

100. *Sketch for 1908 Version of "William Rush Carving His Allegorical Statue of the Schuylkill"* 1908
oil on paper mounted on panel
6″ × 8¾″ (15.3 × 22.2 cm.)
LR, by Bregler: Original sketch by Thomas Eakins

101. *Sketch for an Abandoned Version of 1908 Version of "William Rush Carving His Allegorical Statue of the Schuylkill"* 1908
oil on canvas
20″ × 14″ (50.8 × 35.6 cm.)

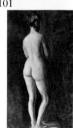

101

102. *Standing Female Nude, Back* c. 1908
oil on canvas
24″ × 14″ (60.9 × 35.6 cm.)

103. *Standing Female Nude, Front* c. 1908
oil on canvas
24″ × 14″ (60.9 × 35.6 cm.)

104. *Unfinished Portrait of Dr. Edward Anthony Spitzka* c. 1913

102

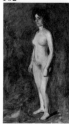

103

oil on canvas

30″ × 25″ (76.2 × 63.5 cm.)

Cut down from a larger canvas by the Babcock Galleries. Eakins' last known work, said to have been worked on by Mrs. Eakins.

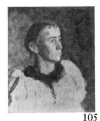

105

105. *Unfinished Portrait of Girl with Puff Sleeves* Undated

oil on canvas

24″ × 20″ (60.9 × 50.8 cm.)

106

106. *Landscape* Undated

oil on canvas

10½″ × 14⅛″ (26.7 × 35.9 cm.)

On the reverse, *In Grandmother's Time*

107. *Self Portrait* Undated (1902?)

oil on canvas

20″ × 16″ (50.8 × 40.7 cm.)

107

108. *Study for Portrait of David Wilson Jordan* Undated (1899?)

oil on canvas

14″ × 11½″ (35.6 × 29.2 cm.)

* * *

In addition to the preceding, the Hirshhorn Museum owns eight small, casual sketches fixed in an album that was part of the Samuel Murray purchase. Three of these are pencil on paper: *Sketch of "The Courtship,"* 3″ × 3¼″ (7.6 × 8.3 cm.), LR, possibly by Eakins: T. E., evidently done many years after *The Courtship*; *Sketch of [or for?] "Salutat,"* 3⅜″ × 4″ (8.6 × 10.2 cm.), LC, by Eakins?: 19½; and *Sketch of Portrait of Samuel Murray, ATT.,* 6″ × 4¾″ (15.3 × 12.1 cm.). A fourth is a combination of blue, red, and lead pencil, *Diagrammatic Sketches of Bone Structures,* 7½″ × 7¾″ (19.1 × 19.7 cm.) with numerous pencil notations by Eakins at the right. A fifth is in ink and wash, *Woman Writing,* 5″ × 4″ (12.1 × 10.2 cm.). A sixth and a seventh are in ink alone, *Woman Asleep,* 4¾″ × 4″ (12.1 × 10.2) and *Nine Profile Drawings of Nude Males,* 3⅞″ × 9¾″ (9.8 × 24.8 cm.), traced from an Eakins motion photo. And an eighth is an oil on paper, *Sketch of Man Wearing Pince-Nez,* 5⅜″ × 4½″ (12.7 × 11.4 cm.). In this last sketch the paper is ruled—suggesting a sketch of a Central High School teacher.

108

The Hirshhorn Museum also owns, in addition to several Eakins letters cited in this book, a great deal of Samuel Murray material, including numerous photographs by Eakins, a number perhaps by Murray, several miscellaneous photographs, and numerous Murray correspondence items; an Eakins palette, pastel box, draftsman's instruments; wood forms used by Eakins in teaching; Eakins camera and accoutrements; a cowboy suit, hat and lariat he bought in Dakota in 1887; Jefferson Medical College and Academy of the Fine Arts admission cards; an admission card to the 1876 Centennial; miscellaneous printed material, in-including several catalogues relating to Eakins or Murray, an announcement of the Art Students' League season and the League's 1888 anniversary program; several books; and five albums kept by Samuel Murray. In these latter are most of the Eakins photographs owned by Hirshhorn, of which a number have been reproduced in this book and in my *The Photographs of Thomas Eakins* (New York, 1972). There are also a number of clippings, letters, and other material in these albums.

The National Collection of Fine Arts:

109. *Mother* c. 1903

oil on canvas mounted on masonite

24⅛″ × 20¼″ (61.2 × 51.4 cm.)

Annie Williams Gandy. Inscribed on reverse: "To Addie from Tom of Annie."

The National Gallery of Art:

109

110. *The Biglin Brothers Racing* 1873?

oil on canvas

24⅛″ × 36⅛″ (61.2 × 91.8 cm.)

111. *Portrait of Louis Husson* 1899
oil on canvas
24″ × 20″ (60.9 × 50.8 cm.)
UR: To his friend/Louis Husson/Thomas Eakins/1899.

112. *Portrait of Monsignor Diomede Falconio* 1905
oil on canvas
72⅛″ × 54¼″ (183.2 × 137.8 cm.)
On reverse, LR: Eakins; across top: Hanc effigiem illmi ac revmi/Diomedi
Falconio archlarissensis/et Delagati Apostolici in Statibus/Foederatis Americae
Septentrionalis/pinxit Thomas Eakins Washingtonii/MDCCCV

113. *Portrait of Mrs. Louis Husson* c. 1905
oil on canvas
24″ × 20″ (60.9 × 50.8 cm.)
UR: T. E. (not by artist): on reverse: "To Kitty Husson from her friend/
Thomas Eakins

The Phillips Collection:
114. *Portrait of Miss Amelia Van Buren* c. 1891
oil on canvas
45″ × 32″ (114.3 × 81.3 cm.)

The White House:
115. *Portrait of Ruth Harding* 1903
oil on canvas
24⅛″ × 20⅛″ (61.2 × 51.1 cm.)
Inscribed on reverse: Laura K. Harding from Thomas Eakins 1903

HAWAII

HONOLULU
Honolulu Academy of Arts:
116. *William Rush and His Model* c. 1908
oil on canvas
35¼″ × 47¼″ (89.6 × 120 cm.)

116

ILLINOIS

CHICAGO
The Art Institute of Chicago:
117. *Nude [Study for "William Rush Carving His Allegorical Statue of the Schuyl-
kill"]* 1876
oil on canvas mounted on board
14¼″ × 11¼″ (36.2 × 28.6 cm.)

117

118. *The Zither Player* 1876
watercolor on paper
12⅛″ × 10½″ (30.8 × 26.7 cm.)
LR: Eakins/76.
William Sartain, left; Max Schmitt, right.

119. *Portrait of Riter Fitzgerald* 1895
oil on canvas
76″ × 64″ (193.1 × 162.6 cm.)
LL: Eakins 95

119

120. *Addie, Woman in Black* c. 1899
oil on canvas
24″ × 20″ (60.9 × 50.8 cm.)
Mary Adeline Williams

INDIANA

INDIANAPOLIS
Indianapolis Museum of Art:
121. *The Pianist* 1878 [*Portrait of Stanley Addicks*]
oil on canvas

121

24″ × 20″ (60.9 × 50.8 cm.)
LR: Eakins./1878.

NOTRE DAME

Art Gallery University of Notre Dame:

122

122. *Portrait of the Reverend Philip R. McDevitt* 1901
oil on canvas
20″ × 15⅞″ (50.8 × 40.4 cm.)

KANSAS

WICHITA

The Wichita Art Museum:

124

123. *Starting Out after Rail* 1874
watercolor on paper
25″ × 20″ (63.5 × 50.8 cm.)
LR: Eakins/74
It was this painting that Eakins gave to James C. Wignall, a Philadelphia ship-builder, in exchange for a boat. According to Eakins' catalogue title in the 7th Annual Exhibition of the American Society of Painters in Water Colors, the men in the boat are Harry Young, of Moyamensing, and Sam Helhower, "The Pusher." See CL-133 and CL-242.

124a

124. *Study of Billy Smith for "Between Rounds"* 1898
oil on canvas
21″ × 17″ (53.3 × 43.2 cm.)
LR: Billy Smith/from his friend/Thomas Eakins/1898
124a. *Portrait of Mrs. Mary Hallock Greenewalt* 1903
oil on canvas
36″ × 24″ (91.4 × 60.9 cm.)
UR: Eakins/1903

MAINE

BRUNSWICK

Bowdoin College Museum of Art:

125

125. *Portrait of A. Bryan Wall* 1904?
oil on canvas
23″ × 19½″ (58.4 × 49.5 cm.)
Wall was a member of the Fine Arts Committee of the Carnegie Institute when Eakins served on a Carnegie jury, as was another Eakins sitter, Joseph R. Woodwell, whom the artist painted in 1904. Thus the date, which is from the museum, may be conjecture.

MARYLAND

BALTIMORE

126

The Baltimore Museum of Art:

126. *Portrait of William H. Macdowell* c. 1891
watercolor
27″ × 21⅜″ (68.6 × 54.3 cm.)
There is a parallel work in oil of the same size at the Randolph-Macon Woman's College, Lynchburg, Virginia.

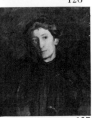
127

127. *Portrait of Mrs. Samuel Murray* c. 1897
oil on canvas
24″ × 20″ (60.9 × 50.8 cm.)
Jennie Dean Kershaw. The sitter did not become Mrs. Murray until 1916.

MASSACHUSETTS

AMHERST

Amherst College Museum of Fine Arts:

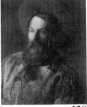
128

128. *The Cowboy* c. 1890

oil on canvas
24″ × 20″ (60.9 × 50.8 cm.)
Franklin L. Schenck

ANDOVER
Addison Gallery of American Art:

129. *Elizabeth at the Piano* 1875
oil on canvas
72″ × 48″ (182.9 × 121.9 cm.)
LR: Eakins/75
Elizabeth Crowell

130. *Sketch for Portrait of Prof. Henry A. Rowland* 1897
oil on canvas
12″ × 9″ (30.5 × 22.9 cm.)
Inscribed UR, not by artist: original sketch/for Portrait of Prof. Rowland/by
Thomas Eakins/1891 [*sic*]

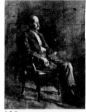

130

131. *Portrait of Prof. Henry A. Rowland* 1897
oil on canvas
82½″ × 53¾″ (209.6 × 136.5 cm.)
LL: Prof. Henry A. Rowland/Thomas Eakins 1897
Eakins' date for this portrait, 1897, was misread for 1891 at the time of Good-
rich's book. Mrs. Eakins gave the sketch to Eakins' pupil Charles Bregler in·
1934, and Bregler, who inscribed it, took his date from Goodrich. There are a
number of letters at the Addison Gallery from Eakins to Rowland concerning
the sittings. Rowland's machine for ruling 14,000 to 20,000 lines to an inch is on
the table beside him. Eakins painted the machine and Schneider, Rowland's
assistant at Johns Hopkins, where Rowland taught. The frame, which Eakins
himself built, is ornamented with rulings and formulae relating to Rowland's
work.

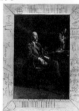

131

132. *Salutat* 1898
oil on canvas
49½″ × 39½″ (125.8 × 100.4 cm.)
LR: Eakins/1898
The fighter is Billy Smith, the fighter in *Between Rounds*. The spectator di-
rectly above the head of the man carrying the bucket is Clarence Cranmer
and at the left of Cranmer is Eakins' pupil David Wilson Jordan. At the right
is Samuel Murray, and above Murray's left shoulder Benjamin Eakins. Accord-
ing to Goodrich, Eakins carved the following Latin inscription on the original
frame: Dextra victrice conclamantes salutat.

BOSTON
Museum of Fine Arts:

132a. *Perspective Drawing for "John Biglin in a Single Scull"* 1874
pencil and ink on paper mounted on cardboard
32″ × 48″ (81.2 × 121.9 cm.)
Signed at right of figure: Eakins.
Perspective notes in French at top and right. See CL-13.

132a

133. *Starting Out after Rail* 1874
oil on canvas
24″ × 20″ (60.9 × 50.8 cm.)
LR: Eakins 74; LL: Eakins
Harry Young and Sam Helhower
This work is parallel to the Wichita Art Museum's *Starting Out after Rail*
(*q.v.*)

134. *Sketch of Walt Whitman* 1887?
oil on panel
5¼″ × 5¼″ (13.3 × 13.3 cm.)

135. *The Dean's Roll Call* 1899
oil on canvas
84″ × 42″ (213.4 × 106.7 cm.)

LR: Eakins/1899
This painting shows Dr. James William Holland, Dean of Jefferson Medical College, reading the diploma list at Commencement. It was painted for the College but was not accepted.

136. *Portrait of Mrs. Gilbert Lafayette Parker* 1910
oil on canvas
24″ × 20″ (60.9 × 50.8 cm.)
Inscribed on the reverse: To his friend/Mrs. Parker/Thomas Eakins/1910.

CAMBRIDGE
Fogg Art Museum:
137. *The Critic* c. 1890
oil on canvas
23¼″ × 19⅝″ (59 × 49.8 cm.)
Inscribed on the reverse: To my friend/Francis Ziegler/Thomas Eakins
Francis J. Ziegler

138. *Portrait of a Young Woman* 1903
oil on canvas
23⅝″ × 19¼″ (60 × 48.9 cm.)
LR: Eakins
Alice Kurtz

138

NORTHAMPTON
Smith College Museum of Art:
139. *In Grandmother's Time* 1876
oil on canvas
16″ × 12″ (40.7 × 30.5 cm.)
On side of spinning wheel: Eakins 76

139

140. *Portrait of Mrs. Edith Mahon* 1904
oil on canvas
20″ × 16″ (50.8 × 40.7 cm.)
Inscribed on reverse: To my friend Edith Mahon. Thomas Eakins, 1904

WORCESTER
Worcester Art Museum:
141. *Study for Gross in "Portrait of Professor Gross"* 1875
oil on canvas
24¹⁄₁₆″ × 18³⁄₁₆″ (61.1 × 46.2 cm.)
Inscribed on reverse, not by Eakins: Eakins

141

142. *The Spinner* 1876
oil on canvas
30³⁄₁₆″ × 25³⁄₁₆″ (76.7 × 63.9 cm.)
Inscribed at bottom, possibly by Mrs. Eakins: [S] tud [y for P] icture [of] Spinning E [akins]
This painting is a study for *The Courtship* (CL-6.)

MICHIGAN

DETROIT
The Detroit Institute of Arts:
143. *Unfinished Portrait of Arthur B. Frost* 1886
oil on canvas
26″ × 18″ (66 × 45.8 cm.)
See page 163.

142

144. *Portrait of Dr. Horatio C. Wood* c. 1889
oil on canvas
64″ × 50″ (162.6 × 127 cm.)
LR: Eakins

145. *Sketch for Portrait of Robert M. Lindsay* 1900
oil on academy board
11¾″ × 10⅝″ (29.9 × 27 cm.)

145

146. *Portrait of Robert M. Lindsay* 1900
oil on canvas
24″ × 20″ (60.9 × 50.8 cm.)
RC: Eakins 1900
Lindsay was a print collector. The bust on the case at the right may be Samuel Murray's sculpture of Benjamin Eakins, and thus a kind of memorial to Benjamin, who had recently died.

146

MINNESOTA

MINNEAPOLIS

The Minneapolis Institute of Arts:
147. *Portrait of Elizabeth L. Burton* 1906
oil on canvas
30″ × 25″ (76.2 × 63.5 cm.)

MISSOURI

KANSAS CITY

William Rockhill Nelson Gallery of Art:
148. *Portrait of Frances Eakins* 1870?
oil on canvas
24″ × 20″ (60.9 × 50.8 cm.)

ST. LOUIS

City Art Museum:
149. *Black and White Version of "A May Morning in the Park"* 1899
oil on canvas
24″ × 36″ (60.9 × 91.4 cm.)

149

Washington University Gallery of Art:
150. *Portrait of Professor William D. Marks* 1886
oil on canvas
76″ × 53½″ (193.1 × 135.9 cm.)
Signed on side of table: Eakins. 86

NEBRASKA

LINCOLN

University of Nebraska Art Galleries:
151. *Portrait of Mrs. Samuel Murray* c. 1897
oil on canvas
40″ × 30″ (101.6 × 76.2 cm.)
Inscribed on reverse, not by artist: T. E.
Jennie Dean Kershaw

OMAHA

Joslyn Art Museum:
152. *Portrait of J. Laurie Wallace* 1885?
oil on canvas
50¼″ × 32½″ (127 × 82.6 cm.)
The date is uncertain: see page 156.

In addition, the Joslyn Museum has a plaster of the Schuylkill *Nymph* from the *William Rush* complex, and three casual pieces evidently by Eakins: 1, Two oil studies on piece of canvas mounted on cardboard 3½″ × 13¼″ (8.9 × 33.7 cm.) of the same three objects—two rounded ends of wooden cylinders and a wooden ball (the museum also has three of the rounded cylinder ends); 2, two oil studies on one piece of canvas mounted on cardboard 14″ × 10½″ (35.5 × 26.7 cm.), one of three balls of yarn and the other a vague representation of a rosebush; 3, an oil on board sketch of a girl under a tree, *Girl in Shade*, 4″ × 5¾″ (12 × 14.6 cm.) on the reverse of which are slight studies said to be

of shad fishing. A 49½″ × 32″ charcoal of the Wallace portrait, said to be a study for that portrait, is likely a tracing or a rough copy of it by George Barker, the Wallace pupil who gave the Eakins items to the museum.

NEW HAMPSHIRE

HANOVER
Hopkins Center Art Galleries:

153. *Portrait of the Architect John Joseph Borie* 1896–1898
oil on canvas
79½″ × 41½″ (201.9 × 105.4 cm.)

153

NEW JERSEY

MONTCLAIR
The Montclair Art Museum:

154. *Portrait of Charles Haseltine* 1901?
oil on canvas
24″ × 20″ (60.9 × 50.8 cm.)
A label on the reverse by Eakins' pupil Charles Bregler states that this work was originally signed on the reverse. This is the Haseltine who was Eakins' art dealer. This portrait was also called *The Connoisseur*.

155. *Portrait of Charles L. Fussell* c. 1905
oil on canvas
49¾″ × 39½″ (126.4 × 100.3 cm.)

155

NEWARK
The Newark Museum:

156. *Legs* 1866–1867
charcoal
22½″ × 17″ (57.1 × 43.2 cm.)
LL, by Eakins' pupil Charles Bregler: Drawing by/Thomas Eakins; UR, scattered: T.M., L. D., ?, P. M.

157. *Five Models for "William Rush Carving His Allegorical Statue of the Schuyl-kill":* 1876
plaster
Head of Rush
height: 7¼″ (18.4 cm.)
The Schuylkill Harnessed
height: 4¾″ (12.1 cm.)
Washington
height: 8½″ (21.6 cm.)
Nymph
height: 9½″ (24.1 cm.)
Head of Nymph
height: 7½″ (19.1 cm.)

156

157

158. *Portrait of a Man with a Red Necktie* 1890
oil on canvas
50″ × 36″ (127 × 91.4 cm.)
LR: Eakins
Dr. Joseph Leidy, II. Leidy was the anesthetist in *The Agnew Clinic*.

159. *Sketch for Portrait of Harrison S. Morris* 1896
oil on canvas
18¼″ × 13¼″ (46.4 × 33.7 cm.)

158

PRINCETON
The Art Museum Princeton University:

160. *Seventy Years Ago* 1877
watercolor on paper
15⅝″ × 11″ (39.7 × 27.9 cm.)
UR: Eakins/77.

159

This is another painting of the chaperon in *William Rush Carving His Allegorical Statue of the Schuylkill*, from a slightly different angle. It is also related to the model for *Knitting* (CL-59.)

New Jersey State Museum:
161. *Bas-relief of "The Continental Army Crossing the Delaware"*
bronze
55″ × 93½″ (139.7 × 237.5 cm.)
Inscribed at bottom left, not by Eakins: Presented by the Commonwealth of Pennsylvania
The three figures in the bow of the left-hand boat are, from left to right, Colonel William Washington, Alexander Hamilton, and Lieutenant James Monroe. In the middle boat are, from the left, George Washington, a Jersey farmer, and Colonel Knox. The standing figure at the right is unidentified.
162. *Bas-Relief of "The Opening of the Fight"*
bronze
55″ × 93½″ (139.7 × 237.5 cm.)
At the right, mounted, is Alexander Hamilton.

NEW YORK

Buffalo
Albright-Knox Art Gallery:
163. *Study for "Cowboys in the Badlands"* 1887
oil on canvas, mounted on board
4¾″ × 6⅜″ (12 × 16.2 cm.)
This sketch was originally grouped on a single piece of canvas, along with a sketch of a saddle and of a stirrup.

163

164. *Music* 1904
oil on canvas
39⅜″ × 49½″ (100 × 125.8 cm.)
LL: Eakins/1904
Hedda van den Beemt, violinist; Samuel Myers, pianist. Whistler's *Sarasate* on wall at upper right.

164

CANAJOHARIE
Canajoharie Library and Art Gallery:
165. *Portrait of Mrs. M. S. Stokes* 1903
oil on canvas
24″ × 20″ (60.9 × 50.8 cm.)
The inscription on the reverse is not by Eakins.

165

GLENS FALLS
The Hyde Collection:
166. *In the Studio* 1884?
oil on canvas
22⅛″ × 18¹/₁₆″ (56.2 × 45.8 cm.)
LR: T. E. 1884 (not by artist.)
Possibly a study for *Lady with a Setter Dog*, CL-187.
167. *Portrait of Henry O. Tanner*
oil on canvas
24″ × 20¼″ (60.9 × 51.4 cm.)

166

HUNTINGTON
Heckscher Museum:
168. *Study for "The Cello Player"* 1896
oil on canvas mounted on panel
16½″ × 12¾″ (41.9 × 32.4 cm.)
LL: To my dear pupil/Samuel Murray/Thomas Eakins
The cellist is Rudolph Hennig, leading cellist of the Theodore Thomas Or-

167

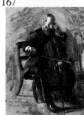
168

chestra of Philadelphia, the forerunner of the Philadelphia Orchestra. See CL-220.

The Brooklyn Museum:

169. *Home Scene* c. 1871
oil on canvas
22″ × 18¼″ (55.9 × 46.3 cm.)
LR: Eakins
The artist's sisters Margaret, at the piano, and Caroline.

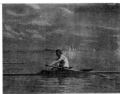

170

170. *Oarsmen on the Schuylkill* 1874?
oil on canvas
27⅜″ × 48″ (69.5 × 121.9 cm.)
Signed at right of boat: Eakins
Mrs. Eakins identified "the second man in the boat" as Henry Schreiber, the photographer. But the second man is evidently Max Schmitt (see CL-239.)

171. *Whistling for Plover* 1874
watercolor on paper
11″ × 16½″ (27.9 × 41.9 cm.)
LR: Eakins 74
William Robinson

172. *Drawing for "Mr. Neelus Peeler's Conditions"* 1879
Ink wash and Chinese white on paper
11″ × 16½″ (27.9 × 41.9 cm.)
Illustration for *Scribner's Magazine*, June 1879.

173. *Portrait of Letitia Wilson Jordan Bacon* 1888
oil on canvas
60″ × 40″ (152.4 × 101.6 cm.)
LR: To my friend/D. W. Jordan./Eakins 88

174. *William Rush Carving His Allegorical Statue of the Schuylkill* 1908
oil on canvas
35¹⁵⁄₁₆″ × 47¾″ (89.7 × 121.3 cm.)
Signed on scroll, bottom center: Eakins 1908

Metropolitan Museum of Art:

175. *The Champion Single Sculls* [i.e., *Max Schmitt in a Single Scull*] 1871
oil on canvas
32¼″ × 46¼″ (81.9 × 117.5 cm.)
Signed on Eakins scull: Eakins/1871.
Max Schmitt and the artist himself on the Schuylkill River above the Girard Avenue and Connecting Railroad bridges.

176. *John Biglin in a Single Scull* 1873 or 1874
watercolor
16¾″ × 23″ (42.5 × 58.4 cm.)

176

177. *Pushing for Rail* 1874
oil on canvas
13″ × 30¹⁄₁₆″ (33 × 76.3 cm.)
LR: Eakins 74

178. *Drawing for Autotype for "Portrait of Professor Gross"* 1875
ink wash
22″ × 28″ (55.8 × 71.1 cm.)
LR: Eakins 1875.

179. *Perspective Drawings for "The Chess Players"* 1876
pencil and ink on cardboard
24″ × 19″ (60.9 × 48.2 cm.)
Perspective notations by Eakins at the left. Label by Eakins' pupil Charles Bregler upper left. Mounted on cardboard by Bregler.

180 *The Chess Players* 1876
oil on panel
11¾″ × 16¾″ (29.9 × 42.5 cm.)
LL: Benjamini. Eakins. Filius. Pinxit. 76

From left to right: Bertrand Gardel, a French teacher, Benjamin Eakins, and
George Holmes.

181. *Young Girl Meditating* 1877
watercolor on paper
8¾″ × 5½″ (22.2 × 14 cm.)
LR: Eakins 77

182. *Study of Negroes* [*Negro Boy Dancing*] 1878
watercolor on paper
18⅛″ × 22⅝″ (46 × 57.5 cm.)
Signed on bench at right: Eakins/78.
A drawing of a photograph of Abraham Lincoln with his son Todd at his knee
is upper left.

183. *Spinning* 1881.
watercolor on paper
14″ × 10⅞″ (35.1 × 27.6 cm.)
UR: Eakins 81.
Margaret Eakins. Cf CL-60.

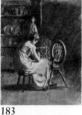
183

184. *Taking Up the Net* 1881
watercolor on paper
9½″ × 14⅛″ (24.6 × 35.9 cm.)
Signed on boat: Eakins 81

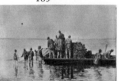
184

185. *The Writing Master* 1882
oil on canvas
30″ × 34¼″ (76.2 × 87 cm.)
LR: Eakins 82

186. *Arcadia* c. 1883
oil on canvas
38¾″ × 45½″ (98.4 × 115.6 cm.)
The two right-hand figures and the tree at the left were painted from pho-
tographs (see Figs. 129, 132.)

187. *Lady with a Setter Dog* 1885?
oil on canvas
30″ × 23″ (76.2 × 58.4 cm.)
Mrs. Thomas Eakins with the Eakins' dog, Harry. See CL-166.

188. *Cowboy Singing* c. 1890
watercolor on paper
18″ × 14″ (45.7 × 35.6 cm.)
LR: Eakins
Franklin Schenck

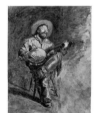
188

189. *Sketch for Portrait of James MacAlister* [*Man with a Red Tie*] c. 1895
oil on canvas
14¼″ × 10¼″ (36.2 × 26 cm.)
The portrait for which this is a sketch is now unlocated. This sketch formerly
had two other sketches on the reverse.

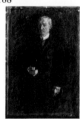
189

190. *The Thinker* 1900
oil on canvas
82″ × 42″ (208.3 × 106.7 cm.)
LR: Eakins/1900
Louis Kenton, who married Mrs. Eakins' sister, Elizabeth Macdowell.

191. *Portrait of Mary Arthur* 1900
oil on canvas
24″ × 20″ (60.9 × 50.8 cm.)
On reverse: "To his dear friend Robert Arthur, Thomas Eakins, 1900." Robert
Arthur was the sitter's son.

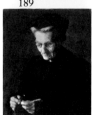
191

192. *Portrait of Signora Gomez d'Arza* 1902?
oil on canvas
30″ × 24″ (76.2 × 60.9 cm.)
On reverse, by Eakins?: T. E. 1902.
Signora d'Arza, according to Lloyd Goodrich, was an actress in a small Phila-

delphia Italian theater. Eakins is said to have visited the d'Arzas often, and McHenry (page 107) gives a chilling d'Arza recipe for Italian spaghetti: four cans of tomatoes, two lbs. spaghetti, two heaping tsps. basil, a half pound of butter, a heaping teaspoon garlic—"When cooked to a mush, cold water to thin."

The Metropolitan Museum also owns 69–75 photographs attributed to Eakins, including 2 glass negatives and 5 glass positives. A number of these have been reproduced in this book and in my *The Photographs of Thomas Eakins* (New York 1972.)

The National Academy of Design:

193. *Self-Portrait* c. 1902
oil on canvas
30″ × 25″ (76.2 × 63.5 cm.)
This is the so-called "diploma" portrait produced when the artist became a Member of the Academy in 1902.

194. *Portrait of Edward Redfield* 1905?
oil on canvas
30″ × 26″ (76.2 × 66 cm.)
Inscribed on reverse, not by Eakins: Edward C. Redfield, A. N. A. Painted by Thomas Eakins, 1905.

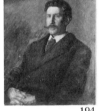

194

ROCHESTER
Memorial Art Gallery of the University of Rochester:

195. *Portrait of William H. Macdowell* c. 1891
oil on canvas
24″ × 20″ (60.9 × 50.8 cm.)

YONKERS
Philipse Manor Hall:

196. *Portrait of Rutherford B. Hayes* 1912
oil on canvas
29″ × 24″ (73.7 × 60.9 cm.)
LR: Eakins

NORTH CAROLINA

WINSTON-SALEM
Reynolda House:

197. *Portrait of A. W. Lee* 1905
oil on canvas
40″ × 32″ (101.6 × 81.3 cm.)

OHIO

CINCINNATI
Cincinnati Art Museum:

198. *Hauling the Seine* 1882
oil on canvas
18″ × 12⅛″ (45.7 × 30.8 cm.)
LR: Eakins 82

198

CLEVELAND
The Cleveland Museum of Art:

199. *The Biglin Brothers Turning the Stake* 1873
oil on canvas
40¼″ × 60¼″ (102.2 × 153 cm.)
Signed on right of boat: Eakins 73

200. *The Biglin Brothers Turning the Stake* 1880?
pencil on paper
13¹⁵⁄₁₆″ × 17″ (35.4 × 43.2 cm.)
This drawing has been called preliminary to the painting, but it appears to be

after the fact. Bregler has evidently added reflections and shaded the reverse and traced the figures for transfer. Probably the drawing was made by Eakins or Alice Barber for Barber's engraving of the painting as *On the Harlem* in *Scribner's Monthly*, June 1880, page 165.

COLUMBUS
Columbus Gallery of Fine Arts:
 201. *Portrait of Weda Cook* c. 1895
 oil on canvas
 24″ × 20″ (60.9 × 50.8 cm.)
 202. *The Wrestlers* 1899
 oil on canvas
 48¾″ × 60″ (123.8 × 152.4 cm.)
 UR: Eakins/1899.
 Joseph McCann is on top.

TOLEDO
The Toledo Museum of Art:
 203. *Portrait of B. J. Blommers* 1904
 oil on canvas
 23½″ × 19¾″ (59.7 × 50.2 cm.)
 On reverse: To my friend B. J. Blommers 1904 by Thomas Eakins

203

YOUNGSTOWN
The Butler Institute of American Art:
 204. *Bas-relief of Horse Skeleton with Details of Farther Legs* 1878
 bronze
 11″ × 14″ × 2″ (27.9 × 35.6 × 5.1 cm.)
 Signed between details: Eakins/78
 205. *Portrait of General George Cadwalader*
 oil on canvas
 39″ × 25″ (99.1 × 63.5 cm.)
 206. *The Coral Necklace* 1904
 oil on canvas
 43″ × 31″ (109.2 × 78.7 cm.)
 Signed on back of chair: Eakins 1904
 Beatrice Fenton

204

OKLAHOMA

TULSA
The Gilcrease Institute:
 207. *Portrait of Frank Hamilton Cushing* 1895
 oil on canvas
 90″ × 60″ (228.6 × 152.4 cm.)
 LL: Eakins
 Cushing's head and bust were painted from a photograph (Fig. 241)

205

OREGON

PORTLAND
Portland Art Museum:
 208. *The Oarsmen* c. 1873
 oil on canvas
 14″ × 18″ (35.6 × 45.8 cm.)

206

PENNSYLVANIA

GREENSBURG
Westmoreland County Museum of Art:
 208a. *Ernest Lee Parker* 1910
 oil on canvas

208

24″ × 20″ (60.9 × 50.8 cm.)
LR, not by Eakins: T. E.
Inscribed on the reverse: To my Friend Ernest Parker/1910/Thomas Eakins.

The Pennsylvania Academy of the Fine Arts:

209. *Perspective Drawings for "The Schreiber Brothers"* 1874
pencil and ink on paper
28″ × 48″ (71.1 × 121.9 cm.)
Besides elevation and ground plan drawings of the projected painting, angle and footage notations and a signature and date—"Eakins 1874"—there are numerous inscriptions by Eakins' pupil Charles Bregler, an 1879 photograph of Eakins, and a reproduction of *The Schreiber Brothers*. Lower right is the following inscription in Bregler's hand: "A boat is the hardest thing I know of to put into perspective. It is so much like the human figure. There is something alive about it. It requires a heap of thinking and calculating to build a boat/The above is by Eakins recorded by Bregler."

210. *Bas-relief of Écorché Cat* 1877
plaster
13¾″ × 25⅝″ (34.9 × 65.1 cm.)
Center: Eakins/1877
This cast, along with casts of a dog, was described in Dr. W. W. Keen's April 7, 1877, report to the directors of the Academy.

211. *Cast of Front Leg of Cat* 1877
plaster
10½″ (26.7 cm.)

212. *Cast of Hind Leg of Cat* 1877
plaster
13¼″ (33.7 cm.)

213. *Cast of Front Leg of Horse* 1877?
plaster
28¼″ (71.7 cm.)

214. *Cast of Hind Leg of Horse* 1877?
plaster
33¼″ (84.4 cm.)

215. *Ten Casts of Anatomical Dissections of a Human Male* 1878-1879
plaster
size range from 9½″ (24.2 cm.) for 8 to 37¾″ (95.9 cm.) for 7. 1, Bas-relief of head, 2, cast in round of torso, 3, cast in round of shoulder, 4, cast in round of back of shoulder, 5, cast in round of right arm, 6, cast in round of left arm, 7, cast in round of leg, 8, cast in round of knee, 9, cast in round of hip, 10, cast in round of limb segment. Some muscles are named, probably by Eakins. These casts were mentioned as having been recently produced in Dr. W. W. Keen's May 1879 report to the Academy directors.

216. *Bas-relief of Écorché Horse and Detail of Neck* 1882
plaster
22½″ × 29½″ (57.2 × 74.9 cm.)
Lower center: Eakins/1882

217. *Bas-relief of "Spinning"* c. 1883
bronze
18″ × 14½″ (45.7 × 36.8 cm.)

218. *Bas-relief of "Knitting"* 1883
bronze
18″ × 15″ (45.7 × 38.1 cm.)

219. *Portrait of Walt Whitman* 1888
oil on canvas
30″ × 24″ (76.2 × 60.9 cm.)
UR: Eakins/1887
Probably dated from memory by the artist. The second "8" was originally "9".

220. *The Cello Player* 1896

oil on canvas
64½″ × 48½″ (163.8 × 123.2 cm.)
The cellist is Rudolph Hennig. See also CL-168.

221. *Portrait of Charles Edmund Dana* c. 1902
oil on canvas
50″ × 30″ (127 × 76.2 cm.)
Dana was a painter, a professor of art at the University of Pennsylvania, and a student at the Academy.

222. *Delaware River Study* [correct title?]
oil on board
4¼″ × 7½″ (10.8 × 19.1 cm.)
LL, not by artist, presumably by Charles Bregler: T. E.

The Philadelphia Museum of Art:

223. *Drawing of Woman's Shoulder and Arm* c. 1865
charcoal on paper
24″ × 18″ (60.9 × 45.7 cm.)
LR, by Mrs. Eakins: Thomas Eakins
The primitiveness of this drawing and the fact that the artist did not immediately draw from life after he began his study at the Pennsylvania Academy, suggest this pre-Paris date. It is possible, however, that CL-224 and CL-225 are Eakins' first Paris drawings, and CL-226 through CL-231 later ones in Paris, since the artist's charcoal work did not necessarily terminate when he began to work regularly in oil in probably March 1867. It has been said that CL-228 through CL-230 are from the artist's pre-Paris days, Mrs. Eakins' dates on the reverse notwithstanding, because a mask would not have been used in Paris and would have been used in Philadelphia. The Fussell drawing of the actual studio where Eakins worked contravenes the latter theory, and a closer knowledge of the Paris academic world of the 1860s weighs against the former. The École des Beaux Arts atmosphere in Eakins' years was quite formal. Further, it is impossible to believe that Eakins' first Paris drawings would have not been conspicuously identified for years during his lifetime. And Mrs. Eakins always believed them to be Paris works.

224. *Two Drawings of Nude Woman, Reclining* c. 1865
charcoal on paper
24″ × 18″ (60.9 × 45.7 cm.)
LR, possibly by Mrs. Eakins: T. E.

225. *Five Drawings of Parts of a Female Nude* c. 1865
charcoal on paper
24″ × 18″ (60.9 × 45.7 cm.)
On the reverse of 224.

226. *Nude Woman, Reclining, from the Back* 1866–1867
charcoal on paper mounted on cardboard
24″ × 18″ (60.9 × 45.7 cm.)
LR, on mount, by Mrs. Eakins: Thomas Eakins

227. *Nude Woman, Standing, from the Back* 1866–1867
charcoal on paper mounted on cardboard
24″ × 18″ (60.9 × 45.7 cm.)
LR, on mount, by Mrs. Eakins: Thomas Eakins

228. *Nude Woman with a Mask, Seated, from the Front* 1866–1867
charcoal on paper mounted on cardboard
24″ × 18″ (60.9 × 45.7 cm.)
LR, on paper: T. E.; LR, on mount: Thomas Eakins—both by Mrs. Eakins.

229. *Nude Man, Seated, from the Front* 1866–1867
charcoal on paper mounted on cardboard
24″ × 18″ (60.9 × 45.7 cm.)
A watermark at upper right, with the letters "E" and "B" and Mercury's caduceus, are typical of the Second Empire, when Eakins was in Paris.

230. *Nude Boy, Standing, from the Front* 1866–1867

221

222

223

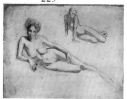

224

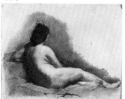

226

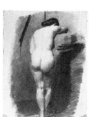

227

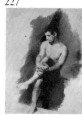

229

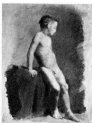

230

charcoal on paper mounted on cardboard
24″ × 18″ (60.9 × 45.7 cm.)
LR, on paper: T. E.; LR, on mount: Thomas Eakins—both by Mrs. Eakins.
This may be the nine-year-old son of a Madame Derue, of 40 rue Mazarin, just as the following oil may be of Madame Derue's ten-year-old daughter. An entry in Eakins' Paris notebook is as follows: "Madame Derue/40 rue Mazarin/ Garcon 9 ans Fille 10 ans."

231

231. *Drawing of Child* 1866–1867?
charcoal on paper
24″ × 18″ (60.9 × 45.7 cm.)
Signed LR, twice, by Eakins?: Thomas Eakins

232

232. *Portrait of a Young Girl* 1867–1868
oil on canvas
17¾″ × 14½″ (45.1 × 36.8 cm.)
A label on the reverse, by Mrs. Eakins, dates this work in about 1868. Again, it is difficult to believe that Tom's first Paris oils would not have been carefully distinguished. Like the following two oils, the relatively naïve technique supports this dating.

233. *The Strong Man* 1869
oil on canvas
21½″ × 17¾″ (54.6 × 45.1 cm.)
A label on the reverse, by Mrs. Eakins, dates this work in 1869. Like the following work, this date may be an example of the work done in Bonnat's atelier. It is reasonable to think that Eakins would have kept work done with his second Paris painting master, and could reasonably account for the definite difference in dating.

233

234. *Nude Man with Arm Upraised* 1869
oil on canvas
21½″ × 18¼″ (54.6 × 46.3 cm.)
Inscribed on the reverse, not by the artist: T. E. A label by Mrs. Eakins again dates this work in 1869.

234

235. *Margaret in Skating Costume* 1871
oil on canvas
24″ × 20½″ (60.9 × 52.1 cm.)
LR: T. E. 1871
Evidently originally inscribed "Eakins" by the artist on the reverse. In re-backing this word was copied with the "N" reversed.
Margaret Eakins

236. *A Pair-Oared Shell* 1872
oil on canvas
24″ × 36″ (60.9 × 91.9 cm.)
Signed on pier at right: Eakins/1872
Bernard (Barney), left, and John Biglin. The studies for this work may have been made on May 17, 1872 (see page 74). The bridge in this painting is said to have been the Columbia Railroad bridge. But a comparison of photographs of that bridge with the stone structure of Eakins' bridge suggests that the two are dissimilar, and that, indeed, Eakins' bridge could not cross the water.

237. *Perspective Drawing for "A Pair-Oared Shell"* 1872
ink and pencil on paper mounted on cardboard
38″ × 48″ (96.5 × 121.9 cm.)

238. *Perspective Drawing for "A Pair-Oared Shell"* 1872
ink and watercolor on paper mounted on cardboard
32″ × 48″ (81.3 × 121.9 cm.)
LR, by Mrs. Eakins: Perspective picture painted before 1876
Numerous perspective notations are on the paper in the artist's hand.

238

239. *Oarsman in a Single Scull* 1874?
oil on canvas
10″ × 14⅜″ (25.3 × 36.5 cm.)
Probably Max Schmitt.

239

The Brooklyn Museum's *Oarsmen on the Schuylkill* may have been painted in 1874 (see CL-170), suggesting the same date for *Oarsman in a Single Scull*, since the second from the right sculler in the Brooklyn painting appears to be closely parallel to the oarsman in the Philadelphia painting.

240. *Sailboats Racing* 1874
oil on canvas
24″ × 36″ (60.9 × 91.4 cm.)
Signed on side of boat at right: Eakins 74
Inscribed on reverse, probably by Charles Bregler or Mrs. Eakins: T. E.
A regatta of August 31, 1874, which involved a large number of boats, may have been the inspiration for this work. No other race of the year was appropriate.

240

241. *Ships and Sailboats on the Delaware* 1874
oil on canvas
10⅛″ × 17¼″ (25.7 × 43.8 cm.)
LR: Eakins 74
Inscribed on reverse, probably by Charles Bregler or Mrs. Eakins: T. E. Sometimes called *"Becalmed on the Delaware."*

242. *Starting Out after Rail* 1873
oil on canvas
32″ × 46⅜″ (81.3 × 117.8 cm.)
LR: To his friend/William M. Chase./Eakins
October was the best month for rail-shooting, and a corollary work was painted in time for a January 28, 1874, exhibition, thus the likely time for studies for this work is the fall of 1873. It is unfinished: the sail has no reef points, no ribs, no main boom sheets; there is no "pusher's" pole or gun in the boat; there are no oars. This work has sometimes been called *Sailing*, but this boat could not sail. See also CL-123 and CL-133.

243. *Sketch for "Portrait of Professor Gross"* [*The Gross Clinic*] 1875
oil on canvas
24″ × 20″ (60.9 × 50.8 cm.)
Scratched LR by Charles Bregler: "Sketch ("Gross Clinic") T. E." On reverse, possibly by Mrs. Eakins: "T. E. 75" and "Sketch ("Gross Clinic") T. E." An X-ray has revealed an oil sketch of a sculler.

244. *Drawings of Heads of Drs. Gross and Barton for Autotype of "Portrait of Professor Gross"* 1875?
ink by pen and brush on paper
11¾″ × 14¾″ (29.8 × 37.5 cm.)
LL, by Mrs. Eakins: Drawing in India Ink/by Thomas Eakins/1876
Gross' head is drawn with brush and pen, and Barton's with brush alone, evidently to determine which technique would be better for autotype reproduction. Since the entire wash drawing was completed, sent to Europe, reproduced and returned in time for a March 7, 1876, exhibition, Mrs. Eakins' date of 1876 must surely be incorrect.

245

245. *Autotype of "Portrait of Professor Gross"* 1876
photograph (carbon print) on paper mounted on cardboard
11¼″ × 9⅛″ (28.6 × 23.2 cm.)
LR: "Copyright by Eakins 1876;" the mount is inscribed LR: "To Florence A. Einstein/from her friend Thomas Eakins." See my article, "Thomas Eakins's *Gross Clinic*," *The Art Bulletin*, March 1969, page 58, for a discussion of the autotype process.

246. *Sketch of Bertrand Gardel for "The Chess Players"* 1876
oil on paper mounted on cardboard
12″ × 10″ (31 × 25.4 cm.)
LR, by Mrs. Eakins?: T. E.
Gardel was a teacher of French who lived in Germantown. See a letter of October 30, 1866, from Eakins to William Sartain in the Sartain Collection, the Historical Society of Pennsylvania. See also CL-180.

247. *Portrait of Harry Lewis* 1876

246

oil on canvas

24″ × 20″ (60.9 × 50.8 cm.)

LR: Eakins 76. A label on the reverse by Mrs. Eakins dates this work 1875. I have not identified Harry Lewis. Evidently he was a brother of Lucy Lewis. This painting has been considerably worked over.

248

248. *Sketch for Interior of Rush's Shop for "William Rush Carving His Allegorical Statue of the Schuylkill"?* 1876?

oil on canvas mounted on cardboard

8⅝″ × 13″ (21.9 × 33 cm.)

The identification is tenuous, and evidently by Mrs. Eakins more than fifty years after her husband's *Rush* painting. It is unlike Rush's shop in the finished painting.

249. *Five Models for "William Rush Carving His Allegorical Statue of the Schuylkill"* 1876

wax on wood bases

Head of Rush

height: 7¼″ (18.4 cm.)

Head of Nymph

height: 7½″ (19.1 cm.)

Washington

height: 8½″ (21.6 cm.)

Nymph

height: 10½″ (26.7 cm.)

The Schuylkill Harnessed

height: 5½″ (14 cm.)

The Museum also owns plaster casts of these models (Fig. 96).

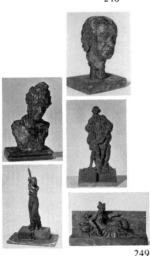

249

250. *William Rush Carving His Allegorical Statue of the Schuylkill* 1877

oil on canvas

20⅛″ × 26⅛″ (51.1 × 66.3 cm.)

LR: Eakins. 77

See my article on this painting in *The Art Quarterly*, Winter 1968, pages 383ff, for a full discussion of the elements in the work.

251. *Sketch of Lafayette Park, Washington* 1877

oil on wood

10½″ × 14½″ (26.7 × 36.7 cm.)

LR, by Mrs. Eakins?: T.E.

Clark Mills' equestrian statue of Andrew Jackson is in the center, and the cupola of St. John's church at the right. Sketched from what is now the Family Dining Room of the White House. See my article on the Hayes portrait in *The American Art Journal*, Spring 1969, pages 104ff, for a discussion of this work.

252. *Bas-relief of Fairman Rogers' Horse Josephine* 1878

bronze

22″ × 28″ (55.8 × 71.1 cm.)

Signed in center: Eakins/78.

252

253. *Sixteen Casts of Anatomical Dissections of a Human Male*

bronze

from 6½″ × 2½″ (16.6 × 6.4 cm.), Number 13, to 20⅛″ × 9″ (51.1 × 22.9 cm.), Number 10.

1, cast in round of right hand, 2, cast in round of right foot, 3, cast in round of shoulder, 4, cast in round of right thigh, 5, cast in round of right arm and shoulder, 6, cast of dorsal surface of shoulder, 7, cast of half head, 8, cast of ventral surface of torso, 10, cast in round of left half of pelvis, 11, cast in round of left knee, 12, cast in round of portion of left pelvis, 13, cast in round of right elbow, 14, cast in round of left arm and shoulder, 15, cast of dorsal surface of torso, 16, cast in round of left side of neck.

The date of the casting is unknown, but the plasters from which the casts were made were evidently produced sometime during the Academy school season of 1878–1879. Some of these plasters are still at the Academy. Some of

the muscles have been named, probably by Eakins.

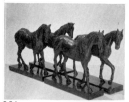

254

254. *Four models of Horses in "A May Morning in the Park"* ["*The Fairman Rogers Four-in-Hand*"] 1879
bronze
9⅜″–9½″ × 12″–12½″ (23.8–24.1 × 30.5–31.8 cm.)

255

255. *Sketch of Hind-quarters of Near-Lead Horse in "A May Morning in the Park"* 1879
oil on wood
14⅝″ × 10⅜″ (37.1 × 26.4 cm.)

256. *The Boatman* 1879
oil on wood
14⅝″ × 10⅜″ (37.1 × 26.4 cm.)
This name was given by Mrs. Eakins, but whether as the result of inference or special knowledge is unknown. More likely it is of a Rogers groom.
On the reverse of CL-255.

256

257. *Sketch of Fairmount Park Site of "A May Morning in the Park"* 1879
oil on wood
14½″ × 10¼″ (36.8 × 26 cm.)
LR, by Mrs. Eakins: "Fairmount Park/T. E." and, by an unidentified hand: "Eakins."
See my article, "A May Morning in the Park," *The Bulletin of the Philadelphia Museum of Art*, Spring 1965, pages 48ff, for a discussion of this site, and other elements of the picture. There is a slight sketch of the left end of the parapet in this picture on the reverse.

257

258. *Study of an Alternate (Newport?) Version of "A May Morning in the Park"* 1879
oil on wood
10¼″ × 14½″ (26 × 36.8 cm.)
LL and LR, by Mrs. Eakins?: T. E.

259. *Sketch of Mrs. Fairman Rogers' Head for "A May Morning in the Park"* 1879
oil on wood
10¼″ × 14½″ (26 × 36.8 cm.)
On the reverse of CL-258.

258

260. *A May Morning in the Park* [*The Fairman Rogers Four-in-Hand*] 1879
oil on canvas
24″ × 36″ (60.9 × 91.4 cm.)
Signed on stone SL: Eakins./79
Left to right: George Gilpin, Fairman Rogers, Mrs. George Gilpin, Mrs. Fairman Rogers, Mrs. Franklin A. Dick, Franklin A. Dick, and two grooms, atop a coach near Horticultural Hall in Fairmount Park, Philadelphia.

259

261. *The Crucifixion* 1880
oil on canvas
96″ × 54″ (243.8 × 137.2 cm.)
Signed on reverse: Christi effigiem Eakins Philadelphiensis pinxit. MDCCCXXX. J. Laurie Wallace. Although Pilate is said to have ordered (John, 19.20) that the charge should be written in Greek, Latin and Hebrew, Eakins has painted only the Greek and the Latin.

262. *Portrait of Ella Crowell?* c. 1880
oil on canvas
16″ × 12″ (41.2 × 30.5 cm.)
LR: Eakins
Inscribed LR on reverse: T. E.
This sitter has been previously unidentified. But it is very like Ella Crowell, Eakins' niece, who would have been six in 1880.

262

263. *Retrospection* c. 1880
watercolor on paper
14⅝″ × 10⅝″ (37.1 × 27 cm.)
LR, by Mrs. Eakins: Thomas Eakins.

263

264

264

265

269

270

272

273

275

The sitter has been said to be a Mrs. Perkins. This work is parallel to Yale's *Retrospection*, CL-16. Unfinished.

264. *Landscape Sketch* c. 1880?
oil on cardboard
8¾″ × 13″ (22.2 × 33 cm.)
Painted over a man seated in a wooden chair.

265. *Landscape Sketch* c. 1880?
oil on cardboard
8¾″ × 13″ (22.2 × 33 cm.)
On the reverse of CL-264

266. *Mending the Net* 1881
oil on canvas
32″ × 45″ (81.3 × 114.3 cm.)
A label on the reverse by the artist—a rare occurrence: Mending the Net/ T. Eakins.
When Goodrich saw this picture in about 1930 it was signed on the lower right capstan spool: Eakins 81. Possibly William Sartain sitting on a pile of capstan spools on Prospect Ridge in Gloucester, New Jersey, near the mouths of Little Timber and Big Timber creeks on the Delaware River.

267. *Shad Fishing at Gloucester on the Delaware* 1881
oil on canvas
12⅛″ × 18¼″ (30.8 × 46.3 cm.)
The figures on shore at lower left suggest Eakins' two sisters, his mother (posthumously), his father, and his dog Harry.

268. *Drawing the Seine* 1882 (The Johnson Collection)
watercolor on paper
8″ × 11″ (20.3 × 28 cm.)
LR: Eakins/82.
Copied directly from a photograph (Fig. 124). Looking across the Little and Big Timber estuaries south of Gloucester, New Jersey.

269. *Sketch for "The Writing Master"* 1882
oil on wood
8¼″ × 10⅛″ (21 × 25.7 cm.)

270. *Bas-relief of Écorché of Fairman Rogers' Horse Josephine* 1882
bronze
22½″ × 32″ (57.2 × 81.3 cm.)
Signed in center: Eakins/1882

271. *Meadows, Gloucester* c. 1882
oil on canvas
32¼″ × 45¼″ (81.9 × 114.9 cm.)

272. *Bas-relief of "Spinning"* c. 1883
bronze
19″ × 15″ (48.3 × 38.1 cm.)
Inscribed at bottom, apparently at time of casting: Spinning./Thomas Eakins./ 1881. This date is incorrect.

273. *Bas-relief of "Knitting"* c. 1883
bronze
18¾″ × 15″ (47.6 × 38.1 cm.)
Inscribed at bottom, apparently at time of casting: Knitting./ Thomas Eakins./ 1881. This date is incorrect.

274. *Professionals at Rehearsal* c. 1883
oil on canvas
16″ × 12″ (41.2 × 30.5 cm.)
UL: Eakins
J. Laurie Wallace playing the zither (with incorrect finger positions), and William MacLean (according to Goodrich) or Robert Reid (according to Charles Bregler), playing the guitar.

275. *In the Studio* 1884
watercolor on paper

21″ × 17″ (33.3 × 43.2 cm.)
Inscribed at bottom, by Mrs. Eakins: Unfinished water color/T. Eakins.
Unfinished. The Hyde Collection oil (CL-166) may be an oil study for this
work.

276. *Mrs. Thomas Eakins, Nude, from Back* c. 1884?
watercolor on paper
17″ × 9″ (43.2 × 22.8 cm.)
Bottom center, by Mrs. Eakins: Unfinished Water Color/T. Eakins.

276

277. *Unfinished Portrait of Blanche Hurlbut* c. 1884
oil on canvas
24″ × 20¼″ (60.9 × 51.4 cm.)
LR, by Mrs. Eakins: Thomas Eakins; on reverse by the artist: Eakins
Miss Hurlbut was an Academy pupil of Eakins. She may be seen in Illustra-
tion 40 in my book, *The Photographs of Thomas Eakins.*

277

278. *Portrait of Arthur B. Frost* c. 1884?
oil on canvas
27″ × 22″ (68.6 × 55.8 cm.)
Inscribed on the reverse: T. E.
Frost was an Academy pupil of Eakins and later a prominent illustrator. He is
probably second from the left in *The Swimming Hole* (CL-322). See also
CL-143.

279. *Sketch for Portrait of Professor George F. Barker* 1886
oil on cardboard
12½″ × 10⅛″ (31.8 × 25.7 cm.)
Barker was a professor at the University of Pennsylvania, and worked with
Eakins on the Muybridge Commission. The finished portrait, cut down, is in a
private collection (Fig. 158). The reverse has a sketch of a woman reading to
another.

279

280. *Sketch of Horses and Rider* 1887
oil on canvas mounted on cardboard
10½″ × 14½″ (26.7 × 36.8 cm.)
Made in the Badlands during Eakins' Dakota trip.

280

281. *Sketch of Cowboy in "Cowboys in the Badlands"* 1887
oil on canvas
24″ × 30″ (60.9 × 76.2 cm.)
Inscribed LR, not by artist: Study for picture/"Cow Boys in Bad Lands"/
Eakins
The right-hand cowboy of the finished work (Plate 33). Squared-off for en-
larging.

282

282. *Sketch of Landscape in Dakota Badlands* 1887
oil on canvas mounted on cardboard
10½″ × 14½″ (26.7 × 36.8 cm.)

283. *Sketch of Landscape in "Cowboys in the Badlands"* 1887
oil on cardboard
10½″ × 14½″ (26.7 × 36.8 cm.)
On the reverse of CL-282.

283

284. *Sketch of Landscape for "Cowboys in the Badlands"* 1887
oil on canvas mounted on cardboard
10½″ × 14½″ (26.7 × 36.8 cm.)
Rough brush strokes show the position of figures at the brink of the chasm.

284

285. *Sketch for "Portrait of a Lady"* 1888
oil on cardboard
14″ × 11″ (35.6 × 27.9 cm.)
LL, not by artist: T.E.
Mrs. Letitia Wilson Jordan Bacon, David Wilson Jordan's sister. The finished
portrait is in the Brooklyn Museum (CL-173). The finished portrait is in-
scribed 1888.

286. *The Red Shawl* c. 1890

285

286

287

289

291

293

295

296

oil on canvas
24″ × 20″ (60.9 × 50.8 cm.)
Formerly signed on reverse: Eakins
Probably a professional model.

287. *Sketch for "The Singer"* c. 1890
oil on canvas mounted on wood
14⅜″ × 10⅜″ (36.5 × 26.3 cm.)
The finished portrait for which this is a sketch is said to have taken two years to produce. Since that portrait is dated 1892, I have given this sketch an estimated date of 1890.

288. *The Concert Singer* 1892
oil on canvas
75″ × 54″ (190.5 × 137.2 cm.)
UR: Eakins/92.
Weda Cook, later Mrs. Stanley Addicks. The hand lower left is said to be that of Charles M. Schmitz, conductor of the Germania Orchestra. Miss Cook is shown singing "O Rest in the Lord" from Mendelssohn's *Elijah*, and likely the note on "for" in the second phrase of the song. Eakins himself produced the frame, on which he carved (incorrectly) a phrase from the aria.

289. *The Black Fan [Portrait of Mrs. Talcott Williams]* c. 1891?
oil on canvas
80¼″ × 40″ (203.8 × 101.6 cm.)
Sophie Wells Royce Williams. Unfinished.

290. *Portrait [The Bohemian]* c. 1890
oil on canvas
24″ × 20″ (60.9 × 50.8 cm.)
LR: Eakins
Franklin Lewis Schenck, Eakins' pupil.

291. *Cowboy Singing* c. 1892
oil on canvas
24″ × 20″ (60.9 × 50.8 cm.)
LR, by Mrs. Eakins: Eakins
Franklin Lewis Schenck dressed in Eakins' cowboy clothes.

292. *Portrait of Franklin Lewis Schenck with a Guitar [Home Ranch]* 1892
oil on canvas
24″ × 20″ (60.9 × 50.8 cm.)
Signed on table at right: Eakins 1892
Samuel Murray is seated at table at right.

293. *Bas-relief of Grant's Horse for The Brooklyn Memorial Arch* 1892
plaster
c. 25″ × c. 26″ (c. 63.5 × c. 66.1 cm.)
Lower center: Eakins/1892
Inscribed upper left, possibly by founder: Clinker charger/belonging to/A J Cassatt Esq/Chesterbrook Farm Berwyn/Penna. The dimension and markings are somewhat conjectural since specific information was not made available. The museum also owns a bronze cast of this plaster.

294. *Portrait of Joshua Ballinger Lippincott* 1892
oil on canvas
30″ × 25″ (76.2 × 63.5 cm.)
LL: T. E./92.
Painted from a photograph after the sitter's death.

295. *Sketch for Portrait of Dr. Jacob Mendez Da Costa* 1893
oil on canvas mounted on cardboard
14½″ × 10½″ (36.8 × 36.7 cm.)
LR, possibly by Mrs. Eakins: Sketch. T. E.

296. *Portrait of Mrs. Frank Hamilton Cushing* 1895?
oil on canvas
26″ × 22″ (66.1 × 55.8 cm.)

LR, probably by Mrs. Eakins: T. E.

The logical time for this painting is the time of Mrs. Cushing's husband's portrait, 1895 (CL-207.)

297. *Portrait of Mrs. James Mapes Dodge* 1895
oil on canvas
24¼″ × 20¼″ (61.6 × 51.4 cm.)
LR: Eakins 96/to his friend/James M. Dodge

298. *Portrait of Benjamin Eakins* c. 1895
oil on canvas
24″ × 20″ (60.9 × 50.8 cm.)
The father of the artist. Goodrich wrote, possibly from information from Mrs. Eakins, that this portrait was painted about 1899. But it was shown in an exhibition in 1896, hence the earlier estimate.

299. *Study for "The Wrestlers"* 1899
oil on canvas
40″ × 50″ (101.7 × 127 cm.)
Squared-off for enlarging. Joseph McCann on top. See CL-202.

299

300. *Study of Billy Smith for "Between Rounds"* 1899
oil on canvas
20″ × 16″ (50.8 × 40.7 cm.)

300

301. *Between Rounds* 1899
oil on canvas
50¼″ × 40″ (127.7 × 101.6 cm.)
Signed LR: Eakins 99
Depicts a prizefight of April 22, 1898, in the Arena, at the corner of Broad and Cherry streets, Philadelphia. The fighter is Billy Smith, the timekeeper is Clarence Cranmer (page 284), the second is Ellwood McCloskey, and the towel waver is Billy McCarney. Cf *Salutat*, CL-132, Fig. 259. Another of Eakins' perversities is in *Between Rounds*. As I have noted in *Salutat* (CL-132), the shows advertised here in the posters opened on April 11, 1898, and April 18, 1898. Thus, by the time of this fight, April 22, they were anachronisms.

302. *Portrait of Dr. Edward J. Nolan* c. 1900?
oil on canvas
24″ × 20″ (60.9 × 50.8 cm.)
LR: Eakins
Nolan was Secretary of the Academy of Natural Sciences of Philadelphia, and Eakins had considerable contact with him when he prepared his 1894 paper. Goodrich dates this in about 1900, but I have added the question mark because of the earlier contact.

302

303. *Addie* c. 1900
oil on canvas
24″ × 18″ (60.9 × 45.8 cm.)
Inscribed on reverse, probably by Mrs. Eakins: T. E.
Mary Adeline Williams.

304. *Antiquated Music* 1900
oil on canvas
96″ × 72″ (243.8 × 182.9 cm.)
LR: Eakins 1900
Mrs. William D. Frishmuth, collector of musical instruments. An identification of the instruments is given in a key in Fig. 265.

305. *Sketch for Portrait of Professor Leslie W. Miller* 1901
oil on cardboard
13¼″ × 9½″ (33.7 × 24.7 cm.)
Squared-off for enlarging. There is a sketch of the dog Harry on the reverse.

305

306. *Portrait of Professor Leslie W. Miller* 1901
oil on canvas
88⅛″ × 44″ (223.8 × 111.8 cm.)
LR: Eakins/1901

307

308

311

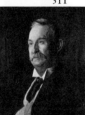

312

313

315

Miller was principal of the School of Industrial Art in Philadelphia, and the poster in the left background contains instruction material.

307. *Unfinished Portrait of Mrs. Elizabeth Duane Gillespie* c. 1901?
oil on canvas
45″ × 30″ (114.3 × 76.2 cm.)
Inscribed on reverse, possibly in Eakins' hand: Unfinished. Portrait./Mrs. E. D. Gillespie./By. Thomas. Eakins./Presented. by. Him. to. the./Pennsylvania. School. of./Industrial. Art. 1901.
Mrs. Gillespie was a great granddaughter of Benjamin Franklin.

308. *Portrait of a Young Man* c. 1902
oil on canvas
45″ × 26″ (114.3 × 66.1 cm.)
LR, apparently by Mrs. Eakins: T. Eakins
Kern Dodge, Mrs. James Mapes Dodge's son. Unfinished.

309. *Unfinished Portrait of Suzanne Santje [The Actress]* 1903
oil on canvas
80″ × 59½″ (203.2 × 151.2 cm.)
LL: Eakins/1903
A portrait of, possibly, Miss Santje's husband, Al Roth, is on the wall at the right.

310. *Sketch for Portrait of Mother Mary Patricia Joseph Waldron* 1903
oil on canvas mounted on cardboard
14⅜″ × 10½″ (36.5 × 26.7 cm.)
LR, by Mrs. Eakins: Sketch/T. E.
The finished portrait is lost, possibly destroyed by William Antrim, who was asked to paint Mother Waldron's portrait from a photograph after Eakins' work was rejected.

311. *The Oboe Player* 1903
oil on canvas
36″ × 24″ (91.4 × 60.9 cm.)
Signed on back of chair at LL: Eakins 1903
Dr. Benjamin Sharp, an amateur oboist and a zoologist.

312. *Portrait of Edward Taylor Snow* 1904
oil on canvas
24″ × 20″ (60.9 × 50.8 cm.)
Inscribed on reverse: To my friend/E. Taylor Snow/Thomas Eakins/1904
Snow was a prominent member of the Art Club of Philadelphia.

313. *Sketch for "Music"* 1904
oil on canvas mounted on cardboard
13″ × 15″ (33.1 × 38.2 cm.)
Hedda van den Beemt, for a number of years a member of the Philadelphia Orchestra.

314. *Portrait of Rear Admiral George Wallace Melville* 1905
oil on canvas
48″ × 30″ (121.9 × 76.2 cm.)
LR: Eakins 1904
Inscribed on reverse in capitals: Rear Admiral/George. Wallace. Melville. U. S. N. Born New York City January 10 1841/entered U. S. Navy July 29, 1861./1881 Chief Engineer/1887 Engineer in Chief/1898 rear Admiral/1904/Retired/Member of the Hall relief/Expedition 1873/Chief Engineer Jeanette Expedition 1879–82/Chief Engineer Greeley Relief Expedition 1883/Degrees/L. L. D. (Pa) D. E. (Stevens) M.A. (Georgetown) M. E (Columbia)
Melville is wearing three medals, left to right: the Veteran Medal of the Grand Army of the Republic, 2, the medal of the Military Order of the Loyal Legion, and 3, the Jeanette Expedition medal. The Hall, Jeanette and Greeley expeditions were Arctic explorations, and Melville distinguished himself in these.

315. *Sketch for Portrait of Monsignor James P. Turner* c. 1906

oil on cardboard
14½″ × 10½″ (36.8 × 26.7 cm.)
LR, by Mrs. Eakins?: T. E.
The portrait for which this is a sketch is now at the Miseracordia Hospital in
Philadelphia.

316. *Portrait of Helen Montanverde Parker* [*The Old-Fashioned Dress*] c. 1907
oil on canvas
60⅛″ × 40¼″ (152.7 × 102.3 cm.)
LR, evidently not by Eakins: T. E.
A photograph of Miss Parker relates closely to this portrait (Fig. 293). The
Museum also owns the dress in which Miss Parker posed.

317. *Landscape with Dog* Undated
oil on canvas
18″ × 32″ (45.7 × 81.3 cm.)
If the dog in this painting were Harry, we could at least date the work within
Harry's lifetime, c. 1880–c. 1895, but it is not Harry.

317

Recent conservation work has also revealed a drapery study and a sketch of
two figures in an interior on the reverses of two of the above works. Informa-
tion concerning these has not been made available.

In addition, the Philadelphia Museum also owns approximately 34 photographs
I attribute to Eakins; a small wooden object used in teaching; the account book
referred to frequently in this book (e.g., page 22); a manuscript dealing
with the subject of perspective evidently used for lectures; a manuscript
describing Eakins' work with Muybridge, including several sketches, and cor-
responding closely with the published version; an Eakins letter to his father of
April 1867; miscellaneous photographs of Eakins and his students; and nu-
merous letters from Mrs. Eakins and others. The Museum also owns a cast of
Eakins' hand by Murray, Murray statuettes, a portrait of Eakins by his wife
(Fig. 156), and a portrait of Eakins by Charles Fussell (Fig. 31).

PITTSBURGH
Museum of Art Carnegie Institute:

318. *Portrait of Joseph R. Woodwell* 1904
oil on canvas
24″ × 20″ (60.9 × 50.8 cm.)
LR: To my friend/Joseph R. Woodwell/Thomas Eakins/1904

318

READING
The Reading Public Museum and Art Gallery:

319. *Portrait of Charles L. Fussell* ATT.
oil on canvas
42″ × 36″ (106.7 × 91.4 cm.)
UR: Eakins

RHODE ISLAND

PROVIDENCE
Museum of Art Rhode Island School of Design:

320. *The Ball Players Practicing* [*Baseball Players Practicing*] 1875
watercolor and pencil on paper
10¹³⁄₁₆″ × 12⅞″ (27.5 × 32.7 cm.)
LC: Eakins/75

TEXAS

AUSTIN
The University of Texas Art Museum:

321. *At the Piano* 1870?
oil on canvas
22″ × 18¼″ (55.9 × 46.4 cm.)

The artist's sisters, Fanny at the piano and Margaret listening. Probably one of Eakins' first works after his return from Paris. Heavy impasto and errors in perspective make it seem experimental.

Fort Worth Art Center Museum:
322. *The Swimming Hole* 1883–1885
oil on canvas
27″ × 36″ (68.6 × 91.4 cm.)
Signed at right of rock pier: Eakins 1883
Left to right: Jesse Godley?, Arthur B. Frost?, unidentified model, J. Laurie Wallace, Harry, George Reynolds?, Eakins. This painting, like *The Concert Singer* and perhaps *A May Morning in the Park*, was years in finishing. Although Eakins signed and dated it in 1883 he continued to work on it for two more years.

VIRGINIA

The Virginia Museum of Fine Arts:

323. *Portrait of Eleanor S. F. Pue* 1907
oil on canvas
20″ × 16″ (50.8 × 40.7 cm.)
See my article, "The Belle with the Beautiful Bones," *Arts in Virginia*, Fall 1968.

323

WASHINGTON

Charles and Emma Frye Art Museum:
324. *Maybelle* 1898
oil on canvas
24″ × 18″ (60.9 × 45.7 cm.)
On reverse: To my friend, Mrs. Schlichter. Thomas Eakins, 1898
Mabel Schlichter, the wife of the referee in *Taking the Count* (CL-23).

324

In addition to the preceding public collections, there are two notable private collections of Eakinses, both in Philadelphia: the Jefferson Medical College (now called the Thomas Jefferson University), and the St. Charles Borromeo Seminary in Overbrook.

Jefferson Medical College:
325. *Portrait of Professor Benjamin Howard Rand* 1874
oil on canvas
60″ × 48″ (152.4 × 121.9 cm.)
LL: Eakins 74
Eakins had a great deal of trouble with this portrait. X-rays show many false starts and changes.
326. *Portrait of Professor Gross (The Gross Clinic)* 1875
oil on canvas
96″ × 78″ (243.8 × 198.2 cm.)
Signed on operating table, LR: Eakins 1875
Samuel David Gross is in the center; Dr. Franklin West is taking notes on his lecture; the patient's female relative (sometimes said to have been posed by Eakins himself, which I believe to be unlikely) is at lower left; bottom center, Dr. Charles S. Briggs; lower right, Dr. Daniel Appel; right center, Dr. James M. Barton; between Gross and Barton, Dr. W. Joseph Hearn; at right of stairwell, Dr. Samuel W. Gross; at left of stairwell, "Hughie" the janitor (see my "Thomas Eakins's *Gross Clinic*," *The Art Bulletin*, March 1969, for a discussion of this identification); third from upper right, Robert C. V. Meyers (Fig. 75); right center, seated in amphitheater, the artist himself.

327. *Portrait of Professor William Smith Forbes* 1905
oil on canvas
84″ × 48″ (213.4 × 121.9 cm.)
LR: Eakins 1905; right center: Gvlielmus S. Forbes, M. D., qui legem novam de re anatomica gvbernio statvs Pennsylvaniae proposvit commendavit defensione stvdiosa ex Senatvs consvltv ferendem cvravit
This Latin inscription, all in Roman capitals, has been copied, with considerable error, on the reverse when the painting was rebacked. The following inscription has been added: Effiegem pinxit Thomas Eakins Philadelphiensis A. D. MCMV. Below and to the right the names of the committee who presented the painting are also written. The Latin inscription celebrates Forbes' authorship of the 1867 Anatomical Act of Pennsylvania.

St. Charles Borromeo Seminary:
328. *Portrait of Archbishop James Frederick Wood* 1877
oil on canvas
82″ × 60″ (208.3 × 152.4 cm.)
LR: Eakins 77
This portrait has been crudely "restored." A sketch for it is in the Yale University Art Gallery (CL-15).

329. *Portrait of Monsignor James P. Turner* c. 1900
oil on canvas
24″ × 20″ (60.9 × 50.8 cm.)

329

330. *The Translator* 1902
oil on canvas
50″ × 40″ (127 × 101.6 cm.)
Lower center: Cygni Vaticani Leonis XIII vocem canorum auribus Anglicis accommodavit Hugo Thomas Henry E vivo depinxit Thomas Eakins A D MCMII
The Right Reverend Monsignor Hugh T. Henry, a prominent Catholic translator of, including other items, works of Pope Leo XIII, whose portrait is at the left.

330

331. *Portrait of James A. Flaherty* 1903
oil on canvas
27″ × 22″ (68.6 × 55.9 cm.)
UR: T. E. 1903

332. *Portrait of Monsignor James F. Loughlin* 1902
oil on canvas
90″ × 45″ (228.6 × 114.3 cm.)
LR: Eakins 1902

331

333. *Portrait of the Right Reverend Monsignor Patrick J. Garvey* 1902
oil on canvas
24″ × 20″ (60.9 × 50.8 cm.)
Inscribed on reverse: REVERENDVM. DOM. VM./PATRITIVM. I. GARVEY. S.T.D./ RECTORVM. SEMINARII./STI. CAROLI. APVD. OVERBOOK./VIVVM. DEPINXIT./THOMAS. EAKINS. A.D. MCMII.
In inscriptional Latin it is customary to place a period between each word, halfway up the side of the last letter.

332

PAINTINGS BY EAKINS NOT IN PUBLIC COLLECTIONS:

The works listed above in the Checklist include all known works by Eakins in public collections throughout the United States. The following works are paintings by Eakins mentioned in the text of this book that do not belong to public collections but are in private hands or unlocated.

Portrait of Carmelita Requena 1870 (oil on canvas; private collection; page 61.)
Sketch of Benjamin Eakins c. 1870? (watercolor on paper; private collection; page 67.)
Portrait of M. H. Messchert 1871 (oil on canvas?; unlocated; page 71.)

Portrait of Mrs. James W. Crowell c. 1871 (oil on canvas; private collection; page 67.)

The Schreiber Brothers 1874 (oil on canvas; private collection; page 74.)

A Pair-Oared Shell c. 1874 (oil on canvas?; unlocated; page 82.)

Drifting Race 1874? (watercolor on paper; unlocated; page 81.)

Sketch of Robert C. V. Meyers for "Portrait of Professor Gross" 1875 (oil on paper; private collection; page 88.)

Baby at Play 1876 (oil on canvas; private collection; page 110.)

Abandoned Version of "William Rush Carving His Allegorical Statue of the Schuylkill" 1876 (oil on canvas; private collection; page 114.)

Nude Woman (Study for "William Rush"?) 1876 (oil on canvas; private collection; page 114.)

Sketch of Columbus in Prison c. 1876 (oil on canvas; Kennedy Galleries; page 188.)

Portrait of Rutherford B. Hayes 1877 (oil on canvas; unlocated; page 116.)

Portrait of Dr. John H. Brinton 1878 (oil on canvas; Armed Forces Museum; page 110.)

Portrait of Mrs. John H. Brinton 1878 (oil on canvas, private collection; page 110.)

Illustration for "Scribner's Magazine," November 1878 (unlocated; page 147.)

Illustration for "Scribner's Magazine," November 1878 (unlocated; page 147.)

The Brinton House c. 1878? (private collection; page 110.)

Portrait of George Cadwalader 1880? (oil on canvas; Mutual Assurance Company, Philadelphia; page 170.)

Illustration for "Scribner's Magazine," July 1881 (unlocated; page 147.)

Sketch for "Meadows, Gloucester" c. 1882 (oil on wood, private collection; page 150.)

Portrait of Mrs. William Shaw Ward 1884 (oil on canvas; private collection; page 170.)

Study of Harry Barnitz 1884? (oil on canvas? private collection; page 173.)

Copy of "Lady with a Setter Dog" 1886 (unlocated; page 168.)

Portrait of George F. Barker 1886 (oil on canvas; private collection; page 169.)

Cowboys Circling 1887? (unlocated; page 178.)

Portrait of Douglass Hall c. 1888? (oil on canvas; private collection; page 179.)

Portrait of Edward Boulton c. 1888? (oil on canvas; unlocated; page 187.)

The Agnew Clinic 1889 (oil on canvas; the University of Pennsylvania; page 184.)

Portrait of Samuel Murray 1889 (oil on canvas; private collection; page 186.)

Portrait of Talcott Williams c. 1890 (oil on canvas; private collection; page 180.)

Portrait of James Wright c. 1890? (oil on canvas; private collection; page 188.)

Portrait of Thomas B. Harned c. 1890? (oil on canvas; private collection; page 191.)

Portrait of Dr. Jacob Mendez Da Costa 1893 (oil on canvas; The Pennsylvania Hospital; page 225.)

Portrait of Gertrude Murray 1895 (oil on canvas; private collection; page 230.)

Portrait of James MacAlister c. 1895? (oil on canvas; unlocated; page 232.)

Portrait of Harrison Morris 1896 (oil on canvas; private collection; page 219.)

Portrait of Dr. Charles Lester Leonard 1897 (oil on canvas; University of Pennsylvania; page 253.)

Portrait of John N. Fort 1898 (oil on canvas; unlocated; page 241.)

Portrait of David Wilson Jordan 1899 (oil on canvas; Kennedy Galleries; page 241.)

Portrait of Frank St. John 1900 (oil on canvas; private collection; page 248.)

Clara c. 1900 (oil on canvas; Musée d'Art Moderne, Paris, France; page 247.)

Unfinished Portrait of Emily Sartain 1890s? (oil on canvas; private collection; page 37.)

Portrait of Ellwood Potts 1890–1900? (oil on canvas?; unlocated; page 244.)

Portrait of Monsignor James P. Turner 1902 (oil on canvas; Miseracordia Hospital, Philadelphia; page 253.)

Portrait of Archbishop William Henry Elder 1903 (oil on canvas; Archdiocese of Cincinnati; page 254.)

Portrait of Mother Mary Patricia Joseph Waldron 1903 (oil on canvas; unlocated; page 254.)

Portrait of Mrs. Kern Dodge 1904 (oil on canvas; private collection; page 255.)

Portrait of William R. Hallowell 1904 (oil on canvas; private collection; page 254.)

Portrait of Admiral George Melville 1905 (oil on canvas; private collection; page 254.)

Portrait of John B. Gest 1905 (oil on canvas; Fidelity Bank, Philadelphia; page 258.)

Portrait of Cardinal Martinelli 1906 (oil on canvas; private collection; page 253.)

Portrait of Dr. William Thomson 1907 (oil on canvas; College of Physicians of Philadelphia; page 261.)

Portrait of Thomas Eagan 1907 (oil on canvas; private collection; page 262.)

Portrait of Dr. William Thomson 1907? (oil on canvas; private collection; page 261.)

Portrait of Rebecca Macdowell c. 1908 (oil on canvas; Kennedy Galleries; page 263.)

Portrait of Dr. Gilbert Lafayette Parker 1910 (oil on canvas; private collection; page 267.)

Portrait of Gilbert Sunderland Parker 1910 (oil on canvas; unlocated; page 267.)

Index

This book was set on the linotype in Janson by Brown Brothers Linotypers Inc., New York. The display type is Goudy Old Style.
The black-and-white photographs and text were printed by Halliday Lithograph Corp., Hanover, Mass., on Mead Matte stock. The color printing is by Dai Nippon Printing, Ltd., Tokyo, Japan.
The book was bound in the United States by Halliday Lithograph Corp. Designed by Jacqueline Schuman.